CHASING BEAUTY

ALSO BY NATALIE DYKSTRA

Clover Adams: A Gilded and Heartbreaking Life

CHASING BEAUTY

The Life of
ISABELLA STEWART GARDNER

NATALIE DYKSTRA

MARINER BOOKS
New York Boston

The List of Illustrations on pages 403–8 is an extension of the copyright page. All art insert illustrations unless otherwise specified are courtesy of the Isabella Stewart Gardner Museum, Boston. Images 2, 4, 7, 9, 12, 15, and 17 licensed by the Museum via Bridgeman Art Library.

CHASING BEAUTY. Copyright © 2024 by Natalie Dykstra. All rights reserved. Printed in the United States of America. No part of this book may be used or reproduced in any manner whatsoever without written permission except in the case of brief quotations embodied in critical articles and reviews. For information, address HarperCollins Publishers, 195 Broadway, New York, NY 10007.

HarperCollins books may be purchased for educational, business, or sales promotional use. For information, please email the Special Markets Department at SPsales@harpercollins.com.

FIRST EDITION

Designed by Alison Bloomer

Library of Congress Cataloging-in-Publication Data has been applied for.

ISBN 978-1-328-51575-9

24 25 26 27 28 LBC 6 5 4 3 2

For Mike Bundy

*It was only a picture, but sighing deeply
he let his thoughts feed on it, and
his face was wet with a stream of tears.*
—VIRGIL, *THE AENEID*

CONTENTS

Prologue: Notes on a Museum 1

PART I: BECOMING BELLE

One: A New York Girl, 1840–55 11
Two: "A Far-Famed City," 1856–58 20
Three: Mr. and Mrs. Jack, 1859–61 33
Four: "Remaining Dear Ones," 1862–65 46

PART II: AROUND THE WORLD

Five: A Return, 1866–67 59
Six: "Mrs. Gardner's Album," 1868–73 64
Seven: "Zodiacal Light," 1874–75 74
Eight: "Millionaire Bohémienne," 1876–80 87
Nine: The Cosmopolitan, 1880–83 96

PART III: MOTION AND LIGHT

Ten: The Way of the Traveler, 1883–84 111
Eleven: "A Whirlwind of Suggestion," 1884 125
Twelve: "The Fiddling Place," 1884–87 134
Thirteen: Love and Power, 1886–88 148
Fourteen: Seeing Wonder, 1888–89 160

PART IV: FANCY THINGS AND ORDINARY OBJECTS

Fifteen: "Dazzling," 1889 173
Sixteen: In the Middle of Things, 1890–91 182
Seventeen: The Concert, 1892 193
Eighteen: To Remake the World, 1893 204
Nineteen: "The Age of Mrs. Jack," 1894–95 214
Twenty: A Poem, 1896 226
Twenty-One: "List of Things for the Museum," 1897 237
Twenty-Two: "I Always Knew Where to Find Him," 1898 246

PART V: ONE-WOMAN MUSEUM

Twenty-Three: Fenway Court, 1899–1901 *261*
Twenty-Four: God Is in the Details, 1902–3 *277*
Twenty-Five: Unfathomable Heart, 1903–4 *289*
Twenty-Six: "Lonesome Cloud," 1904–5 *305*
Twenty-Seven: "The Whole Interesting World of Paris," 1906 *314*
Twenty-Eight: "Undying Beauty and Light," 1907–9 *324*

PART VI: A DREAM OF YOUTH

Twenty-Nine: Seeing and Hearing Modernism, 1910–13 *339*
Thirty: The Dancer, 1914 *356*
Thirty-One: Blood and Thunder, 1915–18 *364*
Thirty-Two: "Very Much Alive," 1919–22 *373*
Thirty-Three: Spring, 1923–24 *383*

Epilogue: Lacrimae Rerum, or The Tears of Things *389*

ACKNOWLEDGMENTS *393*
A NOTE ON SOURCES *399*
LIST OF ILLUSTRATIONS *403*
NOTES *409*
SELECTED BIBLIOGRAPHY *473*
INDEX *479*

CHASING BEAUTY

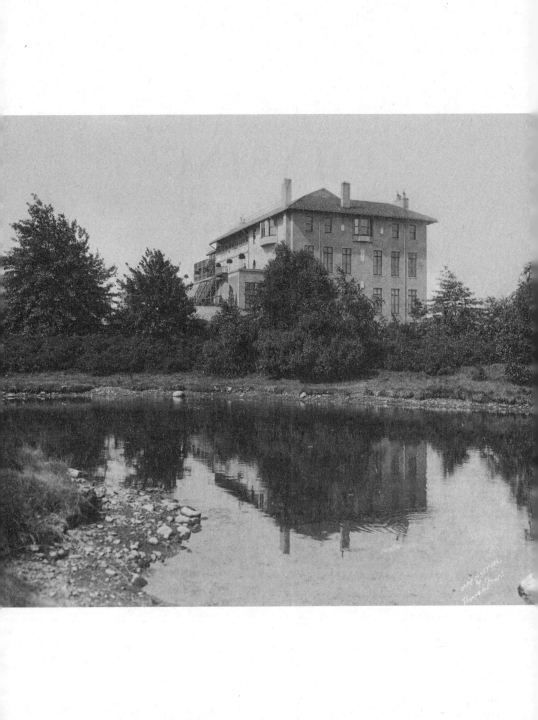

Prologue

NOTES ON A MUSEUM

At the turn of the twentieth century, a large palace rose on the edge of Boston's Fenway, marshland that would soon become part of a series of city parks called the Emerald Necklace. The plain facade of the four-story gray brick building was skirted on its east side by a high wall. Few people had seen beyond the building's spare wooden doors.

When the palace, known then as Fenway Court, opened as a museum in 1903, a surprise awaited the first visitors.

Pink stucco walls, resembling the exterior walls of palaces lining Venice's Grand Canal and pierced with balconies and arched windows, enclosed a stunning courtyard garden. High above, a glass roof let light pour in. Paintings, tapestries, prints, porcelain, rare books, manuscripts, and fine furniture filled three stories of the surrounding spacious galleries. Classical marble figures stood tall in the courtyard amid palm trees and delphinium, and at its center was a second-century Roman mosaic floor fabricated during Hadrian's rule featuring a snake-wreathed head of Medusa.

Rubens and Holbein portraits, three Rembrandts, and a small Vermeer, *The Concert,* hung on green silk-covered walls; nearby galleries displayed Italian Renaissance paintings by Raphael and Botticelli, Fra Angelico and Titian; intricate Chinese embroidery, animal figures made of jade, and a large Japanese screen could be found in another. Painted and stamped leather panels covered the walls of one room decorated with a large eighteenth-century Venetian mirror,

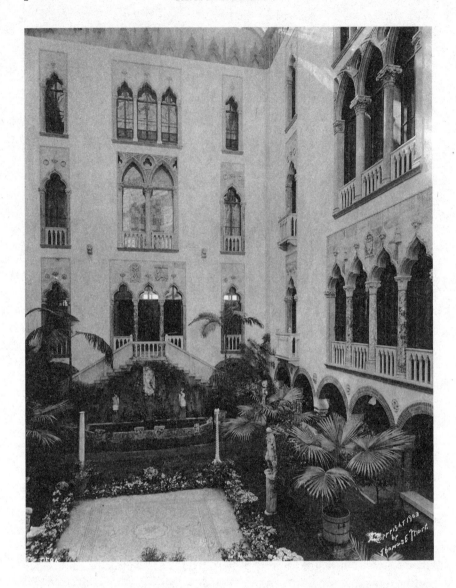

ten walnut armchairs, an exhibit of precious old lace, and four small pastels by James Abbott McNeill Whistler. On a balcony railing overlooking the courtyard a Japanese roof tile in the shape of a dove perched, keeping watch, while the sounds of the courtyard fountain filled the air.

Visitors were then, as today, drawn in by the expanse and revelation of the courtyard and galleries, by the way one moves from outside to inside, as if experiencing the light and shadow of a Venetian day. No single artwork

appears in isolation but rather in assemblages or tableaux of historical, cultural, and personal import. Anne Hawley, the museum's emerita director, rightly calls Isabella Stewart Gardner an "installation artist" because of the way she put artwork and other objects together in unexpected combinations. Francine Prose has written that to step into the museum is to enter "Isabellaland."

Here, one of the most important art collections in America is displayed in a singular and dramatic way. A question posed in a popular journal near the time the museum opened is still relevant all these years later: "What manner of woman is she who . . . has built this unique temple of art?"

ISABELLA STEWART GARDNER, WIDOWED AFTER ALMOST FOUR DECADES of marriage, was informally known as "Mrs. Jack," a reference to her late husband, John "Jack" Lowell Gardner Jr. She had opened Fenway Court just before her sixty-third birthday, having imagined and planned for every part of it—from choosing and purchasing the art to collecting the building parts to supervising the design of the palazzo from the ground up to applying a sample of the specific Venetian pink paint to the courtyard walls.

She wrote little about what the museum meant or her reasons for creating it; she preferred to let her visitors form their own impressions. Yet she knew very well how much she had accomplished. She said to a friend at the end of her life: "Years ago I decided that the greatest need in our country was art. We were a very young country and had very few opportunities of seeing beautiful things . . . So I determined to make it my life's work if I could." She also ensured that future visitors to her museum would see the art in much the same way as those first visitors in 1903, stipulating in her will not only that the museum would be known as the Isabella Stewart Gardner Museum after her death but also that her arrangement of the rooms could never be changed. She hired the best architectural photographers, Thomas E. Marr and his son, Arthur Marr, to document every gallery in order to safeguard her vision.

IN HER OWN TIME AND NOW, ISABELLA STEWART GARDNER SEEMS LIKE A bright sun—we can look around her but not directly at her. She radiates but confuses. A relative remembered how she "filled the air." Another thought

her charisma was "like dynamite." She carried herself with noted sureness, with a "gliding walk" like a "proud ship in full sail." Young people particularly liked to be with her because of how she "annihilated the thought and possibility of failure." She had a wonderful wit. Morris Carter, her friend, the first director of the museum, and later her first biographer, recalled in his private notes: "I said I wished I could find out what was the first thing she did that startled Boston. I said I used the word 'startle' to avoid the more terrible world 'scandalize.' She looked as roguish as possible and said that she 'never did anything of the kind, that [she] had always led a very quiet uneventful life.'"

She had had many advantages. The eldest daughter of a wealthy New York family, she was educated at a Paris finishing school, followed by an early and envied marriage into the prominent Gardner family of Boston. But all this did not protect her from the terrible pain of losing her only child. A friend noted her tendency to be self-protective, remarking that she "rarely expressed her feelings" directly. She was fiercely loyal. She donated large sums to a wide variety of causes, without expecting acknowledgment. When visiting women in hospital who were recovering from childbirth or illness, she dressed as inconspicuously as possible.

Yet she had a reputation for being an attention-seeking busybody, with money enough to boss most everyone around. Isabella surely relished having all eyes on her. Early on, she carefully collected reports of her to-ings and fro-ings in society, knowing that mentions in the newspapers need not be positive to be good. She was often portrayed as imperious and eccentric. She provoked proper society with her shenanigans, such as taking a carriage ride with lion cubs from the zoo or wearing a headband emblazoned with the words "Oh, you Red Sox" at Boston's Symphony Hall. At one point, she so alarmed upright Bostonians that they forbade their daughters to go to her home, afraid their honor would be besmirched.

The stereotype recast her intense drive, her fearlessness, and her entrepreneurial skills as something far less potent and disruptive, easier to mock and set aside. But many recognized her distinction. Morris Carter wrote, in a letter to his niece in 1963, "When I knew her, she did not seem as flamboyant as writers think she was. She was independent, original, and determined." She had a method to her work, which she explained in an undated letter: "I am obliged to correct my steps—that is, to do only certain things

and not to add outside ones. I have a great deal of constant and necessary work to do that I can accomplish only in that way." No one, except maybe her husband, Jack Gardner, would have suspected she could accomplish all that she did.

Isabella was a late bloomer, a woman who saw what was expected of her as a Boston matron and decided to be something else. She made sense of her long life through far-reaching travel, avid collecting, and an all-consuming pursuit of beauty, which came to form the through line of her story. The record she left to the world is her *Wunderkammer,* her world of things.

There is a journey one makes at Fenway Court. From the exuberant celebration of earthly life on the first floor, with the Farnese sarcophagus and the blooming courtyard; up the staircase to galleries that display the enormous power of queens and kings and popes; to the Titian Room—its walls covered with luxurious red textiles—named after the painting by the Italian Renaissance master that was one of Isabella's greatest prizes. From this triumphant moment, a turn into the Long Gallery, with its Bardini Blue walls, presents images of ultimate sacrifice and pain: Botticelli's Madonna cradling the boy she knows will one day die; Giovanni della Robbia's *Lamentation over the Dead Christ,* sorrow sealed in Mary's face; and a final turn to the glorious colors of the medieval French stained-glass window at the end of a narrow corridor in the small chapel. *This* is what mattered to her—as one ascends the steps of the museum, one is immersed in splendors of temporal power, but then a turn is made near the end to the spiritual, to everything that can never be contained in a museum.

AT THE TIME OF FENWAY COURT'S OPENING, A FRIEND NOTED THAT "YOU have her when you have the museum"—so much does it express her aesthetics, desires, preoccupations, and inner life. Her "letter to the world," to borrow Emily Dickinson's phrase, is not made up of words but rather stone and fabric and flower and paint and object. And she invites us to join her. The motto above the entry to her palace tells us why: *C'est Mon Plaisir,* "It is my pleasure."

ON SEPTEMBER 14, 1922, AN ESPECIALLY WARM DAY, THE PAINTER JOHN Singer Sargent paid a visit to Fenway Court, where Isabella Stewart Gardner,

now eighty-two years old, lived on the fourth floor, as she had since her museum's opening almost twenty years earlier. He knew the palace well. The two had been friends since Henry James introduced them in 1886. Two years after that, Sargent's large oil portrait of her, with its ropes of pearls and show of milky arms, scandalized Boston's elite Brahmin society—much to her delight. She invited the painter to live and work for a month at her museum after its opening, which he did, using the third-floor Gothic Room, kept closed to the public and one of her favorite galleries, as his studio. She collected a number of his works, including scenes of Venice and the American West, and his extraordinarily theatrical *El Jaleo*, with its life-size dancer in midstep, seemingly ready to sweep across the entire south wall of the first-floor Spanish Cloister.

Now Sargent asked to paint his friend's portrait again. He did so quickly—in the span of a morning's visit. A debilitating stroke in 1919 had paralyzed Isabella's right side, and though she managed to dress every day and was able to sit upright, her life had been much changed. She used the hydraulic elevator that she had installed decades before to travel from her fourth-floor apartment to spend time with her magnificent art collection on the lower floors of the palace. She liked to sit in her office, the Macknight Room on the first floor, surrounded by artwork made by her contemporaries, men and women both, with her books and travel mementos near at hand. She kept small treasures, including the tiny elephant figurines a friend sent from central Africa, in the drawers of an eighteenth-century Venetian desk placed against one window. Here in her office she received visitors and welcomed Sargent, who brought along his paints.

Sargent's composition, entitled *Mrs. Gardner in White*, is a harmony of color and pattern, suggested with light washes of color. Isabella is seated on a sofa against red-striped pillows, swathed head to foot in a shroudlike white fabric that frames her face and hides her crippled hand and right side. The painter's genius for depicting draped fabric is on full display. The watercolor painting has "both clarity and mystery," to borrow Colm Tóibín's precise phrase for what characterizes Sargent's best portraits. Sargent also catches a quality of Isabella's observable since childhood: a powerful force of feeling. If her body and limbs are still, her eyes hum and buzz with life. She had seen much—searing loss but also accomplishment

and great beauty. Margaret Chanler, a friend, thought it "a wonderful sketch of her in this last stage, pale and frail and dominating to the end," noting how "her green eyes had lost none of their bright malice—seeing, appreciating, appraising."

Sargent pictures Isabella in the here and now, even as her garment references what is to come. But he also renders something of a surprise. In his masterpiece of old age and impending death, he does not forget youth, her youth. A woman's bright lip and cascade of dark, curly hair is just visible in the shadow on the pillow behind the sitter's left shoulder. The image in the shadow is as unmistakable as it is provocative. It's as if Sargent is saying that even the ravages of age cannot dim the vitality of who Isabella once was, who she still is.

This, then, is her story.

PART I
BECOMING BELLE

※

*I'm sure Belle will go some way or rather,
for she has set her heart upon it.*
—HELEN WATERSTON, PARIS, 1857

One

A NEW YORK GIRL

1840–55

A ll her life, she was known for the way she moved, for her speed, for wanting to be first. She was thought to be the fastest runner at her girls' school in New York City, and when she flew across the dance floor, queries were made: wherever did she learn to dance like that?

Isabella Stewart was born on April 14, 1840, the first of four siblings, in New York City, a metropolis also on the move. Lithographs from the time show tall sailing ships crowding its waters. The city's protected port on the south end of Manhattan and the opening of the Erie Canal in 1825 made it ideal for foreign and domestic trade. New York would more than double in population as Belle grew up, to approximately 800,000 residents by 1860. The Stewart family lived first at 142 Greene Street, and then, in 1842, they leased a red-brick mansion at 10 University Place, which crosses Eighth Street, two blocks from Broadway and Washington Square. The neighborhood was then popular with rising merchants and the city's social elite. Belle's sister, Adelia, was born in 1842; David Jr. six years later; and James much later, in 1858, when Belle's mother, also named Adelia, was in her late forties.

Broadway cut a swath from the bustling lower harbor to farmland in the north, the avenue's width a striking contrast to the city's narrow streets laid

out generations before by Dutch settlers. A contemporary writer compared the crowds and rush of Broadway to a "constant river." Appleton's bookstore, bakeries, fruit stands, print and dry goods shops, auction houses and art suppliers populated the avenue. The photographer Mathew Brady established his Daguerreian Miniature Gallery on lower Broadway in 1844, next to P. T. Barnum's American Museum, which had opened a few years before. Düsseldorf Gallery, with its showings of international art, commenced business in 1849. Nearer to Washington Square, Dr. Henry Abbott, a British collector, charged twenty-five cents to see his many antiquities, over two thousand, at his large Egyptian Gallery. James Fenimore Cooper, then a New York–based writer, compared Broadway to the promenades of Europe. The abolitionist reformer Lydia Maria Child marveled at what she saw in the many large store windows that lined the avenue: "Beautiful candelabras gracefully held out their lily-cups of frosted silver, and prismatic showers of cut glass were upborne by Grecian sylphs, or knights of the middle ages, in gold armour." After a visit in 1842, Charles Dickens would list the many ways people traveled on the crowded avenue: "hackney cabs and coaches too; gigs, phaetons, large-wheeled tilburies, and private carriages . . ." But it was women and their fashion that elicited the novelist's exclamation. "Heaven save the ladies, how they dress! We have seen more colours in these ten minutes, than we should have seen elsewhere, in as many days." Henry James, then a child growing up on West Fourteenth Street, not a half mile from the Stewart family, recalled the hurly-burly of the street and how enormous theater billboards "rested sociably against trees and lampposts as well as against walls and fences." Though their families lived so close by, no record indicates these two contemporaries and later friends knew each other as children.

Belle's father, David Stewart, was a second-generation Scots American, born in 1810, the youngest son of Isabella Tod and James Stewart. When the elder James Stewart, who was a merchant in the city, died nine years after marrying in 1805, he left a wife and three young sons—James Arrott, Charles, and David. Madame Stewart never remarried.

The American painter Thomas Sully highlights the strength and forward-looking mien of the elder Isabella in his 1837 oil portrait, even as she wears the deep-black dress of proper widowhood. She debated whether to purchase property on Canal Street or farmland in rural Jamaica, Long Island, with her husband's very large bequest of $75,000. She chose the latter,

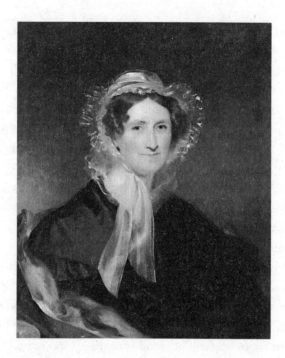

buying first ten acres and then adding to her property with half a dozen parcels of land purchased over three decades. There she raised her three sons and managed a thriving agricultural enterprise, which included milk cows and large, lush gardens. Morris Carter's account suggests some of her farm's profitability may have come from enslaved labor before New York outlawed slavery in 1827. But census records show this was not the case.

Belle, who would spend summer weeks at the Stewart farm to escape the city heat, would remember sitting by her grandmother's side for worship at Jamaica's Grace Church on the pew the older woman had purchased, as was done by wealthy members to support the congregation. Her essays published in agricultural journals describe the butter-making skills that won her first-place awards. One prize, a small silver pitcher with an engraved cow, is inscribed "Presented by the Agricultural Society of New York to Isabella Stewart, 2nd June 1821." The pitcher would be passed down to her namesake granddaughter, along with numerous other items, including her 1792 music book, mahogany furniture, and several of her dresses. Belle also kept a small New Testament, with a moss-colored cover, inscribed in her grandmother's hand: "Presented to Isabel Stewart from her affectionate Grandmother, 1847."

Belle's father, David Stewart, expanded on his parents' successes. While one of his older brothers went to work as a seaman and the other to farm on the Maryland shore, David, bookish and hardworking, left his mother's farm for Manhattan before he turned seventeen to make his own way. He started as a sales clerk at the importers Russell and Company and after several years joined with Thomas Paton to establish the two men's eponymous firm Stewart and Paton, at 65 Pine Street, which traded mostly in Irish and Scottish linen. By the time he and Adelia Smith (called Delia by the family) were married, at Saint John's Church in Brooklyn on May 7, 1839, he had purchased their home on cobblestoned Greene Street. He was twenty-nine, and she was twenty-four.

A portrait of David Stewart from the 1860s, a hand-colored albumen print, an early form of photography, shows his erect, self-assured posture and other features Belle would share—a high forehead, a round face with piercing eyes, and a confident, bemused expression. They held their shoulders in a similar way, and both had elegant hands with long fingers. They differed, however, in height—he stood at nearly six feet tall according to his passport, whereas she would grow to five foot four.

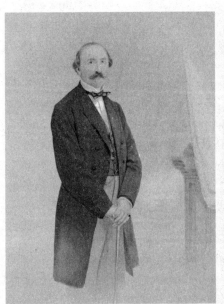 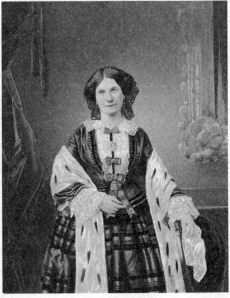

The only portrait of Belle's mother, Adelia Smith Stewart, is also a hand-colored albumen print from about the 1860s. It shows a trim, pretty woman, with a sweet smile and dark hair parted in the middle, following mid-century fashion. The ermine stole she holds around her shoulders signals her family's comfortable financial standing. Morris Carter, who began making notes for his 1925 biography of Isabella Stewart Gardner while his subject was still alive, recounts a brief memory suggesting that Adelia Stewart felt called upon, at least on one occasion, to be a disciplinarian. Little Belle takes off her uncomfortable shoes, the story goes, on her way home from Grace Church, ruining her Sunday stockings. This earns her a spanking from her disapproving mother.

A school friend of Belle's, Julia Gardner, who knew mother and daughter well, recalled a woman of warmth and confidence. When Julia visited the Stewarts at their New York home, Mrs. Stewart greeted her with "her arms wide open," urging she make herself "perfectly at home" and insisting she consider the Stewart home a "Liberty Hall." What is also clear: Belle and her mother shared interests in fashion and travel, theater and music. On the inside cover of a leather-bound album filled with portraits of European royals, Belle made this note: "photographs of royalties that belonged to my mother." This too was a shared interest.

BELLE WOULD TALK INFREQUENTLY OF HER CHILDHOOD OR HER FAMILY, which is not the same thing as a lack of interest. Sometime in the 1880s, she filled out a large, elaborate family genealogy chart, measuring sixteen by twenty-one inches, recording birth and death dates, marriages and children of the previous generations. Her mother's side of the family had been in America since the 1600s. Her Smith grandparents, Selah Smith and Anna Carpenter, were born in Jamaica, Long Island, in the revolutionary 1770s. Selah operated a tavern and stable at Old Ferry in Brooklyn. Belle left out, perhaps because she did not know, that he died in his forties in 1818 with sizable debts, so that his property, possibly including an enslaved person he owned, had to be sold to pay them off. Belle lists none of their nine children except their youngest, her mother. An ancestor on her father's side, his great-grandfather Lieutenant Elijah Kent, the father of Isabella Tod's

mother, Rachel Kent, qualified Belle to join the Daughters of the American Revolution.

The Stewart side of the family dominates Belle's genealogical chart, and her Scottish forebears were her particular interest. Entries go back as far as Allan Stewart Laird of Appin, who died in 1448. Under the entry listing James Stewart, born in 1660 and descended from Alexander Laird of Invernahlye, Belle includes the detail that he was "one of 10 sons who all attended church with their father in kilted plaids and arms." Fascinated by a hoped-for link between her branch of the Stewart family and Mary, Queen of Scots, she collected images of the doomed queen as well as relics—a fragment of Belgian needle-and-bobbin lace and a very small scrap of floral silk damask purported to be from one of Mary's dresses. A lifetime membership in the Stewart Society in Edinburgh was "hereby certified for Mrs. I. Stewart Gardner" in 1921.

Missing on the chart is a key piece of information—Belle's birth date. The official date, April 14, 1840, is stated in Morris Carter's 1925 biography and appears on the plaque marking her grave at Mount Auburn Cemetery, but there are discrepancies. Evidence in other records points to 1839 as her birth year.

THE STEWART SISTERS HAD PRIVATE TUTORS EARLY ON, AS DID MANY daughters in wealthy families, and something of their education can be gleaned from their earliest books, such as the popular *Line upon Line* and *Peep of the Day,* both published by John S. Taylor and Company. The daily devotionals for children connected correct behavior with religious belief. At five, Belle carefully inscribed the inside cover of each book with "I. Stewart, Nov. 4, 1845." Another volume on Belle's shelves, *Thoughts on Self-Culture,* encouraged restraint and discipline.

By 1854, Belle started attending school at 8–10 Clinton Place (now Eighth Street), a ten-minute walk from home. There were many educational establishments for girls, but the Stewarts chose to send their daughters to an academy started thirty years before by Mrs. Mary Okill, the daughter of Sir James Jay and niece of a Supreme Court justice, John Jay. Okill had divorced her husband, and her own mother had never married her father, refusing to say "obey" as required in marriage vows. Either Okill did not publicize her marital history or the Stewarts did not mind it. Okill had strongly held

beliefs about the importance of education for girls, promising in her advertising that she would "devote her time . . . to the religious principles, morals, and manners of those young ladies who may be confided to her care." Okill Academy students studied rhetoric, ancient Greek poetry, geography, and French and Italian while seated at a long seminar table in a high-ceilinged room with chandeliers hanging above their heads. Miss Stewart, as Belle was called at school, didn't mark the margins of her books. Her signature "I. Stewart" can be found on the opening page of some, such as Abraham Mills's *Lectures on Rhetoric and Belles Lettres* and *The Poets and the Poetry of the Ancient Greeks;* and August Mitchell's *Ancient Atlas, Classical and Sacred.*

Belle continued making entries in a sketchbook she'd started the year before, practicing lessons from a book of drawing instruction published in Paris. She drew horses, dogs, a man walking down a road. This was an important part of her preparation to enter society. An appreciation for art and the ability to draw would be, like fancywork and musical performance, essential accomplishments for a young woman of Belle's status. To become an artist, however, was seen as an ambition more proper to a young man. On a page of her sketchbook dated February 7, 1854, Belle wrote in a clear script, in the upper-left-hand corner, her opinion of her lopsided depiction of a house with a lake in front: "This is done very badly." Her other efforts were a little better, but not much. Nonetheless, she kept her work in safekeeping and would try again later, when she traveled abroad, to make a visual record, in line and color, of what she saw.

༺━༻

AT THE BEND OF BROADWAY AT TENTH STREET, THREE BLOCKS NORTH OF the Stewart home, the wooden steeple of Grace Church (her grandmother's church in Jamaica was also called Grace Church) rose high above other buildings and treetops, visible from almost any angle in the city. The French Gothic revival sanctuary had been finished in 1846, after the church's older building, located downtown near Battery Park, was deemed too small for its growing congregation. Its architect, the twenty-four-year-old prodigy James Renwick, who went on to build Saint Patrick's Cathedral in New York, had not yet been to Europe, so he studied every book on church architecture the congregation's leaders could find. When the Stewarts joined, and when little Belle and her siblings attended, the sanctuary windows were a mix of

clear and pastel-colored glass. The floor under the elevated pews was wood planking, and the walls and arches were made of Sing Sing marble, so called because it had been cut by inmates at the prison north of the city. George Loder, a distinguished composer from England, was the church's longtime musical director and organist.

David Stewart, who would serve as a trustee, bought a pew as a founding member for $650, paying a yearly rent of $52. From pew number 189, Belle and her family had an unobstructed view of the elevated and elaborately carved pulpit near the front of the nave.

In its fast-evolving neighborhood, Grace Church, a part of the Episcopal Diocese of New York, became one of the city's most fashionable congregations in the years before the Civil War. Surnames engraved on small brass plaques attached to pews were a who's who of antebellum New York: Astor, Schermerhorn, Brevoort, Rhinelander, Aspinwall, and Stuyvesant. Edith Newbold Jones, born in 1862 to Lucretia Rhinelander and George Frederic Jones, of the clan reputed to have inspired the phrase "keeping up with the Joneses," was christened in the church. The services were sometimes so packed that people would stand in the aisles or outside the windows to hear the preacher and the hymns. The pageantry of Grace Church, a potent and exclusive joining of sacred music, belief, and beauty, could be electrifying. It left a very strong impression on Belle.

On April 2, 1854, less than two weeks before Belle's April birthday, her sister, Adelia Stewart, died of a fever. She was twelve years old. There are no images of Adelia, no books with her name inscribed on a page, no letters or handiwork. She was buried first at Prospect Cemetery in Jamaica, Long Island, in colonial-era land connected to Madame Stewart's church, and later reburied in the family mausoleum at Green-Wood Cemetery in Brooklyn. "In the midst of life, we are in death" was the opening line to a prayer Belle would have known well from her church's Book of Common Prayer. The stark reminder appeared too in sermons and stitched samplers. Sudden loss, the kind that the Stewarts experienced, shakes foundations, as it must have done for Belle those spring days of her fourteenth year, with her parents in disarray from grief and worry and burning questions: "Why her? Who's next?" And more calamities followed.

Belle's parents recorded their losses in light and color, commissioning a set of stained-glass windows by the British Pre-Raphaelite artist Henry Holi-

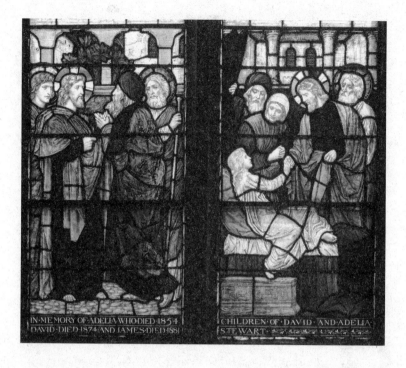

day for Grace Church's sanctuary. Installed in 1883, when Belle was traveling through Asia, the windows are known as "The Raising of Lazarus and of Jairus' Daughter." They remain today in memory of Adelia, and also of Belle's brothers: David Jr., who died of brain cancer in 1874, and James, who died in 1881 at the Stewart home, at the age of twenty-two, of a malarial fever that lasted nineteen days. Belle would see her mother and father when visiting in New York until their deaths in 1886 and 1891, respectively. Presumably, she attended Grace Church when in the city, but she made no record of the windows, nor of the siblings' deaths they commemorated, in her letters or private papers.

Even so, a line moves from Grace Church to Belle's future museum in Boston. In constructing Fenway Court all those years later, she testified to her vision of life through a circuitous return to a sacred space of her childhood, where relishing artistic splendor was a profound form of worship and remembrance. As innovative and sui generis as the museum was, it also followed a family path. Belle did as her parents had done but on a much larger scale. She transformed overwhelming personal loss into art, into beauty.

Two

"A FAR-FAMED CITY"

1856–58

Belle Stewart left Okill Academy sometime before the end of the school year in 1855 and finished the semester at Saint Mary's school. The exact location of her second school remains unclear, as do the reasons for the switch. Belle had thrived under Mrs. Okill's tutelage, earning on her school certificates both a "six perfect weeks" and "excellence in reviews." Yet she and her family had grappled with the sudden loss of her sister the year before; perhaps the academy was too full of those memories. Belle's friendship album, bound in leather, with poesy entries written in elaborate script on large pages, leaves little trace of these months. Only a classmate's signature here or a date there appears. Even so, a goodbye entry from May 1856, when she had been at her new school for a year—"A place in thy memory, Belle," wrote Sue Delafield—indicates that she would not return to Saint Mary's either.

Mr. and Mrs. Stewart were preparing to take Belle and little David for an extended tour of Europe. Mr. Stewart had several business interests to attend to in London while the rest of the family toured the sights. Belle tracked their early movements in her album: a colored print of Shakespeare's birthplace in Stratford-upon-Avon, followed by prints of scenes along the Rhine River and at Lausanne, Switzerland. The family's ultimate destination was Paris, where they arrived in the fall of 1856 in time for Belle to enroll in

a *pension* to continue her education. The Protestant boarding school—there are no records of its name—was located on the Right Bank at 37, chemin de Versailles, a block southeast of the Arc de Triomphe and a stroll down the wide and elegant Champs-Élysées to the Jardin des Tuileries. Here she would stay, then travel with her family to Italy, finally returning to New York two years later. Paris, aptly named the "far-famed city" by a boarding school friend, would change Belle's life.

꒰──꒱

PARIS IN THE SECOND EMPIRE, FOLLOWING THE 1848 REVOLUTION AND the ascendency of Napoleon III, was being remade yet again. By the 1850s, the city had grown to over a million residents. Thousands of horse-drawn carriages clattered through its narrow winding streets. Baron Haussmann, charged by the emperor to modernize the city, conceived a plan that, in his words, "ripped open the belly of old Paris, the neighborhoods of revolt and barricades, and cut a large opening through the almost impenetrable maze of alleys, piece by piece . . ." The center of the city became one enormous construction zone. Victor Hugo never forgave Haussmann for destroying much of medieval Paris, even as the latter installed clean water, planted thousands of trees, and lit the evening sky with row upon row of gas lamps along widened boulevards, which inspired the capital's sobriquet—"City of Light."

By mid-century, upper-class American families were sending their children to Paris for their education, intending them to become fluent in the lingua franca of art and music, science and literature. This finish of prestige and sophistication would be needed for navigating high society, where, in the American context, what you knew and what you wore and what you owned—more than birth—signaled and secured social status. (This may have been true more for New Yorkers than Bostonians, who "cultivated their genealogies," as the historian Henry Adams remarked.) But there were risks. Mrs. Stewart had a copy of the popular 1840 English novel *The School-girl in France, or the Snares of Popery; A Warning to Protestants against Education in Catholic Seminaries,* which alerted readers to the dangers of Catholic boarding schools. Young Protestant women, unaccustomed to the liturgical drama of the Catholic Mass, were vulnerable, the author gravely warned, because these sacred rituals had a seductive lure, an "almost irresistible power to the senses."

Belle boarded at her school from Monday through Friday. On weekends, she joined her parents at their hotel nearby. She returned early on Monday mornings, rang the school's large bell, and walked through its gate to a building surrounded by high walls. Stained-glass windows topped the interior walls and let in light that tinted the floors. She and the other girls wore the school uniform: a dark dress covered by a high-necked apron in black silk. School days were regimented, as was typical of a French education, which tended to be highly formal, with an emphasis on rote learning. A morning bell rang at 5:15 A.M. in a barracklike upper room, where the students slept on cots with sheets so "new that they rustled like paper." A first breakfast followed, usually a warm soup, not very appetizing, then singing and dancing lessons; next, a second breakfast of vegetables or applesauce with a selection of cheeses. Schoolwork continued until 5 P.M., followed by social time, a walk, one more meal, then to bed promptly at 8:30 P.M.

Subjects included geography and French history as well as intensive language study, in which students copied out long passages from literature and poetry. Belle's teachers, Mademoiselles Hanson and Betzy, required that everyone speak in French only, even after classes were finished for the day. This was terrifying at first for the students, all international, in part because they were not familiar with conversational French. Belle copied out long French poems on the pages of her friendship album, which she'd taken along to Paris. Her French composition book, which she put in an old floral lacquer box for safekeeping, is filled with practice phrases: "*à bout de souffle*—out of breath"; "*Je n'y comprends rien*—I understand nothing about it"; "*Elle aime se faire remarquer*—She likes to be conspicuous."

The girls had religious instruction at the Oratoire du Louvre, a Reformed Church located just off the newly completed rue de Rivoli, directly across from the Louvre Museum. Once a week, they walked from their school to the church to listen to lectures given by Rev. Athanase Coquerel, the senior preacher and a prominent liberal theologian whose writings combined strict Calvinist doctrine with the rationalism of the French Enlightenment. Students had to write summaries of his sermons and lectures, which they submitted for his review. Speaking first in English, then in French, Rev. Coquerel lectured on Abraham, the prophecies, and on the last words of Christ—"Why hast thou abandoned me?" He was noted for his eloquence and as a "sincere lover of tolerance and freedom of thought."

Later, when Belle was asked if she worked hard at school, it was said she replied that she did so only "if it was against the rules." The rigor of her Paris schooling and her personal papers show something else: an intense diligence she disavowed. Perhaps she didn't want to be seen as too smart, a boring bluestocking, the epithet thrown at women intellectuals, with its implications for the marriage market. Later in life, though, she chased knowledge with fervor.

The sixteen students at the *pension* came from Italy, Germany, Holland, Russia, India, England, and Ireland. Only three students were American, and two of them came from Boston. Julia Gardner, sixteen years old, was the second-youngest child of John Lowell Gardner, a prominent Boston merchant, and Catharine Elizabeth Peabody Gardner, originally from Salem. Helen Waterston, a year younger, was the only child of Robert Cassie Waterston, a Unitarian minister, and Anna Cabot Lowell Quincy Waterston. Helen's grandfather was Josiah Quincy, who had been a congressman, a Boston mayor, then the longtime president of Harvard College. Like Mr. and Mrs. Stewart, both girls' parents stayed at hotels nearby while their daughters attended school during the week. Helen started on December 8, 1856,

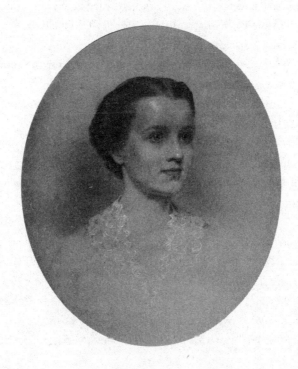

two months after opening day, on the advice of Julia's mother, Mrs. Catharine Gardner. It was the day Helen first met Belle, noting in her daily journal that the other American besides Julia was "Isabella Stewart, a New York girl."

Helen described Belle to a friend back home in Boston as "bright, intelligent," also calling her "jolly and splendid" in her journal. Julia, by contrast, was a bookworm who liked to play chess. Helen and Julia knew each other before coming to Paris, and Helen thought her friend serene, open, and "as pleasing as ever." Helen was not in the same class as Belle and Julia, being a year younger and not yet as fluent in French. But the girls immediately hit it off, so much so that Helen mused at one point: "what should I do if Julia & Isabelle were not here?" They'd sit together at the end of the day and talk. They read aloud to one another—Belle had the 1856 London editions of Jane Austen's *Pride and Prejudice, Mansfield Park, Emma,* and *Northanger Abbey*. They compared one another's home cities. They wrote in one another's albums. They laughed at the other girls' impromptu theatricals. They walked together in the garden near the school. On Mondays they couldn't wait to tell one another about their respective adventures over the previous weekend: an evening at the opera Le Peletier; a stroll through the Palais-Royale, with its arcades of jewelry and fashion shops and crowded cafés; and concerts at the grand Notre-Dame cathedral and the église de la Madeleine, a neoclassical temple erected by Napoleon in honor of conquering armies, consecrated only a decade before as a Catholic parish. The girls sewed for the poor of Paris. They helped one another dress for parties and put up their hair, once placing all sorts of "absurd things" in their high Marie Antoinette–like poufs—three pens in Julia's hair, an open fan in Belle's.

The Paris streets in December were filled with crowds strolling in holiday finery and elaborate equipages going up and down the Champs-Élysées, all of it illuminated in the evenings by gaslight, which gave a warming glow. On Christmas Day, Helen and her parents walked to the nearby église de la Madeleine for a service. There, they spotted Julia's older brother, Jack Gardner, who was also in town. Jack, nineteen years old, was handsome and athletic, a little shy, but also rumored to be one of the finest American dancers in Paris. There was an emotional spaciousness in Jack Gardner. As a teenager, he'd spent Sunday evenings with his grandmother Rebecca Russell Lowell Gardner, who lived nearby on Summer Street in Boston, in a large home known for its "generous hospitality." She loved her grandson's genial

company: "He is in the most flourishing condition," she wrote to another grandchild, saying he looked "as well and happy as ever." His thoughts had a habit of turning from himself to others, as shown in his letters, where he'd inquire about a long list of friends and relatives.

Jack's father had requested his son be released from Harvard College, where he had already attended two years as a member of the class of 1858, so he could join the travels of his parents and younger sisters, Julia and little Eliza. His parents may have worried about their son being at the age of military service, given the increasing division and turmoil in American politics. He was now, on Christmas Day, looking for his mother and Julia among the large crowd. Whether he found them or not is unclear, but he did join Helen and her parents as they went on to église Saint-Roch, a nearby baroque church aglow with countless little candles for the season, its facade still bullet-ridden from the French Revolution.

The next day, the three girls returned to the *pension,* where they read French history and practiced their singing in preparation for a large celebration set for December 30. Helen told Belle and Julia all about her weekend, possibly mentioning seeing Julia's brother, Jack Gardner, in the crowds at the église de la Madeleine. She had also attended an evening Christmas party across the Seine, on the Left Bank, with the famous American writer and abolitionist Harriet Beecher Stowe, who had published her best-selling *Uncle Tom's Cabin* four years before. Helen was interested in Stowe's writings, having also read her more recent *Dred: A Tale of the Great Dismal Swamp.* The Stowe daughters were attending another Protestant boarding school in Paris while their mother toured England and Europe. Fame had made Stowe somewhat wary, but she "appeared very pleasing particularly at the end of the evening when she was drawn out in conversation," according to Helen's description in her diary.

New Year festivities at the school opened with the *pensionnaires,* outfitted in white fancy dresses and elaborate coiffures, standing in a circle around a tabletop Christmas tree with presents piled high. They sang energetically, sometimes falling into laughter, for the audience, which included Mrs. Waterston, Mr. and Mrs. Stewart, Mrs. Gardner, and Julia's younger sister, ten-year-old Eliza Gardner. Jack is not in Helen's list of attendees for the evening.

Over the coming months, Belle, Julia, and Helen did everything together.

They began referring to one another by a made-up nickname—the *Vestagine*, or little Virgin Vestals. They each had a secret name: Alonso Vigirato (alias Julia), Danilo Brignole (alias Belle), and Giovanni Amour (alias Helen). And they "swore by our brooches to stand by each other in troubles, scraps, & etc."

In early spring 1857, Mr. Stewart gave Belle and her friends a copy of the recent epic by the popular dramatist and historical novelist Alexandre Dumas. "We hear it's splendid, an immense book," Helen wrote, but wondered "how we shall ever finish it." The three friends at first kept the book to themselves, though the other "girls were dying to know what it was." They wrapped it in a plain cover and gave it an innocuous-sounding title, *History of France*, which was not far off the mark.

Dumas's four-part serial, *La Comtesse de Charny*, was the fourth installment of his popular Marie Antoinette romances, which fictionalize the queen's extravagant life, from her arrival at Versailles from Austria as a fourteen-year-old girl, to her unhappy marriage and supposed exploits at Le Petit Trianon, and finally to her execution at the end of 1793. The schoolgirls, not much older than the doomed queen and staying not far from the Palais des Tuileries, the setting of the drama, eagerly read passages aloud.

Soon their classmates gathered round to hear Dumas's descriptions, such as this one, depicting the queen after her desperate flight with the king and their children from Versailles to Paris: "The Queen had suffered in mind and heart, in love and self-esteem. Her thirty-four years were written on the poor lady's cheeks in lines of purple and violet, which told their story of tear-filled eyes and sleepless nights, which testified the deep malady of the womanly heart, which is never entirely healed, be she queen or commoner, till it is utterly extinguished." The novelist divulges, like the undoing of so many corset stays, all the supposed details, including the wrenching scene of the king's farewell to the queen before his execution in January 1793. The volumes end with a moral: "As has been seen in the more romantic portion of this book, the Queen let herself be easily drawn to the picturesque side of life. She possessed a very lively imagination, which does more than temperament to make women imprudent. The Queen had been imprudent all her life, imprudent in her friendship, imprudent in her passion. Her captivity was her regeneration, in a moral point of view. She reverted to the pure and

holy love of her family, from which she had been alienated by her youthful and errant inclinations."

The sweep and emotion of the story, with its youthful energy and a glamorous woman at its center, were intoxicating, particularly for Belle, with her penchant for flights of fancy and rebellion. It was way too much for the girls' teacher, however, who feared that the story of Marie Antoinette's flirtatiousness and frivolity would corrupt the young readers. The girls probably knew this—it was likely the reason for the plain wrapper disguising the book's cover.

Helen recorded the ensuing tumult in her March 1857 journal. After a dinner on one particular Thursday, as was usual, the *Vestagine* read aloud from the novel. That night their teacher intervened and confiscated the book, arguing that while "in America we might perhaps read such a book, our manners were freer, but in France a young girl who had read such a book by Alex. Dumas would not be received into society." The stakes were high. Helen and Julia looked "rather sheepish and all," while Belle "looked all confounded at seeing Mademoiselle with the book in hand; she had not much time to think, for she was immediately pumped by Mademoiselle as to how she had got the book, where, etc." When Belle answered, Mademoiselle took the book away. Helen protested, a little disingenuously, that they had not the "least idea it was a bad book."

The teachers summoned Mrs. Stewart and Mrs. Waterston to the school. Two days later, Mrs. Stewart apologized to Mademoiselle and explained that the novel had been a gift from her husband, recommended by one of Belle's American teachers who perhaps hadn't understood what it was all about. Mademoiselle responded in a "good-natured" way. Afterward, Belle went to her teacher to retrieve the book.

Soon Helen and her mother were in their carriage, riding back to their hotel. When Helen happened to turn around, she spied Belle "holding [the book] up exultingly." The "picturesque side of life," what Dumas warned against in his novel even as he gave all the gritty details, was what Belle loved most. Her proud stance, upraised arm with book in hand, signaled defiance toward authority and censorship. With her mother's help, she'd won.

BELLE LEFT THE *PENSION* IN EARLY JUNE 1857, A WEEK AFTER HELEN AND Julia. The Stewart, Waterston, and Gardner families all planned further European travels. Even so, there had been a good deal of crying and carrying on as the girls said their goodbyes. Helen exclaimed: "the name of Isabella Stewart was now so dear." Belle was good at friendship. She was always game to try things and had a gift for what Helen called "jollification." She would later copy out part of a quotation by the British writer Walter Savage Landor about friendship between girls, which must have been a reminder of these years: "No friendship is so cordial or so delicious as that of a girl for girl . . ."

While Helen and her parents stayed on in Paris for several weeks, later going on to Germany, the Stewarts traveled south to Italy, though it's not clear where they visited first. When they arrived in Florence, they stayed at the Hotel de la Ville, newly opened and not far from the Ponte Vecchio and the Arno, where they planned to spend the winter months. Belle took music lessons, most likely on the piano. It was her first time in the city of Dante and Fra Angelico and Botticelli, figures of the Renaissance she'd come to know well. They saw all the sights, including Santa Croce and the sixteenth-century Uffizi Gallery in the Piazza della Signoria, the center of Florentine life, with its long line of towering marble statues and galleries full of favorites, including the *Venus de' Medici* and Raphael's *Madonna of the Goldfinch*. (After her own visit to the Uffizi, Helen favored this Raphael painting above all others and wondered in her diary if, at night when no one was looking, the "statues and pictures did not start from their pedestals and canvases and talk together.")

By mid-November, the Stewarts' plans were upended by the Panic of 1857, the first financial crisis to spread worldwide. That month, Mr. Stewart rushed first to London, then to New York, to deal with any fallout for his businesses. Belle and her mother left Florence on November 20 for the Eternal City, Rome, where Helen and her parents were already ensconced after their own travels through Florence.

On December 15, 1857, Helen noted with glee: "Isabella in Rome!!" The close friends would spend the next five months together.

Also in Rome, and staying with the Waterstons, was Ida Agassiz, the daughter of the scientist and naturalist Louis Agassiz, whose second wife, Elizabeth Agassiz, had opened an innovative school for girls in Cambridge, Massachusetts, in 1855. Ida, several years older than Helen and Belle, was

fun-loving and bookish, already a teacher at her stepmother's highly regarded school. Ellen Emerson, the oldest daughter of Ralph Waldo Emerson, had attended the school, and she remembered Miss Ida as "beautifully dressed," a creative teacher who wrote letters to her students in German so they'd learn the language more easily. Ida's original travel plans had fallen through, and the Waterstons had taken her in. With Julia Gardner back in Paris after travels in Germany, lonely and miserable without her friends, Belle, Helen, and Ida now formed a trio, traveling everywhere together.

Belle and Mrs. Stewart greeted Helen "literally with open arms." Mrs. Stewart dissolved in tears after reporting her husband's sudden departure, though she'd lost none of her "warm cordial manner." Belle, affectionate as ever, was excited to see her friend and "talked as fast as possible" while recalling her summer adventures. "She has grown very stout after her travels," Helen mused, "owing perhaps to her diet." When the telegram came to report Mr. Stewart's safe arrival in New York, the friends all celebrated.

Rome shone in December, "sunny & beautiful." There was so much to see and do. Helen recalled scenes in her diary: a walk up the Spanish Steps to Trinità dei Monti, then to the Pincio on "a beautiful walk bordered by roses in full bloom" and its famous view over the Piazza del Popolo. "Turning around . . . the whole panorama of Rome, the grand, noble city with its towers & domes, all lay before us and with one great dome above all." They saw "splendid pictures in Roman mosaic" almost everywhere. At the Palatine (Palace of Caesars), ancient Rome was brought very near with the "power of its many charms." A descent down the hill led to the Colosseum, which loomed both larger and grander than could be imagined, with its "moldering arches now covered with moss."

The girls studied Italian together. Belle excelled at this and enjoyed it—almost as much as she did her flirtatious banter with their handsome young instructor.

After attending a Midnight Mass, Belle and Mrs. Stewart returned on Christmas morning to meet Helen and her family for the hours-long Mass at the Vatican. Five thousand worshipers crowded Saint Peter's Basilica. The friends sat near the front and watched as brightly robed cardinals processed down the aisle, followed by the pope, who was "arrayed in white satin and silver and gold" and carried high on the "shoulders of six men in crimson velvet in a sort of throne, with a canopy over his head and two large fans of

peacock feathers carried on each side of him." The congregation bowed their heads when he passed by, bestowing his blessing.

The festive mood was darkened by what happened next. "Bella Stewart," Helen reported the next day, had rushed into the Waterstons' hotel rooms "with great excitement" and described an imbroglio "at length." Apparently Mrs. Stewart had taken off her two diamond rings, which made her gloves too tight, and put them in her "*portemonnaie*, and put that into her pocket and someone in the crowd had cut a hole in her pocket and stolen the purse and the rings." Little David, "whose head was full of robber-stories," regaled the group with more. Mrs. Stewart never did get her rings back.

The new year, 1858, began bright and warm. Belle received a letter from Julia Gardner, who was enjoying Paris and its round of holiday parties. Helen was impressed with Belle's piano playing—she had "greatly improved since her lessons in Florence." Now Belle played duets with a violinist (Helen did not give the name). The next day the group visited the studio of the American sculptor William Wetmore Story, admiring in particular his recently finished *Marguerite*. For Helen's birthday, Belle sent her friend a beautiful bouquet of violets, always a favorite flower.

But the brilliant event of the season would occur on January 11. As Helen put it, "Belle's mind was entirely engrossed in the cause of charity, namely, a charity ball . . . to which she is *wild* to go." They practiced a dance called the Laurier to be "OK for the ball." Finally the anticipated night arrived. Helen and her mother joined Ida, Belle, and Mrs. Stewart in a carriage ride to the palace. Helen did not specify its location in her account of the occasion in her diary, except to say the large ballroom was equipped with a spring floor and decorated with bright ornaments and sweet-smelling flowers. Ida wore a wreath of soy-leaves, "very lovely & pretty," while Mrs. Waterston had ostrich feathers that "waved with Oriental magnificence." The crowd was international: Russians, English, Americans, Germans, French, many Italians, and one Canadian. After the queen of Spain arrived at 10 P.M., "glittering with diamonds" but looking "frightful," the dancing commenced—a round of waltzes, polkas, and then the well-practiced Laurier. Isabella, in her blue dress, with a halo of flowers atop her wavy sandy-brown hair, was very pretty, but mostly, Helen said, "it was a pleasure to see anyone having such a good time."

AT SOME POINT THAT SPRING, THE FAMILIES PARTED WAYS. THE WATERstons went on to Naples, while the Stewarts went north to Milan. It is likely Ida went along with the Stewarts, though the record is not entirely clear. In any case, Ida would remember an important moment for Belle during her weeks in Milan. At some point, Belle saw the extraordinary art collection of Gian Giacomo Poldi Pezzoli, who had opened his private residence, a three-story palace adjacent to La Scala, to the public in 1855. (The Poldi Pezzoli would become a public museum later in the nineteenth century.) The palazzo was filled, room after room and floor to ceiling, with Northern Renaissance master paintings, accompanied by textiles, glass works, sculpture, furniture, and other objects of luxury. Belle saw in the palace a concentrated beauty, an experience that never left her. A collection of this size and in this setting, so different from the cavernous Louvre, seemed to tell stories on a more human scale. And in response, Belle confided to Ida Agassiz the dream of her heart: "If I ever have any money of my own, I am going to build a palace and fill it with beautiful things."

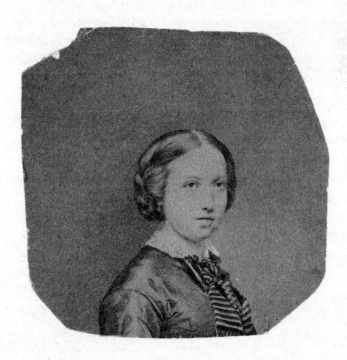

A salted paper print of Belle Stewart, made when she was perhaps eighteen, shows a young woman with a white lace collar and smart striped bow. Her thick hair is braided and fitted close to her face, in the mid-century fashion. She has beautiful posture. She looks a little younger than her age. What isn't obvious from the image is her blooming sophistication and confidence. The crowded, lively streets of New York had been her home, but an American city was very different in scale and cultural import than the cities of France and Italy, where centuries of art at every corner, in every church, in innumerable museums, bombarded the senses. By the time she arrived back in New York, sometime in the summer or fall of 1858, she'd returned a cosmopolite, able to read and speak French, Italian, and German, conversant about the music, art, and architecture of major European cities.

As the new decade approached, Belle received a holiday present from her father that she would always keep in her personal library. *The Stratford Gallery; or The Shakespeare Sisterhood,* by Henrietta Lee Palmer, was a large, recently published book of forty-five profiles of Shakespeare's main women characters—Lady Macbeth, Juliet, Ophelia, Miranda, Rosalind, Portia, Desdemona, Cordelia, and Isabella, the female lead in *Measure for Measure*. The volume's New York publisher, D. Appleton and Company, whose vast store on Broadway was a block or two from the Stewart home, spared no expense with the book's detailed engravings of each character. The brown-leather binding was embossed with an elaborate gold design on the front cover and endpapers of intricately patterned green, red, pink, and gold. Belle must have loved this artistic, glamorous gift from her father. David Stewart knew his daughter well. Was he giving her permission to be as memorable as these women; did he suspect she would be?

She signed the book in her by now distinctive handwriting, with letters that slant far to the right, as if in a windblown rush toward the new decade and a new life: "Isabella Stewart from her father/1860 Jan 1st."

By April of that same year, Belle would become Mrs. Jack Gardner.

Three

MR. AND MRS. JACK

1859–61

Belle returned to New York no longer a child. Though her formal education was over, once back at home she pursued a wide range of interests. She went to theatrical and musical performances of all sorts, including the vaudeville shows then rising in popularity. She sought out art. She first saw *The Heart of the Andes* (1859) by the American painter Frederick Edwin Church in November 1859 at the exhibition room in the newly built Studio Building on Tenth Street, not far from the Stewart home. Before the advent of public art museums in New York, such as the Metropolitan Museum of Art, which opened in 1870, paintings were often displayed in artists' studios and in the various galleries and showrooms crowding Broadway; some artists also sold books and picture frames. Often a single painting was put on display, such as Jacques-Louis David's *Coronation of Napoleon* or Titian's *Venus*.

Church's ten-foot panoramic landscape was composed, in the words of twenty-five-year-old Samuel Clemens, of "wayside flowers, soft shadows and patches of sunshine and half-hidden bunches of grass . . ." He declared it "the most wonderfully beautiful painting which this city has ever seen." Its enormous wooden frame created a kind of stage. Lighting amplified this effect, making it seem as if the scene itself was the source of its own illumination. Advertisers, touting Church's masterpiece as the "finest painting of

modern times," suggested people bring their opera glasses so they could see the colorful flora and fauna in greater detail. Church, at thirty-three, had climbed to "the summit of the New York art world."

There is no record of Belle's reaction to Church's painting. She did jot down a quip by the British actress Fanny Kemble, who also had attended a French boarding school a generation before: "New Yorkers compare their sapling to the oak of the old world." Perhaps Belle felt likewise. She surely viewed the painting with a discriminating eye, one trained by everything she'd seen in Paris, Rome, Florence, and Milan.

The Stewarts had returned to New York during an eventful time for the family. On December 18, 1858, Mrs. Stewart, by then in her late forties, gave birth to her youngest child, James, named after Mr. Stewart's eldest brother, James Arrott, who had died of yellow fever in 1829. Soon after little James's birth, the family moved from their Washington Square neighborhood to 27 East Twenty-Second Street, farther north. There David Stewart had purchased one of the high, narrow brownstones lining the streets just south of Madison Square Park.

In the midst of all this hubbub and change, Belle took her first trip to Boston, in February 1859. She wanted to reunite with her Paris friend Julia Gardner and to see the city they had talked about so much as *pensionnaires*. "I have been enjoying extremely Belle's visit here, and I think she has also," Julia wrote proudly to her father, John Lowell Gardner, who was away on business in New York. The girls had tea parties and attended small soirees. One cold day, they bundled up for a ride in *Cleopatra's Barge,* a large, elaborately carved sleigh piled high with furs. They traveled with twenty other young people to see Mrs. Margaret Forbes, who lived thirty miles south of Boston on Milton Hill, in an enormous Greek revival mansion built by her son, Robert Bennet Forbes. There they danced and played games, then sang with their loudest voices all the way home.

Missing from the group was Helen Waterston, the third member of "we jolly three," as Helen had called the friends. For all the fun of this reunion in Boston, Belle and Julia were also mourning Helen, who had died the previous summer, while in Naples with her parents, from a fever or a previously undetected heart defect. Reports differ. She was seventeen years old. Her death had been a terrible shock to her parents, who had buried their only other child, a young son, a decade before.

The three girls had spent many hours in Paris talking about their respective hometowns, imagining visits back and forth when everyone was stateside again. Belle and Helen had much in common—a fascination with art and fashion, with storytelling and history, with Paris itself. Little trace of Helen remains in Belle's records, except for her signature in Belle's album. As she did in response to the death of her sister four years before, Belle again kept silent.

IN SPITE OF THE PALL CAST BY HELEN'S DEATH, BELLE STEWART'S VISIT TO Boston in the winter of 1859 became less about her past and more about her future. Soon after she arrived in the city, Julia's older brother Jack Gardner, now twenty-one years old, asked her to walk with him along the crisscrossing pathways on the Boston Common and the adjacent Public Garden, which was then being expanded farther west. Belle and Jack strolled up and down snowy Beacon Street, the city's fashionable residential avenue facing the Common, where Jack lived with his family at the top of the hill at number 7, a large white mansion across from the city's Athenaeum and near the capitol building with its gold dome, which glinted in the winter sunlight.

Playfully, Jack gave her small sketches. In one he had drawn tiny stick figures in action: two men are shooting each other; another man is drinking; a man with a hat and a large arrow through his heart is facing a full-skirted

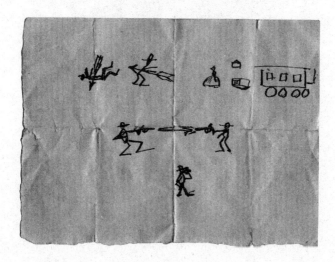

woman with a bonnet. Is that a train car behind her, a train that brought the woman from out of town? Was Jack telling Belle he'd been pierced by love's arrow? His feelings were only a bit clearer in the affectionate message he wrote on his calling card on February 22, noting the first American president's birthday: "Please accept, dear Belle, this souvenir of the birth of Washington with the best love of—John L. Gardner, Jr."

Belle had known Jack since they'd first met in Paris in 1856, when he had a reputation, according to a Harvard classmate, for being "the most popular young American in Paris." His mother, Catharine Gardner, expressed her pleasure in him in a letter to Jack's older brother, George Augustus Gardner, sometimes referred to by family as Gag, saying that Jack was "handsome, quiet, gentlemanly, sufficiently at his ease with ladies, dances beautifully and with a perfect taste in the dress both of gentlemen and ladies." He had a

stronger interest in sailing and other outdoor pursuits than in politics. Photographs of him at about this time show his appeal: relaxed limbs, luminous eyes, a long straight nose, a strong square-ish face with a hairline slightly receding, and a shy demeanor. At five foot eight inches, he stood slightly above average height for the time but seemed taller because of his easy confidence.

When he and Belle crossed paths in Rome and Naples and their families were part of a social circle that included the Waterstons, Jack never signed Belle's autograph album. Jack's name does, however, show up several times in Helen's journals, where he hovers on the edge of various scenes, a harbinger of Belle's future. In Paris, after Helen and her parents met Jack while looking for Julia and Mrs. Gardner in the crowds milling outside the église de la Madeleine on Christmas Day 1856, Jack joined his father and the Waterstons on a New Year's Day walk along the boulevards. Again, on Helen's sixteenth birthday, January 6, she met with Julia, Jack, and Mr. Gardner, and together they walked to the Paris Circus in the Bois de Boulogne. Helen noted at the end of her diary entry for February 22, 1857: "Evning [sic], Jack Gardner called." She wrote nothing more.

For his part, Jack reported in a letter to his brother, George, eight years older, that he had met the Stewarts and Waterstons while they were all in Rome in April 1858 to see the "usual sights" and again in Naples. He mentioned that Helen had gotten to be a "very tall, handsome, and stylish young lady," summarizing his obvious feelings: "she is a very nice girl." He added cryptically that she'd fallen ill after a group of people had ascended Mount Vesuvius.

So Jack too felt the loss of Helen. Whether he acknowledged a greater desire for Helen to himself, or to anyone else, is impossible to know. He would not have told Belle. Maybe this shared loss, whether spoken of directly or not, propelled two young survivors, in the bloom of youth, closer to each other during their long walks together those cold February days. Eliza Gardner, then twelve years old, would remember that something changed between her brother Jack and Belle after one of their strolls down Beacon Street. An early biographer reports that he asked her, while at a ball, whether she could imagine making Boston her permanent home. Her reply: "If you want to ask that question, you will have to come to New York."

Jack promptly did so, and by the end of the month, the two were engaged. After asking Mr. Stewart for his daughter's hand, Jack wrote to

George, on February 25: "To use your expression, 'I've gone and done it.' You probably are not surprised. The young lady has appeared charming since I have been on here, and I am confident you will soon learn to love her not only on my account but her own." He invited his brother, with his wife of five years, Eliza Endicott Gardner, to New York, along with his parents. Jack would leave to them the "time and manner of announcing the engagement," though he and Belle felt "all ready," waiting only for a go-ahead from her parents before announcing the good news more widely.

Three days later, Belle wrote eagerly in a letter to Julia, her dear friend and soon-to-be sister-in-law, calling herself the "happiest of human beings." Jack's proposal had been "the great event," but she also gloried in joining the Gardner family, which made her "most deeply sensible of the happiness that is my lot." This wasn't flattery for Julia's sake. Belle had a clear-eyed recognition of her good fortune—Jack's character first of all, but other things too. The Stewarts, compared to the Gardners, were rising but not yet fully arrived. She was joining a family more elevated than her own, intermarried as the Gardners were with some of the wealthiest, most powerful families in America—the Lowells of Boston and the Peabodys of Salem. When Jack's mother, Catharine Peabody, married his father, John Lowell Gardner, the elder Joseph Peabody, by then the wealthiest man in Salem, gave his son-in-law shares in numerous ships of his fleet, which traded mostly in pepper from Sumatra.

The Stewart and Gardner families did have important qualities in common. Belle's intense interest in culture, particularly theater, music, and art, was familiar to the Gardners, though she'd prove far more capacious and unconventional than her in-laws in pursuing them. Even so, Catharine Gardner had grown up in the biggest mansion in Salem, filled with artwork and books. She had traveled extensively throughout Europe and responded eloquently in her early journals to what she saw. She and her husband also collected fine things for their houses at 7 Beacon Street, at Green Hill in nearby Brookline, and on an island off the coast of northern Maine.

Belle had their approval. The eldest Gardner brother, Joseph Peabody Gardner, as yet unmarried, wrote her a sweet poem for Valentine's Day, which celebrated her "vivifying influence," a token of affection she tucked away in her autograph album. In a March letter to her future father-in-law,

John Lowell Gardner Sr., Belle expressed again what she'd told Julia: "My dear Mr. Gardner, I can never be sufficiently grateful to your family for the very kind manner, in which each member of it has treated me since the event that the last week has brought forth . . ." Then she turned a light on his son, her future husband: "The praises that have been bestowed upon Jack, as a son & brother have served to confirm mother's good opinion of him & she now feels that it is possible to bear the thought of parting with me, as she is sure that better hands in which to trust me could not have been found." No wonder Mr. Gardner felt such fondness for his lively new daughter-in-law-to-be, an affection and regard that would endure.

Where Belle was fiery, Jack was calm; where Belle was instinctive, Jack was deliberate. In impeccable handwriting, he filled notebooks with lists—of prices, of items purchased, of places and people he visited. He loved good coffee, saying the way to get it was "to buy the best and use a lot of it!" He was a keen observer of people and also quite good at drawing. The margins and back pages of his schoolbooks, such as Aeschylus's *Agamemnon* and Aristophanes's *The Birds,* are full of figures and landscapes. Between the pages

of his copy of *The Works of Horace*, he hid a small convincing sketch of a voluptuous woman's nude torso.

Jack's father had a reputation for being "dignified, affable," and the younger Jack resembled his family: careful and generous. Another friend would remember how he'd been a "tower of strength and support in all ways." His parents and siblings felt likewise, relying on him to settle disputes. Belle would be no different. Jack may not have been the most scintillating conversationalist. He listened more than he talked. But his adoration of Belle was steadying to her, and he didn't try to compete. He seemed to respond with bemused admiration, rather than any pang of jealousy, to the attention she would increasingly receive.

The following October 1859, Julia Gardner arrived at the Stewarts' New York home to help Belle with wedding plans. Jack, who would celebrate his twenty-second birthday on November 26, joined them later. Julia reported to her father how they explored Belle's New York world, meeting childhood friends, attending a cricket match, and promenading up and down Broadway, going into its many shops and galleries. They went to the opera and also the French Theater, at the corner of Fourteenth Street and Sixth Avenue, to see "little vaudevilles," as Julia described them. They played popular parlor games—Fox and Geese, Hunt the Ring, and Consequences—with dinner party guests or "convives," which included another Joseph Peabody, this one a Gardner cousin. Mrs. Stewart took Belle and Julia, together with a nurse and baby James, for a walk through Green-Wood Cemetery in Brooklyn. Belle's childhood friend Lily Oddie invited them to her family home on Fifth Avenue and Fourteenth Street to view a firemen's parade. Fires would be a fascination for Belle, but Julia thought it all somewhat dull, just "a mass of red flannel shirts and black hats, relieved now and then by an engine or a hose-cart gaudily painted and decked out with flowers." In the evenings, Belle read aloud from Lord Bulwer-Lytton's 1841 *Night and Morning*, a detective novel set in Paris about the pursuit of a family inheritance.

In this way, Belle and Julia's time together reprised their school days, only now, instead of schoolgirl *pensionnaires*, they would soon be family.

The next spring, four days before turning twenty, Isabella Stewart married Jack Gardner at Grace Church. The elaborate occasion involved six attendants, including Julia, Lily Oddie, and Belle's cousin Adelia Hicks Hud-

son. The *New York Times* announced the marriage two days later: "Gardner-Stewart—In this city, on Tuesday, April 10, in Grace Church, by the Rev. Dr. Taylor, John L. Gardner, Jr. of Boston, to Isabella, daughter of David Stewart of this city." There are no extant engagement or wedding photographs, but a few small photographs survive from around this time. Belle is thinner, compared to an earlier image from her girlhood. Her hair is strictly parted in the middle, as was the fashion. She was not known for her beauty on first glance, but Jack saw her vivacious personality and her love of fun, her capacity for "jollification," Helen Waterston's memorable term.

She would later claim to have been "a very blushing bride." After the marriage ceremony, the young couple traveled to Washington, D.C., then a popular honeymoon destination. Her signature now changed, from I. Stewart or Belle Stewart to I. S. Gardner; later she would use Isabella, Isabella Stewart Gardner, or simply I.S.G.

The young Gardners lived first with Jack's parents at their spacious summer home, Green Hill, located on a rising acreage in Brookline near Boston, and then later at Hotel Boylston on the corner of Tremont and Boylston Streets, which bordered the Boston Common. They were awaiting the completion of their new home on a single lot at 152 Beacon Street, a wedding gift from Belle's father. He had bought an allotment of newly filled in land south of the Public Garden on Beacon Street in 1859.

Jack had joined his father's firm shortly after coming back from Europe in 1858. John L. Gardner Sr. first started as a merchant in 1825, with the firm Gardner and Lowell, and then formed a partnership with his younger brother, George Gardner, doing business as John L. Gardner and Company. The company, located at several addresses before moving to 22 Congress Street in 1857, traded in East India, the Caribbean, and Russia. Its most lucrative import, Sumatran pepper, continued Jack's Peabody grandfather's trade. John Sr. owned many ships, and Jack had a financial stake in several, including one-sixteenth of *Arabia,* five-eighths of *Lepanto,* and a quarter of *Nabob*. Jack's father's wealth also derived from his dealings in real estate. He inherited significant property in Salem from his grandmother Elizabeth Pickering Gardner, and he early on purchased lots of recently filled in land in the Back Bay, first on Beacon Street, then, from his cousin Francis C. Lowell, a large frontage of land on Commonwealth Avenue. In 1842, he also

acquired Green Hill from H. R. Kendell; this twenty-acre estate in Brookline eventually went to Jack and Belle.

BELLE BECAME PREGNANT VERY SOON AFTER THE WEDDING. SHE FELT terrible in those early months, when they were living with Jack's parents at Green Hill. She retreated to her room, where she spent the mornings in bed. On September 10, exactly five months after her wedding day, she went into labor and delivered a stillborn baby boy. It was a shock for the young couple. Belle was expecting to be a mother; she was no longer a mother. They didn't name the baby, but they did bury him, and he would later be reburied in the Gardner crypt at Mount Auburn Cemetery in nearby Cambridge.

Belle struggled. She lived with her in-laws, who, though kind, had ways that differed from her own family's. She was used to being the eldest sibling; now she was a younger member of a large family. The rhythms of another household, along with the adjustments of a new marriage, proved challenging. And now she had lost a first child. She felt herself a failure.

Suffocating social isolation compounded her loss. Upon arriving in Boston, almost from the start Belle was seen as someone different, someone hard to understand. "Her ways were different from Boston ways," observed Morris Carter. She wasn't invited to join one of the many sewing circles where women gathered every week, ostensibly to do sewing projects for charity but also to talk and gossip. These had become increasingly popular in previous decades, a key part of feminine sociability at the time. Once formed, a woman's sewing circle served as a secure social perch ever after. Belle went to cotillions and other dances, where, with her natural athleticism and Parisian dance training, she often outshone her peers. This generated envy rather than friendship.

It's hard to know what set Belle apart in these early years. Was she more voluble or more outwardly rebellious than others; did she express her enthusiasms in a manner that people deemed awkward or not sufficiently reserved? Later speculation suggested that she didn't know how to be a good friend to other women. But this is at odds with the closeness of her friendships in Europe with Julia, Helen, and Ida, and with the fact that she later sustained friendships with women such as Gretchen Osgood Warren, Caroline Sinkler, and Julia Ward Howe and her daughter, Maud. There is not a murmur of negative gossip in the Gardner family's large collection of papers.

Even so, Boston society withheld its welcome. It seemed that the young girl who had gripped Alexandre Dumas's novel of imprudent womanhood and lifted it high above her head was somehow unknowable or unreadable to her social peers.

Maybe the problem was simple: she'd come from somewhere else. She was not from a family that could trace its lineage to the founding of the Massachusetts Bay Colony more than two centuries before. The strength and power of the Brahmins, a nickname given to the city's upper class by Oliver Wendell Holmes Sr., derived from how these families had intermarried to form a tight weave of wealth and privilege. They also had many children. One Coolidge descendant remembered playing the game of relations at the family dinner table, as the children were quizzed about who was who: "What do you know of Cousin Jack? And do you have a second cousin Jack?"

The city's nineteenth-century merchant class generated extraordinary wealth and took up the civic obligation to fund many important institutions: the Boston Athenaeum, Massachusetts General Hospital, Harvard University, Massachusetts Historical Society, Massachusetts Institute of Technology, the Handel and Hayden Society, the Boston Symphony Orchestra, and the Boston Public Library. Antebellum Boston was also a center for leading writers, scientists, doctors, theologians, and politicians, such as Daniel Webster and Charles Sumner. It was a hotbed of abolitionists and women's rights activists, such as William Lloyd Garrison, Leonard Grimes, Wendell Phillips, George Lewis Ruffin, Margaret Fuller, and Lucy Stone. It is no accident that some of the nation's leading institutions dedicated to caring for people with physical and intellectual disabilities, treating mental illnesses, and protecting animal welfare were based in Boston.

Yet those in the dominant social group felt strong ownership of the city, and even the country, that their ancestors had helped establish in the American Revolution. They patrolled the social borders, confirming who belonged, keeping out interlopers, and resisting change—at their worst, they constituted a deeply parochial whispering gallery. A misstep here, a careless word there could spell doom. If Brahmins held outsiders at arm's length, as they did with Belle, they could be cruel to insiders as well. The writer and collector Thomas Gold Appleton captured the social temperature of the city with his oft-repeated phrase—"cold roast Boston." Henry Adams, Belle's contemporary and eventual friend, complained that the city of his

famed patrimony was a place where "everything is respectable, and nothing amusing. There are no outlaws." At the first chance, he and his wife, Clover, would flee to the warmer clime and less punishing social world of Washington, D.C.

Belle kept a brave face. When later asked if she'd ever felt downhearted at this time, she replied with a question—if she did, why would she ever admit it? Being rebuffed by women outside the Gardner family stung. Envy was hard to counter, and Belle made little effort to do so. She covered her hurt by declaring, as she reported much later, that she found Boston impossibly dull. If they didn't want her, well then, she didn't want them either. Social rejection taught her to defy expectations and hold her own counsel.

What mattered was Jack. Belle had folded his tiny sketch of the bonneted woman and the man with an arrow through his heart and put it, together with his calling cards, into a small hidden drawer in a black-lacquer sewing box, which might have been his gift to her during their courtship.

For Christmas 1861, their second holiday season together as husband and wife, they returned to New York to stay with Belle's family. They spent time with her brother David Jr., who would later graduate with a bachelor of arts degree from Columbia College, and little James, now three years old. The day before Christmas Eve, Jack bought for his wife a print of *The Studio of Raphael* for twelve dollars, with a four-dollar frame, at Goupil and Company, located at 772 Broadway, a block from Grace Church, which the Stewarts still attended. Goupil and Company was the New York branch of a Paris-based gallery that sold artist supplies and engravings of French, English, and American art. Jack bought a second print there, an engraving of Marie Antoinette, who had come to France from another country and generated intense scrutiny and scorn, a story that Belle, of course, could understand well. It cost four dollars, with an additional three dollars for a frame.

Two years later, the day after Christmas, Jack returned to Goupil and Company and purchased another portrait of the doomed queen, this time a larger engraving measuring twenty-two by seventeen inches, for which he paid twenty-two dollars. He carefully listed both prints in a register of early purchases, putting down the title of the second gift as "Gluck at Trianon." He didn't mention the artist, nor does the gallery receipt. Most likely, this was an engraving of the history painting by the nineteenth-century Belgian artist Édouard Hamman. It depicted the German composer Christoph

Willibald Gluck presenting to the queen his score for *Iphigénie en Aulide*, a popular opera that premiered in Paris in 1774. Gluck had been the queen's music teacher before she became his royal benefactor. Jack's gift to Belle, a portrait of a powerful woman patron and a grateful artist, would prove prescient. The scene would replay many times as Belle championed musicians, composers, writers, and painters.

The subject of both prints—Marie Antoinette—suggests that Jack understood Belle's plight. Belle had come from elsewhere and struggled to find her way. No matter. Jack thought of his wife as his queen. Even his father noticed that he was "a devoted husband." Steadiness and security—these qualities he had in abundance from his own family. Belle saved him from the rigidity of a Brahmin's life. She was so alive and expressive, so open to fun. Jack wanted Belle not to worry, at least not on his account. His early gifts suggest what became abundantly clear in his later ones: he felt he had married the most interesting woman he had ever met.

Of the many fine things she would eventually accumulate, Belle kept these two relatively inexpensive prints, by lesser-known artists, in her boudoir, first at Beacon Street, then at Fenway Court. The images of Marie Antoinette remained there, beside a photograph of Jack, for the rest of her life.

Four

"REMAINING DEAR ONES"

1862–65

The Civil War consumed Boston's attention in these years. Though far from the slaveholding states and the war's battlefields, Boston had long felt itself close to the front lines of the era's great national conflict. William Lloyd Garrison had started publishing the *Liberator*, calling for abolition of slavery, in Boston in 1831. When the Fugitive Slave Act passed in 1850, white and Black Bostonians together formed the Vigilance Committee, which helped fugitives escaping from slavery to evade the authorities. After the Kansas-Nebraska Act of 1854 opened the door for slavery to spread northward into new territories, Boston businessmen like Amos Lawrence helped fund both settlers and rifles to go to the aid of the Free-Soil forces in Kansas that opposed this expansion. And once the war began, Governor John Andrew quickly mobilized several Massachusetts regiments to join the Union army, with a host of Brahmin names, such as Putnam, Lowell, Perkins, Shaw, and Higginson, among the volunteers.

Yet many Brahmin families had made their fortunes in textile manufacturing, which of course depended on a regular supply of cotton from

the South to be processed in mills throughout the Northeast. When the Whig Party dominated Massachusetts, before the Republican Party arose in the mid-1850s, there had been two factions: the antislavery Conscience Whigs and the Cotton Whigs, who were not overtly proslavery but aimed to maintain stable relations with the South. Though Boston's conservative business class fell in behind the Union cause once the fighting started, not all groups felt equally fervent in their support.

Political fervor was not in the Gardner family's nature. Their watchword was toleration, which made them genial friends and loyal business partners but did not place them firmly on the right side of history at this time. While they did not have a direct stake in cotton manufacturing, their shipping and business interests certainly felt the impacts of the war, and they would have wished mainly for normal economic conditions to return. Discussion of the Civil War appears very little in Gardner family letters in these years; the focus is on family matters. Jack apparently entertained no thoughts of volunteering, as so many of his peers did. Yet it is remarkable that no rift seemed to open between Jack and his friends who served. A photograph from early in the war shows Jack and Belle with a uniformed Benjamin Crowninshield, who'd enlisted with the First Massachusetts Cavalry in November 1861. Henry Lee Higginson, badly wounded and scarred by a wartime saber wound to his face, would remain Jack's close friend throughout his life.

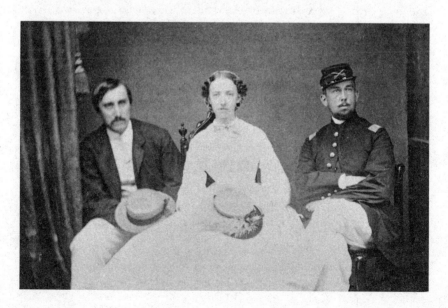

Belle took her cues about the Civil War from the family she'd married into. She too lacked political passion; there is no evidence that she reckoned at all with the outrage that was slavery, at least at that time. If she had been accepted into the social world of women of her class in Boston, she might have been invited to roll bandages, as many did, or participate in other activities in support of those fighting for the Union. But she was not included. Her reaction, when Morris Carter asked her about the Civil War near the end of her life, is telling. She reportedly replied, "I was too young to remember it." She would never have dared make such an evasive remark to Higginson.

<p style="text-align:center">⁂</p>

JACK GARDNER WOKE VERY EARLY IN THE MORNING AND WENT EVERY DAY to his family's business offices, a twenty-minute walk up Beacon Street to the city's business district. By 1862, he and Belle were able to move into their new home at 152 Beacon Street, a five-bedroom, five-story mansion in the French style, with a mansard roof and a spacious wine cellar. Jack filled a small notebook with detailed measurements of each room, including the sizes of windows and doorways. The walls of several rooms were covered in soft green chintz. Jack listed the addresses for showrooms of the finest French-style furniture in New York, given to him by Mr. Stewart. They bought a dining room table and chairs at L. Marcotte and Company and two writing tables made by Alexander Roux, who specialized in an elaborate rococo revival style. A pair of candelabra from Tiffany's cost $125. Belle knew the truth of what the New York decorator Elsie de Wolfe, later a friend, would write in her 1913 book *The House in Good Taste:* "A woman's environment will speak for her life, whether she likes it or not."

Belle's father had presented her with a grand piano, which she put in the second-floor library. Though she doesn't mention playing the piano in her correspondence, her pursuit of music since her early lessons on the piano in Rome was serious and lifelong. She loved a wide range: instrumental, song, and opera. She would host musical performances in her home and support the efforts of many musicians, including individual performers, chamber groups, and organizations. To her delight, Boston would come to be considered America's musical capital.

Also in 1862, the couple joined the newly established Emmanuel Church,

located at 15 Newbury Street, between Arlington and Berkeley Streets and near the Public Garden. The church's Gothic-style sanctuary, built from Roxbury puddingstone, was a dramatic space, with dark-colored pews and a timbered ceiling made of black oak. The Episcopal congregation had called as rector Rev. Frederic Dan Huntington, a professor of theology at Harvard College who had converted from the "One God" faith of Unitarianism, then dominant at the college, to a Trinitarian belief in the divinity of Christ. Jack's older brothers, Joe and George, also charter members, had bought pews in the upper gallery, while Jack and Belle chose pew 28, located on the sanctuary's main floor.

Emmanuel Church drew some of the city's wealthiest. It also was known for its strong antislavery stance. Huntington preached against the national scourge, knowing full well that many of his parishioners were heavily invested in cotton interests. Conservative business-minded members, wanting stability above all, sat side by side in the church with abolitionist members who demanded that the country live up to its noble ideals. Catharine Beecher, the older unmarried sister of Harriet Beecher Stowe, and Stowe's three grown daughters joined the theologically liberal Emmanuel in April 1862, in a break from the Beecher family's Calvinism. The famous abolitionist author herself worshipped there with her sister and daughters from time to time.

By October 1862, Belle was pregnant again. John Lowell Gardner III was born the following spring, on June 18, at their new home. Everyone called him Jackie, a slight variation on his father's childhood nickname, Jacky. The birth had been very difficult. Belle's doctor, Dr. Henry Jacob Bigelow, a leading physician of his generation, afterward told the couple she must not have more children. It was too dangerous. She took the utmost care to make a good recovery, and family members recalled her being stoic and still, awaiting the return of health and strength.

At that same time, following the bloody battle at Gettysburg in early July 1863, military conscription started in Boston. Jack's name was picked on the first day, July 8. Newspapers published instructions for how to evade the draft legally. Draftees with the means to do so could pay a substitute to fight in the Union army for the length of the war, for a fee from $300 to as much as $1,000, equivalent to approximately $5,000 to $16,000 today. Jack may have done this. Or his work in trade and finance may have been

deemed necessary to support a battered wartime economy. Also, he was a brand-new father. Neither he nor Belle ever wrote about the decision he made in letters or records that survive. In any event, Jack did not go to war.

THE BABY OCCUPIED THE CENTER OF HIS PARENTS' LIVES. BELLE WOULD sit with him in the large front window of their home, so passersby on Beacon Street could admire him, with his round, chubby face and shining blue eyes. The couple would take him from his cradle, made in the shape of a ship's keel, and show him off to their dinner guests, no matter the hour.

At the time, they were living in a world of children. Jack's siblings were all having little ones of their own. By 1864, the Gardner grandparents could boast of nine grandchildren under the age of ten. The eldest Gardner sibling, Joe, and his wife, Harriet Sears Amory, had Joe Jr. and William; George and his wife, Eliza Endicott Peabody, had Georgy, Caty, Ellen, and Sam; and Julia, who had married (in the same year as Belle and Jack) Joseph Randolph Coolidge, a great-grandson of Thomas Jefferson, had by this time two sons, Joseph and John. And then there were all the many cousins. Up and down Beacon Street they ran. George's Caty, a bright little girl, had a special fondness for Jackie, treating him, as Jack would recall, "in such a kind and motherly little way." Belle herself would tell her mother-in-law that she felt matronly as she accompanied Caty and little Georgy to Emmanuel Church whenever George and Eliza traveled. Belle finally belonged—to Jack and Jackie, to the larger Gardner family, to Beacon Street. She was knowable, legible as a mother, maybe especially to herself. To consecrate her sense of blessing, she took part in a confirmation ceremony on her fourth wedding anniversary, April 10, 1864, at Emmanuel Church.

A picture of Belle with Jackie, taken some time in early 1864, strongly conveys her connection with him and her deep pleasure in motherhood. She nuzzles the back of his neck, as if inhaling his new-baby smell. He's hoisted in front of her on a banister, and she balances him in her hands with confidence, her long fingers cradling him. She puts her head slightly behind his. She grins. He's the star of the picture, the focus of the camera. The body language makes the photograph seem almost contemporary, except for how Belle is dressed, in the shiny, billowing silks of mid-century fashion, with her curly, complicated hairdo parted straight down the middle.

It is Belle as nineteenth-century Madonna. It is also a visual motif—a

woman holding a young child—that she would come to surround herself with, one that never left her view.

During the fall of 1864, Jackie had been sick on and off. She and Jack had had a "siege with the baby," as she described it to her mother-in-law. First, they thought he had measles, then whooping cough, so they felt enormous relief when it turned out to be a bad cold exacerbated by four new teeth coming in. Though not yet two, he was already saying "any quantity of words very distinctly," Belle told Jack's mother proudly. She mentioned too that she'd been quite busy and was feeling better, though she was still quite thin. The next month, in early December, Jack wrote to his ten-year-old nephew Georgy, who was being educated at a Paris *pension*, a vivid description of their contentment: "Aunty Belle is very well this winter," he crowed, adding that "little Jack has grown a great deal since you saw him. He is beginning to walk alone and says a great many words and some short sentences."

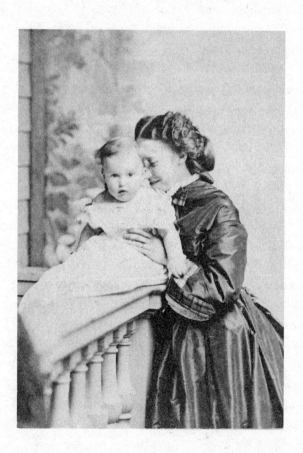

The winter months of 1864 and early 1865 were bitterly cold and snowy. The papers were filled with politics and reports of the war. President Lincoln had been reelected in November; Boston war dead were listed in the papers. Little of this enters into the letters of the extended Gardner family.

March began with pouring rain and biting wind. Isabella and Jack found themselves beset with worry. Little Jackie, who would celebrate his second birthday in three months, had come down with another terrible cough. This time the cough turned into lung fever, then pneumonia. On March 5, Jack's mother reported to his brother George, who was in Paris at the time with his family, that the toddler had been very sick the previous day and the fever hadn't yet broken. "The time for a change has not arrived," she wrote, "and we can only hope & pray that when the change comes, it may be favorable." For days and days, Belle and Jack sat by Jackie's bedside, suspended in agony as their little boy got neither better nor worse.

Then the weather turned. Wednesday, March 15, was warmer, more like spring. "Half cloudy and half sunshiny," reported Anna Cabot Lowell, one of Jack's cousins, in her diary.

That same warm day Jackie died.

Belle would not leave her child. She insisted on washing his body and combing his blond locks one last time. Three days later, on March 18, his funeral was held at Emmanuel Church. The next day his obituary in the *New York Times* read simply: "Gardner—In Boston, on Wednesday, March 15, John L. Gardner 3rd, only child of John L., Jr., and Isabella Stewart Gardner, aged 21 months."

Belle didn't keep the condolence letters that must have poured in from family and friends in Boston and farther away in New York. Her mother-in-law kept a note sent to the elder Gardners, who were with George and his family in Paris at the time of Jackie's death. Catharine Gardner's friend Lucia Gray Alexander, who lived in Florence, wrote, "I felt very sorry to hear of your son's loss of his little child," observing that "it does seem sometimes as if the finest and loveliest children are taken away."

Jack seems to have been stoical, trying with all his might to comprehend their loss in larger terms, somehow as a part of God's divine plan, hidden though it was from human understanding. Belle fell apart. Her cozy domesticity with Jack and little Jackie was in ashes. Jack made discreet and fleeting references to how she wasn't doing well. An observant cousin of the family

said she was "very delicate." On her twenty-fifth birthday in April, that year a Good Friday, President Lincoln was assassinated. The terrible news arrived by telegram in Boston the next morning.

Sometime in late summer, Belle was pregnant again, in defiance of the doctor's order. When she had a particularly hard day, Jack would stay away from his office to be near his wife.

Over that same summer and fall, Jack's older brother George and his family remained in Paris. George and his wife, Eliza, had first gone overseas two years before for George's health; it seems he suffered from some combination of nerves and exhaustion. His mother had scolded him, saying he'd been too consumed with work, had indulged in "the three C's—company, cigars, and coffee"—all of which sapped his strength. He had a temperament like hers, not Jack's, which was steadier. He needed to take care. George's son Georgy was at the Paris *pension,* along with several other Boston boys, including close cousins Percival and Abbott Lawrence, sons of Augustus and Katharine Bigelow Lowell. George and Eliza Gardner had taken along their daughter Caty, now a precocious eight-year-old who already read and spoke French fluently. Ellen, age five, also joined them, and their youngest, little Sammy, had been born in Paris the previous July.

Back in Boston, on November 5, Harriet Gardner, wife of Jack's other brother, Joe, gave birth to their third son, Augustus Peabody Gardner. They named him after checking with George that his first name, popular with Gardner relations, would be available. It was a brotherly courtesy.

Only days later, the first alarm sounded. Something awful had happened. The news came via a neighbor, a Mrs. Hooper, who had arrived from Europe on the steamship *Cuba* on November 9. George and Eliza's little Caty had died of cholera on October 22, in Lausanne, Switzerland, where the family had fled from Paris, hoping to escape the dreaded disease. The baby had perished four days later. The two Gardner children were among the first casualties of the 1865–66 cholera epidemic, which had started in Egypt six months before and would sweep through Europe the next year. George and Eliza only barely escaped with their two surviving children, Georgy and Ellen.

The next day Jack wrote to George and Eliza, saying that he and Belle had heard the "news of your terrible bereavement. Entirely unprepared, as we were it came upon us with a tremendous shock, and we could hardly realize the sad truth."

That same day Joe Gardner wrote to George: "Words cannot convey to you an idea of the grief and anxiety with which the sad news of the death of little Caty and of little Sam has overwhelmed us all." Their father, John Gardner Sr., in a letter also dated November 10, wrote unguardedly: "I write in the first moments of the great grief I feel for the loss of our two darling children. Little Sammy was a dear, but Caty of all children was the one I loved best—& this not without reason—& I looked forward with pleasure & pride to what she would one day become. I feel I can say nothing which will avail to assuage the pain of the dreadful bereavement, & you & Eliza must know too well how deeply I am destroyed to need any assurance of my sympathy." He did not hold back: "I wish I could have been near you at the time of these dreadful trials . . ." He tried to stiffen their spines, knowing from intimate experience the depth of their suffering. A generation before, he and Mrs. Gardner had themselves lost four of their eight children before the age of six, two of them, in a too-cruel twist of fate, also named Catherine and Sam. "I know that you & Eliza have the wisdom humbly to accept the decrees of Providence, however strong, and the fortitude to fulfill as heretofore your duties to God & to your family & the World." He added that "for your mother . . . it is beyond her power to write."

More letters followed. Four days later, Jack wrote a note lengthier than his first, touching on his and Belle's own dreadful knowledge of sitting vigil at a child's sickbed. "Belle and I can understand, from our own sad experience, your agony of suspense while your darling baby was hovering between life and death." He added that "little Sam was so near little Jack's age when he died, that we feel a twofold sympathy and appreciation of your loss." Remembering that "dear Caty" had been so fond of their own "darling," he reminded his brother of a letter George had written earlier, with a message to "little Jack to remind him that he had a cousin Sam, who hoped one day to be great friends with him." Jack added: "You little thought that their friendship would begin in heaven and that so soon." Mostly, he tried to reassure his older brother: "Our little Angels are far happier than they could ever be here, and we have the brightest reminiscences of their lovely lives— reminiscences, which, when the first bitter pangs are over, it will be one of your greatest joys to recall. They were blessings indeed to us while they were here and we can look back on their short sojourn with us, as the brightest

spots of our lives." He concluded his remarkable missive with a benediction for "my dear brother and your remaining dear ones."

News of the double loss stirred Belle's harrowing memories of watching her own Jackie die, with no way to save him. The next week, Joe wrote to George and Eliza, who had by then returned to Paris from Switzerland: "Belle is not very well."

The dark wind continued to blow. On Sunday, November 26, Joe's wife, Harriet, suddenly died, most likely from complications after having given birth earlier in the month. She had just turned thirty. Servants sent word to Jack and Belle, herself now four months pregnant, because they lived closest. They rushed over so quickly that they arrived at the house before Joe himself could get home. A neighbor recalled that "Belle did everything for Harriet that she insisted upon doing for her own child." In other words, she washed her body and combed her hair. She kept constant company with Joe and stayed up all hours, somehow holding herself together until after the funeral, when she collapsed. For four days, she wavered between life and death. Jack never left her side, and Joe too, in gratitude for her help with Harriet, stayed close by. In the stress of such accumulated suffering, she lost the pregnancy.

Belle's courage in aiding her brother-in-law Joe, her willingness to stay with him, to tend to Harriet's body, left a deep impression on Jack and the rest of the family. When they'd been engulfed, she stepped toward, not away from, the catastrophe. Maybe her response at this moment was another source of the family's steady love for her. A neighbor commented in another letter during this time that the Gardners were "extravagantly fond" of Belle, adding "she is a superb person."

She had escaped with her life, but she and Jack would have no more children.

DECADES LATER, BELLE GATHERED TOGETHER SEVERAL LETTERS WRITTEN by Mary Lowell Putnam, Jack's father's first cousin and the older sister of the poet James Russell Lowell. She put them in one of the display cases on the first floor of Fenway Court. Most missives in the stack were thank-you notes for flowers Mrs. Putnam had received from Belle at Christmastime. On top, in full view of visitors to the museum today, she placed a much

more personal message, a condolence letter Mrs. Putnam had sent after visiting Belle all those years before, when the younger woman was plunged in grief. Mrs. Putnam was an accomplished author and could speak many languages; they had most likely first crossed paths in Florence in the late 1850s. A thread that connected the two women was a shared intimacy with loss. Mrs. Putnam had buried three of her four children. Her third child, Lieutenant William Lowell Putnam, had been a war hero at the Battle of Ball's Bluff and had died of grievous injuries in October 1861. Two months later her husband died, on Christmas Eve.

"I must write to you, dearest Bella," Mrs. Putnam began with a sense of urgency. "I did not hear of your great sorrow until Tuesday evening. It grieved me to have remained so long ignorant of your grief. I could not but go to your house to have news of you . . ." She recalled their heartfelt conversation but admitted that "I could not, while I was with you, say that of which my heart was full. Yet I know, by experience, that the expression of a true and tender sympathy is not felt an intrusion. Accept mine, dear Bella, and believe that affectionate thoughts will follow you on your journey, and earnest wishes for your health and happiness, from a friend and cousin who loves you."

On a small bookshelf under the display case, Belle placed a copy of Julia Ward Howe's 1854 *Passion-flowers,* a book of poems that Howe had given her on Easter Monday, 1886. Twenty years older and an ardent supporter of abolition and women's suffrage, Howe had welcomed Belle to Beacon Street. She too was a New Yorker who had married into a Boston family, and she had suffered the loss of a little boy, the youngest of her six children, in 1863. Howe's inscription on her book's first page begins: "Full of death and resurrection is our life of every day. Fire consumes our imperfection, our true glory shines always." Belle would later use this image of a consuming fire in the museum's crest, designed by her friend Sarah Wyman Whitman, which she positioned on the north-facing outside wall above the palace's original entry. At the crest's center is an emblem of what Belle wanted to be: a phoenix rising from the ashes. She had suffered cruel heartbreak, and the museum stands as a kind of testament to the way she transmuted her grief. Though Belle didn't speak openly of the grievous losses of 1865, it is not accurate to imagine she hid from them.

It would take a long, long while to find her way through this "ruin of private happiness," but over time Belle did let herself live.

PART II
AROUND THE WORLD

I have never had such an experience, and I felt as if I never wanted to see anything again in this world; that I might shut my eyes to keep that vision clear... I felt it, even more than I saw it. It was a terrible that fascinated.
—ISABELLA STEWART GARDNER AT KARNAK, EGYPT, 1875

Five

A RETURN

1866–67

It seemed that small children were underfoot wherever she went. Julia Gardner lived steps away at 145 Beacon Street. Now, in March 1866, she and her husband, Joseph Randolph Coolidge, welcomed Archibald "Archy" Cary Coolidge, their third blue-eyed boy in as many years. Belle gave Jackie's goose-necked cradle to Julia's growing family, a gesture both salve and heartbreak.

Belle would be listed in the 1870 census as "keeping house," but what might that role mean without children of her own? Boston had a long roster of ambitious women, including Abigail Adams, who in 1776 had famously challenged her husband, John Adams, to "remember the Ladies." Writers, thinkers, activists—Elizabeth Peabody, Margaret Fuller, Louisa May Alcott, Julia Ward Howe, and many more, those with children and those without—had defied social conventions. One historian called the neighborhood of Beacon Hill "an incubator for female achievement." But those women were hardly typical. In any case, Belle's talents and sophisticated understanding of art pointed to few obvious paths other than a wifely role, which, by definition, included children. Social constraints may have compounded her grief for Jackie and her loss of hope for more children.

In late 1865, the news in the Gardner family had been that Belle was doing "pretty poorly," as Jack had reported to his brother George, with no

more elaboration. There didn't seem to be any change in succeeding months, though she did keep a commonplace book, or miscellany, which she filled with carefully clipped newspaper articles. A wide range of topics caught her eye: a suspension bridge over the Ohio River, explanations of how magicians pulled off certain tricks, sayings of Socrates, anecdotes about George Sand, news from Japan, exposés of Napoleon III, gossip about the writer Maria Edgeworth. A charming profile of the Danish sculptor Bertel Thorvaldsen at his home in Rome describes how his "sympathies were freely given to all poor artists, and he aided many by letting them hang their works on his walls, and when strangers came to see him, he would point out the merits of the pictures . . ." She placed each cutout, with ruler-straight edges, on the page, signing the album's inside cover "I. S. Gardner Feby 15 1866." Maybe the miscellany had been a gift from Jack, with the hope that a project might distract her and give her something to do to pass the time. In any case, neither album keeping nor rest nor extended quiet seemed to loosen grief's hold on her.

No record exists of a diagnosis for Belle. It's quite possible she was thought to have some form of hysteria, a lingering debility that suspended the sufferer in a kind of amber of inactivity. The condition was also called neurasthenia after Dr. George Beard coined the term in 1869. Jack's mother, herself especially sensitive and vulnerable to this sort of struggle, called women with this affliction "sofa invalids," a designation to be avoided at all costs. Jack consulted doctors about what to do. In the spring of 1867, Dr. Bigelow endorsed a cure commonly prescribed to upper-crust Americans: a trip to Europe. This remedy was already familiar to the Gardner family; some members had journeyed overseas in search of better health.

By the time of departure, in late May, Belle had become so weak, she had to be transported by ambulance to the docks in East Boston, then carried on a cot up the plank to the steamer bound for Hamburg, Germany.

The two-week Atlantic crossing did her good. She would later dread long crossings, often getting horribly seasick. While sturdy Jack would smoke cigar after cigar on the upper deck, unfazed by the rolling seas, she would sequester herself in her cabin, put her hair into a single braid that she twisted into a bun, climb into her berth, close the blinds, and consume champagne and biscuits, the only nourishment that calmed her. This crossing seems to have been an exception. Being on the boat, being in motion again, spending

time outdoors under big skies, revived her. When the couple disembarked in Hamburg on June 10, Belle walked off the ship on her own two feet.

Their tour through Norway, Sweden, and tsarist Russia, with several weeks in Vienna and Paris at the end of their trip, was a revelation of dramatic vistas, cathedrals and fine art, music and fashion. Most of their journey can be traced in Belle's travel album, the first of twenty-eight that she kept over the years, this one covered in pebbled black leather and measuring 12½ by 10½ inches, with fifty-four pages. Here she made a careful visual record, page after page, with purchased scenic photographs, quotations, arrival and departure dates, stickers of country flags, and tourist postcards. Later albums would include her sketches and watercolors, pressed flowers, and pieces of fabric, in addition to innumerable photographs of masterpiece paintings.

In Copenhagen, Belle thrilled to the sculptures of Thorvaldsen, the Danish master she had read about the year before. She included photographs of his work, showing a large-scale figure of Christ and several of his bas-relief sculptures in glowing white marble. She added lines from Hans Christian Andersen's fairy tale "The Swan's Nest": "We saw a swan strike the marble rock with his wing so that it cleft asunder, and the forms of beauty, imprisoned in the stone stepped forth into the light of day." From Copenhagen, the Gardners traveled by boat to see the towering chalk cliffs of the Isle of Möen and arrived at Oslo on June 23, after which they sailed up the coast of Norway to see the midnight sun at North Cape, the country's northernmost headland. Jack's copy of *Black's Guide to Norway* suggests the scene: "all is barrenness . . . ; the sun is still above the horizon, and strikes the clouds with varied hues of light and shade."

Belle took an interest in all ranks of society, pasting in her album royal iconography of crests and flags but also commercial photographs of Norwegian peasants in colorful garb. She even fitted herself out in one such costume and posed for several photographs, which she kept but excluded from her travel album. In another photograph, also not in the album, she sits straight up in the back of a Norwegian cariole. The brim of her summer hat shades her eyes. A servant boy is behind her, and Jack, with his pipe and traveler's bag slung across his shoulder, holds the reins of the white horse.

They left Norway for Sweden, stayed twelve days at coastal Göteborg, and then took a three-day boat trip to Saint Petersburg. At the top of her album pages dedicated to this part of their trip, Belle affixed stickers of the

Russian flags on either side of a crest and wrote the name of the capital using the Cyrillic alphabet. The purchased photographs show social types: a coachman with a carriage; a nurse; a husband and wife; workmen drinking from a distinctive Russian-style teapot; a glowering priest in his inky black robe and hat. Placing her images with precision within the confines of a two-dimensional page, she tried to represent what she had seen and felt in a three-dimensional world. She was experimenting with what went where and how best to tell a visual story.

She and Jack traveled south to Moscow on a rail line completed only a decade before. There they stayed only a week, returning to Saint Petersburg for another. She added a brief note in her album, mentioning they spent a day in Nizhniy Novgorod, by then a key trading post along the Volga River, but she didn't specify whether they'd seen the city's baroque Church of the Nativity, with its five bright-green domes. The tour ended with several days in Warsaw, then a stay in Vienna, the city of music, and finally two leisurely months in Paris. It was Isabella's first return to the City of Light since her school days a decade before.

She didn't mention the visits to Vienna or Paris in her album, but what's clear is that by the time the Gardners returned home to Boston in late 1867, she was returning more and more to life. The Old World, which she'd seen as a child, with its grand buildings, the drama of city streets with people on the move, and art around every corner—all its interest and beauty had revived her, just as Jack had hoped. If he'd been stoic about his grief for his son, finding comfort in his belief in an inscrutable divine plan, Belle found strength another way—by seeing and experiencing more and more of a wide world. This was a path forward.

A scene from summer 1868, recorded by Jack's friend Nicholas Longworth Anderson, suggests Belle's habit of directing her intense curiosity outward. Anderson, an Ohioan and a Harvard graduate, the same age as Jack, had volunteered as a private in the Union army. During his service, he'd been wounded twice, both times badly. For his valor, he'd been awarded the rank of brevet major general. In a July 1868 letter to his wife from the Parker House Hotel in downtown Boston, Anderson recounted a recent visit with the Gardners, who had invited him to the city's North Shore. Jack's brother Joe had started buying seaside property in Prides Crossing, a neighborhood of Beverly, and Jack and Belle most likely stayed in one of those houses.

Anderson remembered Belle waiting for him and Jack to arrive from Boston at the train depot in Beverly. He couldn't resist diminishing her somewhat in his letter to his wife, noting she was "homelier than ever in person." But her warmth, asking after Mrs. Anderson and their two young children, won him over. "She is the same generous, hospitable, cheery little body as of yore," Anderson enthused, adding that he'd felt "honored" when she let him "talk of you and the children for hours." Taking a sustained interest in another's children may not have been easy for Belle, but it was indeed generous. She'd do the same, time and time again, in the years ahead.

Six

"MRS. GARDNER'S ALBUM"

1868–73

Back in Boston by the end of 1867, Mr. and Mrs. Jack—so-called to distinguish the couple from all the other Mr. and Mrs. Gardners in town—unpacked their treasures. These included a nineteenth-century silver cup from Norway and, from Paris, a copy of a painting by the eighteenth-century French artist François Boucher, as well as two decorative panels purchased for 500 francs each by the court furniture maker Mathieu Befort Jeune, whose handiwork had furnished the rooms of Napoleon III and Empress Eugénie.

The couple settled into routine for the next several years. Most days, Jack worked at the Congress Street offices of the Gardner family business, for which he was becoming increasingly responsible. John Gardner Sr. had a gift for making a profit. After the war, he increasingly moved his interests from merchant ships to savvy investments in mining and railroads. The devastating fire in November 1872, which destroyed over sixty-five acres of Boston's downtown, would miraculously harm no Gardner property; Mr. Gardner quickly invested in an insurance company, knowing people

would want to take out a policy after such widespread destruction. By the 1880s, his real estate investments in Boston alone would be worth over $5 million.

One of Jack's brothers remarked: "If you had started Dad at the foot of State Street with nothing on, by the time he had reached the Old State House he would have had a new suit of clothes, spats, a derby hat, a Malacca cane, and money in his pocket." But Mr. Gardner liked to say that the difference between success and failure was a mere mistake or two. He knew wealth like his involved an enormous amount of unearned luck.

It was no small compliment to Jack that the elder Mr. Gardner saw his son as dependable and scrupulous and modest. He called Jack "a hard worker." Mr. Gardner Sr. explained to George in June 1871 that he had found little reason to return to the city when he and Mrs. Gardner escaped to their cooler retreat of Green Hill in Brookline. The "whole weight of the business, such as it is, rests on Jack's shoulders and he has shown himself, thus far, well able to support it." Several times, Jack traveled outside Boston on business, once with his father-in-law, David Stewart, to Lake Superior in 1869 and again to the same destination with his own father in 1872. Both trips were likely related to the financial interests both Stewarts and Gardners had in the Calumet and Hecla copper mines, which had opened on the Michigan peninsula in the mid-1860s; numerous Bostonians had invested in them. Ida Agassiz's brother, Alexander Agassiz, was the mine's founding director, and Jack Gardner was later a director.

Business wasn't Jack's whole life. He enjoyed going to his private clubs; he'd be a member of no fewer than six, including the Boston Art Club, the Somerset and the Tavern Clubs, and the Country Club in Brookline. He was well-liked as a member because he had a knack for making sure good food and wine were served and for smoothing over any disagreements between members. He collected rare coins and read history. In the hot months of 1869, he filled his sketchbook with seaside scenes, often featuring sailboats, an abiding interest. Jack's parents mention in letters during this time that he was getting stout: "John is busy and burly," his mother reported; nine months later his father said outright that "John is fat . . ."

Belle "is very pleasant," Jack's father reported in a letter in 1870, elaborating no further. What did she do with her days? She did crochet work.

She spent time at her desk responding to letters, which were delivered up to twice daily, except on Sundays. She likely played her piano, perhaps using the copies of her Stewart grandmother's sheaf of handwritten scores of typical eighteenth-century piano music and songs that Belle had kept.

At the 152 Beacon Street home, she greeted visitors in a small yellow drawing room furnished with low-slung chairs. During the winter season, when the sun set in the afternoon, she and Jack liked to play backgammon. On other occasions they attended one of the many dinners or soirees at the homes of family and friends who lived nearby, in the mansions going up along Beacon Street and the cross streets and avenues of a still-expanding Back Bay, including tree-lined Commonwealth Avenue, designed to look like a broad boulevard in Paris. They attended concerts by the Harvard Musical Association, a forerunner of the Boston Symphony Orchestra, at the city's grand Music Hall on Winter Street. Belle's favorite composers in these years included Brahms, Mozart, Bach, and Beethoven; later her preferences ranged more widely as she heard more music and came to know musicians personally.

In summers Belle and Jack retreated to his parents' spacious Green Hill in Brookline, where they could, in the older Mrs. Gardner's words, "enjoy the great beauty of the country." She reported that her son and daughter-in-law were finding "pleasure in high cultivation." Mr. Gardner liked to talk with Belle about his plans for the estate's gardens and greenhouses. In these years Belle and Jack also went to fashionable Newport, one summer staying at the estate of Edward Darley Boit, whose daughters John Singer Sargent would later immortalize in oil paint.

Belle's mother had given her a guidebook to society by Emily Thornwell, published in 1856, with a title that maps the content and limits of a privileged woman's world: *Lady's Guide to Perfect Gentility, in Manners, Dress, and Conversation, in the Family, in Company, at the Piano Forte, the Table, in the Street, and in Gentleman's Society, also a Useful Instructor in Letter Writing, Toilet Preparations, Fancy Needlework, Millinery, Dressmaking, Care of Wardrobe, The Hair, Teeth, Hands, Lips, Complexion, etc.* These scripts for a woman's behavior are elaborate, confounding, and sometimes laughable. After several items listed in the book's index, Belle wrote satiric finishes in pencil:

Care of the feet *is to keep them small.*
Requisites of female beauty *are hands and hearts.*
Importance of taste *is required in charming lovers.*
To perfume linen, *fill your drawers with onions.*

She usually didn't mark up her books, but she couldn't resist doing so in this one, making comments throughout the chapters. After instructions for how a lady should mount and dismount a horse ("she takes told of the horn of the saddle, and then rises with her right hand, and places her left foot upon the shoulder of the gentleman, who stoops before her, making a stirrup of his clasped hands . . ."), she added: "ridiculous, funny."

She also chafed at the intricate social ritual whereby callers would pay brief morning visits to several homes at a stretch, staying up to thirty minutes, depending on the closeness of the relationship. If no one was home, the visitor left a calling card with her name, which obliged the recipient of the card to return the visit, and so on, in a never-ending loop. Belle dispatched her etiquette book's prescriptions concerning visits in a single word: "foolish." A later observer would describe the artifice of polite society in this way: there was "no invitation to enter, to converse, to substitute the real for the pretended. The cards were symbols. And I thought of *Alice in Wonderland* when the whole pack of cards tumbled about her . . ."

The city's high social season ran from autumn until the start of Lent in early spring. Debutante teas and dinner receptions were followed by opera and theater performances in January and February. The evening events Belle liked best were fancy balls. If London was known for its theater, Paris for its dinners, and New York for its "high gaiety," in the words of the mid-twentieth-century observer Emily Price Post, then Boston became renowned for the beauty of its lavish balls, also called assemblies.

They were frequently held at the Papanti Dance School on Tremont Street or the nearby Horticultural Hall, with its ornate facade of white Concord granite and an enormous third-floor exhibition hall that did double duty as a dance floor. *Harper's Weekly* compared it, on its opening in 1867, to the very best public buildings in Paris. The papers breathlessly reported on attendees—who danced with whom, the current fashions.

The waltz had been danced in Boston since the 1830s, its first showing

in America, but the French quadrille was also popular. Dances allowed sensuous movement and flirtation; it was a stage performance, a heightened reality, for which revelers wore their finest attire. Belle glided across the ballroom floor like the girl she'd been, the fastest runner in her class—confident and at ease in her body. She knew her steps. When she met the handsome Mr. Louis Papanti, the Italian-born dance instructor of generations of Bostonians, at his school, he asked in admiration: "Where did you learn to dance?" "Paris," she must have told him.

She also knew what to wear. A tight corset suited her beautifully proportioned, curvaceous figure. She had long arms and hands, a shapely neck, blue eyes, and an alabaster complexion, which she safeguarded from the sun all her life by wearing hats and veils. She cared about fashion because she cared about aesthetics, and fashion was her most immediate access to beauty—she could literally put her hands on it. She also had a keen knowledge of fabric and textiles. After all, her grandfather had traded in lace and her father had imported Irish and Scottish linens. She had fingered cloth, knew how it draped and how it absorbed or reflected light. It is not clear when she first walked up the red-carpeted stairs at 7, rue de la Paix, on Paris's Right Bank, and entered Charles Frederick Worth's atelier, which he had opened in 1858. Soon enough, though, she'd become a habitué of the House of Worth, wearing his creations of sumptuous cut velvet and watered silk.

Eye-catching jewels—rubies, emeralds, and diamonds—heightened the drama of her couture. When she and Jack were in London, later in 1874, he would buy her a single-row necklace of forty-four "very fine" pearls. Strings of gorgeous milky-white pearls would be his biennial gift to her, purchased in subsequent years at the jeweler to the *mondaines* of Paris society: Frédéric Boucheron. Pearls would become Belle's signature accessory. She wore them as a long rope, circled around her neck once or twice, with a third loop that hung far down in front, finished with a glittering ruby or two.

Belle's dress and adornment signaled her place in society but also something more—her originality and her desire for a place apart. She was not studying the dress codes of Boston matrons. Women pictured in her mother's album of European royalty and the high-flown women in masterpiece paintings hanging in London and Paris galleries wore many jewels, including ropes of pearls.

Not surprisingly, men took notice. Morris Carter reports in his early biography that "young men watched for her arrival, speculating on what she would wear." The morning after an assembly, Belle would receive notes like this one: "Accept my respectful congratulations on one of the most perfect dresses I ever saw . . ." One observer later recalled that she was "most favored of our belles," remembering a particular Worth gown of luxurious white uncut velvet. Sometimes the comments were more pointed, as when Thomas Gold Appleton ran into Belle coming up the stairs to a party and noticed the cut of her gown: "Pray, who undressed you?" "Worth," Belle reportedly countered. "Didn't he do it well?" Her own physician, Dr. Jacob Bigelow, sent an astonishingly flirtatious letter that somehow escaped destruction, the fate of much of her correspondence of this period: "No wonder so many gentlemen admire you. I hesitate to put on paper the way I feel," he began. "The trouble is you excite all these emotions in other people's bosoms and remain so perfectly hard-hearted yourself." He concluded rather helplessly: "there seems to be no alternative but to sit on the top of Oak Hill and think of the way your dress fits."

All of this, of course, did not endear her to the cohort of women in Boston who found her both too much and hard to dismiss. So they gossiped. Hedwiga Regina Gray, one of the arbiters of elite society who was a generation older than Belle, reported in her diary on Belle's attendance at several assemblies, in particular one following a debutante ball the Grays had hosted for their daughter in December 1868. She gave the opinion that the younger woman was "fast," meaning she too often ignored decorum. Mrs. Gray made fun of Belle when describing how she and several other women entered into "retreat for religious contemplation," which required that they refrain from walking and talking "in the street with anyone" or receiving "company at home." This practice of Belle's—an early sign of her deepening faith—was too attention-getting for Mrs. Gray. And anyway, these women were, in her words, "very toplofty dressers." The idea that they'd don "dowdy shabby clothes for the whole three weeks," as the ritual required, was comic.

"Belle goes to New York for a visit," her mother-in-law reported in 1870, a not uncommon occurrence in these years. New York's high society was, like Boston's, "hieroglyphic," as Edith Wharton would write of the city in the 1870s in her novel *Age of Innocence*. But the "sifted few" of Boston's elite

society was smaller, and opinion had a tendency to run more "in grooves." A newspaper called it "fossilized conventions." Close proximity to family relations left few places to hide, as a later historian noted, so that "virtues and vices" could be scrutinized and "characters judged." The writer John Jay Chapman called the "slight mental cramp" common to this slice of Boston a "grief to many." To a younger woman friend, Belle would later issue a sternly worded warning: "Please don't get intimate with any horrid women."

The social whirl cut both ways—it could be tiresome and tedious, but it gave Belle a stage on which to display herself, where she might claim distinction through artful dancing and beautiful clothes, though the attention carried risks.

In the commonplace book she began keeping in 1868, she started to work out what this might mean. Instead of newspaper clippings, she copied out aphorisms and quotations from a wide range of writers and poets—George Sand, William Blake, and Alexis de Tocqueville—in handwriting that loops and lopes across the pages. From George Eliot's *Middlemarch:* "The quickest of us walk about well-wadded with stupidity"; from Novalis, the German poet and novelist: "We touch Heaven when we lay our hand upon a human body"; from Schiller: "Death cannot be an evil for it is universal"; and from the German Romantic writer Bettina von Arnim: "If two are to understand each other, it requires the inspiring influence of a third divine one. And so, I accept our mutual existence as a gift of the gods, in which they themselves play the happiest part."

She was alert to commentary on the character of women: "There is nothing fixed, enduring, vital, in the feelings of women; their attachments to each other are so many pretty bows and ribbons" (Eugénie de Guérin); "Men are the occasion that women do not love each other"(Jean de La Bruyère). If this line recalled her time at the *pension* in Paris—"No friendship is so cordial or so delicious as that of a girl for girl"—the second half of the quotation now seemed of interest: "No hatred so intense and immovable as that of woman for woman" (Walter Savage Landor).

She was also attuned to mottoes for how to live. John Ruskin begins with a simple declaration: "This I know," and goes on to say that "reverence is the chief joy & power of your life. Reverence for what is pure & bright in your own youth; for what is true & tried in the age of others, for all that is gracious among the living, great among the dead & marvelous in the powers that can-

not die." Belle's desire for a map that might show her how to navigate a world so glittering and so precarious still hovers over these pages. She was also inventing herself by collecting—dresses and jewels, of course, but also quotations, images, experiences. With this inventory, she began to make her own path.

⁂

THE DAY AFTER NEW YEAR'S, 1871, JACK'S MOTHER WROTE TO GEORGE from Boston that "in the way of gaiety, I have little or nothing to record," adding that "Belle gives her usual amount of dinners." Six weeks later, she told George that "Belle is over head and ears busy about the fair." The fair in mention was the Fair for the Relief of Suffering in France, a charity event where Belle helped mount what might be called her first art exhibition.

The previous fall, the Prussians had attacked France, and the capital city had been under siege, cut off from the rest of the country. News got out of Paris via reports sent in hot-air balloons, which floated high over the city's boulevards to the government in exile in southern France. Parisians were fighting back but were outmatched and in desperate straits. At the turn of the new year, American newspapers told of an ever-deepening crisis: "Bombardment of Paris Vigorous on All Sides" was an early January headline in the *New York Times,* followed by a detailed report several days later: "Hospitals, ambulances, schools, the public libraries, the churches of St. Sulpice, the Sorbonne and Vol de Grace, and many private houses have been struck. Women were killed both in the streets and their beds, and infants in their mother's arms." A few days later another headline simply read "What Shall We Eat?"

Elite Bostonians felt a kinship with Paris. Many, including the founding doctors of Massachusetts General Hospital, had toured or been educated in France. Many spoke or read French. In the run-up to the centennial of America's Revolution, a sense of debt to France had been expressed in the newspapers, specifically for its decisive help in treasure and military leadership during the country's founding. The firebrand William Lloyd Garrison, publisher of the important abolitionist newspaper the *Liberator,* put it this way in the *Boston Advertiser:* "May our nation, remembering how immensely it is indebted for its independence, and consequent existence as a republic, to the French people in the days of our revolutionary struggle, avail itself of this commanding opportunity to render a helping hand, by the most liberal contribution of money and material supplies!"

Soon newspapers reported on a general drive for donations to an emergency shipment of food and clothing and other goods to France. By early January 1871, an auxiliary committee had formed to plan an ambitious fundraiser, the Fair for the Relief of Suffering in France, to be held at the Boston Theater and Horticultural Hall for two weeks in mid-April. In the months leading up to the fair, numerous events or entertainments were presented to raise money. Readings and theatricals in French, hosted in private homes or public halls, were popular. Over six hundred people paid fifty cents to attend the lecture by the renowned Dr. Charles-Édouard Brown-Séquard on "The Normal and Morbid Influences of the Nervous System upon the Organic Functions of Man and Animals" at Tremont Temple. The next week a hundred people attended the Soiree Musicale at Brackett's Concert Hall at 409 Washington Street. A dollar bought entrance to a reading by Julia Ward Howe at the Fraternity Hall; the same price secured a seat at the Lowell Institute, to hear Professor Louis Agassiz give a lecture called "A Journey Through Switzerland," illuminated by photographs.

For the main event, the committee set up fifty tables in the theater, with a variety of items on view or to purchase. Each table had a name, such as Revere House, Marie Antoinette, Beacon Street. Mrs. Waterston, mother of Belle's school friend Helen, was in charge of the Curiosities and Antiquities Room. A restaurant served classic French fare—foie gras and patisserie. Jack signed up to be a marshal at the Beacon Street table. Belle, meanwhile, helped with the fair's art room, an exhibition gallery of paintings and objets d'art on loan from residents and the Boston Athenaeum's large collection of paintings. The display included landscapes by Washington Allston and numerous portraits by John Singleton Copley and Gilbert Stuart. Several French, Dutch, and Italian painters, not as well known to Boston audiences, were also included.

Susan Hale, daughter of Nathan and Sarah Preston Everett Hale, published six issues of *Balloon Post,* a daily newspaper that described all the goings-on at the fair. Hale had persuaded a range of writers—Ralph Waldo Emerson, Bret Harte, and a young Henry James—to contribute pieces to her publication. The painter William Morris Hunt designed the masthead. Mary F. Curtis, a Bostonian who had been at Versailles during the siege and witnessed the Commune, the bloody radical rebellion threatening to poison the well of support for republican France, served as the publication's

war correspondent. Copies of the *Balloon Post* sold for fifteen cents—Belle would have her copies specially bound as a keepsake.

The headline on page six of the first issue, dated April 11, asked, "What Is the Object of Our Fair?" The article's writer, Louis Agassiz, Ida Agassiz's father and the esteemed Harvard College professor of zoology and biology, answered simply that it was to "help the sufferers in France, and especially those irresponsible sufferers whose homes are destitute and whose fields are waste for no fault of their own. They stood in the path of the whirlwind, and it swept over them." He reassured readers that support of the French people did not mean support of the Commune. Instead, he argued that it "would ill become us to offer to the sister nation who has been our benefactor in many ways anything less than a whole-hearted charity." By its conclusion, the Fair for the Relief of Suffering in France had raised over $75,000 (equivalent to almost $1.5 million today), with $5,000 sent to Rev. Athanase Coquerel Jr., an activist for women and children and son of the French Calvinist preacher whom Belle had known when she'd attended the Paris *pension* almost fifteen years before.

The *Balloon Post*'s April 15 edition urged readers to stop by the exhibition gallery and included this detail: "Mrs. Gardner's Album, in the Art Room, requires serious study . . ." Was this a reference to the album Belle had put together of her travels in northern Europe and Russia several years before? Or was it another album altogether, which she had assembled specifically for the fair? The newspaper didn't specify. Regardless, there she was, thirty-one years old, in the fair's gallery room, her time and attention held by the interest and solace of a blooming passion: art.

THE WRITTEN RECORD OF BELLE AND JACK IN THIS PERIOD IS SPARSE. Her regular appearances in the newspapers would begin soon enough, as would her art collecting. In 1873, they paid $650 for *Sheep in the Shelter of the Oaks,* a small oil painting by Charles-Émile Jacque, at the Boston art gallery Doll and Richards, one of the early purchases she would later include at Fenway Court. It would be several seasons before they traveled, but when they did, it would be a long journey to the other side of the world, one that would propel Isabella into her future.

Seven

"ZODIACAL LIGHT"

1874–75

In the fall of 1874, Belle got the awful news from New York that her twenty-six-year-old brother David, eight years her junior, had died on October 5 after an agonizing struggle with brain cancer. His funeral at Grace Church took place three days later. He had never married. His Columbia College class of 1869 memorialized him in a public tribute, calling him "a faithful friend, a finished gentleman . . . whose character and disposition have endeared him to all who knew him." Now only Belle's youngest brother, sixteen-year-old James, remained at home with Mr. and Mrs. Stewart. James likely was intellectually disabled. There is no record that he attended a school. The single hint of what might have afflicted him comes much later, when Jack's nephew Harold Jefferson Coolidge requests that Morris Carter not refer to James as "half-witted" in an early draft of his biography of Isabella—presumably because doing so might cause unnecessary pain in the family.

Little else is known about David's death, as would be the case with James's death from malarial fever seven years later. There's scarcely a mention of Belle's brothers in her collections and papers. She was quite a bit older than they were, already married and in Boston when they were still children. They must have seemed far off, part of a different generation. She tucked into her autograph album one of David's sketches, dated 1860, of an old bearded man. There is a tiny gemtype photograph of him from the

same period. She also kept in her private library a handsome volume of John Keats's poems, which David had given her as a New Year's gift in 1873, eighteen months before he died. Book I of *Endymion* begins with these lines: "A Thing of beauty is a joy forever: / Its loveliness increases; it will never / Pass into nothingness; but still will keep / A bower of quiet for us . . ."

Her parents' public tribute would be the large stained-glass window they erected in 1883 at Grace Church to honor all three of their deceased children. One of its panels shows Lazarus rising from the dead. The inscription on the glass reads in part: "He that was dead came forth with grave clothes / Jesus saith unto them / Loose Him Let Him Go."

<hr />

A MERE MONTH AFTER DAVID'S FUNERAL, BELLE AND JACK EMBARKED ON a long overseas journey. It was a reprise of a pattern set by the Stewart family after little Adelia's death almost two decades before, when they'd decamped to Paris. It occurred again when Belle and Jack lost Jackie and escaped on a tour of northern Europe and Russia. Getting away, seeing new prospects—all of it was balm.

"Many people [came] to see us off," Jack noted in his diary about their departure on November 7 from Boston by train to New York. The next morning, the Gardners attended Grace Church with the Stewart family. Early the following morning they started for Jersey City, where their overseas steamer awaited. Their passage across the Atlantic took only nine days, and after a week's stay in bitterly cold London, they crossed the Channel for Paris, where they stayed at Hôtel Vendôme, in the fashionable first arrondissement, for a week. Paris wasn't their goal. Their destination was Egypt and a fifteen-week boat trip on the Nile.

Belle began the first entry of her travel diary while still on board the *Hydaspes,* the steamship they took from Brindisi, an ancient port city on the eastern side of Italy's heel, across the Mediterranean to Alexandria. She mused: "When I went on deck on the morning of Decb.10, I knew that it was a dream, for never had I seen such a colour as was the sea. There is no word for it—and on the horizon was a low stretch of sand and waving Palms. I felt that it was Africa and from that moment everything was interest and excitement." She gloried in the tonic winter weather of the Mediterranean. She'd been liberated from her usual domestic and social routine.

From Alexandria, the Gardners went immediately to Cairo, where they spent another week getting their boat, a *dahabiyya,* and its provisions ready. They had much shopping to do at the city's crowded bazaars. John Murray's *Handbook for Travellers in Egypt*—Jack had its 1873 edition—urged readers to bring, among other things, field glasses, mosquito nets, tea, wine, brandy, butter in jars, and paraffin candles. Before provisions could be laid in, the boat had to be beached and dried out in the sun to get rid of vermin. Jack hired the crew, which consisted of Giovanni Maria Bonnici, their dragoman (interpreter); a cook and waiter, both Europeans; and ten other crew members, all Egyptians. He kept careful track of their pay; the cost of the entire trip would be £720 (or $115,971 today). Belle bought recently translated editions of Homer's *The Odyssey* and *The Iliad* as reading material on their journey. She and Jack liked to read aloud to each other at the end of the day. She took along a copy of *History of Civilization* by Henry Thomas Buckle, who had published the first volume of the series two decades before, and J. G. Wilkinson's multivolume *Custom and Manners of the Ancient Egyptians*. She also traced on a large sheet of paper a chart of hieroglyphics and their meanings, so she could decipher any ancient writing she might spy on the ruins.

By December 18, their *dahabiyya*, the *Ibis,* was ready. Isabella announced in her diary that they were "charmed." The long, two-masted boat measured just nine feet across and sat high in the water, better to maneuver and float above an ever-changing riverbed. "With a few touches," she went on, "the little parlour became very pretty and as we could spread ourselves well over the boat, we were quite comfortable, with our separate dressing rooms, bath rooms, etc." The spacious upper deck, which Belle called their "sky lounge," was decorated with "Eastern rugs, couches, plants and awnings . . ." The scenery from onboard seemed quivering and alive. She personified Cairo in a runaway sentence that ends with these words: ". . . the lights of Cairo looked at themselves in the water, the palms waved and whispered to us from the bank, the moon looked down on it all, and when the crew, with their turbans and many coloured robes squatted in a circle about their little lurid, flickering fire, cooked their coffee and chanted their low weird songs to the tapping of the tarabuka—it was too much." Too much for a single sentence and too much for her senses to take in at all once—she found the scene reminiscent of one of Scheherazade's tales in *Arabian Nights,* as she'd noted on first arriving the week before.

Those familiar tales, translated from Arabic into English in the early eighteenth century, along with biblical stories, made up common reference points for first-time travelers on the Nile. As Belle would observe later, "The harvest scenes are full of incident. There is so much life: people, camels, donkeys, goats, sheep, dogs, cows, and buffaloes, and all such Bible pictures." Egypt had long stirred the popular imagination in the West, but in the decades after Napoleon's expedition at the end of the eighteenth century and the deciphering of hieroglyphics by Jean-François Champollion in 1822, the ancient land and its river had become de rigueur on the grand tour. By 1872, when the squeaky-voiced teenager Teddy Roosevelt and his family traveled on the Nile, the river was crowded with seasonal tourists. That same year Ralph Waldo Emerson, whose memory was badly fraying, visited the sights with his daughter Ellen. He most wanted to see the tomb of Osiris on the island of Philae, the so-called jewel of the Nile.

The Gardners encountered tourists from England, Germany, France, and Brazil, but they also met familiar faces. When they came across the boat of fellow Bostonian Thomas Gold Appleton, all they could do was wave like mad and shout across the water. They dined with General George B. McClellan and his wife, Ellen, on each other's boats.

The Nile's current ran from south to north, so the arduous part of the trip was the first leg upriver. It could be done by sail when northerly winds blew but otherwise required quite a bit of tracking, or pushing by poles. Sometimes the crew had to scramble onshore to pull the boat along by a series of pulleys and ropes. A calm day meant little progress; a direct headwind also posed difficulties, or as Belle remarked: "great blow little go." Jack kept detailed notes of when they were sailing and when they were tracking, down to the quarter hour.

Whether moving fast or slow, Belle didn't seem to mind. She enjoyed her floating home, named after the long-legged shorebird common along the riverbank and revered by ancient Egyptians for "its hostility to locusts," as Appleton quipped in his journal. She affectionately described what happened on the boat in bird terms, as when noting how the *Ibis* folded her wings for the night. Jack tried to learn photography, with not very good results. At one point he received advice from Antonio Beato, a professional photographer from whom he bought numerous prints. Belle spent time on the sky lounge reading, writing letters, absorbing the sights and sounds. Twelve days after they'd started out from Cairo, she made reference to Homer's Odysseus and his visit to the land of the lotus-eaters: "No wind, we went not quite so surely as slowly I think—but the air was perfect and I felt that I could sit forever, lotus eating, watching the birds, the camels, and the people." Likewise, in the evening two days later: "As I lay upon the couch with the fragrance of the frankincense stealing over me, the wake of the moon was a fit path by which my thoughts went straight to Cleopatra, and I forgot it was Xmas eve."

Belle collected experiences and impressions almost as if they were objects that she could put in her hand. She wrote expansively almost every day in her modest-size album, which she also used as a diary. Sometimes she included a purchased photograph that illustrated her prose observations, as at the Temple of Esnah, which they visited on January 21: "The temple now consists chiefly of 24 columns, with capitals different and some beautiful." Here and there, she illustrated her prose with her own carefully composed watercolors, depicting what she'd found interesting or what had moved her. She was fascinated by the visual and the verbal, and the combination of the two—how one might amplify the other. The night before their visit to the Esnah, onboard the *Ibis,* Belle was overcome with emotion at the beauty of

the scenery: "What nights we have! The river runs liquid gold and everything seems burned into the precious metal, burning with inward fire; and then the sun sets and the world has hardly time to become amethyst and then silver, before it is dark night. And the moonlight nights! How different from ours. Nothing sharp, clear and defined, but a beautiful day turned pale. It was so beautiful, inexpressibly lovely tonight on deck and everything was so still when the Muezzin's call to prayer was wailed through the air, that the tears would come."

She drank up the sights and sounds. At the Pyramids near Cairo, which they'd visited first, before boarding the *Ibis,* Belle exclaimed: ". . . when I got away from the carriages and many of the people and could lie on the sand near the Sphinx, with the silent desert beyond and on every side and the Pyramids a little away from me—then solemnity and mystery took possession and my heart went out to the Sphinx." Her experiences engaged all her senses.

She could be typically Western in her views of the people, calling the women "rarely handsome" and saying that "all Arabs beg." When they early on went to see the Mosque of the Howling Dervishes, she said she'd "never seen anything so terrible." But she marveled at antiquities in the Cairo museum, calling the statues unequaled in their artistry. And she was deeply curious watching "graceful women coming and going with the water jars on their heads" near the riverbanks. She declared that the crew on the *Ibis* were a great delight, noticing how they were "so vain of their dress—I mean, their turbans. They are always washing them, fingering them and helping each other to wind their heads up in them." She relished how they sang and how they enjoyed "their oft repeated cups of coffee and their occasional whiffs from the hasheesh pipe." She quietly observed "the steersman at his prayers, his forehead touching the deck." Her elegant watercolor of two women sitting on the ground of a "ruined mosque" captures her hushed appreciation for their world. The purchased photographs she included in the diary were not mocking but rather show people expert at what they do, proud and at one with their surroundings.

The Gardners came ashore again three days after Christmas Day to see the colossus at Ed Dayr. Unafraid of travel by any means, Belle got on a donkey while one of the red-turbaned crewmen "trotted by my side and held me on and the donkey up." They saw the caves of Tell el-Amarna and the caves in the Libyan hills, which were gracefully decorated. Later, at Temple Koorneh, she traveled by "men's arm's, donkeys, ferry boat, and donkeys again." By mid-January, they arrived at their—in Belle's excited words—"first Egyptian Temple!" Dendera was a later Roman temple built to honor an Egyptian goddess and thus "very modern for Egypt." She felt "rather suffocated at first by its massiveness and its 18 giant columns in the portico" but found the temple's inner room "so mysterious and dark with its huge walls." She shivered when thinking of the ritual sacrifices that had taken place within its halls but marveled at how they were "covered with sculptures" and noticed with pleasure the frieze of "Cleopatra and her son Cesarean on the walls, with their cartouches."

The next day they anchored the *Ibis* near the Temple of Luxor at Thebes, where they picked up newspapers and letters. Neither Belle nor Jack re-

ported any news from home in their diaries. On January 16, they started out on donkeys, under moonlight, for the great Hypostyle Hall at Karnak, the forecourt of the Luxor complex, with its hundreds of enormous columns and pylons, some twelve feet in diameter, all reaching to the sky and inscribed with hieroglyphics and friezes. Interestingly, Belle didn't describe what she saw; she described her feelings and reactions to what she saw. "I have never had such an experience and I felt as if I never wanted to see anything again in this world; that I might shut my eyes to keep that vision clear. It was not beautiful, but most grand, mysterious, solemn. I felt it, even more than saw it. It was a terrible [sic] that fascinated. I never can forget that night and Karnak will always be to me at the head of everything."

A week later, as they approached Nubia to the south, the riverbanks began to change from limestone to sandstone. Belle painted a tranquil sunset, a favorite time of day. They were headed for Aswan, the first cataract, where many travelers turned around for the trip back down the Nile to Cairo. They were not alone there. "It was a race for the cataract," Belle wrote on January 25, listing the other boat names, including the *Nautilus* and the *Philae*, which she found "very pretty and fast." The next day Jack counted seventeen boats, either turning around to go back to Cairo or waiting to go through the cataract. Local villagers, called the Shellalee, had to pull each boat, one at a time, through a passage of rapids and whirlpools to avoid the jagged outcroppings. The Gardners were at the end of the line, and so passed the time by socializing. They had tea with Englishmen, dinner with a Mr. Foster to talk about hieroglyphics, and then exchanged visits with the McClellans. When Queen Victoria's third son, Prince Arthur, arrived at the cataract, his boat went ahead of theirs, as did the boats of two German princes.

They got through the cataract on February 10, a hot day, with the Shellalee on board to guide the boat. "It was a most exciting time," Belle noted, so when the end came, "the stillness was so great and so sudden that I felt like fainting and never was there a lovelier or quieter evening as we gently sailed past Philae." By the time they got to Wadi Halfa, on February 22, they'd traveled over sixty days and almost eight hundred miles. Now it was time to turn around to row back down the river to Cairo. Belle lamented: "It was really sad to wake up to the realizing sense that it was the last day's

sail." They had one more stop to make five miles past Wadi Halfa, at the Rock of Abusir. They went by boat, instead of overland by donkey, on the advice of the McClellans; Belle thought it a "fresh pleasant way of getting to the mountain and it was very interesting threading our way through the 1000 islands of the 2nd cataract." At its top, Belle had the mountain to herself—"there was nobody to laugh at me for being absolutely unhappy because our journey was over and our faces were to be turned to the north." She hunted for "carved names for those of friends and found several, as well as the historical ones," while Jack was busily scratching their surname into the ink-black rock.

On their return, they stopped again to see the massive sculptures at Abu Simbel, which they did by moonlight on February 24. Belle returned early the next morning to say "goodbye to one of the old world's wonders at sunrise." She got there before anyone else and lay on the golden sand, as she watched the "light streak in the sky getting deeper and deeper, and by and by a yellow light began to creep down the rocks and over the benign calm of the great Ramses." Under her watercolor sketch capturing the rising yellow light at the horizon and the blue and pink streaks of the dawn sky, she wrote: "Zodiacal Light."

Jack listed other places they visited on their return trip: El-Derr, Amada, two days at the island of Philae, then Aswan and Edfu. At Thebes in mid-March, they visited the Valley of the Kings and the Valley of the Queens on the western side of the river, and that evening, back at the boat, they hosted the American consul, Ali Muraad Effendi. Bonnici, the dragoman, lit many candles to illuminate the *Ibis,* which "greatly delighted" the dignitary. The next morning, Belle couldn't resist another visit to "glorious Karnak for farewell," adding a photograph of the temple complex mirrored in its sacred lake to her diary. They left Thebes "bathed in a golden glow." By April 12, with the Pyramids near Cairo "looming" in the distance, their river journey was at its end. "Good-bye to the dear Nile Voyage," Belle wrote mournfully at the end of her Egypt diary.

The trip was not nearly over, though. The Holy Land, Syria, and Greece came next on the itinerary. Jack's family would later observe that

Belle was "a tremendously energetic person as regards sight-seeing, amusements, excursions when travelling," an apt description of her on this trip, except that after Egypt, she struggled on and off with various illnesses, some not identified. When they arrived back in Cairo on April 3, they arranged for passage later that month on the *Vladimir,* from Port Said to the ancient port city of Jaffa, then called Joppa. Belle had felt "wretched" with fever in the days before, and the eighteen-hour crossing made it worse with seasickness. Even so, she thought Joppa a beautiful sight, with pilgrims in bright-colored clothes filling the streets. In the tent where she and Jack were staying, she rested on a sickbed, where she could hear the tinkling bells of donkeys and camels passing nearby.

At the next stop, they pitched a tent on a cliff hanging over the seas, near Andromeda's Reef. She wrote that she was "struck with the difference from Egypt. There the people are still and grand as their old temples; here everything is life; so much more like South of Europe, the people, with a good dash of the East. No nationality prevailing, but a confused mass of Persians, Russians, Syrians, Arabs, Greeks." With Belle still not feeling well, they left early the next morning for Jerusalem, a "very jolty" ride, though she couldn't help but be interested. On Sunday, May 2, she went to the Church of the Holy Sepulcher, in the center of old Jerusalem. Its beauty overcame her weariness: "Impossible to describe the Church with its many chapels of the different sects, the gorgeous silver and gold lamps." As at Karnak, "the impression one receives is only to be felt, not spoken."

A week later they left for Jordan, with Belle riding a little chestnut horse, Mustapha. Together she and Jack would ride and camp in the desert. Jack had kept on the capable Bonnici from their Nile travels, paying him six pounds a day, and hired Ahemed as head muleteer and Assaid, Habeis, and several more crew to manage their six riding horses, five mules, and three donkeys. They took along a parlor and bedroom tent, along with separate tents for cooking and a water closet. They traveled through the wilderness of Judaea to Jericho, and then started for the Dead Sea, where they bathed in its clear waters. "The most delicious bath I ever remember—so buoyant," Belle noted in her diary. They went on to Solomon's Pools, the Mount of Olives, then Bethel, Galilee, Nazareth, and

Cana, and finally arrived in late May at the Mount Carmel Convent, where they stayed six days.

Belle again felt terrible. Even a week later, after a day's journey on the coast toward Tyre, she wrote: "not feeling very well, and so terribly tired." On the seventeenth, they heard a report of cholera in Damascus and decided not to go. A week after that they climbed to the top of Lebanon, then down to the Cedars, where they pitched their tents in the grove. "Glorious to be there under the 'shadow shroud' of those kingly trees and then the delicious fragrance," Belle wrote, quoting the book of Ezekiel. By the time they got to Beirut, on June 28, they'd spent forty nights in camp, and, according to Jack's calculations, more than 212 hours in saddle.

Belle did not put watercolors or photographs in her second diary, from this part of their travels, as she had done in the first, on the Nile. Instead, she placed purchased photographs into their own album, which she bought in Cairo. She did, however, press between the diary pages the flowers she'd plucked from various sites—a pink poppy flower at Joppa; a sprig of thyme at Calvary; a laurel leaf at the Dead Sea. She was also weary and often sick. She was no longer on the river, with long evenings on the moonlit sky lounge to mull over what she'd seen that day—by this point, they'd traveled a long way by boat, donkey, camel, and horse, and on foot, in increasing heat. Given that Jack never mentioned that he felt poorly or sick, and that Belle's illnesses seemed to fade and then return, the possibility of another pregnancy comes to mind, though there is no direct mention of this at the time, or later. In any case, Belle was wearing out.

And yet they went on—to Cypress, Rhodes, Smyrna, and then Constantinople (now Istanbul). By July 9, they arrived in Athens: "Wretchedly—so to bed—can't quite believe I am in Athens." The next day they drove by the theater of Dionysius and up to the Acropolis; they sat on the steps of the Parthenon as the sun sank in the western sky. They stayed until after 9 P.M., "feasting our eyes. Perfect, pure and beautiful."

Waiting for letters while traveling was always nerve-racking—it was impossible to know how things were going back home. "Letters and no bad news, thank God," Belle had remarked earlier in March. Now they weren't as fortunate. Belle reported on July 16 that they'd received "two terrible telegrams about poor, dear Joe." Joe Gardner, Jack's eldest brother, had died

by suicide on June 11, 1875, news that didn't reach Jack and Belle until they were back in Constantinople. Joe had sat down in the middle of a road near his summer home on the North Shore and shot himself in the head, as Henry Adams told a friend in a letter. A line in the parish register at Emmanuel Church, which held the funeral, states that the coroner had determined the cause of death to be an "accidental shooting." But, given the public setting of his death, everyone knew the sad truth.

Belle had always had a tender spot for Joe, who had welcomed her with great affection into the Gardner family. He had even named a schooner, *Belle*, in tribute to her. He had not been the golden son, like George, or the reliable one, like Jack. He never quite recovered from losing his wife, Harriet, after she died shortly after giving birth in 1865. He had three young sons, now orphaned: Joseph Jr., fifteen; William Amory, eleven; and Augustus, nine—everyone called him "Gussie."

BELLE'S ENTRIES IN THE LAST PAGES OF HER SECOND DIARY ARE LESS EXpansive, more factual, shadowed as she and Jack were by Joe's death and their worry for his three boys. She and Jack traveled from Constantinople to Budapest, then Vienna, where she recorded family news—her father had bought a mansion at 322 Fifth Avenue in New York. Then to Germany, where in Nuremberg they purchased eleven late-fifteenth-century stained-glass pieces from the dealer A. Pickert. Four had been in the city's Schüster Kirche, now torn down, and later they would be the first objects from abroad included in Belle's museum. When they got home to 152 Beacon Street several weeks later, the Gardners had been gone almost nine months. The trip changed Belle. Her frame of reference for many things—religious practice, art, architecture, landscape, fashion, folkways, food, landscape—now included non-Western points of view. The two would not travel overseas for another four years, when they would take Joe's boys on a tour of English and French cathedrals.

Years later, Belle placed on a bed of cotton in the second drawer of her work desk in the Macknight Room some of the scarabs and amulets and small carved figures that she had collected while traveling on the Nile. Did she like to pull that drawer out on an overcast New England day to

remember the sun on the river water and to hear the ancient calls to prayer? Very likely. On a table on the other side of the room, she placed two elegant bottles, etched with delicate ferns, a symbol of eternal youth. Each is filled halfway with sand she may have gathered near the sphinxes or the colossi at Abu Simbel or Karnak; each has a cork in the top, as if she were preserving her memories to always, always remember.

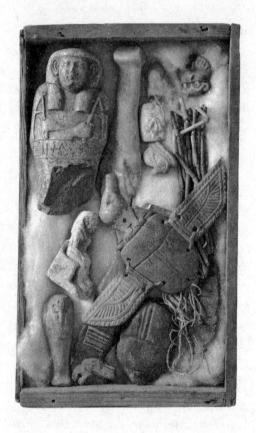

Eight

"MILLIONAIRE BOHÉMIENNE"

1876–80

Joe Gardner's death a decade after he had lost his wife, Harriet, left their three young boys, Joe Jr., William Amory, and Gussie, in need of guardians. Though orphaned, they were not alone, surrounded as they were by extended family: aunts and uncles, grandparents, and most especially Jack and Belle, who took them into their home. Apparently there was little discussion about where they should go. Certainly, the other Gardner siblings were busy raising housefuls of their own children. Whatever the case, Jack and Belle took over, letting go of the English governess who had overseen the boys' education up until then and arranging for them to attend Hopkinson's Preparatory School on nearby Charles Street, and then on to Harvard College. From Belle's mid-thirties until the youngest, Gussie, went off to Harvard seven years later, she and Jack had the direct care of these nephews.

Maud Howe, daughter of Julia Ward Howe, would remember Mrs. Gardner arriving at the old Music Hall on Winter Street for the Harvard Music Association's Thursday afternoon concerts, together with three young "tow-haired gentlemen," well dressed and equally well behaved. Belle slipped

into her parental role with ease. She brought the boys to New York when she visited her parents, and she especially loved to watch their various sports. Belle and Jack summered at one of the two houses Joe Gardner had built on the seashore in Prides Crossing on the North Shore. The larger was named Beach Hill, the smaller one Alhambra; the Gardners used the latter as a guest house. Here they swam and boated and rode horses, as the boys had done with their father. They did not own the property outright, and Jack paid rent to contribute to the three boys' eventual inheritance.

Belle began a Saturday tradition that extended into the boys' time at college: reading aloud to them in the evening, in her low sonorous voice. She began with Dickens's *Pickwick Papers,* Amory would remember, and he and his brothers were "so enthusiastic and eager for more that Aunt Belle followed with *Oliver Twist, Nicholas Nickleby, David Copperfield,* and *A Tale of Two Cities*—also, I think *Martin Chuzzlewit.*" A close friend of the Gardner boys,

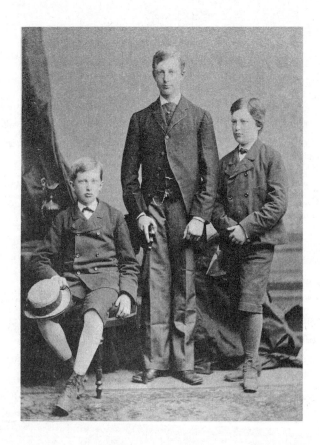

John Jay Chapman, thought she mixed "devotion and rigor," a combination confirmed by Amory. Once, when he fell off a horse while riding with only a blanket and girth, and showed "symptoms of scare," she insisted he stay home the next time, while the rest of the family "pranced forth." She had learned something he needed to know—showing fear would not do.

Jack, meanwhile, took the boys along on trips to Washington, D.C.; West Point in New York; and Florida and Cuba. They went camping in the White Mountains and made a train journey out west. He enjoyed their company. When they were at boarding school, he sent them letters, undoubtedly in a tone similar to what he used when writing to George's son Georgy, when the boy began working at the family office. When important questions arose, he told Georgy, "Act to the best of your judgment and then feel that you have done your duty, whatever the result may be. Do not worry if you make mistakes—the wisest of men do that." The ability to take chances was the very definition of upper-crust privilege. Even so, such encouragement must have provided much-needed compass to Joe's growing sons.

Jack and Belle also took the boys to the Church of the Advent, recently relocated to Brimmer Street on the flat of Beacon Hill, where they had transferred their membership in 1874 from Emmanuel Church. Advent had its origins in the 1840s Oxford movement, a revival in the Church of England which emphasized reverent worship closer to traditional Catholic practices. Belle loved the drama of high church services, with robes and rituals, incense and music, and recitation of prayers, all a reminder of what she grew up with at Grace Church in New York. But if its liturgy was formal, Advent's mission was down to earth. It invited residents of poorer neighborhoods nearby, the North End and Scollay Square, to evening meals and religious instruction. A longtime vestry member remarked that Advent's mission "was never intended to be a tinselly clubhouse for the resort of the cultivated and wealthy," a not-so-subtle reference to the larger Trinity Church, where more of Boston's elite worshipped.

The Advent's rector Charles Chapman Grafton, a powerful preacher and one of Jack's relatives, had established in Boston an Anglican monastic order called the Society of Saint John the Evangelist, after his involvement with the order in the village of Cowley near Oxford, England. Grafton's assistant and another so-called Cowley Father, Arthur Hall, a tall Englishman with fine features, gave informal lectures in the drawing rooms of Advent

members. Such gatherings were a part of the spiritual ferment in the city following the rise of Unitarianism, growing interest in Persian mysticism and Buddhism, and even the appearance of Mary Baker Eddy's Christian Science. Hall became Belle's first spiritual mentor and met with her one-on-one "teaching her to pray," a practice that gave her ballast, something she wanted also for the three boys now under her care. Found in her papers is a line she had written down that may have served as her quiet creed: "Our faith might cause our light to shine on some other heart which as yet had no light of its own."

THE NEWSPAPERS INCREASINGLY TOOK NOTE OF BELLE. ONE OF THE MORE remarkable reports, by an anonymous Boston reporter, appeared in late 1875. The piece begins with hyperbole—"Mrs. Jack Gardner is one of the seven wonders of Boston." It continues with striking claims: "There is nobody like her in any city in this country. She is a millionaire Bohémienne. She is eccentric, and she has the courage of eccentricity. She is the leader of the smart set, but she often leads where none dare follow. She is 35, plain and wide-mouthed, but has the handsomest neck, shoulders and arms in all Boston. She imitates nobody; everything she does is novel and original. She is as brilliant as her own diamonds, and is as attractive. All Boston is divided into two parts, of which one follows science, and the other Mrs. Jack Gardner."

These favorable details must have pleased Belle to no end. But this higher profile also made her a target for those who had never accepted her "novel and original" ways. Later newspaper reports and profiles sometimes mocked or scolded; most notices, whether positive or critical, registered the strong impression she made.

Interestingly, the anonymous reporter left out the detail that would come to define her: pursuit of beauty by way of collecting art. With little fanfare, Belle and Jack had begun buying more expensive artwork for 152 Beacon Street. A few years after their purchase in 1873 of the small oil painting by Charles-Émile Jacque, they paid $1,000 at auction for a charming outdoor scene, *On the Terrace,* by the mid-nineteenth-century painter Narcisse Virgile Diaz de La Peña, who'd been born in France, the child of Spanish refugees from the Peninsular War. Both Jacque and Diaz, along with more well-known artists, such as Jean-Baptiste-Camille Corot and Jean-François Millet,

were part of the Barbizon School, a group of plein air painters who lived and worked southwest of Paris and were prized for their rustic landscapes and bucolic genre scenes. Belle also purchased American work influenced by the Barbizon style. These included the moody pastel-on-paper canal boat at sunrise originally titled *Landscape Dawn Newport,* by Sarah Wyman Whitman, as well as *The Old Barn Under Snow, Newport,* by John La Farge. Both artists later became her friends.

Belle's taste in painters—contemporary artists who'd been selling well in Boston at this time—went hand-in-glove with the tastes of the day. Doll and Richards, which by 1878 occupied lofty rooms at 2 Park Street, overlooking the Common, had become the city's leading art gallery and dealer for Barbizon-style artists. The American painter William Morris Hunt championed these artists. He'd studied in France with Jean-François Millet and was also an influential art teacher, first at Newport and then in Boston, where his students included Sarah Wyman Whitman, John La Farge, and the young brothers William and Henry James. Winslow Homer, also Boston-born though not a student of Hunt, sold his work exclusively with Doll and Richards.

Unlike Philadelphia or New York, Boston had had no early art academy. Beyond the galleries and private collections of friends and family, only the Boston Athenaeum, a private library founded in 1807, had exhibited art since its gallery extension opened in 1827. The Athenaeum later moved to the top of Beacon Street, with exhibition space dedicated to painting on its third floor and sculpture on its first. Sixteenth- and seventeenth-century Dutch and Spanish painters such as Cuyp and Murillo were hung alongside the American artists Gilbert Stuart, Chester Harding, Washington Allston, and others. After the Civil War, as the Athenaeum dedicated more of its space to books, the Museum of Fine Arts was founded in 1870 and opened on July 4, 1876, in celebration of the nation's centennial. It was located in the newly filled in Back Bay, at James and Dartmouth Streets. The new museum would fill its large halls with a range of works, from textiles and porcelains purchased at the Centennial Exhibition in Philadelphia to a large collection of casts of Greco-Roman sculpture and architecture that filled a gallery. Belle had helped put together the art gallery for the Paris Fair in 1871, borrowing works from the Athenaeum to do so; soon Jack Gardner would serve on the board of the Museum of Fine Arts as treasurer. Belle would have been

familiar with all these collections and the public institutions that came to house them.

※

VAN WYCK BROOKS, THE LITERARY CRITIC AND BIOGRAPHER OF nineteenth-century American writers, would posit in 1958 that an "epoch of American collecting" started in 1875, when "Mrs. Jack Gardner bought her first small landscape." Mrs. Jack was hardly singular in her turn toward collecting art as a passionate pursuit. Other wealthy American men and women displayed their riches and sophistication by means of their collections of fine and decorative arts. For these women and others, who were largely constrained to a domestic sphere no matter how privileged, the act of collecting empowered some of them to cross from a private to a more public life. Women such as the Bostonian Susan Cornelia Clarke Warren, with whom Gardner would sometimes compete for artwork, and later, the feminist activist Louisine Elder Havemeyer, accumulated significant collections that also gave them a platform.

Belle's early purchases seemed to unlock a deeper interest in art, particularly painting, more than mere viewing had done. She wanted to understand what she was seeing and buying in a more systematic and educated way. In 1878, she purchased a semester's ticket to the blockbuster lectures at Harvard College given by Charles Eliot Norton, who had been appointed the college's first professor of art history three years before. That spring, Belle joined the hundreds of students who now regularly packed a large lecture hall to hear the lanky, bald fifty-year-old professor, with large hooded eyes, expound on art. She was not the lone society lady there, though it is not known how many others attended that year.

Norton was something of an iconoclast. Born in 1827 to an old Puritan family, he early on developed an educational program of night courses for working-class young men in Boston and Cambridge. He supported abolitionist causes. As he got older, his Unitarian faith was informed by "a slight hostility to Christianity." After spending some time in England and his beloved Italy, he devoted himself, as Morris Carter wryly noted, to the "discouraging task of spreading culture among his practical countrymen." Students never forgot him. One said he gave them "not only what he knew, but what he was," remembering that he was so passionate about art and aesthetics, he

lectured "often with tears in his eyes." His life had been riven when his wife, Susan Sedgwick Norton, died while giving birth to their sixth child in 1872. He never remarried. He had a habit of keeping people at a safe remove, in "the vestibule," as a friend remembered, though he often occupied the center of a vibrant social world of writers, poets, philosophers, and artists.

At the Harvard lecture hall, Belle heard Norton talk, in his conversational way, about contemporary thinkers, reading passages aloud in a voice that got softer as he got to the nub of the message. He didn't teach his students how to draw or paint. He showed few prints or photographs of art. The history of art was not yet a formal field of study; up to this point it had been "a matter of craft and technique taught by painters to other painters." His focus in these lectures, grounded in the classics and the Renaissance, was the meaning of art.

In Norton's class notes from this time, he wrote out quotations from Plato: "Few are they who are able to attain the sight of absolute beauty" and "The love of the beautiful set in order the empire of the Gods." Belle would have heard him emphasize that art itself went back as far as human history, and that the Renaissance masters, having rediscovered the Greeks and Romans, had put humanity at the center of the aesthetic project. Norton quoted too from Emerson and his essay "On Beauty," but more than Emerson and other Americans, Norton had been influenced by two Englishmen, the philosopher John Stuart Mill and the art critic John Ruskin. Mill's claim that the study of art was on par with an intellectual and moral education had been part of Norton's argument to Harvard when he proposed this class: American students, coming of age in an increasingly money-oriented society, needed art to refine their taste and character.

Years later, Belle would recall to John Jay Chapman that she "loved Norton." She felt indebted to Norton because he took her seriously in those early years of her passion for art. He encouraged her to use her fortune to collect more than fashion and jewels, to begin acquiring rare books—to collect, in a word, culture. The two also shared the experience of deep loss. Norton spoke little of his wife, but her memory resided in him as the hidden treasure of his life; the emptiness he'd experienced in the wake of her death had been part of what propelled him toward art and aesthetics. He knew, as Belle was beginning to know, how beauty can meet loss, how aesthetic experience assuages.

THE FOLLOWING SPRING, THE GARDNERS LEFT AGAIN FOR EUROPE, arriving in London in late May. They intended to tour English and French cathedrals with Amory and Gussie, now fifteen and thirteen respectively. Joe Jr. stayed back in Boston because he was about to enter Harvard College, but the younger boys' education needed Europeanizing. "We have been on the go all the time," Jack wrote his brother George. They had just returned from horse racing at Ascot, which they "enjoyed immensely." They attended the Theatre François Company and the opera. Jack philosophized in a minor key: "it was all a tremendous change from the Boston life to that we are now leading. Perhaps each lends a zest to the other." As always, for Belle, travel released her from the confines of Boston into larger horizons, more variety.

London did not disappoint. She found the city utterly "fascinating." They visited the National Gallery. The Grosvenor Gallery on New Bond Street had opened two years before and was the refuge of Pre-Raphaelite painters. These artists, such as Dante Gabriel Rossetti and John Everett Millais, pursued "art for art's sake," arguing that art, sufficient unto itself, required no political or moral or religious purpose. At Grosvenor, Belle for the first time met the American painter James Abbott McNeill Whistler, who was a part of this circle and whose portrait of the actress Connie Gilchrist, *Harmony in Yellow and Gold*, was then on view. On July 21, Henry and Clover Adams, whom the Gardners knew well as Back Bay and summer neighbors on Boston's North Shore, attended a late-night party at the gallery. Clover, also interested in art, declared Whistler "even more mad away from his paint pots than near them," as she reported to her father, Dr. Robert Hooper. She thought Whistler was trying to "woo a muse whom he can't win." Belle disagreed. She admired him right away—for his facility in creating an intense tone or feeling with a limited color palette and for how he used the vocabulary of music, such as the words *harmony, symphony,* and *nocturne,* in his paintings' titles.

At the end of the evening, she and Clover stood in the foyer, waiting as their husbands arranged for the carriages. They didn't talk about art or Whistler but rather took pity on the "awful gowns" favored by the Britons.

By early August, Belle and Jack and the two boys had started on a two-week tour by train of English cathedrals, stopping at Ely, Peterborough, Boston, Lincoln, Ripon, and Durham. When they returned to London, Jack wrote to his father, without a lot of specifics, that they'd seen "many interesting things of different kinds & beautiful places." He was proud of how the two young nephews had behaved on the trip—"very good and intelligent." He added that "what Amory doesn't know about English ecclesiastical architecture isn't worth knowing."

Paris followed. Here the Gardners met up again with the Adamses as well as Henry James, who'd just started to make a national name for himself with the publication of his recent novella, *Daisy Miller*. After starting off in New York and then making forays to Europe, the James family returned to America and settled on Beacon Hill in 1864, in the waning years of the war, then moved to nearby Cambridge. The James and Gardner families undoubtedly had known of each other, circulating as they did in similar social worlds, but Isabella now directly connected with the writer. At thirty-six, Harry, as he was called by his friends, was full of ambition and fascinating talk.

The five Bostonians spent leisurely evenings dining along the Seine, attending the opera, going to the Cirque, strolling in the Bois de Boulogne, and attending the theater to watch plays such as the new *Les Trente Millions de Gladiator*, which was, in Clover Adams's words, "as absurd and vulgar as possible, with a fat thirty-million-dollar American as its hero." At one point, the two women had an appointment at the House of Worth, at 7, rue de la Paix, near the Louvre. Henry Adams wanted his wife to be outfitted in the very best fashion. Belle, whose costumes had gotten approving mention in Clover's letters to her father, made the introduction to the "great Mr. Worth." The Englishman had grown in popularity with American women for many reasons, including a shared language and his success three years before showing his fashions at the Centennial Exposition in Philadelphia. Worth shrewdly cultivated the fast-growing market of rich Americans eager to display their wealth and cultural sophistication, a market he would command until his death in 1895. Belle ordered a dress in blue merino wool trimmed with black satin; Clover chose an outfit in dark green, with a dark-blue trim. Both knew well that a woman's fashion, the figure she cut, was part of her eloquence and social power.

Nine

THE COSMOPOLITAN
1880–83

Society had taken notice of Belle on her overseas travels, according to Henry James, who wrote to her from London several months after she and Jack returned to Boston, in October 1879. In the first of many letters that she would save from the American writer, he recalled their "talks and walks and drives and dinner" and thanked her for her cheering words about his recently published biography of Nathaniel Hawthorne, which had gotten mixed reviews. He teased her, quoting her own comment about how much she liked "'being remembered'" and assured her she'd left an "indelible" mark. "Look out for my next big novel," he concluded, with an affectionate joshing he used both to connect with her and to stay at a safe distance when he felt crowded by her intense sociability. "It will immortalize me. After that, some day, I will immortalize you." His flattery was both pleasing and a little obvious. A year later he sent her this description of a scene from a dinner he'd attended, where the "ladies were charming." "But what made the most impression on me," he went on, "was that we talked of you. They wanted to know about you—they had heard you were so original! I gave a sketch—with a few exquisite touches—and then they sighed and said to each other: 'Ah, if we only knew how to be like that!' But they don't!"

A few months after their return, the Gardners purchased the house next door, at 150 Beacon Street, doubling the size of their already spacious home. Belle wanted a room large enough for musical performances, with premier acoustics. The mansion next door would do wonderfully. The architects joined the two houses ingeniously, connecting each of the staggered floor levels with a short stairstep. Over the years, Belle's first-floor music room, equipped with her Steinway grand piano and able to accommodate a small chamber orchestra, would be a center for musical performance in the city, especially for rising musicians. When Henry Lee Higginson, who founded the Boston Symphony Orchestra in 1881, asked Belle for her candid assessment of the new orchestra's performances, he did so because he knew of her acumen.

This new music room was central to Belle's ambition to shift the use of the Beacon Street home from a purely domestic space to a salon, along the lines of those in Paris and Venice. The Gardners aimed to fill the new rooms with art, buying quite a few more pieces in 1880. These included several charcoal drawings and a painting by William Morris Hunt and *Noonday* by Jean-Baptiste-Camille Corot, which they purchased at Doll and Richards for $1,500. Later that year, when in New York to visit her parents at their townhouse at 322 Fifth Avenue, she purchased three large mid-seventeenth-century tapestries made in Brussels, depicting the story of Noah's ark. Another

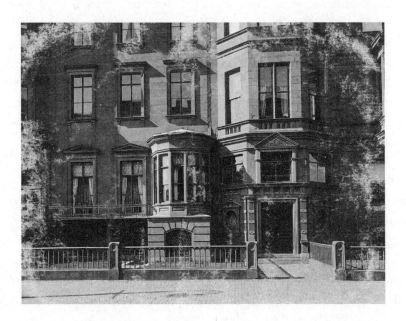

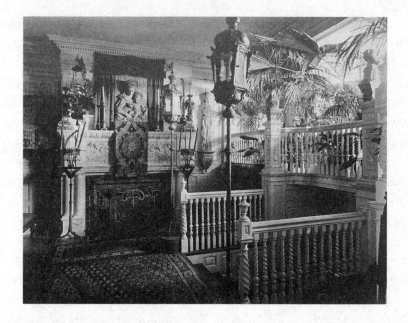

three tapestries followed the next month. She and Jack also bought a graphic flag of the First Regiment of Napoleon's Imperial Guard, which they hung to the left of the fireplace in the Beacon Street house foyer, near the landing of its winding central staircase. Large palm trees and flowering plants of all kinds filled the large solarium above the front entry. Her drawing room, painted in a bright yellow, recalled Parisian interiors; she favored Italian furniture. So much caught Belle's eye in these years—paintings, drawings, and watercolors, to be sure, but also sculptures, porcelains, and textiles. She had a particular fondness for chairs. While her preference for a specific style or period with regards to painting had yet to clarify, she was carefully curating her Beacon Street home in a mix of what was currently fashionable and what pleased her eye.

<center>�066⟩</center>

THE FOLLOWING MARCH THE GARDNERS EMBARKED ON A THREE-MONTH train trip to California. There is no record, made either by Jack or Isabella, as to whether they took any of the three boys along. On unused pages of an earlier album, from her 1867 trip to Europe, Belle pasted images of what they saw: the 1610 San Miguel Chapel in Santa Fe, landscapes in Yosemite Valley, and Pueblo villagers. She included a blurry photograph of the hang-

ing of outlaws, which she inscribed "San Antonio Justice." In the years after the Civil War, scores and scores of eastern tourists traveled to the West, drawn by its expansive landscapes and skies. They had read about this region in newspapers, including the frequent reports on the U.S. Army's wars with American Indians. They had seen it in paintings and large-scale images taken by early photographers such as Carleton Watkins. A decade before, Yellowstone had been declared a national park. The *Boston Daily Globe* had designated the naturalist and writer John Muir the geologist of Yosemite.

The Gardners too wanted to see the region for themselves. They had financial interests in mines in western states and in the railroads crisscrossing the country. Yet Belle's written expressions and collected objects do not convey an intense curiosity about or identification with the open skies or Native American peoples of the American West. She didn't even give the photographs from this trip their own album, as she would do for her future travels.

Generally, Belle looked not west, but east to Europe. Soon she would travel to Asia, which nineteenth-century Americans referred to as the Orient, the vast area stretching from North Africa all the way to China.

AFTER A QUIET SUMMER AND FALL, BELLE TURNED AGAIN TO THE SOCIAL. In the early months of 1882, she hosted a series of lectures on Japanese art and culture given by Edward Sylvester Morse, a professor and recent director of the Peabody Academy of Science in Salem. Erudite and charmingly enthusiastic, Morse had traveled through Japan in the 1870s, becoming an expert in a whole range of topics, most especially Japanese ceramics and domestic architecture. An observer remarked that "his mind was full of Japan." These lectures, at the newly expanded Gardner home on Beacon Street, were a repeat of those Morse had delivered the year before at the Lowell Institute in Boston. In them he described the country, compared to industrializing America, as a culture of "simplicity and taste, of good manners and aesthetic contemplation." Belle's curiosity was piqued.

Henry James returned to Boston in early February, taking rooms at Mount Vernon Street on Beacon Hill. He had published his novel *The Portrait of a Lady* the previous year to critical success. His Isabel slightly echoed Belle beyond the almost identical first name: she no doubt recognized something of herself in the story of a vagabonding American woman in Europe

in search of her future when she read her copy of the novel. Henry's mother had recently died, and he wanted to be near (but not too near) his father, Henry Sr., now infirm and living with his daughter, Alice, in Cambridge. The writer announced to Belle that he wanted to "see you one of these days." After finishing a day of writing, which ended usually at four or five o'clock, he'd walk down the hill in the winter darkness to the Gardner home, where Belle would serve him tea and little French cakes at a small table in her third-floor sitting room. He wore a close-clipped beard and mustache, his hairline already receding. His piercing gray eyes conveyed an unmistakable seriousness. He talked in a low voice and with some deliberation, in a "hesitating manner" the writer Edith Wharton would later recall, as if taking his time to find the exact word. For two nights, they sat on low rattan chairs fitted with plush pillows near a roaring fire, while he read aloud to her from the play he'd been writing that winter, based on his popular novella, *Daisy Miller*. As Belle always did, she put bundles of weeds on the fire so that the room smelled of a forest. He loved, as he later told her, the "sound of your conversation."

As much as Belle must have thrilled to the Morse lectures and her conversations with Henry James that winter, the man who took up more

and more of her quickening attention was F. Marion Crawford. Fourteen years her junior, Frank—also called Franko or Frankino—had come to Boston the previous winter to stay with his mother's sister, Julia Ward Howe, now a widow. Julia and her daughter, Maud, recently had moved to 241 Beacon Street, not five minutes from the Gardners. Frank used the first-floor reception room for his writing desk and study. At twenty-seven, he was already a world traveler, but he was also at "sixes and sevens" for what to do next.

His father, Thomas Crawford, had been an important American sculptor in the 1840s and 50s—his bronze figure *Freedom* stands atop the nation's Capitol building. The artist had taken his wife, Louisa Ward, to study and live in Rome. Frank, the youngest after two sisters, was born in the Italian resort town of Bagni di Lucca in 1854. Three years later, his father died; his mother remarried in 1861. Frank spent several years at boarding school in Concord, New Hampshire, then as a teenager returned to Rome, where he had tutors. He did not have much companionship with boys his own age and always felt more comfortable with adults. He managed to study one year at Trinity College, Cambridge, another at the Technische Hochschule at Karlsruhe, and finally finished his education at the University of Heidelberg. Before coming to Boston, he spent a year as editor of the *Indian Herald* in Allahabad (now Prayagraj), India. He was fluent in Italian, French,

and German, and was studying Sanskrit. His extensive travel had made him chameleon-like. He blended into his surroundings.

Frank had energy, flair, and a baritone singing voice, all qualities that enhanced his attractiveness, which, according to his cousin, Maud Howe, was considerable. She would remember him as "one of the handsomest men I have ever seen—tall, splendidly built, with a noble head, classic features . . . His eyes were blue, dancing, full of light, real Irish eyes." But his family worried over him. His foray in the newspaper business had been a fiasco. He'd been told by his singing teacher, Georg Henschel, who'd become the first conductor of the Boston Symphony Orchestra, that he couldn't stay on pitch. At one point, Frank's mother despaired: "My splendid boy, with all his talents, he will never do anything!" Romance went no better. Shortly after coming to Boston, he pursued a Mary Perkins, but this too ended in disappointment when she returned from Europe with a fiancé in tow. Frank thought they were to be engaged. "With me, things have not gone well," he admitted to his mother, telling her that the breakup with Mary on Christmas Eve had made him "physically ill."

Frank's uncle Sam Ward, who lived in New York, had written his sister, Louisa Ward Crawford, during this time that the watchword for her son, Frank, must be "patience and shuffle the cards." By early 1882, Frank had begun to make forays into a writing career, publishing brief articles and book reviews. He'd also started writing his first novel, about his time in India. *Mr. Isaacs* would find a New York publisher through Sam Ward's many connections. It later became a bestseller, much to everyone's surprise, including Frank's.

Belle likely met Frank through the Howes, Julia or Maud. He was writing his novel at his desk in the Howes' front room; he was also spending quite a bit of time at the Gardners'. With Jack, he talked business and sports and sailing, which both men enjoyed. With Belle, he talked a wide range of topics, dipping in and out of French, which they both spoke fluently. She was refreshing her Italian, after attending Norton's lectures, and she loved hearing Frank discuss Dante in his flawless Italian. She praised his writing ambitions and delighted in listening to him describe the intricate plot points of his novels in progress.

At first it was all innocent. Belle and Jack, inspired by Morse's lectures, were making plans for a trip to Japan the following year, and also to China

and India. Frank got an idea. Perhaps he and his uncle Sam Ward "might join forces and make a square party," Frank suggested in a February 11 letter to his uncle. He proposed that nephew and uncle would collect "information about Buddhism" on the trip. Three days later, Frank reported to Uncle Sam that Mrs. Jack had asked him to accompany her to Manhattan, where she wanted to inspect the widely talked about art collection of Uncle Sam's friend William Henry Hurlbert, the editor of the *New York World*, then up for auction. "A married lady, to whom I am both indebted and attached," Frank wrote rather archly to Uncle Sam, "has begged me to escort her to town on Thursday," quickly adding that she "admires you from a distance, and you will be charmed with her grace, conversation and consummate knowledge of the world."

Presumably, Belle and Frank went to New York, with Belle staying with her parents and Frank at his Uncle Sam's. She was a middle-aged matron, and Frank was so much younger, not her peer but rather more like one of the Gardner nephews. Did it matter that Frank had written her a Valentine's Day poem with the title "To My True Love"? The poem began: "Before I knew thee / Love seemed but an idle dream" and went on to make this declaration: "That my heart is full of anguish / And as restless as the sea / Listen darling to my pleading / Put thy little hand in mine."

Jack Gardner apparently didn't make the trip to New York, at least according to his list of travels for that year. He joined his wife later in February, for a stay of several weeks in Washington, D.C., while Frank remained in Boston. During this stay, Henry and Clover Adams, now living on H Street overlooking Lafayette Square, with a view of the White House, several times hosted the Gardners. One small dinner was also attended by Henry Cabot Lodge, then a Massachusetts legislator, and his wife, Anna. Calling Belle and Anna "Beacon-streeters," Clover wrote to her father that she and Henry had invited "a Baron, Baroness, and Austrian Count" as well as an Italian minister and his wife to satisfy the Beacon Streeters' interest in "foreigners." "Mrs. Gardner," she added, as if with an eye roll, thought a diplomatic existence "the sum of earthly bliss!"

While the Gardners were in Washington, Frank was trying to quell some buzzy stories that had started circulating about the amount of time he'd been spending at the Gardners', confiding to his mother: "If you hear rumors of my attachment to a certain married lady, do not be distressed."

He reassured her that Mrs. G, as Frank called Belle, had been a good friend when he'd felt lost and unsure, and that she was "one of the purest and best women living—in spite of the slander tongues of petty Boston." By May, he'd written Mrs. G another poem, this time a sonnet, with a first stanza steamier than his earlier effort:

> *My lady late within my chamber tarries*
> *In sweet dark vesture, all her fair hair flowing*
> *In ripples o'er her shoulders; and she carries*
> *Her beauty with such royal air, as sowing*
> *Her path with jewels from love's Treasure quarries*
> *That I was awed, and low before her bowing*
> *Felt all my body by sweet love-strings harried*
> *And all my soul with silent pleadings glowing.*

On July 1, Belle retreated to Beach Hill, the Gardner summer home on Hale Street at Prides Crossing. Hale Street ran along a large bay skirted with pines; waves pounded there with unusual force. The wide piazza of the spacious house overlooked a tangle of greenery down to the coast beyond; only its roof was visible from the road. Jack stayed in town much of the summer for business, taking his dinners usually at the Somerset Club.

In August, Frank decamped to the Gardner estate for a three-week stay. Belle fussed over him. They read Dante together. They swam. In the mornings, they rowed several miles on the bay, and in the lazy afternoons they took long horseback rides in the woods. On August 12, Frank wrote to his uncle from Prides Crossing, sounding satiated and happy: "The life here is everything that a man could desire to nurture body and soul," adding: "I need very little sleep here, and so in the morning hours I have done a good deal of writing." He was already at work on his second novel, to be called *Dr. Claudius,* which he proudly told his uncle Mrs. G thought "better and more highly finished" than his first, *Mr. Isaacs,* which was scheduled to be published at the end of the year.

Belle was taking a dreadful risk; Frank likewise, though a smaller one. Whether she and Frank consummated the relationship is impossible to confirm, but even the appearance of a romantic affair was perilous in a society where gossip was the evening sport. A decade before, the shocking affair between Rev. Henry Ward Beecher and Elizabeth Tilton, a much younger, and

married, parishioner, had blazed across the front pages of the New York and Boston papers for months, resulting in a trial. Marriage was holy, adultery a sacrilege. The law referred to adulterous affairs as a "criminal conversation," and even if the affair did not result in a civil trial, as did Tilton's, a woman could be nonetheless cast out of polite society for stepping out of line.

And yet the risk must have seemed worth it. Frank got the attention and encouragement he craved; Belle got the gratitude of an attractive and creative man, someone she thought cosmopolitan, someone she could champion and believe in. The flirtation, the secrecy, the conversation—all of it made her feel young and beautiful and necessary, not just another Beacon Streeter, as Clover Adams had called her. Morris Carter, in his notes about Belle's courtship with Jack years before, mused that "holding her affection" required "a little domineering devilishness," which was "a better prescription than goodness, gentleness, and fidelity." These last three qualities Jack had in abundance. Devilishness was not in his repertoire, as it was in Frank's. After two decades, Jack's steadiness and dependability, which had made him attractive when they were young, may have seemed, by now, a little ho-hum.

The evidence can also be interpreted in another way. In his boyishness, Frank may have represented the next generation for Belle. He was, after all, only eight years older than Jackie, who would have turned twenty in 1883. Perhaps being near to and needed by someone much younger lent a maternal slant to Belle's attraction to Frank.

On August 16, Belle and Frank commemorated their time together by going to the large studio of A. B. Cross in nearby Salem to take what was called a boudoir photograph. This was the name for standard-size portraits, 5¼ by 8½ inches, and its double-entendre is appropriate in this instance. The image shows their clasped hands only, Belle's long white fingers comfortably embraced by Frank's larger hand, her wedding ring conveniently obscured. Each is instead wearing a simple gold bracelet. This was no conventional photograph. It did, however, recall a small sculpture by the American artist Harriet Hosmer, depicting the clasped hands of two great English lovers and poets, Elizabeth Barrett and Robert Browning. Hosmer created it in 1853, and Nathaniel Hawthorne had referred to it in his 1860 novel, *The Marble Faun*. Belle was familiar with the poetry of both Brownings. She owned volumes of their collected works and referred to them in her letters. She would later know Robert Browning in Venice. She had read Hawthorne's novels.

Due son le mani unite dall'amore— Un spirto dell'unisce, ed un sol core.

Or maybe it was Frank who knew about Hosmer's tribute to the Brownings' grand romance, conducted in secret before their marriage. Crawford's father, after all, was also a sculptor, and both Hosmer and the Brownings had lived for a significant amount of time in Frank's childhood hometown, Rome. Regardless of whose idea the photo had been, Frank inscribed it with lines from Dante's *Paradiso,* canto 33: "*Due son le mani unite dall'amore—Un spirto dell unisce, ed un sol core*" ("Two are the hands united in love—One spirit united and a single heart").

If Belle and Frank had imagined they were successful at safeguarding their single heart from gossip, they were wrong. People knew and were talking. Early in December, Clover Adams warned her father, who lived steps away from the Gardners, that he should not invite Mrs. Jack and Mrs. Helen Choate Bell to his holiday party in Boston because "the latter cannot endure the former; she is eloquent on that subject." Mrs. Bell, ten years older than Belle and also a member of the Church of the Advent, was a powerful cultural force in her own right, but in a more conventional way. She was a leading member of the New England Women's Club, the oldest official group for women in Boston. It might be the two women didn't get along because the older saw the younger as competition; or Belle may have envied what Mrs. Bell enjoyed—wide acceptance in Boston. Likely, one matter Mrs. Bell

would have waxed "eloquent" about was Belle's relationship with Frank. By the spring, Henry James was still gossiping about the two in a chatty letter to the writer William Dean Howells, complaining that the only compensation for the "desolation" of Boston's social scene was the small thrill of "Mrs. Jack Gardner's flirtation with Frank Crawford."

Belle was acting less like a Boston matron and more like the women of the French demimonde whom she'd read about in novels, women who managed their business and private affairs with aplomb. Like them, she'd be no martyr to the rules of society. The trouble was, she wasn't in Paris.

Nevertheless, in the early months of 1883, a different plan for travel to Japan was being hatched, this time involving Maud and her mother, Julia, who would accompany Belle. Belle would pay the bills, and Frank could go along. Jack did not feature in these plans, at least according to Julia's journals.

Then, behind the scenes, something happened. Rather abruptly, Frank decided to return to his mother's home in Rome. He planned to leave Boston on the steamer *Florio* on May 12. "You are not, darling, to say one word about Marion's [Frank's] departure," Julia warned Maud. "The other party will wish him to go to Japan . . . Cannot say any more on paper. Mum's the word." For his part, Frank wrote to his uncle Sam Ward, "I will ask you not to mention my plans to Madame, if you write to her . . . There is a time in a man's life when certain things must stop, and I think the time has come."

What happened to change Frank's plans? His Boston family had reason to be wary of an entanglement that might escalate into a scandal—thus the relief at his decision to leave. Perhaps his aunt Julia had persuaded him to go, though, formidable as she was, she had not earlier been able to steer him away from Belle. Did Jack Gardner take part in a joint effort? There is no report, in any letters or diaries that survive, of Jack's losing patience with Belle or Frank or both. Their attachment must have stung him, though. If Jack had intervened, he would have done so discreetly yet effectively, so that no one would know—that was his way.

Sixteen months later, Frank married a young flaxen-haired American girl in a Catholic ceremony at a French church in Constantinople, with only her family in attendance. For a man who'd found it hard to settle down, to make up his mind, he had conducted a quick courtship. It was an unhappy marriage almost from the start. A decade later, Frank would return to Boston and visit Belle. They would find each other much changed.

Frank's quick exit left Belle distraught. Frank's half-sister, Margaret "Daisy" Chanler, would remember Maud Howe hurrying over to the Beacon Street house to comfort Belle in the weeks after his departure. Once again, she had wanted something just out of reach, a familiar sensation, but this concern was more private. The secretiveness of her relationship with Frank had been part of its sweetness—it was all hers, something she could own for a time.

Frank, in his boyishness, represented what Jack could not: the next generation. Belle would keep Frank's poetry, yes, along with his letters and handwritten manuscripts and first-edition copies of his novels, and even the boudoir photograph, which she included in the museum, in the first-floor Blue Room, buried beneath a stack of his correspondence in a display case. But she also kept Frank's baby picture and a lock of his silky blond baby hair, similar in color to Jackie's. These are the kinds of mementos a mother keeps.

Whether or not Belle had wanted to hurt Jack, she surely did. It would remain a sore point between them. For the moment, Jack swept Belle up in the much-talked-about trip to Japan and many points beyond. He took out a $40,000 line of credit and accompanied her himself. Travel, as always, would prove both balm and remedy.

PART III
MOTION AND LIGHT

All experience is an arch, to build upon.
—HENRY ADAMS, *THE EDUCATION OF HENRY ADAMS*

Ten

THE WAY OF THE TRAVELER

1883–84

At forty-three, Isabella was more than a little unsure of her next steps. Still, she liked to fling herself into things, looking more outward than inward, more forward than backward, especially when her feelings were bruised, as had happened when Frank Crawford had suddenly decamped to Italy. At the end of June 1883, she wrote to Maud Howe from spacious accommodations at the Grand Hotel on the waterfront of Yokohama: she found life in Japan "bewitching," and she felt "wild with excitement." She and Jack had arrived twelve days earlier, on June 18, on the American steamer *City of Tokio*, which they'd taken from San Francisco. Their journey over the "great, desolate Pacific" had taken a swift seventeen days, though Belle suffered from her usual seasickness: "I was wretched," she told another friend back in Boston, while "Jack [was] as happy as a king." In Yokohama in late July she was still thinking of Frank Crawford, casually dropping his name in a letter to Maud, who had been in close proximity to the romantic drama. "The papers say that Crawford is to return in the autumn to give lectures, is that true?" Belle asked hopefully.

This around-the-world journey, unlike earlier plans for the Asia trip, included only Jack and Belle, along with Belle's maid, Mary O'Callaghan. The Gardners traveled well together, falling into their distinct roles, with Jack taking care of all the details and Belle animating their days with her almost fevered curiosity. Whether close proximity, day by day, gave eventual salve to the hurt between them, it was surely a relief for both to get away from Boston gossip and out into the wider world. Jack said as much when he wrote to his brother George that he'd enjoyed excellent health on the boat and felt "awash with a perfect relief from worry and care." Their year-long travels, which Belle documented in letters, journals, and six large albums, would take them from Japan to China to Indochina, then to Java, Singapore, and India, with numerous stops along the way.

In those first two months in Yokohama, they made almost daily trips by train to Tokyo, which had over half a million residents at the time of the Meiji restoration of imperial power in 1868. Belle thought the ancient city, called Edo during the two-and-a-half-century reign of the Tokugawa shogunate, more delightful than the smaller Yokohama, where most European and American visitors stayed. Tokyo, by contrast, seemed to her "so much more Japanese." She learned to take off her shoes when indoors, so as not to ruin the "pretty mats" on every floor. On shopping excursions, she and Jack lay prone—as was customary—on "soft, clean mats, in funny little shops, looking at curios." Ceramics, lacquered boxes, carved vases, silks, painted screens, woodblock prints, and medicine cases called *inro*, the size of a person's hand and decorated with delicate netsuke figures attached by a braided cord—all of it fascinated her. She was dazzled by the clothes, "so soft in colour and fabric," with women teetering on high wooden clogs, their hair pinned in tight chignons, with silver or carved tortoiseshell pins. Even Jack, not given to flights of enthusiasm in his letters, reported to his nephew Georgy that there'd been "no end of interesting things to be seen and done."

"It is a much more beautiful country than I had imagined," Belle confessed in a letter to Anna Lyman Gray. She'd had a passing knowledge of what to expect from Morse's lectures on Japan, on its landscape, school system, food ways, temples, houses, ceramics, and pictorial arts. They had most likely walked through the Japanese Bazaar at the 1876 Centennial Exposition in Philadelphia, the pavilion showcasing art and handcraft; it had ignited the American fascination for all things Japanese. It was here that Morse himself

had seen remarkable displays of enormous bronze vases and vibrant silks. Reliable information was nonetheless hard to come by about a country that had become widely accessible to the West only thirty years before, when Commodore Perry had led U.S. Navy ships into Edo Harbor, forcing an end to Japan's policy of being a country closed to foreigners, a *sakoku*. Unlike on earlier trips, the Gardners took along few guidebooks. They did consult a well-worn copy of *The Pocket Guide Around the World* by Thomas Knox, with pages describing what to expect in Japan. On arriving in Yokohama, Jack bought a copy of *A Handbook for Travelers* by Ernest Satow, the English scholar and diplomat who had written the first English-language guide to the country.

Neither Gardner read or spoke any Japanese, so they relied on their books and a hired guide and translator, Isatsu Hakodatè, a handsome man from Nagasaki whose photograph Belle included in her travel album. They also counted on friends. Percival Lowell, one of Jack's second cousins, had arrived in Tokyo the month before. Now twenty-eight, he'd been the little Percy often mentioned in Gardner family letters, running up and down Beacon Street or sliding down the snowy hills of the Common. Jack found him "tremendously interested in things here," having already "accomplished wonders" with the language and getting around the city. Percival took the newcomers to a "very swell" dinner on June 22 at a teahouse, where several geishas entertained with magic tricks, music, and dancing. The young women were—Jack hastened to add in a letter to nephew Georgy—"very respectable in appearance." The association of geishas with the erotic had made Jack extra cautious in the descriptive letters sent back home.

Another Bostonian in town was even more knowledgeable than Percival. William Sturgis Bigelow, the unmarried son of the Gardner family doctor and a first cousin to Clover Adams, had given up his medical practice to come to Japan in 1882, traveling with Edward Sylvester Morse. Tall, meticulous, a little aloof and gloomy, Bigelow was in flight from his demanding father and the strictures of Boston society. His mother, Susan Sturgis Bigelow, had died by suicide when he was a little boy. A friend remembered that he was "not happy himself, but tried to bring happiness about for others." Bigelow claimed that he stayed away from marriage because he'd not wanted to risk passing on to his children the family curse of depression and suicide. Even so, suspicion about his private life was heightened by the fact that his summer retreat on Tuckernuck Island, off Nantucket, was a well-known gathering

place for men only. Whatever the root of his melancholy, Bigelow was already a collector, amassing, in the words of the scholar Christopher Benfey, the "tokens of an alternative life: exotica, erotica, Buddhist icons, samurai swords." He would accumulate the largest collection of Japanese artifacts and artwork in America, over sixty thousand objects, which he later donated to the Museum of Fine Arts. In this amassing of things, he and Mrs. Jack were aligned and understood each other. Their conversations, which started on this trip, would continue, on and off, for the rest of their lives.

From the Gardners' first week, the four met for tiffin (Anglo-Indian for a light meal) and dinners in "every conceivable place and style." They went to the enormous old Shinto shrine at Asakusa, which one English writer described as "ancient, holy, dirty, and grand, with pigeons and priests, bazaars and bookstalls." Sweet-smelling incense burning at the shrine mixed with aromas common in Japanese markets, those of pickled daikon, sake, and miso soup. They met too with the dapper Ernest Fenollosa and his rich wife, Lizzie Millett Fenollosa, both from Salem, Massachusetts. Fenollosa, an early art student of Charles Eliot Norton, now taught Western philosophy at Tokyo Imperial University, a position Edward Morse had secured for him. His true passions were Japanese art and Buddhism. Belle reported to Maud Howe that Fenollosa's "fresh, enthusiastic greeting was unlike anything else." Their connection would continue long after. One of his students during these years was the brilliant Okakura Kakuzō, who later became a curator at the Museum of Fine Arts and one of Belle's dearest friends.

Belle and Jack next headed to Nikko, eighty miles north of Tokyo, which by that time was a de rigueur stopping place for Western travelers. Its mountains, rushing river, and magnificent temples were reached by a long road canopied by enormous cedar trees. Nikko meant "Sun's Brightness," Belle explained to Maud. But here, with the gilded and elaborate shrines built to honor two great shogun leaders, "man had done his best to rival nature."

Jack expressed relief that Japanese fashion required far fewer layers than expected in the West. "A shirt or waistcoat is rarely worn," he reported. Instead, in steamy hot weather, men wore a suit of white linen or light flannel buttoned up to the throat, topped with a low standing collar. Belle didn't seem to mind the heat as much as Jack, despite her tight-fitting dresses and layers of undergarments, including a corset, chemise, drawers, and the requisite bustle.

By mid-August, they turned west to Kyoto. On the way, they stopped in Osaka to watch a sumo wrestling match. Belle had long loved contests and sports: horse racing, boxing, sailing competitions, and the nascent games of baseball and football, both first played in 1869. For sumo, the audience sat around the square of sand at the arena's center, where the action took place. She and Jack took seats higher up, in wooden boxes ten feet above the ground, for a better view. Everyone waved colorful paper fans to keep cool. Belle regaled Maud with all the eye-catching details.

> I was immensely amused by a man [a wrestler] in the box next to us. He was a great swell, servants and all that—his beautiful clothes were carefully laid aside on account of the heat and there he sat, smoking a most beautiful pipe with nothing on but a waist cloth and a European straw hat. We didn't even notice his want of clothes, as everybody is

almost always in that undress. He had a dear little boy with him, who would have been stark naked but for an amulet bag of such beautiful damask that was fastened by a fold of red silk round his neck and that went in bow and end [*sic*] nearly to his heels behind. This man was intensely interested to know which wrestlers I thought would win and asked me each time. Once I couldn't form any idea, so he coached me and said it was a sure thing for the small lithe man against a huge great fellow, so I interested myself properly in the little one—and when he threw the big one most cleverly and wonderfully, I thought my friend would have convulsions of delight, as I clapped my hands and called out.

Belle added: "Please don't be shocked dear, at all these dreadful proceedings," referring to the nakedness, saying, as if with a wink, "'when in Turkey, etc.'"

On arriving in Kyoto, she found the city even more entrancing than Tokyo. "It straggles over a valley to the foot of densely wooded hills," she wrote to Maud. On one side was their hotel, Ya'ami, set above a thick stand of very old cherry trees. In the evenings she sat out on the veranda to listen to the sounds of whippoorwills, locusts, nightingales, and cooing doves, which made her think she was "buried in some secluded spot." The town below was illuminated with a "thicket of lights," as residents, dressed in their finest outfits, laughed and talked, sang and danced.

During the day, she and Jack shopped the warren of stores that lined the central streets. "I've not had time to think; there has been so much to do," she told Maud. She might have also added "so much to purchase," though she didn't. It was Jack who sardonically remarked that "*somehow* the boxes and packages accumulate," but of course he knew exactly how. He truly didn't complain. It was his job to arrange for everything to be boxed up and shipped back to Boston: embroideries, a pair of lustrous gold-painted screens, a pedestal of lacquered wood in the form of a lotus; small *inro* medicine boxes.

They also toured the sights: a silk factory, a girls' school, and the city's numerous Buddhist temples and Shinto shrines. They visited Shu-gaku (Shugakuin Imperial Villa), the lush gardens of the seventeenth-century emperor, with its famous teahouses. Belle pasted into her album several maple leaves from a tree planted by Emperor Meiji to frame a large photograph of the view. She purchased professionally produced images like this one along

the way for her albums. At Nara, Belle and Jack stood before the Great Buddha, the Daibutsu at Todaiji, marveling at its massive size and impassive expression. For a small sum, they were allowed to ring the enormous bell.

Belle reacted strongly when she visited places expressing a faith not her own, something that had happened on her travels through Egypt a decade before. "How beautiful are their Buddhist temples," she now exclaimed to Maud Howe, adding that when she entered one, "I never want to come away—I could lie on the mats and look forever through the dim light." Unlike other Western travelers, she had no impulse to contribute to proselytizing. Instead, she found this kind of immersion freeing and intensely moving. She listened for the bells and chants of the Buddhist priests in nearby temples while reading or writing letters on the veranda of the hotel where she and Jack stayed. She carefully noted in her letters and journals how the different religions were practiced.

She was not alone, of course, in her attraction to Buddhism. Ernest Fenollosa would convert to Buddhism, as would William Sturgis Bigelow, who joined the Tendai sect of the faith. For Belle, the temples and shrines awakened her eye, not so much to profess a belief or faith but to feel more deeply through aesthetic experience. Beauty of all kinds—in nature and the human-made—had a direct path to her heart and imagination. Beauty felt healing and expanding.

Interwoven in all of this, like a red thread, was something else. To be away from the familiar, from home, from the chatter of Beacon Street, and to be immersed in a wholly different scene liberated Belle. Away on this trip, she warned Maud Howe to be careful about the "horrid women" of Boston society. She knew well how their gossip and exclusions could sting and also how the resulting hurt could blunt a woman's feelings and narrow her world. When Belle was on the move, she felt unleashed from close scrutiny, from constraint, from the tedium of upper-class womanhood; its well-worn scripts couldn't follow her across the sea. Japanese women were, of course, no more free than American women—a primer for young Japanese girls listed "gentle obedience, chastity, mercy, and quietness" as chief requirements. No matter. Where no one recognized or expected much of Belle, she could be herself and give free rein to her senses and her feelings.

She felt downhearted as they left for Shanghai on August 31 for the next leg of their journey. She well understood why her friend William Sturgis

Bigelow had found he'd been utterly unable to "tear himself away" from the mysteries and panoramas of Japan.

⟶·⟵

THE LIST OF PLACES THE GARDNERS VISITED OVER THE NEXT EIGHT months reads like names on a geography exam: Shanghai, Tianjin, Chefoo (Yantai), Peking (Beijing), back again to Shanghai, then Hong Kong, Canton (Guangzhou), Macao, Saigon, Phnom Penh, Siem Reap, Java, Surabaya, Madiun, Surakarta, Yogyakarta, Borobudur, Semarang, Batavia (Jakarta), Singapore, Malaya, and Malacca (Melaka), Penang, Burma, Moumain (Mawlamyine), Prome (Pyay), Rangoon (Yangon). The last part of the trip, through India, was almost as long in miles and included Calcutta (Kolkata), Darjeeling, Bombay (Mumbai), Hyderabad, Madras (Chennai), Madurai, Allahabad, Benares (Varanasi), Lucknow, Agra, Delhi, Lahore, Simla (Shimla), Jaipur, Mount Abu, and Ahmedabad. When Belle reported in her writing that Jack rested, is it any wonder?

She described all their travels to the Gardner family in lively and entertaining letters. She was, according to Julia Gardner's brother-in-law, Thomas Jefferson Coolidge, another correspondent during this time, the "best letter writer I know," who lamented burning Belle's letters at her request, which she made later.

In one of Jack's father's return letters, he mused that Belle might not enjoy China as much as she had Japan. This speculation was likely based on his knowledge of both countries through his shipping business and also his prodigious reading. Certainly she noticed, as other travelers did, that China's streets and buildings were not as manicured as those in Tokyo or Kyoto. When the Gardners arrived at Tianjin, the location of foreign embassies, she observed that they'd been all day in the city's "dirty, small, crowded streets . . ." But Mr. Gardner needn't have worried. Belle didn't require that everything be just the same at each stop on the tour. Soon enough she was marveling at a passing wedding celebration, with its parade of passengers in sedan chairs carried high above the crowd and a cacophony of exploding firecrackers. She enjoyed the differences, the dissimilarities, because these signaled another place and culture to explore, and that diversity was exactly what grabbed her attention, what fired her imagination.

She was eager to get to Peking, notoriously difficult to reach because

of its inland location. China, in contrast to Japan, had not built up much tourist infrastructure across its enormous landmass. Jack secured the use of two houseboats, hired the necessary help, and placed orders for daily supplies. They traveled by river for four days, then by horseback the rest of the twenty kilometers from Tung-Chow to the storied capital, where they arrived on September 21. They stayed nineteen days. The wonders of Peking "bewitched" Belle. They went to see the Temple of Confucius, then the Lama Temple, with its priests dressed in bright-yellow cloaks and matching yellow hats. She noticed the "chanting in very low voices" and the "very large gilded Buddha," which stood high in one of the temples.

On September 25, they received a telegram saying that Jack's mother, Catharine Peabody Gardner, had died suddenly at the age of seventy-five, news especially hard to absorb in the midst of whirlwind travel so far from home. Jack made note of the loss in his diary, as did Belle, who remarked it was an awful blow. The next day she wrote a letter of condolence to Jack's father, to whom she continued to feel particularly close. A month later, Mr. Gardner wrote a reassuring note, stating that he was holding up. He didn't want them to worry or feel guilt. "I am & have been very well . . . My children & Grandchildren have been so devoted, and their thoughtfulness and affection so persistent, that notwithstanding our sad bereavement & our lasting sorrow, no gloom has been allowed to settle upon us." Belle and Jack socialized somewhat less, but otherwise they didn't miss a step. Sorrow would wait.

Their excursion to the Great Wall at the end of September took a day and a half on a wildly uncomfortable mule litter, or cart, which clattered along over a hard road. If Belle hated sea travel, she was fearless on land, no matter how bumpy the ride. They spent a long afternoon walking on the ancient wall. When they had to leave Peking, she remembered to Maud Howe how she craned her "neck out of the mule litter to catch a last glimpse of the walls," as if to memorize what she was seeing: "The pigeons were all whirring through the air with their strange Aeolian-harp music, made by the whistles in their tails!" She was glad to see how two "rainbow clad" people greeted each other "under the shadow of the Great Gateway, with such graceful politeness."

None of this extensive touring would have been possible without a retinue of servants. Mary O'Callaghan had been sent back to Ireland from Shanghai, but once in China, Jack had hired a guide, Yu-Hai, and a

pony-handler, Mafoo, while relying on more local assistance along the way. The entire trip, including transportation, lodging, food, servants, and other help, would cost almost $24,000 (more than $600,000 today). Their wealth paved the way. The Gardners and other rich American travelers were, as a later scholar aptly puts it, "closely bound up with colonial structures," and this fact can make some of Belle's omnivorous orientalizing gaze discomfiting. But it is also true that she had little interest in imposing herself or Western values on cultures not her own. If anything, she longed for a frame of reference stretching beyond the West, especially beyond the cultural narrowness of America. Morris Carter, her first biographer, explained the dynamic in relation to religious faith, noting how Eastern faiths, with their promotion of "peace, contemplation, the negation of desire," exemplified for her "ideals which her restless spirit had not previously conceived . . ." She had no trouble recognizing that people's lives, "directed and controlled by these faiths," were indeed "beautiful."

THE SMOOTH PAGES OF SIX LARGE, HANDSOMELY BOUND TRAVEL ALBUMS map the Gardners' itinerary. Belle liked to spend time in the morning pasting down large purchased photographs, accompanied sometimes by an identifying phrase, and often decorated with pressed flowers or leaves that she'd gathered at the site depicted in the image. She had done this with a large photograph spanning two full pages of the album of the teahouse of the Mikado (a name for the Japanese emperor) and pleasure grounds in Kyoto, attaching to its upper left-hand corner two dried maple leaves. It's possible to follow, page after page, a long day in early October spent touring the vast Summer Palace (Yellow Temple) just outside the center of Peking. The day began with breakfast on the "marble terrace over the lake under a pretty kiosk," followed by visits to verdant parks, temples, tiled pagodas, and impressive bridges, one with seventeen gleaming arches. Belle wanted to remember what she'd seen, of course, using the album as a memory book. She was also practicing with visual composition on the page and would take back with her to the West a version—her version—of Eastern aesthetics.

After several weeks in Shanghai, the Gardners traveled on to Hong Kong, and the city "with its feet in the water and its head on the Peak" did not disappoint. They arrived at sunset, and "the clear cut hills were every colour from

bright red—pink—orange, to pale blue, all reflected in the water; then the light faded, night came so slowly; and one by one the stars, in the heavens, in the still water and in the city came out and it was all atwinkle." A day after arriving, they traveled to the high mountain range that rings the city to see a view of the harbor. Belle and Jack turned to each other and exclaimed: "this alone paid for the whole journey from home!" All she could say later in her journal: "beautiful, beautiful, beautiful." A few days later, after touring the streets, she wrote: "A most wonderful city. Such crowds, such movement, such colour—on our way back it was getting dark, the shops were being closed with great shutters, and fresh joss sticks, lighted in all the little stone niches."

By November, they'd decided to skip Bangkok and go to Angkor Wat on the advice of two Frenchmen they had met in Hong Kong. The extraordinary series of buildings had been described first for European and American readers by the French naturalist Henri Mouhot several years before. To reach the ancient ruins of the Khmer Empire, the largest religious complex in the world, they'd go first by riverboat as far inland as possible, and then farther into the jungle by bullock carts and elephants.

On Sunday, November 18, they rose at 5 A.M., drank steaming hot coffee, then started off, arriving at the gateway of Angkor Thom (which means "town") in less than an hour. "A wonderful ride," Belle enthused. At a certain point, they had to tramp by foot through dense jungle to see the enormous ruins. "The 48 great towers . . . with each side carved with huge Buddha heads" were awe-inspiring, overrun by a riot of banyan trees. She and Jack clambered up the structures to see as much of the enormous complex as possible. They were transfixed by the countless bas-relief friezes that covered almost every surface, and they returned the next day to see more. At the place they were staying overnight, they sat near the fire on logs and cushions, talking and smoking Mexican cigarettes. Belle would often recall her experiences at Angkor Wat, urging others to go. Years later, when a group of women in a competitive spirit wanted to discuss a foreign country Belle could not have possibly been to, they chose Cambodia, only to be shown up when she regaled them with her colorful memories.

AT PHNOM PENH, THE GARDNERS PLANNED TO GO TO THE PALACE, which was really a village, as Belle explained in her diary. Arrangements

were made for them to ride there in the royal carriage. Belle spruced up her black-and-white foulard dress, at this point "very dirty [and] old," by wearing a diamond-and-pearl collar necklace, attaching two white diamonds on the strings of her black-lace bonnet, and pinning a large yellow diamond to the front of her dress. The first king was unwell, so they met the second king, who was very bashful. He asked them to return the next evening, which they did. They feasted on peacock, accompanied by music humming in the nearby temple. They returned a third time and met both kings, ending the evening with a palace tour, during which Belle shook hands with a Siamese princess "who wore a yellow scarf and a flower in her hair." The second king complained about the Protectorate de France, which had become the country's colonial overseer in 1867. When he spied Belle's sparkling yellow diamond, he told her that even as a king, he had "no such thing."

From Cambodia, they crossed the equator to Surabaya, to tour Java. Then, while sailing to Singapore, they witnessed the aftereffects of the catastrophic eruption of Mount Krakatoa six months before. "We passed through the fields of pumice stone floating on the sea," she explained to Maud, adding that they'd "picked up some pieces." The "most appalling" volcano had killed over twenty-three thousand people and "obliterated" the west coast of Java, "with all its towns and all that it had . . . The sea [is] now calmly splashing above it."

Belle and Jack arrived in Singapore in late December. After a 7 A.M. service at the English-speaking cathedral, they spent Christmas afternoon at the city's celebrated botanical gardens, with its many kinds of birds on view—hawks and owls, kingfishers and cuckoos. They were preparing to leave after the holidays for the last part of their journey, a three-month tour of India. Belle's thoughts turned toward home. She mused to Maud Howe that she'd be "most interested to see Crawford's new book," adding that she hoped "it is good." Frank had not left her mind. She briefly mentioned him in several earlier letters to Maud, wanting to know his plans and how his writing was going.

In her late December missive, she elaborated further. She had devoured a recent short novel by the English writer Margaret Wolfe Hungerford titled *Loÿs, Lord Berresford*. She urged Maud to read it, adding that her friend "must guess why I like it and want you to read it. Beg, borrow or steal it." The reasons why were not hard to fathom. Its main character, Miss Theo

Blake, is a woman torn between the love of a younger charismatic man and her rather dull fiancé and later husband. Thrillingly, she experiences no social repercussions for her romantic transgressions. Belle must have recognized a version of herself in Miss Theo, "a confirmed flirt, not so much perhaps from practice as from nature," who is notorious for how she "coaxed and tormented and frightened everybody from her birth upwards" into giving her exactly what she wants, until she becomes "both the terror and admiration of every soul."

"THE WAY OF THE TRAVELER IS HARD," ISABELLA WROTE TO A FRIEND from Benares, India, in early March—"at least it is hurried." The Gardners had been on the move since leaving Singapore at the first of the year in 1884. They had "worked off some of the places to be seen," as Belle explained, adopting Jack's phrase for their mission. The coastal city of Malacca was "an uncanny sort of place, as if under a spell," bordered by a pink-colored sea and masses of waving palm trees. She marveled at the dramatic waterfalls at Penang. In Burma (Myanmar), they went to see the wildly colorful pagoda temples, which were, as Belle reported, "*even a* sensation to Jack!" One scene in Rangoon, as if out of a painting, stood out to her: "woman with a long soft pink silk skirt tight about her, trailing a foot at least; a light shimmery yellow scarf about her shoulders and hanging down her back. She is holding, like Titian's woman, a large silver bowl . . . with those long native cigarettes, the tobacco rolled up in green leaves."

Once in India, Belle seemed weary. Maybe she felt unable to take in anything more, or the travel infrastructure of Victorian British rule took something away from experiencing the country more directly, as they sped from one place to the next by fast train. There were highlights, of course. She wrote of two wondrous days on the Ganges, which was a "Hindu world in itself." She noted the Hindu temples in the south and the astonishing views of the Himalayas and Mount Everest. The perfection of the Taj Mahal, which she and Jack visited in mid-March, she compared to a pearl. She hated to leave places. She confessed to her brother-in-law in a mid-April letter from Bombay: "As this is our very last day here, we have many little things to do . . . I am awfully busy and so glad to be, for then I can't remember how dreadful it is to leave this Golden Land."

Nevertheless, she sounded a note of relief in her long letter to Maud Howe when mentioning their hopes to head to Venice soon, via Cairo: "There we mean to rest a little and try and see if I can stop a beastly little cough I got a month or two ago." She'd enjoyed almost perfect health the entire trip, but now she wondered if she should be taking better care of herself. She had few dresses left that weren't torn or stained. She weighed a mere 115 pounds, noticeably lighter than she'd been at the trip's start. While she loved "to see all these wonderful things," she also admitted to Maud, with not a little understatement, that she'd been "rather unquiet for a year nearly, and one does get tired."

Belle and Jack would stay in Venice for five weeks, followed by brief visits to Paris and London, before finally returning to Boston later in the summer. This visit to Venice would be her introduction to the Palazzo Barbaro, the extraordinary palace on the Grand Canal that would be a potent inspiration and refuge for her ever after. In the city Charles Dickens once called "a strange dream upon the water," Belle's life would be transformed. She had seen so much, a lot more of the wide world than most nineteenth-century women travelers. Everything she had noticed, enjoyed, disliked, and felt, she brought with her, and in the light and shadows of Venice, she would turn her educated eye from three-dimensional views to two-dimensional ones, to paintings and the glories of Renaissance art.

Eleven

"A WHIRLWIND OF SUGGESTION"

1884

Belle and Jack arrived at the waters near Venice in the early morning of May 14, 1884. Cholera was circulating that summer, so incoming boats had to stay in quarantine offshore for two days as a protective measure. La Serenissima, as the city was affectionately called, gleamed in the distance. "Strange morning," Belle wrote in her diary while waiting on board, her anticipation palpable: "The sea [is] like oil—and boats all yellow and red sails. An idle delicious [*sic*] looking at it—i.e. the sails, the strange sea, and Venice afar off." Both Gardners were exhausted by their travels. They settled into lodgings at the Hotel de l'Europe at the mouth of the Grand Canal, across from the high-domed Santa Maria della Salute; its reflection shimmered on the water's surface. On their first day, Belle wrote in her diary with her typical optimism: "Very long getting ashore and established at Hotel de l'Europe—trunk lost. Good rooms."

She spent an idle first week catching her breath. She and Jack had "ices and coffee" at the famed Café Florian in Piazza San Marco, the enormous

square fronting the towering five-domed eleventh-century basilica that Napoleon once characterized as Europe's biggest drawing room, where people went to see and be seen. A leisurely gondola ride up and down the Grand Canal followed. She ended the diary entry with a single word: "Music." The city of Vivaldi and Monteverdi was filled with it, with impromptu performances in the square and along the canals, concerts at the many theaters, including Teatro La Fenice, the fabled opera house, which was crowded each night with rapt patrons.

The weather was a relief after the blasting heat of summer in India. "It feels cold to us," Jack marveled to his brother George. They quickly hired an Italian teacher as well as a young local, Giovanni Battista, as their personal gondolier. Soon enough Belle regained her strength, helped no doubt by her intense interest in her surroundings—art around every corner, in every church, in galleries and on the walls of palazzi. When Jack admitted to his brother that he felt "very lazy," with a bad knee that bothered him, he wryly noted that "Belle never is." She kept going, though at first she kept to a strict rule that she'd enter no more than two churches or galleries a day. She wanted to pace herself. There was so much to see. She wanted to really look.

Belle owned a copy of *The Stones of Venice,* John Ruskin's influential midcentury treatise on Venetian art and architecture. She'd also kept a notebook dated 1883, the year before arriving in Venice, in which she wrote thumbnail biographies of painters and traced aesthetic influences and contemporaries in other arts. She noticed that Giotto had taken many subjects for painting from Dante and that Cimabue had been Giotto's first teacher, after discovering him drawing a sheep on a stone. Raphael, Titian, Leonardo—she made records of them all, wanting to place artwork in its historical context. Now she saw the work of the Italian masters up close. She saw the magnificent Bellini altarpiece, measuring sixteen feet high, at San Zaccaria, its Virgin and child surrounded by saints from many time periods in a single scene, a sacra conversazione, rendered in saturated gemlike colors. In her travel diary she mentioned a figure of one of those saints, Jerome, a patron of learning, who wears a cardinal-red cloak, the color of the Holy Church. She clambered up a high ladder to inspect the exquisite cycle of panels painted by Bellini's student, Carpaccio, at the Scuola di San Giorgio degli Schiavoni, a fifteenth-century confraternity, or brotherhood. Carpaccio's paintings, including his dramatic depiction of a determined Saint George killing the

dragon, a spear thrust into the beast's bloody mouth, were placed all around the room near the ceiling, safely above the heads of members of the civic society who gathered below on large wooden benches. Unlike Bellini, who painted more religious scenes, Carpaccio chose subjects that were often angled toward "commonplace things," in John Ruskin's phrase—for instance, fishing on the lagoon or townspeople going about their everyday chores. In *St. Augustine in His Studio,* which hangs at San Giorgio, a small white dog eagerly awaits his food while watching the saint at work in the late afternoon light. Carpaccio's wit was not lost on Belle—she characterized several of his smaller paintings at Sant'Alvise as "funny" in her diary.

Belle's Venice album had begun with a photograph of the swaggering winged lion, an emblem of the city's patron saint, Mark, riding high on a post above the basilica's square. Photographs of well-known scenes of the city followed. After ten or so pages, she switched to photographic prints of paintings she had purchased at local shops. The purpose of her album had shifted from tracking memories of her travels to a record of art, which she could consult again and again to memorize the differences between painters, a Carpaccio or a Veronese, a Tintoretto or a Titian.

AMERICA IN THE TUMULTUOUS YEARS AFTER THE CIVIL WAR LOOKED forward and out, from east to west, hurling itself into a glittering global future—the so-called Gilded Age. Yet, as a character quips in Oscar Wilde's play *A Woman of No Importance:* "The youth of America is its oldest tradition": it was a country characterized by its sense of newness. This was a strength but also a source of deep unease. The terrible, confounding ravages of slavery and seizure of land from Indigenous peoples had fueled the country's rising financial power, a success often built by ignoring the country's founding values. Elites worried about what some called the enduring cultural "belatedness" of the United States. For all its dynamism and moneymaking, the cultural standards of the Old World still dominated. What was there of cultural value in a country so relatively new? American literature and history would not merit their own disciplines of study until the twentieth century. In this context, Isabella Stewart Gardner occupied an interesting position. She was on the cutting edge, supporting American artists and, more radically, doing so as a woman.

Italy, in contrast to America, was the ideal of a centuries-long history and culture. There, the past felt tangible, sometimes pressing in hard. Henry James described the feeling in a letter to his brother on his first visit back to the country a few years after the Civil War, saying that here the "aesthetic presence of the past" was inescapable. Later he wrote that nowhere do "art and life seem so interfused." Walking along canals and through campi means moving from deeply shadowed narrow alleyways and covered walkways into sunlit courtyards and squares, as if experiencing the daily turning of the earth, or how life moves from deep shadow to light and back again. Certainly, Belle knew well this alternating rhythm in her own life, from great loss to hope and back again. It may have had something to do with her identification with Venice and her pleasure in being there, a pleasure that would only deepen over time.

The Gardners were hardly the only Bostonians in Venice, which at that moment was fairly well populated with Yankees, including Jack's youngest sister, Eliza, and her husband, Francis Skinner. Belle referred to her simply as "Mrs. Skinner" in her diary, though she used first names for Jack's siblings Julia and George, suggesting a chilliness between the sisters-in-law for reasons not entirely clear. There were also mentions of Louisa and Katharine Loring, sisters who had a large summer estate on Boston's North Shore, as well as Jack's cousin Nina Lowell and her traveling companion, Ellen Coolidge. The latter two women joined the Gardners in mid-June, on Corpus Domini Day, at San Salute to watch a celebratory procession of priests and congregants. Even so, the Boston names appear in Isabella's diary only briefly, as if they were part of the scenery but not the main act.

The Gardners' social world in Venice lay elsewhere, specifically at two palaces near their hotel on the Grand Canal. Casa Alvisi was the palazzo owned by Katherine de Kay Bronson, who had moved to Venice ten years before. Mrs. Bronson, a New Yorker like Belle, and her young daughter, Edith, were on their own after her husband's breakdown had required care in Paris. Casa Alvisi, located directly across from San Salute at the mouth of the Grand Canal, became a salon that Mrs. Bronson, six years older than Belle, oversaw with a benign and generous welcome. Compared with other palaces along the canal, hers was on the small side, with intimate rooms lined with pink marble and filled with her collections of gilded glass and old silver. Frequent guests included American artists such as Frank Duveneck and James Whistler; Sir

Henry Layard, the English discoverer of Nineveh; Countess Pisani, a member of a fabled Italian family; and Olga of Montenegro, daughter of the queen of Montenegro, whose husband had been assassinated. "Titles two to a penny," one guest remembered. Mrs. Bronson was powerfully attached to the aging poet Robert Browning, a widower, who stayed at her palace each autumn. She felt sympathy for her local Italian neighbors in the struggling economy of post-Risorgimento Italy—the formation of one nation-state from many small states had led to much economic hardship. She invited underpaid gondoliers to occupy her top floor in the winter and started a school for poor children. The scene couldn't have been more different from proper Boston. Henry James, who'd frequented her "accessible refuge," recalled in a reverie: "If you are happy you will find yourself, after a June day in Venice (about ten o'clock), on a balcony that overhangs the Grand Canal, with your elbows on the broad ledge, a cigarette in your teeth, and a little good company beside you. The gondolas pass beneath, the watery surface gleams here and there from their lamps, some of which are colored lanterns that move mysteriously in the darkness . . ."

Belle asked Harry James, as his friends called him, to write a letter on her behalf to Mrs. Bronson, after his plans had changed, so he would no longer be in Venice to make introductions in person. "Please be kind and helpful to Mrs. Gardner, who is [a] forlorn, bereft, emaciated lady," James wrote, adding that the peripatetic traveler would not want for either cigarettes or social introductions once she got to where he was in London. He assured Belle too that his letter was hardly necessary because Mrs. Bronson was "absurdly easy to know." The two women got on famously. Mrs. Bronson appreciated Belle's "octagon character," while the younger woman expressed her gratitude with gifts—small candlesticks, a lush green-velvet bag, a sparkling lizard pin, which Mrs. Bronson acknowledged with affection. Later Mrs. Bronson, who addressed Belle as "my charmer" or "Lady Isabel" in her letters, would say she knew from their first meeting that they would see eye to eye. In one undated letter she asked: "You love all things beautiful, do you not? But is art dearer to you than nature?" She didn't keep Belle's reply but in that same letter expressed the depth of her attachment: "My thoughts are often with you," she wrote. "I can never forget you . . . [though] time and distance lie between and never a word written or spoken across the separating seas." Mrs. Bronson gave Belle all the knowing affection she'd longed for in Boston. No wonder she would form such a powerful bond with Venice.

Farther along the Grand Canal, across from the Gallerie dell'Accademia, stood a competing center of the social whirl, the much grander fifteenth-century Palazzo Barbaro, which had been through the centuries home to various members of the Italian aristocracy. The Gardners' hosts were Daniel and Ariana Curtis, also from Boston, who had rented one floor of the many-storied palace that summer; by the following year, they would own the palace outright. The couple, several years older than the Gardners, were in flight after an obscure scuffle between the elder Curtis and a Boston judge, which had resulted in the judge's injured nose, a trial, a brief jail sentence for Curtis, and the family's determination to live elsewhere. Their son, Ralph Curtis, in his thirties and an aspiring painter, often stayed with them.

Belle and Jack visited the Curtises a day after they arrived in the city and again two nights later. Thereafter, a frequent refrain in Belle's diary would be "went to Mrs. Curtis' in the evening." Visitors reached the Barbaro, actually two palaces that had been joined together, by a gondola ride to a wide step at the water's edge, then a short walk through a dark hallway that led into a sun-splashed inner courtyard, with a scrap of a column's capital remade into a large wellhead. The stone staircase rose up and up to the piano nobile,

or principal floor. Large rooms were decorated in an elaborate eighteenth-century rococo style, festooned with sculptural putti and lustrous with gold and white marble. The *salone*, or salon, managed to be both grand and intimate. Candlelight refracted from one shimmering mirror to the next. Henry James recalled in an essay how "old ghosts seemed to pass on tip-toe on the marble floors." Dank, almost bittersweet smells and birdsong floated through the tall windows that opened onto balconies facing the canal. From these high porches, San Salute's white dome and its reflection on the water commanded the view.

Laura Ragg, in a 1936 essay, imagines the effect of "leaving one's gondola in the darkness" to enter a palazzo, describing how "one felt an actor in a beautifully staged pageant," or a dream evoked by a "reading of an ancient chronicler." The glamour and mystery of the Barbaro had a theatricality that appealed to Belle's sense of drama, her wanting to be lifted out of the ordinary. James conveyed the palace's effect in his novel *The Wings of the Dove*, partly set in its many rooms, with a single phrase: "a whirlwind of suggestion." Here, his main character, the doomed American heiress Milly Thiele, found "a freedom for all the centuries."

Though Belle spoke French more fluently than Italian and knew Paris better, the culturally dominant French capital was not her city. Its upper-crust society admitted very few outsiders. Venetian society, with its hodgepodge of writers and artists, expat Americans and those hard on their luck, was cosmopolitan, less constrained, and small enough for her to join. With its sweet promise of freedom, her sharp elbows, much needed in Boston, could unbend.

Belle closed her Venice album with a single wish: "O Venezia benedetta, no le vogio piu lasar" ("O blessed Venice, I do not want to leave her anymore"). She would return again and again.

THE GARDNERS ARRIVED IN PARIS AT THE END OF JUNE AND STAYED A little over a week at the Hôtel de Hollande on rue de la Paix, near the place Vendôme. They didn't know many people in Paris, but Belle needed to refresh her wardrobe, so they returned to Worth's atelier, steps away from their hotel. Worth, the impresario of women's fashion, had studied portraits at the Louvre to understand line and form, how fabric could transform and

elevate a woman. His designs, some deceptively simple, could cost as much as a fine painting. Henry James would tease Belle from London, advising her not to spend all her money on fashion.

Jack didn't record her specific clothing purchases that year, but he kept the receipts from their visit to Frédéric Boucheron, the jeweler to European royalty, whose elegant store at the time, the Galerie de Valois, was located in the famed arcades of the Palais-Royale. Belle was already known for her jewelry. She had worn two white diamonds, with a yellow diamond on the front of her dress, when meeting the two kings of Cambodia. She would purchase in 1886 two more extraordinary diamonds, "The Light of India" and "The Rajah," with the legacy she inherited after her brother James had died in 1881. She bought them at Tiffany of New York; they were formerly owned by J. P. Morgan's mother, Mrs. M. J. Morgan. Belle later had Tiffany design hair ornaments with gold springs to hold the glittering diamonds suspended above her head: not a typical way to wear jewels, but memorable, which was exactly the point.

Jack had bought Belle an expensive strand of pearls in London in 1874, and now, after their long travels, he purchased another string from Boucheron. At the time pearls were prized above all other jewels, even diamonds or rubies, because they were rare and exceedingly expensive to harvest. Before the process of culturing pearls was developed in the 1890s, a single round, luminescent gem was found in approximately one out of every thousand wild oysters. Fortunes and lives were lost in their pursuit. They came to symbolize wisdom, as in this quotation from the seventeenth-century English poet John Dryden: "He who would search for pearls must dive below." Ropes of pearls worn by royalty conveyed status and power, and pearls were also a token of love. The receipt in the Boucheron sales book reads: "Monsieur John L. Gardner—22/07/1884—1 strand of 39 pearls, 650 grams (16gr. on average) with a 2-carat diamond clasp." The price was $10,600, an extravagance.

Jack couldn't read Dante aloud to Belle in Italian, as Frank Crawford had done the summer before; he was no longer a young man and was aging faster than his wife: balding, with a portly figure and a bad knee. What he could do was give her these small, shimmering, incomparable worlds that, like words in a sentence, spoke his heart. She, in turn, would have her strings of pearls made into a single long rope, which she wore so often, it became

her signature accessory. It must have pleased Jack to see her adorned with his gifts in this dramatic way.

~※~

Belle had experienced much on her travels, and she had fallen under the spell of Venice. How she might carry its spark back to Boston remained unclear. In London, their last stop before returning home, she confided her troubles to Henry James, who explained her plight in a gossipy letter to Grace Norton, Charles Eliot Norton's younger sister. Belle felt "in despair" at going back to Boston, "where she has neither friends, nor lovers, nor entertainment, nor resources of any kind left." James was overdramatizing the litany of complaints she had confided to him. Of course, she had many resources, including friendships. But he didn't explain what he meant by "lovers." Was this a veiled reference to Frank Crawford, and what did he mean when he mentioned elsewhere in the letter that she'd been full of "strange reminiscences"?

Morris Carter, Gardner's first biographer, would explain this time in her life a little dryly: "Some of the cleverest women" in Boston "were still unfriendly" to her. In his notes, he'd also written down this line, sometimes credited to Isabella: "Not a charitable eye or ear in Boston." No wonder she dreaded her return. Henry James was more direct in his conclusions about Belle, telling Grace Norton the worst thing possible: "I pity her." But Belle wanted many things, and pity was not on the list. She was up to something neither she nor Henry James could yet see, something inspired by a Venetian "whirlwind of suggestion."

Twelve

"THE FIDDLING PLACE"

1884–87

When the Gardners sailed for Boston on July 26, 1884, they'd not yet heard that Jack's eighty-year-old father, John Lowell Gardner, had died in his sleep two days before, at the place he loved most, his Green Hill estate in Brookline. He was a modest, widely admired man whom the Brookline newspaper memorialized as "dignified, affable, [and] courteous to all . . ." A Peabody cousin concurred in a long letter to Jack's brother George, saying that the words *generosity* and *sweetness* best characterized Mr. Gardner, especially his intense interest "in us and our doings." In his letters to Jack, he always sent his "finest love to Belle," and his letters addressed to her were characteristically playful and confiding, full of family news. In one, he described how his five grandsons, children of Jack's sister Julia, played endless games of tennis in the summer heat on the new court at Green Hill. He concluded another letter with a line to his fashionable daughter-in-law, knowing it would make her laugh: "there is consolation to a woman in being well-dressed, which religion cannot give." His

approval had been ballast for Belle, especially in the storms of nasty gossip and social displeasure.

Because of Jack's father's death and Belle's own dread of returning, the Gardners' homecoming was muted. They had missed the funeral, as they had missed Jack's mother's eleven months before. On their arrival in New York, on the SS *City of Rome,* they were greeted by Belle's parents and several members of the Gardner family, who had come to New York eager to welcome them stateside and to accompany them back to Boston. The Gardners present included nephews Joe and Augustus, and Jack's sisters Julia and Eliza and their young sons, John Coolidge and Frank Skinner. An elaborate code of mourning rituals governed the months that followed, prohibiting attendance at large parties or any dancing. Stationery pages edged in black reminded both writer and reader of death's nearness. Each stage of grief was marked by the color of Belle's clothes: first a dull black, made of silk woven with wool to prevent it from shining, followed by somber grays and purples. Jack likely wore a black armband over his jacket sleeve.

In late August, Mr. and Mrs. Stewart came to Boston and stayed at 152 Beacon Street to pass the week with their daughter and son-in-law. Belle also visited Maud Howe in Newport for several days. Small gatherings were allowed in those months, and Jack enjoyed hosting intimate suppers, where he took care of everything, including the choice of what to serve. Belle celebrated many of life's pleasures, but not culinary ones, unlike her husband. The reasons why are elusive. Certainly, she wanted to fit into the tightly tailored Worth gowns that showed off her tiny waist and curvaceous figure. Once, she advised that the best tactic for dinner parties was to serve mediocre food, because then guests, especially women guests, would leave the evening feeling superior to the host or hostess.

BELLE BEGAN HOLDING MUSICAL OCCASIONS IN HER NEWLY FINISHED MUSIC room at 152 Beacon Street, a sparsely furnished space with bare wooden floors, which enhanced its acoustics. She liked a small musical soiree in the morning as a way to greet the day. Often a performance would be accompanied by talks by musicians, so that attendees could learn something about the music they were hearing. The composer-pianist Clayton Johns recalled one

such performance in his memoirs: "Mrs. Gardner invited me and Charles M. Loeffler to play the whole range of piano and violin sonatas in her music room before a room of twenty-five people each time—Bach, Mozart, Beethoven, Schumann, and Brahms."

Belle enjoyed a remarkable recall for any music she heard. Many years later, when a group of musicians offered to play from memory a favorite piece by César Franck, assuring her they'd improvise what they couldn't remember, she declined: "O, dear no, I just can't bear to have anything happen to it." She did not want a stray note to cloud her memory of an earlier performance. As the Swedish painter Anders Zorn rightly knew and memorably said to her in a letter: "The key to your heart is music."

Belle also pursued the kind of intellectual knowledge she might have gained from formal higher education, an effort complicated by being an elite woman. The young women attending colleges in this era were most often from the middle classes, wanting to secure through work their own rise in status. So when Charles Eliot Norton invited Belle to join the Dante Society in 1884, she leapt at the chance. She had attended Norton's art history lectures several years before, and now she went to his Dante readings with writers and scholars held in his large, airy study at Shady Hill, his home in Cambridge.

Norton had long held a passion for the great Florentine poet. In the mid-1850s, he began translating Dante's *Vita Nuova,* with its glorious opening line: "Here begins the new life." He'd been an instrumental member of an informal Dante club, a precursor of the society, which met on Wednesday evenings in the years after the Civil War at Henry Wadsworth Longfellow's home on Brattle Street. Longfellow, poet and Harvard professor of languages, had translated the *Inferno* and the *Commedia* in the years leading up to the six-hundredth anniversary of Dante's birth, in 1865. Also attending those early meetings was another poet, Jack's father's cousin James Russell Lowell, the founding editor of the *Atlantic Monthly*. He had succeeded Longfellow as Harvard's professor of languages.

The Dante Society was established in 1881 to nurture interest in the Florentine poet and to make English translations available for American readers, a goal that stirred up some controversy in a city still puritan enough to be wary of the poet's lavish, tactile description of human life. Of its fifty members, Mrs. Jack was one of seven women. If Boston women weren't inviting her to their gatherings, she would participate in these conversations

instead—in and among New England's leading literary lights. Lowell captured Dante's appeal to readers—Belle included—with his dictum that the poet was "part of the soul's resources in time of trouble."

Belle enjoyed this activity immensely, and she had what the organizers needed: financial resources. She anonymously paid for publishing the society's ambitious *Concordance of the Divina Commedia*, by E. A. Fay. When Norton acknowledged receipt of her first year's dues for the society, he requested her support for another of his causes—the opening of the School of Classical Studies in Athens. She replied with her usual quickness and sent him a check for $400. She proudly kept her Dante Society membership current for the rest of her life and later dedicated the largest display case in the museum to Dante. There she placed, among other items, his so-called death mask; each society member received a copy of it. On the case shelves she put her important editions of his work, including a fifteenth-century copy of *The Divine Comedy*.

Early in 1885, Jack traveled by train all the way to Mexico, while Belle busied herself with arrangements to attend the presidential inauguration of Grover Cleveland in Washington, D.C., in early March. Though not particularly interested in politics in these years, she didn't want to miss out on the pomp and celebration. She sent a flurry of telegrams to another cousin of Jack's, William Crowninshield Endicott, the newly appointed secretary of war, who secured tickets to the festivities, including the ceremony commemorating the completion of the Washington Monument. Belle found the capital city abloom in a warm Southern spring.

Clover Adams braced for Mrs. Jack's arrival. The two women were acquaintances more than friends, though they shared many interests. (Clover took photographic portraits of many in their social circle, but not one of Belle, who later included two of Clover's platinotype photographs at Fenway Court.) Mostly, Clover found the more confident woman's visits a lot of work and likely agreed with some of the negative gossip she had overheard. Even Julia Ward Howe could understand Clover's sense of dread. The next year, Howe went so far as to ask Mrs. Jack not to attend her lecture at the Concord School of Philosophy, saying in a letter that she "would take people's minds off" philosophy: "My hair stands on end at the thought of the mischief you might work" in the lecture hall.

Henry Adams was more sanguine. On Belle's arrival in Washington, he joked to the statesman John Hay that "Mrs. Jack Gardner is here on the

war-path, and asked tenderly for you." His comment captured something of Isabella's dual nature: her forcefulness and the side of her that was sensitive. She wasn't all rush-ahead energy, though women tended to react to that aspect of her personality.

Back in Boston, as the weather warmed, the Gardners moved to Green Hill on Warren Street in Brookline, which they had inherited from Jack's parents. The large white-and-green clapboard house, first built in 1806 by a Salem ship captain, Nathaniel Ingersoll, sat like an Italian villa on high rolling acreage, shaded by age-old New England pines. Its many porches looked out on lush, green fields. The house's exterior was dramatically rimmed by a two-story arcade, heavy with grapevines.

The Gardners had owned the forty-acre estate since the early 1840s, when wealthy Bostonians established second homes west of the city to escape its hot summers and the threat of disease. Jack's father had made the greater part of his later fortune in real estate, buying up parcels of land in Brookline and residential lots as the long, elegant streets of the city's Back Bay were filling in with mansions. He divided the properties among his children, giving 200 Beacon Street to Eliza Gardner Skinner, 147 Beacon Street to Julia Gardner Coolidge, and 51 Commonwealth Avenue to George Augustus Gardner. He saved his beloved place, Green Hill, for Jack Gardner, knowing his daughter-in-law was already familiar with how to manage the sprawling property, especially its prize-winning gardens and flowers.

Its parlor walls were covered in antique Chinese wallpaper, and Belle arranged in its comfortable rooms innumerable treasures from her travels, including Japanese screens—one, depicting the eleventh-century classic *The Tale of Genji,* stretched across two walls. She liked to sit at her desk with the windows open, looking out over the treetops to Boston, which could be seen on a clear day.

Belle's métier was the gardens, an all-encompassing interest she'd shared with her father-in-law. She had filled the large bay windows that faced the street above the front door at 152 Beacon Street with towering plants and flowers, changing the display according to the season. Boston newspapers sometimes reported on what was blooming in the Gardner windows. These plants came from Mr. Gardner and his large greenhouses at Green Hill, managed since 1868 by Charles Montague Atkinson, the English gardener who won many prizes for Mr. Gardner.

Now the gardens at Green Hill offered Belle a fresh and expansive canvas where she could experiment. She became known for her fearlessness with color, planting bright cornflowers and every shade of petunia, which created a kind of "rainbow mist," according to one journalist. Blooming fruit and lilac trees perfumed the air. Another writer observed how "each mood and each part of the day" had its own agreeable area, so there were hills to climb in the morning and conservatories for "duller" moments. Walled gardens gave shade for walks in the heat of the day. On warm spring days, Belle liked to serve afternoon tea outside, arranging chairs under the allée canopied with tall trees—linden, elm, oak, and beech. A friend recalled the "superb show" when her "famous Japanese Irises in their flooded bed" were in "full blossom." After sending home rhizomes from Yokohama, she had piped in water to make a large sunken garden, so the irises could flourish like those she admired in Hiroshige's woodblock prints.

Soon enough she was winning prizes at the Massachusetts Horticultural Society competitions for her irises, orchids, rhododendrons, foxgloves, Canterbury bells, cucumbers, nectarines, and yes, brussels sprouts.

THAT SUMMER OF 1885 BELLE AND JACK RETREATED TO ROQUE ISLAND, located off the coast of Maine thirty-five miles from the Canadian border.

They arrived by steamship at the end of July to stay for several weeks. A large archipelago of ten islands comprises approximately eighteen hundred acres. The three smallest are barred islands, accessible dry-shod at low tide. The H-shaped Roque, the only island of the ten that the Gardners inhabited, was a hilly reserve of deep woods, pastureland, and beaches, with magnificent views of the deep-blue Atlantic waters on all sides. Irises, wild roses, bunchberries, daisies, yarrow, and goldenrod covered it. Fog rolled in and out with the tide.

Joseph Peabody, Jack's maternal grandfather, had first secured the island for lumber and saltwater farming; he built several of his ships there. The family had sold the property after the Civil War, but Jack and George repurchased it in 1882 from Gilbert Longfellow. Ahead of their mother's first visit the next summer, the brothers made special renovations to the second floor of the Old Farmhouse. They sited her bedroom, soon known as "Mrs. Peabody's Room," on the southeast corner, with a view of the sea. She couldn't have been more pleased with the "luxurious appointments," telling Jack she found the "Island home" to be "far more beautiful than I had supposed." According to one guest-book entry, Roque was a "Faerie Realm of Pine and Sea."

Belle loved the adventure of being there right from the start, how it harkened back to an earlier time. She walked the shimmering white sand on the mile-long Great Beach and enjoyed sitting by an outdoor fire. She liked to take out the birch-bark canoe, christened *The Owl*, for long rides to visit the seal colonies along the craggy coastline.

GRIEF AWAITED. THIS TIME IT WAS ADELIA STEWART, BELLE'S MOTHER, who died, on January 6, 1886, of "neuralgia or pain of the heart," likely a heart attack. Though Mrs. Stewart had reached the age of seventy-one, beyond that era's average life span, her death was no less surprising, as Belle would recall many years later, when she wrote a consolation note to a friend who'd lost a parent. Hearing the sudden news of her mother's death had been one of "those unforgettable moments" in her life. Mrs. Stewart was buried alongside her children Adelia, David Jr., and James in Green-Wood Cemetery. Belle and Jack rushed to New York soon after to be with Mr. Stewart.

Father and daughter looked uncannily alike and had much else in common, including an entrepreneurial spirit. Now they shared something else—they were survivors. A family of six reduced to two. Father and daughter

spent six weeks together, traveling south to Saint Augustine, Florida, where many northerners had invested in citrus farms. Then on they went to Havana, Cuba, where they stayed a week. Belle returned home on March 6, during a New England winter that would not let go. She had entered Dante's "dark wood." As her social world contracted, her grief was marked less by what she did than by what she didn't do. The papers noted that she wouldn't be giving her usual parties and dances, though one report added that she kept one day a week open for afternoon tea—but only for her immediate circle. Her mourning dress and black-bordered stationery signaled her grief.

A distraction that helped make this season bearable would bloom into a lifelong passion—collecting rare books and manuscripts. She called it "book ardor." Charles Eliot Norton sent a letter in June about the London sale of the library of one of his friends, Edward Cheney, who was, as Norton explained, "a great lover of Italy and of fine books." He suggested the purchase of two editions of Dante's *Divine Comedy*, the first known as the Aldine Dante of 1502, printed in Venice. The second volume was the Brescia Dante of 1487, with woodcut prints based on engravings after illustrations by the Italian master Botticelli. The next year, she would buy the Landino Dante of 1481, illustrated by nineteen Botticelli engravings, a very rare copy she got for £420. "Books, I fear," she told Norton, "are a most fascinating and dangerous pursuit—but one full of pleasure and I owe it entirely to you if I have made a good beginning." She would display these treasures, along with other rare books, in the large Dante Case in the Long Gallery at Fenway Court.

As before, travel followed close on the heels of loss, and by July, the Gardners returned to Europe for an extended stay. "Your Aunt is better than she has been for months," Jack wrote in September 1886 from Venice to his nephew Georgy, George's eldest son, now almost thirty years old. The Gardners were establishing a routine that would persist for the next twelve years: one year stateside, followed by a months-long overseas tour in the even-numbered year. On this trip in 1886, they took along their nephew Joseph Peabody Gardner Jr., now twenty-four, deeply affected by his father's death by suicide and struggling mightily to find a path. Maybe Europe would provide balm for Joe Jr. too.

The Gardners, now a group of three, arrived in London at the beginning of July. The city was crowded with Americans and, best of all, Jack's eldest brother, George, and his sixteen-year-old daughter, Olga, had timed

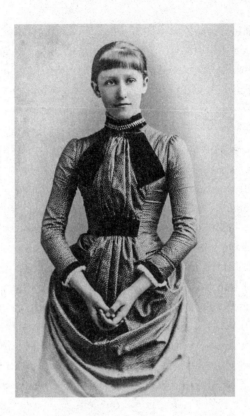

their arrival from Paris so the extended family could be together. George had lost his wife, Eliza, ten years before, and Olga had taken on the role of her father's traveling companion. It was a role Olga would increasingly take with her Aunt Belle as a frequent visitor at Green Hill, then later in Venice. She'd become a favorite niece. The family stayed at the same hotel. Henry James, with whom they lunched, complained about all the Americans wanting his care and attention.

Belle and Jack didn't stay long in London, and after several days in Paris, they traveled via Heidelberg to Bayreuth, the site of the summer festival dedicated to Richard Wagner's grand operas. Jack called the midsize town "the fiddling place." A day after they arrived in late July, the Gardners attended a performance of *Tristan and Isolde*, Wagner's masterpiece of doomed romance, at his Festspielhaus, a complex of buildings that attendees called—coincidentally for the Gardners—Green Hill, for how it seemed to rise out of the surrounding landscape. Joe's younger brother William Amory Gardner, known as Amory and called Billy by the family, joined them for this part of

the trip. Also in town were their Boston friends Henry Lee Higginson, who had recently founded the Boston Symphony Orchestra, and his wife, Ida Agassiz Higginson. The next day, Belle and Jack attended a performance of the mystical *Parsifal*, which had premiered in 1882, a year before the composer's death in Venice. Belle had heard beautiful music in Paris and Venice, in New York and Boston. But Wagner's music—mythic, monumental—was utterly immersive, a strange, unsettling plunge toward the future. Wagner believed that he was the conduit of the German soul. For him music was a form of faith, an expression of the unconscious. He designed his theater to engulf listeners completely in titanic stories conveyed through sound, color, movement. Those who attended never forgot the intensity of the experience.

Jack escaped for a few days to nearby Munich, saying simply in a letter to his nephew Georgy that he'd had "nearly enough." Belle couldn't get enough though, returning for repeat performances of both *Tristan* and *Parsifal*.

Amalie Materna, the renowned Austrian soprano, was a primary singer that season. She and Belle had met before, most likely when Materna had been on tour in New York. In any case, it was Materna who broke the news to Belle that the Hungarian composer Franz Liszt had died suddenly in Bayreuth at the age of seventy-four. With Jack still in Munich, Belle accompanied the singer to the citywide funeral, where the two women sat next to Cosima Wagner, Liszt's daughter, who was also Wagner's widow. At the gravesite, Belle was one of the first to throw dirt onto the lowered coffin. Her wreath, with its banner "Hommage de L'Amerique," was placed next to the one sent by Queen Victoria. Belle received a lock of Liszt's hair, which she put in a silver box later included in her museum's first-floor gallery, the Yellow Room, which is devoted to music.

When Jack returned to Bayreuth from Munich, he was talked into attending the nearly four-hour-long *Tristan* again. It was Belle's third time. Before the performance, they stopped at Wagner's burial place, where she picked ivy leaves from vines covering the grave's enormous funeral stone. She pasted several of these into her travel album, next to pictures of the town and theater. She also collected photographs of the singers decked out in their operatic costumes, early celebrity shots for fans. In letters, Jack declared his wife "happy."

Venice was next. The Gardners didn't know when they might arrive because an outbreak of cholera was spreading there. So they meandered by train through the Alps, from Munich to Salzburg to Innsbruck and finally to Vienna, where they visited the graves of Schubert and Beethoven. They saw as many paintings as possible in the galleries of Munich and Vienna. Belle bought photographic reproductions of Dürer and Holbein, of Mantegna and Rubens. Even Jack thought Vienna "delightful," if too hot in early September.

Ten days later they finally arrived in Venice. They couldn't stay again at the Hotel de l'Europe because of several cases of cholera, so they engaged rooms at the Hotel Britannia. They met often with Daniel and Ariana Curtis and their son, Ralph, for walks and for dinners at the Palazzo Barbaro. The year before, the Curtises had purchased the top floors of the palace for a comparatively paltry sum. The Gardners, as they had during their previous stay in Venice, felt grateful for the generous hospitality of the Curtis family. Maybe this time especially, because during these same weeks, Jack was managing a crisis brewing back home.

The Gardner nephews Joe Jr. and Amory had traveled back to Boston several weeks before. Soon after their arrival, Jack wrote to their cousin, George's son Georgy, about a telegram that had arrived, telling of Joe's unhappy return and how he'd become "much depressed." This was alarming, and Jack offered to return immediately. Joe Jr. had had privileges—a Harvard education, a seemingly close relationship with his brothers and cousins and with Belle and Jack, a love of outdoor life and work. He bought for himself a relatively remote estate, Sagamore Farm, bordering the Miles River in Hamilton, twenty-five miles north of Boston. But he couldn't seem to find his footing. Rumors swirled that he'd fallen in love with a young man from England who'd been in his college class. There is no mention of this in Jack's letters; he uses phrases like "very bad times" and "great suffering." Back in Boston, his cousin Georgy arranged for a doctor to be with Joe full time. Jack advised Georgy to consult with Aunt Julia, who "would also give you excellent advice," and he hoped that "Joe would outgrow his troubles as I believe that is often the course in such cases." They would hope for the best, adding that he and Aunty Belle were next on their way to Florence.

Belle had not seen Dante's city since spending several months there as a girl, taking piano lessons and studying Italian. The weather was "very

fine," according to Jack, but they knew few people in a city dominated by British expats and tourists. On the morning of September 30, they went to the Uffizi Gallery, viewing its treasures of Renaissance painting and its famed sculpture gallery. Belle bought many reproductions of paintings, filling almost a hundred pages of her album with works by Cimabue, Titian, Leonardo da Vinci, Botticelli, and Raphael. She positioned each image on its own page to make a kind of two-dimensional gallery. She included two paintings by the sixteenth-century artist Bronzino. The first was a charming portrait of eighteen-month-old Giovanni de' Medici, wearing a bright red suit, smiling broadly, and holding a bird in his right hand. The second painting that caught Belle's eye showed Giovanni together with his mother, Eleonora de Toledo, the duchess of Florence. The evident affection between mother and son; the beauty of her pearls, looped twice around her neck, with a drop jewel on the first loop; and the golden chain belt around her waist combined in what many considered a masterpiece of sixteenth-century portraiture. The Gardners saw more art: Giotto at Santa Croce; del Sarto at Galleria Pitti; and the exquisite Fra Angelico frescoes decorating the convent

cells at San Marco. She kept careful track of names and titles and places, adding dates and an occasional quotation.

There was more to do. They traveled to nearby Fiesole, the medieval town perched high above the city. Belle also spent an afternoon with Violet Paget, who wrote under the nom de plume Vernon Lee, on a wide range of subjects, including Walter Pater and eighteenth-century Italian culture. They had been introduced earlier in the summer in London by Henry James, who found Lee "most astounding" for her intensity and penetrating intellect. Belle found Lee excellent company and invited her to join her to search for old books in the antiquaries and bookshops, a pursuit Lee later recalled fondly in a letter to Belle.

The Gardners stopped a few days in Milan and then made their way to Paris for fashion and another set of Boucheron pearls. Three days after they arrived at Hôtel du Rhine, they received a telegram with dreadful news: Joe Jr. had died by suicide. He had just turned twenty-five. "He was a dear noble-hearted fellow and everybody that knew him loved him," Jack wrote immediately to Georgy. They had worried it would come to this, even as they hoped Joe "might pull through his attack." Jack went on to say he felt confident of the course of action that had been taken, which had given Joe "the best chance of recovery." No matter. "His life has been for years one of suffering and misery and I think that if he had lived, it could never have been very different. I am very sorry that I could not have been at home to share your care and responsibility and to be with the boys in their trouble but I do not think that my presence or advice would have suggested any better (or different) course of treatment or led to any other result." If he sounded soothing, wanting to spare Georgy and Joe's brothers, Amory and young Gussie, a crushing sense of guilt, it is likely he also wanted to reassure himself. Jack knew well what it was to feel sickening remorse after his own brother Joe Gardner Sr. had died by suicide a decade before.

BELLE LEFT NO RECORD OF HOW SHE WRESTLED WITH HER GRIEF AND guilt over Joe Jr. She had taken her responsibilities toward the three Gardner brothers very seriously. No letters between Belle and Joe Jr. survive. Ralph Curtis, who had just seen the Gardners in Venice, wrote a condolence letter,

saying that his father, Daniel Curtis, had been "particularly charmed" by Joe. Another friend fondly remembered that Joe was the "wittiest man" of his generation. But for the most part, his was a silenced life.

At some later point, Isabella placed a small photograph of Joe as a young man between early photographs of her and Jack in a small box with a velvet backing, as a kind of relic or shrine. In the center, above all three, is an oval painted portrait of her blue-eyed Jackie, rimmed in gold. These were the two boys she and Jack lost. She'd not banished Joe Jr. from her memory. She placed the assemblage in a corner cabinet of the Little Salon of Fenway Court, the last gallery she would curate and furnish. They had been a family. She would remember.

Thirteen

LOVE AND POWER

1886–88

In the stunned weeks after the news of Joe Jr.'s death reached Belle and Jack in Paris, in October 1886, they must have debated whether to keep to their plans or immediately return home. Perhaps because Joe's death was not a complete surprise, they continued to London, where they spent two weeks, then left for home. They may also have been looking forward to meeting a young American portrait painter; they had heard remarkable reports about him. Jack made no mention of their deliberations in his diary. Instead, he wrote a simple factual entry for October 22: "left Paris; arrived in London, Albermarle Hotel."

Soon after, Belle received a friendly letter from John Singer Sargent. The artist, then just thirty, had moved to London from his Paris studio in the seventeenth arrondissement, partly on the advice of Henry James, who'd settled permanently in England a decade before. The younger man was in some ways James's double: both were hard workers and roaming Americans, with carefully concealed private lives. They even looked alike, each with a sturdy build and in those years sporting a fashionable beard, though Sargent kept his head of dark hair far longer than his friend did. James loved to talk, whereas Sargent was almost shy, his large, watery, all-seeing eyes the dominant feature of his handsome face. James once said that the well-mannered Sargent was "civilized to his fingertips." In an admiring 1887 essay in *Harper's*

Magazine, he summed up his view of the artist: "It is difficult to imagine a young painter less in the dark about his own ideal, more lucid and more responsible from the first about what he desires."

Sargent explained in a note to Belle that "Ralph Curtis and Henry James have both told me of your arrival [in London] and authorized me to call on you." James had also told the artist of his plans to go with Belle to the London Academy of Art and to Grosvenor Gallery, with a stop afterward at Sargent's studio. A visit "would be doing me a very great pleasure," Sargent assured her.

Several days later, the friends arrived at Tite Street in Chelsea. Sargent had taken the studio at number 31, once used by James Abbott McNeill Whistler, in the bohemian neighborhood. There, decades before, the great English artist J.M.W. Turner had had a studio overlooking the River Thames. The friends had come to see what Sargent was working on and also to admire his enormous and dramatic portrait of Madame Virginie Gautreau—renamed *Madame X*—which had caused a stir at the 1884 Paris Salon. The portrait's overt sensuality, its liberal show of alabaster skin, the languorous lines of neck and arms, the jet-black gown with its dropped right strap (which Sargent

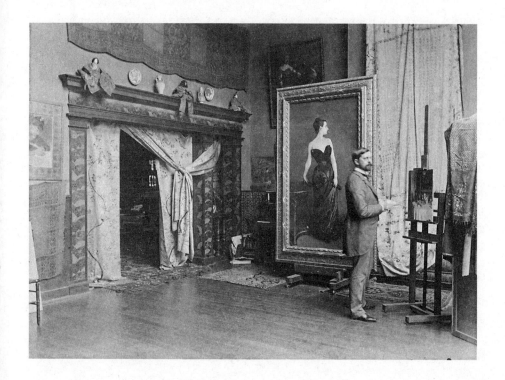

later repainted)—the "radical strangeness" of the painting had appalled the French. The portrait, measuring almost seven feet tall by four feet wide, was far too mannered, complained one critic; another thought it shallow and licentious. The fact that both artist and model were expatriate Americans in Parisian society had no doubt energized some of the hostile reviews. Henry James himself had confided in a letter to a friend that he "only half liked" the scandalous portrait after first seeing it in Paris, though he didn't specify why. The blasting criticism had disheartened Sargent so much that he said, at one point, he thought of leaving painting altogether. But instead of doing that, he moved to London.

No one chronicled what the three Americans talked about on that October day, while *Madame X* towered over them. Sargent must have shown his visitors around his studio to see other work. Maybe he talked with Belle about music—he was a gifted pianist and an avid Wagnerian. Regardless, this first meeting between painter and patron would prove auspicious for the fortunes of both.

⁓⋆⌇

The Gardners returned, exhausted, to New York on November 16. They spent Thanksgiving with Belle's father at his large home on Fifth Avenue. Jack's brother George, then staying in France, sympathized in a holiday greeting about the hazards of returning home after extended travel: "I am rejoiced to learn . . . that your Thanksgiving visit to New York did you much good, and that you and Isabella were getting over the upsetting effects of getting home from abroad. Terrible business I always find it." Touring was two-edged: an escape that also took a toll. And Belle had a lot to sort out—the loss of her mother, the death of Joe Jr., her own next steps, and the fact that in just a few months her father would marry Mary Hicks Peck, a wealthy widow only three years older than Belle. Complicating matters, Mary Hicks Peck was the daughter of Adelia Stewart's sister, Mary Ann Smith Hicks. So David Stewart was to marry Isabella's first cousin, his own niece by marriage. There is no record of Belle's relationship with her cousin before her father's remarriage, and there is no direct comment on this situation. But Belle never again stayed with her father when in New York. Shortly after his wedding, Mr. Stewart conveyed the title of the Beacon Street house directly to his daughter, protecting her inheritance from any future claims

by his new wife. Even so, Belle would have to share her father's attentions and, when the time came, his sizable estate.

Belle unpacked her traveling trunks. She touched the yards and yards of antique lace and beautiful old silk that she had bought in Venice and Florence. Her father's tenure in the linen trade likely had given her a familiarity with fabrics. She knew their delicacy and strength, how they transformed rooms and bodies.

Among the various treasures were two small pastels by James Whistler. Near the time she'd gone to Sargent's studio with Henry James to view *Madame X,* she'd also met with Whistler, who was a generation older than Sargent. She'd encountered him on previous visits to Paris and London. Whistler, born in Lowell, Massachusetts, had left for Paris at twenty-one and was settled in London by 1859. He never returned to America. In these years, he found himself at an unlikely pivot in an already lucrative career, having won a libel suit against the all-powerful British art critic John Ruskin, who'd called one of his paintings nothing more than a pot of paint thrown at a canvas. But hefty legal fees had bankrupted the artist, who had to sell almost everything he owned and start again.

Society portraiture provided a ready way to make money, and Belle was happy to pose for Whistler. Though in a "whirl of hurry," he assured her he'd be happy to dine together, adding in his scrawled note that "to paint the little picture will be a joy." These two shared a social flamboyance and a love of Venice, and he portrayed her in that city's sunny, glowing colors, calling the small-scale pastel on colored paper *A Little Note in Yellow and Gold*. He captured her straight-back posture, how light she was on her feet, her long arms and graceful neckline, though there was something a little coy or generic in her expression, something not quite Belle in the picture's sweetness. Whistler later acknowledged as much in a letter, saying he wished she'd been able to take home "a more brilliant proof" of his admiration.

Mrs. Jack paid £105 for the Whistler portrait and another £105 for his tiny oil of an English sweetshop, *The Study in Orange and Blue*. For another £63, she bought *The Violet Note,* also a pastel but a more sumptuous image of a young woman dressed in a diaphanous robe bending over an opened trunk, with clothes spilling over its rim. She would hang these, plus another of his pastels she'd buy much later, together in a row in the Veronese Room in Fenway Court.

If she appreciated the charm of Whistler's portrait—and it would be the

earliest image of her that she'd include in her museum—the small pastel had none of the daring of Sargent's large-scale *Madame X*. That painting held in balance a smoldering sensuality with a palpable command—*that* was what she wanted.

<hr />

THE GARDNERS REMAINED STATESIDE IN 1887, WITH SUCCESSIVE STAYS at their various homes: 152 Beacon Street, Green Hill, Beach Hill on the North Shore, and Roque Island. "We are enjoying the Island immensely," Jack wrote to Georgy, from Roque. Early in the year, they attended Maud Howe's wedding to John Elliott, the English-born artist who'd been pursuing Maud for almost a decade, at the Howes' Beacon Street home. Belle had arranged for bushels of hibiscus and laurel to be sent from her greenhouses at Green Hill to make a wedding bower for the couple. Jack reported that the bride "looked very handsome" but disapproved of her new husband because he had not enough money to compensate for his uncertain artistic talent. The Elliott marriage would eventually put a strain on Belle and Maud's friendship for reasons not entirely clear—maybe because of Jack's initial concern or because Maud, now a properly married woman, had grown weary of being Belle's confidante, a role she had served during the Crawford fiasco. Maud would later confide in her diary that she had found Belle "not easy—hardly possible—to work with." Whatever the causes, a rift developed in these years and their letters all but stopped for a time.

That spring, Belle received a small gift in the mail, the recent novel *A Week Away from Time* by her friend Annie Fields, the talented widow of James T. Fields, a founder of the *Atlantic Monthly* and the Boston publishing company Ticknor and Fields. Belle inscribed the inside cover of the book so she'd remember the date and its sender: "Bernhard Berenson I. S. Gardner May 31, 1887." She had met the young Harvard student, who would later spell his first name "Bernard," the year before, most likely when both attended Charles Eliot Norton's lectures on Dante. She'd been impressed and intrigued.

Berenson, the eldest child of a poor Jewish family then named Valvrojenski, was born in 1865 near the city of Vilna, Lithuania, in an area of the Russian Empire known as the Pale of Settlement. A decade later the family immigrated to America and eventually settled on Minot Street in Boston's West End. Berenson was a voracious reader and gifted conversationalist,

with an extraordinary memory. He attended college first at Boston University and then switched to Harvard College, where he excelled in ancient and modern languages, literature, and art history. As a top student in his cohort, he applied for the college's prestigious Parker Traveling Fellowship for a year's study of art in Europe. He didn't get the prize. One obstacle involved Charles Eliot Norton, who'd been Berenson's professor in several courses yet had withheld his recommendation, in effect sinking his best student's chances. Berenson never forgot the slight or a comment made by Norton at this time to another Harvard professor: "Berenson has more ambition than ability." This attitude toward Jews at Harvard was nothing new. Fewer than five thousand Jews lived in Protestant-dominated Boston when Berenson's family had immigrated, and the city's well-known chilliness to outsiders also expressed itself in a casual, thoroughgoing anti-Semitism.

In protest against this injustice, several of Berenson's other Harvard professors and the Gardners raised sufficient funds to restore the young man's opportunity to study overseas. So began the enduring friendship between Berenson and Mrs. Jack, during which Berenson would become a leading connoisseur and art dealer for wealthy Americans at the turn of the century, with Mrs. Jack his most important patron. Their lengthy back-and-forth would be marked by real sympathy and understanding but also evasions,

apologies, and rapprochements. Both finally recognized that neither could have achieved what they did without the other. Whereas Gardner's other friends obeyed her request to burn her letters, Berenson did not. She was too important to his story; their growing fame was mutually dependent. She would keep all his letters as well and later neatly stack them in a display case at Fenway Court, his youthful picture clearly visible on the lower left.

But all of that would come later. For now, the gift of Annie Fields's novel was a young man's thank-you.

BY LATE FALL, JOHN SINGER SARGENT HAD ARRIVED IN BOSTON FROM London. His star was on the rise again. The debacle with *Madame X* had been a real setback for him, but his move to London had proved to be right: commissions came in one after the other, and the furor had done nothing to dampen Americans' interest in him. Women from elite international circles clamored for a portrait, eager for his attentions on canvas.

Belle was one of the first in Boston to secure sittings with Sargent. They began during Christmas week, 1887. Whistler's portrait had been graceful but very small, more like a sketch. She wanted something big and dramatic, qualities that were Sargent's forte. He stayed with the Gardners over the course of his commission. The arrangement stirred the Boston papers to speculate about the exact nature of his relationship with "the festive Mrs. Jack," as *Town Topics* characterized her that season.

A scene recorded by Ellery Sedgwick gives the sense that the relationship was indeed quite festive. At some point during these months, Sargent and Mrs. Jack went together to Groton School, where her nephew Amory Gardner gave his classics students "the sense of living in an immaterial world," according to Sedgwick, one of his students. Early one Sunday morning, Sedgwick escaped to the school gymnasium to bury himself in a new novel, *Ben Hur*, when "suddenly the gymnasium door was thrown wildly open and a woman's voice thrilled me with a little scream of mockery and triumph." From his hiding place, Sedgwick "caught sight of a woman with a figure of a girl, her modish muslin skirt fluttering behind her as she danced through the open doorway and flew across the floor, tossing over her shoulder some taunting paean of escape. But bare escape it seemed, for not a dozen feet behind her came her cavalier, white-flannelled, black-bearded, panting with

laughter and pace. The pursuer was much younger than the pursued but that did not affect the ardor of the chase. The lady raced to the stairway leading to the running track above. Up she rushed, he after her. She reached the track and dashed round it, the ribbons of her belt standing straight out behind her. Her pursuer was visibly gaining. The gap narrowed. Nearer, nearer he drew, both hands outstretched to reach her waist."

Pausing, Sedgwick writes: "'She's winning,' I thought. 'No, she's losing.'" Sedgwick doesn't say more, except that he'd gotten the "sickening sense that this show was not meant for spectators" and that he'd been "eavesdropping." Belle had chased Sargent for a sitting; now, in this heated scene, she makes him run after her. It was at the least a chance for her to move fast, something she'd always loved to do.

Sargent and Mrs. Jack worked together in a room on the north-facing side of 152 Beacon Street, overlooking the Charles River, to catch the most even light from morning to afternoon. While posing day after day, she sometimes got fidgety and forgot to stand still or looked out the window to the river below. Edward "Ned" Darley Boit, a Boston lawyer, stopped in at the Gardners' to see the work in progress. He knew the painter well and was himself a gifted watercolorist. The Boits' four young daughters had posed for Sargent in 1883, in the family's cavernous Paris apartment, for what would become one of Sargent's most celebrated works, *The Daughters of Edward Darley Boit*. The mother of the girls, Isa Boit, had had her own portrait done by Sargent earlier in November, when the artist stayed with them at their Back Bay home. Ned Boit didn't make a comment about what he thought of Mrs. Jack's portrait, but he was curious enough to stop by 152 Beacon again when it was finally finished, in mid-January.

THE TALL AND NARROW OIL PAINTING, MEASURING MORE THAN SIX FEET by two and a half feet, shows Belle squarely confronting the viewer. She wears a tightly fitted black dress, with a V-neckline and short sleeves. Behind her, a tapestry woven in red and gold forms a kind of halo around her head. Sargent had placed a swath of late-fifteenth-century Venetian velvet and brocade fabric behind Isabella, enlarging the scale of its intricate design several times in the painting itself. (It was a piece of fabric she had most likely bought in Venice; it now hangs in the museum's Long Gallery.) The

red-and-gold swirling pattern is the only background, so her figure is close against the surface of the image, flattened in perspective like a medieval religious icon. This has the paradoxical effect of bringing her very near and keeping her at something of an emotional remove.

Her eyes look directly at the viewer, as if with expectation. Her hair is sandy red, complimenting a complexion a friend would characterize as "translucent alabaster." Her bare arms are held in suspension, as if they could be cradling something, though they are empty. To accentuate her figure, Sargent tied a black shawl snug around her hips to bring her black velvet dress even closer to her body. Shimmering beneath her gown's hemline, a single ruby is attached to the buckle of each gold-colored shoe.

But the pearls are what attracts the eye. Circling once around her neck and twice around her impossibly small waist are ropes of sumptuous pearls, punctuated by drop rubies. Gifts from Jack, they telegraph his love and echo the swirling pattern of the brocade. It wasn't current Paris fashion to wear such precious jewels around the waist. Pearls, the most expensive of all gems because of the exorbitant cost of their harvest, were easy to nick and damage. But this adornment referenced not the present but the past: the royal portraits of earlier times. Two years before, Belle had seen for herself the Bronzino portrait of a Medici duchess with jewels draped around her neck and waist in just this way. The way Belle wore them claimed a worldly, cultural power, not the political power—equality under the law, the vote—talked about in Boston's more progressive circles. The pearls' placement also echoes and repeats the swirling pattern of the brocade, which invests the image with enormous energy. Sargent captured in a static medium, paint on canvas, something long noticed about Belle: the beauty of her gestures, the sense that even when still and composed, she radiated energy, the feeling that she would soon be *on the move*.

Newspaper reports had long characterized Mrs. Jack as plain or no real beauty. Sargent himself would rather cruelly comment to a friend that her face looked like "a lemon with a slit for a mouth," and he'd had trouble capturing the expression on her face, revising it again and again over the course of several weeks. Her mouth, slightly open, is somewhat awkward, as was the case in real life—she may have held her mouth in such a way to hide protruding or crooked teeth or an unattractive smile. None of that mattered now. She was

overjoyed with Sargent's work, later telling people that the portrait "had been done over eight times," until the ninth, Dante's mystical number, proved a miraculous success. She declared it Sargent's very best painting and wanted him to concur. He wisely demurred: no portraitist would ever choose a favorite.

With its paint barely dry, the portrait—originally titled *Woman, An Enigma*—appeared in public in a show of Sargent's work that opened on January 30, 1888, at the St. Botolph Club at 4 Newbury Street, directly across from Boston's Public Garden. Twenty-two works of the young virtuoso's paintings were displayed. One newspaper reported that fifteen hundred people attended the gallery show; another claimed that five thousand had; later estimates said that ten thousand people had seen the exhibition. The paintings included *El Jaleo*, celebrated when first shown at the Paris Salon in 1882. The club member Thomas Jefferson Coolidge, brother-in-law of Julia Gardner Coolidge, had bought it. That monumental painting measures seven feet high and eleven feet wide. Its vibrant dancer is caught mid-swirl at the canvas's center, with musicians gathered along the perimeter, playing instruments or singing at the top of their lungs, with everyone tapping their feet. Its composition and scale invite the viewer into the lively scene.

The show also included the picture of the Boit daughters and *Lady with the Rose,* an 1882 portrait of Charlotte Louise Burckhardt. Henry James praised this painting in particular. Like the Boit portrait, it offered a "slightly 'uncanny' spectacle of a talent which on the very threshold of its career has nothing more to learn . . . it is the freshness of youth combined with the artistic experience, really felt and assimilated, of generations." Translated: Sargent had proved himself, in James's estimation, an American master.

Reaction to the portrait of Belle was more complicated. Mrs. Frances Lang, wife of the esteemed conductor B. J. Lang, who lived on Brimmer Street, wrote a breathless note to Belle soon after the opening: "You must let me tell you this moment while the 'glow' is upon me, that I never saw anything so daring, so splendid, so really great as your portrait. It is first great as a likeness, after that it is everything enthralling." Whereas Mrs. Lang may have spoken for Belle's friends, there was a predictable uproar in the papers. One said with a sniff that her dress's neckline was "cut very low," while another implied that proper Boston couldn't possibly understand this sort of portrait. The community required "more dignity in dress and pose

of subject," the writer stated. Sargent worried. He sent a note to Mrs. Jack in early February from his hotel in Boston: "The newspapers do not disturb me. I have only seen one or two at any rate." But he added: "Do you bear up?" Susan Hale, in her Chit Chat column in the *Boston Sunday Globe*, was relieved when the exhibition closed in mid-February, explaining it was time to "gain pause from the volume of comment generally, made up of distraction and ridicule poured out . . . upon the subjects of the portraits."

Worse than the commentary in the papers, however, were murmurings heard in men's clubs and around town, which infuriated Jack Gardner. One remark implied that the V-neckline of Belle's dress pointed all the way down to "Crawford's Notch." Crawford's Notch is a well-known mountain pass in New Hampshire, but the line was a crude allusion to Belle's rumored indiscretions with Frank Crawford. Jack paid Sargent $3,000 for the portrait. He recognized its value and displayed it in his study, but he hated the humiliating gossip. He would tell his wife at one point: "It looks like hell but looks like you." He also asked her not to show the portrait ever again, at least while he was alive.

Isabella Stewart Gardner had wanted Sargent to paint her portrait, particularly after seeing his daring and sensuous *Madame X* a little more than a year earlier. Daring was what she sought, wanting to go right up to the edge of Boston's tolerance. This dazzling image was to serve as her calling card and announcement, declaring: Here I am, independent, strong, commanding. Her disappointment at not being able to display it must have been profound. But if she had underestimated Jack's sensitivity to her relationship with Crawford, it was a measure of her respect for him that she complied with his request and left no record of complaint. When she finished Fenway Court in 1903, she placed the iconic portrait out of public view in the third-floor Gothic Room, a gallery she kept as a private space until her death.

Now the Gothic Room is the culmination of the museum, the last room visitors enter, imposing and beautiful, with Isabella's portrait at the far corner, as if surveying all she sees.

Six months later, Isabella posed for another portrait, this one by the London photographer John Thompson. The image shows a shapely woman dressed in watered black silk. She has the posture of a dancer, a fashionable bustle, and a high neckline. She stands at an angle to the camera, and the line formed by the front of her body is parallel to the angular line of tall trees

on the painted backdrop in the photographer's studio. Once again, her eyes look directly at the viewer, shadowed just a bit by a black hat with generous plumage on its front brim. She holds her gloved hands together, intertwining her fingers, so her long arms again form a graceful circle, as in the Sargent portrait. She had turned forty-eight four months before. The platinum print measures the arc of her last decades, from a fragile, grieving mother who had to be carried on a cot to a waiting ship almost twenty-five years before to a grown woman near the start of another kind of life. Her posture is confident, at ease, unapologetic. She's already seen and learned much. She is ready to do more. Below the image, she inscribed her name and the date in her looping script, using only her first name, like a queen—"Isabella 1888."

Fourteen

SEEING WONDER

1888–89

Soon after the Sargent show closed at the St. Botolph Club in mid-February 1888, the Gardners did what they always did after tumult—they packed up for an overseas trip, this time to Spain. John Singer Sargent, who had found early inspiration in the work of Diego Velázquez, the country's most celebrated painter, likely talked with Isabella about the seventeenth-century master. Henry James had said this of Velázquez, a strong echo to his description of Sargent's prodigious talent: "it was impossible to imagine a greater *maestría* of the brush, or a better example of the way in which a genius of the caliber of Velázquez has all his powers in hand at any moment, and never needs to step backward to take his jump." Isabella no doubt wanted to see this for herself.

The Gardners sailed for Europe early in March, and after a few days in Paris, they traveled by train to the town of Burgos in northern Spain. They stayed long enough to take in Burgos's immense thirteenth-century gothic cathedral, built into the side of a hill and decorated with bas-reliefs, friezes, and sculptures so intricate, they seemed at a distance like embroidery in stone. Henry James sent his greetings upon hearing they had arrived in Europe: "What a wonderful Mrs. Jack-in-the-Box you are," joking that she'd developed a habit of "popping up with all sorts of graceful effects and

surprises, purely your own, in the most unexpected parts of the universe." He added one of his flatteries: "I envy you Spain—and envy Spain you." On March 19, Isabella made note of the departure by overnight train from Burgos south to Madrid, with its azure skies and celebrated art collection at the Prado Museum. The Gardners would circle back to Madrid several times during the three-month sojourn through Spain, where she would return to the Prado to do what she loved most—look at art.

They hadn't traveled before to Spain, which after the American Civil War was increasingly popular on the grand tour itinerary, after the usual destinations in England, France, and Italy. Washington Irving fifty years before had described the "rugged mountains and long sweeping plains" of the Iberian Peninsula as "melancholy." Isabella owned a copy of Cervantes's *Don Quixote* as well as Washington Irving's romanticized *Tales of the Alhambra* and a portion of the manuscript of his "Conquest of Grenada." The Gardners took along Jack's copy of the 1882 edition of Richard Ford's famed two-volume *Handbook for Travellers in Spain,* one of the first guides in English when it was published in 1845. Ford provided detailed information on all aspects of Spain—its geography, maps of various cities and many cathedrals, recommendations for travel arrangements, a royal history, and a review of the country's politics. By the 1880s, Spain was ruled by a constitutional monarchy.

Ford also gave readers his learned and lively opinions, especially on architecture and art. The Prado, a "not quite successful building," suffered from dust and poor light in its galleries, which made the paintings hard to see on dim, cloudy days. It was packed to the brim, however, with treasures, which Ford meticulously described. Works by Italian and Flemish masters, including Raphael, Titian, Tintoretto, Veronese, Rubens, and van Dyck, could be found in its rooms. Formed in the sixteenth and seventeenth centuries, the period spanning the Spanish Empire's worldwide expansion and steep decline, the collection was begun by Charles V, continued by his son Philip II, and vastly expanded by Philip IV, whose patronage of all the arts gave rise to Spain's Golden Age.

Isabella stood before graceful Madonnas by Murillo, mysterious religious images by Zurbarán, and strikingly naturalistic portraits by Zurbarán's teacher, Jusepe de Ribera. She pasted photographs of all of these artists' works in her travel albums, careful not to let the extra-thin photographic paper warp or cockle. The paintings that most crowded her albums' pages, however,

were by Diego Velázquez, court painter to Philip IV. Born in Seville in 1599, he was apprenticed at the age of eleven to the painter and theorist Francisco Pacheco and accepted into the painters' guild as a master at seventeen. He was twenty-four when he was summoned to court and painted the portrait of the seventeen-year-old king; within months Philip made him his royal painter. Ford described him as "the greatest painter that Spain has produced," explaining that "his freedom of touch and power of producing truthful effect by the simplest means are truly wonderful."

The National Gallery in London had purchased in 1882 one of his stunning life-size portraits of his patron, known as *Philip IV in Brown and Silver* for the king's richly embroidered costume. Isabella likely saw this painting on her visit to the National Gallery in 1886 with Henry James. Sargent too probably told her about a pivotal season in Spain in 1879, when he liked to go to the Prado and fill his sketchbooks with copies of Velázquez paintings to absorb everything that made the old master great: his handling of figures in space, the ease and economy of his brushstrokes, his acute realism and humanity. Sargent may have relayed to Isabella a specific anecdote about his first teacher in Paris, Carolus-Duran, who told his students he had three things to teach them about painting: "Velázquez, Velázquez, Velázquez."

The Prado had more of the celebrated painter's oeuvre than any other single museum—62 of the 120 or so known works by him, according to Ford. (These numbers change from time to time because the painter rarely signed his pictures, making attribution especially complicated.) Now Isabella finally saw for herself the Velázquez paintings in the museum's galleries dedicated to the Spanish School. If the photographs in her travel albums compose a record of what she saw in person, which is likely the case, it is possible to imagine her looking at the painting of the king's second wife, *Mariana de Austria,* with the teenage queen's expansive dress embellished by elaborate silver embroidery conveyed in loose, unhurried brushstrokes. She saw too his *Aesop,* a homely old man with weary eyes, full of the world's sorrows, holding his *Fables* and standing in worn-out shoes.

In a portrait, the subject, long dead, seemed palpably present in the room. Velázquez had the uncanny power to make it seem as if the person pictured was looking right back at the viewer. Up close, the brushwork was visible, but a step or two back from the canvas, the paint dissolved into something startling—a lace-trimmed garment, velvet, hair, hand, face became the

presence of a person alive. When Isabella stood in front of such a painting and really looked, the past rushed forward into her present. Morris Carter put it this way in the notes he took for his biography: "Her quick eyesight and quicker insight enabled her to perceive instantaneously the qualities of a work of art. She knew what she saw, her judgement was immediate and she trusted it." In the burgeoning field of art history, eager to establish its bona fides as a rigorous discipline, close observation and historical accuracy were prized. Emotion was somewhat beside the point. For Isabella, emotion was the lodestar.

She likely stood a long time in front of Velázquez's *Las Meninas*, the life-size masterwork depicting the daughter and members of the court of Philip IV. At the center of the almost square painting stands the Infanta Margarita, with the king and queen reflected in the mirror behind her. Arrayed about the princess are an obedient dog as well as her attentive maids-in-waiting, including the queen's German dwarf, Maria Barbola, and Nicolas Pertusato near the painting's lower right corner. On the left, the painter gazes at the viewer from behind an enormous canvas, its rough backing and wooden framing clearly visible. The artist is at work making a portrait of the king and queen, while the viewer witnesses the scene from the opposite end of the room: it's like being there with Velázquez. The scene is so realistic one can almost feel the air moving. Even so, what it all might mean is ambiguous. The critic Laura Cumming aptly writes that "this painting accepts as many interpretations as there are viewers, and part of its grace lies in allowing all these different responses to coexist, no matter how contradictory, by being such a precise vision of reality and yet so open a mystery."

Isabella did not specify what she made of the painting. She would, however, one day build a museum full of mystery, with no wall labels and no explicit instructions as to how to think about what was exhibited, much as Velázquez had done in paint. For the moment, she included a photograph of his *Las Meninas* in her travel album, likely recognizing how much the "strong tincture of the Velázquez style" had influenced her friend John Singer Sargent in all of his work, but particularly in his haunting group portrait of the Boit daughters.

Nor did Isabella leave a record of what she thought of Velázquez's *Fable of Arachne*, also known as *The Spinners*. She would have read Ford's characterization of it in his guidebook as "one of his most wonderful works," marveling

at how the "effects of light and shade" were "produced by such simple and masterly means." At first look, it is a genre scene depicting a tapestry factory at court. Women are hard at work, pulling thread and carding wool, with the wheel at the lower left in full spin. As was typical of Velázquez, there is a mythological underpinning to the work, in this instance the competition between the goddess Pallas Athena and the mortal Arachne, a supremely gifted weaver. Athena, recognizable by her helmet and the owl in flight above her, faces Arachne in front of the finished tapestry. For this excellent work, the jealous goddess will turn her into a spider. The tapestry reproduces a famed Titian painting, then a part of the royal collection in Madrid: *The Rape of Europa*. This was Velázquez's way of paying homage to the great Italian, whose work had influenced him. Isabella could not know then that she would one day buy that very canvas by Titian. When she viewed this painting at the Prado in 1888, she was, in effect, getting a small glimpse of her own future.

"I write you from Seville," Ralph Curtis—who usually occupied his family's Palazzo Barbaro—announced to Isabella earlier in the year, enumerating his pleasure in its "cloudless, warm delicate sky, flowers, guitars, mantillas, toreros, gitanos, manolas, [and] flamencos." The city of Velázquez's birth in the south of Spain was the Gardners' next stop after Madrid. Thirty-four-year-old Ralph, already establishing himself as a painter of some skill, met the couple at the city's train station when they arrived on March 24, just as Holy Week began.

There was so much to see and enjoy. They watched flamenco dancers performing various styles of tango, malagueña, and jaleo. Elaborate religious processions poured through the streets of the city, with officiants raising an enormous crucifix high above the jostling crowds. Jack Gardner wrote to his nephew that Seville was the "most delightful place we have yet seen in Spain." Isabella agreed. On the opening page of her second album of the trip, she copied out in Spanish Lord Byron's remark: "One who has not seen Seville has not seen wonder."

Jack admitted, though, he'd had "enough of bullfights." On April 1, Easter Sunday, they sat in the crowded stands of the enormous Plaza de Toros for the most important fight of the season. Luis Mazzantini, a celebrated

matador of the day, killed a bull in Isabella's honor. While the spectacle was "tremendous," she couldn't quite "ignore the awful cruelty." This was far more violent than sumo wrestling or the football games Isabella would attend at Harvard College, but the contest was, in another way, not that different—a high-stakes display of male cunning and athleticism played out on an enormous stage, with all of its attendant drama. As she'd done with her favorite Wagnerian opera singers, she collected glamorous photographs of handsome bullfighters, celebrities and performers in their own right.

"Here one feels existence," Isabella exclaimed in her travel album, a heightened sentiment on full display in a photograph of a party at the fairgrounds, famous for horse racing. She hired a tent and invited locals to join her and Jack for a celebratory lunch on April 19. She didn't identify the guests seated at the table, though Jack, with his bald head and walrus mustache, can be spotted seated at the back, and standing tall to the right, Ralph Curtis, with his fair hair and mustache. Isabella, seated front and to the right, in her black costume and lacy mantilla, lifts a drink, a small smile just visible on her relaxed face. She fits right in.

The next day Ralph Curtis gave her a mysterious sketch he'd made of her as a señorita, with hooded eyes, jet-black hair, and a swashbuckling dagger piercing her enormous heart.

From Seville, the Gardners traveled to Cádiz, Gibraltar, and Malaga, then back again to Seville to stay another two weeks. On their last day, Isabella purchased her first old master painting, *Virgin of Mercy*, from the art dealer Jacopo Lopez Cepero, who sold it as a Zurbarán. She paid 2,250 pesetas (almost $4,000). "Your Aunt bought an old picture in Seville, of no great value, but which she liked," Jack wrote to his nephew Georgy. He was right about the painting's value. It would turn out to be from the busy workshop of Zurbarán, not by the old master's hand. The Madonna gently holds the happy Christ child, cradling his tiny right foot in her left hand. His cheeks are blazing red and his hair a pale tuft atop a darling round face. No wonder Isabella liked it, an almost spectral reminder of the photograph of her holding Jackie twenty-five years before.

Many other purchases from the trip, some more costly than the painting, were carefully packed into the Gardners' numerous traveling trunks: quantities of old silk and lace, thirty-three meters of red damask fabric, a velvet cloak, and untold handheld fans, among other things. No matter. This Madonna and child, *The Virgin of Mercy*, would always hang in Isabella's

boudoir at 152 Beacon Street, as if it had power enough to weave together a memory of her motherhood with religious belief and love of art. Much later, she would rehang the painting in Fenway Court in a small, quiet room with iron gates in the northeast corner of its first floor, which she called the Spanish Chapel. She placed an altar table draped in yellow fringed fabric directly below the painting, along with six candleholders on either side of a small iron cross hung with a diminutive Christ. A tomb figure of a Spanish knight, made of alabaster, rests on the floor nearby. Across from the painting and above the doorway on the inside wall, safely out of view, is the inscription: "In Memoriam." The tableau memorializes all that can be—will be—lost in death. It is also one of the few direct references to her son Jackie and her loss of him in the entire museum.

After Seville, the Gardners went by train three hours west to Granada. There, on the crest of a high, craggy hill, stood one of the glories of Spain, the Alhambra, a Moorish citadel and palace built chiefly in the thirteenth and fourteenth centuries. Isabella cited in her album a saying inscribed in one of its chambers, which Ford translated in his guidebook. It expressed her own sense of anticipation and pleasure: "What is most to be wondered at is the felicity which awaits in this delightful spot." Ford explained too the element of surprise for visitors to the site: "The severe, simple, almost forbidding exterior of the Alhambra, gives no promise of the Aladdin gorgeousness which once shone within, when the opening of a single door admitted the stranger in an almost paradise." Together, she and Jack took their time, almost two full weeks, discovering the many layers of history embedded in the Alhambra's myriad rooms and arches, colonnades, tiled floors, fountains, and baths.

Jack thought that the complex wasn't as impressive as those they'd seen at Nikko in Japan or the seventeenth-century Agra Fort in India, but Isabella couldn't get enough, spending all day exploring and then filling her album, page after page, with depictions of its intricate grandeur. The Qur'an forbids the representation of animals, so stylized depictions of flowers and trees, along with lines from the holy book inscribed in gold, were shaped into elaborate designs. The motto of the Arab leader who built the Alhambra was simple enough: "And there is no conqueror but God." In the warm Andalusian evenings, Isabella and Jack promenaded under a clear sky and the bright moon, which lit up the enormous citadel. Its marble surfaces glowed like

something out of an ancient Arabian tale. "Your energetic Aunt has strolled me *out* after dinner to enjoy the views," Jack observed drolly to his nephew.

After the Gardners returned to Madrid and made another series of day trips to nearby locations, Jack wrote again to Georgy, all but sighing: "travelling and sightseeing pretty hard." To his brother George a few weeks later, from Nîmes, on the way through southern France to Venice, where they planned to settle for a month at the Hotel de l'Europe on the Grand Canal, Jack wrote: "At last we have done Spain or at least we have done with Spain for the present—Isabella is full of regrets and thinks we have left much unseen—we have been to Burgos, Madrid, Seville, Granada, Cadiz, Gibraltar, Malaga, El Escorial, Toledo, Leon, Segovia, La Granja, Cordova and Barcelona."

In Venice, they shopped, rode through the city in gondolas, attended concerts, and shopped some more. They often joined the Curtis family, who lived steps away from their hotel at the Palazzo Barbaro, for teas and evening soirees, where they hobnobbed with a roster of visiting Americans, European princesses, artists, musicians, poets, writers, and hangers-on.

Time spent in the glorious embrace of the Barbaro gave Isabella ideas. She craved a Barbaro of her own. Jack said as much in a letter to his nephew, noting that while the squares and canals were virtually empty of tourists because the "season is over," there was nothing "over" about his wife's "desire to buy a palace." No luck. She had to content herself with purchasing other things, which Jack carefully listed at the back of his diary, each with its price. Sometimes something escaped her grasp. She had debated buying an ancient bas-relief of unknown description at one of the antiquities shops that lined the canals, but passed on it. Professor Louis Dyer, at one point a classicist at Harvard, wrote to tell her that the Louvre purchased it soon after. This, to him, demonstrated her acumen. Though she had missed her chance with this piece, he said she could "trust your eye to pick out a good thing and leave a bad one, and [the Louvre acquisition] proves that you do not need to lean upon the advice of other people in the purchase of antiquities."

A few years later, in 1893, when the Gardners were staying again in Venice, Isabella bought from a local antiquities dealer, Antonio Carrer, a large stone fireplace for 1,300 lire. This time she trusted her eye. Not much is known about the fireplace, except that the original pieces, including its apron, were made in the fifteenth century, most likely in northern Italy. Its

gracefully scalloped hood, with relief carvings of garlands and vines, appealed to her. The Latin inscription at the center of its apron read "*Motu et Lumine*." How apt. The motto from the Venetian fireplace looked simultaneously to her past *and* her future—and to her aim to live "with motion and light."

Sexism would later make it convenient to set Isabella aside from the achievement of her own collection. She had not been formally trained. Some people thought she was all instinct and drive and avarice. Wasn't her accomplishment at Fenway Court dependent on the men around her? She suspected this would happen, so she made sure the name would change from Fenway Court to the Isabella Stewart Gardner Museum on the occasion of her death. That way no one would forget. During many years and many travels, she'd been gathering force, refining her taste, meticulously documenting what she had seen, teaching herself about paintings and artists, and absorbing the wonders everywhere she went.

PART IV
FANCY THINGS AND ORDINARY OBJECTS

Come out—all of you. This is too beautiful to miss.
—ISABELLA STEWART GARDNER, 1894

Fifteen

"DAZZLING"

1889

"Tonight is *the* night! The Fancy Ball night!" exclaimed Ellen Wayles Coolidge, teenage niece to Jack's sister Julia Gardner Coolidge, in a letter dated April 26, 1889. Boston society had been agog for months about the upcoming ball. Also called the Artists' Festival, it was being sponsored by the Art Students' Association (now called the Copley Society of Art) and hosted by Boston's Museum of Fine Arts, then located in the highly decorated Gothic revival building on the rim of Copley Square. The "social atmosphere" had been "full of a delightful mystery," reported the *Saturday Evening Gazette,* because "Bohemia and Back Bay were to meet on common ground" for one spectacular evening of dress-up. Varying parts of Boston society—from the arts and from business and patrons such as Isabella—intermingled for the good cause of raising funds for the association. A neighbor described in great detail all the different costumes she anticipated seeing that night: a Pyrenees peasant, a Joan of Arc, a Portia from Shakespeare. She shared that Mrs. Gardner had encouraged a Miss Cabot to dress as "La Primavera by Botticelli" and gushed: "I imagine Mrs. Brimmer and Mrs. Gardner as too dazzling to behold."

Festivals like this one were popular in Europe, with townspeople donning historical costumes to bring beloved paintings to life in day-long pa-

rades through city streets. The evening at the Museum of Fine Arts had taken months to plan. Outfits had to be submitted for review to a committee of artists to check for historical accuracy. Wearing Grandmother's embroidered shawl would not do. Ten members of the Boston Symphony Orchestra were hired to play the evening's music, from *Hungarian Dances* by Brahms and the overture to *The Merry Wives of Windsor* by Otto Nicolai to *Spanish Dances* by Moszkowski. The musicians were to stay hidden from view, so music would seem to float spontaneously through rooms hung with "fine, old tapestries."

When the night came, gale-force winds and lashing rain delayed the 8 p.m. start time, as attendees struggled to disembark from shiny black carriages lined up like a brigade on either side of the street. An elaborate arch of laurel spanned the museum's main staircase. Entryways were filled with towering palm trees. Pages dressed in Elizabethan costume stood at attention in the doorways.

Inside the main gallery, fourteen patronesses wearing gowns in the style of sixteenth-century Venice sat arrayed on an elevated dais—like "a living picture" by Paolo Veronese, according to one attendee. Isabella was among them, along with her friend the artist Sarah Wyman Whitman; Octavie Apthorp, who with her husband, William Foster Apthorp, hosted Sunday evening musical soirees at their Louisburg Square home; Frances Lang, wife of the pianist and conductor B. J. Lang; and the imperious Marianna Brimmer, who together with her husband, the long-time president of the Museum of Fine Arts, Martin Brimmer, were hosts of the evening and arbiters of much of Boston's high society.

The women watched as costumed partygoers—the event drew almost eight hundred people—paraded past the dais, some in groups enacting historical paintings, such as Rembrandt's *Night Watch*. Forty Grecian maidens strolled by, and a group of young girls outfitted as Fra Angelico angels struggled with cumbersome wings made of wire and gauze. The young painter Dennis Bunker attended as a lute-carrying troubadour, while Clayton Johns came as Robin Hood, with his Merry Men. The Apollo Club sent a troupe of Pilgrims, who sang old songs. The *Boston Daily Globe,* in a next-day review titled "Fairyland," reported on "the huge amounts of creams, ices, cake, lemonade, etc." consumed throughout the evening, which ended promptly at midnight, as noted by the *New York Times,* with a bit of a sniff at the city's puritanical ways.

"DAZZLING," 1889

Isabella loved such occasions, reminiscent of the costume parties she'd attended as a young student in Paris, with her hair piled high like Marie Antoinette's. The evening had everything she enjoyed: art and music, fashion and performance. It also inspired her fiery competitiveness. She made suggestions to other attendees on what to wear and helped supply costumes. She liked getting noticed and liked even better to be the best. She'd made sure to get her V-necked gown in a shiny salmon-colored silk sewn especially for her when she was last in Venice. There'd been gossip that neither she nor Mrs. Brimmer had jewels enough for the occasion and so were borrowing from among their friends, but this wasn't true. Isabella pinned sparkling diamonds atop her upswept hair and wore her signature pearls with one loop close around her neck and a second hanging low in front. This had the intentional effect of reminding everyone of Sargent's portrait of her, from the previous year, with her pearls worn in exactly the same way.

In a group photograph of partygoers, Isabella stands in the back row, third from the left, a little awkward on her feet, her long arms held at an angle as if she were about to join her hands in her characteristic pose. In the lower right of the photograph sits a young Amy Heard Gray, with her stark

white hairdo matching her glimmering French gown. Next to Mrs. Gray is Jack Gardner, dashing in his dark velvet robe as Shakespeare's Antonio from *The Merchant of Venice*. He sits in profile, facing Mrs. Brimmer, whose ravishing costume of yellow and white satin brocades won praise in the papers.

Henry Adams didn't attend the event but passed on gossip that the evening's most "successful beauty" had been "Jeff Coolidge," meaning Thomas Jefferson Coolidge, Julia Gardner Coolidge's art-loving brother-in-law, then president of the Santa Fe Railway. He stands at Isabella's left, above Mrs. Brimmer in the front row, dressed in women's fashion of the eighteenth century. He wore a tightly curled wig—he was mostly bald—and his high-necked gown revealed his beefy forearms. Hasty Pudding Club theatricals at Harvard College had long featured cross-dressing; photographs of men dressed in women's clothing were a frequent feature of student albums.

Everyone was crossing eras, pretending to be someone else from another time—"our historical other selves," as the *Saturday Evening Gazette* put it. Young America loved to dress up as Old Europe. The Artists' Festival would win the prize for most lavish evening of its kind that social season.

༺⁂༻

Six months before, in September 1888, the Gardners had returned to Boston after three months in Spain and another month in Venice. After Venice, they had stayed a week at Bayreuth for more performances of Wagner's operas. In London, they joined Whistler for one of his famous Sunday breakfasts, where the artist served the guests himself while regaling them with story after story. In Paris, they went again to Boucheron to purchase another string of pearls, and then to Worth's atelier for more gowns.

The Gardners' homecoming had differed in tone and mood from previous years—for the first time in a long while they were not in mourning. That November Isabella hosted a large concert in her music room at 152 Beacon Street, directed by Wilhelm Gericke, the Austrian conductor just finishing his first stint as maestro of the Boston Symphony Orchestra. Gericke, tall and dark-haired and urbane, combined gracious Austrian manners with a commanding beat at the symphony podium—music-going Boston had concurred he had elevated the musical program of the orchestra since Higginson had hired him away from the Vienna Opera in 1884. Isabella greatly admired Gericke; the two became friends. He had taken the Gard-

ners to Wagner's house in Bayreuth earlier that year, after an evening's opera performance. Clayton Johns, the young Boston composer-pianist, had been there too and would recall how the soprano Madame Materna sang from *Götterdämmerung* until the wee hours of the morning. Now the program at Isabella's Beacon Street concert listed Wagner, but also pieces by Mozart, Bach, Berlioz, and Schubert.

More musical evenings followed. In February 1889, a few months before the Artists' Festival, Isabella hosted an evening occasion with the Manuscript Club, a musical group she'd started the year before to give a hearing to young American composers such as Clara Kathleen Rogers, Arthur Foote, and Owen Wister, later famous as the author of *The Virginian*. Clayton Johns, fine featured and somewhat shy, had starred in the first year's performances, with several songs and an unfinished suite for piano and violin. He did so again this second year, playing his original compositions on Mrs. Jack's Steinway grand piano. Wilhelm Gericke suggested a reprise of their November triumph, with another of her court-concerts in March, this time opening with Beethoven's Eighth Symphony, followed by a movement from Berlioz's *Romeo and Juliet* and ending with Brahms waltzes, which Gericke orchestrated especially for the occasion. Isabella insisted everyone sign the evening's program, which had become her custom. Gericke gave her a copy of his score of the Brahms waltzes to memorialize their mutual success.

The swirl around her—the fascination and scrutiny—was intensifying. By the time she sat on the dais at the Artists' Festival the next month, late April 1889, Mrs. Jack was regularly mentioned in the city's newspapers. When, a few years later, a letter seemingly sent from Kentucky was held at the post office, addressed simply to "Mrs. Gardner, well known lady in high life, Boston," a note was added by a postal worker: "try Mrs. Jack." There wasn't any doubt about who the "lady in high life" might be.

Isabella was daring and took great pleasure in what she did, qualities that caused a stir. She cut out and kept mentions of herself in the newspapers. Attention was attention, even if it sometimes shaded to notoriety. Her affection for lions would inspire a number of articles, some more credible than others. In one, she brought two lion cubs from the Boston zoo home with her in her carriage for an afternoon reception at 152 Beacon Street. "Heretofore," the paper noted, "Mrs. Gardner has confined her receptions to men and women." In another, with the headline "Mrs. Jack's Latest Lion,"

the reporter marveled at how Mrs. Jack "sauntered about" with Rex, an enormous yellow-eyed lion whose zookeeper had let it out of its cage.

Belle would often appear in stories in the New York gossip magazine *Town Topics*. Once, according to a report, she had reserved seats on the roof of a fast new model of four-horse coach for its inaugural ride. The problem was that she and Jack missed their train to Prides Crossing, the coach's departure point. So Jack arranged with a train crew in Boston to hire their locomotive. As the coach was about to leave, an engine steamed into Prides Crossing, whistle tooting, with Belle "cozily tucked up beside the engineer."

Nothing deterred her. As she reminded a friend, who couldn't figure out how to get to Green Hill, "there are all sorts of ways and means."

If Isabella was going to be in the spotlight, she needed something to wear. She had kept her figure for couture fashion—a tiny waist, beautifully shaped arms, a graceful neckline. She understood how fabric could catch the candlelight and which shapes and cuts flattered her. She was said to glide across a room, like a boat on calm seas. The cut of her dress only amplified this graceful effect. And, of course, she had Charles Frederick Worth, couturier to European courts, as her principal dressmaker. At about this time, Isabella asked him to make a redingote, a style of riding coat popularized by Marie Antoinette. Glass beading in an abstract floral pattern borders the front opening of the coat and runs along its back seam and around its three-quarter-sleeve openings. The waist measures twenty-eight inches. The fabric, a plush midnight-blue velvet, absorbs the light, even as the elaborate beading of pale blues and pinks shines and glistens.

She understood fashion as a language—a way she could put herself on display and signal what she did not say. Look at me. I am important. I have power. This is female power in the Old World European sense, but it also held sway in Boston and New York, where newspapers devoted long passages to describing in great detail the ladies' dresses worn at various occasions. Isabella usually made the list. Beauty, impeccable taste, knowledge of art and music gave a woman the ability to command a room. But this was not to be confused with political power, the focus of feminist activists of the day, such as Elizabeth Cady Stanton, Lucy Stone, and Isabella's friend Julia Ward Howe, who were demanding equality in the public square.

Fashion worked for Isabella in a more private way, as a means to conceal her tender side and shield her from hurt. She'd had terrible losses, had been badly stung by Boston's founding families, who set so many of the rules she chaffed against. Yes, she was more a part of things now than she had been in the first years of her marriage. She'd sat on the dais alongside the leading women of Boston society at the Artists' Festival. Her social invitations to dinners, dances, and musical events were being accepted more frequently, as people realized they could not predict what they might miss. Even so, her forward-leaning tilt did cast shadows. Some people didn't like all that push and intensity, thought she was far too much of an individual. Sparkle less, conform more. Morris Carter would later try to find words for her at this moment: "She's a will o' wisp, leading Boston society on a merry chase, always pursued but never caught."

As she kept her inmost feelings largely to herself, a divide widened: there was the high-spirited, flamboyant persona, which she put on much like she wore her Marie Antoinette coat, but also someone engaged in a deep, ambitious pursuit of knowledge and beauty. The first was legible, easy to caricature, and thus set aside; the latter was hidden but far more threatening to the status quo. Her flamboyance, what she became so well known for, was in the end less subversive than what she would accomplish with Fenway Court.

TWO PORTRAITS OF ISABELLA FROM AROUND THIS TIME CAPTURE something of this duality. In the first, she is decked out in her Artists' Festival costume, sitting at ease in a Venetian-style chair, draped in her pearls, and holding a letter in her right hand. The painter was Dennis Bunker, just twenty-seven years old, who'd studied at Paris's prestigious École des Beaux-Arts. It's not Bunker's best portrait. The previous year, he'd had more success with exquisite renderings of three other Gardners—Jack's brother George; George's daughter, nineteen-year-old Olga; and Olga's younger brother, John Jr. Bunker's portrait of Mrs. Jack, by contrast, is stagy and inert. Maybe he felt intimidated by the sitter, whose good graces he needed as an up-and-coming artist. Or maybe he was stymied by the strikingly similar *Portrait of a Lady (La Dama in Rosso)* by the sixteenth-century Italian Renaissance painter Giovanni Battista Moroni, which is so alike, it seems he'd somehow modeled his portrait after the earlier one, right down to the chair.

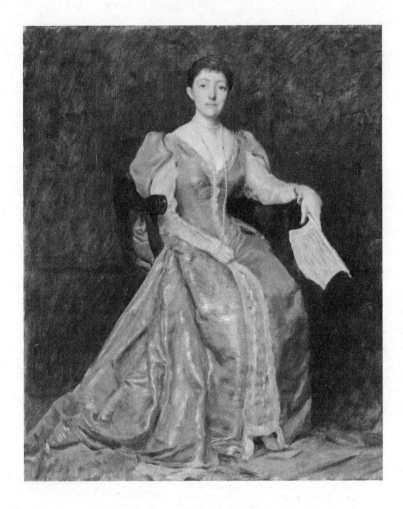

Whatever the case, Bunker did capture Isabella's straight-ahead, confident posture and the opulence of her Venetian gown, how the fabric reflected and scattered light like so many mirrors.

The second image of Isabella is a photograph of her sitting in a modest black chair, this time turned away, as if the viewer were coming into the room behind her. It is not known who took the photograph, which was printed on albumen paper. Isabella liked crowded interiors, with a lot of chairs nearby and walls covered with paintings and prints. A white marble statue of a woman is clearly visible in the corner. She is using a portable writing desk, which she could fold up and take with her from house to house.

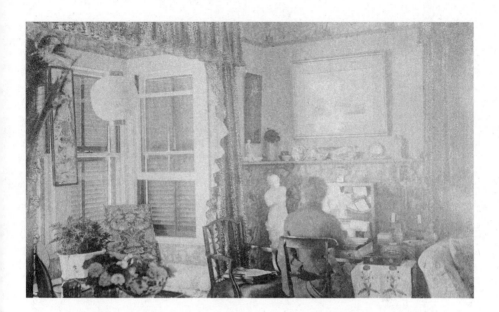

The desk kept her correspondence in one place and was supplied with her stationery and favorite pens. Stationery bordered in black, which she used when in mourning, is just barely discernible. Here she wrote out her many lists and kept up with writing cards and letters. There's an underlying seriousness to this image, something missed by many around her—she was a woman *at work*.

Sixteen

IN THE MIDDLE OF THINGS

1890–91

Mrs. Jack would celebrate her fiftieth birthday in April, but she had no intention of slowing down. She had few physical or medical complaints, and she liked bragging that her couture never had to be let out. Even so, she loathed admitting her age. She'd begun coloring her hair a version of blond and often wore veils or nets draped across her face as part of a chic millinery design. These features shielded her from the sun and also provided a kind of softening, flattering enclosure.

More than anything, a deep restlessness propelled her forward. "Travelling must be so common place a thing to you that you scarcely think of it," a young Bernard Berenson noted wryly in a letter from these years. And indeed, in early May of 1890 she and Jack were off again to Europe, following their pattern of an overseas escape during even-numbered years. After their Asia trip seven years before, they kept almost exclusively to destinations in England and the Continent, making the social rounds in London and Paris, traveling sometimes to Bayreuth for opera, but always to Venice.

Before embarking for France on the steamship *City of Rome,* the Gardners went first to New York, where their friend John Singer Sargent called on them. He had a plan for an evening's memorable entertainment. He needed Isabella's help.

<center>⁓⋆⁓</center>

"You must see the Carmencita," Sargent had written Mrs. Jack from New York in March 1890. He was referring to the twenty-two-year-old Spanish dancer Carmen Dauset Moreno, whose portrait he'd already begun to paint. Sargent had seen her dance the year before in Paris, and now she was fascinating New York audiences and the newspapers with her shows at Koster and Bial's, a theater on Twenty-Third Street near Sixth Avenue usually known for its raucous vaudeville performers. Polite society couldn't risk being seen at such a venue. So the owners cordoned off an upper balcony to protect the reputations of those wanting to witness Carmencita's whirling dance, a performance that would be captured four years later with a brand-new technology—motion pictures.

Another more popular solution for the upper crust was to host private performances in the spacious ballrooms of mansions that lined Gramercy Park and Fifth Avenue. This too posed risks, as *Town Topics* breathlessly described it: "On stage, the torsal shivers and upheavals indulged in by Carmencita might be allowed to pass for art, but in the privacy of a richly furnished room, with innocent eyes to view her, nothing but the fatal earthiness of the woman's performance could make any impression." Sargent knew this was just the sort of thing that Isabella liked. He knew of her love for Spain and for dancing. Sargent had one question for her: where might Carmencita dance for them?

The painter, who had sailed to New York from England several months before, had been letting Mrs. Jack know about upcoming performances of Wagner's music in New York, including a six-hour production of *Parsifal* in Brooklyn. He wanted to tell her too of his plans to come again to Boston in April to "paint a portrait or two." Now he asked if Carmencita might dance at Isabella's father's home on Fifth Avenue. They had to be sure the flooring was right and that no low-hanging chandelier would cause injury, given how Carmencita flung her arms about with each turn. Isabella didn't want

to miss out on seeing for herself the "Pearl of Seville," and she wasn't worried about ruining her own reputation. But the idea of hosting the occasion made her feel squeamish. Her father's remarriage was recent, and she didn't want to ask such a favor of his new wife.

Sargent turned to his friend the painter William Merritt Chase, who had a spacious if cluttered studio on Tenth Street—a "stunning" space, as Sargent wrote to Chase in a flattering letter. It was the same studio where Isabella had seen Church's enormous painting *The Heart of the Andes* (1859) all those decades ago. On April 1, near midnight, attendees arrived at the Tenth Street studio, where a large, square piece of cloth had been put on the floor in front of a backdrop of white canvas, the better to see Carmencita's movements. The gathering was small—a few guests of Sargent's, two or three of Chase's, the young artist Joseph Lindon Smith and his wife, Corrina, and Jack and Isabella. Sargent had arranged for sandwiches and wine. Mrs. Jack paid the exorbitant bill—$120.

Things got off to a terrible start. Carmencita had let her luxuriant hair fall into its natural curl, which infuriated the otherwise temperate Sargent, who'd wanted to show off her expertly coiffed hair to the guests. What happened next is not entirely clear. Corrina Lindon Smith would recall that Carmencita pitched a rose at Mrs. Jack's face, accompanied by some sort of "rude gesture." Corinna's husband, Joe, rescued the evening by picking up the flower and bowing to the tempestuous dancer, who was mollified enough to begin her performance, accompanied by the music of two guitarists. After she finished, in the wee hours of the morning, according to *Town Topics*, Mrs. Jack took to the floor herself to execute "her world-renowned *pas-seul*." Perhaps, for a moment, she felt like the dancer in Sargent's magnificent *El Jaleo*, the 1882 painting displayed at the St. Botolph Club two years before, along with Sargent's portrait of her. This glimpse of how she weathered Carmencita's fury, then danced for others and for her own pleasure, is of a piece with her nature: impulsive, generous, and certain of herself at the same time.

By mid-May, the Gardners were settled in Paris at the Hotel Westminster on rue de la Paix, with the place Vendôme nearby in one direction and the opera in the other. Also conveniently close were the House of Worth and Boucheron, which by 1890 had moved from the Palais-Royal

to a prime position along the turnabout that circled the Vendôme. Isabella and Jack went to the theaters and the dog shows, to the opera, and to the storied Cirque with the painter Ralph Curtis to see acrobats do tricks atop fast-moving horses in the center ring.

⁓⁂⁓

THEY LEFT FOR LONDON IN TIME FOR THE DERBY. THEY PREFERRED PARIS to London, generally, but they didn't want to miss the horse racing. Isabella wore her new wide-brimmed hat, with its enormous plumage, refusing an umbrella when the rain started. "Whoever heard," she remembered, "of anyone's carrying an umbrella on the way to the Derby?" The unhappy result—a ruined hat—offended Jack and, in Isabella's phrase, his "New England conscience," but not enough to spoil what he admitted was a most enjoyable occasion, especially given that she had placed a bet on an obscure but winning horse. They celebrated, damp but triumphant, with a dinner in Piccadilly.

They returned to Paris for another short stay, then went on to visit Antwerp, Dordrecht, The Hague, Cologne, Munich, and Oberammergau, for the once-every-ten-years performance of the five-hour Passion Play, first presented in 1634 in the small village tucked away in the Bavarian Alps. Henry James had just seen the play, writing to Mrs. Jack that he thought it "intensely respectable and intensely German" and way, way too long. She didn't mind. At Verona, she and Jack toured in the course of a single day the town's amphitheater, Juliet's tomb, the Giusti Garden, and, for good measure, the "most important churches." She did not flag in stamina. Jack's brother George described Isabella's greediness for experience, writing to his son Georgy after a stretch of activity when they were all together in London: "Aunty Belle is a tremendously energetic person as regards sight-seeing, amusements, excursions, so that we have been pretty steadily on the go ever since she came, leaving no time for letter writing or lazily sauntering about the streets looking in the shop windows." There was something hectic about it all, as if she feared missing something—and if she did, she would somehow be diminished. Or is it that stopping somehow meant quitting, and that was something she'd never do.

Whatever the case, all this moving around wore Jack out, and when they finally arrived in Venice, he wrote in his diary with palpable relief: "Installed at the Palazzo Barbaro—Hurrah!" For the first time, they rented an entire

floor of the Barbaro from the Curtises for the month of August, for £200. They wanted to be ensconced in a place suitable for hosting soirees. Isabella was beginning to take up a position as a social figure in her own right in the city on the water, and the Barbaro provided a dramatic stage. The spacious rooms were "delightful beyond description," Jack told his nephew, adding that he and Belle felt they had landed "in clover." In another letter he compared the Barbaro to "an enchanting dream" that made him "afraid it will spoil us for future things."

For Isabella, the palace was inspiration. Now that they were hosts instead of guests at the Barbaro, she asked the butler, Arcangelo, to light every candle in the crystal chandeliers and in the enormous candelabra stationed in each room's corner to illuminate the evening's *festa*. Everything seemed to glow in the candlelight, especially her rope of pearls. The gondoliers, Fernando, Batisto, and Tito, stood at the ready for guests at the canal entrance to the palace. Late at night, with the balcony doors open, guests could hear water lapping.

She had invited Henry James to stay with them that summer, but he had demurred. He had turned his attention to writing for the theater, admitting to a friend that "my books don't sell." Mostly, he didn't like to be summoned by anyone, least of all Mrs. Jack. They had a teasing friendship. James took the position of knowing courtier to the queen, but when she was too insistent, he backed off, pleading other plans. He didn't like a walk-on part in someone else's drama. At the last minute, he asked if he could stay with the Gardners for a "snatch of Venice," only to change plans again. "The Palazzo Barbaro is divine," he wrote to Isabella, "and divinely still: don't make it spin around."

But spin around is what she did best, as she began to assemble her court. Gathering in the Barbaro's cool rooms those summer evenings were the Apthorps from Boston; the Count and Countessa Pisani, who had owned the Barbaro before selling it to the Curtises; Cardinal Agostini in his red robes as Catholic patriarch for Venice; and Isabella's admiring friend Mrs. Bronson, whom Jack treated with a case of the very best wines he'd chosen on their travels. The musician Clayton Johns played the grand piano in the *sala* to everyone's delight, especially Mrs. Jack's. Johns, a thirty-three-year-old bachelor, had trained in Berlin in piano and composition; he was now staying at the Barbaro, after joining up with the Gardners earlier in the summer. He was indebted to Mrs. Jack for her patronage of his burgeoning career, and if that

obligation colored some part of their friendship, he also found her endlessly interesting, unlike anyone he'd met before. She told him at one point, rather grandly, that instead of "building hospitals, I am going to try to make the world more beautiful." He in turn felt enlisted in Mrs. Jack's project. As he remembered later: "She had the power of getting the best out of each thing and person."

Otherwise, the hot August weather emptied out the city's squares of most other travelers, and Belle was at liberty to do what she loved best—take long excursions on the water, look at art, and shop. Her purchases in Venice were recorded in the back pages of Jack's diary. The list is long: two red velvet strips; four mirrors with candelabra; two stone statuettes; two bronze candelabra; brass gondola lanterns; a pair of small brass lions; a small bronze dog's head; pieces of silk; blue velvet; eighty-four meters of red damask; two small picture frames; and "4 gilt wood things." If Jack didn't quite know how to describe that last purchase, he at least needed a record. The "4 gilt wood things" cost twenty lire.

WHEN THE GARDNERS RETURNED HOME IN MID-OCTOBER 1890, THEY settled at Green Hill in Brookline. The glories of Belle's gardens had faded by then, but she loved the autumn light in the tall trees. Jack left on a trip out west, to return by Thanksgiving. The mood in the city was glum. The Panic of 1890 had frightened Boston businessmen, though the losses were but a foretaste of what was to come a few years later. Other changes were afoot. Elevated train lines were being built. The city since the war had become increasingly crowded with immigrants, mostly from Ireland, but now also from Italy and Russia. The tight command exerted by the Brahmin class, which had so thoroughly dominated Boston's various institutions, now had to compete with a far more diverse population. Boston's first Irish mayor, Hugh O'Brien, elected in 1884, was also its first Catholic leader.

At this time, Isabella was deeply involved with the Church of the Advent. She had arranged for an astonishing gift: a towering reredos for the front of the sanctuary. Designed by the English architect Harold Peto and made of pale Caen stone, it was carved to give a lacy, ethereal effect.

The reredos was revealed to the congregation for the first time on Easter Sunday, 1891. Its white stone seemed to shimmer and float, especially with

the candles used at the service. The senior warden of Advent wrote a note of thanks to Isabella that same day, saying he would find it "easier even to worship, with so much beauty before us."

Isabella continued her engagement as well with the Society of Saint John the Evangelist, which during these years was building an Episcopal mission, the Church of Saint Augustine, for African American families who lived on Beacon Hill. Father Charles Field, head of the society, was tall and stately in demeanor, with kind eyes and a generous manner. He had tremendous charisma. He credited his own father, an important prison reformer in England, for his abiding commitment to the poor and forgotten. Saint Augustine started first in a small warehouse on Anderson Street. As word spread, the mission church's services proved so popular that congregants needed a larger building, where they could lead and manage day-to-day operations. Funds were raised to buy land on Phillips Street, in the Black neighborhood of Beacon Hill. The firm of Sturgis and Cabot donated their architectural services. Isabella gave the money needed to complete the sanctuary, in the amount of about $12,000. Thus the congregation was able to begin its activities in the new building debt-free.

The sanctuary, a high square room lit by large windows, was finished in dark pine with buff plaster walls. Chairs, not pews, were the main furnishings, so the large room could be used for occasions besides worship. The simple Italianate facade had proportions common in northern Italy, with two large, square towers housing open belfries. Its roof was dark-red Italian brick. Isabella and Jack, away on European travels, would miss its opening celebration service on Christmas Day, 1892. There is no record as to whether she ever attended a service at Saint Augustine, but she stayed closely connected to Father Field and his work with the church's summer camp for boys and girls in Foxboro, Massachusetts. At one point, Isabella asked the Audubon Society to send the children books of all sorts on birds and flowers.

Father Field also served as Isabella's spiritual director during these years. According to a story from the time told by the Cowley Fathers, Field urged Isabella to go periodically to the Boston Lying-In Hospital, which was dedicated to the city's poor, at night and dressed incognito, to talk with patients there. Some of the women were the mothers of newborns; some had suffered the kinds of tragedies that Isabella knew intimately. Field may have suggested that comforting others as she would have liked to be comforted was a key to healing. It seems impossible that one of the most talked-about women in Boston did this without any report appearing in the papers. Father Field had stressed that her action would be worthless if it was public. Veils, which Isabella wore with regularity, can have many uses.

In June 1891, the Myopia Hunt Club (so called because its founder brothers were all nearsighted) threw its annual ball in downtown Boston. For a pre-ball occasion, Isabella and Jack hosted several young friends in their music room for dinner and dancing. They hired a local photographer, James Notman, to make a visual record, which he did in a series of eight photographs that capture the joie de vivre of the evening. In one photograph, Isabella's guests gather around a large table covered in fine white linen: Alice Perkins, Frank Seabury, Anna Anderson, Randolph Appleton, Helen Mixter Appleton (Randolph's wife), Augustus "Gussie" Gardner, Isabella, and Frank Peabody, with Jack politely offering tea to Ellen Bullard at the far right. These names, except Gussie, the youngest of Joe Gardner's boys, and Helen Mixter Appleton, appear little in Isabella's records—maybe they were

mostly Gussie's friends. In an albumen print, with color added, she dances with Randolph Appleton, an image right out of a Renoir or Degas painting.

Isabella wore a choker with jewels attached and two large diamonds in her hair. Her Worth-designed dress, nipped in close at the waist, was made of extraordinary pale-green compound satin with a weft of silver thread in the pattern of large tassels that seemed to move with her.

She would keep the pale-green satin dress. Many years later she cut its fabric into sections and framed a large piece to place beneath her most momentous purchase by an Italian Renaissance genius: Titian's grand painting *The Rape of Europa*. It is still regarded as one of the most important paintings in any American collection. As elsewhere in Fenway Court, she would situate this masterpiece within an assemblage of images and objects. Titian's work would not appear in isolation but rather in an unfolding historical, cultural, and personal narrative. These were the years when she was in the middle of things and making her social claim, which was not a distraction but a path. The gorgeous fabric under the painting reminds the viewer of her daring, as a woman, to choose to display art in the way that most pleased her.

Three weeks after the June party, a telegram arrived with news that Isabella's father had fallen badly ill while vacationing with his new wife at the Hotel Champlain in Clinton County, New York. Isabella was on Roque Island in Maine when she heard, but Jack was away, most likely on a sailing cruise with nephews or friends. Arthur Jephson, an Irish-born adventurer whom they'd met several years before, had been staying with the Gardners that summer, first on the North Shore and then on Roque. The young man accompanied Isabella on the overnight train to New York so she could be at her father's side. Mr. Stewart had a bad heart, but this attack was unexpected. For a short while, he seemed to rally but then quickly worsened. He died on July 17, 1891, a few weeks shy of turning eighty-one. It's not known if Belle arrived in time to say goodbye.

Isabella's father's death came as she was still in the midst of mourning a very close friend, the painter Dennis Bunker, who had died of pneumonia suddenly, at the age of twenty-nine, shortly after his marriage. She had bought one of his—in his words—"parti-colored" canvases the year before,

The Brook at Medfield, which she kept on display, first at Green Hill and later at Fenway Court. She felt a special bond with him not only because of his large talent but because he was the same age her Jackie would have been, had he lived.

Once again loss haunted her like a dark sun circling. Jephson remembered coming to visit Isabella, shortly after her father's death, at the Fifth Avenue house, and how she sat "sadly at the window in your deep mourning, looking at the deserted street." She canceled all engagements and retreated to Roque Island. By then, Jack was with her. She picked armfuls of wildflowers and swam and took long walks on the beach surrounded by the shimmering sea. The weather was so splendid that summer, they practically lived outdoors. She loved rowing out on still water to small coves to watch the herons catch fish and the seals sun themselves on the rocky shoreline. In the evenings, she immersed herself in poetry, especially lines from "A Song of Joys" by Walt Whitman, whose embrace of the world was ballast: "O to have life henceforth a poem of new joys! / To dance, clap hands, exult, shout, skip, leap, roll on, float on! / To be a sailor of the world bound for all ports, / A ship itself, (see indeed these sails I spread to the sun and air,) / A swift and swelling ship full of rich words, full of joys."

Isabella's father had early on given her much of her confidence, believing she too could be remarkable like the women pictured in the book of Shakespeare's female characters that he'd given her for her twentieth birthday all those years ago. At age fifty-one, she was the only survivor of her family. Much later, people would speculate about where she came from—who is this remarkable woman? She seemed to have come out of nowhere, so unlike her surroundings, arising Athena-like out of Zeus's head. The truth was more lonesome. Her father had survived all of his siblings and had lost three of his four children to early deaths. Now she had this—outliving one's family—in common with him. David Stewart was buried in Green-Wood Cemetery in Brooklyn alongside his first wife and three younger children in the mausoleum he'd commissioned from the architect Stanford White. Two bronze bas-relief angels by the American sculptor Augustus Saint-Gaudens guard its ornate door.

Belle's inheritance from her father, $2.75 million, was not a fortune on the scale of the Vanderbilts' or J. P. Morgan's or Henry Frick's. It was, however, more than enough for her to launch headlong into her future.

Seventeen

THE CONCERT

1892

By the end of 1891, "a musical meteor," in the words of the young musician Clayton Johns, arrived in Boston "in the person of Paderewski." Isabella was still in mourning for her father and at a remove from the din of the social season. Even so, the arrival of the charismatic pianist and composer Ignacy Jan Paderewski could not be missed—she was determined to see him perform somehow. Preternaturally talented, dynamic, with an enormous shock of hair, Paderewski had become a highly paid international star after a celebrated Paris debut in 1888, at the age of twenty-seven. He'd studied first in Warsaw at the city's famed music academy, where Chopin had trained, then with the foremost piano teacher in Vienna, Theodor Leschetizky. A reporter at one concert noted how the handsome young man filled the air with "flying hands and hair." Now he was on the second of his American tours, which had brought him to New York, where he played a remarkable range of composers, including Scarlatti, Schubert, Haydn, Beethoven, Liszt, Saint-Saëns, Chopin, and Mendelssohn at brand-new Carnegie Hall.

When he performed at William Merritt Chase's Tenth Street studio, the place where Carmencita had danced, he'd had an unpleasant experience. The air was close, with many people crowding around him, and he had no elbow room for his style of play. He vowed to avoid this kind of event when he got

to Boston. Isabella would not be dissuaded: she asked him to play for her alone in her spacious music room at 152 Beacon Street and offered to pay him $1,000 for a single performance. He agreed to her terms.

The other part of her plan would be told by Clayton Johns in his memoirs. "Mrs. Gardner, out of the kindness of her heart, smuggled me into an adjoining room, where I sat and listened behind the tapestries" as Paderewski played Schumann's Fantasia, op. 17, and selections by Chopin. An intimate dinner followed the private concert. Then, to quiet the gossip that Isabella had been showing off by such an extravagance (which wasn't entirely false), Jack Gardner paid Paderewski another $1,000 to play for a large audience of fans and Boston-based musicians at the old Music Hall Building on Winter Street. The Boston Symphony Orchestra's Henry Higginson attended with his wife, Ida, and thanked Isabella afterward, noting how her "charming idea" of arranging a performance by Paderewski had been made "better still" by inviting "all these guests." "As for the music," he added, "it was wonderful . . ."

⁓※⁓

BY THE END OF MARCH 1892, THE GARDNERS WERE IN NEW YORK. THEY didn't stay at the Stewart home, now occupied by the twice-widowed Mary Hicks Stewart, who'd soon marry again, this time the American painter

Albert Bierstadt. The Gardners lodged instead at the Hotel Imperial at Thirty-Second Street and Broadway. They attended a dinner with General Philip Schuyler, who was named after his famous grandfather, who'd been a lieutenant to General Washington. General Schuyler had served with distinction in the Union army. He and his fashionable wife, Harriet, were members of the "Four Hundred," a legendary listing of New York's social elite. Also at dinner was Dr. Weir Mitchell, a well-known neurologist whose considerable reputation had been secured with his "rest cure" for neurasthenic women. When Isabella went to the Metropolitan Opera on April 1, Jack took care of last-minute travel details—they were leaving for Paris by steamship early the next morning.

It was an even-numbered year and time again for an overseas tour. This year their travels would extend over several seasons.

EUROPE WAS FULL OF FRIENDS. IN PARIS, THEY WENT TO THE VAUDEVILLE at Théâtre des Variétés in Montmartre, the neighborhood of crooked streets and windmills, with the British writer Charles Hamilton Aidé, a friend of Henry James. They had dinner with James Whistler and his new wife, Beatrix Godwin, at the famed Café Corazza, located in one of the arcades of the Palais-Royal, where the Jacobins had plotted during the French Revolution. In fact, the foursome spent quite a bit of time together that spring.

By mid-May 1892, the Gardners were in London, where they dined with Henry James and John Singer Sargent at the Savoy Hotel and went with Aidé to a performance of Ibsen's *A Doll's House*. Isabella kept a printed invitation from the Earl of Dysart, president of the Wagner Society's London branch. He had invited her to a concert at Ham House, his seventeenth-century estate in nearby Richmond, to celebrate the composer's birthday on May 22. They also had a meal with Oscar Wilde, whom Isabella had met a decade before at an impromptu lunch organized by Julia Ward Howe during his year-long American tour, when he gave lectures on the decorative arts and aestheticism. The *Boston Globe* had christened the aesthete—disapprovingly—the "apostle of the sunflower and the lily . . ." Henry James called him "fatuous" in a letter to Isabella. But she appreciated his talent and showiness and legendary wit. By the time of their lunch in London, the writer of the recently published *Picture of Dorian Gray* had grown in fame, no doubt making his presence even more enjoyable to her.

It wasn't just the social whirl that drew the Gardners to London. Frederick Leyland's magnificent collection of old masters and contemporary art was scheduled for auction at Christie, Manson and Woods in Saint James's Square at the end of May. They knew of Leyland via Whistler—the shipping magnate had commissioned Whistler for design work in his large London townhouse fifteen years before. Relations had soured between the two men because of a complicated dispute involving artistic choice and compensation, but Whistler's achievement in the mansion's dining room, what came to be known as the Peacock Room after the artist's depiction of warring peacocks on one of its walls, was widely acknowledged. The Gardners had a chance to see the room themselves on the day of the Leyland auction; Isabella would proudly keep sketches of Whistler's designs for the room tucked between his letters, photograph, and bamboo walking stick in a display case named after him in the Long Gallery.

Up for sale were paintings by Rembrandt, Tintoretto, and Botticelli, among others. Isabella bought two. The first, *Love's Greeting,* by the Pre-Raphaelite artist Dante Gabriel Rossetti, depicts the courtly love rituals

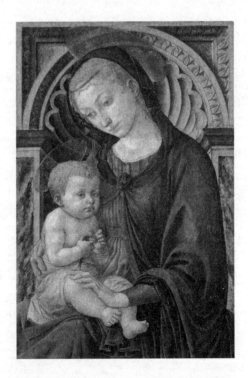

described in the poetry Isabella knew well—Dante's *Divine Comedy*. The second purchase was the *Virgin and Child with a Swallow*, attributed at the time of the sale to the Florentine master Fra Filippo Lippi. Isabella had collected photographic reproductions of Lippi's work in that year's travel album, as if schooling herself on his oeuvre. It was discovered later in her lifetime that the painter of her *Virgin and Child* was the equally admired Francesco Pesellino, also of mid-fifteenth-century Florence. What attracted her was the painting's subject matter of mother and son, rendered with the charming, humanizing realism of the High Renaissance—the baby's arm appears solid, boylike, as he holds tight to the swallow, a symbol of resurrection.

The Gardners didn't stay in one place for long. They'd go next to northern Italy, via Paris and Basel, Switzerland. They spent several early June days in Bologna, then many more in the Byzantine city of Ravenna. Isabella filled page after page in her album with purchased photographs of the beautiful sixth-century Basilica San Vitale, shaped as an octagon, with walls covered in exquisite mosaics. She was besotted too with the frescoes by Giotto in Saint Francis's church in Assisi, the way the thirteenth-century

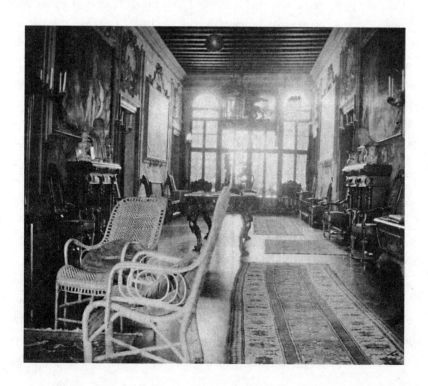

master conveyed what Henry James called Giotto's "fierce familiarity" with his figures.

By the time Isabella and Jack arrived in Venice, after several days in Florence, they were hot and worn out. The Palazzo Barbaro awaited them. Its high, cool rooms would prove once again to be—in Jack's word—"enchanting."

They'd rented the palazzo's top two floors and filled the bedrooms with quite a few overnight guests. Fanny Peabody Mason, George's twenty-eight-year-old niece and a music aficionado, joined them. So did the young painter Alfred Quinton Collins and his pretty wife, Mary Collins, from New York. Jack also listed in his travel dairy the "Parkman Blake family" from Boston and "one of the N.Y. Miss Dunhams." Belle had planned a surprise for her guests to celebrate the Fourth of July. After a leisurely dinner, they all gathered on the second-story balcony overlooking the canal to enjoy the moonlight. Then, to the wonder of everyone, the gondolier Guillermo and "his music boat arrived and gave us a delightful serenade." The party then boarded another gondola and "floated along," with the "music accompanying us and the moon sinking into the lagoon." No one got back to the palazzo before 1 A.M. Jack admitted to a friend back home that he'd "growled about keeping the servants working all day + night," though he also could not hide his immense pleasure in his wife's "success."

⁓⋇⁓

THREE DAYS LATER, HENRY JAMES ARRIVED TO STAY AT THE BARBARO. Back in April he had welcomed Isabella to the "ancient world" on her arrival in Europe. "I hope Paris speaks to you still, and says civil things," he wrote, adding that he'd been through "a series of melancholy weeks" after the death of his sister, Alice James, from cancer on March 6. Belle quickly wrote back, urging him to stay with them. She knew the palace's spaces offered remedy for heartbreak. He called her invitation in his responding letter a "charming open door—into bliss." Though he had deferred her invitation to the Barbaro two years before, this time he couldn't resist.

With the bedrooms already taken, she put him in the long, spacious library on the top floor, furnished with pink chairs, a bed canopied by mosquito netting, and a bright lemon-colored sofa, from which he liked to view the "rosy dawn." He told Ariana Curtis a few days after his arrival that if she'd not stayed in that room, and "gazed upward" toward the "medallions

and arabesques" whirling on its high ceiling, then she didn't really "know the Barbaro." He even loved the way it smelled of the briny lagoon.

Henry James gives a verbal picture of Isabella in Venice, how she liked to sit in a comfortable sea-green-colored chair in one of the palazzo's rooms, with her hair "not quite 'up'—neither up nor down," wrapped in her "gauze dressing-gown." They walked along the canals together. Once, she brought him to the antiques dealer Antonio Carrer, who had a workshop near the Rialto Bridge. Carrer was restoring a set of gilded eighteenth-century chairs, first made for the Borghese Palace, which Isabella had bought at auction in Rome with the help of their mutual friend Ralph Curtis. James relayed the scene to Ralph's mother, Ariana Curtis: "the little lady is of an energy. She showed me yesterday, at Carrer's, her seven glorious chairs (the loveliest I ever saw); but they are not a symbol of her attitude—she never sits down."

James exaggerated for effect, of course. But he got right the spirit of her to-ing and fro-ing. She was indefatigable. She loved to go on sprees. "Went to shops; saw sights" became a common refrain in Jack's diary. On a single day in late July, she and Jack scoured the antique shops of Venice: the atelier of the extraordinary wood-carver Valentino Besarel; the antiques dealer Moisè Dalla Torre; the Babli Palace workshop of Moses Michelangelo Guggenheim. The dealers Antonio Carrer and A. Clerle, in the Palazzo Avogadro, were also on the Gardners' itinerary. James, who'd begun addressing his friend playfully as Donna Isabella (or Isabel), found all this dizzy acquisition seductive. From his next continental hideaway, in Switzerland, he wrote: "I want to know everything you have bought these last days—even for yourself."

THE TRAVEL CONTINUED: TO SAINT MORITZ, INNSBRUCK, WEIMAR, Dresden, then back to Venice for two months, then to "raw and cold" Paris for two weeks and back again to Venice for another month. When the Gardners finally returned to Paris, on Saturday, December 3, they settled into their usual accommodations at the fashionable Hotel Westminster on rue de la Paix, between the Place Vendôme and the opera. The next day they went to services at L'Oratoire du Louvre, the Protestant church Isabella had attended more than thirty years before. She hadn't been in Paris for the holiday season since that time, when both she and Jack as teenagers were in the

city with their respective families. Paris was flourishing. From the fiery disaster of the 1871 siege of Paris, at end of the Franco-Prussian War, the city had risen to be the epicenter of every form of culture—theater, literature, music, art, fashion, and food. With an optimism in the might of Europe in the realms of diplomacy and innovation and science, the French would look back at this era—nostalgically—as the *belle époque,* the "beautiful time." The Gardners were having their own beautiful time. At fifty-two and fifty-five years of age, they were both healthy, though Jack was slowing down compared to his wife, who rarely did.

The previous June, Isabella had arranged with Frédéric Boucheron to purchase one of her largest jewels, a ruby drop weighing nine carats, with a portion of her bequest from her brother David. Jack added to her collection with another strand of thirty-seven pearls, also from Boucheron. Together both purchases cost almost $70,000, another staggering sum.

On Monday, December 5, 1892, Belle and Jack left their rooms at the Hotel Westminster for a leisurely lunch at the nearby Café de Paris, joined by Ralph Curtis. From there the three Americans traveled by carriage to the premier auction house in all of France, the Hôtel Drouot, a few blocks from boulevard Haussmann in the ninth arrondissement, a crowded neighborhood of busy shops. Up for sale that day was an important well-known collection of Dutch art.

The Drouot had been established in 1852 and was housed in a broken-down building of cream-colored Caen stone, which had been "sullied and defaced by the smoke and storms" of urban life, according to one account. There, anything that could be sold was sold: "wines, pictures, old clothes, furniture, machinery." Even stage scenery from local theaters was broken up and offered at auction. The rooms were bustling, crowded with people from every social rank. Sales of finer items occurred on the upper floors, "where the best society of Paris—nobles, bankers, journalists, authors, artists, elegant ladies, and celebrated collectors"—gathered in the *salons d'élites*.

Belle had bought a pair of elegant eighteenth-century silver goblets at the Hôtel Drouot the previous May. But the December auction would be on a wholly different scale. The collector and French critic Théophile Thoré-Bürger had done more than anyone to revive the reputation of the

seventeenth-century Delft painter Johannes Vermeer, who had fallen out of favor earlier in the century. Fifty-nine paintings, the core of the collection, were now on view at the Drouot's large salesroom. Isabella would have seen Rembrandts, Steens, and the exquisite *Goldfinch,* by Rembrandt's student Carel Fabritius, the painting Thoré-Bürger most liked to gaze upon at the end of his day. The auction catalog listed five works by Vermeer. Belle chose a luminescent painting, measuring just twenty-five by twenty-eight inches, aptly titled *The Concert.* It depicted a scene both familiar and dear to her heart: a musical performance in a private home.

A WOMAN IN YELLOW AND WHITE, PEARLS AT HER THROAT AND EAR, WITH her hair drawn up, sits in profile, playing a clavichord at the back of the room. Its lid is raised and reflects a soft-colored landscape outside an unseen window at the left of the composition, with trees and clouded blue skies, much like the painting on the white wall directly above her. To her right sits a man in a brown coat, his back to us and his chair turned to the window outside the frame of Vermeer's painting. Its light illuminates the woman's yellow sleeve and the red rectangle that forms the back of the man's chair. This way of lighting an image was Vermeer's signature.

A young girl stands to the man's right, holding a paper in her left hand; her right hand makes a subtle gesture, lending expression to her song. She too is wearing pearls. Viewers' eyes are guided inward by the geometric pattern of the black-and-white flooring, on which, in the painting's foreground, lies a large stringed instrument. On a table covered with an oriental rug a lute is positioned. The harmony of color, composition, and form is exact. The viewer has just enough information to imagine a possible narrative— maybe a teacher with his students or a father with his daughters—but not so much as to know for sure.

ISABELLA ARRANGED WITH HER REGULAR PARIS AGENT, FERNAND ROBert, a scheme whereby she, a woman, could participate in the Drouot auction discreetly. That day she sat directly outside the salesroom, in a spot where he could see her. To signal interest in an object, she was to hold her white handkerchief over her mouth, but pull it away when she wanted out

of the bid. The bidding was brisk. There was a lot to sell that day. Did her heart race a little as the price went up and up? Did she have a limit in mind, one she didn't want to exceed? She got her painting for 29,000 francs ($6,000), outmaneuvering far more experienced bidders. Agents from London's National Gallery took home a pair of Vermeers: *Woman Standing at the Virginal* and *Woman Seated at the Virginal*. The small *Goldfinch* sold for 5,500 francs.

The Gardners ended the day with an evening at the opera, near their hotel, for a performance of *Samson and Delilah* by Camille Saint-Saëns, one of Isabella's favorite composers. Sargent and Whistler joined them for the evening to raise a glass and celebrate.

By this point in her life, Isabella had amassed a sizable collection of many kinds of beautiful objects, placing them with care in her homes. Thomas Russell Sullivan, playwright of *Dr. Jekyll and Mr. Hyde*, remembered, in a journal entry dated February 6, 1891, "Lunched today with Mrs. J. L. Gardner, in her boudoir . . . It is filled with rare and beautiful things from every clime. Above the wainscot is a frieze of portrait-heads, early Italian, thirty in all. A Dutch landscape, all gold and red and brown, is let into the wall over the fireplace. The hangings are priceless, Chinese and Indian from imperial looms. A little Bartolozzi print in one corner once belonged to Byron." She was already skilled in casting a spell with her surroundings, creating moods and feelings and experiences. During their visit, Isabella gestured to Sullivan, saying, "Everything here is a remembrance." The seeing, purchasing, having, arranging, and admiring: all of it was filled with memories of chasing beauty.

But with the Vermeer purchase, Isabella stepped through a kind of portal—she became a collector. Hers was the first Vermeer brought to Boston and the second to America. Its acquisition confirmed—most of all, to her—that she now had formidable expertise in choosing art.

Morris Carter writes that she'd "acquired a perfectly clear understanding of the qualities she valued in people and things and her decisions to like or dislike, to possess or reject, were instantaneous . . ." This passage of his has the force of Isabella's own voice recalling to him this turning point: "The idea that her collection would be important enough to be considered a museum was not yet born, but she had found the absorbing purpose for which she had been groping the past twenty-five years." Her many discussions with

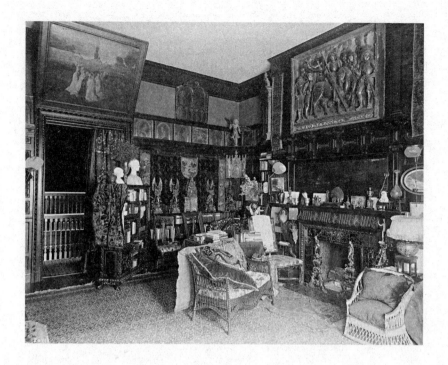

John Singer Sargent and James Abbott McNeill Whistler over dinner and in the painters' Paris and London studios, her tutorials with Charles Eliot Norton, her book collecting and travels, her long hours at the Louvre and the Prado and London's National Gallery, and her conversations with Henry James—all these had prepared her for this moment—to trust her eye, to be confident in her taste, to buy the object or painting she wanted. Object after object arranged in a room, like word after word on a page, would speak what she could not or did not choose to say aloud.

<center>⚜</center>

ON DECEMBER 22, TWO DAYS BEFORE THE GARDNERS BOARDED THE steamer for home, Jack wrote: "busy all day packing, goodbye-ing, &c." A few days later, Isabella noted the date of their return to New York in her travel album—January 2, 1893. They shipped the Vermeer painting separately, along with the objects they'd purchased on this trip, to pick up at the Custom House when they got back to Boston.

Eighteen

TO REMAKE THE WORLD

1893

Isabella and Jack Gardner arrived home to a frigid Boston in January 1893. A nor'easter lashed the coastline and carpeted the city streets with snow. Newspapers warned of frostbite. The paths of the Public Garden glittered under newly installed electric lamps, reminiscent of the Paris streets the couple knew so well.

The Gardners did not tour Europe in 1893, but they didn't stay in place either. They were on the move again by April, this time on a train west to Chicago for a month's stay in the Windy City, already America's second largest metropolis, after New York City. They'd been invited for an early viewing of the 1893 World's Columbian Exposition, ahead of its opening ceremonies on the first of May, and would be feted, along with their neighbors Mr. and Mrs. Martin Brimmer, by Mrs. (Bertha Honoré) Potter Palmer, who ruled Chicago society. She was the chair of the exposition's Board of Lady Managers. Palmer had bought a trove of paintings by the French impressionists during the run-up to the exposition.

A vast construction project had transformed more than six hundred acres

in Jackson Park, along the western edge of Lake Michigan, which stretched to the horizon like an inland sea. The fair was to be a show of American power and know-how, an attempt to outshine the 1889 World's Exposition in Paris, with its iconic Eiffel Tower. But weeks of drenching rain and several workers' strikes had conspired to delay just about every aspect of construction. When the Gardners arrived, building debris still surrounded unfinished structures, and sweeps of muddy ground were as yet unplanted. The Gardners' Brookline neighbor Frederick Law Olmsted, in charge of landscape design, despaired. The towering Ferris wheel, which promised to be an engineering marvel, was only half-built.

Even so, the central complex, seven white buildings in a grand Beaux-Arts style situated around a large lagoon dotted with waterfowl and boats, was extraordinary. The buildings loomed large on the flat plains of the Midwest, under seemingly infinite skies. As a group they would come to be known as the Celestial City, or the White City, designed by American architects to "out-Eiffel Eiffel."

Henry James wrote Isabella a teasing, staccato note from Paris: "I figure you somehow—strange as is the association of ideas—at the remarkable Chicago—with a 'building'—an infinitely more barbarous Barbaro—all to yourself. Won't there be the Federal buildings, and the States buildings, and then, in a category by itself, Mrs. Jack's building?" Her friend knew her well. She didn't get a building, but she'd been asked to send artwork from her collection for a special exhibit in the Palace of Fine Arts, which would showcase foreign masterpieces owned in the United States. (Paintings by American artists, and owned by Americans, were shown in a separate gallery nearby.) Sara Tyson Hallowell, the organizer of the exhibit, selected two hundred paintings and sculptures that graced America's rooms—a Corot and a Rousseau, lent by the estate of Jay Gould; a Courbet, lent by Henry O. Havemeyer; and a Pissarro, lent by Mrs. Potter Palmer. John Singer Sargent sent his marble figure of Andromeda by the sculptor Rodin.

Isabella provided a large oil painting by the French artist Paul César Helleu, which she'd just bought when last in Paris, on the advice of a mutual friend—John Singer Sargent. Helleu's 1891 *The Interior of the Abbey Church of Saint Denis,* with its pointillist blue Gothic window, announced her affection for France, maybe more so than her growing taste as a collector. The

reasons for this choice are obscure—perhaps she simply didn't want to risk shipping a more prized painting. Surely, though, she was glad to be in the company of other American collectors, most of whom were men.

Women's representation at the fair had been the subject of a fractious debate. The Board of Lady Managers had been appointed by Congress, with the powerful Mrs. Potter Palmer in the lead. The board was determined to showcase the contributions of women throughout the exposition, alongside the accomplishments of men. The all-male planning committees for various buildings foiled this mission from the start, turning down women's applications for exhibit space. So the Board of Lady Managers poured its energies into the separate Woman's Building, which would celebrate female contributions to art, music, and literature; home economics and education; and the fine crafts of textiles, lace-making, and pottery.

Here and elsewhere in the White City, Black Americans and Indigenous peoples (men as well as women) had been shut out from the planning of the exposition's scheme of exhibits, which was designed to herald the progress of civilization. There were no Black commissioners on the planning board, despite appeals to Congress for representation. Near the Woman's Building, the Midway Plaisance hosted a sequence of "ethnological villages," which displayed scenes from non-white cultures—for instance, forty Egyptians traveled to the fair to set up an elaborate Cairo street scene. Frederick Douglass, in his mid-seventies, attended the exposition not as a representative of his own country but as a commissioner for Haiti's pavilion. Douglass and Ida B. Wells explained in their pamphlet, bluntly titled *The Reason Why the Colored American Is Not in the World's Columbian Exposition*, that their exclusion revealed not America's civilization but rather its barbarism. Twenty-eight years after the end of the Civil War, the reason they were shut out, Douglass said, could be answered with a single word: "Slavery."

It's hard to know whether Isabella took any of this in. She would return to the exposition before its close at the end of October, so she could see everything fully finished. After this second visit she described the fair's fascinations with such fervor to Ralph Curtis that he wrote in reply: "Your enthusiasm knows no bounds, and you communicate sparks to all . . ." We don't know what else she expressed about the exposition because, like most of her letters from this time, this one to Ralph Curtis is lost. As she got older,

her interests became more expansive, and she grew more curious about people who lived differently than she did. She was a strong supporter of the Society of Saint John Evangelist and their work with the Black community in Boston, both at the mission church and the day camp for children. In her travel albums and diaries she expressed respect for people in non-Western countries, especially for their daily life and religious practices. She would have recognized the Cairo exhibit for what it was—a stage set created as spectacle and entertainment—because she had seen the real place for herself. There is no record of her attitude to what was, and what was not, on display. Boston had remained a hotbed of moral abolition up to and through the Civil War, yet Isabella left no trace of commitment to this cause. If she wasn't willfully blind to the disregard and ostracism that marred the exposition, neither did she seem to protest it. Her world was full but insular.

SOMETIME DURING THESE SPRING WEEKS IN CHICAGO, BELLE TOURED the exposition's immense Palace of Art, built of light gray stone, with high windows set in imposing iron frames. Over half a million dollars had been spent on this building, one of the few to be converted for later use, first as the Field Museum of Natural History, now as the Museum of Science and Industry. Its large terraces led to a glistening pond. Inside, smaller galleries rimmed a broad central gallery showing various kinds of art and sculpture from forty-six nations. Isabella's official guide exclaimed: "Never had there been so comprehensive and brilliant a showing of modern works of art as is here assembled." Her painting by Helleu was exhibited here.

One day, while strolling through a side gallery for artists from Sweden, a painting caught Belle's eye. Its colors were muted and few, but it conveyed an urban scene of people huddled on a crowded omnibus, traveling through Paris. A young Parisian woman, dressed in soft black, sits, holding a large package on her lap. She is lost in thought, somewhere between where she's been and where she's going. A shard of light to the right illuminates her sharp profile. Just visible, on the bottom right-hand corner of the painting, is a signature: "Zorn—1892."

Isabella didn't know this artist, had never seen his work before. A handsome, intense-looking gentleman, with close-cropped hair and a fashionable

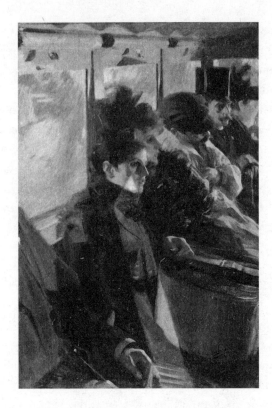

handlebar mustache, stood nearby. What might he know? As it turned out, a lot, for he was Zorn, Anders Zorn, Sweden's commissioner of art for the fair. These two must have talked away as they studied his six other paintings on view. By the end of their conversation, Isabella had bought *The Omnibus* for $1,600 and agreed to lend it to the gallery for the duration of the fair.

Zorn had grown up on a farm in the Dalarna region of central Sweden. He was a prodigy, gifted in watercolor and soon sent to study at the Royal Academy in Stockholm. After he'd won a gold medal at the 1889 Paris Exposition, at twenty-nine years of age, he had been elevated to commissioner. He had an imposing presence and spoke perfect English. Through the influence of his wife, Emma Lamm, who came from an elite family, and because of his exorbitant talent, he began circulating among the international set in Paris and London. Portrait commissions soon followed. His work would move between two poles—pictures of lush, rural Sweden and sophisticated, urbane portraits. He had a reputation for direct honesty in his portraits, sometimes to the disappointment of his sitters.

Soon after meeting Zorn, Isabella made arrangements with the Museum of Fine Arts for his first gallery show in America, which was held the following spring to broad acclaim. This gesture set the tone for their long friendship. She would open as many doors for Zorn as she could, introducing him to friends and family, urging commissions—he would paint pictures of three Gardner family members over the years—and inviting him into her inner circle. With an easy intimacy, he liked to address her in his letters as "Mrs. Isabella G."

THE GARDNERS WERE HOME AGAIN FROM CHICAGO BY MID-MAY. THE financial news was grim. Banks and businesses had failed with terrifying speed. Panic seized Wall Street. Unemployment in some areas would exceed 40 percent. If the exposition had demonstrated America's empire-building energies to the world, its supercharged economy had a terrible undertow: staggering inequality coupled with no stopgaps or protections for banks or workers. Henry Adams rushed home from Europe to save his family's finances, writing to John Hay that he had found "Boston standing on its head, wild with terror, incapable of going to bed . . ." The Panic of 1893 plunged the country into a four-year depression. The Gardners were not entirely exempt, but they were much more insulated than most.

ISABELLA AND JACK TOOK UP RESIDENCE AT GREEN HILL IN BROOKLINE, as they did each spring when not overseas. Green Hill that year was in its own "hopeless confusion," according to the novelist and playwright Thomas Russell Sullivan. He had reached some fame after the Boston premier of his theatrical adaptation of Robert Louis Stevenson's *Dr. Jekyll and Mr. Hyde*. He liked to join Isabella for afternoon tea and literary gossip. "The house is in process of reconstruction," Sullivan wrote in his diary, noting that a "fine music-room has been added . . ." Isabella had long wanted another space for the musical soirees so popular at 152 Beacon Street. She also liked building projects. She enjoyed designing in three dimensions and arranging rooms. She had a lot of ideas. And if her house was in temporary disarray that summer, the spacious gardens more than compensated, as masses of "tulips nodded in the grass" and countless lilac blossoms sweetened the air.

Clayton Johns and Charles Loeffler gave a small concert to inaugurate the music room, which proved to be—in Sullivan's words—"a complete success." Sullivan thought all the old Venetian things in the new room were wonderful, though he didn't especially mention the room's enormous Venetian fireplace, with its motto, "Motion and Light." La Serenissima was being transported to hilly, tree-lined Brookline, object by object.

"I don't know if I have one moment to call my own," Isabella would exclaim to a friend, with a mix of pride and desperation. The newspapers reported her on the go: hosting dinners or attending the theater and symphony or joining in some party or soiree. Morris Carter would summarize all this activity by remarking that Boston had "definitely accepted Mrs. Gardner." She started something new in June 1893 to keep track of the hubbub, asking her guests to sign their names in a large oblong notebook produced for that purpose. In addition to their signature, they could add where they were coming from, where they were going, or anything else they wanted—a photograph, a sketch, a doodle, a quote. The pages of these guest books (eventually they would number sixteen) compose a who's-who roster of names.

Her first guest book documents the Johns and Loeffler concert to commemorate the new music room at Green Hill. A photograph shows how sunshine pours into the large room with high ceilings and a bare wooden floor. Johns is playing the grand piano. He and Loeffler included a motif that reappears in all her guest books: musical notes careening across the page.

There was lots of goofing off for the camera; photographs of horses and carriages, copied out snippets of conversation, inside jokes, and lofty quotes. Signatories started competing to be the most clever or witty. When, after 1896, Belle started raising smooth-haired fox terrier puppies, their wiggly bodies began to populate the pages. Belle loved the high spirits and sociability of these days at her court.

※

In August, Henry James wrote to Isabella, asking a favor. The French writer Paul Bourget and his shy young wife, Minnie, were sailing for America—they will be "helpless and hot," he wrote. Would she assist them and introduce them to Boston society? Paul Bourget had been hired by the *New York Herald* to write his take on the modernizing of America, including its gilded social worlds. These dispatches would later be collected into his

popular book *Outre-Mer: Impressions of America* (1895). He had already published several novels recognized for their psychological insight, as well as books of nonfiction. He was darkly handsome, a brilliant talker and mimic, sophisticated, eager to understand the New World. He wasn't intolerably French—happily, he shared Belle's passion for all things Italian, especially Dante.

The Bourgets arrived at the Gardners' North Shore home Beach Hill in September, by yacht from Newport, Rhode Island. Bourget wanted to meet their famous North Shore neighbor Dr. Oliver Wendell Holmes, then eighty-four-years old, a conversationalist extraordinaire and father of a future Supreme Court justice. Isabella arranged a luncheon, inviting just one other guest, Sarah Wyman Whitman, whose portrait painting of Dr. Holmes had been one of two of hers picked for the Woman's Pavilion at the World's Columbian Exposition. With six around the table, Holmes recited from his poetry, including his oft-anthologized "Last Leaf," with its speculative lines "And if I should live to be / The last leaf upon the tree . . ."

In November, the Bourgets returned to Boston, full of impressions of the exposition in Chicago. Isabella took them to a Harvard-Yale football game, a contest she adored. Her nephews would remember how she hollered from the sidelines. The Frenchman recoiled, horrified at the game's violence, calling it a "terrible sport." He did admire Sargent's portrait of Isabella, which he described as a vision of an American woman both "delicate and invincible." Her dinner party for the Bourgets drew together the intellectual lights of Boston: her friend Annie Fields and the writer Sarah Orne Jewett; Thomas Bailey Aldrich, recent editor of the *Atlantic Monthly*, and his wife, Lillian (whom Mark Twain famously detested); Ernest and Lizzie Fenollosa (who would soon divorce); Alexander Agassiz, son of Louis and Elizabeth Agassiz, who ran the Calumet mines in Michigan; the philosopher William James and his wife, Alice; and a thirty-one-year-old Edith Wharton, not yet a published author. Wharton's and Gardner's many interests—art, fashion, society, gardens, houses—overlapped. They were both from New York, and both had married Bostonians at the same Grace Church. But they would not be friends. The reasons were complicated but also a little obvious: no room was big enough for both personalities, though in these early years Wharton would have spent more time trying to figure out Gardner—and deferring to her—than the reverse. Whatever the case, Wharton *was* friends with Isabella's friends, including Henry James, and later, Bernard Berenson.

The Bourgets had already dined at the Whartons' table at their grand summer home, Land's End, in Newport.

In November Anders Zorn and his wife, Emma, arrived in Boston, ahead of his gallery show at the Museum of Fine Arts, scheduled to open the following March. More parties were thrown. When the couple returned again in early February, there was a birthday concert for Zorn at 152 Beacon Street, with the pianist Ferruccio Busoni. Julia Ward Howe thought Busoni pounded the piano dreadfully. Zorn dashed off a sketch of the pianist and another of Charles Loeffler playing the violin, an image Isabella prized, perhaps because it caught something of the violinist's precision and intensity. Zorn wrote to Isabella soon after, saying he longed to have Dante's pen to express his "grateful feelings" for everything she had done for him and Emma when they were in Boston.

Isabella enjoyed bringing together people, especially young artistic people, and making things happen. Minnie Bourget called the young men who crowded around her "The Isabella Club." Isabella's largesse made a lot possible; the devotion of these guests, in turn, made her feel young and needed and connected to the next generation, the future.

IN EARLY MARCH 1894, A PACKAGE ARRIVED FOR ISABELLA AT 152 BEAcon Street. Inside was a slim book with the title *Venetian Painters of the Renaissance,* published by G. P. Putnam's Sons, and an insert that read "compliments of the author—Bernhard Berenson." She had not heard from Berenson since his hurried letter from Florence five years before, when he described how he liked to read Dante with his "morning coffee" and how he'd become "quite quite picture wise." He'd gone abroad to study literature originally, but his true métier was looking at and writing about art. He had an astonishing visual memory, wide cultural references, and a graceful style on the page. The reasons for these years of silence between the two friends are murky. In a follow-up letter to the package, Berenson mentions that she had "put a stop to our correspondence." Gardner's reply the very next day states the opposite—"I have heard nothing from you for a long time which was bad of you!" But she didn't dwell on this. She was eager to "talk over the book, the painters, and in fact many things," adding, with her usual urgency, "Let me hear from you . . ."

Berenson's return to Isabella's life was propitious on several fronts—he was at the start of a career as leading connoisseur of Italian Renaissance art just at the moment when she had the financial resources to collect in a big way. She already had a highly educated eye and enormous nerve. She'd bought the first Vermeer for a Boston collection. She'd been counted among the important American collectors at the World's Columbian Exposition. Now was the time to find more art, and Berenson could help her.

By summer 1894, she was sending him black-and-white photographs of paintings she needed attributions for—who painted this, and when? By August, he responded with this question: "How much do you want a Botticelli?"

Nineteen

"THE AGE OF MRS. JACK"

1894–95

Bernard Berenson wrote to Isabella early in their friendship about the work of Walter Pater, the critic and novelist who made him feel, as he later said, "keenly alive." While a student at Harvard he'd often read Pater's masterpiece *The Renaissance: Studies in Art and Poetry* late into the night, absorbing the critic's argument that art, as Berenson would put it, "teaches us not only what to see, but what to be." Pater urged a direct response to art, emphasizing feeling and intensity and beauty in his articulation of aestheticism's nineteenth-century rallying cry: "art for art's sake." This belief countered the moralizing idea that art had to accomplish something, had to uplift or improve, an idea that John Ruskin and Charles Eliot Norton had advocated. Pater's work would have a wide influence, including for such figures as Oscar Wilde, James Whistler, Henry Adams, and Henry James—and even the later modernists, such as Virginia Woolf.

Isabella knew the Englishman's work, had admired his 1885 *Marius the Epicurean*, a novel about a second-century Roman hero on the chase for a guiding philosophy of life, tacking from hedonism to the threshold of Chris-

tianity. She had sent a missive of praise to Pater, and then tucked his letter of response into the pages of her copy of the novel: "I greatly value," he'd written in his careful script, with a trace of what reads today as condescension, "the opinion of cultivated Americans in all matters of art and literature, and was much pleased to hear that you like my writings." She would list *Marius* in a privately published bibliography of her library, *A Choice of Books,* and she owned his 1887 *Imaginary Portraits* and *The Renaissance.* There are few marks on the margins of any of Gardner's books, so her specific reaction to Pater is hard to measure. Pater was homosexual and influenced other homosexual men—toward a decadent hedonism, according to some, taking the case of Oscar Wilde as an example. It is unclear what Isabella thought about this. She certainly recognized her own point of view and values in many of Pater's lines, as when he declaims at the start of *The Renaissance,* "What is important, then, is not that the critic should possess a correct abstract definition of beauty for the intellect, but a certain kind of temperament, the power of being deeply moved by the presence of beautiful objects." Likewise his oft-quoted aphorism at the book's conclusion: "To burn always with this hard gem-like flame, to maintain this ecstasy, is success in life."

Pater was writing directly to critics. Though Isabella wasn't a critic in this way, she did share the temperament he described, with its ability to be "deeply moved by the presence of beautiful objects." She'd been honing this capacity to respond, to know in a flash what she liked and didn't like, since she was young.

So when Berenson came back into her orbit, they had much to talk about. They shared a worldview. As she would write from Venice a few years later to a mutual friend, "Berenson is here—he and I are loving pictures together."

THAT SPRING OF 1894, THE *BOSTON GLOBE* PUBLISHED A LONG ARTICLE that began with two portraits of Isabella. The first was a snapshot by the paper's "lightning photographer," showing her climbing into her carriage in front of 152 Beacon Street. The paper claimed it was the first photograph of her ever published. The paper next described the 1888 Sargent portrait, calling it an "interesting study" that is "strikingly characteristic of her whole character." She is portrayed in the painting as a woman "full of tact and resources." By the *Globe's* measure, she is "by no means beautiful." Her face and

features are "almost destitute of those lines of beauty" that defined "womanly charm." Yet she is "more irresistibly attractive" than most women. Why? They noted the "animation of her eyes, the mobility of her mouth," and her "vivacity" and "intelligence," finally summarizing her appeal in a very conventional way: "The fact of the matter is, Mrs. Gardner's secret of social success lies entirely in that she has a knack of making herself popular with men."

The *Boston Journal* had published its own profile of Mrs. Jack the year before, on her fifty-third birthday. "A leader of society! What is it that makes a woman of fashion?" The article tried to sort out the mystery, using tropes the *Globe* would employ: her appearance and her appeal to men. "Mrs. 'Jack' Gardner, as she is always called, cannot by any stretch of the imagination be described as a handsome woman," the *Journal* opined. Mrs. Jack didn't have the common source of a woman's power, feminine beauty, a lack that left this unnamed newspaper writer in a quandary—how to account for her undeniable social clout? The writer turned to her "many advantages," listing her three homes—on Beacon Street, in Brookline, and on the North Shore—as "the white lime lights which throw all other society women a little in the shade. Others may have as much money, but few use their luxuries as . . . does Mrs. Gardner." Her "marvelous string of pearls" and the current season's "string of diamonds" that "wanders about her neck" distinguished her, while her allure could be summed up by her extraordinary listening skills. "That she has a charm of manner cannot be denied . . . [and] arises from the rare gift of being able to concentrate her attentions on one person at a time. The man to whom she is talking for the time being is the only man in the room. The incipient flattery has its speedy effect."

The most interesting speculation in the article regards her individuality and emotional discipline. "It is said that no more self-contained woman ever lived," the writer surmises. "Even those who have known her best have never been indulged in any confidences." Then the writer employs the language of the theater to explain further: "She plays a brilliant part in the world, but she plays it alone. Of what is in her mind, of what goes on when the lights are down, no one knows. She never asks advice; admits no one behind the scenes. The same brilliant spectacle that she is to the world she is to her friends." This isn't exactly true—she did ask for advice, she did confide in friends, such as Maud Howe, John Singer Sargent, and later, others: A. Piatt Andrew, Caroline Sinkler, and Gretchen Osgood Warren. But the article

grasped her front-stage personality, a kind of performance. She was protecting her feelings, yes. She was also shielding from common knowledge the scale of her ambition and the serious work forming in her mind—something well beyond her homes or her jewels or her appeal to men.

WHILE BOSTON SPECULATED AND GOSSIPED, ISABELLA TRAVELED. The even-numbered year 1894 meant another European tour, and this one would be the Gardners' longest stay. Morris Carter discreetly mentions in his biography a possible reason why: "As Mrs. Gardner was in poor health, they planned to be away nearly a year" to make time for recovery via the water cure. One friend, Theodore Dwight, referenced her "neuralgia and rheumatism." When Frank Crawford heard that she'd been struggling, he sent a solicitous letter around the same time: "I am distressed to hear that you are half ill and feeling altogether miserably. It seems to me that of late these attacks come much more often, and they scare me." Whatever the cause, part of her trip would include a stay at the mineral baths at Langen Schwalbach (now Bad Schwalbach) near Wiesbaden, a detour she dreaded. She told Berenson it would likely be a great bore. After all, she usually liked to recover in a more active way.

By June 30 the Gardners had arrived at their usual accommodations at the Hotel Westminster in Paris, where Ralph Curtis joined them, as he'd done in years past. They went immediately to Whistler's studio and dined with him and his wife. In London soon after, they lunched with John Singer Sargent, attended a concert by Paderewski, and had dinner with the English architect and garden designer Harold Peto, who had designed the reredos for the Church of the Advent and was a friend of Henry James. They would meet James the next week. Sargent alerted her to a splendid seventeenth-century Persian court carpet for sale at a tiny London shop, which she purchased for £350. She let him use it as a backdrop for one of his portrait sitters, but the carpet outdazzled the model, so the picture "never came off," as he later told her. London revived her—there was so much to see and do.

They spent ten days in and around the spa in Langen Schwalbach, where the doctor who examined her instructed her to rest. Judging by her activity in Paris and London, Isabella was clearly feeling better even before she arrived there, but she and Jack followed the fashion of a restorative stay

at a European spa. By September, they were in the alpine town of Ischl, near Salzburg, where they went to a piano concert by George Proctor, who was touring Europe with funds from his patron, Isabella. The Gardners, with Jack signing the checks, had subsidized Proctor's study in Vienna with a piano teacher Paderewski had recommended. Josephine "Josie" Dexter and her daughter, Katharine, friends from Boston who'd also been recovering in Schwalbach, greeted them in Ischl. Isabella got word that one of her favorite composers, Johannes Brahms, was residing nearby at his roadside home, and she was determined to meet him. By the next day, Josie Dexter reported seeing Isabella and Brahms "having tea together like old friends."

The backstory to the meeting was a little more involved. Wilhelm Gericke, by now the former conductor of the Boston Symphony Orchestra, lived near Ischl. (He would return to Boston and lead the orchestra again in 1898.) Gericke arranged the visit with Brahms. The composer, a bachelor who made his start playing the piano in brothels, loved to smoke, as did Isabella. Perhaps they smoked cigarettes together, which seems the case because, like a smitten schoolgirl, she stashed the butt of his cigarette in an envelope as a memento of that unforgettable September day. She'd include this scrap in a large display case dedicated to music, along with several of his signed scores and photographs, in the museum's first-floor Yellow Room. Brahms would have loved that detail.

Paul Bourget's wife, Minnie, had complained to Isabella earlier in May that she was leading, as a fashionable woman in Paris, the "most imbecile life of social and domestic drudgery." Going out every afternoon until well past dark to promenade and leave calling cards at the same homes again and again got tedious, like so much superficial glitter. "It is all clothes [and] visits (!!!)," Minnie exclaimed. Henry James, in his private notebook, would try to sort out what all this hectic activity of Americans might mean. The richest vein of his fiction continued to concern Americans in Europe, the new clashing with the old, particularly the fate of American women. In his notebook, he poured out a scathing indictment of the rich American tourists who were crowding Europe: "the deluge of people, the insane movement for movement, the ruin of thought, of life, the negation of work, of literature, the swelling roaring crowds, the 'where are you going?'" James was protesting the modernization that had swamped his beloved old Europe in noise and commerce. But his complaint rhymed with Minnie Bourget's: what was

the point of all the endless travel, the dreary roulette of days packed with dinners, concerts, and soirees? And Mrs. Jack came to his mind as an embodiment of this phenomenon, calling it "the age of Mrs. Jack, the figure of Mrs. Jack, the American, the nightmare . . ." What James didn't yet know was that Mrs. Jack was pivoting away from this European roulette toward her own center of social and cultural gravity.

Isabella and Jack arrived in Venice on September 5, 1895, where they were met at the train station by Angelo (Jack did not record a last name), along with several other gondoliers, who took them by boat to the Palazzo Barbaro. They would stay nine weeks. They took Italian lessons, shopped at antique dealers, hosted traveling friends, "gondoled," as Jack wrote in his diary, and gave many parties in the palace's *salone*. Each time Isabella returned to the Barbaro, it felt a bit more familiar, a little more hers. "Mrs. G. held a little court in the Palazzo Barbaro," Julia Gardner's brother-in-law Thomas Jefferson Coolidge recorded in his diary. "She was surrounded by musicians and artists, some of them of distinction." Her guest book filled up with names, familiar and unfamiliar. Joseph Lindon Smith, who had been so diplomatic to fiery Carmencita, and the musicians George Proctor and Clayton Johns stayed at the palace in the Gardners' first days; the Brimmers from Boston arrived soon after. Josie and Katharine Dexter visited in September, which Mrs. Dexter characterized in the guest book as "ten days of healing and consolation." The writer, artist, and also engineer of the base for the Statue of Liberty, Francis Hopkinson Smith, came from New York with his wife and daughter for four days. Of his time in Venice, Smith would write that the Barbaro's exquisite *salone* was "by far the most beautiful in all of Europe." In the evenings, after dinner, the composer and violinist Pier Adolfo Tirindelli and the cellist Gigi Agostini, together with Clayton Johns, made beautiful music that could be heard by people in gondolas on the water below.

Anders and Emma Zorn arrived in early October from Verona. The foursome went everywhere together—to the Lido, to Murano to watch the glassmakers, to the lush Venice public gardens. When not touring the city, Zorn spent the afternoons painting. He had made an etching of Isabella the year before, which had been a failure—or maybe a little too accurate. He conveyed her hauteur and something of her awkward smile. But he'd not been able to express something deeper about her, how he knew her in these years—alive, in the moment, responding so freshly to everything and everyone.

And then, on the evening of October 21, Zorn saw the scene he wanted. She had stepped onto one of the Barbaro's large balconies that looked out on the great expanse of the Grand Canal. Musicians were playing in boats while fireworks lit up the sky, making the water shimmer. Isabella urged her guests to "come out—all of you. This is too beautiful to miss." As she was stepping back inside, pushing against the panes of glass in the French doors, her arms opened wide, Zorn cried out to her—"stay just as you are! That is the way I want to paint you." He began working that night, and by the next day, he had "finished [the] picture of Mrs. G. in the window," as Jack noted in his diary.

WHEREAS SARGENT'S 1888 PORTRAIT OF ISABELLA HAD THE RATHER static quality of a Byzantine icon, Zorn caught Isabella in movement, as if on a stage. Her pose is dancerlike; she is a performer in front of her adoring audience. Her long, shapely arms are thrown wide, her heart available, the ends of her long fingers placed on the windows of the French doors. Her gown, set off by its background of fireworks and lit water, is like the one that had won praise in the *Boston Sunday Herald* the summer before: it was again

a simple, elegant confection with an "airy diaphanous effect" that was "characteristic of the peculiar refinement of Mrs. Gardner's taste." Her long rope of pearls hangs almost to her knees, with an enormous ruby at the bottom. A bouquet of red flowers is visible at her feet, as fireworks boom in the painting's background. She completely owns the space. The painting was later criticized as too much of a draft, too impressionistic, as was current in French painting, but the *New York Times* reported that the portrait's likeness was "excellent."

Isabella loved the painting. A few weeks later she described to Joseph Lindon Smith several of Zorn's canvases that he'd painted during his stay at the Barbaro—of gondolas, of girls working at the lace factory, and then exclaimed, as if she couldn't help herself: "The other is a portrait of me, astounding! A night scene, painted at night. I am on the balcony, stepping down into the *Salone* pushing both sides of the window back with my arms raised up and spread wide! Exactly like me . . ." It captured her energy, her fearlessness, her sense of freedom. Zorn would remember in his memoirs that he'd caught her personality, which he described as "grandly majestic more than most . . ." Maybe this was the "age of Mrs. Jack" after all, if not in the way Henry James had quite imagined it.

BERNARD BERENSON HAD ASKED ISABELLA, IN HIS AUGUST 1894 LETTER, "How much do you want a Botticelli?" He was writing about the Florentine master's magnificent late-fifteenth-century *Story of Lucretia*, owned by Lord Ashburnham, which Berenson called one of the artist's "greatest"

works. Berenson speculated that an offer near £3,000 (about $16,000 in 1894 dollars) would be looked on as reasonable. He'd be happy to make arrangements for its purchase as a thank-you for her enthusiastic support and "kindness." Berenson's recent biographer, Rachel Cohen, notes that "Italian pictures were not yet generally in demand, and Botticelli and this picture in particular, still seemed ethereal and strange." The large oil-and-tempera painting on wood panel—Berenson had mistakenly thought it had been part of a *cassone,* or wedding chest—told the story of the rape and death by suicide of Lucretia, tragedies that led to the founding of the Roman Republic. The drama of the scene and the vigor of Botticelli's line, how he could capture movement on a still surface, appealed especially to values Gardner and Berenson shared—"the living and breathing aesthetic experience."

Gardner made Berenson wait on her decision. Their communication back and forth in the months after this initial August letter is lost. They saw each other when they looked at pictures together at the Louvre in Paris during the holiday season near the end of 1894, and Gardner finalized her purchase of the Botticelli on December 19. Jack sent £3,400 to Colnaghi and Company, the London firm started in the eighteenth-century whose dealer, Otto Gutekunst, had made the sale arrangements with Berenson. Berenson would work through Gutekunst at Colnaghi over the next many years, functioning as a middleman and taking a cut of profits, sometimes to Isabella's advantage and sometimes not. Going forward, she didn't wait to decide, as she had done with the Botticelli, having learned that waiting often meant missing out. Collecting old masters wasn't like collecting old furniture—deciding fast was often imperative.

News of Isabella's purchase of the first Botticelli in an American collection generated great excitement in Boston. The Japanophile William Sturgis Bigelow wrote to her rather grandly, if sincerely, on behalf of the city's art circles: "It has been a weary dreary winter without you . . . But the gloom has lifted . . . and we all—especially the Art Museum Trustees—are wagging our tails and uniting our voices like Memnon in a paean of gratitude for your most *mu-&mag-nificent* performance . . . Really, we shall have to put up a statue to you, right under the picture, and when the haughty New Yorkers come here and ask with an aristocratrical sneer whether we have any pictures in our Museum as good as the Marquand Collection, we shall say, casually—'oh yes—we have the best Botticelli in America—would you

like to look at it?'" Bigelow knew what Gardner knew—Boston collectors were in strong competition with New York collectors, a contest that would intensify in the coming years.

―※―

THE GARDNERS HAD STAYED ON IN EUROPE—THERE WAS SO MUCH MORE to do. After Berenson's visit in Paris and a glorious midnight service at the église de la Madeleine on Christmas Eve, Isabella and Jack arrived in Rome, where it was unusually cold and snowy. She remembered her time there as a young girl in the 1850s, but she and Jack had not traveled much in Rome in the past years. Maud Howe Elliott and her husband now were living on the large top floor of Palazzo Rusticucci, right next to Saint Peter's Square. Also in Rome was the Story family. Its eighty-five-year-old paterfamilias, William Wetmore Story, had been a part of the longtime Roman American enclave of Nathaniel Hawthorne, Thomas Crawford (Frank Crawford's sculptor father), and Charles Eliot Norton a generation before.

The person in Rome Isabella most wanted to meet was the pope, Leo XIII. She'd convinced the pope's chamberlain, Baron Schönberg, to arrange for a private audience with the popular pontiff, and soon she had her instructions: be at the Vatican on January 20 at 11 A.M., not a minute later. She donned her best Worth-designed dress, recently made, black and simple and fitted, with a veil, no gloves, and her rope of pearls in one long string. A large ruby attached at the bottom caught the light, as it had done in Zorn's painting. At one point during their interview, the pope remarked on the splendor of her pearls and took them in his hand. When he asked if she had any special request, she answered that she did—she wanted to attend a mass in his private chapel, with him as the celebrant, which is just what occurred the following Sunday. She wasn't only interested in his celebrity; the high holiness that he embodied also drew her strongly to him.

Isabella's exuberance, so much a part of her charisma, could get her into trouble. When she sent a large bouquet of yellow roses as a birthday greeting to Italy's king, Umberto I, whose enormous mustache overwhelmed even his piercing black eyes, a hubbub ensued. What did such a forward gesture mean, inquired the king's equerry? Only courtesans would send flowers to a king. Jack apologized while Isabella sputtered, arguing that she enjoyed sending flowers to men she admired, and what difference did it make that

she'd sent them to a king? Of course, she knew it made all the difference in the world. This was the vulgar American in Europe that Henry James found alternately fascinating and unpleasant. Wayne MacVeagh, then the American ambassador to Italy, intervened on Jack's behalf, explaining that Mrs. Gardner surely meant no disrespect and assured the Italian courtiers that this American was really and truly "a lady."

After Rome, the Gardners had another month at the Palazzo Barbaro, where the painter Antonio Mancini commenced work on a portrait of Jack, which Mrs. Jack found to be a very good likeness. It captures his dignified posture and the details of his gentlemanly attire—hat, monocle, cane, starched white collar, and gloves. Berenson stayed with them in late April, which he described in the guest book as the "most quintessential, halo-fitting day I ever spent in Venice." Back in Paris, their final stop before home, Isabella purchased from Whistler his *Nocturne: Blue and Silver—Battersea Reach*, its canvas awash with thinned blue pigment and spotted with sharp orange and yellow marks, which suggest boats on the water and far-off lights on the shore. Whistler had once said that paint "should be like breath on the surface of a pane of glass." She would hang the painting in her Yellow Room at Fenway Court.

They arrived home in early July and soon settled at Beach Hill on the North Shore, where they were greeted by friends and family, glad to see them back. Belle felt much improved. If the European tour had been planned because Isabella hadn't been feeling well, travel had given her what it had always—other horizons, refreshment, energy, focus, wonderful stories to tell. And the Gardners brought home many beautiful things. A partial list includes the Botticelli and Whistler paintings, Mancini's portrait of Jack, green-velvet copes and a red-velvet jacket and trousers, a pair of large iron torchères, yards and yards of old lace, four pieces of old silver, two Dresden china boars, Moroni's sixteenth-century *Portrait of a Bearded Man in Black*, and a view of Isabella's beloved Venice by the seventeenth-century painter Francesco Guardi. She placed Zorn's portrait of her in the doorway leading to the music room at 152 Beacon Street, as if in greeting to her friends and guests.

In Rome, a day before her fifty-fifth birthday, Isabella had entered one of the city's crowded picture and antiquities shops, where she bought a large fourth-century B.C.E. Egyptian Ptolemaic stone sculpture of Horus, a hawk and sky god, the son of Isis. Long ago, she had copied the hieroglyphic

profile of Horus into her travel album while floating down the Nile. The hawk's stance and sharp-eyed gaze, imperious and sure, was a portent of the posture she'd take on for herself. She placed the figure, standing almost two feet high, prominently in her Brookline garden, as a kind of talisman. In a year's time, she would write to Berenson of her "museum idea."

Twenty

A POEM

1896

The Gardners stayed at their idyll at Green Hill into the late fall months of 1895. Isabella loved its wintry aspect, how the high bare trees loomed in the sky "like smoke." Nieces and nephews crowded around their Thanksgiving table, including Julia's boys, now in their twenties and thirties: Joe and his wife, Mary, came with sons Archibald and Harold Jefferson. The nephews Isabella and Jack had raised also came home. William Amory Gardner was now thirty-two years old and a highly regarded teacher of Greek and classical studies at Groton School, which he had cofounded in 1884, and Augustus "Gussie" Gardner was now thirty and married, with a two-year-old daughter. George's youngest daughter, twenty-six-year-old Olga Gardner, also joined in with her cousins.

Jack and Isabella wouldn't be traveling to Europe in the New Year, though that had been their usual custom during even-numbered years. There was much to do at home, which was becoming more and more the center of their social world.

⁂

"Dear Mr. Berenson," Isabella wrote from Green Hill on December 2, 1895: "Your two letters have come. I thank you very much for keep-

ing me in your mind. I should only like to say first that in future and for all time, please don't let me and someone else know of the same picture at the same time." She was referring to Berenson's recent letter, in which he explained how a work by the early Florentine painter Giottino, which she'd wanted, had been sold out from under her. Some paintings, he warned, "are so desirable that they disappear quickly." There were many risks in collecting, which required nerve, judgment, quick decisions, and a belief in one's own taste and the advice of one's dealers. Much could interrupt a purchase. The worries for everyone involved, from seller to buyer, were many and complicated, as listed by Rachel Cohen: "forgery, misattribution, gaps in provenance, contested wills, the transfer of works out of their countries of origin, import tax evasion, hasty and destructive restoration, and the wildly fluctuating value of the paintings." Then, there was always risk of damage to the artwork in transit: "I have had very bad luck with a Moroni," Isabella lamented to Berenson in this same letter, referring to her recent purchase of the sixteenth-century *Portrait of a Bearded Man in Black*. The painting had "arrived with a hole through the man's heart six inches in diameter."

Collecting at this level was a high-stakes game; Isabella needed to establish her terms. "It may be only a prejudice of mine," she continued in her note to Berenson, "but it is disagreeable to me to be put *en concurrence* in these things. So if you want to get pictures first for anyone else, do so; and after that is all settled, have me in mind another time, when I am to be first—and wait until you hear from me before passing on the chance. Now I have said my disagreeable little Say, and I hope that you will be amenable..." She added some goading encouragement: "My foremost desire is always is for a Filippino Lippi and a Velázquez very good—and Tintoretto. Only the very good need apply!"

The next day she wrote to Berenson again, this time about a landscape of the Venetian lagoon by the great eighteenth-century painter Francesco Guardi, who would influence everyone from Turner to Whistler to Monet with the exquisite atmospheric effects of his skies and reflective waters. She initially had passed on the painting *View of the Riva Degli Schiavoni and the Piazzetta*, citing the too-high expense (Berenson's letter with its asking price is lost). But she had changed her mind. "Mr. Gardner thinks it is very dear and wants to know if it cannot be had cheaper." Berenson rejoiced: "I cannot tell you how happy it makes me to think of your possessing that most glori-

ous of all Guardis." Then he hit a snag. His bargaining for a lower amount had angered the owner enough to sell to someone else. Now he'd have to scramble to get it for her after all, at one point urging her: "I must beg you to be prepared to be disappointed." In the end, the sale went through, for £1,575. Berenson's commission was 5 percent of the sale price. Fresh off the victory, he told her what she wanted to hear—that she'd soon "possess a collection almost unrivalled of masterpieces, and masterpieces only."

BY THE 1890S, REMBRANDT HAD BECOME ONE OF THE MOST COLLECTED old master painters in the rapidly expanding art market in America. His fame had not receded in the centuries since the Dutch Golden Age, and his portraits appealed to American collectors in particular. In January, Berenson sent Isabella a black-and-white photograph of one of Rembrandt's early self-portraits, dated 1629, when the artist was twenty-two years old. (She would base most of her purchases through Berenson on black-and-white photographs.) Berenson described the image and its prestigious provenance, saying it was "one of the most precious pictures in existence." In it Rembrandt is clothed in a soft moss-green-velvet doublet and gold chain, with a large feather in his cap—he is all youth and confidence and future. A later friend would write of "the golden charm of the young Rembrandt." If she didn't act quickly, cabling Berenson either a "Yes Rembrandt" or "No Rembrandt," it would be sold to the National Gallery the next month. He also offered her a work by Tintoretto (now ascribed to the studio of Tintoretto).

Isabella replied the very next morning, a Sunday, saying she was "bitten by the Rembrandt," adding that she'd cable him first thing on Monday—"yes Rembrandt!" She also wanted the Tintoretto. "What do you think of that!" She had a momentary pang about the money—£3,000 for the Rembrandt and £500 more for the Tintoretto. "I shall sell my clothes, eat husks, and be very prodigal with my pictures. Even my ears covered with debts!" The heat of her excitement seems to rise from her letters to Berenson in these early years—a large, easy, open script, lots of exclamation points, and periods at the end of sentences that smudge into dashes because she's writing so quickly. She got the Rembrandt portrait at 152 Beacon Street on

March 10 and had a small dinner party to celebrate. The writer Thomas Russell Sullivan wrote in his diary that evening of Mrs. G's "newest treasure," adding that "day by day, the wonderful little Musée Gardner gains in value."

By late April, Isabella told Berenson of the arrival of another of her recent purchases that he'd facilitated, this one a portrait of Isabella d'Este, Marchioness of Mantua, the Renaissance patron of the arts known for her fashion and musical talents. She was also a voracious collector of art, a startling enterprise for a sixteenth-century woman. This Isabella, with her wonderfully bemused expression, had been a part of the Scarpa collection and long ascribed to Titian. That was Berenson's explanation. But the painting wasn't by Titian, which meant he could get her a portrait of a namesake—"a potent attraction"—for a mere £600. (It would turn out that she wasn't an Isabella either, but rather an unnamed woman; *Portrait of a Lady in a Turban* is attributed to Francesco Torbido.) "Isabella d'Este is here," Isabella exclaimed to Berenson. "She arrived safely and is most delightful." She put the painting next to the Rembrandt portrait, a fine-looking pair. To celebrate, she invited friends over for a fete she described to Berenson this way: "[d'Este] and Rembrandt held quite a little reception this afternoon. I had some delicious music. When that was over, the devotees put themselves at the feet of the lady and the painter." It was exactly what she enjoyed, "a tête-à-tête with things," as the cultural critic Walter Benjamin would later describe a collector's happiness. The paintings became personages, accompanying her, populating her home. She was overcome with pleasure. "They and music—all three—had a great success," she boasted to Berenson.

MUCH HAD DEMANDED ISABELLA'S ATTENTION SINCE THEIR RETURN from Europe, including season tickets to the Boston Symphony Orchestra and the Boston Artists' Festival, where she wore a costume from Egypt "tightly swathed round and round with layers of gauze," with a large pendant jewel, likely a ruby, hanging down at the center of her forehead. She attended horse shows in New York and Boston. Green Hill Stable had been established two years before—the colors of the jockey uniform, green with a yellow cap, were registered with the American Jockey Club. Jack's involve-

ment is unclear. Isabella's racehorse, Halton, had cost her $3,600 in 1893, a whopping sum, but had won only four out of seventeen races that first year and then nothing the next. Everyone told her to sell him, but she resisted. As it turned out, 1896 would prove a much better year.

Isabella and Jack moved back to Green Hill in May, where they resided, as she put it, "with the birds and flowers. Everything is jumping and throbbing into life." Isabella's expansive Italian garden had been established the previous autumn on a hilly area behind the estate's main house. Her Japanese garden would be built a little distance away the next year. The recent Harvard graduate Gaillard Thomas Lapsley, who had joined the Gardners for Thanksgiving the previous season and would become a favored correspondent, marveled at how she'd already made "a past for" her brand-new garden, writing to her that "the very earth is rich with tradition before the first year's rose petals have given themselves to it." Wild grapevines covered trellises that led to a fountain, with a statue of Neptune in its center. She had embellished the confining wall with insets of old bas-relief fragments and placed marble sculptural pieces, including the Horus hawk, amid tall hollyhocks. One writer described the Green Hill gardens as "a great outdoor fair-weather museum." Hildegarde Hawthorne, granddaughter of Nathanial Hawthorne, noted the "subtle harmony linking art and nature." She thought the Italian garden had a marvelous "simplicity of coherence and perfection" combined with a "fearless use of color," with banks of rhododendrons, masses of petunias and cornflowers, scarlet poppies, and pale-blue larkspur.

She enjoyed "grubbing in the earth," as she'd write in a later letter. She loved to sit under high trees and whispering pines on a hot summer day. Her head gardener, Charles Montague Atkinson, grumpy and fat, had worked on the Gardner estate since 1862, twenty years after Jack's father, John L. Gardner, first bought its forty acres. Isabella didn't seem at all bothered by Atkinson's thundering temper. She relied on him for practical knowledge and physical work, as had her father-in-law, who'd been a serious gardener and an early member of the Massachusetts Horticultural Society. Large, fine-looking greenhouses, or conservatories, with elegant Gothic arches, had been built by Jack's father. He had grown a wide variety of ferns, palms, and Belle's favorite flower—violets. She filled the conservatories to bursting with wildflowers of every kind: roses, ferns, orchids, chrysanthemums, and many

kinds of violets. She was known to appear at balls and other public events with a bouquet of these.

Also this summer, Isabella was completing a year-long project to build a new home, called the Mansion House, on Roque. She was an enthusiastic driver of its construction, together with Jack and his brother George, hiring Willard T. Sears, her eventual architect for Fenway Court, to design the home, a three-story, elegant yet comfortable affair located just steps away from a full working farm. She loved such projects—she bought furniture for the house, decorated it, populated it with guests, and arranged an opening celebration in August. "Busy Ella" was Jack Gardner's fond nickname for his very busy wife.

IN SPITE OF HER NEW STABLES AND NEW GARDENS AND THE NEW HOUSE at Roque, much of Isabella's attention was taken up with collecting. Letters between her and Berenson whizzed back and forth several times a week. She badly wanted Thomas Gainsborough's masterpiece, *The Blue Boy*, a painting she had seen in London. She was also taken with a photograph Berenson had sent of a large painting known as the Forli Titian (named after a small Italian town), even though Berenson warned her that its provenance was very shaky. They would go back and forth about both works, debating merits and strategies and prices.

In a long letter on May 10, Berenson broke the news that the owner of the Gainsborough had no intention to sell and had just wanted to test the market. But the same letter also brought better news: "One of the few greatest Titians in the world is the *Europa*—which was painted for Philip II of Spain, and as we know from Titian's own letter to the king, dispatched to Madrid in April 1562." In addition to calling attention to its royal provenance, Berenson noted the painting's intense "poetical feeling" and its "gorgeous colouring." But she needed to decide quickly. He'd already misjudged things by offering it to one of Isabella's Boston competitors, Susan Warren, wife of the director of the Museum of Fine Arts, Samuel Warren, who hadn't yet replied. If, however, Isabella cabled right away, "then the *Europa* shall be yours." This was exactly what she had asked him not to do—put her in competition with another collector, even worse, a Boston collector, but he pled

special circumstances. He'd thought her resources would be tied up with *The Blue Boy* purchase. Plus, as he at one point wryly observed, "there's nothing so resembles picture-buying as trouting, and at times it almost seems impossible to land your fish." There were some hitches and wrangling, even after he received her "Yes, Europa" cable, but land the fish they did, at the price of £20,000.

Then came the excruciating wait for its arrival by boat to New York City. By mid-July, Isabella was getting a little desperate, asking Berenson, "When comes *Europa*? I am feverish about it." The anticipation, though, had its own deliciousness— "I am leading such an open air life just now," she wrote, after moving from Green Hill to Prides Crossing: "Shan't you and I have fun with my Museum?" A few weeks later, Berenson replied: "I hope you have now received her, and had your first honeymoon with her. What a beauty. Titian at his grandest . . ."

Isabella bought *The Rape of Europa,* painted between 1559 and 1562, on the basis of Berenson's vivid descriptions and a black-and-white photograph, which captured nothing of its grand size or glorious colors. She had, of course, seen numerous Titian paintings in Venice, at the Uffizi Gallery in Florence, and at the Prado Museum in Madrid. She had glimpsed Velázquez's reference to *Europa* in his own masterpiece, *The Spinners,* when she'd spent time at the Prado in Madrid. But *Europa* was one of the Venetian's greatest masterpieces, which he'd painted for Philip II as part of a series of six mythological scenes known as the *poesie,* or poetical inventions. Titian thought painting could do what poetry does—distill the great truths of life with image and color and rhythm and texture. Taking Ovid's *Metamorphoses* as his source, he depicted myths of Danae, Venus and Adonis, Perseus and Andromeda, Diana and Actaeon, Diana and Callisto, and the myth of Princess Europa being carried off to Crete by Jupiter, the greatest of the gods, who had taken the shape of a bull.

Europa, the last of the six *poesie* paintings, was the master's favorite, combining depictions of fear and transcendent beauty. A viewer doesn't need experts to explain the look in the bull's eye, the panic of the friends on the far shore, the sensuality of Europa's body, and her terrible danger. Titian's brushstrokes are visible up close—those delicate pinks and vibrant blues—and they magically cohere as the viewer steps back from the enormous can-

vas. As Berenson had said when instructing Gardner to look very closely, especially at the head of the bull, "There is the whole of great painting!"

Finally, on August 25 from Prides Crossing, Isabella wrote to Berenson: "She has come!" Her sigh of relief is nearly audible. "I was just cabling to you to ask what could be the matter, when she arrived, safe and sound. She is now in place. I have no words! I feel 'all over in one spot,' as we say. I am too excited to talk."

She hung the Titian in the red drawing room at Beacon Street, next to a large mirror above the room's fireplace. Vermeer's *The Concert* was nearby, as was Botticelli's *Death of Lucretia* and Rembrandt's self-portrait. She couldn't get enough of *Europa*, writing a few weeks later: "I am having a splendid time playing with Europa." It was rumored that she liked to lie on a bearskin rug in front of the Titian, imagining that she herself was Princess Europa or was inside the painting itself. Another letter to Berenson from Green Hill conveys her deep pleasure. "I am breathless about the *Europa*, even yet!" She'd gone back to Beacon Street, she explained to Berenson, "for a two days' orgy," explaining that the "orgy was drinking myself drunk with *Europa* and then sitting for hours in my Italian Garden at Brookline thinking and dreaming about her. Every inch of paint in the picture seems full of joy." She was not insensitive to the violence depicted. That wasn't what she meant. It was the painting's equipoise of elements—action and stillness, light and darkness, desire and alarm—that she couldn't stop thinking about. How had he managed it, how had he accomplished this great thing, and how had this great master's achievement come to her, to her own wall in the drawing room at Beacon Street in Boston?

She showed her friends and fellow collectors. Edward Hooper, Clover Adams's brother; Quincy Adams Shaw, head of Hecla Mines; and the eager William Sturgis Bigelow all came for visits. A painter she doesn't name began to cry tears "all of joy!" Another wrote her a note that simply said: "Dear Mrs. Gardner, TITIAN," writing out the name in enormous letters. She did likewise in a message to Berenson that captures her own thrill. It was hers, and it was her pleasure to share it with others.

Charles Eliot Norton much later would remember to Isabella his very first reaction to seeing *Europa*, recalling how he had told a friend at the time that "Boston was changed by it and made better worth living in."

Isabella was changed by it too. Near the time *Europa* arrived, she mused to Berenson that her museum should be called Borgo Allegro (cheerful town): "The very thought of it," she exclaimed, "is such a joy." That was the word she used most in these months: *joy.* The painting and the feelings it stirred stimulated her deepest ambitions, as if she could not quite believe it was all finally happening, a constellation of her interests and passions and ambitions and love of beauty. Her taste and power as a collector were being recognized. Her social desire to win, to be first, to be noted and noticed and admired, was being fulfilled.

There was a shadow side too, something breathless and destabilizing in all of this excitement. She couldn't think of anything else. She had a hard time sleeping. The next year a mysterious illness felled her for several months. Her temper, always formidable, was more and more on display. She used her inheritance from her father for most of her art purchases—Jack was

careful to make note of this in the records he kept. But she had also borrowed vast sums for her purchases from Jack's money, something he frowned on. "He says it's disgraceful," she admitted to Berenson. She had a great deal on the line, everything invested in a dream that didn't have a precedent, at least in the context of America. In the same letter, she compared her "picture-habit" to something "as bad as the morphine or whiskey one." And like those all-consuming habits, she admitted, "it does cost."

Twenty-One

"LIST OF THINGS FOR THE MUSEUM"

1897

On the cold and clear evening of December 14, 1896, a large fire broke out at the main house on the Sargent estate, called Holm Lea, next door to the Gardners' Green Hill in Brookline. Charles Sprague Sargent, a Civil War veteran and eminent Harvard professor of arboriculture, was the founding director of the Arnold Arboretum, which had been designed by Frederick Law Olmsted, also a Brookline neighbor. Sargent, notoriously aloof, more comfortable with trees than people, was on friendly terms with Mrs. Gardner, conferring with her from time to time about plans for her Green Hill gardens. According to the report in the *Boston Chronicle*, the fire most likely started in one of the mansion's chimneys, while Sargent, his wife, Minnie, and their two young daughters were gathered around the dinner table. By the time smoke was discovered, the entire house was at risk. Everyone rushed to rescue as many belongings as possible. Carpets were spread out on the lawn; furniture was pitched through windows. No one died, but the south wing of the house was destroyed, in part because of high winds and a fire hydrant situated too far from the property to be of use.

In the mid-1940s, a descendent of the Sargent family, William Phillips, remembered the terrible event, adding this detail: "While all the members of the family were absorbed in trying to rescue as much as possible from the stricken house, they perceived to their great indignation none other than Mrs. Jack seated comfortably on the lawn and watching with apparent grim satisfaction the entire scene. My cousin Minnie (Mrs. Sargent) was so upset that she told my mother she would 'never speak to that woman again.'"

It's not hard to imagine why Isabella would have stepped out of her Brookline home to witness what was happening next door. The detail that pricks and unsettles is that she seems to have gotten a chair, or had a servant fetch a chair, so she could sit down—in comfort—while she watched the disaster of her neighbors fill the night sky. Isabella had a voracious appetite for sensation and immersive spectacles: the circus, Wagner's operas, the World's Columbian Exposition in Chicago. The power and awful splendor of an all-consuming blaze in the cold and dark would be yet another spectacle. Maybe too she was facing down a fear of any collector: one's property destroyed by a destructive fire. Whatever the case, Minnie Sargent's feelings about the incident are understandable. Isabella had been rude, unneighborly, blinkered by her own fascinations. And yet there were chatty letters and notes from Charles Sargent to Isabella in the years after the fire. In the end, the story of Isabella at the fire illuminates and obscures all at once.

"His Majesty is here!" Isabella exclaimed to Bernard Berenson in an early February 1897 letter. She was referring to a portrait by Diego Velázquez of Philip IV, the seventeenth-century king of Spain, grandson of Philip II, who had commissioned the series of *poesie* paintings by Titian, one of which, of course, now hung in Isabella's red drawing room at 152 Beacon Street. She had sent an eager "YES" cable to Berenson on the day after Thanksgiving, asking that the portrait, which she bought for £15,000, be shipped to her in the same manner as the Titian. Then she waited and worried. A lot could happen to a painting in transit; it could be misplaced or mishandled or lost at sea. "When do you think *Philip* will be here," she'd asked Berenson on New Year's Day, "to see this new world and get new subjects?" She asked after the painting twice more, in two separate letters dated on the same day in late January.

Her relief upon its arrival a month later is palpable. "I have been unpacking him and trying to hang him all the morning," she enthused to Berenson about the enormous painting, which measured almost eighty by forty inches. The young Hapsburg king is clothed in simple black, with a white linen collar (called a *golilla*) encircling his long, distinctive face, topped by sandy hair. He holds a folded note in his right hand and the hilt of his sword in his left, a typical pose for him, with his feet placed beneath him, like a dancer's. The king was aptly described in an 1897 book on Velázquez that Isabella kept on her shelves: "Few characters in history have offered such a curious compound of contradictory qualities as Philip IV," the author stated. He had "many of the gifts that make a strong and wise ruler, but never were such qualities less effectively exercised. To a handsome person, a distinguished bearing, courtly manners, and proficiency in all the accomplishments of a cavalier, he added the more sterling virtues of a kind heart, a tolerant disposition, and a self-control so remarkable that he is said never to have shown anger, and only to have laughed three times in his life!" The author offers a possible reason for the king's shortcomings as a ruler, speculating that his "innumerable love affairs no doubt diverted his attention from more weighty matters." It was said that he fathered thirty-two children.

Isabella couldn't have been more pleased with the portrait, eventually hanging it in her Beacon Street dining room. She finally had her own Velázquez. She told Berenson: "He is glorious. I am quite quivering and feverish over him. How simple and great."

At this time, she and Berenson exchanged numerous letters about the purchase of other works, including *A Lady with a Rose* by the Flemish painter Sir Anthony van Dyck, which she won for £4,000. She also bought a small but striking portrait of a weeping Christ, thought to be by the Italian Renaissance master Giorgione, now attributed to Giovanni Bellini or his circle. She and Berenson would go back and forth about the latter painting, *Christ Carrying the Cross*, over the course of more than a year, until it finally arrived in Boston in late 1898, much to the relief of both. With stakes so high, these exchanges both strengthened their friendship and strained it.

Isabella didn't acquire all her treasures through Berenson. She sometimes bought directly from galleries or through friends. When she and Jack went to New York in March 1897, she purchased a portrait of Isabella Clara Eugenia, painted in 1600 by the Flemish artist Frans Pourbus the Younger,

from the dealer Durand-Ruel for $7,000. She had fallen for another portrait of this same Isabella, the archduchess of Austria and beloved daughter of Philip II, which she had seen at the Prado. She jotted down in her 1888 travel album a biographical detail she didn't want to forget: Philip II called his daughter Isabella "the light of his soul." She knew about strong bonds between a daughter and a father.

Friends were also on the lookout for treasures for her to consider; some facilitated her purchases. Isabella had followed John Singer Sargent's suggestion that she buy a seventeenth-century Persian carpet from a London shop in 1894. At the same time, Sargent wanted her to buy Claude Monet's 1877 *Les Dindons Blanc,* a magnificent landscape, with its flock of wild turkeys crowding the foreground of the large canvas. She declined the Monet, perhaps because other Boston collectors were keenly buying up paintings by the French impressionist. The painter Ralph Curtis organized her acquisition of the eighteenth-century gilded Borghese chairs in 1892 (now in the Titian Room); Joseph Lindon Smith described various items in his letters, often including a vivid sketch of whatever object was up for sale.

Richard Norton, son of Charles Eliot Norton, helped her acquire a large coffered ceiling from Orvieto, the hill town near Rome, decorated with painted scenes from ancient myths. (Berenson viewed Richard Norton as direct competition for Isabella's financial resources. His sense of threat was compounded by the resentment he felt for how the elder Norton had treated him at Harvard.) Isabella came to depend on Richard Norton for his expertise in antiquities after his appointment as assistant director of the American School of Classical Studies in Rome (later renamed the American Academy). It was a trust grandly rewarded when at the end of 1897 Norton secured for her the purchase of the extraordinary Farnese sarcophagus, *Revelers Gathering Grapes,* from third-century Rome. It cost 52,000 lire and weighed over seventy-five hundred pounds. Norton reassured her that Boston gossips wouldn't object to the "frank but slight sensuality" of the dancing satyrs and maenads that graced its sides.

Isabella's ongoing romance with objects absorbed much of her time and imagination. She kept track of her growing collection in a large black-leather notebook with gilt edges, where she signed her full name, in her looping script, across its first page along with the date: March 25, 1897. She

put the notebook's title on the next page: "List of Things for the Museum." Ideas were coalescing in her mind. She needed a sequence or syntax for a vision as improbable as it was alluring—her very own museum.

Both Gardners realized something needed to be done about how to keep and show their ever-growing collection. The previous September 1896, Isabella had met with the well-known Boston architect Willard T. Sears about the possibilities of expanding their Beacon Street residence. She knew Sears well after his work designing the house at Roque Island and the renovations and additions to the Gardners' property at Green Hill. She went so far as to ask that Sears draw up preliminary plans. Maybe they could buy yet another townhouse on one side or the other, reserving the top floor for a private apartment. She made Sears promise to keep the project secret.

But they ran into difficulties. Jack didn't think a museum in the middle of a residential street was such a good idea. A friend remembered him saying that a building of that size would block out the neighbors' light. He may have also worried about securing the collection from theft and fire, a particular concern after Boston's Great Fire in 1872, when so many buildings, set close together, had been destroyed. The recent disaster at the Sargent estate was also a caution. Unlike adjoined townhouses, a freestanding building had the advantage of windows on all four sides, which would make it easier to see the art without electrification. Their Brookline neighbor Frederick Law Olmsted was in the midst of implementing his landscape design for newly filled-in marshland south of the Back Bay, which would become part of the city's lush series of parks and waterways known as the Emerald Necklace. Real estate lots already had been sold to developers.

For whatever reason, the timing for a real estate purchase wasn't quite right, and a definite decision had to wait. Still, Isabella's dream for a museum with many kinds of objects was coming into clear focus. She would have paintings, to be sure, but also furniture, textiles, sculpture, screens, lace, fabric, mirrors, ironwork, manuscripts, photographs, and so on. Her collection would be seen in situ, like the art at the Poldi Pezzoli, the house museum that had inspired her as a teenager, or like her idyll in Venice, the Palazzo Barbaro. Her homes on Beacon Street and at Green Hill had been a kind of laboratory, where she set up scenes and tableaux and combinations of textures and colors to fabricate a mood, a feeling, a memory. In the phrase

of a contemporary scholar on collections, she was assembling a "homemade universe."

"Things to be taken for Museum from Green Hill," she began in her notebook. "From Music Room—old Italian chimney piece and gilded iron brackets with tapestries . . ." A slash on the page, then a list of more items: "large old Venetian mirror, one small one, with the table under it that goes with it—everything in the room in fact, including etchings, and manuscripts, medals, Dresden clock and candelabra, furniture, etc., and pictures except the panel pictures on the wall." Her inventory from the dining room at Green Hill is longer: "The chair, two Venetian lacquered and painted green side tables and needle work tapestry." She also wanted the "Japanese screens, engraving of Mary Queen of Scots, French wood writing table, old bronze seal, bronze Buddhist bell, large curtain of old Chinese embroidery." She itemized paintings by the artist names on a single page: Corot, La Farge, Courbet, Bunker, Smith, Curtis. Under "Things to be taken from 152 Beacon Street," she began with the dining room: "Gothic tapestries, stained glass windows, Philip IV by Velázquez," and added many more. The list of pictures from the red drawing room included many of her prizes—Titian's *Europa*, the Vermeer, Rembrandt's self-portrait, and Botticelli's *Death of Lucretia*.

Isabella's lists gave her a kind of prospectus, an organizing spine, for her nascent museum. They give order to the inchoate and take on the quality of a poem, akin to Whitmanesque lists, having an almost incantatory power when read aloud. And they make up a verbal self-portrait of an omnivorous collector.

The Gardners spent spring 1897 back again at Green Hill for Isabella's favorite time of year. Colorful blooming foliage and her fox terrier puppies were everywhere. "Here I am again in this beautiful Brookline," she wrote to Berenson. "Someday you must come and sit in my Italian garden, which is of course not really Italy—but very delightful and does have a taste of that dear land." Friends joined her in her gardens, someone visiting nearly every day. Gaillard Lapsley, now teaching history at Harvard, frequently stopped by. She enjoyed his wit and easy manner. Lapsley, whom she would introduce to Henry James, would later become literary executor for Edith Wharton. Entries in her guest book from May until early July record well over one hundred signatures and include her regular salon attendees—Clayton Johns, Thomas Russell Sullivan, Charles Loeffler, and George Proctor—as well as many Gardner nephews and nieces. Julia Gardner Coolidge sometimes stopped by to see the new litters, often with one of her sons. Although the tenor of the relationship between Julia and Isabella is difficult to track over time—there are few letters between the two women living so close to one another for so many years—they shared the uncomplicated pleasures of the spring season.

By July, Isabella and Jack had returned to Europe, following their usual path during the first weeks: from Paris to London, then on to Bayreuth for more Wagner operas. But this trip had a mission—to collect what they could, but especially architectural elements salvaged from Italian palazzi. Once settled in the rooms on the top floor of the Palazzo Barbaro in Venice, they were joined by Joseph Lindon Smith and Clayton Johns. Isabella hired a boat on which Johns could perform, so she had her own music wafting up from the Grand Canal in the evenings. Their niece Olga Gardner and her new husband, Dr. George Monks, stayed with them, as did Berenson, who arrived for a week in mid-September. He was at the start of writing what would become his lasting art historical achievement, the massive two-volume *Drawings of the Florentine Painters*. Berenson, now thirty-two years old, was a little wary of his patron in person, whom he always addressed as

Mrs. Gardner. In a letter to his future wife, Mary Costelloe, he said: "She is the one and only real potentate I have ever known." Berenson needed Isabella, and he was relieved to sense that not only did she need him in return, but that she seemed "really fond of me, of me, not of my petty repute . . ." He couldn't help but marvel and envy how she "lives at a rate and intensity and with a reality that makes other lives seem pale, thin and shadowy."

Isabella and Jack went on a shopping spree at dealers and shops throughout Venice, buying up columns and capitals, frescoes, candelabra, carved wood, balconies, fountains, and *facciate di palazzo,* or building facades. They bought two matching dolphin fountains and a sculpture of a dog from the antique dealer A. Clerle on October 2, for the sum of 500 lire. She would place a pair of large marble guardian lions, which she bought from Francesco Dorigo, the Venetian stonemason and dealer, outside the museum's main entrance.

The Gardners, along with Berenson, traveled southwest to Florence, then to Siena and Sicily, which proved particularly intoxicating. Isabella gave an account of the trip in a letter to Gaillard Lapsley from the Grand Hotel in Palermo: "The Sicilian dream is nearly over—At first it seemed to be almost a failure. Bad weather (rather bad) & wild beasts like gnats, & very hard travelling . . . Syracuse was better & the beautiful Greek art seemed to take hold of us there in the great theatre." The small but ancient town of Girgenti "filled our souls—perfection," while Palermo proved "a delight." She marveled at the city's twelfth-century Palatine Chapel, the mystery and shimmering beauty of its intricate ceiling.

They stayed at the Grand Hotel in Rome, where they went on another splurge. On November 1, they paid 5,000 francs for seven antique sculptures bought through the art dealer Saturnino Innocenti, a trove that included a child-size marble sarcophagus from the third century, decorated with carved garlands and a small bust of a young boy. The next day they purchased for £10,000 one of the glories of their collection, a second-century Roman mosaic floor with the head of Medusa at its center. They had seen this mosaic two years before, when they went to the Villa Livia to look at the many mosaics unearthed there. They had been laid during the reign of Emperor Hadrian and were rediscovered in 1892. The Gardners chose the largest mosaic floor, from the Villa Livia, measuring about five meters square, with twenty-seven panels. Floral arabesques and birds surround the head of the Gorgon, who

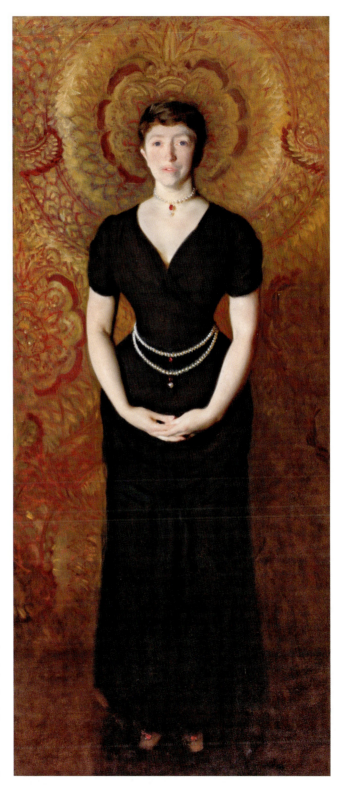

"Woman, an Enigma" was an apt first title for this portrait that caused a scandal upon its only public showing, at Boston's St. Botolph Club when Isabella Stewart Gardner was forty-eight years old.

John Singer Sargent, *Isabella Stewart Gardner,* 1888, oil on canvas

Gardner's passion for music equaled her passion for art; she bought her Vermeer, the first in a Boston collection, the second in America, at auction in Paris in 1892.

Johannes Vermeer, *The Concert,* about 1663–1666, oil on canvas

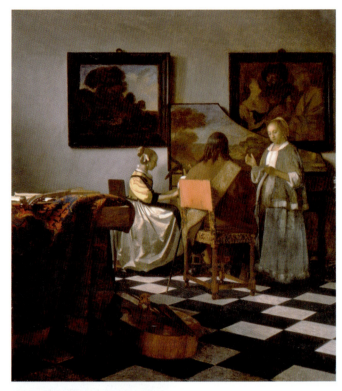

Purchased in early 1896, this painting spurred Gardner to chase only masterpieces for her dream of creating "a real museum collection," according to Morris Carter, first director of the museum and her first biographer.

Rembrandt van Rijn, *Self-Portrait, Age 23,* 1629, oil on oak panel

"She has come!" Gardner exclaimed when Titian's masterpiece arrived "safe and sound" in August 1896. "She is now in place. I have no words!" Titian (Tiziano Vecellio), *Rape of Europa*, 1559–1562, oil on canvas

The designer Charles Frederick Worth used compound satin with silver wefts in a tassel pattern for a gown Gardner wore in the late 1880s. She later placed a section of the gown's skirt beneath the *Rape of Europa*.

The Palazzo Barbaro on the Grand Canal in Venice, where Gardner found respite and inspiration from her first visit in 1884 to her last in 1906.

Joseph Lindon Smith, *The Courtyard Stairway of the Palazzo Barbaro,* 1892, watercolor on paper

Gardner, veiled, at her moment of triumph after the opening of Fenway Court.

John Singer Sargent, *Mrs. Gardner at Fenway Court,* about 1903, watercolor on paper

The architect Willard Thomas Sears's preparatory drawings of Fenway Court and its interior courtyard, this version without its eventual glass roof.

Willard Thomas Sears, *Design for the Courtyard of Fenway Court,* 1900, pencil and watercolor on paper

The picture's subject, the annunciation of the coming Savior, conveys a sense of anticipation and hope.

Piermatteo d'Amelia, *The Annunciation,* about 1487, tempera on panel

This painting by the Florentine master Botticelli was one of Gardner's favorites. It depicts the most frequent motif in her collection: the Madonna and Child.

Sandro Botticelli (Alessandro di Mariano di Vanni Filipepi), *The Virgin and Child with an Angel* (Chigi Madonna), about 1470–1474, tempera on panel

The first Raphael in America.

Raphael (Raffaello Sanzio of Urbino), *Portrait of Tommaso Inghirami,* about 1510, oil on panel

The screen depicts scenes from the tenth-century novel by Murasaki Shikibu, lady-in-waiting in the Imperial Court in Kyoto. Gardner may have purchased this work during her trip through Asia starting in 1883 or later when she started avidly collecting Asian art.

Kano Tsunenobu, *Scenes from the Tale of Genji,* 1677, one of a pair of six-panel folding screens, color and gold on paper

The lion skin around the figure's neck and waist signals this is a young Hercules. The large fresco set against a flame-stitched embroidered textile occupies center stage of the Early Italian Room.

Piero della Francesca, *Hercules,* about 1470, tempera on plaster

This painting, the first Matisse in an American museum, was given to Gardner by scholar and archaeologist Thomas Whittemore.

Henri Matisse, *The Terrace, Saint-Tropez,* 1904, oil on canvas, © 2024 Succession H. Matisse/Artists Rights Society (ARS), New York

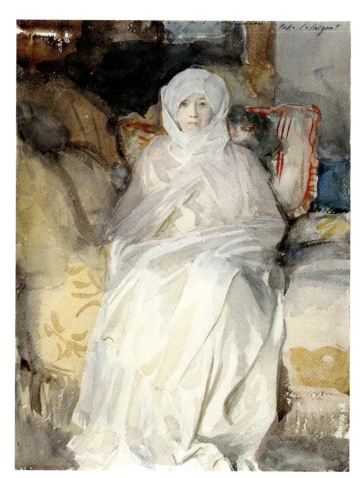

Gardner placed this last portrait of her by John Singer Sargent—calling it "exquisite"—above a bookshelf in the Macknight Room, where he had made it.

John Singer Sargent, *Mrs. Gardner in White,* September 1922, watercolor on paper

Fragments of glass from Reims Cathedral shattered by bombing in the Great War were sent to collector and decorator Henry Davis Sleeper with instructions to give them to Gardner. Sleeper had them remade into a modernist panel that she placed in the first-floor Chinese Loggia.

Henry Davis Sleeper and Phipps, Ball & Burnham, *Fragments from Reims Cathedral,* eighteenth-century glass, 1919 panel, stained glass

Gardner considered every detail as she installed the galleries of Fenway Court, incorporating rich color with paint, tiles, and especially extraordinary textiles.

FROM TOP TO BOTTOM: Tiles from the Church of San Agustin, Atlixco, Puebla, seventeenth-century, Spanish Cloister; paint chip of Bardini Blue sent to Gardner by Bernard Berenson from Florence and used for the Long Gallery, Chapel, and stairways; late eighteenth-century silk damask, Yellow Room; seventeenth-century Italian brocade with silver threads, Little Salon; eighteenth-century Italian red and yellow-gold silk and linen brocatelle wall fabric, Titian Room.

had once been a beautiful maiden until Athena turned her hair into snakes as punishment for her dalliance with Poseidon. These two artifacts would take center stage in the courtyard, the heart of Gardner's museum, the child-size sarcophagus a poignant reminder of the terrible fragility of life positioned alongside an ancient vision of a woman's power and vengeance.

Isabella and Jack were back in Paris in early November, where it was bitterly cold and cloudy. "I cry for Italy," she wrote to Lapsley. Jack organized the shipment of their treasures back to America, paid their servants, and wrote letters back home, with instructions to prepare for their return. Isabella refreshed her wardrobe with visits to Worth, something Berenson teased her about in a letter from his home in Fiesole, outside Florence: "What fun you must be having at Worth's," adding "and what about the hat?" She was exhausted, laid up with a badly swollen gland near her face, which made her appear misshapen, according to Henry Adams, who was also in the city for the holiday season. Isabella still wasn't feeling well by Christmas week, when they got back home and were met with frigid New England winter weather. The Atlantic crossing, a dreaded voyage because of how it stole her appetite, had been "one seething storm," she told Lapsley in a Christmas Day greeting. She concluded a holiday message to Berenson with a quip: "No sleep and no food make Mrs. Jack a dull boy."

Twenty-Two

"I ALWAYS KNEW WHERE TO FIND HIM"

1898

Jack Gardner left for a four-week train trip to the West Coast at the start of 1898 to tend to business interests. Isabella didn't mind staying in Boston, surrounded as she was by all her beautiful things. "Inside in this my boudoir, where I am writing, it is charming," she boasted to Berenson in January. "Everywhere bits of Italy. Stuffs, pictures, frames, and on a chair quite near me and the light [is] the little Cima *Madonna*. And downstairs, I feel, are all those glories I could go and look at if I wanted to! Think of that. I can see that *Europa,* that Rembrandt, that Bonifazio, that Velasquez et al. any time I want to." Her contentment wasn't only solitary. Her social calendar was crowded with "14 dinners and 5 balls before Lent." The days when she was left off guest lists were long gone.

On February 7, while rushing down the staircase at a friend's home, she slipped on the last step and fell hard, breaking the fibula of her right leg, just above the ankle. The notice in the *New York Times* declared that

"all social functions of the season in which Mrs. Gardner was interested as a promoter have been declared off." People sent armloads of flowers. Visitors tired her out.

Soon enough, though, she regained her high spirits while holding court in bed, according to Thomas Russell Sullivan, who observed in his diary that she resembled nothing so much as a "French *grande dame*!" Henry James, wishing her well from England, teased her that her "lamentable little accident . . . was the only thing one could think of that had *not yet* happened to you." The *New York Times* reported that she still planned to attend a piano concert at New York's Music Hall shortly after her fall, imagining how she would get there: "She will be lifted from her carriage at the door of the hall, and, after being deposited in a rolling invalid chair, will be wheeled across the floor to her seat." The paper got the location wrong—she didn't go to New York that spring—but the description was nonetheless apt. She arrived at several performances in Boston, to see the wildly popular magician Harry Kellar and hear Walter Damrosch conducting Wagner's *Lohengrin*. *Town Topics* soon observed that "Mrs. Jack Gardner is doing the high rolling act in her wheelchair . . . looking as well as ever."

Isabella was out of plaster by early spring, just in time to host a party of a thousand guests at Green Hill. The aim was to raise money for the Carney Hospital in South Boston, the city's first Catholic hospital, and the Industrial School for Crippled Children (renamed the Cotting School), causes she continued to support. The party also gave her a chance to show off her gardens. Musicians serenaded the crowd, and a profusion of blooming lilacs perfumed the air. The papers particularly praised the Italian garden; one called it the afternoon's "pièce de résistance."

Also in May she welcomed four young artists in residence to Green Hill. Isabella had long supported young artists, among others the musicians Charles Loeffler and George Proctor and the painters Dennis Bunker and Joseph Lindon Smith. But this was new: until now she had not dedicated a specific time and place to her sponsorship. Perhaps she was styling herself after the Renaissance patronesses of art. Isabella's first group included Andreas Andersen, a young painter from Norway; Howard Cushing, a former Groton student who studied five years at the Académie Julian in Paris; John Briggs Potter, also an Académie Julian student, soon to be keeper of paintings at the Museum of Fine Arts; and Edmund C. Tarbell, the most talented

of the four, a popular teacher at the Museum School and part of a newly formed group called the Ten American Painters, which included John Henry Twachtman and Childe Hassam. In the new scheme, the four artists would spend their days at Green Hill and paint in Isabella's gardens for the entire month. (There is no record as to whether they stayed overnight.) They "chose what they want to do," as she explained to Berenson. The artists might use her statuary as models and her gardens to spur ideas for their landscapes.

She loved being with young people—young men especially—and reveled in how this group found inspiration in the verdant settings she had designed. Their accomplishments became her pleasures. "Green Hill is now American Villa Medici: the prix de Brookline instead of the prix de Rome," she told Berenson. She set the scene or tableau and then elevated the romance of the moment. "They paint, they paint," she wrote to Lapsley, while she worked "always in the garden, so it only needs nightingales to make it perfect." Her commitment to this sort of formal patronage would continue on, in many forms; it would be woven into her museum's mission, where up-and-coming artists could commune with her collection for inspiration.

A few months later, she wrote to Berenson, from the Gardners' Beach Hill home, of the relief she felt. "The air from the sea under my window is absolutely delicious," she enthused, and added that "the continuous persuasion of the sea is irresistible! Do you know that sound that I mean?" But she couldn't stay away from her gardens at Green Hill, so she traveled back and forth. Her larkspurs, foxgloves, and Canterbury bells, and Japanese irises were "raking in 1st prizes" at the Horticultural Society competitions.

Isabella's guest book gives a record of her whereabouts that summer, from the North Shore to Brookline to Newport, then Nahant, and back again to Brookline. She was giddy about her time in Newport, as expressed in a letter to Berenson: "Such festivities, such smart people, and such an open-air horse show." From Roque Island, in early August, Belle wrote teasingly to Lapsley—"here it is wild and oh! the things that have gone on—!" She doesn't detail exactly what she meant by "wild," but the exclamation marks in her correspondence suggest a torrent of activity. Even she had to admit to Berenson—it was all "a little too much of everything."

Throughout these first months of 1898, with all the frothy movement, Isabella was also busy with collecting. "Let us aim awfully high," she urged Berenson. Doing so took a fortune, of course, but also luck, decisiveness, and steely nerves. She knew her own mind, knew what she wanted. She coveted her own Madonna by Raphael, the great High Renaissance painter whose exquisite powers of observation, conveyed with liquid-clear colors, inspired a reverence in viewers that was almost "semi-sacred," in Henry James's telling phrase. She pleaded with Berenson to be on the lookout. He finally had a Raphael to offer at the start of 1898, but it wasn't a Madonna. Instead, he advised her to buy Raphael's *Tommaso Inghirami*, a life-size portrait of the early-sixteenth-century papal scribe and librarian. The portly man sits at his desk, quill in hand and dressed in a vibrant red coat and hat. He looks heavenward, which was Raphael's way of disguising his wandering right eye. Berenson described the painting with his usual flair, which also carried the tone of salesmanship, claiming this painting was surely "one of Raphael's two or three best existing portraits." They both knew that no American collection yet boasted a Raphael. He offered it to her for £15,000, saying that if she turned him down, he would be tempted to buy it himself to resell and "make my fortune." In other words, she had to hurry up and decide.

Isabella felt tremendous pressure, pushed and pulled from several sides, including her own ravenous appetite to acquire and to be first. Buying didn't sate her hunger but rather begat more buying. External factors set some limits. American tariffs on imported works of art had just been reestablished with the Dingley Act in 1897, adding another 20 percent to the purchase price of any old master picture. And there was competition. Isabella had been ahead of the New York collectors, but now Andrew Mellon, John D. Rockefeller, Henry Clay Frick, and especially J. P. Morgan were fast joining the high-stakes old masters market, competing for masterpieces with their far greater fortunes. While the Italian elite, once the uncontested holders of the Italian states' wealth of artistic patrimony, had been buffeted by a crumbled economy after the Risorgimento, the union of the country in 1870, Americans had immense financial resources. Frick would turn his Fifth Avenue mansion into a museum to house his enormous collection of Dutch, French, and Italian Renaissance art. Morgan, who "seemed to want all the beautiful

things in the world," as his biographer Jean Strouse notes, scooped up entire collections, estates, and churches and decided later which parts he wanted to keep, eventually giving most of his enormous collection to the Metropolitan Museum of Art in New York. America's future was being stocked with the Old World's past.

OTHER PRESSURES BORE DOWN CLOSER TO HOME. JACK GRUMBLED ABOUT Berenson's frequent letters and the way they tempted Isabella to accumulate more and more. They'd spent an exorbitant amount of money on art in 1897: over $250,000. Isabella cast Berenson as her tempter in a warning flare in January 1898, telling him that Jack "thinks every bad thing of you, and I too am beginning to look upon you as the serpent; I myself being the too-willing Eve; and oh! the price she and I do pay!" There had also been a frustrating misunderstanding with Conalghi, the London firm that Berenson worked with from the start, regarding the painting *Saint George Slaying the Dragon* by the Venetian painter Carlo Crivelli, a work Isabella had bought at the end of 1897. A shipping delay meant the painting had to be stored, for additional fees, until passage could be arranged. This sort of mix-up frustrated Jack. He was very precise about such things. Isabella faulted Conalghi, saying that the firm got confused "too easily" by her instructions; Berenson didn't do much to deflect the blame.

Jack also didn't particularly like the Raphael *Tommaso* for reasons he kept to himself. That made the purchase "quite impossible," as Isabella explained to Berenson at the end of February 1898. She pleaded poverty, saying she had no way to raise funds for the Raphael without Jack, who "hates it." All of this was further complicated when the Gardners learned that Berenson's initial asking price of £15,000 was almost twice the amount set by the owner of the painting. What was going on? Isabella wrote Berenson in early March that the Raphael "affair seems a mystery." Why didn't Berenson let her know the painting could be had for almost half the price he had offered initially? "Mr. G says find out from Berenson," she curtly wrote Berenson, wanting to know the best course of action and whether she should buy the painting directly from the owner. She deflected whatever her misgivings might have been on to Jack as a way to protect her relationship with Berenson.

Berenson quickly replied that the "Inghirami is yours." He had slashed his original asking price from £15,000 to £7,000, explaining that the owner

had agreed to a much lower price, an account Isabella seems to have accepted. Berenson even boasted that she'd gotten "one of Raphael's very greatest works, and for a price that must be considered the greatest bargain of the century." Jack's suspicions deepened.

In fact, Berenson had been double-dipping, or charging fees to *both* Colnaghi and Isabella, without being entirely upfront about it. She had known of his 5 percent dealer fee from the beginning, but he sometimes added to it by also charging a percentage to Colnaghi or elevating the asking price for a piece of art and not letting Isabella know. Otto Gutekunst from Colnaghi urged Berenson to forgo charging his client a percentage and to instead use a flat-fee system. Gutekunst reminded him that they both had been huge beneficiaries of the American woman's spending habits. Berenson worried endlessly over the matter that summer, he lost sleep and got sick, but he refused Gutekunst's advice to charge a flat rate and do so openly, a system that would be less tricky for Isabella. It was as if he was asking to get caught. Berenson's biographer Rachel Cohen speculates that "cheating Gardner was a sort of resolution of the painful position Berenson was in with people who looked down on him but made use of his services." Whatever the case, Isabella's need of him gave him a certain protection. He knew she would dread severing the relationship.

In July he wrote her a cheery, chatty letter, this time with an offer of three paintings from the famed Hope Collection of Deepdene, from an estate in England: *The Storm on the Sea of Galilee* and *A Lady and a Gentleman* by Rembrandt and *A Lesson on the Theorbo* by Gerard ter Borch. There was steep competition for the trio. "As there are at least six buyers waiting for these same pictures, you can imagine my difficulties, and my rejoicing." He added that he did "love to give you the chance of getting the best that the world offers."

"I have just got your letter about those wonderful pictures," she wrote back as soon as she got his letter. She desperately wanted them, saying that his description of *The Storm* had made her "fairly ache for it." Jack was away, but when he returned she would show him the photographs of the paintings that Berenson had sent. Soon after, she wired Berenson YES to all three pictures. Then everything seemed to unravel, as explained by Isabella a month later in a very serious letter to Berenson. "My dear friend," she began, "you must understand what I write and why I write it. There is a terrible row

about you. Undoubtedly, you have heard it all before, and many times. I have been sorry always when I have heard of disparaging things about you; but now the vile things have been said to Mr. Gardner. That is why I am writing. They say (there seem to be many) that you have been dishonest in your money dealings with people who have bought pictures." She relayed that when Jack heard this, he immediately brought up the Raphael picture. She apologized for writing to tell him of her suspicions, but she felt she had to, adding that in reference to the three paintings from the Hope Collection, "Mr. G says 'now we shall see if he is honest.'" She was discomfited by the situation, but also worried, warning Berenson to "always be on your guard."

It is a little unclear what happened next. Isabella wired the purchase price of the three Hope pictures to Berenson's account, saying she'd been in bed sick for a week and ending her brief note with a modest bridge-building question: "how are you?" Berenson replied in two letters, both dated October 18, 1898, but only fragments of the letters remain, most likely because Isabella tore up the parts she didn't want anyone else to read. Berenson is diplomatic in what few lines are left, saying, "Please, dear friend, do not conceive that I am feeling any animosity toward Mr. Gardner." Then he praises her to the skies: "I shall worship you as without exception the most life-enhancing, the most utterly enviable person I have had the good fortune to know." He also reiterates the struggle he had in securing the three paintings for her—"it took all my persuasion, all my threats, and all my influence." In other words, he was worth all her worry.

Though this issue of trusting Berenson would not go away entirely, she was ready to blame the whole fracas on Colnaghi. "And do you understand why I hate Colnaghi," she asked Berenson in a November 7 missive, again referring to how Colnaghi had delayed the delivery of the Crivelli. She wanted to change the topic and talk about friendlier things. "The November gray look is over the land—but I love it," she enthused to Berenson a few weeks later, from Green Hill. "As I write I look over the waving trees, see the dim city beyond . . ." She regaled him with a funny scene at the Somerset Club, where she had recently lunched. "At another table was a man I knew, eating with another I didn't know. This latter turned out to be Dibblee . . ." Benjamin Dibblee was the dashing captain of Harvard's winning football team. "Up got the man I knew," she explained, who "came to me and said, 'Mrs. Gardner would you mind knowing Dibblee; he has asked to be presented?'

Mind? It was the proudest day of my life!" She couldn't help herself; she turned into a giggly schoolgirl around young, handsome athletes. Flirtation, even a description of a flirtation, was also an efficient means of defusing conflict.

THE DAYS TURNED DARKER IN DECEMBER. "WE HAVE HAD SUCH STORMS— snow and wind," Isabella noted to Berenson, with another strong nor'easter expected. Jack had been unusually tired, and in a break from custom, they did not host the family Thanksgiving at Green Hill. She was fighting off a nasty cold, which she blamed on two mishaps, when her carriage hit snowdrifts that made passage on the streets almost impossible, and she was delayed out in the frigid air.

On the freezing cold evening of December 10, Jack dined at the Exchange Club on the corner of Milk and Batterymarch Streets in the city's financial district. This was typical of his routine, particularly if matters had kept him at his office until later in the day. At some point during the evening,

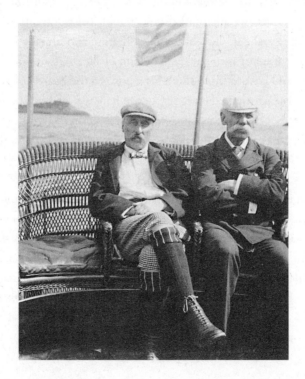

he collapsed after suffering a devastating stroke. He was rushed back to Beacon Street, where Isabella sent for their physician, Dr. Paul Thorndike. It was too late. Jack Gardner died later that evening, shortly before nine o'clock. He had just turned sixty-one.

He seemed to have sensed that something was awry with his health earlier in the fall, but it's not clear whether he confided any concerns to his wife. He worried more than usual about their spending; she no doubt noticed he had slowed down. At some point in these months, he reached out to a lawyer, William C. Endicott Jr., a family cousin, to familiarize him with their estate. Jack wanted to be sure everything was in tip-top order. He also wanted someone Isabella could trust, who was conversant with all facets of her collecting, especially its financial aspects. Jack made his nephew George Peabody Gardner a trustee of the estate, but he gave Isabella access to one of his two trusts, believing she'd know what to do, just as his father John Lowell Gardner Sr. had confidence that she would know how to make Green Hill flourish. As he'd so often done before, Jack was setting her up for success and putting his faith and confidence in her.

Two days later, his obituary in the *Boston Evening Transcript* called him "one of the best-known men in Boston," then listed his public accomplishments: his large stake in the Chicago, Burlington, and Quincy Railroad; his service as longtime treasurer at the Museum of Fine Arts and on the Board of Overseers of Harvard since 1889; his tenure on the board of the Humane Society of Massachusetts. Harvard College had awarded him an honorary degree in 1898, on the occasion of the fortieth anniversary of his class. He had left Harvard before graduation to join his family in Paris in the 1850s, where he first met his dear Belle.

There was some speculation among friends that the Gardners had lived rather apart in their later years, at least when they weren't traveling overseas. Like many couples in long marriages, they had developed somewhat separate lives, with Jack often retiring to one of his men's clubs in the city, as on the night of his stroke, while Belle pursued her array of social occasions. She didn't need his chaperoning. He continued to find her go-go-going interminable. He was a man of habits. He enjoyed working with numbers, keeping lists of all sorts, writing down train schedules to the exact minute. No detail was too small to include. He could seem something of a starched

collar, maybe even dull. He relaxed with his burgundy wine and cigars and newspapers.

But she needed—very badly—what he had given her. Like a partner in a pas de deux, he showcased her moves, not his own. He was the de facto manager of their domestic life, making sure guests felt welcome at dinners, planning menus, keeping track of finances, organizing travel, smoothing hurt feelings and misunderstandings. There were dust-ups. Isabella had been restless in midlife—her flirtation with Frank Crawford was an expression of that. And she could be trying, tyrannical even, "running rough shod" over propriety and expectation, as a friend would later recall. There's a story of how Jack instructed the Gardner household servants to come to him always about their employment, to ignore her when she lost her temper and fired them, as she did on occasion. Once, when Isabella was behaving "uproariously" at a dinner, Jack turned to his table companion and observed, in a quiet voice, that the "trouble with Belle is she never grew up," then added that her immaturity was "a secret of her charm."

Isabella may have had a kind of "perverseness in her conflicted nature," in Morris Carter's evocative phrase, which made her sometimes "trample devotion." But Jack Gardner had been enchanted by his wife. Whatever disagreements they had, whatever confusions or hurt feelings between them—most of this was surface disturbance, ruffled waters on a clear, deep pond. After all, as Carter jotted in his notes, Jack had given her "his heart and himself completely." During their courtship, Jack copied out several lines by the Irish poet Thomas Moore for her, on his stationery embossed with a large *G*, a paper she kept in a small drawer in her black-lacquer sewing box. Its sentiments are affectionate and private and tender. "My Mopsa is little," the poem began, "her cheek is as smooth as the peach's soft down, / and, for blushing, no rose can come near her; / In short, she has woven such / nets round my heart . . ."

A neighbor who lived nearby on Marlborough Street noted how much Belle had secured from the marriage. "It has been interesting, has it not," this neighbor wrote to the philosopher William James, "to see her become more & more of a person through her intelligent cultivation of her taste & powers, & through the affection her husband & all his family have for her—."

FRIENDS AND FAMILY RALLIED AROUND BELLE, SENDING CABLES AND flowers and letters of remembrance. Charles Sprague Sargent, her Brookline neighbor whose house had partly burned and whose wife detested Belle, wrote to remind her that he could help with anything she needed for the gardens at Green Hill. James Whistler, from Paris, wrote: "You may well suppose that I have not only sympathized deeply with you in your great sorrow, but grieved at the loss of one whom all like and who was always so nice and charming to us." Henry James, self-conscious that the news had reached him while traveling, wrote awkwardly from Lamb House in Rye: "I can't tell you why I didn't instantly write you—though I can partly tell you—it was because I felt that I must already have seemed to you dumb and distant, and that consciousness weighed upon me and paralyzed . . ." He stumbled: "I beg you to believe that all the while it has made you only more present to me—and made him so, by the same strange force." He got on better footing: ". . . I think of the kindness and courtesy that, like the generous gentleman he was (and all abundance and health and gaiety as I last saw him) he for such long, long years always showed me . . . What a change in your life!—that is all I dare say to you."

Henry Lee Higginson, a close friend to both Gardners, wrote immediately and with great feeling. "Higgie," as he was called, had grown up with Jack, as privileged boys from Beacon Street homes, playmates in boyhood games on the grassy Common, and students at Harvard College. Higginson had been badly injured in the war, with broken bones and a bullet in his back. A saber's sharp blade had left a long scar across his cheek. Yet despite his own sacrifice, he didn't seem to hold against Jack the fact that he had avoided military service in the war. "My dear Mrs. Gardner," he began: "No words of mine will tell the loss, which Jack's death brings to us all—and if to us, what must it be to you?" When listing his qualities, Higginson knew that Jack's greatest accomplishments were private, domestic. Jack had been "just, reasonable, high-minded, kind, affectionate, considerate, intent on doing another a kindness." A particular line rang out: "Since he was born he has been the same person, and for fifty years I've always known where to find him." No one expressed better what Jack had given Belle.

Jack Gardner's funeral service was held at the Church of the Advent on Brimmer Street at 11 A.M. on December 14. The weather was freezing cold

but bright. His coffin was draped with a purple pall that Belle had bought in Venice. A cross made of fresh violets, the kind of flowers he had so often brought to her, was placed on top. He was buried in the family crypt at Mount Auburn Cemetery in Cambridge, his gravestone set in the wall next to the marker for the couple's little boy, Jackie.

For the rest of Isabella's life, she kept a photograph of Jack above her bed, near the print of Marie Antoinette, the gift he'd bought for her when she had felt unsteady at the start of their marriage. "You are my queen," he told her with his purchase. And so she was.

AN ACHING LONELINESS DESCENDED ON ISABELLA. SHE HAD TROUBLE sleeping or eating. She put on her blackest crepe and silks. A neighbor, Mary Munro, who lived across the street at 173 Beacon Street, recalled a scene most likely from this time. Isabella had taken Mary home in her carriage after an unnamed event, when she suddenly asked Mary "What are you having for dinner tonight?" Mary answered that it would be "very commonplace," something Mrs. G "wouldn't like," just a "New England boiled dinner." The older woman quickly replied: "Oh, I'm so fond of that and my cook never lets me have it." After Mary told her that for company, it would be just her and her doctor husband, Isabella asked: "May I come over?" She stayed on about an hour after dinner. She talked with Dr. Munro about music and listened to him play the violin and viola and the kettle drums, which "greatly amused her." She asked about Mary's hobby of embroidery and other textile arts. According to Mary, it had been "a delightful evening." "She had a great gift of finding out people's interests and drawing them out." As Dr. Munro was about to escort Isabella home, at the front door she called up to Mary, asking: "Whose room is that front room opposite my boudoir?" "That's my guest room," Mary said. The response: "Couldn't you put some kind of signal in the window when you were going to have a boiled dinner, so I might come again?"

Isabella dealt with her grief by throwing herself into work, into a vision she and Jack had shared. Before his death, she had built enormous momentum with her collection. Now she needed everything she had learned to bring to fruition "a beautiful house with beautiful things": her expert eye, all the energy she could muster, and maybe most of all, her fearlessness.

A photograph of her in a later album shows her standing atop a ladder as the exterior of Fenway Court is being built. She wanted to be involved intimately in every aspect of the project, so she often brought a lunch pail to the worksite on the Fenway and ate with the builders, plasterers, and artisans—many of them Italian immigrants with whom she could speak Italian.

She wasn't afraid of heights. Her ascent up the ladder was her ascent up from grief. In the work ahead, she was like a phoenix rising from the ashes, as in the image on the crest that would soon grace her very own museum.

PART V
ONE-WOMAN MUSEUM

It is well to leave one stone on the great heap of human work, isn't it? And you have surely done it.
—HENRY LEE HIGGINSON

Twenty-Three

FENWAY COURT

1899–1901

After the terrible shock of Jack Gardner's death, friends and family gathered around Isabella to give her comfort. In January, the Swedish artist Anders Zorn came for an extended stay at 152 Beacon Street and brought his paints. The two friends knew each other well. Zorn had visited the Gardners at the Palazzo Barbaro over the years, and his 1894 portrait of Belle revealed his deep understanding of her nature. "Z—was very dear and delightful," Gardner wrote to Gaillard Lapsley at the end of January. Zorn worked "like mad all the time" on portraits, each of which she found "perfect in its way," though also "very unlike each other in feeling and handling." Her brother-in-law, Joseph Randolph Coolidge (Julia's husband), seemed to appear on the canvas "at first glance." The artist captured the qualities of the younger Gardner generation too, especially George Peabody Gardner, with his long legs and seriousness. Isabella loved to be around Zorn's exuberance and artistry, telling Lapsley that seeing him at work had been "a great delight to us."

The Australian soprano Nellie Melba, whom Isabella had met two years before, brought all the news from New York. This made Isabella feel "in touch with the world." Melba was a principal soloist at the Metropolitan Opera, where she was performing in that season's production of Charles

Gounod's *Faust*. "She is having amazing success—houses packed, they say," Isabella told Lapsley, relishing her new friend's triumph as if it were her own.

Her nephew Amory Gardner liked to stop by and read to her. Isabella had read aloud to him and his brothers from Dickens novels when they were growing up, and now he returned the favor, bringing along the adventures of Mr. Dooley, a fictional detective who spoke with a strong Irish brogue. She enjoyed reading detective fiction, had a large collection of titles on her shelves, and this serial in the newspaper was all the rage that season.

Though her black-crepe dresses signaled widowhood, Isabella was terrifically busy. Since the end of December, she had been conferring with her architect, Willard T. Sears, whom she had asked some months before to draw up plans to expand her 152 Beacon Street house. Sears was a large man, discreet and confident, who had established his reputation in part on designing New Old South Church in Boston in the 1870s. When he arrived, on December 29, to give his condolences, he brought along preliminary sketches to show. Sears returned the next day to go over several amendments to the plans when Isabella announced that everything would need to change—she had a whole different project in mind. The architect recorded his surprise in his diary: "Called on Mrs. J. L. Gardner at 2 P.M. with the drawings for the Museum at 152 Beacon Street, and she informed me that she had purchased a lot of land 100 ft. by 150 ft. on the Back Bay Park to build the Museum upon. That she wanted me to make new drawings, & to include a small theatre with the Museum . . ." Although she "made no reference to the probable cost of the building," she did want the "drawings made as soon as possible so that they could be referred to in her will."

The exact date when Isabella secured the Fenway lot from the land developer Henry M. White is not known. Sears's account implies she made up her mind from December 29 to December 30, which seems improbable. Maybe she told Sears on his second visit that she *intended to* buy the Fenway lot, not that she'd already done so. In any case, the purchase deed to the Fenway lot is dated January 14, 1899. The document lists George Augustus Gardner's son-in-law, the lawyer Augustus Peabody Loring, of the prestigious firm Ropes and Gray, as the owner. Gardner had to buy the land undercover, with an understanding that she would receive the deed outright in July, six months after Jack Gardner's death, because a purchase of that size and importance—which would make the newspapers—did not conform to

societal expectations for a woman in mourning. The speed of her decision indicates something else—that this plot of land was likely one she and Jack had chosen together. It had been his idea to build the museum on the Fenway, despite her objections that it was too far from the center of town. Now she didn't want the lot to be bought out from under her.

In addition to George Peabody Gardner, Jack Gardner named two more trustees for his estate: his cousin, the esteemed lawyer John Chipman Gray, also of the firm Ropes and Gray, founded in 1865, and Augustus "Gussie" Peabody Gardner, Amory's brother, whom Jack and Isabella had helped raise. The bequest was split into two trusts, one in the amount of $275,000, with the principle reserved for Massachusetts General Hospital, the Museum of Fine Arts, the Boston Lying-In Hospital, and the Brookline Public Library. Isabella had much more control over the larger trust, which totaled a little more than $2 million. Jack's will was specific about this, instructing the trust "to pay over, transfer and convey to my wife or her appointee, the whole, or from time to time, any portion of the trust fund or property then existing in their hands, as she may in writing appoint . . ." In other words, if she wanted to dip into the principal of this second trust, she could do so. The yearly interest income from both trusts totaled a little over $95,000. Jack had gone against custom with the structure of the second trust, giving her more discretion than was usual, an arrangement that raised eyebrows once news of it got around town. After all, Isabella was known for outrageousness rather than prudent judgment. But Jack knew the woman behind the theatrics, the one who worked at her desk surrounded by papers and artworks, carefully making lists and plans. He knew her for her efficient correspondence, her remarkable memory, her careful attention to detail as she compiled written records of her ever-growing collection. Morris Carter later observed in his notes that Jack realized "she had a level head & did not want her to be hampered by lack of funds."

All the while, Berenson sent her letters almost weekly. In a letter dated January 22, 1899, she confessed to him that she'd experienced "too much of mental confusion to really be able to answer letters of a business character." She did have a favor to ask: could he please remind her of what she'd bought from him recently, as well as the works she had rejected?

She also admitted to a newfound uneasiness about money. Jack had taken care of their finances, and now her increased responsibilities made her sometimes feel unsure.

As spring overtook the gardens at Green Hill, a pulse of excitement seemed to quicken her. In mid-May, she told Berenson that she felt "torn in a thousand directions trying to have the necessary, the useful, and the ornamental all done at once. So, I get your letters and read them with joy, between bird and bush, horse and dog, but find time to answer—no—absolutely never!" She was always at her most playful at Green Hill, and this spring season was no exception. She had added a water garden, where "a turtle has heard of it and climbed the hill and plunged in, and now lives there a monastic life." Several days later she wrote of her fox terriers and being "on the hunt for a new variety of lilacs."

The mood of her missives to Berenson, however, changed abruptly at the end of May with a very stern note, which began with this dictum: "Tell me exactly what you paid for the Holbeins." Several months before Berenson had offered her a pair of portraits by the sixteenth-century German-Swiss master Hans Holbein the Younger, court painter to Henry VIII. Berenson wrote a glowing description of the portraits, which depicted Sir William Butts, physician to the king, and his wife Lady Margaret Butts, saying the quality of each painting was "almost as jewel-like as Van Eyck's . . . The modelling is superb, the colouring gorgeous." He told the truth about the quality of the paintings but not their sale price, which he gave as £20,000. She subsequently received a letter from the former owners, stating a different price: £16,000. Now she was convinced there was "something wrong in the transaction." She repeated that she had never liked the London dealer, Colnaghi, returning to the matter of the delay in sending her the Crivelli painting. She reminded Berenson that she had told him she "absolutely did not want to have anything to do with them again . . ." Then she gave a warning: "Before going to the bottom of the Holbein matter myself, I want you to tell me exactly all you know. It looks as if it might be a question of the Law Courts. This I want to avert."

She never brought a lawsuit. In June she wired Berenson his original asking price for the Holbein portraits, but it is not clear from their correspondence that summer exactly how they resolved the discrepancy. A likely scenario: she once again set aside her misgivings about Berenson because

she couldn't bear to lose him, especially so soon after losing Jack. She conveniently blamed a target far more distant—Colnaghi. Berenson was too central to her ambitions. In addition, the paintings she'd gotten through him had already shot up in value, an ascent that was sure to continue. Besides, she had countless things to attend to with the design and construction of her enormous building project.

The process of designing Fenway Court consumed much of Isabella's spring months. Sears's initial renderings of the building, sketched on large sheets of architectural drawing paper, showed a structure that resembled a Georgian house more than a Venetian palazzo along the Grand Canal. Sears reported in his diary in mid-April that Isabella had spent two hours at his offices in the large Mason Building at 70 Kirby Street in downtown Boston to pore over recent plans. She specifically asked that the main entrance of the museum line up more exactly with what would be the midpoint of the central courtyard. She wanted Fenway Court to be built in the style of a fifteenth-century Venetian palazzo but with an ingenious twist. She would turn the palazzo inside out, so that the walls of the large interior courtyard, encircled by three stories of gallery rooms, resembled the exterior walls of the palaces on the Grand Canal. Sears based aspects of his design for the glass ceiling high above the courtyard on her greenhouses at Green Hill, with a pitch steep enough to slough off New England snows. The top floor above the galleries would be a modest-size apartment for Isabella.

The plain facade of the four-story gray brick building would be skirted on the east side by an unusually high garden wall that curved around its northeast corner. Newspapers would report on the "weird wall" as it arose on the worksite, not knowing that the building's unadorned exterior, along with its odd-looking wall, served as a kind of brown paper wrapper that disguised the glittering prize inside.

On a sunny day in June, Isabella rode out in her carriage the two miles from Beacon Street to the Fenway to watch as the first foundation piles were driven into the ground. Olmsted's project to build the Emerald Necklace, a series of parks and waterways connecting Boston's colonial-era Common with newly filled-in city land, was a work in progress. A writer at the time remarked that the whole marshy Fenway area looked "dreary and unpromising." Brackish ooze—part fresh water from the Charles River and part salt water from the Atlantic—gave off a wretched stench. The only trees in view were far in the

distance, in the settled part of the city. The Museum of Fine Arts would open its new building in the Fenway in 1909, very near to Fenway Court, and an assortment of other buildings—apartments, fine houses, college facilities—would soon spring up out of the marsh, but all of that came later.

When Isabella arrived that day in June, she saw the future. As she stepped out of her carriage, she spotted a four-leaf clover growing on the patchy land. She couldn't help but think this was a very good omen. She preserved the emblem of luck in a crystal locket and included it in a vitrine with other keepsakes in the museum. She would claim it was the only four-leaf clover she had ever found.

Isabella hurried back to Europe in July 1899, her first overseas travel without Jack. Ella Lavin, her trusted longtime maid, accompanied her, as did Lena Little, an amateur singer, until she was called away to a family emergency. As plans for the museum became clearer, so did the need to procure more architectural elements: antiques from the fifteenth and sixteenth centuries and reproductions that Gardner could order from Italian workrooms.

She met Berenson for dinner at the Savoy on her arrival in London at the end of July, and they talked not of architectural elements but of paintings and business. This time he told her about a Titian masterpiece, *Sacred and Profane Love*, part of the Borghese collection in Rome. She wanted it very badly, she said, given how much she thought about her *Europa*. But the price was a staggering £160,000, almost three-quarters of a million dollars. She knew that George Peabody Gardner, one of the trustees of Jack Gardner's estate, would think that the price was "insanity," requiring her to pull funds from the principal of the estate. Finally, in late August from the Palazzo Barbaro, she declined Berenson's offer, blaming her nephew's cautious ways. (The painting was not sold to a private buyer. Its owner, Prince Borghese, decided to give his entire collection to his country.)

The London dinner with Berenson may have been a smoothing over of their relationship after the tumultuous spring concerning the Holbein portraits and another painting—Botticelli's *The Virgin and the Child with an Angel*, also called the Chigi Botticelli, after the Italian prince who owned it. The luminous painting showed all of Botticelli's early genius for color and composition and delicate feeling. Richard Norton had alerted Isabella to its sale for an eye-popping $30,000 in late 1898, and she quickly consulted Berenson over the painting's true worth. He replied that he didn't think Prince Chigi

was ready to part with it. She persevered, though the route to purchasing the masterpiece would prove incredibly circuitous. As the historian Patricia Lee Rubin relates, the cast of characters included a "cagey prince, rival dealers, named and unnamed intermediaries, the Italian government, the Russian and German emperors (offstage), and a Rothschild." Berenson played his familiar hidden role, pretending to Isabella that he played no part in the syndicate with Colnaghi, who was handling the sale of the picture. But for all the machinations, Gardner finally secured the masterpiece for £14,500, or $70,000; she would wait another two years for its delivery to Boston.

―――

ISABELLA'S RETURN TO THE PALAZZO BARBARO WAS A HOMECOMING. It connected her to memories of Jack and also spurred ambitions for the future. On Jack's last visit two years before, he had spent some hours measuring the doorways of the palace, so that those in Isabella's museum would precisely replicate the size and scale. The palace's enduring beauty inspired, as it had since she first saw its perfectly proportioned rooms. She liked to rise very early in the mornings and write letters, with the watery sounds of the canal coming in through the open doors and windows. One morning "a grand old *temporale*," or thunderstorm, blew through, "sweeping things clean." She found contentment living "*au niveau de la mer*," as she told Berenson.

Sears wrote to her in those weeks that he had sent her his completed architectural plans for the museum. She asked him when Boston would pave the street in front of her Fenway property and when the rest of the construction pilings would be set in the ground. She told him to refrain from doing anything about arches or pilasters or the large staircase that would connect the first three floors, which was planned for the west side of the building, fronting Worthington Street (now Palace Road). She wanted to assemble all those elements herself, telling him: "It is most interesting and delightful looking up materials here."

Isabella visited a host of dealers and antique shops. The receipt from the dealer Francesco Dorigo, for instance, lists her many purchases, including an antique wellhead or basin, an inset relief of a winged ox, a gracefully carved fragment of a sixteenth-century fireplace apron, and a large stone portal, with the inscription *Ave Maria Gratia Plena*. She also ordered the fabrication of the three-story marble staircase from Dorigo.

Two weeks in Rome after leaving Venice were followed by a brief stay in Genoa—she gave Berenson no reason for her comment "how I hate Genoa." After arriving in Paris, Isabella spent time with Henry Adams, who had found refuge in the city after his wife's death by suicide almost fifteen years before. With Adams, she talked of medieval art and the best books to buy on the subject, and they took a side trip to Chartres to see its jewel-like cathedral, the topic of his later book. Adams noted to a friend, with a tinge of envy, how Isabella that summer had bought up "all the gems she could find in Europe."

After meeting Whistler on a stop in London, she traveled to Rye for a brief visit with Henry James. He gossiped with Charles Eliot Norton about meeting Isabella at Dover "to see all her Van Eycks and Rubenses through the Customs and bring her hither, where three water-colours and four photographs of the Rye School will let her down easily." He called her paintings her "spoils." What Henry James meant by three watercolors and four photographs is not entirely clear, but his jealousy of her "spoils" is plainer, with a sly reference to his recently published novella, *The Spoils of Poynton*, about another aging Mrs. G (Mrs. Gereth) with an old house full of "valuable things." James admired Isabella for her individuality and taste but envied her money and the power it conferred. A mocking tone was the best way to

diminish some of that power; it was even easier to dismiss a woman's power by making reference to her age.

Back in London, Isabella was laid low by a sore throat and a hacking cough, which required, according to her London doctor, recovery at the spa in Bournemouth, where Henry James's sister, Alice, had often gone to convalesce. Isabella hated being there. Sick and lonely, she also dreaded the long voyage home, especially without Jack.

She got back to Boston in mid-December. The "din and the worry" of everything she had set in motion with Fenway Court had to be faced, and her rooms at 152 Beacon Street were too quiet. On Christmas Day, she packed up her roast turkey and cranberry sauce and escaped to Green Hill to dine "in peace" and spend the night, accompanied only by her maid, Ella. As solace, she had a view of the tall trees out of her bedroom window, with a glimpse of the city beyond.

Isabella rallied in the New Year, the one in which she'd celebrate her sixtieth birthday. "Keep well," she wrote to Berenson, adding a line to gather her courage that might also count as one of her creeds: "keep always the power to work. That is the best of all things."

One task she set for herself in these early months was to document her collection in a more thoroughgoing way, a task she found "very slow work." She had much information already—Jack's many lists of their purchases and her own lists of which artworks she kept in which house. Now she wanted to illustrate this documentation with black-and-white photographs—she would use those she had purchased for her travel albums as well as photographs that Berenson had included with his written descriptions of whatever work he was offering her. She asked Berenson to send any information he might know about the provenance of the pictures she had bought through him. "Don't let all this make you cross! I want to be thoroughly *au courant*." On the front page of a large album, she pasted a rather fanciful rendering of its title: *The Isabella Stewart Gardner Museum in the Fenway*. This is most likely the first time she put in writing the official name of the museum, which during her lifetime would be referred to as Fenway Court.

In these same months, she had the idea—Berenson called it a "jolly idea"—of showing part of her collection arranged in several rooms on the

first floor of 152 Beacon Street to an interested paying public. The three-day event in late March would raise money for the building fund of the Industrial School for Crippled Children (now the Cotting School). She charged two dollars for morning tickets and three for an afternoon tour. Her scheme proved wildly popular. She bragged to Berenson that all the tickets had sold out, and over forty people had to be turned away. She ended up raising $1,500. She turned her home into a museum as she was making a museum to be her home. The *Boston Globe*'s review of the event declared 152 Beacon Street the "Mecca of fashionable Boston," noting that hers was "a collection worth going many miles to see."

THESE EFFORTS, HOWEVER, WERE RELATIVELY MINOR COMPARED TO THE task that consumed her waking hours—the enormously complex project on the Fenway. Henry Swift took over the day-to-day money management in July 1900, replacing her nephew George Peabody Gardner. Swift, a lawyer whose own business interests did not take up all his time, was tall and elegant and spoke with a noticeably high voice. Isabella immediately liked him, calling him "my man of business." The architect Willard T. Sears noted this switch in his diary but gave no further explanation; likely this change in roles helped smooth the family waters. Isabella intended to supervise every step of the construction, and she was relentless. Some weeks she went almost daily to the worksite, clambering over scaffolding and climbing ladders to get a better view. She carried a lunch pail and ate her meal at noon, like the rest of the workers. She contributed ten cents for raw oatmeal, which was added to the tank of drinking water to keep it fresh.

She had very specific ideas about every aspect of the building, from footings to rooftop. For instance, she insisted on a design for the foundation that differed from the typical. She wanted the dressed foundation stone, clearly visible above ground, to run the length of the wall, in a straight line. She decided that the foundation's design would follow Italian methods, by which undressed stone of various heights is combined with brick, so the building doesn't seem to float on top of the stone. Instead, the two parts appear to be woven together. This would be the first attempt at this sort of foundation in America, and there was concern initially from all quarters that it might not work on the Fenway's marshy land. Isabella, however, prevailed.

Hundreds of wooden cases, packed with treasures from her recent travels

in Europe, arrived at a large storage facility near the harbor, and she oversaw the unpacking of each case. Every stone or column or capital or sculpture had to be numbered and checked against the shipping list, sorted, then transferred again to one of two large storage sheds built next to the worksite.

Tensions were running high by late summer 1900, when it was time for the marble columns along the perimeter of the inner courtyard to be set in concrete. Isabella had already clashed with two highly skilled stonecutters about the installation of the large stone doorway at the front of the building. The first, John Evans, renowned for his work on Boston's Trinity Church, quit in frustration, telling Sears he "would not be bothered with her anymore," given how she had treated his crew. His replacement, Mr. Sullivan, fared little better; within weeks, Isabella refused to accept his work. Sullivan was furious, and she wanted him fired. Both relented after Sears intervened. Skilled craftsmen, he pleaded to her, were exceedingly hard to find.

Now, in September, the marble columns—of differing colors and finishes and diameters—were ready to be ferried from the harbor to the worksite. Kodak snapshots, likely taken by Isabella herself, with her box camera, convey something of the hubbub of the scene: the workmen uncrating the columns wrapped in protective burlap; their maneuvering of the enormous stylobate lion of Carrara marble into place; the construction debris and the mud.

At every step, she fought with Sears and the city authorities about what she could and could not do. Captain John Damrell, the city's building inspector, was her particular nemesis, especially regarding the use of steel, which his office required in buildings of a certain size, to ensure stability and to reduce fire hazard. She didn't want to use any steel. If Italians could build palazzi that lasted for centuries, surely she could do likewise. She wanted authenticity. But the concern was twofold: the interior spaces in the design were too large for wooden construction without steel support, and imported marble columns might not have sufficient tensile strength for the weight of a four-story structure. She explained the situation to Berenson in March: "I am fighting with architects and city government because I won't have 'Steel Construction'—so I may have to end by having nothing!" She finally relented to having a small marble sample tested by engineers at the Watertown Arsenal. She also allowed some marble columns to be hollowed out and filled with a steel core and made other concessions for steel trusses.

Later, Isabella loved to regale listeners with stories of these battles, relishing especially one exchange with Damrell. "I am well aware that you can stop my building," she had told him. "But in view of what that would mean to Boston, I think it would be folly for you to do so; if however, Fenway Court is to be built at all, it will be built as I wish and not as you wish."

No detail escaped her. When the large wooden beams for the ceiling of the third-floor Gothic Room didn't look sufficiently rough-hewn and medieval, she took an ax to a beam herself to mark it in the way she'd remembered from one of her trips. The workmen sputtered and stammered as she chopped, desperate that she not cut off her foot with the heavy ax, but they followed her example in shaping the rest of the ceiling beams. A similar scenario played out with the high interior walls of the courtyard. The first efforts of the painters working on the surface did not meet her standards. So she got on a ladder herself. She dipped a large sponge in a pail of pink paint and then into a pail of white paint and showed the painters how to daub the mixture onto the wall to mimic the marble of Venetian palazzi.

Isabella had in mind the perfect wall color for several rooms: a shade of deep blue used in the sculpture showroom of Stefano Bardini, an antiquities dealer in Florence. She asked Berenson in March 1900 to "get on a piece of paper the blue colour that Bardini has on his walls. I want the exact tint." Maybe, she speculated, someone could "paint it on a piece of paper." A half

year later she asked about it again, reminding Berenson to "get me a piece of paper painted with the blue of Bardini's walls. You know you promised this before. I am working hard over my new house." He made a few excuses for his delay, then quickly sent a sample, along with the recipe for creating it.

Sometimes Isabella's attention to detail narrowed into capriciousness. Sears's diary is littered with these moments, from the start of the project to its finish. She despaired at the ineptitude or inefficiency of on-site workers. She canceled, on the spot, a builder's contract for oak floors because he was late in delivering the supplies; she fired a plumber when his work displeased her. A cycle developed: she would approve a design element or a fabrication, Sears would instruct the workmen, she would inspect the work, and then she would insist that no, she had not given her approval. Or she said she had changed her mind. Walls went up one day; the same walls were torn down the next. It seems that Sears kept his temper, even in his diary, but he protected himself by writing down what she said and did. He also hired an able and genial assistant, Edward Nichols, whom he sent to Fenway Court as needed to meet with Isabella and mediate disputes.

Labor relations also improved due to the many skills of Teobaldo Travi, an Italian immigrant whom one of the contractors had hired. Everyone called him by his nickname, "Bolgi." Not only did he have an intimate knowledge of the building materials and methods of his native country, but he and Gardner could talk in Italian together. He humored her and understood her. He protected workmen from her wrath, just as Jack Gardner had done when she lost her temper with their servants from time to time. Isabella soon elevated Bolgi to overseer of architectural materials—their transport and installation. He became the de facto foreman, and together they came up with a scheme to communicate with the rest of the crew. He would play his coronet according to a code: "one toot for mason; two for the steamfitter, three for the plumber; four for the carpenter; five for the plasterer; six for the painter."

With Fenway Court Isabella was attempting something sui generis. She could not talk with a friend to ask how an art museum is built and run. Her accomplishment seems inevitable after the fact, but from her

point of view at the time, it was far from that. The expense of it all alarmed her. Maybe this time she had aimed too high. At moments she despaired that things might fall apart altogether. As she exclaimed to Berenson, after yet another frustrating tussle, "This ungrateful America, with its tariff and building laws and petty ignorant officials is fast persuading me to give up the whole Museum idea. Every man's hand is against me . . ."

She was a woman on her own, a fact she sometimes felt keenly. When the city wanted to install a streetlamp and a hydrant on her property, she exclaimed to Henry Swift, "It is always the same old story of the lone woman who is taken advantage of." On December 1, 1900, she and six others gathered to incorporate the museum. Around the table sat her newly minted board of directors: Harold Jefferson Coolidge, William Amory Gardner, John Chipman Gray, Charles L. Pierson, Willard T. Sears, and Henry Swift. They were all family and friends—associates who had earned her trust. They agreed to constitute a corporation with bylaws and a charter that stated its aims: "for the purpose of art education, especially by the public exhibition of works of art." In shares of ten dollars each, capital stock was set at $50,000. Isabella was, of course, the only woman at the table.

Certainly simpler options had been available to her. One way to put her treasures on view for the public would be to donate them to Harvard College or the Museum of Fine Arts, as had the avid Boston collector Susan D. Warren. Mrs. Potter Palmer, whom Isabella had met at the 1893 exposition, would give her entire collection to the Art Institute of Chicago. If Isabella had done this, the professionals would have decided how to display the objects she had so carefully acquired. Donating such a collection signaled the taste, social status, and wealth of the giver, but not more. And Isabella wanted more, far more, than a wall plaque to honor a donation.

ISABELLA MOVED TO THE TOP FLOOR OF FENWAY COURT IN THE EARLY winter of 1901. The interior of the building, including her apartment, wasn't finished yet. She had insisted the workmen re-create her bedroom as it had been on Beacon Street. Her first night at Fenway Court was December 19. The next morning the workmen placed the Medusa mosaic in the courtyard floor. To celebrate the holiday season and to mark this moment, she held a midnight

service in the third-floor chapel in the museum's southeast corner. The rector of the Church of the Advent officiated, an occasion that must have brought some familiar spiritual comfort. Candlelight illuminated the extraordinary Bardini Blue on the chapel walls, the color of an evening sky. A sixteenth-century choir stall from Venice, which Isabella had bought through Daniel Curtis, lined one wall. High above the large window at the front of the chapel, she placed her first old master purchase, the Madonna by Zurbarán, which she had acquired on her 1888 trip to Spain—a painting that had, in a way, started it all. (She moved this painting to the first-floor Spanish Chapel in 1915.)

Five years before she had written to Berenson, "I think I shall call my museum the *Borgo Allegro*—the very thought of it is such a joy." Now, on Christmas Eve, she wrote him a greeting: "I send a dear little Kodak of my new house. Please like it. The proportions are wonderful. Quite the best I know." She would take the whole next year to design and furnish each gallery, putting one object next to another, a chair here or a carpet there, then probably standing back to take in the whole view. Soon the process would start again, as she moved objects until their arrangement pleased her.

Soon after finishing, she asked the Boston architecture and landscape photographer Thomas E. Marr to photograph Fenway Court's galleries and individual artworks. As early as 1900, Marr had documented Isabella's homes at 152 Beacon Street and at Green Hill. He had a particular "command of lighting," as the photography scholar Casey Riley rightly notes. Whether photographing Isabella's domestic rooms, conservatories, and gardens, masterpiece paintings, or her monumental gallery spaces, his images convey—in Riley's phrase—both "visual scale and material details." His use of the silver gelatin printing process made his images seem to shimmer. Now Isabella secured a visual record of what she had accomplished at Fenway Court, one she would continue updating with an eye toward safeguarding her legacy.

For her, the collection in its entirety, not simply individual objects, was what made meaning, like words gathered in a sentence. She had a reputation as a wonderful letter writer, with lines full of wit and surprise. Anders Zorn once told her that "your letters make me love life." But the world she built at Fenway Court was made not of words but of stone and color and flower and paint and object. In the furnishing of each room, she would reveal the chambers of her own heart.

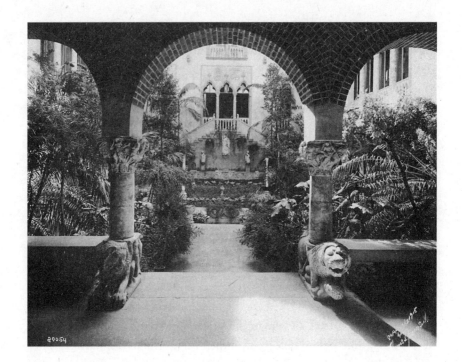

Twenty-Four

GOD IS IN THE DETAILS

1902–3

Fenway Court is not a singular accomplishment but the accumulation of a series of choices made by its creator over a long time. Morris Carter called the museum a "human document," rightly highlighting its deeply personal qualities. Moving from grand to intimate, from the light of the courtyard to shadowed galleries and back creates a symphony of mood and feeling, much like walking through Venice, the city that inspired Isabella. And yet, though Fenway Court represents a backward glance to older civilizations and traditions, there is also something brand-new about it. While Isabella displayed her collection in a palace of great wealth, akin to the settings in which most European art had been viewed for centuries, her decision to display her collection in this way was innovative in the American context. Also, she drew like and unlike objects into close relation, objects from different countries and eras, by artists working in many media. She did not explain why. Her highest aspiration was to move and surprise the viewer, favoring an immersive experience over her particular interpretation. She had come to her life

in art through trusting her emotions and intellect and instincts. Now for her museum she invited visitors into a freedom to ponder and decide for themselves.

Isabella's assembled images and objects compose a sequence reminiscent of a narrative or plot. First this happens, and then around a corner something else comes into view, and then the viewer stands before another unexpected tableau. The former curator Alan Chong notes the similarities between Fenway Court and a late Henry James novel, particularly the way both the museum and James's later works shift in points of view, resisting easy or obvious meanings.

The American artist John La Farge also looked to literature for an apt comparison—not to fiction but to poetry, likening Fenway Court to a poem "woven into the shape of a house by a mind recalling likings and the memories of the past." Isabella had witnessed a concentrated beauty, like the compression of a poem, when as a young girl she walked through the Poldi Pezzoli, the house museum in Milan. It had an effect on her she never forgot, one that she took with her into a future that had now arrived.

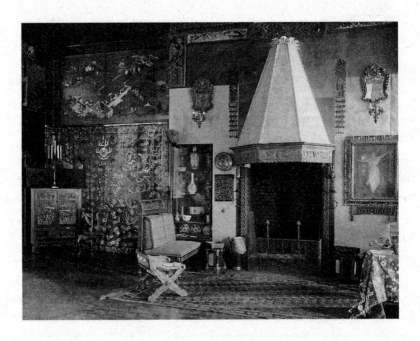

A walk up the Venetian staircase to the museum's second floor leads to a gallery Isabella called her Chinese Room. As Alan Chong points out, it wasn't really Chinese. Instead it's a gathering of objects from several sources, including Isabella's travels in Asia and the flurry of buying she started in 1901 at auctions held by the Boston dealers Bunkio Matsuki and Yamanaka Sadajirō—the latter had set up his popular showroom on Boylston Street in 1899. In this first room, Isabella displayed a whole range of large carved wooden panels, elaborate embroidered fabrics, a lacquered table, and jade figures of various animals. There were pieces she purchased in this time that she did not put in the gallery, in particular the three enormous gilded bronze Buddhas from China, which William Sturgis Bigelow had advised her to buy. Interestingly, she put these sculptures, along with other items, in storage, as if she was already imagining a larger display at a later time. For now, the room with its diffuse and "random Orientalism" functioned to greet visitors, with Mancini's portrait of Jack and Zorn's portrait of Isabella prominently displayed as a kind of visual welcome and a reminder of the guiding spirit behind the museum experience. (Isabella later transformed this room into a gallery for early Italian art and created a new Chinese Room in a lower corner of the museum.)

The next second-floor gallery was named after the great master of the High Renaissance. Raphael's portrait of Cardinal Inghirami, the purchase that had given Isabella so much trouble with Berenson several years before, takes pride of place in the far corner on the east wall, illuminated by a large outside window. Isabella put another much smaller painting by Raphael, *Lamentation over the Dead Christ*, with its jewel-like colors, nearby, on top of a small desk with a chair in front of it, creating an unexpected layering of visual elements. This was not a typical museum setting, but a place of contemplation. Crivelli's dynamic *Saint George Slaying the Dragon*, from the fifteenth century, is nearby, and next to it, but with a large doorway in between, is her prized *Lucretia* by Botticelli. Below the Botticelli sits a fifteenth-century Sienese cassone containing a chasuble (ecclesiastical vestment) and a Turkish textile. She had purchased the beautifully carved and gilded chest (one of two cassoni in the room) at the same time as the Botticelli painting, in 1894, and had placed them together at 152 Beacon Street. She was incorporating into her museum familiar combinations she

had test-run in her homes and looked at for years before unveiling them in her museum. She draped an eighteenth-century red velvet with a fleur-de-lis design over the lid of the cassone; a peek inside reveals a rare eighteenth-century Cavelli guitar cradled in more lush fabrics.

On the other side of the room is *The Annunciation,* which Isabella bought in 1900 for $30,000 as a work by Fiorenzo di Lorenzo. (It has been identified subsequently as by Piermatteo D'Amelia, a fifteenth-century Umbrian artist.) The archangel Gabriel conveys the news to the Virgin Mary that she will bear the child of God, with the white dove of the Holy Spirit in flight between them. The space they occupy is defined by barrel vaults overhead and an ever-receding black-and-white marble floor. It is a masterpiece of pictorial perspective, the Renaissance innovation of conveying a three-dimensional view on a flat surface. It was one of Isabella's favorite acquisitions during these years of building the museum, not because of its painter per se, but perhaps because it depicted a scene of expectation, the moment when the human is touched by the divine and the future is foretold.

Numerous paintings of the Madonna and child decorate the walls of the large room, including compositions by Francesco Botticini, Francesco Pesellino, Cima da Conegliano, Francesco Francia, and Giovanni Bellini (a work Isabella added in 1922). She put a highly decorated Nativity scene by the late-fourteenth-century painter Francesc Comes the Younger, painter to the king of Aragon, high above one of the doorways. On the wall opposite the Raphaels is a work of tempera and oil on wood by an unnamed fifteenth-century northern Italian painter titled *The Virgin and Child in the Clouds.* Holy angel heads float on watery clouds on either side of mother

and child, her long fingers cradling the toddler, who looks as if he has just learned to stand. She is draped in a beautifully patterned gold-and-red-velvet cape with a light-green lining. Jack Gardner bought this painting for Isabella as a Christmas gift in 1892 from a dealer in Venice for $500.

Near Piermatteo's *Annunciation* and against the wall pierced with interior windows that overlook the courtyard, Isabella placed a tall nineteenth-century cabinet made of black-painted walnut and inlaid with an intricate pearl design. On top of the cabinet, at approximately head level, is a single object: a marble foot from the sixteenth century. This room is filled with many more examples of statuary and decoration from ancient Greece and Rome, the wellspring of the Renaissance. A large marble bowl with two climbing lions on its rim, from 170 to 210 C.E. purchased in Rome in 1897 on the advice of Joseph Lindon Smith, tops a first-century. C.E. marble pedestal that came into Isabella's collection in 1903. But this fragment of a single foot, almost life-size, and its placement at face level suggesting a possible "foot in the mouth," is characteristic of Gardner's wit. And also—tenderly—the marble foot is a visual rhyme (as former curator Christina Nielsen suggests) with the baby's foot cradled by Mary in the adjacent *Virgin and Child* by Cima da Conegliano, making a viewer pause at the painting's portrayal of the maternal bond.

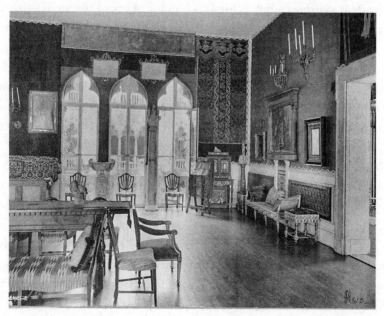

Isabella had used electrical lighting at Beacon Street to showcase Titian's *Europa*. New England weather was often cloudy, and it was difficult to see into dim corners unlit by windows. After haggling with the city, she decided not to electrify the museum galleries. The rooms would be lit as a palazzo was—by daylight and by candles and firelight. And so, six large iron sconces and two pairs of French sconces, made of crystal and brass, dot the walls of the Raphael Room. She did, however, put in some other modern conveniences—an elevator that ran from the first to the fourth floor and a telephone, which had a special line to the local police department. She would add to the room in future years, including a Madonna and child by Giovanni Bellini as well as the enormous Venetian fireplace, with its motto "Motion and Light," which she had first put in her music room at Green Hill. She flanked the fireplace with two large hangings covered with intricate sequined embroidery, which sparkled in the firelight.

Several motifs of the Renaissance run through the Raphael Room, including a reverence for ancient Greece and Rome and the innovation of perspective. The dominant motif, however, is women's lives, specifically motherhood and home. The woman most revered in the Renaissance for her virtue and maternity was, of course, the Madonna, and there are more depictions of her in this room than in almost any other. *Lucretia,* with its graphic scenes of violence, is a jarring counterexample, a warning of what happens to a virtuous woman who disobeys.

Isabella draped luxurious woven textiles, a woman's prized possession, over the cassoni, which would have stored the intimate goods of marriage—undergarments, bolts of linen, sewing necessities. The walls of the room are covered in rich, ruby-colored textiles. She understood how shiny damasks, brocades, and brocatelles enliven a space by scattering light and moving the eye. She offset those textures with panels of plush red velvet, which do the opposite—they soften and stifle light. To achieve these effects, she covered one wall with thirty-two different swatches of fabric. In keeping with the theme of the room, several damask panels have embedded in the weave discreet symbols of the Virgin Mary. Running along the ceiling line and the corners, Isabella used trim salvaged from the red drawing room at Beacon Street, a delicate vinelike pattern made of carved wood and painted bright white. Rumor had it that Isabella favored the Raphael Room over all the other galleries.

It is not entirely clear from the records when in 1902 she installed each gallery. At the start of the year, she told Berenson, writing while on a visit to Chicago, that her "house is only partly done; a year more is necessary . . ." But its outlines were clear enough in January 1902 for Elizabeth Agassiz, Ida Agassiz Higginson's stepmother, now eighty years old, to come for a morning visit. Agassiz observed in her diary: "There is but one thing to be said,—what the newspapers call her 'palace' is simply a beautiful creation . . ." If the timeline is uncertain, Isabella's total involvement in furnishing every room is not. For instance, the notes she made specifying where each painting would be hung are clearly visible on the architectural plan that Sears sent to her in Venice in 1900. She employed many of the design strategies she used in the Raphael Room in the other galleries intended for public view: the Dutch Room and the Chinese Room on the second floor; the Veronese Room and the Titian Room on the third floor. Smaller rooms on the first floor were reserved for separate men's and women's receiving rooms and an apartment for guests. Matthew Stewart Prichard, a young curator from England who had just started working at the Museum of Fine Arts, lived for a time in the apartment during the museum's construction. (These rooms were later reworked as the Yellow Room and the Blue Room, and the apartment where Prichard stayed became the Macknight Room.)

It was all a risk. This mishmash of old and new could have been a monumental and embarrassing failure. At some point Isabella copied out on a slip of her stationery a poem by her friend Thomas Bailey Aldrich, the longtime editor of the *Atlantic Monthly*. Its lines read like a brace against failure: "Build as thou will—unspoiled by praise or blame / Build as thou will; and as thy light is given / Then if at last the airy structure fall / Divide & vanish—Take thyself no shame— / They fail, and they alone, who have not striven." She realized that her vision demanded a damn-them-all bravery as well as a great eye, organizational skill, and physical stamina. She found the work wholly absorbing.

Her letters that spring and summer convey something of her happiness. From Fenway Court, she exclaimed to Berenson in April: "What an Easter. Pure joy." Three weeks later, from Green Hill, she wrote again: "This place this morning is as good as heaven. If you were only here and could breathe the air!" She added that she had to "go to work," though she wasn't complaining. Sure, she missed Venice. It was an even-numbered year, when

she might otherwise have been traveling. She told Berenson that when she thought about the city on the water, "half of me seems gone." But she had her future. As she told Mary Berenson as late as that November: "I still go daily, dinner pail in hand to my Fenway Court work..."

By Thanksgiving, Isabella could see the finish line, calling her friend, the singer Nellie Melba, with the good news on the newly installed telephone. Melba would remember the distinct "note of triumph in her voice." Isabella planned to move fully into her apartment on the fourth floor of the palace before the Christmas holiday. "Finished," she wryly noted to Mary Berenson in a letter, "will, of course, always mean a lot more to do..."

On a clear and cold night, New Year's 1903, Isabella Stewart Gardner welcomed a large gathering of almost three hundred guests for the opening night celebration of Fenway Court. At sixty-three, she was still lithe and lively, in full command of an evening she had planned to its last detail. She dressed in a gown of black silk crepe, with her signature rope of pearls around her neck, a look reminiscent of her 1888 Sargent portrait. An aigrette of pearls and two enormous diamonds adorned her hair. A news-

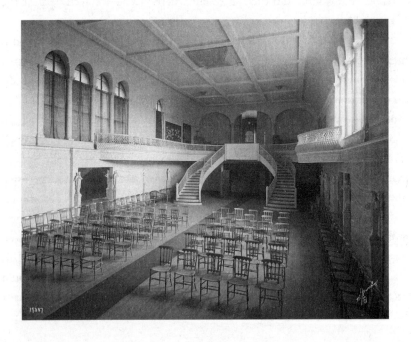

paper (unnamed in the records) reported that her "long flowing black lace sleeves were an original feature of her costume" and that she looked as she intended—"very regal."

Guests descended from their carriages and walked under a long wooden awning, expressly built for the occasion, through the large wrought-iron gates at the front of the museum. The guest list included Charles Eliot Norton, now seventy-five years old, and his daughter, Sara Norton; the philosopher William James; a young Edith Wharton, flush with early success with her short stories and now in the midst of writing her first novel. Julia Ward Howe, who had penned the lyrics of "The Battle Hymn of the Republic" forty years before, arrived looking magnificent, her hair white and and her dress black silk, with an intricate lace collar.

Guards wearing coats trimmed in fur led everyone from wintry darkness through an entryway into a music room two stories tall. The white plaster walls were decorated with a low-relief pattern that mimicked the curtains of an Old World concert hall. A horseshoe staircase at the back faced a large stage at the front. Wood blazed in the fireplace; Isabella hated the smell of burning coal. Bird's-eye-maple chairs with wicker seats were lined up in strict rows on the pale wood floor. She wanted the best acoustics money could buy. The concert started promptly at 9 P.M. Isabella sat alone in a large Italian chair on the balcony at the top of the staircase, regally overlooking the crowd. Fifty members of the Boston Symphony Orchestra played a Bach chorale, selections by Chausson and Schumann, and Mozart's overture to *The Magic Flute*, conducted by the orchestra's director, Wilhelm Gericke. She paid each of the nine singers from the Cecilia Society $100 in gold.

After the musical salute, two large mirrored walls were opened to unveil the grand inner courtyard, ringed by three stories of galleries. It was a wonderful surprise, as if Isabella were unwrapping Venice itself on the Fenway. Everyone fell silent. Candlelit brass lanterns hung on long chains above an interior dressed in greenery—enormous palm trees and native ferns, blooming roses and violets and orchids. Fruit trees filled the air with fragrance. Flame-colored lantern globes decorated the eight balconies that had once graced the facade of the Venetian palace Ca'd'Oro. Flickering light mingled with shadows on the hand-colored pinkish walls. The sound of the fountain at the front of the courtyard recalled the watery music of the Grand Canal,

and birdsong could be heard, though the cages that held the birds were hidden. The ancient goddesses Artemis and Persephone stood tall on their pedestals. In the middle of the courtyard floor was the third-century Roman marble mosaic with its snake-wreathed head of Medusa, aglow in the moonlight shining through the glass roof high above.

Fires were lit in every fireplace, and a champagne supper was served on small tables in the Dutch Room, which had an ideal view of the courtyard. Portraits by Rubens and Rembrandt, van Dyck and Dürer, which Isabella had hung on walls covered with soft green textiles, could be glimpsed over the guests' shoulders. She served doughnuts and champagne and nothing else, or at least that was the story that went around. On the third floor, in the Titian Room, *Europa* took center stage. Along the lower edge of the masterwork ran a large panel of pale-green satin fabric, with a tassel pattern and glistening silver thread. Isabella had salvaged it from a Worth-designed gown and set it within its own frame. Did visitors ask her about *Europa,* one of her most important paintings, or the complementary swatch of fabric? Or did they peer over the balcony to the courtyard below and comment on the Roman throne, with its stone footstool, at the edge of the image of Medusa, which seemed to peer back up at them?

There were grumblings about the evening, to be sure. Some said it was far too cold in the galleries. Cornelia Bowditch, wife of the archaeologist Charles Pickering Bowditch, quipped, after shivering her way through the museum's rooms, that Isabella had by the end of the evening added "a *freeze* of Best Boston" to her collection. Some attendees seethed at their host's queenliness, especially how she insisted that guests, before the orchestra's performance in the music hall, hike up the staircase to greet her, seated in her high-backed chair, and then hike back down, as if they were her subjects, not her fellow citizens and friends. Another much-passed-on story was Edith Wharton's remark that refreshments were no better than what was offered at a railroad restaurant in provincial France. She had whispered this in French, not realizing that Isabella understood French perfectly.

On the whole, the opening night proved a triumph. Newspapers gasped for ways to describe the occasion. The music critic William Apthorp, in the *Boston Evening Transcript,* raved about the perfect acoustics, comparing Fenway Court's music hall to one of the best in Europe, the Conservatoire in Paris, which had exquisite resonance without any echo. The *Boston Post* the

next day ended its account by saying that the occasion "will long be memorable in society annals." Letters poured in to Isabella. Julia Ward Howe called Fenway Court simply "your house beautiful," a knowing allusion to the palace on Hill Difficulty in *Pilgrim's Progress*. Charles Eliot Norton wrote admiringly of how her "poetic conception has found a poetic expression." Wilhelm Gericke kept saying, in his note from two days after the opening, that he couldn't find words to describe his impressions of her "wonderpalace" or adequately express his "highest admiration for your knowledge about history, art, and architecture." Even William James sounded a bit breathless, writing of how deeply moved he was by the new museum: "the aesthetic perfection of all things . . . seemed to have a peculiar effect on the company, making them quiet and docile and self-forgetful and kind . . . It was a very extraordinary and wonderful moral influence . . . quite in the line of a Gospel miracle!"

Isabella was enormously pleased. In the first weeks of the New Year, she told Norton, who had introduced her to Dante and rare books and collecting all those years ago, that she'd been "completely turned by your praise" of Fenway Court. Berenson had not attended the opening festivities, though she had begged him to come, wanting to share the triumph with him. His health had broken down after finally finishing his own magnum opus, *The Drawings of the Florentine Painters* (1903), the first complete catalog of old master drawings and a lasting multivolume work of scholarship. Seeing her museum in person would have to wait. Isabella sent him a brief note, written with more understatement than was her usual style: "All went well, and really I was delighted with the way everything looked."

<p style="text-align:center">⚜</p>

ON A SNOWY FEBRUARY 23, ISABELLA OPENED THE DOORS OF FENWAY Court to the wider public for the first time. It was front page news for the *Boston Daily Globe;* its headline blared "Mrs. Gardner's Art Museum Opened to Public Inspection." The sub-headline was equally telling: "Courtyard a Wonder Scene of Summer Beauty Amid Midwinter's Cold and Snow." The reporter marveled at the novelty and surprise of the masses of blooming flowers in the courtyard: jonquils, petunia, daisies, and geraniums. Isabella planned for the museum to be open the first and third Monday and Tuesday of every month, from 11 A.M. to 3 P.M. Tickets cost a dollar and had to be

purchased ahead of time, with no more than two hundred visitors admitted on a single day. Ten police officers stood guard, and each gallery room had a woman attendant to oversee visitors.

Something hard to remember in an image-saturated age: though comprehensive art museums had opened in post-bellum America with some regularity—in New York in 1870; Philadelphia in 1874; Boston in 1876—and artwork could be reproduced in black-and-white photographs and colored prints, Americans actually had few chances to see a good deal of art all at once, and certainly not in this idiosyncratic way. The thrill of doing so was almost "beyond words," according to Morris Carter. Visitors were transfixed, transported to another place and time, which had been Isabella's intent. Fanny Baker Ames, a leading suffragist and board member of the newly formed Simmons College, Isabella's near neighbor on the Fenway, expressed a common theme of several letter writers that spring: "Our life in America is so often banal, and so far as beauty is concerned, so Sahara-like, that we owe a more than common debt of gratitude to one who gives us such a chance to see Beauty so enthroned in harmonious surroundings."

Twenty-Five

UNFATHOMABLE HEART

1903–4

Isabella had put all she knew and felt into Fenway Court. In the months following its debut, everything seemed like a postscript. An inevitable question hung in the air—now what? John Singer Sargent captured something of this uncertainty in the watercolor he sketched of Isabella soon after opening night, as she stood beside marble pillars in the museum's courtyard. She is bundled in furs, her body turned in profile, but her head turns to Sargent, as if he's calling her name. Her posture is as upright as the columns. Her fair hair is only just visible under her fur hat. Greenery and pale-pink blooms contrast with her wintry garb. Sargent left her facial features a blur, with only a faint pencil line indicating her left eye. It may be that she was wearing a veil of some kind, one of her signature accessories. Whatever the case, she is more statue than woman, as if inscrutable in this triumphant moment, even to a friend like Sargent.

A few months after the New Year's opening, the *New York Sun* published a profile of Gardner, which portrayed her in familiar terms: "No more self-contained woman lives," the newspaper proclaimed. "She plays a big part in the social world, but she plays it alone." Henry Adams would tell her in a letter

after his first visit to Fenway Court: "You are a creator, and stand alone." In early January 1904, she used the same language in a letter to Bernard Berenson: "I fancy no one is quite as alone in the world as I, or with no one to care." It was unlike her to admit such vulnerability. She thanked him rather dramatically for thinking of her, saying, "it made me glad and happy" to know he cared. She wrote to him six months later, again saying: "You ask if I am happy? Oh yes, I want to be—and when I don't feel alone, I am." She said once that she was afraid of only one thing—the dark. Now she lived on the fourth floor of an enormous palace that filled with darkness at the end of every day.

Isabella had gone from collector to museum-maker, a turn that enhanced her stature and cultural authority. Other American men and women were amassing large and important art collections. Turn-of-the-century industrialists, railroad magnates, and bankers continued to pour their vast fortunes into an increasingly frenzied art market. Mrs. Potter Palmer in Chicago bought a trove of paintings by French impressionists during the run-up to the 1893 exposition, a collection that Isabella had seen when she attended. But she was the only American collector at this time who had designed and built, from the ground up, a new structure to house her collection for public view. That was new.

The day-to-day mechanics of running a museum were not entirely obvious. Conundrums and practical concerns piled up. Fenway Court was somewhat closer to a *Wunderkammer*, or cabinet of curiosities, than an art museum like those in Boston, New York, Chicago, or Philadelphia, where artwork was displayed to convey a chronological narrative of change and progress. Isabella needed some way to guide visitors from room to room, without allowing them to sit on the priceless furniture or pick up objects or stand too close to the paintings. Early on, a woman took out a small pair of scissors, wanting to clip a scrap from one of the wall tapestries to study its weave. She was stopped only just in time.

Isabella's solutions to these problems sometimes created more difficulties. She favored offering tickets to teachers of art and art history but then forbade any sketching or notetaking in the museum, putting visitors in an exasperating bind. She was especially keen that local college students have access, but the ticket fee of a dollar (about $35 today) was considered awfully high. Visitors could consult a small paper catalog, on sale for twenty-five

cents, as a guide through the galleries; it listed the most important paintings and some limited information on provenance. No wall labels or signs gave the titles of the works or the artists' names; Isabella did not want to break the illusion of being in a Venetian palace. The *Boston Daily Globe* critiqued her strategy in its first review of the museum, noting visitors' frustration with a catalog deemed inadequate. The booklet gave "so little information as to be rather an aggravation than a help," the paper complained. "It only stimulated curiosity to know something more," especially given that so many objects "suggested possibilities of a history full of interest."

By mid-March, she was overwhelmed. Corinna Lindon Smith, Joseph Lindon Smith's wife, early on served as a gallery attendant. She remembered how Isabella was "a bundle of nerves" by the end of a public visiting day. She followed people around, scolded them if they broke the rules, feared for her collection. She told Henry Swift that the "past weeks have taught me a great deal," explaining that her "experiment of exhibiting to the public this spring has proved to me that it is absolutely impossible for me to live such a life as the present exhibition entails." She didn't yet know the remedy.

YET FOR ALL HER DIFFICULTY IN RUNNING A PUBLIC MUSEUM AND HER sometimes intense feelings of loneliness, these days were leavened with pleasure and friendship. From the start, Isabella was determined to animate the palace with artists and performers of all kinds, an expansion of the salons she had presided over at Green Hill, 152 Beacon Street, and the Palazzo Barbaro. She collected artists and writers and musicians as she collected art: the more the better. They had something she wanted to surround herself with: talent. And they brought life to Fenway Court and pointed to the future. The artists, in turn, benefited from her largesse and enthusiasm. She didn't always choose well—George Proctor's piano playing was more hope than glory, though she never gave up on him.

Isabella invited John Singer Sargent to be the museum's inaugural artist in residence for the spring of 1903, when he was at the peak of his fame and powers. (This program continues at the museum.) That February, he was a guest at the White House, after President Theodore Roosevelt had commissioned an official portrait. The young president refused to pose for more

than thirty minutes at a time and at one point questioned Sargent's expertise. Sargent explained to Isabella from D.C.: "every day it gets more and more difficult . . ." Much wrangling ensued. Sargent memorably remarked that working with the president made him feel like "a rabbit in the presence of a boa constrictor." Painter and subject finally hit on a solution: they had Roosevelt pose on the landing of a staircase, his right hand holding the globe-like newel post as if he were master of the world. Roosevelt loved the final painting—all vigor and confidence.

Sargent arrived at Fenway Court at last in early April, with his "trains of baggage" full of canvases and paint. He settled into a small, first-floor apartment, where Matthew Stewart Prichard had stayed in 1902 and which is now the Macknight Room. The large Gothic Room on the third floor would be Sargent's studio, a space Isabella reserved for her private use during her lifetime, along with the chapel at the end of the Long Gallery. She had already designed and furnished most of it, imbuing it with a medieval aura inspired by her visits to Gothic cathedrals.

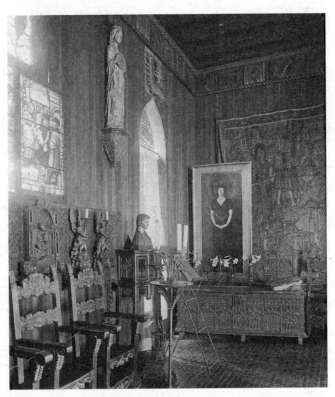

Terra-cotta tiles cover the floor, and the long tables and solidly built chairs in the middle of the room are from France and Germany. A large Spanish wheel window and stained-glass windows from Milan cathedral punctuate the far wall. Isabella hung the Holbein portraits at the room's entrance, while Simone Martini's small, exquisite gold-ground panel *Virgin and Child over Saints,* from 1325, forms part of a devotional table. A large fourteenth-century French sculpture of painted limestone, the figure of Mary holding her child, stands on a pedestal set high on the wall between windows that overlook the courtyard. Much like the stance familiar to any mother, her hip is slightly cocked to counterbalance the weight of her little one. On the wall next to the statue is a large fragment of tapestry from early-sixteenth-century Flanders nearly a meter square, depicting a field of flowers and woven of silk and wool. Across the way, looming in the far corner, is Sargent's own masterpiece, his 1888 portrait of Isabella, with her black form-fitting dress, rope of pearls, and long, empty arms cradled in front of her.

Sargent moved furniture and objects around to his liking in the Gothic Room. He propped his large easel in the middle of the room and hung a dark sheet over the Spanish wheel window to soften the incoming light. The violinist and composer Charles Loeffler, now thirty-three years old, sat for one of Sargent's first portraits that spring. Isabella had invited Loeffler to practice in Fenway Court's music room, with its ideal acoustics. She adored his serious demeanor and the graceful way he moved through a room. He was generous with her, but he did not bow and scrape, as some younger artists did at times to get into her good graces. She knew Loeffler was a musician's musician, as did Henry Lee Higginson, who had hired him as assistant concertmaster at the Boston Symphony Orchestra, a position he held for twenty years before stepping down in 1903 to compose full time. His French-inflected style pointed to his training in Paris and helped shift Boston music aficionados from their preference for German composers, particularly Wagner, to an interest in the French, such as Saint-Saëns and Debussy, the latter of whom wrote a new-sounding music, full of color and texture that seemed to float on air.

Isabella worried about Loeffler and how his seriousness could shade to melancholy. Sargent's sympathetic half-length portrait captures something of this sadness, especially around the eyes. Loeffler holds his violin upright,

his long fingers mirroring the curve of the violin's scroll. The instrument was Isabella's prized Stradivarius, which she had bought in 1895. She loaned it to Loeffler, then later gave it to him outright.

On April 13, the night before her sixty-third birthday, Isabella hosted a concert during which Loeffler performed an arrangement of his recently completed *A Pagan Poem,* inspired by Virgil's *Eclogues,* one of his most well known compositions. In this version, he put two pianists up front on the music room's stage, while three trumpet players stood on balconies throughout the palace. The haunting call of the trumpets, resounding high above the courtyard, had a wonderfully dramatic effect. Loeffler dedicated the composition to his patron, giving her a signed copy for her ever-growing collection of musical scores. Sargent too gave her a precious birthday gift—Loeffler's portrait, which she hung in the first-floor Yellow Room, dedicated to music. It was a remembrance of her friendship with both artists.

The day after her birthday, Isabella welcomed another group of visitors to the museum: the painter Cecilia Beaux from Gloucester; her nephew, the young lawyer Henry Drinker; and Abram Piatt Andrew, who at thirty had just been named professor of economics at Harvard. Piatt, as his friends called him, recorded his impression of his first visit with Isabella in his diary,

in a brief entry: "went over to Fenway Court with Mrs. Gardner—a delightful experience." It was the start of many such meetings between the two. Piatt also mentioned the distinguished painter in her house. "Saw Sargent at Mrs. Gardner's—a very businesslike unaesthetic burly man."

By the time of Isabella's birthday celebrations, Sargent had begun work on his dual portrait of Gretchen Osgood Warren and her only child, twelve-year-old Rachel. The two posed in the Gothic Room at Fenway Court. Gretchen, a generation younger than Isabella, was a talented poet and had a wide array of interests and abilities. Her father, Dr. Hamilton Osgood, had studied with Louis Pasteur in Paris, where she took singing lessons. She enjoyed performing on stage (her family disapproved) and was active in women's rights organizations. She had married into the well-known Warren family, who had made their fortune from paper mills. The Gardner and Warren families knew each other well. Gretchen's husband, Fiske Warren,

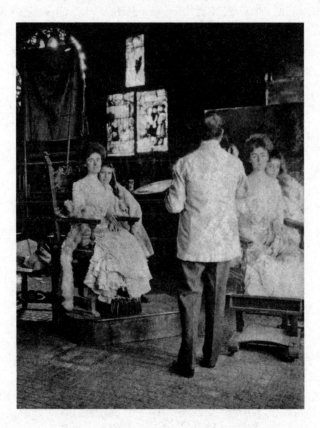

a tennis champion, was eccentric in a New England kind of way. He was the youngest of five Warren siblings, including Sam Warren, longtime president of the Museum of Fine Arts, and the younger Ned Warren, an aesthete who collected antiquities.

A series of candid photographs by the artist John Templeman Coolidge show Sargent at work on the Warren painting. He wears a crisp white jacket with pressed slacks, his good nature and energy on full display. He worked fast, often drawing the figure on the background with his brush and diluting his paints with oil to achieve a fine, smooth finish. His virtuosity made it all seem easy, but his process was complicated, and he had very definite ideas about what he wanted. Gretchen Warren worried about what to wear. She first chose a green-velvet frock, but Sargent disapproved of it, insisting she dress in pink instead. Warren ended up borrowing a gown much too big for her. He improvised with what Rachel wore, wrapping her in shiny pink silk. Mother and daughter huddle close together, with Gretchen seated on a large cherry-and-walnut Italian chair from the seventeenth century. Sargent sweetened the looks of both, narrowing their chins, putting more color in their cheeks. But he captured their closeness, an affection emphasized by the exquisite painted stucco *Virgin and Child* (from Ghiberti's workshop) visible just over Gretchen's right shoulder, on the mantel between two candelabra.

Soon after his residency at Fenway Court, Sargent wrote a letter that must have pleased his host and friend: "At the risk of boring you with my daily notes, I again seize the typewriter to tell you that my thoughts are often at the Palazzo, sometimes in the clear-sounding court, sometimes in the boudoir, or in the Gothic Room. They follow you about and have taken permanent abode at Fenway Court—and are very happy to be there."

WITH THE COMING WARMER DAYS, ISABELLA PUT FENWAY COURT "INTO curl papers and then to bed," as she once quipped about closing it for the season. She was relieved to spend most of her summer at Green Hill. One week in June was so filled with racing that "we talk and eat horse," as she put it. Her guest book is filled with pictures of dogs and gardens and friends. A foray south to the Biltmore, the Vanderbilt estate in North Carolina, inspired a little envy. "Fancy owning 150,000 acres," she wondered in a letter to Berenson. "It is quite wonderful." She was, of course, very rich but not on the scale of the Vanderbilts or other robber baron families, whose fortunes greatly surpassed her own.

All summer long, she corresponded with Berenson about his trip back to America with his wife, Mary Smith Costelloe, whom he had married in 1900, after a ten-year clandestine affair and the death of her first husband, with whom she had two daughters. It was Berenson's first return in almost a decade. At thirty-eight years old, he cut a dapper figure, with his full beard and finely tailored suits. The ongoing publication of his multivolume magnum opus on Renaissance drawings coincided with and helped generate an increasing desire for old master paintings among America's wealthy, which made him more and more a "figure of consequence." He was returning to visit several of his sisters, who lived in the Boston area, to establish new contacts with art dealers, and to see Isabella and Fenway Court, which he had done so much to help her create.

Isabella was eager for his visit. "Hip, hip, hurrah," she exclaimed, when they finalized plans for a ten-day stay in mid-October at Green Hill. But first, she explained in a hurried note, she had to be away in Washington, D.C.—"*pour affaires*"—to plead her case about tax difficulties. She had been accused of not paying the 20 percent duty owed to the U.S. Custom House on imported art over a certain value—in her case, the value of her collection,

most of it now displayed at Fenway Court, which added up to over a million dollars. It is a little unclear how she had overlooked this. Maybe she had not wanted to face reality; maybe she felt that Fenway Court itself, though only open to the public for several weeks a year, was a gift to the country. Wasn't that generosity sufficient?

"What a government!" she wailed to her finance manager, Henry Swift. She faced selling either artwork or Green Hill or borrowing money to cover the charge. "It is better not to sell, but to borrow?" she asked Swift. "It seems vastly better to me." She felt genuinely hurt by the imbroglio, as if her contributions to public culture were unappreciated. "Do they really deserve such a gift as I had proposed to give them?" Soon she would be sixty-four years old, and she worried about running out of time "to arrange a future for my works of art." She knew that a large endowment—funds she did not have—would be necessary to ensure that her collection was kept in one place, Fenway Court. She complained to Sargent, who wrote back, saying "it is astonishing that such a benefactor as you have been met with that treatment. Could not Roosevelt do something about it?" But this was impossible, as Sargent acknowledged, because the president was no despot.

The Berensons arrived at Green Hill in October. He had promised he would view no art while Isabella was in Washington, waiting in a "state of vigil for the feast that is to follow when I come to you." For somewhat obscure reasons, she kept Fenway Court from the Berensons for a time. Mary Berenson complained about the delay in a letter to her family, saying that "she refuses to show us [Fenway Court] until December, being a very imperious lady, and determined we shall remain in Boston longer than we meant to!" Then, on November 14, 1903, Isabella invited them for a tour. They were quite taken aback, as they slowly made their way through the museum's many galleries and rooms. Mary, always ambivalent about Isabella, wrote that the "whole thing is a work of *genius*." But she also noted how several unnamed Bostonians had sidled up to her and her husband during their time in the city to "hear evil of her and her works . . . It is the biggest gift Boston has ever had. Yet all they think of is envy, and small spites; and she remains a very lonely and unloved person."

Berenson's reaction was somewhat muted by intense worry. Fenway Court had been a shared dream in many ways, one he had done much to help realize. His reputation was in a sense on view. In the third-floor Long Gallery, he almost fainted, according to Mary Berenson, on seeing *The Nativity*, a tondo, or round painting, by Botticelli. Isabella had hung it opposite the Chigi Botticelli, which Berenson had secured for her collection. He had advised her to pass on the tondo, calling it a far inferior school picture, but Isabella ignored his advice and listened instead to Richard Norton, who helped her buy the painting for roughly $40,000. Berenson now feared that he would be blamed for what he considered a mistake made by his competitor and nemesis.

Isabella extended her time with the Berensons by meeting them in Chicago in early January 1904. She traveled with George Proctor, who performed at several of the city's concert halls, because of some behind-the-scenes arranging she had done. She was ever hopeful for his success. Berenson wrote that her departure a few weeks later made the city seem "very quiet." In her next letter, she replied that she had felt, during their time together in Chicago, that "you had for me a *truly really* affection. It did me good to think of it."

She needed all the courage she could get. "The waters are closing over me," she wrote in the same letter, and she meant this literally. The pipes had burst at Fenway Court: "Floods everywhere! And plumbers!" But she also meant it in other ways, for upon her return home, she had gotten final word from the government that her appeals had failed, and she would have to pay a very large tax bill. Fenway Court had not met the federal requirements to be considered a charitable organization. "All the papers are full of the payment of duties," she wailed, bemoaning her fate: "I am really down on my luck."

In the end, Isabella paid almost $200,000 in custom duties and fines, and she did it with borrowed money. She was scared and furious. She threatened to close the museum to the public. Even before the government's final judgment, she warned Berenson that her finances had changed; the period during which she was buying a painting or two almost every week had come to a close. She could afford to buy only one or two more pictures, underlining her predicament in a second letter: "I am really *very poor*." She had to economize. Guests grumped that her larder was spare, as compared to occasions in the past, when Jack Gardner liberally filled the dining table with delicious food and wines from around the world. Mary Berenson described to her family how Isabella burned candles until they were small stubs and had servants follow guests to the bedrooms, to turn off the gas lighting. When Paul Sachs, a professor of art at Harvard and heir to the Goldman Sachs fortune, asked Isabella much later to donate to an archaeological expedition, she summarized her position with memorable brevity: "It is just as much as I can do to run Fenway Court, because that is, as you know, a one-woman museum. To fill it as I have done has taken everything I had, even my dress money."

To help with costs, Isabella finally put her beloved 152 Beacon Street property up for sale. It was, by 1904, largely uninhabitable; she had torn out many of its fireplaces, crown moldings, wall coverings, and even a door or two, which she reinstalled throughout Fenway Court. The new owner of the Beacon Street property, Eben Draper, demolished the rest of the house to build his own. As part of the sale, Isabella asked that the lot's street number be changed, so that no one else would ever live at the address most associated with her and Jack: 152 Beacon Street. An era had vanished.

Even as Isabella fretted over finances, she continued raising money for causes she believed in. In February, after her return from Chicago, she held a fundraiser for the Society for the Prevention of Cruelty to Children; an evening of vaudeville performances by the local Vincent Club, a troupe of young fashionable ladies. She had been hosting garden parties at Green Hill and open houses at 152 Beacon Street, which raised money for the Cotting School, for some time. Having Fenway Court as her stage and arena energized her philanthropy. She would preside, the center of attention, at these events, yet she was also doing good works.

She connected this activity to her religious belief and what it required of her. She had taken to heart the teachings of the Church of the Advent and the Cowley Fathers at the Society of Saint John the Evangelist. Isabella did not trot out her philanthropy. The museum had no list of the recipients of her generosity. She kept with the modesty of her religious mentors at the society, who led a life of prayer and ministry. Her religious faith reached outward, toward others in the here and now. She did not seek to save souls, but rather to improve lives, which required a spirit of humility and self-sacrifice. When she had the chance to hear the revivalist preacher Billy Sunday in Boston, she declined, telling A. Piatt Andrew: "I don't like the curiosity idea mixed up with religion." She was more in sync with the progressive politics of the time, believing that religious commitment could fire up social change. In the coming two decades, she would raise and give away hundreds of thousands of dollars, the current equivalent of several million.

Isabella was also in step with the current American president, Theodore Roosevelt, with whom she talked in May 1904 at the twentieth anniversary of Groton School, cofounded by her nephew Amory Gardner. Roosevelt had been invited to attend the day's festivities, including the yearly presentation of student medals, at which he spoke for fifty minutes on the making of good citizens. His two sons, Kermit and Theodore Jr., were in the audience as Groton students. In a vivid snapshot at the event, showing a veiled Isabella with Roosevelt, it was clear that the two New Yorkers had much to say to each other. They both loved horses and Japanese sports (he installed a judo room in the White House), and they knew many of the same people. The young president, a Harvard graduate, was so full of

energy that a newspaper once likened him to "a steam engine in trousers." The two shared equal dynamism and optimism—all push and drive and determination. When the president told the students that a combination of courage and hard work would win the day, Isabella no doubt nodded her wholehearted agreement.

Through all of this activity, she kept collecting. An 1867 portrait of Madame Gaujelin, by Edgar Degas, arrived at Fenway Court. The oil painting shows the Parisian dancer and actress sitting in her dressing room, her clasped hands on her lap and her black costume an inky contrast to the red-patterned chair cushions and the deep-mustard-yellow wall. Madame Gaujelin, a frequent model for Degas, rejected the portrait for the dour expression he gave her, which partly accounted for its appearance on the market. Berenson secured the picture for Isabella via Eugene Glaenzer, the New York dealer whom he had met on his American tour. The astounding purchase price, $30,000, put the lie of course to Isabella's claims of being "poor." She tried to finesse this apparent contradiction in a letter to Berenson announcing the painting's safe arrival. The dealer, she explained, "is happy to leave her here, and will be paid some day! In the meantime, I must still more economize. It is Holy Thursday, and I am fasting religiously and financially." It was as if she had to remind herself to save, save, save. Berenson replied with a salesman's line, telling her what she loved hearing—that her "beautiful Degas . . . is among your greatest possessions." The picture was certainly an outlier in her collection, given that she had bought, up to this point, few French impressionist paintings. Berenson's relief that the spigot of Isabella's spending had not dried up, despite her protestations otherwise, was palpable in his letters.

When Isabella's old friend Henry James wrote from England in mid-summer 1904 that he would be arriving soon on a return trip to America, he seemed to flutter with self-consciousness. The two had been out of touch more so than in earlier years. He apologized for his silence, saying that he'd been made "miserably conscious of my long failure to make you the sign of faithful remembrance . . ." Then he flattered her by referencing Fenway Court: "All your recent splendid history and accomplished glory have filled me with the impulse to show you how admiringly . . . I think of you and how I have devoured every echo of your greatness that has penetrated

my solitude." He claimed to be "dumb" as to what "to say that would be in proportion and *on the scale.*"

The novelist had just finished writing *The Golden Bowl,* about the tightly wound relations of a daughter and her father, an art collector who filled his American mansions and "unfathomable heart" with culture he could buy at auction. Now, like Berenson the previous year, Henry James felt the need to cross the Atlantic after a twenty-year absence. America haunted his fiction, though it was no longer his home.

James admired his old friend, but he continued to stand at a distance from her intensity and demands. Something—maybe the scale of her ambition—made him sound twitchy in his letters to her, and he kept using oxymorons when writing about her to mutual friends. She was an "extraordinary little woman" in one letter and "a great little personage" in another, as if he had to cut her down to size.

She likely found references to herself in James's fiction: the long rope of pearls draping the neck of Milly Theale in his 1903 *The Wings of the Dove* was unmistakably hers, and the novel's setting, a Venetian palace, was modeled after the Palazzo Barbaro, where he had stayed as Gardner's houseguest. The figure of Mrs. Gereth, a collector of Chinese porcelain and rare French furniture in his *The Spoils of Poynton* was another Mrs. G who thought that "things" were "the sum of the world," in this case, to the detriment of everyone around her. Isabella said nothing to the Berensons about the arrival of their mutual friend. As with the Berensons' visit, she didn't open Fenway Court for Henry James to see right away—"her palace of art is closed and muffled, the petticoats thick until December," he explained in a letter. It was a rigmarole to take down all the white sheets that hung over many of the paintings and the antique furniture in the off-season. Whatever the undercurrents between Isabella and Henry James, she resisted the steady beam of his scrutiny and made him wait.

After he finally got to see Fenway Court, James praised her in letters to others and in print. To their mutual friend Paul Bourget, he said that her "*Palais Musée is* a really great creation." He echoed that praise in print, in his 1906 *The American Scene,* where he concluded his essay on Boston with Isabella's creation, describing her collection as "wonderfully-gathered" and "splendidly-lodged," a "great idea" that had been able "to flower."

On the evening of December 23, Isabella brought together her "waifs and strays," including Matthew Prichard, George Proctor, John Briggs Potter, and the singer Lena Little, for a celebration dinner at Fenway Court. Isabella liked to preside at intimate, familylike gatherings such as this one, not wanting anyone to be alone for the holidays and also not wanting to be alone herself. The guest of honor at her holiday table was a new friend who was celebrating his forty-second birthday: Okakura Kakuzō. Okakura had arrived in Boston from his home in Tokyo at the start of 1904 to begin work at the Museum of Fine Arts as the first curator of Japanese and Chinese art. John La Farge had sent Isabella a letter of introduction that talked of his "great learning" and called him "the most intelligent critic of art." The timing of Okakura's arrival could not have been better, and once the two met, they were frequently in each other's company.

"I had put magnificent little gifts on their plates," Isabella reported to Berenson about the holiday party, "and made a rule that all conversation was to be general. So we really talked." Okakura, the birthday guest of honor, sat next to her at one end of the table. Selections from Bach, Beethoven, Scarlatti, and Chopin were played, and Lena Little sang Schubert's Shakespeare-inspired "Who Is Sylvia?" Then Isabella's friends "wandered through the house . . ." Candles and fireplaces were lit in the galleries. The Rembrandt paintings in the Dutch Room seemed almost alive, aglow with their own inner light. The evening was cold and clear, and "the moon," Isabella wrote, was "pouring down into the court."

Twenty-Six

"LONESOME CLOUD"

1904–5

Most objects Isabella Stewart Gardner collected while visiting Japan in the mid-1880s—intricately decorated hand-size *inro;* exquisite kimonos and painted fans; a gilded wood pedestal in the form of a lotus plant—fit into one of her traveling trunks. She had a haptic intimacy with the country's art—the smooth polish of the ivory or lacquer netsuke or the finish of the kimonos' silks and brocades. There were large-scale exceptions: her purchase of several six-paneled screens, including a gilt-covered screen depicting the famed *Tale of Genji* produced during the seventeenth century, in the style of the Kanō school. Mostly, what she recorded in her diary of her weeks-long tour of Japan were not objects but immersive experiences: watching a rousing celebration from a hill high above a town; cheering on sumo wrestlers; marveling at the delicacy of the bamboo forests that surround Kyoto; lying down on a temple floor, with its soaring rafters high above, to listen to the silence of its enormous space.

This earlier immersion in the country, however, had not prepared Isabella for the force and draw of Okakura. Soon after their meeting, in late March 1904 at Fenway Court, she conveyed her enthusiasm in a list of adjectives about him to Berenson, saying that she found her new friend "so interesting, so deep, so spiritual, so feminine." Why was she so captivated?

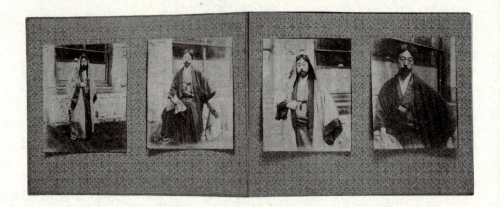

She would try to answer that question from one direction and then another in the years to come.

Okakura was born on December 23, 1862, in Yokohama, one of the first treaty ports open to foreign residents and trade. His father, Kan'emon, born into the samurai class, was a successful businessman who traded in fine silks. Under the old order, a man born a samurai would not have engaged in trade, but after the class was abolished by the Meiji government, former samurai had to fend for themselves. Less is known about Okakura's mother, Kono, who died when her son was eight years old. The busy streets of Yokohama were crowded with traders and merchants, cacophonous with the sounds of many languages. Okakura's father sent him to a Methodist mission school, so his son could speak the language of another rising world power and gain the skills necessary to be an ambassador or an intellectual. But when his father discovered that Okakura soon could speak flawless English yet had trouble reading the town's Japanese signs, he sent the boy instead to a Buddhist school to learn Chinese literature, Japanese music (instead of Methodist hymns), and the fine art of calligraphy. He was also trained in the rituals and tenets of Buddhism and Shinto.

At fifteen, Okakura enrolled at Tokyo Imperial University, where Ernest Fenollosa, the Bostonian who had been a brilliant student of Charles Eliot Norton at Harvard, taught him Western philosophy, assigning the work of German philosophers such as Hegel as well as selections from Ralph Waldo Emerson. In 1882, the year before the Gardners sailed for Asia, Fenollosa and Okakura traveled across Japan to draw up a kind of taxonomy, or list, of the artistic treasures in the country's many shrines and temples. Four years

later, Henry Adams, in flight after Clover's death by suicide in 1885, joined John La Farge on a months-long sojourn through Japan, accompanied by Clover's cousin William Sturgis Bigelow, Fenollosa, and the young Okakura. La Farge later told Okakura that "you were Japan to me." The conversations between East and West, between Japan and America, between Okakura and Boston, had been underway long before the brilliant curator and philosopher arrived at Fenway Court.

By this point, Okakura's life was in tumult. He had done groundbreaking work since 1889 at the Tokyo Art Institute, a new school dedicated to supporting traditional Japanese arts. He had been pushed out for tangled political and personal reasons. The Japanese Art Institute, which he started in 1898, encountered financial difficulties. He felt engulfed by scandal and began to drink too much. His early marriage was unhappy, though enduring. On his first American tour in the mid-1880s, he carried on multiple affairs, one with a New York opera diva, Clara Louisa Kellogg, almost twenty years his senior. The second affair, with Hatsu Kuki, the homesick wife of the Japanese ambassador to the United States, was more lasting. When she returned to Tokyo, with Okakura accompanying her, she was pregnant with their son, Shuzo.

A way forward for Okakura came via a sleight of hand by William Sturgis Bigelow, who secured a position for Okakura at the Museum of Fine Art, partly by arranging in secret to pay the salary himself. It was a measure of how much Bigelow wanted Okakura's expertise for the museum's vast collection of Japanese objects, the majority of which had been donated by Bigelow himself.

Okakura was elegant and tall, with knowing eyes and a smooth, memorable voice. He recognized, as did Isabella, the power of fashion. He avoided Western dress, preferring garb from an earlier, and romanticized, samurai era. It amplified his otherness to Western observers. All eyes were on him when he accompanied Isabella to performances of the Boston Symphony Orchestra, as they sat in her prominent orchestra box on the balcony. This was part of his project. If Commodore Perry's Black Ships had been the tip of the spear in opening Japan to trade with the West, then the East might open the West—or so Okakura posited—through its refined culture and spirituality. It would do so not as a lesser civilization but as an equal one.

Japan was much in the news in the spring of 1904. In fact, Okakura left Japan on the February day that his country declared war on its much larger neighbor, imperial Russia, commencing an eighteen-month battle to determine, among other issues, influence over the Korean Peninsula. Japan's rising nationalism and militarism got the West's attention. But Okakura surmised early on that the source of his country's standing in the West was not its technological prowess or its high literacy rate or its ferocity in battle. Instead, its prestige resided with its storied culture: high art and craftsmanship, culture and spirituality, temples and shrines, ceramics and woodblock prints, and, of course, the tea ceremony. He would publish his short masterpiece, *The Book of Tea,* in 1906, which brought together his ideas on beauty and strength, ritual and its cultural relevance. Tea, and the ceremonies connected with it, symbolized a nation's resistance to colonization. Okakura's Boston readers were reminded of their own tea-party defiance, in what the literary historian Christopher Benfey calls a "vivid cultural rhyme." In Okakura's curatorial position, where he replaced his former mentor, Fenollosa, he evaluated and sorted thousands of artifacts and art objects. Isabella reported to Berenson that Okakura was "busy at the Museum cataloguing the Japanese things that have been huddled there since Fenollosa's time, and finds forgeries and forgeries!!!"

"Dear Mrs. Gardner," Okakura would write at the top of his notes to her on the museum's stationery. The salutation later turned more intimate and playful: "To the Presence at Fenway Court." She requested his company at this dinner or that concert, invitations that he sometimes declined. His favorite place to visit her was Green Hill, which became a refuge. The path to her Japanese garden, located on a high hill at the back of the large property, was lined with large stone lanterns that she lit in the evenings. The garden itself had two rectangular ponds, framed by trellises. A rustic pavilion joined zigzagging wooden walkways positioned over the water, which was filled with papyrus and lotus plants. Isabella raised bonsai, including a three-hundred-year-old dwarf cedar tree that won a prize.

She proudly described her "new oriental life" to the Berensons, telling Mary how Okakura enjoyed long afternoons in the garden, where he "scribbles (as he calls it) instead of doing Art Museum work (catalogues)." He often brought along younger colleagues, Shisui Rokkaku, a lacquerer, and

Kakuya Okabe, a metalworker; everyone signed their names in her Green Hill guest book. "Okakura plus his two friends . . . constantly come up my green hill—'*aoyama*' as they call it," Isabella told Berenson in another letter. "And we sit under the trees, one of them sketches (not in our manner), one arranges flowers as only they can and through it all we become far away and hear only Okakura's voice as he tells those wonderful poems and tales of the East. Perhaps tomorrow night I shall see them mistily coming up over the grasses, the light, their cigarette. It has really made the summer different."

Okakura seemed to bring something of the wide world to her doorstep, which gave her the sensation of being "far away." Overseas travel had always provided ready balms for sadness and loneliness, and perhaps Okakura's presence had a similar effect.

He seemed to meet her there in her loneliness. Or he found words for it in the poems he wrote for her. In a late September letter to Mary Berenson, Isabella copied out Okakura's long poem titled *A Night-thought* (not to be confused with his more well known "Night Thoughts" from a year later), which he wrote in the gardens at Green Hill. She had been feeling blue in the late summer, but his poem, ending with these lines, lifted her sadness.

> *It is the floating world*
> *Which the Budha never renounced.*
> *It is the Budha which the world ever forsook.*
> *Was it a parting or a meeting?*
> *Why the meeting?*
> *Why the parting?*
>
> *Stars are my tear drops,*
> *O Galaxy!*
> *Rush on forever, through river of Heaven*
> *In the restless search of Infinity.*
> *Aum to the Eternal Light of Sadness*
> *Aum to the Darkness of Love.*

Here were the contradictions of life: how sadness held light and how love could be made of darkness. Isabella closed the letter to Mary Berenson

comparing Okakura to a beloved bird at Green Hill: "Do love it. *Aum* is even more than *Hail*. I have a Japanese robin who is singing to burst his soft throat. He is giving a message, so I sent it on to you both for it must be full of love."

OKAKURA'S ARRIVAL IN BOSTON COINCIDED WITH AN ONGOING AND AT times ferocious debate at the Museum of Fine Arts about the direction the institution would take as it made plans for a new building on land very near Fenway Court. Essentially, the argument turned on whether the plaster-cast copies of famed statuary, which had populated the museum's galleries since its start, should be moved to the new building. One side claimed that the copies had been valuable to the public and to all the art students unable to travel overseas. They too could see something of the Parthenon's frieze or Michelangelo's genius. Isabella's friend Matthew Stewart Prichard, now acting director of antiquities, argued strongly that no self-respecting art museum should showcase copies of original artwork. Like Okakura, Isabella took Prichard's side, and she inserted herself into the controversy. She invited her old friend William Sturgis Bigelow, who favored keeping the copies, for tea with Okakura at the end of August to distract Bigelow from a vote by the building committee. Eventually, her side won the argument, with Bigelow remaining on the other side, and for years the plaster copies stayed in a storage room.

"People do seem to hate me!" she exclaimed to Berenson several months later. "Why? But it can't be helped, so must be endured. At any rate, I shall always go straight for my own goal." Berenson gently teased her in his reply: "So this Lady of the Fens knows after all *why* she is hated."

In November, following a dinner party Isabella hosted at Green Hill, where everyone played the board game sugoroku, Okakura sent her a letter of thanks, with a request. He had arranged a gallery show of the work of Japanese artists, called the Nippon Exhibition, at a private home in Cambridge, which would open in a few weeks. "Will you pour tea for them some afternoon?" he asked, wanting her to be part of what was on display. He added that "it will be a great attraction for the Exhibition—and as it is the first Japanese Exhibition, I wish to make it a success." He ended the letter with a facetious question: "Am I not terrible to ask this of you?" Four days later he made the request again: "we will be very honored if you will open

the exhibition with your presence." As a postscript, he offered that she could ask other women to join her, which she did, including her friend the artist Cecilia Beaux. The papers called the Exhibition a triumph.

Okakura returned the favor by performing the ritualized tea ceremony at Fenway Court for a small group of Isabella's friends in January 1905. "I am still full of the sentiment and flower of the great Tea Ceremony, the *Chano-yu,*" she told Berenson, "which was performed here yesterday at 5pm (candlelight) by Okakura." She did not describe the ceremony's elaborate steps, but William Sturgis Bigelow, who had brought her to tea ceremonies when they were both in Japan, was one of the five guests and marveled at how the ceremony had been re-created in an American context.

That spring, Isabella hosted several more themed occasions, including a Japanese Festival. For the first three days of May, she transformed the museum's Music Room with ten booths staffed by Japanese friends, who sold souvenirs and penny toys. Okakura, who by then had returned to Japan for his work with the museum, had shipped nineteen items to Boston for the festival. These included a blue-and-white square waterpot, a tea bowl, an incense case and incense, an ivory tea scoop, a bamboo tea scoop, a lacquer tea jar, a porcelain tea jar, a feather brush, and a package of freshly powdered tea for the tea ceremony. There was singing and dancing, games and "the jiujutsu men," who were, as Isabella explained to Berenson, "wonders and beautiful too."

Okakura writes in his *Book of Tea* that the tea ceremony was "founded on the adoration of the beautiful among the sordid facts of everyday existence." Isabella had been mired in everyday facts—the details of opening and managing Fenway Court and the tax controversy—and she would be so again. Like the tea ceremony, though, Okakura's friendship had been a glorious respite.

She saw the chance for further events, these to raise funds for causes she cared about. She donated the proceeds of one of these to the Sharon Sanatorium for women of limited means in the early stages of tuberculosis. The next month, she held a smaller Japanese bazaar in the museum's Music Room and outside garden to benefit yet another sanatorium. Fenway Court continued to be one large stage set.

Soon after Okakura returned to Boston, in late 1905, he stayed with Isabella at Fenway Court, and during this visit, he wrote her another poem, which she later titled "Night Thoughts."

> *The One,*
> *Alone and white.*
> *Shadows but wander*
> *In the lights that were;*
> *Lights but linger*
> *In the shadow to be.*
> *The Moon,*
> *White and alone.*
> *The stars have dissolved*
> *To make a crystal night.*
> *Fragrance floats*
> *Unseen by flowers;*
> *Echoes waft.*
> *Half-answered by darkness.*
> *A shadow glides*
> *On the stairway of jade.*
> *Is it moonbeam?*
> *Is it the One?*
> *At the abode of the Solitary Shadow, Tenshin*

Isabella felt entranced and honored by his poem, which, like his earlier *A Night-thought,* he wrote first in English and then copied into Japanese. Again, he elevated her aloneness into something singular, otherworldly, almost mystical—"A shadow glides / On the stairway of jade." Grace Schirmer, whose husband published Charles Loeffler's compositions and who was present at the evening occasion when Okakura composed the poem, called it a "word-painting," on par with or "even better" than the portraits of Isabella by Sargent and Zorn.

In some ways, Isabella's attachment to Okakura had aspects of a late-life romance. She had to steel herself when he traveled back to Japan, knowing she'd fall into a swoony sadness. Inevitably, rumors swirled that Isabella Stewart Gardner had fallen in love. Okakura had come to Boston with the

reputation of a philanderer, and the two did little to hide the time they spent together. His poetry and letters to her are intimate. This was not the first rumor of romance involving Isabella, of course. She had been the subject of torrid chatter twenty years before, related to her too-close friendship with the much younger Frank Crawford. And it would not be the last. She would be the focus of another rumor the next year, in 1906, when newspapers would breathlessly report that she was engaged to W. Bourke Cochran, congressman from New York, after he paid her too much attention at the White House wedding of Alice Roosevelt.

There were layers of connection between Isabella and Okakura. He was almost the same age as her Jackie would have been, and he liked how she fussed over him, worried over his illnesses, and cared about his comfort. She helped him navigate Boston and its internecine society. He, in turn, made her laugh. Several years later, after she sent him a cat with luscious white fur, he wrote her lines in the voice of the cat, whose only lament was "over some hairs singed in snuffing a candle with our tail." He understood her theatricality, how she played a role. They both loved adulation. Crucially, their missions aligned: he wanted to bring traditional Japan to Boston, just as she imagined transporting the Old World to the New. Okakura understood Fenway Court, with its evocative "fusion of past and present," a phrase he used when arguing a future path for Japanese culture.

These two friends recognized something essential in each other—they both had seen worlds beyond their immediate horizons, and this cosmopolitanism made them sometimes restless, not quite at home wherever they found themselves. At one point, when traveling back to Japan, Okakura mused to her: "I seem to go back to things that do not belong to me." No wonder he named the white cat she gave him *Kowun,* Lonesome Cloud.

Twenty-Seven

"THE WHOLE INTERESTING WORLD OF PARIS"

1906

During the summer of 1906, along winding roads that cut through small medieval villages around Paris, Isabella rode in the back seat of a large white Mercedes accompanied by the car's owner, her old friend Henry Adams. "I have never imagined such speed as the motors," she exclaimed in a letter to Henry Swift. The early models of the time lacked windshield and roof, so she and Adams had to hold on to their hats. "I heard a man just now say, he had averaged 45 miles an hour! It is impossible to make the chauffeurs go slow enough to see anything." Adams, unlike Isabella, was an early motorist. He had bought his eighteen-horsepower Mercedes in 1904 in Paris, where he spent the first half of every year. The car was frequently at a mechanic's shop for repairs. "Three weeks out of nine," he grumbled that summer. Even so, his "idea of paradise" was to go pell-mell down "a smooth road to a twelfth century cathedral."

That was exactly what he and Isabella were doing now—touring medieval Gothic cathedrals that seemed to rise like stone giants, connecting green ground to blue sky on the undulating landscape outside Paris.

THE PREVIOUS FALL, ISABELLA HAD CONFESSED HER FEELINGS TO BERENson about his time in Paris: "I envy you everywhere," she wrote, "and am burning to get over there and taste some of the fruit, so long forbidden to me. I am thinking and contriving to get to Europe next spring." She had not been to Europe in seven years. She had soothed some of her restlessness in the months after the museum's opening by doing what she did best: collect and plan. Already in 1903, after the museum had just opened, she started negotiations for the purchase of two series of very large sixteenth-century Flemish tapestries from the American collection of Charles and Sarah Ffoulke, an acquisition that took several years to complete. The purchase of these tapestries—an extension of Isabella's longtime attraction to extraordinary textiles—also spurred ideas of what to do next with her museum. She would need *more* room and wall space, and she would need *more* architectural elements for newly conceived galleries on the first and second floors. Europe now beckoned.

Henry Adams, who stood eye-to-eye with Isabella at five foot four inches tall, was sixty-eight years old (two years her senior) and, in his words, "very—very bald." After his wife's death twenty years before, he eventually had attained a "surviving capacity to be very well taken care of," according to the slightly envious assessment of Henry James. His H. H. Richardson–designed mansion, overlooking Lafayette Square and the White House, was perpetually filled with politicians and artists, far-flung friends, and a cadre of nieces and nephews. He seemingly knew everyone, read voluminously, and wrote copious letters. He was in these years in the midst of composing his prose masterpiece, *The Education of Henry Adams*, privately printed in 1907 before its publication in 1918. In Paris, he was most often accompanied by Elizabeth Cameron (also a friend of Edith Wharton), who was unhappily if enduringly married to the wizened Senator Don Cameron. The sculptor Augustus Saint-Gaudens caught the contrariness of Adams, in turn expansive and formidably closed off, when he struck a bronze medallion of his friend teasingly called "Porcupinus Angelicus."

Adams walked through the doors at Fenway Court for the first time in early February 1906, three years after its opening, and was, in a word,

astounded by what he saw, which was not a typical reaction for him. "You have given me a great pleasure and greater astonishment," he began in a long letter of appreciation to Isabella. "As long as such a work can be done, I will not despair of our age, though I do not think anyone else could have done it. You stand quite alone." Adams had heard about what she had been up to, of course. He loved attending to the gossip of his friends, and he and Isabella shared quite a few—Henry James and Sargent but also Loeffler and Berenson.

By the time of Adams's visit to Fenway Court, he had finished a draft of his book-length meditation on the art of French Gothic cathedrals, *Mont Saint Michel and Chartres*. Isabella was one of the few friends who had received an early copy, ahead of its eventual publication in 1908. In its pages Adams sums up his thoughts on Gothic architecture, how it defied gravity with stone and light reaching ever upward even as it hid from view how such a feat could be accomplished. On the book's last pages, he writes: "The delight of its aspirations is flung up to the sky . . . The pathos of its self-distrust and anguish of doubt is buried in the earth as its last secret. You can read out of it whatever else pleases your youth and confidence; to me, this is all." The viewer is left to make meaning of soaring spaces and glimmering colored glass, which seemed to suspend the light in midair. Isabella told her friend,

ahead of her trip to France, that she had just reread "your wonderful book." She would list it in *A Choice of Books,* her bibliography of her manuscripts and rare books.

Adams, in turn, recognized the scale of Isabella's ambition. He effused about it not to placate her, as Henry James sometimes did, but because he could imagine how she must have felt, trying to do something so big and original, especially in the city he had fled decades ago. Unlike Henry James, who chafed at her sometimes imperious ways, Adams may have seen her manner more as Okakura did, as a pose or performance. "I feel as though you must need something—not exactly help or flattery or even admiration—but subjects," Adams slyly wrote.

His letter moved her: "Dear Mr. Adams," she replied on the very next day. "There are no words that can tell you the pleasure your letter gives me." She discreetly referenced unnamed hurts, only to say that his letter "heals many wounds and makes me eternally grateful." His esteem mattered. By the summer of 1906, they were both in Paris, with a lot to talk about.

ONLY A FEW DAYS AFTER SHE ARRIVED AT THE HÔTEL DU JARDIN, WITH high rooms that overlooked the Jardin des Tuileries, Isabella got word that a hurried visit to Spain was possible. "For personal reasons, I must see the Prado now or never," she explained to Henry Adams, without saying more. She said the same thing to the novelist Sarah Orne Jewett—"I want to see the Prado again!"

Madrid's royal museum did not disappoint. It has "such wonders," she enthused to Berenson, but this time she looked at the masterpieces with different eyes. During her last time in Madrid, eighteen years before, she had not yet possessed her own Titian and Velázquez nor directed her own museum. In the same letter, she worried about how the Prado paintings were displayed and cared for. "My fingers are itching to be made Director. I have said this before to you, as I think of it every day!" She was still thinking of the Prado when she returned to Paris several weeks later and wrote more to Henry Swift: "I feel about [the Louvre] and many museums as I did about the Prado—if I could only take hold! Some things are so wonderful—and yet so badly presented—and such a lot of not good. Poor Museums! Strength of mind they do need—and taste."

Back in Paris, there was so much to do. Since the spring, she had been corresponding with Henry Adams about purchasing a cathedral glass window for her third-floor chapel. He had told her about a panel of thirteenth-century glass from the Basilica of Saint-Denis (now determined to be originally from Soissons cathedral). After she arrived in Paris, she went to see the panel at Bacri Frères, longtime dealer of antiquities in the eighth arrondissement. She dressed "incognita," she told Adams, because she knew her interest in the glass would have the effect of hiking up its price. By the end of the year, the window, which told the story of the archbishop of Reims, was hers for about 17,000 francs.

Not only things but people drew Isabella's attention. She lunched with the painter Ralph Curtis, who by now was married to Lisa de Wolfe Colt and the father of Sylvia, one of Isabella's goddaughters. Curtis, who traveled more than he painted, wrote Isabella chatty letters from the many addresses of his expatriate life with his family, including the Barbaro. He began his rather arch missives to her with "Dear Queen," offered to track down various treasures for her, and reported on their web of mutual friends. He tried to make her laugh. John La Farge was also in the city, doing poorly with unnamed illnesses that Adams blamed on too much work. Isabella went to see La Farge as frequently as she could. She also stopped in to see Fernand Robert, her longtime Paris dealer, who continued to store her purchases when necessary. As always, theater and musical performances were a powerful draw. For an evening mass at Saint-Sulpice, she sat in the organ loft above the sanctuary to watch the legendary organist and composer Charles-Marie Widor play its storied organ, which had over six and a half thousand pipes.

At the end of July, Isabella took her motor ride with Henry Adams to Saint-Cloud and Versailles, among other places. "Fancy!" she exclaimed to him, and "it is good to want to thank anyone as much as I want to thank you." In August, he sent word again that he could take her touring, first to the small town of Beauvais north of the city. He had advised her, in an earlier letter, to always bring a "power binocle" to see the glass in the faraway upper windows in more detail. Now they craned their necks to look at the highest nave in all of France. The construction of Beauvais cathedral, from the twelfth century through the fifteenth, was stopped before completion because the competitive ambitions of its builders to reach higher and higher

elevations had caused several catastrophic collapses. Edith Wharton called Beauvais a "great hymn interrupted."

Chartres cathedral, located south of Paris, was next on their itinerary. Henry Adams and Isabella had been to Chartres together once before, during her brief stay in France in the fall of 1899, when she consulted with him on which Paris booksellers might have notable works on medieval art. What enthralled Adams about the twelfth-century cathedral, with its intact windows of miraculous blue, was its astounding "appetite," or what he also called "the fun of life." But something about Isabella's presence during this particular trip annoyed Adams. A day or so before, he had told Elizabeth Cameron of his admiration for Isabella's "intelligence" about museums and art. Three days later, he wrote again, this time in a different register, saying at one point that Isabella "has no reason." It was as if he could see her clearly and then she went out of focus, so that he couldn't quite make up his mind. He found her "train of poor art-connoisseurs," who accompanied them to Chartres, tedious. Or she may have interrupted him too often with her many questions. He had to admit, finally, that she was "wonderfully strong and fresh in feeling," an admission he ended with a gallant flourish: "on the whole she is quite the most remarkable woman I ever met."

When the summer weather cooled down enough, Isabella traveled south to Italy—to Venice and a stay at the Barbaro, to Milan, to Florence for a long visit with the Berensons, and then to Rome. Accompanying her was her most constant companion in these years, her lady's maid, Ella Lavin.

Henry Adams was not the only one to descend momentarily into peevishness during travel. While on this trip, Isabella told Maud Howe Elliott that the "history of our roves could be long and dismal." There had been trouble on the way to Monte Cassino, when "slam, bang, all the brakes on," their train suddenly stopped. Isabella's fellow passengers were an Italian family of four, consisting of "an invalid young man, his mother, brother and sister." The young man's trained attendant, who was in the next compartment with the family's maid, had thrown himself "out of the window," she explained. The family was "beside themselves with grief over the accident," not wanting the son to find out. "The train backed to pick up the man, still alive," and the family had a

struggle to keep the son from learning about the incident, all "rushing over me, backwards and forwards, to and from the window!" She went on:

> You can form no idea of the horror of it all. At the next station the would-be suicide was taken out off the train and off to a hospital or something. The maid in hysterics had to be coped with, crowds surrounding our carriage, and through it all, the efforts to keep the invalid son in ignorance. They told me, in English, that they feared the worst from the shock to him. Some people can make a journey in peace and alone in a train without paying for the whole compartment—but no such luck for me . . . You can't think how dreadful it all was. Of course, I am a pig to think of anything but those wretched people . . . Of course, we were hours late. When I at last got Ella and myself into bed, I thought I should break down. Well, that morning hoping for a haven of rest on board the steamer, a telephone came that she might not sail. I rushed to the office of the ship and find the strike is on terrifically, and they do not yet know when they can go, probably not before Sunday night! I don't know a soul in this place and feel as if the last straw had fallen. However, I pray for the best—Perhaps! To steady my mind I went to Pepe's, the *antiquario*. There I found some *nice* things, *very* . . .

"MY DEAR LILLA," ISABELLA WROTE AFTER HER ITALY TRIP, "I am in Paris for two weeks, and I do want to come and spend the day with you if I can. Tell me which day is appropriate." This was Lilla Cabot Perry, who in midlife had become a painter of some note after raising three daughters with Thomas Sergeant Perry, the prolific writer and sometime editor of the *North American Review*. Lilla Perry had met Claude Monet in 1889, and for two decades she spent several months every summer in a rented house next door to the artist's studio and gardens at Giverny, fifty miles west of Paris along the Seine. Isabella asked Lilla to arrange a visit so that she could meet the impressionist master. She had passed on buying one of Monet's early masterpieces, the 1877 *Les Dindons Blancs*, which now occupies its own wall at the Musée d'Orsay. John Singer Sargent urged its purchase in the 1890s, calling it "a famous old picture . . . which is exquisite." But Isabella's attention and resources were directed elsewhere at the time.

Even so, she desperately wanted to meet Monet at his idyll in Giverny. Lilla panicked. She knew Isabella was far less interested in seeing her—or, as her husband cracked, "*nos beaux yeux*" (our beautiful eyes)—than their next-door neighbor, Monet. And she knew the artist hated the sort of intrusion that Isabella represented. To evade the problem, she told Isabella that she and her husband were about to embark on a two-week bicycle trip to Brittany.

On their return, the Perrys found a second missive from Isabella. So, by the second week of November, they found themselves welcoming her to their home. After lunch, they brought her to Monet's studio and house. It was far past the season of riotous blooms in his spacious gardens, but Isabella would have seen his canary-yellow dining room next to the French-blue tiled kitchen and the view out his windows to the gardens and the marshy waters beyond. Just out of sight was the Japanese footbridge spanning the pond where the water lilies bloomed each summer. A descendant of the Perrys remarked that there was a distinct "graciousness" between the artist and the collector. Maybe Monet warmed to her when she expressed interest in purchasing one of his water lily paintings. When she later inquired about it, though, she was told she couldn't have it because Monet had been "very uncertain" about that particular series and "would let none go from his studio." Isabella did not mention this Giverny visit to Berenson in her letters, but to Maud Howe Elliott she wrote that her afternoon with the great artist had been "perfect in every way."

Two weeks later Isabella arrived in dreary London, ready to be home again. She had run herself ragged. She hated long train trips—her travels across Spain had taken an unaccountable thirty-seven hours—and always, she dreaded crossing the often stormy Atlantic. She especially missed Jack Gardner's logistical and emotional support, the way he attended to every detail. As she told Berenson: "I love the things one can see. I do not love travelling."

She set off on December 7 on the *Arabia*, and once at home, she felt immensely relieved to find that "things and people are everywhere and overpoweringly kind. Even the dogs are wild about me!" She hosted her annual Christmas Eve midnight service in her third-floor chapel, which she thought particularly "beautiful and emotioning!" The city was covered in snow, so that everything was "drifting in a white symphony."

ISABELLA WROTE TO HENRY ADAMS NEAR THE CLOSE OF HER EUROPEAN travels that "I had pleasant days in Milan, Venice, Florence, and here [in Rome], but the best were with you, thank you." The trip, her last one to Europe, had been a success. She had bought innumerable Gothic objects to add to her museum, including a large French fireplace decorated with fantastical beasts, candelabra, an iron pulpit, English gargoyles, and six large wooden beams for what would become the Tapestry Room. She had stood before many masterpieces at the Prado, imagining how she would hang the paintings differently if she were director. She had secured the beautiful thirteenth-century cathedral window through Adams, which would help complete her third-floor chapel. Light shining through its jewel-colored glass spilled colors onto the chapel floor, much as in an old French cathedral. She conveys a confident aura in her direct gaze in a striking portrait taken

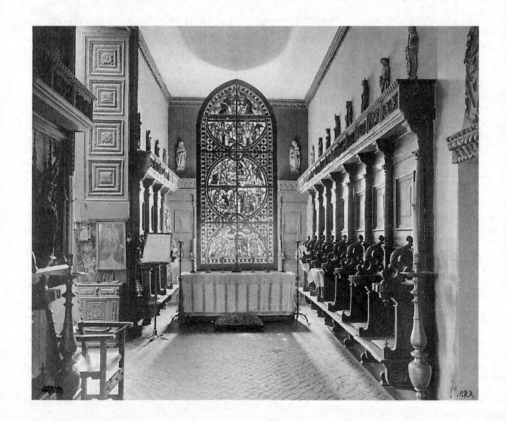

in these months by Baron Adolf de Meyer, a leading figure of Pictorialism, whose highly staged photographs appeared in Alfred Stieglitz's *Camera Work*. The image, its strong light raking in on her right, is the rare clear view of her not wearing a veil.

A few years later, in 1908, after Adams sent her a privately printed copy of his masterwork, *The Education of Henry Adams,* she wrote to him while sitting next to the Italian fireplace: ". . . the motto on my old Italian stone chimney breast is *Motu et Lumine,*" she told him. "I thank God it is Light— and I am glad I can sit by my quiet fireplace and think of the Light." Replying to her letter, he wanted her to know that his *Education* was "meant as experiment and not as conclusion. In the effort to give form to thought, one's object is not so much to teach as to learn." She understood experiments without conclusions; she understood not teaching but learning. He added at the letter's close: "Your work *is* better; Art has sense."

Twenty-Eight

"UNDYING BEAUTY AND LIGHT"

1907–9

Isabella's relief on her return from Europe at the end of 1906 quickly turned. "All is still confusion," she admitted to Berenson after a week at home. Two weeks later, she still felt undone. "January has gone galloping on and is half over. We have had nasty weather, warm and melting..." Illness ripped through the city, and her days were a seemingly endless round from funeral to lunch to concert and then to another funeral. "It is better if one can smile," she told Berenson, without mentioning any names of the dead, "otherwise we should have to go into a corner and howl. It is really too sad."

By the late winter of 1907, Gardner embarked on a new construction project: a large outbuilding on the south side of the museum, referred to alternately as a garden house or a carriage house. It soon acquired a more romantic name, Altamura, after a town in southern Italy with an elaborate gate that inspired the structure's unusual design. Within months of purchasing the land adjacent to Fenway Court, she signed off on blueprints. Construction would begin in June and would be finished soon after. The

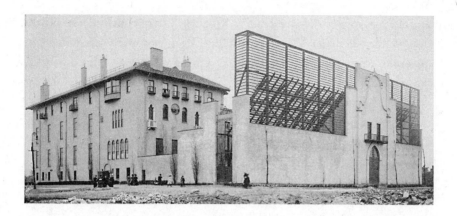

structure's enormous trellises extended the profile of Fenway Court and obscured the view of the cityscape from windows on the south side of building.

Isabella characterized this part of the year as a time of "very hard work and secrecy" in a letter to Berenson. The hard work had to do with more tasks for her museum. Open days at Fenway Court had begun that year at the end of January. She endured weeks of noise and confusion as visitors "tramped" through the galleries, up to two hundred every day from noon to 3 P.M. She would never feel at ease during open days, which occurred twice a year, for ten days to two weeks, at Thanksgiving and Easter. The realities of running a public museum remained, in her word, "wearisome."

The secrecy alluded to in her letter to Berenson had to do with a painting he had secured for her several months before, a half-size portrait of Pope Innocent X by Velázquez. She had long wanted another work by the Spanish master, a desire that had been piqued no doubt by her recent return to the Prado. She wrote to Berenson from Rome that he needed to tell her if he thought this half portrait, owned by the Brancaccio family, was "really truly" a Velázquez. When she had seen it in Paris, she thought it "seemed superb, but I don't even pretend to know!" She was being modest, flattering Berenson a little about his expertise, which in this case would fail them both. He replied quickly that the *Pope* could be had for no less than 500,000 francs. Even at that lofty price, he told her, there were several other buyers competing for the painting, including Mrs. Potter Palmer in Chicago and the English critic and painter Roger Fry, the recently appointed curator of painting at the Metropolitan Museum of Art. He added a word of caution,

one she apparently did not hear: "Of course I may conclude the picture tho' wonderful is not Velázquez." Within days, however, Berenson wrote her again, triumphantly telling her the painting was hers—"what a whacker that *Pope is*!"

The high stakes of collecting were increasing every year, as more and more money poured into the market from extraordinarily wealthy Americans. In addition, overseas governments started limiting how much of their cultural patrimony could be put up for sale. Joseph Lindon Smith and Ralph Curtis reported to Isabella during these years that antiquarians and dealers had far fewer items to show. Berenson complained that the "figures now asked will sound enormous." The situation was further complicated by the 20 percent tariff the U.S. government imposed on imported artwork more than twenty years old. When Berenson asked where Isabella was storing the *Pope,* now that it was hers, she replied that "he's snugly tucked away in a box! So, keep on never mentioning me as owner, please." She echoed the same sentiment in March 1907—"MUM is the word about the *Pope.* Be sure." The federal policies on the tariffs were ever-changing, and her strategy was to store her purchases overseas until the political winds shifted to her advantage.

The *Pope* proved to be Isabella's most costly mistake, but not because of the tariff. A decade later, an art critic cast doubt on the painting's authenticity, a doubt that was confirmed before Isabella's death. She had spent the equivalent of $70,000 (now over $2 million) on a copy of an original Velázquez to be found at Apsley House in London. The direct consequences for Berenson are not recorded by his biographers.

Spring 1907 brought a long weekend visit at Green Hill from Anders Zorn, who had sent a note to Isabella saying that he was "longing so to see you again." She adored Zorn, who liked to sign his letters to her with "your most affectionate painter." Zorn had discovered and arranged for her purchase of a terrific find: an exquisite miniature by the fifteenth-century painter Gentile Bellini, the older brother of Giovanni Bellini, who was summoned by the Ottoman sultan, Mehmet II, from Venice to Constantinople to be court portraitist. The young man sits in perfect concentration, robed in highly patterned fabrics. Isabella loved the piece, telling Berenson that it was an "adorable and exquisite thing. Zorn did this for me. It is joy and

rapture." It also rhymed with her love of books. The previous year, she had published with Merrymount Press a catalog of her enormous library titled *A Choice of Books*. She had prepared for this publication by writing page after page of detailed lists on loose papers, then small notebooks, and finally a manuscript copy of the final book.

Isabella busied herself that summer with her "farming, gardening, etc., etc., rereading books." She oversaw the third annual horticultural competition for people who lived in areas of Boston crowded with tenement apartments unrelieved by green space. Children and adults were invited to cultivate gardens in any space they could find—in windowboxes, along the sides of houses, on roofs, or in alleyways. The competition was part of a nationwide City Beautiful movement, and Isabella had funded the prize money for eighteen winners since its inaugural year, 1905. Judges took into account the scale of difficulty as well as whether plants had been grown from seed. For some, perhaps the best part of the prize was a leisurely afternoon celebration at Green Hill, when Isabella's gardens were blooming. A friend would remember how the children were "all dressed to an inch of their lives" and how one of them exclaimed to Isabella, "Oh, Signora, your garden puts me in despair." Apparently, she leaned down and reassured the boy that things like a garden took a lot of time to grow.

That same summer of 1907, an old friend returned for a brief visit. "I am in America for a very short time," Frank Crawford wrote to Isabella from New York. He wondered if he might "have a sight of you." He had come back into her life once before, almost fifteen years earlier, when he returned from Italy for a months-long stay in America, visiting various cities including Boston. Her feeling about this return is lost, although she saved several of the letters he wrote to her from this time along with a precious gift. He had hired Tiffany to bind together her and his copy of Dante's *Divine Comedy*, covered with green leather and silver decorations of his own design. The inscription on the volume's clasp, "The two are one," recalls the sentiment of the handshake photograph taken all those years ago. She placed this volume along with her other copies of the poet's books in the Dante Case in the museum's Long Gallery.

Now, Frank wanted to meet again. He had yet to see Fenway Court. A relative remembered him on this visit, at fifty-three years of age, as full of quicksilver charm but also "fragile, sunken." After an afternoon at Fenway

Court, he wrote that "Palazzo Isabella" was both "unexpected" and "wholly new." "What I cared for more," he added, "is to have seen you happy in your very own surroundings."

If Crawford saw her happy at this time, he saw only what she wanted him to know. For whatever reason, she could not seem to shake off a sinking loneliness. Berenson tried to encourage her: "Don't get lonely, and don't get tired, triumphant imperial Isabella . . ." But, of course, she did get lonely. "I was indigo blue," she admitted to Berenson some weeks after Crawford's visit. Many of her friends were someplace else. Okakura wrote to her that summer about his visits at London's National Gallery and with Wilhelm von Bode in Berlin. Her usual crowd—Denman Ross, trustee of the Museum of Fine Arts and professor of art criticism at Harvard, the curators Matthew Stewart Prichard and John Briggs Potter—was mostly scattered. "Yes, Ross is delightful, and Potter, and Prichard . . . *et tout le tremblement*. But as Europe has swallowed up all but Potter, what good are they to me?" Isabella felt close to George Augustus Gardner's granddaughter, Catharine Gardner, daughter of George Peabody Gardner (called Georgy as a boy, now "Peabo") and had hosted a series of coming-out balls for her at Fenway Court. That summer, Catharine married a curate at the Church of the Advent in an elaborate wedding celebration. Another generation of Gardner children were grown and setting off on their own.

Soon after, Berenson tried to cheer up Isabella in his usual way: by tempting her to buy more paintings. She replied, "Woe is me! Why am I not Morgan or Frick?" She desperately wanted two of the three paintings he described but could not really afford them, with the market slumping terribly in what would become the Panic of 1907. Even so, she gave Berenson the go-ahead to buy two portraits, one by Andrea del Castagno and the second, a profile of a woman by the fifteenth-century painter Piero del Pollaiuolo, which she later hung in the Raphael Gallery. She lost out on the Castagno, which was bought by J. P. Morgan.

───※───

IN THE MIDST OF BUILDING PROJECTS AND NEGOTIATIONS, FRUSTRATIONS and loneliness, Isabella received an invitation from A. Piatt Andrew. Would she like to spend the day at his home on the rocky shore of Eastern Point in Gloucester? They had met in 1903, soon after the museum opened, when

John Singer Sargent was busily painting portraits in the Gothic Room. Piatt had two lives: he taught economics at Harvard College, and he occupied the center of a group of bohemian friends who all built houses overlooking Gloucester Harbor on the North Shore.

Piatt, born in 1873 in La Porte, Indiana, the son of a successful banker, was an all-around athlete who moved like a dancer. He brought a Midwestern informality with him east, where he attended Princeton, then Harvard for an MA in 1895, followed by graduate education in Europe, where he eventually earned his PhD in economics. By the time he knew Isabella, he was already a very bright light who enjoyed the esteem of his academic colleagues such as the philosopher William James, a sometime guest at the summer home Piatt built for himself in 1902, called Red Roof. Piatt's star rose higher still after he published a prescient article in the *Journal of Commerce* in early 1907, about the impending banking crisis. Now politicians and policymakers sought him out for his economic acumen; he would serve on the National Monetary Commission and then direct the U.S. Mint during the Taft administration in 1909.

Confident, funny, and impossibly handsome, Piatt possessed an uncommon grace that everyone noticed. His love affairs with men were many. When he and Isabella were becoming closer friends, he was falling in love with Jack Mabbett, a twenty-five-year-old senior at Harvard College. Piatt

mentioned Mabbett frequently in letters that recounted their dinners together and nights out at the theater. People, including Isabella, saw them as a pair. She appears with Piatt (on her right) and Mabbett (on her left) in a picture from 1908. Her dark veil, which she often wore at the shore to protect her fair skin, is darkened to pitchblack by the bright sun.

Piatt did not hide who he was, particularly while staying at Red Roof. The close circle of artists and writers, designers and professors, a sort of New England Bloomsbury, were shedding Victorian inhibitions. Isabella called the group of five "The Colony," while they referred to themselves as Dabsville, after the first initials (DABS) of the key members. Joanna Davidge lived next door to A. Piatt Andrew when not running her girls' school in New York City; the painter Cecilia Beaux, known for her vivid portraits, lived on the other side. The single *S* stood for two others: Caroline Sinkler, whose fiancé had died the night before their wedding and who wore shades of violet ever after, and the interior decorator Henry Davis Sleeper.

Sleeper, five years younger than Piatt, began construction of his masterpiece of decorative arts, a fantasy home he called Beauport, in the fall of 1907, just as Isabella began her frequent visits to Gloucester. By the next May, he would move in, continuing to add on to the house's many distinctive rooms; his reputation as a leading interior designer kept growing. The historian R. Tripp Evans convincingly argues that Beauport was Harry Sleeper's grand love letter to Piatt, who reciprocated the friendship but not the desire.

Isabella enjoyed staying at Red Roof, whether Piatt was there or traveling. Towering oaks and old birch and willow trees swayed with the sea breezes; the air was scented by an herb garden and large clematis bushes. She took the house's red bedroom, with an especially large crucifix, and shipped her own clean sheets ahead of her arrival to use on the bed. Ella Lavin, her maid and companion, often accompanied her.

Isabella soon started addressing Piatt as "A," while he called her "Y," after the Spanish spelling of her name: Ysabella. At a soiree where everyone was in costume, "A" draped a dark cloth, with large Y, over the back of Isabella's chair, making her the queen of the evening. He took her for automobile rides along the shore and on a hayride one late Thanksgiving afternoon, just as the sun set. Scenes from their days together fill Piatt's guest books. In one photograph, she clutches Sleeper's arm; in another, she stands proudly with the large group in a rather unusual all-black costume. Piatt is front and

center, with his black bowtie and white summer shoes. Among these friends, all at ease with who they were, Isabella too felt at ease. Everyone in the group was younger than her, some by decades.

A tone of playfulness livened the group and, absent the strictures of Boston society, a scintillating intimacy. If there were romantic intrigues, there were no conventional marriages or children. Isabella did not need to converse about children and grandchildren—a change from the conversation in her other social circles. With this assembled family, talk centered on houses and decoration, sailing and horses, and art, literature, and politics. Piatt recorded a quiet December dinner with Jack Mabbett at Fenway Court with two words: "Music, tears." He sent her a note the day after: "Let me say just this once while the memory of last night's beauty still haunts and fills me and makes it impossible to think of anything else. None of us will ever forget the overwhelming loveliness of what you made us feel."

She must have loved this. Her letters to Piatt are filled with eager exclamation marks. And she wanted the group to be all hers: "Your village is Fogland with the sea's white arms about you all. Don't let outsiders crawl in—only me! For I care. I love its rich, strange people, so far away." As she was sixty-nine years old, more overseas travel was unlikely for Isabella; Eastern Point would be her faraway place.

Pleasure, retreat, belonging—these qualities must have felt critical as the Panic of 1907, a banking crisis, triggered the most severe crash in American history, until the 1930s surpassed it. The crisis drained fortunes, including Isabella's accounts. Things got worse for her when a federal agent from the Treasury Department arrived at her doorstep in the summer of 1908. She was again in trouble over tariffs. Isabella had arranged to keep a cache of art purchases with the Chicago heiress and collector Emily Chadbourne in her large London home, a way to delay paying import duties, with the hope that the tariff law would soon change. (It is not known how Isabella came to know Chadbourne. It was likely through Matthew Stewart Prichard, who was known to accompany Chadbourne, when in Paris, on visits to Matisse's studio.) When Chadbourne decided to move to Chicago, she was informed that her own belongings would not be subject to the tariff. So, in an effort to help Isabella, she packed several of her friends purchases in

wooden crates and shipped them to Chicago—without informing Isabella. When they arrived, in June 1908, custom agents noticed a discrepancy between the insurance for the goods and their stated value. So they opened the crates and impounded what they found inside. Emily Chadbourne sent an anxious telegram to Isabella, saying that she was coming to Boston to explain the situation in person. The Treasury agent arrived at Green Hill ahead of Chadbourne.

Secured in the heaviest crate was one of her prize purchases, a large, unforgettable fresco of a young Hercules by the fifteenth-century artist Piero della Francesca. Joseph Lindon Smith had helped her with its purchase from Elia Volpi, a dealer in Florence. The fresco had decorated Piero's own home in Borgo Sansepolcro. "What a masterpiece it is!" Smith wrote to her June 1903, and a few weeks later stated "no museum certainly has such a picture." The black-and-white photograph that he sent along conveyed little of its power and sensuality. Along with the Piero, the authorities seized two series of magnificent Flemish tapestries, which Isabella had bought in 1903.

She described the debacle in a long letter to J. P Morgan; it is now in the archives at the Morgan Library in New York. "Dear Sir," she began: "I thank you for your letter. I am inclined to tell you the absolute truth about this Custom house matter. Then you can see for yourself, if there is or is not injustice done. I have all my life paid duties to the full on everything I brought to this Country; although it seemed criminal to me that a Government should exact duties on works of art. Finally, the time came, when I could bring no more works of Art in as I could no longer pay duties on them. Therefore, the last few things were left in storage in Paris. I, one day, lamented to a lady living in London how hard it was to have to pay so much for storage. She said: 'don't do that, send the things here to me in my London house' . . . I sent the things to her, the understanding being that she should keep them until the duty on works of art should be taken off."

Isabella went on to explain that she had never heard about Emily Chadbourne moving to Chicago until she learned "that there was trouble" about her artwork. "The Government appraised the things at twice the amount I paid for them & accused her & me of a concerted plan to defraud the Government . . . Well, the Government claimed $30,000 duties & $40,000 penalty & now demands $83,000 more—making it all $153,000 . . . And this comes of trying to do alone what no one else has ever tried to do for the

good & education of the people of this country. I have burdened you with this long story because you were kind enough to write." She signed her name simply: "I. S. Gardner." Chadbourne offered to pay the fine, but Isabella refused, knowing that her friend's mistake had been an honest one.

The newspapers were full of scorn. "Mrs. Gardner's Mistake" was the headline of the *Boston Globe,* which called her one of the "misguided persons" who import works of art. Isabella was used to reading reports focused on her, at one point even hiring a newspaper clipping service to collect all the stories for her. She generally found the reporters' mistakes and mischaracterizations amusing. Her friends sometimes regaled her with gossip they'd overhead, such as this funny scene that Ralph Curtis sent her way: "A lady in a Philadelphia train overheard two matinee-girls' dialogue. 'I waited over an hour to see Mrs. Jack Gardner come out.' 'Mrs. Jack Gardner of Boston?' 'Yes.' 'Is she so very handsome?' 'No, but she is awfully fascinating, and so wicked.' 'Oh Mamie, tell me how wicked is she?' 'Well, just about as wicked as Cleopatra!'" The soprano Nellie Melba remembered, in her autobiography, that "People talked about Mrs. Gardner, of course, as they talk about anybody who takes the trouble to undertake a really big job." They said fantastical things, accused her of having paintings so improper, she had to hide them in her roof. They mocked her for going too far in trying to replicate Venetian life at Fenway Court, to the point of having her daily mail "handed up in a basket each morning." But sometimes the talk had far more malice, Melba explained, as some people tried "to make out that her palace was a failure." This tone was characteristic of the reporting on the case about the tariff. As Isabella wrote to Berenson at the end of the summer: "I am tired and weary and broken down with the accumulation of woes." She felt hounded from all sides.

By the fall, when she failed to announce in the papers when Fenway Court would open for its usual two weeks in early winter, Henry Swift sent Isabella a stern letter of rebuke, warning that her failure to do so would be used against her. "Every day people are asking when the exhibitions will begin. Have you decided to abandon your noble purpose? I shall be deeply grieved and very much ashamed if this is so." His words stung. Isabella wrote back the next day: "It distresses me much to have you say, 'you will be very much ashamed.'" She was not ashamed, and he shouldn't be either. Instead, she was furious with the U.S. government, which she blamed for putting

her in this terrible position. But she would comply: "My position now is, if I am forced to pay, to do it in the most feasible manner, and then thank the Lord, and be free."

⁂

IN THE NEW YEAR OF 1909, GRETCHEN OSGOOD WARREN HAD AN IDEA. She and Isabella had been close friends, especially since Sargent painted the portrait of Gretchen and her daughter, Rachel, at the museum six years before. Though there was a thirty-year difference in their ages, and Gretchen looked to Isabella for inspiration, they shared an equality of spirit. They talked of disappointments and worries as well as moments of great pleasure. In one letter, Gretchen philosophizes: "I don't think a little easy happiness and peace is very interesting or vital. The lives that get happiness through storm are so much more, for they have forged a sword."

Now Gretchen conferred among their mutual friends, Ida Agassiz Higginson and Henry Lee Higginson, about Isabella's situation. Ida had known Isabella as young, irrepressible Belle, learning Italian in Rome and Milan. Higginson, who knew the difficulty of leading a major cultural institution as founder of the Boston Symphony Orchestra, almost never wrote to Isabella without mentioning his undying affection for Jack Gardner, admitting ten years after his death that "daily I miss him." All three friends asked the book designer Mary Crease Sears to craft a special volume with blank pages, a tribute book bound in dark-brown leather, with brass fittings and an enormous emerald-green stone on its front cover. Gretchen and the Higginsons rounded up as many of Isabella's friends and admirers as they could and requested an autograph from each.

The dedication on the inside page of the volume began: "We the signors of this book divine to give you an earnest expression of our feeling about the noble work done by you for Boston. You have conceived and built a beautiful house and have filled it with treasures of art." They memorialized her "untiring energy and love of your task" and called Fenway Court "a unique achievement of imagination, skill, and ardent purpose."

The dedication was signed by the Higginsons, and then innumerable names followed, page after page after page. A single page contains the distinctive signatures of Henry Adams, Henry James, both Berensons, Ralph and Lisa Curtis, and the novelist and later Irish revolutionary Erskine

Childers and his Boston-born wife, Mary "Molly" Alden Childers, Gretchen Warren's sister. The regular retinue at Green Hill appears, including Denman Ross, John Briggs Potter, and various members of the Gardner family. Isabella's Dabsville family and her fellow parishioners at the Church of the Advent all signed, as did the mayor of the city. Edith Wharton, never an intimate of Isabella's but not wanting to be left out, signed at the bottom of the very last page.

The plan was to surprise Isabella on April 14, her sixty-ninth birthday. Higginson led the ruse, asking her if he could come by Fenway Court that day, without indicating any other plans. What he didn't tell her was that two others, including Ida Higginson, would be joining him to present her with the tribute book. They did so in front of a roaring fire in the Gothic Room. A large celebration followed at the nearby home of Susan Cabot.

Gretchen Warren could not attend the gift ceremony or party, but she sent a long letter that same evening. The tribute book "is full of loving gratitude from us all," she began. She did not shy away from a subject she and Isabella had privately discussed before. "Of course, you know what I always think of when I think of you—of your having no children and of the sadness which I know lies at the bottom of your heart," she said. But Gretchen assured Isabella that "you have the perfect joy of having given to all the hungry people who have gone into Fenway Court, and in the future will go, the nourishment and inspiration of undying beauty and light."

Isabella replied the very next day: "That I am writing today . . . proves that emotions do not kill. For I have lived through yesterday. Your hand and heart had touched everything. The wonderful basket of violets and the cable messages from you and Molly were only marginal notes on the book of love . . . I have just now been rereading your beautiful letter. I can only sit still and cry hard! I know I can never tell you anything of it all, but you do feel it."

Isabella Stewart Gardner had an extraordinary capacity to elevate and electrify the everyday. She infused her museum with this feeling. But her sorcery sometimes cast shadows. Ever since her arrival in Boston fifty years before, she had provoked strong emotions in others, some harshly negative and others over-the-top positive. She tried to ignore the naysayers, as Nellie Melba would testify, but the effort created inner tumult. People

mistook her for her persona, Mrs. Jack, the woman "everybody has heard of," as Berenson once called her. That woman was a "stunner," he added, but he did not "long for her." The woman he wanted to spend time with was "the intimate, tender, esoteric Isabella."

This is the Isabella she revealed in her missive to Gretchen Warren, and this is the Isabella who appears again and again, like a leitmotif, in these later years. Morris Carter writes of it this way: "Many a woman who has known the pleasure of being considered charming in her youth has found herself neglected and forgotten in old age, but Mrs. Gardner had the happy experience of knowing herself more appreciated, more admired, and more beloved as the years passed." Instead of pulling inward in the face of age and loss, she became more expansive, more open, unfolding like a miraculous December bloom in her garden.

PART VI
A DREAM OF YOUTH

Qu'est-ce qu'une grande vie? Une pensée de la jeunesse réalisée par l'âge mûr. *What is a grand life? A dream of youth realized in mature age.*
—AUGUSTE COMTE, COPIED BY ISABELLA STEWART GARDNER IN HER COMMONPLACE BOOK

Twenty-Nine

SEEING AND HEARING MODERNISM 1910–13

In early February 1910, Isabella Stewart Gardner wrote to Bernard Berenson about her winter travels: "I have been away for 2 days in Washington and 4 in New York, and I really had a glorious time, seeing and hearing. Some of it was Bohemian, musician-y and such like," she wrote, and then had to add: "But I saw no pictures and came home for that." By pictures, she meant paintings, and home of course was Fenway Court. The thunderclouds of the previous year had lifted somewhat because of the tribute book and because the hated tariff on imported artwork older than twenty years had been eliminated by the Payne-Aldrich Tariff Act, which Congress passed at the end of 1909. Alas, the legislation came too late to remedy her situation, but she was relieved and maybe felt a little vindicated. Future purchases and imports would be less complicated and less expensive.

After her last trip to Europe, in 1906, Isabella's life had settled into something of a seasonal rhythm. She often traveled by train to New York or Washington, D.C., for a few days near the beginning of the year, as she did in 1910. She lived high up on the fourth floor of Fenway Court from late fall to the spring, with expansive views from her windows over the treetops on the Fenway, which sometimes seemed to her like jewels—"peridots with emeralds," as she wrote to Berenson. She had a telephone installed, which she used to call out, but no one could call her—people contacted her by letter or telegram instead.

Ella Lavin, steadfast and efficient, usually traveled with Isabella, while Margaret Lamar, who had worked for her since the 1870s, continued on as housemaid. Teobaldo Travi, always referred to as Bolgi, took care of Fenway Court, supervised other employees, and served as majordomo, or chief steward. He wore elaborate garb designed by Joseph Lindon Smith, and his costume included a large ceremonial staff. Isabella would tell Berenson, several years later, that her "life is saved daily by Bolgi, my Italian, who always is a comfort." Her staff at Fenway Court—a cook, a waitress, and a

chambermaid—was smaller than at Green Hill, where she also employed a head gardener. For years, the master landscaper and gardener had been Charles Montague Atkinson, who had first worked for Jack Gardner's father and had helped her win innumerable horticultural awards. William Thatcher took over in 1896 and helped her build her Japanese garden a year later.

The museum's public hours had been pared down slightly. At Thanksgiving and Easter, Isabella opened it for a week to ten days. All the white coverings had to be removed from the furniture and paintings, tickets had to be announced in the newspapers and sold, gallery attendants hired, and special events coordinated. Open days coincided with the start and conclusion of the social season, with its dizzying round of dinners and theater openings and orchestral performances. Isabella was a staunch supporter of the city's new Opera House, on Huntington Avenue, right from its first performance, in 1909. She tried never to miss an opening night, taking the streetcar home to Fenway Court after an evening performance, which was considered very daring.

She continued to coordinate events of all kinds at Fenway Court, often for charitable causes. She loved dance and theater, and early on provided a venue for the avant-garde dancer and choreographer Ruth St. Denis, who performed *The Cobra, or the Snake Charmer* and *Radha, a Hindoo Temple Dance,* at an evening gala to raise funds for Holy Ghost Hospital for the Incurables, a Catholic organization in nearby Cambridge. Her co-sponsor for that occasion was Boston's mayor, "Honey Fitz" Fitzgerald. The *Boston Evening Transcript* described St. Denis's performance as "poetry in motion," noting the effect of the dance was surely "heightened by its splendid setting." A few years later, Isabella hosted a French Christmas play in the Gothic Room to benefit the victims of the devastating 1908 earthquake in Messina, Italy.

Isabella attended a matinee performance of *Louis XI* at the Majestic Theater, which was produced by the acclaimed Italian actor Ermete Novelli. Isabella decided to invite Novelli for a tour of Fenway Court. The actor had "fallen in love with the Music Room," which gave her an idea: she would host a party featuring Novelli and his troupe of actors, though doing so would prove a two-day "scamper" to get everything ready, as she explained to Berenson. She sent out hurried invitations to friends, including the novelist Sarah Orne Jewett and her companion, Annie Fields, saying their attendance would "give me much joy and pleasure." The acting troupe

performed two short plays followed by a supper in the Dutch Room, with the Rembrandts shimmering in the candlelight. Some weeks later Fenway Court was again crowded with events, including a concert by the esteemed Kneisel Quartet, the last one of the season, in the Music Room.

Lady Augusta Gregory arrived in America in 1911. A celebrated Irish folklorist and playwright, she founded Dublin's renowned Abbey Theatre together with her friend the poet W. B. Yeats. She was a decade younger than Isabella, yet the two women shared several characteristics: an imperious nature, a late arrival into their power and influence, a willingness to do battle, and an intense desire to uplift culture. In March 1912, Isabella invited Lady Gregory to Fenway Court, where the Irish woman read a selection of poems by Yeats and gave a lecture on the possibilities of founding a national theater in America. The playwright reported to a friend that when Isabella greeted her, she did so with both hands, saying: "you are a darling, a darling, a darling."

As the New England snow melted, and after spring open days at Fenway Court, Isabella moved to Green Hill, usually in late April or May, to watch her gardens wake up, a spectacle she never tired of. There she welcomed innumerable friends and visitors, raised puppies, hosted lawn parties, and spent long afternoons outside. One year, 1909, she leased the main house and stayed at the much smaller Warren Street house on the estate, want-

ing to economize. But apparently she did this only once, because the next summer she wrote letters from the main house, with its enormous trellises covering the front and side. "I am so busy—indoors and out of doors," she told Berenson in May 1910, "and such an arbor of wisteria!"

She marveled at the athletic prowess of her grandnephew, George Peabody Gardner Jr., who as a Harvard student won accolades in numerous sports. For his hockey games, she donned her warmest furs and watched him skate, while she perched on a packing case tipped on its side. She cheered on Harvard teams and liked to clip newspaper accounts of especially competitive games to paste into her guest books. As soon as the baseball season began, she attended Red Sox games, proud to say she did not miss one of their victorious World Series home games in 1912. "Oh, you Red Sox," she wrote across a page in her guest book that year, the title of a popular song. The papers reported how she wore a white band emblazoned with that phrase to a symphony performance, "almost causing a panic among those in the audience who discovered the ornamentation." She loved to cause a stir.

She no longer made the long journey to Roque Island, still owned by the Gardner family, and trips to Prides Crossing had become less frequent. Instead, starting in 1905, she traveled to a small arts colony in Dublin, New Hampshire, to spend some days with her close friends Joseph Lindon Smith and Corinna Smith, who had started a children's theater there. She and Corinna often attended the symphony together when in Boston, and Isabella was the godmother of the Smiths' third daughter. She'd asked to be the godmother of the child's older sisters, which Joe Smith politely declined, not wanting his daughters lavished with gifts, which Isabella tended to do. In Dublin, the Smiths dedicated their Chinese-style porch, with its large moon gate, to Isabella in an elaborate ceremony of potions and recitations. She carved her name on the Smiths' unconventional guest book, a tall wooden settee. Corinna remembered how Isabella, "with the use of her given name only (like royalty), somehow achieved in a conspicuous script . . . the attention which she intended. 'Tell me anything you know about that remarkable woman,' was the request frequently made." Other signatories included Mark Twain, Ethel Barrymore, and Amelia Earhart, a distant cousin of Corinna's.

A frequent signatory in Isabella's own guest book in the summer of 1910 was a slim, fine-featured young man, by then in his early thirties, who would rise in importance in her life in its last decades: Morris Carter. Born

in a small town northwest of Boston into a family of precarious means, Carter was bookish and diligent. He graduated summa cum laude from Harvard, where he nevertheless felt himself to be, in his word, a "nonentity." In 1903, he was hired as a librarian at the Museum of Fine Arts, Boston. Matthew Stewart Prichard, who hired him, told her that he found the younger man "sincere and thorough." A friendship slowly developed so that by early 1908 the two often had tea together in the Dutch Room at Fenway Court on Sunday afternoons, which had become Gardner's regular time for receiving visitors. He liked to bring her fresh bowls of *matzoon,* a kind of fermented milk similar to yogurt that had become a health food fad. By 1910, his entries in her guest book made brief mentions of progress on his "little house" in Chestnut Hill, which she was, characteristically, helping him design, furnish, and finance.

In October 1910, Isabella invited Okakura to join her on a visit to the Dabsville colony, an occasion recorded by a pair of images by Thomas Marr's son, Arthur, who by now had taken over the photography establishment run by his father, who had died in May. Here on the terrace at Red Roof was her assembled family: Piatt and Isabella in the back row; Okakura, Caroline Sinkler, and Harry Sleeper in front. Her closeness with Piatt in the second photograph is particularly evident and moving; they sit almost as mirror images of each other, both with crossed legs, shiny black shoes, light-colored clothing—turning toward each other in conversation, as friends do. Mary Berenson would comment in a later letter, after hearing news of her social world, "It is so pleasant to think of all the young life that surrounds you and makes you the centre. That is one of your marvelous Secrets."

Isabella's physical vigor became a topic of conversation as her cohort aged; she seemed almost ageless by contrast. Ellery Sedgwick, who had made the report of Sargent chasing Isabella at Groton, remembered her telling him, when she was well past seventy, about one of her days: "she had risen at six, caught a football train for New Haven at eight, watched the thrilling game [Yale vs. Harvard], applauded the victors, returned in a crowded coast of rollicking hurrahing boys, and then had refreshed herself by going out to supper." Henry Adams observed during these years: "Of all our set,—Henry Higginson, brother Charles [Adams] and the rest,—she is by far the youngest and spryest." He added that she was "a wrinkled old fairy all the same." She kept her trim silhouette and protected her alabaster complexion with a white

or dark veil as a shield from the sun, which also softened her features and hid her wrinkles from the camera. Some remember her hair during these years as being a blond color, others a cinnamon hue. Sometimes she wore a wig.

In July 1910, she told Berenson, "I am not over well, so write only a little." This scared him witless, because, as he said in his immediate reply: "it is the first time I hear you complain of your health." She hated to seem so vulnerable and didn't want to talk about it anymore, urging him: "mum's the word henceforth about my health." But the next year, as she approached her seventy first birthday in April 1911, a horrid grippe waylaid her once

again—"seized me and made a mess of me," she explained to Berenson. This was a more serious case. Her illness lingered so long that news of it got into the *New York Times,* which reported that she was "critically ill in her home in the Fenway and has cancelled all of her social engagements." She was not much better by the time she wrote again in early May that all she did was to take "digitalis and lie still." Digitalis was a medication taken then, and now, for heart failure, though Isabella did not mention anything about her heart. At the end of the month, she sent word to Berenson that no family in Boston had been left untouched by influenza. She assured him that "I am obeying all the *medicos* and *very slowly* getting on my feet."

Regardless of the cause of her debility, these recurring bouts of illness made her worry about the future. Not long after this, she wrote out plans for her funeral and gave a copy to her niece Olga Gardner Monks for safekeeping. There was much to settle for Fenway Court. She was still trying to secure the desired amount for its endowment: one million dollars. In a document she titled "Suggestions for Running Museum, I. S. Gardner in the Fenway," she detailed her instructions: "That it should be opened to the public for the 1st week of every month—the hours to be from 10 to 12 & from 2 to 4pm. Two women to live in the house on board wages to do the cleaning and to be constantly on hand. There should be night and day watchman—one for each time. They should attend to the furnace. There should be one gardener to take care of the 'Monk's Garden' and the courtyard. There should be one janitor to take tickets and help the day watchman in sweeping up and cleaning the cloisters up. The small catalogues should pay for themselves and more—25 cents a copy. The door in the front of the house (Fenway Court) to be used only when the house is open to the public. At other times to be locked."

By June 1911, the worst of Isabella's illness had passed, and she felt well enough to meet Henry James for a day's excursion to Eastern Point. James's return to America from England the previous summer was partly due to the fatal illnesses of two brothers, first Robertson and then William James. This cascade of deaths, William's especially, broke the writer's heart. James looked terrible—puffy and unfit—and felt worse. The sequence of weeks "have all been as a black nightmare," James had told Isabella the previous September. He sent her several letters that fall and winter, promising to "talk . . . better than" his letters could, but then never quite found the right time to do so. Henry James kept his usual posture, a combination of sociability and remove.

Even so, James—three years younger than Isabella—managed to join her for the opera in March 1911, and in June they made a more elaborate plan to meet at the train station in Lynn and travel by car to Gloucester for a lunch with the painter Cecilia Beaux. The weather was wet and misty, but James loved how the fog softened the craggy look of the Atlantic coastline. Beaux had recently sketched James's portrait in charcoal, a forbidding representation—one critic compared it to a death mask—that captured the tremendous tensions in his life. James found Beaux unnerving too, but he recalled in a letter to Isabella their shared lunch overlooking the coastal waters, gratefully telling her it was "a reprieve from death" and "life-saving."

James left for England the next month, never to return. Though these two old friends would continue to exchange occasional letters, they would never see each other in person again. His last known letter to Isabella, sent two years before his death in 1916, was one of his most generous. He gave a vivid picture of her during these years, and his ambivalence, so palpable in their correspondence, is missing, as if he knew he was saying goodbye. Calling himself "your faithfullest, and from further back now surely than anyone," he compared Isabella to one of her precious jewels: "You shine out to me with undiminished interest and in your splendid setting—of so much art and so much honour."

Another kind of leave-taking soon followed. "Okakura goes to Japan tomorrow," Isabella wrote to Berenson in early August 1911, "and I shall be in the dumps." He would return to Boston once more, but every separation pained her. "It will be a 'truly' loss," she said, affectionately mimicking her friend's way with English. Okakura's signature, in both English and Japanese, had filled her guest books, often accompanied by lines of his poetry: "One Pathway / On this Green Hill / Where the incense / of the Ancient Moss / Invites Me." He gave the white Angora cat, Lonesome Cloud, Isabella's gift to him, to the artist Dodge Macknight for safekeeping, then wrote to Lonesome Cloud from Tokyo a few months later: "When you left I have felt the loss deeply—my breast has missed your nightly tread, the table was suddenly large without your prowling presence . . . Be courageous, for bravery is the key into life." Okakura ended his playful missive with a more serious question that was really for Isabella: "Are you lonesome? Loneliness is the lot of many worthier than you or me."

ISABELLA RETURNED TO WASHINGTON, D.C., ONCE MORE, IN EARLY 1912. A. Piatt Andrew, now the assistant secretary of the Treasury in the Taft administration, squired her to dinners and receptions, including one at the White House. She spent a morning with Henry Adams at his corner mansion on H Street overlooking Lafayette Square, where "she chattered away," according to Adams, "as fast as ever, full of the Diplomatic Reception, the diamonds, the handsome women, and the clothes..." She was entertaining that day, but there was a more serious side to their friendship. He judged her the only one of his friends who understood his passion for medieval French music, and he sent her one of the early privately printed copies of his masterwork *The Education of Henry Adams,* which she praised: "I have finished another great pleasure that came from you." When he came for a visit to Green Hill that same year, he marveled once again at her vitality, gossiping to a friend that "in movement and energy she knocks me silly." He mentioned being "just the same age" but appraised her, typically for him, as "wonderfully old and wrinkled, far beyond me."

In early 1913, Isabella received a letter from New York sent by John Quinn, the lawyer for the American Association of Painters and Sculptors.

"There is to be a fine, big exhibition of contemporary art here in New York at the 69th Regiment Armory, for a month beginning February 17th," he explained. The association was sponsoring the International Exhibition of Modern Art, which would travel from New York to Chicago, and then to Boston. Quinn was born in Ohio of Irish descent and, as an avid collector of contemporary European art and a friend of James Joyce and T. S. Eliot, was steeped in modernist conversations. He was also the sometime lover of Lady Gregory, who may or may not have been the link between Quinn and Isabella. In any case, Quinn invited her to be an honorary vice president of the exhibition, along with artists such as "Rodin, Renoir, Monet, and . . . Odilon Redon." England would be represented by D. S. McCall of the Tate Museum and Sir Hugh Lane, founder of the Dublin Gallery; other Americans included J. P. Morgan; Archer M. Huntington, head of the Hispanic Society; and Louisine Havemeyer, suffragist and formidable New York collector. Arthur B. Davies, the president of the association, argued that Americans needed an opportunity to see for themselves new influences in "the art way," so they could "judge for themselves." The speed of Isabella's reply conveys something of her delight: "I received your letter this morning and I am much pleased to accept the honour of being one of the Honorary Vice-Presidents of the Contemporary Arts. It is a distinguished pleasure to be one in such a company."

Quinn needed the imprimatur of the leading art collector of Boston, given the radical nature of the show, which would come to be called the Armory Show. The upheaval in the turn-of-the-century art world was intense and overlapping—the old verities about meaning and beauty were being questioned; everything was in flux, in response to rapid social and technological change. Conventions of representation were upended in favor of instinct and immediacy, from pictorial considerations to the act of art-making itself. The Armory Show would showcase artists most Americans had never seen before, including Brancusi, Braque, Kandinsky, Duchamp, Picasso, and Matisse. American artists would be represented too, such as the Ashcan School painters George Bellows and Robert Henri, the cubist Louise Pope, and Boston's own Maurice Prendergast. But the focus of the show would be the works by Europeans, which numbered approximately three hundred.

The show began in mid-February in New York, at the enormous Armory on Lexington Avenue and Twenty-Fifth Street, where it ran for a month before moving to the Art Institute of Chicago for two weeks. There,

art students expressed outrage at the new art by burning in effigy copies of Matisse's paintings on the museum's walkway. The students were protesting, at a mock trial, what they deemed a "total degeneracy of color, criminal misuse of line, general esthetic aberration." The American public had little interest in modern art when it was first developing, in the years leading up to World War I. Some condemned it as an affront to American virtues. A *Vanity Fair* critic of the time wrote a pithy summary of this reaction, saying that the show "surprised New York, disgusted Chicago, and horrified Boston."

Isabella traveled to New York in March, accompanied by A. Piatt Andrew, who noted simply in his diary that he had visited the "international cubist and futurist exhibition with Y." She did not mention going to the Armory Show in any letters that survive, nor did she preserve a copy of the New York exhibition catalog. When a smaller version of the exhibition, sponsored by the Copley Society and including only the European artists, finally arrived in Boston in late April, the *Boston Herald* called it the "sorriest spectacle," at once "funny and depressing." Isabella kept the catalog of the Boston show but made no marks on its pages.

She did not collect modern art in the quantities that she collected the old masters, but she stayed conversant with many aspects of contemporary art movements. She tried to see all the art she could, not discriminating between schools and styles. When she was in Paris in 1894, the Swedish impressionist painter Anders Zorn accompanied her on visits to the galleries of Antonin Proust and Jean-Baptiste Faure, dealers and collectors of impressionist and post-impressionist artists. She returned to those galleries and others in 1906. She was an early supporter of Whistler, when others discounted him. She bought important portraits by earlier impressionist figures, such as Manet and Degas, and she visited Monet's studio at Giverny.

Isabella's deep interest in what was current extended to other arts. The photographer Edward Steichen gave her the second volume of Alfred Stieglitz's groundbreaking journal *Camera Work*, knowing she would be interested. She hosted a new generation of choreographers and composers at Fenway Court, giving them a chance to try innovative things and have an audience. Charles Loeffler's compositions were a mix of contemporary tonal music with a lushly Romantic element. She bought drawings by the Russian Léon Bakst, the costume and stage designer for the Ballet Russes. The imagist poet Amy Lowell, a relation of Jack Gardner's, read to her and liked

to talk about the New Poets. "It is very agreeable," Lowell once remarked to her, "to read to so sympathetic a listener, I assure you." A young T. S. Eliot had visited Mrs. Gardner as a Harvard student and continued corresponding with her about mutual friends, including Matthew Stewart Prichard, after Eliot's move to London.

Prichard kept her abreast of contemporary artistic debates in voluminous letters from Paris: on what was happening in the galleries, on his friendship with Henri Matisse, on the nature of art. "The formula is: Write to Mrs. Gardner your latest thoughts, [and] they will be understood." Prichard described how Matisse "brought down upon himself a storm of abuse" from the papers and from fellow artists after a showing of his "life-size *La Danse* and *La Musique* with their saturated colors of green, blue, and red . . ." He visited the artist at his studio in Issy-les-Moulineaux, located just outside Paris, which he depicted in his 1911 *The Red Studio,* a masterpiece included in the Armory Show. Matisse "goes from strength to strength," Prichard said to Isabella in 1912, "very rarely putting forth work which is not remarkable as colour and design . . . Of course, he is not understood."

The psychological depths plumbed by Matisse rhymed with the philosophy of Henri Bergson, who proposed that true knowledge, residing beneath rational surfaces, could be accessed through instinct and intuition. Prichard, who attended the famed philosopher's lectures at the Collège de Paris,

reminded his friend of how she wanted him to write "letters which reek of the classroom and oil-lamp"—in other words, everything he was learning from Bergson. And so he did. In a long letter at the end of 1910, Prichard described Bergson's lively manner in front of a packed Paris classroom, and how his students followed on the edge of their seats, because "you have the feeling that you are preparing . . . in the company of a great teacher the future of the world." Bergson posited that "we obtain a wider knowledge by our feeling than our reason . . . and that to understand life itself, we must refer to the data of our feelings and trust our intuitions."

The other side of this correspondence—containing Isabella's reaction to what Prichard was telling her—is lost. What is clear: Prichard's comment to her that "every picture contains for me this unsettled battle between truth and feeling" was a point of view she understood. How often had she stood in front of a painting for long stretches, looking, then looking more, and responding with her intuition, her wide experience, her prodigious memory, and her whole heart. Sometimes, as with her Titian masterpiece, a painting made her knees go weak. Would she have felt likewise in front of Matisse's stunning masterpiece *La Danse*, which Prichard vividly described? She had conceived the galleries at Fenway Court to invite this same experience—immediate, visceral, and emotional. Prichard knew well what others may have missed—that Isabella Stewart Gardner was in sympathy with the verities and currents of modernism.

ISABELLA WAS ABLE TO SECURE THE FIRST MATISSE PAINTING IN AN AMERican collection, though it came to her not via Prichard but through another friend, the Byzantine scholar Thomas Whittemore, also part of Matisse's circle in Paris. Whittemore asked her in 1911 to hold in safekeeping a 1904 oil painting, *The Terrace, Saint Tropez*, and three Matisse drawings. By 1922, Whittemore gave her these Matisse works outright. She hung the painting, with its saturated sun-drenched colors so characteristic of Matisse's Fauvist period, in the Yellow Room on the first floor of Fenway Court. Prichard also gave her a small portrait of himself, which Matisse had etched in 1914; it would stay in storage in Paris during the coming war and arrive at Fenway Court in 1920.

In late summer 1913, a telegram arrived at Green Hill from Japan, announcing that Okakura had died two days before, on September 2, at the

age of fifty. The cause: nephritis, or kidney failure. Okakura's brother Yoshisaburo told Isabella of his last days in the letter that followed, letting her know that Okakura, before he died, had sent "his heartfelt gratitude for your long friendship."

Isabella honored her friend with a Shinto memorial service in the Music Room, recording the date of the occasion, October 20, in the frontispiece of her copy of Okakura's well-known work, *The Book of Tea*. For the service, she placed incense burners and innumerable candles around a large bronze Buddha, one of three she had bought in 1902, with the help of William Sturgis Bigelow. Mourners read passages by writers such as the Indian poet and philosopher Rabindranath Tagore, a close friend of Okakura's and, in 1913, the recipient of the Nobel Prize for Literature: "At this time of parting, wish me good luck, my friends. The sky is flushed with the dawn and my path lies beautiful." Okakura's last gift to Isabella was the English libretto for *The White Fox,* an opera he and Charles Loeffler had been working on, which was never finished or performed. It was based on an old Japanese folktale of loss and separation. Lines from the libretto were also recited that day: "Through Godly deeds / seek higher incarnation / in Buddha's mercy trusting."

A. Piatt Andrew took the train from Washington, D.C., to Boston to attend Okakura's memorial and was a great comfort to Isabella that day and in the following weeks. They dined together, and he accompanied her to the opera. Caroline Sinkler rallied to her side, assuring her that Okakura's "great spirit is immortal somewhere, and the cup of happiness is stretched out to him." Even so, people noticed her deep grief for a friend who had made her feel so treasured and known. Matthew Prichard described their bond succinctly in a condolence letter from Germany: "He knew of your loneliness; he told me so." Artist, teacher, and longtime trustee of the Museum of Fine Arts Denman Ross sent several memorial items, including teacups and a lunch box once belonging to Okakura. Thomas Whittemore wrote that he poured water in Isabella's honor on the stone marking Okakura's grave in Japan. In later years, she collected copies of *The Book of Tea,* which she gave out to friends such as John Singer Sargent and Father Frederick Powell at the Society of Saint John the Evangelist, who she knew would appreciate Okakura's searching spirituality.

The Berensons, when they saw Isabella after Okakura's death, thought she had been profoundly changed by both the friendship and its loss. Mary

Berenson, never the most reliable witness because of her often antagonistic feelings toward Isabella, remembered how she had confessed that Okakura "was the first person . . . who showed her how hateful she was, and from him she learnt her first lesson of seeking to love instead of to be loved." Isabella reportedly told the Berensons that she felt "the core of herself was quite different" after her friendship with Okakura.

What had distinguished Isabella in earlier years—her ravenous curiosity—turned increasingly inward, toward investigating her own nature. She looked in the mirror and took account. Isabella wrote to Morris Carter in 1912 to express her appreciation for his kindness to her, adding: "I really do feel sure that always my first thought and abiding one is 'others.'" But she wondered if that was really the case. "The trouble always is," she wrote to Thomas Bailey Aldrich, longtime editor of the *Atlantic Monthly* one Christmas Eve, "we don't see ourselves as others see us."

FIFTEEN YEARS BEFORE, WHEN JACK GARDNER HAD DIED, ISABELLA threw herself into an enormous project, which served to rebuild her world. By the end of 1913, in the wake of Okakura's death, she was on the brink of doing something similar. Her plans were not new. She had been gathering force for quite a while, at least since she began purchasing monumental tapestries a decade before. She had shown friends preliminary plans for changes she envisioned for Fenway Court already in 1908, so that they could carry out her vision in the case of her death. Now, grief chased her, and her cure for grief was work. Her motto, as stated in a letter to Henry Swift, had always been "Work is the best thing if you are sad or worried."

On the day before Christmas Eve, Swift sent word to Isabella's architect, Willard T. Sears, that the demolition of the museum's two-story Music Room would begin in the New Year. Blueprints for new galleries were finalized, and Sears would receive a 10 percent commission for his work. Replacing the Music Room on the first floor would be the small Spanish Chapel and the long Spanish Cloister, which would run parallel to the Chinese Loggia, with large windows looking out onto the lush garden. At one end of the Chinese Loggia would be a submerged chamber, to replace the original Chinese Room on the second floor. This second Chinese Room would be, as the art historian Alan Chong rightly claims, the "culmination of [her] long dialogue

with Asia." Here, she put her three Buddhas, her screen depicting *The Tale of Genji*, a Japanese writing box given to her by Henry Higginson, and a figure of Kannon, among numerous other treasures. Here too she memorialized Okakura in the way she knew best: with objects. She placed a cabinet of souvenirs given by him, or connected to him in some way, in one corner. On a table near the front of the room she displayed items from the tea service he had given her at the start of their long friendship, objects that were akin to words of a sentence: whisk, iron kettle, bamboo scoop, and bowl.

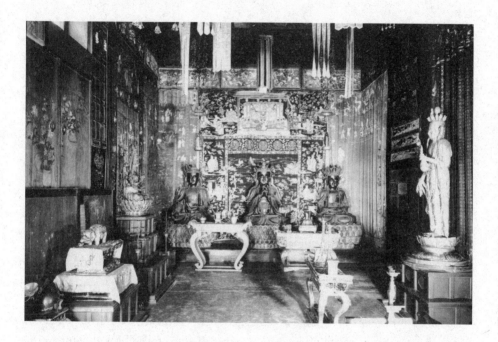

Thirty

THE DANCER

1914

At the start of 1914, Isabella hosted a private afternoon performance of String Quartet in D Minor by the Austrian modernist composer Arnold Schoenberg, which the *Boston Daily Globe* described as the "music of stormy aspiration and struggle." Philip Hale, the city's leading music critic, wrote of the "unearthly beauty" of the performance. It was her fitting way to bid farewell to the Music Room. A few days later, on February 5, she hosted a dinner and concert at which Alice Nielsen sang, accompanied by George Proctor on the piano. A large mirror separated the Music Room from access to the central courtyard. That evening, when Isabella rolled back the mirror, she announced to everyone in her smooth contralto voice that this would be "last time that anyone will go through the mirror." The destruction of the Music Room began the next day. Mary Berenson said that she couldn't bear to think that the grand space would "be no more." But the reconstruction of Fenway Court would give Isabella much more room to showcase all she had collected in the years since the palace first opened. She loved nothing better than a building project. As she had done over a decade before, with the original construction of the museum, she paid attention to every detail, overseeing the workmen and deciding which object went where. "Oh, so busy!" she exclaimed to Berenson in mid-February, just weeks before her

seventy-fourth birthday. If it sometimes made her feel "tired and cross," as she admitted, she was invigorated by the challenge. By July she wrote with, a measure of pride, "I am writing in the debris and amid showers of bricks and mortar."

For the Spanish Cloister, the long gallery on the first floor, Isabella laid down ceramic tile manufactured near Boston in cerulean blue, the color of the Mediterranean. One wall was covered by thousands of brightly colored terra-cotta tiles from a torn-down seventeenth-century church in central Mexico, a purchase secured in 1909 by her friend Dodge Macknight, a friend of van Gogh and contemporary painter in his own right, known especially for his vibrant watercolors of landscapes. Isabella didn't trust her workmen to arrange the wall tiles to her liking, so she composed the design herself. At one end of the cloister a Moorish lintel, with an elaborate scalloped edge, framed an alcove she specially designed for one painting, John Singer Sargent's magnificent *El Jaleo,* then owned by Thomas Jefferson Coolidge Sr.

Coolidge had purchased *El Jaleo* almost thirty years before, the first week it was shown at the Paris Salon in 1882. He proudly called the massive painting "the best picture Sargent ever painted . . ." Isabella knew Coolidge

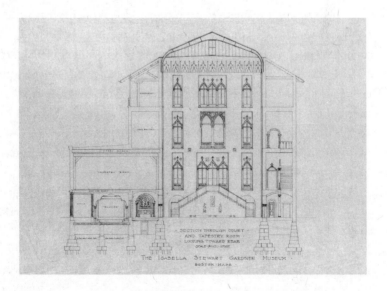

well, and they were near relations through Julia Gardner Coolidge. His name appears frequently in her guest books. A successful textile merchant and banker, Coolidge was an inveterate traveler who spoke fluent French and was later appointed minister to France. He had dressed memorably as a lady for the fancy ball in 1889. These two old friends enjoyed a lively correspondence already by the 1880s, when Isabella sent him countless letters on her travels through Asia, letters he thought good enough to publish, though he honored her request to throw them in the fire.

Though Coolidge was careful that *El Jaleo* not be shown outside Boston, he loaned it several times, first to Sargent for the gallery show in 1888 at the St. Botolph Club, where it hung alongside the painter's iconic portrait of Isabella. Coolidge loaned it twice to the Museum of Fine Arts—first in 1897 and then again in 1912. The museum staff may have hoped that Coolidge would eventually donate the painting to its collection, which had, at that point, few of Sargent's works. But that was not to be.

The architect's drawing for the reconstruction of Fenway Court indicates that Isabella planned to place *El Jaleo* at the end of the Spanish Cloister *before* she possessed it, a fact confirmed by a delivery receipt for the painting, indicating its transfer from Coolidge's Back Bay home to Fenway Court on December 11, 1914. What happened between Isabella's plan for the painting and its delivery is a little hard to decipher, but the story she liked to tell is recorded by Morris Carter in his small, privately published volume *Reminiscences*. At some point, Coolidge had promised to give her the painting in his will, but "wills can be changed, or even contested, and Mrs. Gardner was not taking chances." After the Spanish Cloister had been completed in the fall of 1914, she asked Coolidge if he would like to see *El Jaleo* in the alcove she had created especially for it, something he'd not be able to do if she had to wait to inherit it. He agreed but blanched a little when she asked: "May I send for it this afternoon?" He agreed to this too, and sometime after installing the painting, she invited him over to see it for himself. "He expressed great admiration for the installation, said the picture had never looked so well, and so forth, whereupon Mrs. Gardner said, 'If you really think it looks so much better here, would it be right for you to take it away?'" According to Isabella, "then and there Mr. Coolidge gave it to her."

Whether Coolidge gave *El Jaleo* on the spot is impossible to confirm but not improbable. Maybe Coolidge realized that this way, *El Jaleo* would

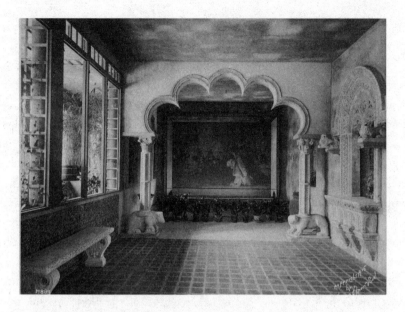

stay within the larger family circle, and she certainly had a very convincing way—she had given the painting an unrivaled setting.

She arranged a row of ten electric footlights along the floor so that the painting was lit from below, amplifying the raking light in the painting itself. She also put a large mirror on one end of the alcove, which seemed to double the space. Colorful ceramic jars, which reference Islamic Spain, were placed on the floor nearby. The whole effect was magnificent—as if the actual movement and sound, the exuberant joy of performance, spilled out into the space. The singer Nellie Melba would remember how she and Isabella would often go to the Spanish Cloister to "sit and watch" the painting as "we drank our coffee after dinner."

The other side of the Spanish Cloister evoked a quiet, almost mournful mood—life's other side. There, a small Spanish Chapel housed a painting of the Madonna and child, *The Virgin of Mercy,* by Zurbarán, which had hung in Gardner's Beacon Street boudoir. On the floor under the outside window, an effigy of a Spanish knight was laid out in eternal repose. "In Memoriam" was lettered in black paint on an inside wall, a little out of view of casual viewers. Directly across from *El Jaleo,* above a doorway, Isabella hung three twelfth-century stone sculptures from a French church in Parthenay, near Nantes: two figures witnessing the apocalypse and a depiction of Christ riding a donkey into Jerusalem. From temporal pleasures to eternal things—

she joined the joy of the dance to the loss of her little boy and then to the promise of salvation.

All through this season of rebuilding and rearranging, Isabella corresponded with Berenson about myriad things, including the Parthenay sculptures from France, miniature Persian prints, and a pair of astonishingly lifelike bear figures, approximately seven inches in height, made during China's ancient Han imperial dynasty. Mary Berenson wrote on her husband's behalf that the bears were really "top notch." "Can I have them," Isabella asked Berenson in her next letter. She could not afford the asking price of $30,000 right off, so she inquired if she could pay "à la Morgan," referring to J. P. Morgan, or two years after the purchase agreement. When the bears arrived in March, she called them "darlings—to live with, and delight in."

Her interest in the arts of Asia had started early during the months-long travels with Jack Gardner through that region of the world in the mid-1880s. Ongoing conversations with friends such as William Sturgis Bigelow and Okakura further shaped her deepening fascination, although Okakura apparently did not help her with any purchases, as Bigelow had done with the three large Buddhas. Chinese antiquities were more and more available

for purchase in the art market. Berenson was eager to be of help—he had already announced to Edith Wharton several years before that the "tide of my interests is flowing fast and strong eastward." In the spring of 1914, he wrote to Isabella of a magnificent votive stele made of sixth-century limestone, which he called the "finest thing that thus far has come out of China." She did not hesitate, and knew just where to place it—in the new Chinese Loggia, adjacent to the Spanish Cloister and near the steps leading to the submerged Buddha room. Having this great work—her most important piece of Chinese art—whetted her appetite for more. She told Berenson, "I only wish I had more Chinese masterpieces" after he had written, "Now promise to save all your money, and let me make you as fine a Chinese collection as you have of Italian."

Isabella wrote out copious notes and lists to keep track of her ever-changing collection. On the pages of a version of the museum catalog, she spelled out specific changes in the galleries. Her notes, written in her distinctive script, also reveal her involvement at every stage of the process: from collection to design; from building to furnishing and installation. "From the Raphael Room," she wrote, "you pass through the Short Gallery, where are etchings, portraits and textiles to the Tapestry Room. Here are two sets of Flemish Tapestries. On [a] table in [a] window a painting of Santa Eugracia by Bermjelo. Backing it, [a] portrait of Innocent X by Velasquez." She placed her grand piano at the far end of the Tapestry Room, near an enormous limestone fireplace from a medieval French chateau, the new stage for lectures and musical performances.

Isabella switched objects around in other rooms as well—for the Dutch Room she mapped out which pieces she wanted where on a large sheet of paper. She transformed the original Chinese Room at the top of the stairs on the second floor into an Early Italian Room. Here she put Piero's *Hercules,* one of the works that had given her so much trouble with the federal tax agents, against a textile with flame-stitched embroidery of vibrant oranges, greens, yellows. Here too is the jewel-like *Dormition and Assumption of the Virgin* by the Florentine master Fra Angelico, which she bought in 1899, soon after Jack's death. She placed it on a side wall close to an outside window, so it could be seen clearly, even on the cloudiest New England day.

The new Little Salon, which opens onto the Tapestry Room, was a small square-shaped gallery that she would experiment with for the rest of her life, refining its eighteenth-century rococo decor. In some ways, this was her most intimate room, with its luxurious furnishings arranged near tables displaying fine china, as if tea might be served there—ghosts of companions long gone seem to fill the space. Fine eighteenth-century porcelain birds and Meissen ware populate tables and mantles. Along several walls, she placed vitrines filled with treasured objects from her travels, most small enough to hold in the hand. In one, she kept Japanese medicine boxes, with their intricately carved netsuke figures; finely decorated Chinese snuffboxes in several shapes; the preserved four-leaf clover she found on the day when ground was broken for the building of Fenway Court. In another, a miniature portrait of young Marie Antoinette, with her enormous pouf, peers out at the viewer.

Though the previous years had been marked by ill health, Isabella seemed revived, energized by the end of 1914. She wrote to Lillie Lawlor, a young

singer from New York who had become a friend, "The time is near when I can say my work is done," adding, in parentheses, "(but of course there will always be things to do)." She finally felt "free enough" to ask her friend to come to Boston. She planned a concert, with George Proctor at the piano, in the New Year to celebrate. "Let me show you what I have been doing," she said.

When Fenway Court opened again to the public, in March 1915, the papers were full of praise. "Mrs. Gardner's Fenway Palace, Just Remodeled, Artistic Triumph" was the full-page headline in the *Boston Sunday Post*. The headline in the *Boston Evening Transcript* agreed: "New Steps Towards Perfection in Mrs. Gardner's Venetian Palace." Friends were equally approving. Henry Sleeper wrote to A. Piatt Andrew that Fenway Court looked "better than ever before," and Maud Howe Elliott would later remark that "these new rooms seem to me the best in the palace."

Six months later, Isabella opened one last gallery on the first floor. The Macknight Room had been a small apartment. Matthew Prichard had stayed there early in 1902 before the museum first opened. Sargent took those rooms during his artist in residency in 1903, as did Okakura and A. Piatt Andrew in later years. She named the gallery after Dodge Macknight, many of whose landscapes populate the walls. She tore out an interior wall to make a bigger space and put her desk against a side wall. Here she put a large portrait of Prichard by John Briggs Potter, a moody moonscape by Dennis Bunker, and an eighteenth-century creamware inkstand decorated with the head of a bearded man. She paired a tiny round photograph of herself, taken when younger, next to the figure of the man, as if they were a couple. Jack Gardner is not often referenced in the museum; maybe he is here.

Isabella also placed a large lacquer box, measuring eight by ten inches, on a chair next to her desk, where she would carefully collect for safekeeping newspaper clippings and all her incoming correspondence about the Great War.

Thirty-One

BLOOD AND THUNDER

1915–18

During the spring and summer months of 1914, the newspapers were full of alarming news from Europe. Americans living there at the time, according to Gertrude Stein, then in Paris, "never really believed that there was going to be war." The shock was great when war was declared on August 4. Ralph Curtis reported to Isabella that for two months, since the war's start, John Singer Sargent had been "stranded in the Austrian Tyrol, isolated from the world!" Clayton Johns was stuck in Germany for several weeks, until the grandson of Felix Mendelssohn paid his passage home in gold bullion. The Berensons stopped their traveling for a time and lived quietly at I Tatti, the estate they had bought and renovated years before in the Settignano hills near Florence. Mary Berenson apologized to Isabella during these same weeks for not writing sooner, saying, "The War has cast such sadness upon us that I have had no heart to write." Thomas Whittemore wrote to her about London in wartime. People were "terrified of the Zeppelin raids in these cold foggy nights! It was raining, not one street-light in ten lit, and those shaded flat down on the ground, like great red eyes peer-

ing fearfully out from under shaggy brows." The Great War turned out to be the cataclysm that undid the Victorian world as Isabella and her generation had known it. "Think of the civilized twentieth-century!" she exclaimed in a letter to Berenson in the fall of 1914. Henry James was so distraught, he gave up his American citizenship in 1915 to join in solidarity with his adopted England. Henry Adams put his feeling simply and definitively, declaring that "Our old world is dead."

The conflict caused immediate economic turmoil at home. The New York Stock Exchange closed trading for three months. Isabella's finances were affected, particularly her longtime investments in the Calumet and Hecla copper mines in Michigan, which cut payments on its dividends, as she explained in a letter to Berenson. Later she wrote to Berenson of skyrocketing food prices, high wages for her staff, resources being tapped for donations to charities and hospitals, and her worry about "heating my big steamer of a house." But it was through her friendships that she came to know the awful immediacy of war.

"LAST NIGHT I MOTORED UP TO BOSTON AND HAD A FAREWELL DINNER with Mrs. Gardner in Fenway Court," A. Piatt Andrew wrote to his parents on December 18, 1914. "We talked for hours, just we two alone, wondering much what the future had in waiting." Piatt had decided earlier in the fall to go to France for a few months after losing the Republican primary to Isabella's nephew, Augustus Peabody Gardner, incumbent in the sixth-district congressional seat of Massachusetts since 1902. Isabella had supported her friend over her nephew, which apparently caused some consternation in the family. Now Piatt wanted to participate in the momentous event of his generation, even if he would stay out of the "way of the armies," as he promised his parents.

SOON AFTER HIS ARRIVAL IN FRANCE, HE ORGANIZED A DOZEN MEN AND twenty ambulances into what would become the American Field Service, a corps of drivers who ferried wounded soldiers and civilians to American military hospitals. He told his parents it was the "most interesting job I can imagine." Over the coming months, he recruited recent graduates, especially from

Harvard and Yale but also lawyers, doctors, architects, and other professions, to help France, expanding the organization to over two thousand volunteers. To Isabella and Piatt's Dabsville friends, he appealed for funds and was grateful for their overwhelming generosity. By the following December, Piatt had sent Isabella a photograph of an ambulance, using his usual nickname for her: "Your car, dear Y . . . which started to Lorraine about the middle of November. Do you see the 'Y' under the driver's seat?" That was her nickname, after Ysabella I, the Spanish monarch, which they used in all their correspondence. If Isabella had been on the sidelines of war as a very young woman, fifty-plus years later she would not sit idly as another conflagration broke out.

Matthew Stewart Prichard, a British citizen, also brought news of the war. In its opening months, Isabella agonized over his fate. She had gotten two brief postcards from him in 1914, from The Hague and then from Ruhleben, an internment camp for British civilians. Prichard had made the unlucky decision to schedule a months-long tour of Germany to improve his language skills in the summer of 1914. He was reading an edition of Mozart's letters on a bridge near the University of Freiburg, in southern Germany, when he was captured. He was subsequently imprisoned in the English-speaking camp, located in Spandau, outside Berlin.

Isabella sent messages to Prichard via the American embassy in Berlin but heard nothing. She wrote about his situation to everyone she could think of in Washington, D.C., except President Wilson, a Democrat. She worried he might not like the name Gardner, perhaps on account of the family's Republican affiliation. T. S. Eliot, then in London, reported to Isabella that he too had not heard from Prichard. Then, in June 1915, she got a letter from Elisina Tyler, a sometime Italian countess and wife of the diplomat and collector Royall Tyler. Mrs. Tyler had heard from Prichard and sent along a copy of his letter. "Thank you for thinking to tell him that phrase 'Vien dietro a me' &c," Isabella hurriedly replied, referring to a line from Dante, which reads: "Come after me and let the people talk. Stand like a firm tower that never shakes its top for blast of wind." Isabella knew Prichard loved Dante, though she noted to Mrs. Tyler that "perhaps a year ago he didn't need him."

By October 1915, she still had not heard directly from Prichard, so she wrote to Mrs. Tyler again, saying it had been such a long time without word from him or about him. She found herself weeping at the thought of the 'poor weary bones of his on that Ruhleben bed.'" A month later, Prichard's first letter from prison arrived at Fenway Court. He described conditions at the camp in a somewhat anodyne tone, no doubt because of censors. His next letter was a little more specific, saying that he was studying Spanish, keeping up with his reading of Bergson's philosophy, and teaching Italian to his fellow prisoners, and in no time, Dante's *Inferno*.

BOSTON STREETS FILLED WITH WAVING FLAGS AND PARADES OF NEWLY recruited soldiers in the weeks and months after America finally entered the war, on April 6, 1917. The *Boston Daily Globe* reported the scene in late May: "You would think the Common was celebrating something" or that "hawkers might be trying to sell something," the reporter observed. But no, "nothing was being celebrated" and "patriotism" was the day's "only commodity." The Boston Common was crowded with tents—for army recruits, for volunteers, for physical examinations. Buglers played, and the noise made by the military units as they practiced their maneuvers filled the air. Construction workers erected speaker's boxes and groomed the rally grounds. Isabella's nephew Au-

gustus "Gussie" Peabody Gardner resigned his position as U.S. congressman in the Massachusetts delegation to join the war effort in the rank of colonel. George Peabody Gardner Jr. enlisted in the Naval Reserve Force and served on transports that kept supply lines open, defending them against German submarines. Julia Gardner's eldest son, John Gardner Coolidge, was already in Paris, having been appointed special agent to the embassy in Paris.

Isabella wrote stoically to Lillie Lawlor from Fenway Court in June: "These are sad times. We have chosen to go to war. Therefore, we must abide by that and do our best." She did not like all the rah-rah patriotism. She was interested in the personalities of leaders, of course, and collected their signatures and photographs and copies of their letters, which she put in a display case in the third-floor Long Gallery. She considered Boston's mayor, "Honey Fitz" Fitzgerald (grandfather of the future U.S. president John F. Kennedy), a friend. Even so, she did not relish politics. Her arenas of action lay elsewhere, and she detested war. She told Berenson her view of the war: "I am pro only one thing and that is peace. I have done all along everything I can to help the wounded. I am running two ambulances and gave one, besides running it (financially, I mean), but I will not give money for ammunitions and I will not make money (as people are doing to the bursting point) by owning stock in war weapons. I call it blood money—now you know my creed."

The summer of 1917, Isabella decided to stay at Fenway Court instead of making her usual summer move to Green Hill and her gardens. She confined herself to two rooms, her bedroom on the fourth floor and the Macknight Room on the first, which she made into her living room. She had her meals in the cloister, from which she could see the courtyard. She was seventy-seven. Berenson expressed worry about her in his letters, but she waved away his concern and refused to feel sorry for herself. She wrote a reassuring reply on the nation's birthday, July 4, 1917: "I am not pitying myself this summer; far from that. It is quiet, cool and comfortable here—much more so than Brookline. My upstairs little corner bedroom has the south and west wind galing through, and at night . . . I sleep with my hair blowing! And my cloister life below is very pleasant. We have had continual rains and very little heat. The trees, from my window, look like peridots, with an occasional vivid emerald—so fresh and green." Beauty, always beauty, saved the day.

Since the declaration of war, a simmering anti-German sentiment had begun to boil over, as boosters for the American cause increased demands for overt displays of patriotism. German street names were replaced; spoken German disappeared from pulpits and classrooms; German composers were removed from musical programs. At one point, Isabella found herself swept up in a furor because of her support for her friend Dr. Karl Muck, the Swiss-born conductor of the Boston Symphony Orchestra. Muck—arrogant, harsh, brilliant—had turned it into a world-class orchestra, on par with the Royal Opera in Berlin, where he had previously been conductor. Henry Higginson had seen his dream for Boston's orchestra finally realized under the maestro's baton. Muck and his wife, Anita, were also Isabella's near neighbors since moving into their spacious home at 50 Fenway. They were frequent visitors.

In late October 1917, before a performance in Providence, Rhode Island, Higginson received a request from several civic-minded clubs that the orchestra play "The Star-Spangled Banner" at the start of the evening, as a show of patriotism. Higginson thought nothing of it, did not tell Muck, and set the request aside. It was a decision he came to regret. The next day the papers blamed the thickly accented conductor, who had not been informed that he should include the anthem, for an anti-patriotic slight, alleging that his sympathies lay elsewhere—with the enemy. Muck protested that he was Swiss, not German, but to no effect. Higginson tried to smooth things over, reassuring Muck that he would be protected. For good measure, he also asked him to play the national anthem at the orchestra's next performance.

Isabella was outraged. Muck had done nothing wrong, in her view. In solidarity with him, and with the principle of artistic freedom, she made a show of walking out of that performance at Symphony Hall. The papers gleefully reported this as a betrayal of her country. Now she was suspect too. At one point, an acquaintance of Isabella's began questioning her: "You live so near him that you must be able to see his signals." "I can," Isabella answered without fear. "And what do you do when you see them?" Again, she was stalwart: "I answer him."

Not long after, Muck was arrested and put in a prison in Cambridge, Massachusetts. Isabella went to visit him in his cell, bringing what she could

to cheer him up, which generated yet more criticism and alarmed her family. Her nephew J. R. Coolidge Jr. spoke with her, asking her to be more careful to avoid attention and trouble. Henry Sleeper agreed with Coolidge, wanting to protect her, but Isabella persisted. She made a point of visiting Anita Muck, now alone and terrified, as often as she could.

When Muck was transferred to prison barracks in Georgia for the duration of the war, he sent Isabella a fulsome letter of thanks: "You can never know . . . what it has meant to me to realize that of all our many friends in Boston at least one has stood by my poor haunted wife." He marveled: "Courage and independence always seemed to me to be an integral part of you." She knew too well what it felt like to be rejected and ostracized, and she was not going to let that happen to a friend, no matter the risk. As she explained to Henry Sleeper: "You and I are very good friends, Harry. We don't see each other often but you know that if you were in any kind of trouble, I would be on your doorstep every day."

Bright colors catch the eye first—blazing reds, grassy yellows and greens, Chartres blues. The rectangular panel, made up of 105 pieces of gleaming glass, is set in a dark wood frame placed against an exterior wall of clear glass. A garden is in view beyond. The panel, located in the Chinese Loggia on the museum's first floor, is not very large, measuring just 21½ by 13½ inches. It seems bigger, though, when the sun pours in from the east, spreading rays of intense color over the dove-gray stone floor. A close look reveals faces in two pieces of glass. In the first fragment on the lower right, one eye peers back, like that of a cyclops. The second, larger face is above the first, more in the center and in three-quarter profile. Its outline is traced, like that of the first, in a brownish line over a dull background. Its half-quizzical expression, eyes looking up, seems to say: "What's this, where did I come from, how did I get here?"

The glass pieces came from the windows of Notre-Dame de Reims, located northeast of Paris, under whose soaring choir France crowned her medieval kings. The city's cathedral, built in the middle of the thirteenth century after the destruction by fire of an earlier Roman basilica in 1210, was deemed a peer with France's other dazzling Gothic cathedrals in Amiens, Soissons, and Paris. A twentieth-century architecture critic called Reims a

polished embodiment of medievalism, grand and complete, comparing its stained-glass windows to the glories of Chartres. The cathedral endured, despite religious wars and revolution. In the nineteenth century, after decades of breakage and disintegration, many of its original windows were refurbished or replaced with copies or clear glass.

The catastrophic assault on Reims came in September 1914, as Germans bombarded the edifice in successive raids, which set the ancient oak-timbered roof on fire. The lead in the windows dripped to the floor, igniting many of the interior furnishings. Soldiers picked up shards of stained glass, scattered throughout the city, to set into rings for their sweethearts. The cathedral was bombed over three hundred times, and used as a field hospital and, by the end of the war, an arms depot. Almost 90 percent of the city, so close to the war's front, was destroyed. Those who couldn't leave hid in underground caves that usually held the mature casks of champagne for which the region had been famous since the seventeenth century. Reims cathedral became iconic as a "martyr of stone," as one newspaper phrased it. Photographs of the first and worst bombings in 1914 were reproduced on postcards and in newspapers around the world. Posters urging American involvement in the war pictured the decimated cathedral as evidence of a German aggression that had to be stopped.

In 1918, when it seemed likely that Reims, including its cathedral, would be completely destroyed, Chester A. Howell, an American ambulance driver from Dorchester, Massachusetts, attached to the American Field Service, gathered and boxed up a hundred-plus pieces of scattered cathedral glass. He sent them to Henry Sleeper, instructing him to give the collection to Isabella in recognition for her help to the American Field Service. In December 1919, Sleeper took the glass pieces to a Boston company, Phipps, Ball and Burnham, noted for its craftsmanship with stained-glass. Soon after, he presented the reconstituted panel to Isabella. Her reaction was not recorded.

The panel does not form a portrait or a landscape. It is modernist in sensibility, focusing on shape and color as things in themselves. The artisans who composed it remain anonymous. There is no way to verify which glass pieces were made in the thirteenth century or in later periods, though those with partial faces seem to be older, according to scholars. How to value something created from such a mishmash of materials, centuries, and makers? "A mere patch of color," an early museum curator called it. And yet, like

everything in Isabella's museum, it is more. Pieces from the far past memorialize the less distant past, one era reaching to another.

Isabella Stewart Gardner's life had been split into before and after with the loss of her only child. Her grief consumed her. She hid away; she floundered. Slowly, slowly, over a long time, she came back to life. The panel made from Reims glass memorializes the tragedy of the Great War, but it is eloquent, too, of Fenway Court, with its assemblage of artistic styles and periods and the woman behind its creation. Isabella, like the small inquiring face near the panel's center, looked up. In the blasted aftermath of loss, she put bits and pieces of beauty together into something new. Life is filled with far too much destruction and loss, and yet it can shine with light and color. She knew both enduring truths.

Thirty-Two

"VERY MUCH ALIVE"

1919–22

Isabella Stewart Gardner stands straight, with her shoulders back, an impeccable posture as in a painting, her thin arms visible under sheer black sleeves. She is dressed to the nines, as usual. Her hat, with a bright fabric band and tall wisps of plumage, encircles her head. She looks fiercely at the camera, her charisma an announcement: Isabella.

Standing tall in his tweed three-piece suit and holding a cigar in his right hand is her old friend John Singer Sargent. It is 1919. She is seventy-nine; he is sixty-three. He has just finished another masterpiece: this one on the Great War, called *Gassed,* part of London's Imperial War Museum. He has returned to Boston from London to resume work on his commission from the Museum of Fine Arts for murals to decorate its high walls. Isabella, whom another friend described in early 1919 as seeming younger than ever, had invited Sargent to Gloucester for a visit with the Dabsville group. A. Piatt Andrew, home from Europe after the armistice in November 1918 and now congressman for the sixth district of Massachusetts, had welcomed them to Red Roof at Eastern Point. At one point, Piatt took a series of snapshots of these two old friends standing side by side on the terrace, the Atlantic coast beyond them.

The year 1919 marked a pivot in Isabella's long life. These are likely the last photographs of her, and, surely the last that show her standing.

⁓❊⁓

ISABELLA AND SARGENT SPENT QUITE A BIT OF TIME TOGETHER WHEN HE was at work, "night and day," as he reported to her, on his mural project, despite lack of sleep and bouts of illness. Letters and telegrams flew back and forth between them, with arrangements for teas and dinners and drives about town. She sent him books to read, including selections of Dante, Okakura's *Book of Tea*, and Fritz Kreisler's *Four Weeks in the Trenches*, which Sargent "devoured." They also shared their passion for music. He explained that afternoons were impossible for him to meet for concerts "unless it is Loeffler's Quartet," but he later asked: "Where and when do we meet tomorrow for Bach?" She was also buying several of his pictures, including the large oil painting of Yoho Falls in the Canadian Rockies, where he had traveled in 1916. Many contemporaries were already gone: Whistler in 1903; Frank Crawford in 1909; John La Farge in 1910; Henry James in 1916. Caroline

Sinkler confided to Isabella that Sargent, who had on occasion spent time with the Dabsville group, had told her he did not want to leave Boston in part because he so enjoyed being near Isabella.

Both suffered grievous losses in 1918. In April, Sargent got word that his sister's daughter, his favorite niece, had been killed in a bombing in Paris, after which he rushed to France for the funeral and to be at his sister's side. Isabella's nephew Augustus Peabody Gardner had died of pneumonia while serving as an officer at Camp Wheeler in Georgia early in the year. She attended his funeral in Washington, D.C., where she visited her old friend Henry Adams, who found her "more magnificent than ever . . . and not in the least disturbed by twenty-four hours' railway journey, which would have knocked me out merely to talk about." The sudden death of Ella Lavin in September 1918, however, left Isabella stunned. Ella had been her maid for decades, but much more than that—she was also a devoted companion who often traveled with Isabella and helped make it possible for her accomplish all she had done in the years after Jack Gardner's death. Isabella replied to a friend's condolence letter that the loss had been "overwhelming."

Though she announced to John Jay Chapman, with the usual glint in her eye, that she intended to live to 150 years of age, there was more letting go ahead. In April 1919, she prepared to sell Green Hill to her great nephew George Peabody Gardner Jr. and his wife, Rose Grosvenor Gardner. Isabella had transformed the property since she had first stayed there as a young bride in the 1860s, most especially its many and expansive gardens. As Hildegarde Hawthorne had observed in a 1910 article on Green Hill, "It is not as easy as it looks. An idea lies behind it." The young couple marveled at their good fortune a year after moving in: "Rose and I love Green Hill better than we ever dreamed we could love any place and we are extremely grateful to you for giving us the opportunity of living here." Even so, Isabella admitted to Joseph Lindon Smith that it had been "a hard year—a turning point with me."

She set her sights even more on legacy. She had suggested to the Society of Saint John the Evangelist that land in Cambridge, along the Charles River on Memorial Drive, was available, and on April 14, 1916, her seventy-sixth birthday, she gave $25,000 toward its purchase. Now, in 1919, she supplemented this gift with another $50,000 to enable the society to build Saint Francis House, a place for guests on the grounds of the monastery. On the occasion of this second gift, Father Spence Burton promised to say

Mass in her honor on her birthday at Fenway Court, to express the society's gratitude. She afterward sent him handwritten instructions for a plan for an annual service, still carried out today: ". . . in the Chapel at the end of the Long Gallery on the 14th of April each year a memorial service shall be conducted . . ." The community would call her its angel of its first fifty years—no other individual had been as generous.

In Isabella's 1919 letter to Joseph Lindon Smith, she wrote that she had long cherished the idea he would eventually direct her museum, though she realized soon enough he had other plans. Instead, she hired Morris Carter away from the Museum of Fine Arts to work with her at Fenway Court, a full-time position he began on the first of June. Though Carter was her second choice, he proved a fortuitous one. An experienced librarian, he had several different roles at the Museum of Fine Arts until his last, as assistant director. Denman Ross, a trustee at the time, was full of praise for his "intelligence, good judgement and ability." Carter also knew Isabella very well. His first task in the summer 1919 was to catalog her enormous book collection.

Morris Carter discovered that being her employee differed from being her friend. He had had many lunches with her over the years at Fenway Court, but no longer. She put up a barrier, formalizing their new relationship and asserting her authority. He would recall, in a later interview, a poignant scene that made this change particularly clear. When Berenson came to see Isabella at Fenway Court the following year, Isabella received him in the Dutch Room, with Carter standing next her. He remembered how Berenson "*came into the room* and he came forward and he was going to greet me, he was so glad to see me or something like that, and, of course, I thought it was Berenson's interests just as well to be on good terms with the future director, but Mrs. Gardner said: 'Oh, don't pay any attention to him, he's just my secretary.'" If this stung Carter, he also understood that "she couldn't bear to let people think she needed anybody to assist her." He realized too what she'd always known—if she wasn't careful, the men around her would get the larger credit for what she had accomplished.

IN THE EARLY FALL OF 1919, JOHN SINGER SARGENT AND HENRY DAVIS Sleeper came for an evening with Isabella at Fenway Court. They brought

along the Harvard professor of medicine, Dr. Richard Strong; his wife, Agnes Strong; and Grace Nichols. All had served in the Red Cross during the war. Sleeper delivered the Reims glass piece later in 1919. Isabella recorded this occasion by asking her guests for their signatures and adding at the top of the page "Spanish Cloister" and the date: September 22, 1919. Gathered in the cloister, in front of Sargent's *El Jaleo,* the friends surely were impressed; Isabella must have basked in this approval of the painting's magnificent setting. Perhaps this was also the evening when Sargent gave Isabella a sheaf of remarkable preparatory sketches for this painting from the 1880s, one showing a woman dancing in an exquisite show of control and abandon. Vitality—everything conveyed by Sargent and embodied by Isabella contrasts sharply with what came next for her. Later, in 1921, Sargent would give her yet more drawings, this time nine preparatory drawings for the museum murals, with Thomas McKeller as his model. These sets of his remarkable drawings were Sargent's nod to his friend and her legacy.

ON THE NIGHT AFTER CHRISTMAS, ISABELLA HAD DINNER WITH FRIENDS. After coming home, she felt weary, undone. By morning it was clear she had suffered a stroke, which left her right side paralyzed.

At first she wanted to hide her debility. In February she told Henry Swift, her financial manager, that she had overworked herself the previous season and needed rest and calm. She pretended to other friends that she was battling a horrid flu, and in the years of the Spanish flu pandemic, this did not seem far-fetched. Ralph Curtis wrote reassuringly from Venice that he wished her well, saying that the grippe, awful as it was, would ease, and she would be back to her old self. She hated to show weakness in part because she felt she could not afford it—her go-ahead strength, combined with stubbornness, had been her coin and so much of her draw. Feebleness was, Morris Carter observed, "awfully hard for her to take."

George Augustus Gardner's daughter, Olga Gardner Monks, now fifty, came by Fenway Court every few days and stepped in to oversee household details. Carter became Isabella's full-time secretary: reading and answering her letters, organizing the bills for the museum, keeping a daily diary, and starting a loose-leaf catalog of the collection. According to Carter, fewer

men came to visit Isabella after her stroke. This may be because she felt especially embarrassed in front of them or because men of her class and era felt that visiting a woman friend under these circumstances was not expected. Her women friends appeared with more frequency, especially Helen Mixter Appleton, in early years a frequent guest at 152 Beacon Street and Green Hill and owner of a large estate near Gloucester. Caroline Sinkler, part of the Dabsville group, also attended to her—in letters full of affection, Isabella addressed Caroline as "Dearest deare."

With the help of her small staff, Isabella managed to dress every day; she was able to sit upright. She used the hydraulic elevator so she could spend time on the lower floors of the palace. She liked to read the most recent detective novels, which the Brookline Library shipped to her, and she relished impromptu concerts and plays held at Fenway Court. When the weather was warm enough, she enjoyed sitting in her Monk's Garden adjacent to the Chinese Loggia, where she could feel cool breezes and enjoy the almond tree blossoms. On a warm evening in mid-July in 1920, she was told that her beloved collie, Roly, was dying. She could not bear to think he would die alone and so insisted that she be brought down to the garden to sit by him until the end.

She also liked being chauffeured about Boston in a motorcar, sometimes several times in a single day. Once in July 1922, she traveled as far as Eastern Point—her last visit there. After the 1914 destruction by fire of Gloucester's Our Lady of Good Voyage, the Catholic church serving Portuguese fishermen and their families, Isabella had donated a full set of carillon bells for the new building. Now she wanted to hear the bells played, how they sounded in the summer air, with sea breezes coming off Gloucester's wide, shining harbor. She wrote to A. Piatt Andrew afterward that the day had been "all perfect from beginning to end."

When guests came to Fenway Court, Isabella usually received them in the first-floor Macknight Room, where among her many treasures she had a comfortable chaise longue and her desk. Margaret "Daisy" Chanler, half sister of Frank Crawford, would describe visiting her there, how she lay "on the couch sumptuously spread with silver sable or finest ermine, her head wound about with a lace turban, agreeable and vivacious far beyond her years." Edward Weeks, later the editor of the *Atlantic Monthly*, recalled a similar scene at this time, when he was a Harvard student. Weeks had been

an ambulance driver with the American Field Service and spoke with Isabella fondly of A. Piatt Andrew and Henry Sleeper, knowing they were all friends. But during the conversation, Weeks felt both awed and distracted. Nearby stood a "tall brass urn, filled to the brim with handwritten letters, elegant stationery of every tint, ripped in half. I could not help reading their salutations—'Dearest Belle . . .'" Weeks thought to himself: "Shouldn't some be saved, surely they had a story to tell?"

At midnight on Christmas Eve, Isabella held services, conducted by the priest from the Church of the Advent, in the third-floor chapel at the end of the Long Gallery, a space not yet open to the public. One attendee remembered her wrapped in an enormous fur cloak, perched upright in one of the ancient choir stalls that lined the walls. Lit candles and courtyard flowers perfumed the air. A neighbor who lived nearby stated that his family would open their windows on this holiday night to hear music coming from Fenway Court.

ISABELLA CONTINUED COLLECTING: MORE OF SARGENT'S WORK, THREE Degas drawings, a small black pencil and white chalk drawing by Ingres, and the art deco sculpture *Diana,* which depicts the goddess-hunter in midflight, bow in hand, by the American sculptor Paul Manship. Her last old master purchase, arranged by Berenson, was *The Virgin with the Sleeping Child on a Parapet* by Giovanni Bellini. She paid $50,000 for the fifteenth-century painting in May 1921 and displayed it in the corner of the Raphael Room. Sometimes she took a tour through the galleries, transported in a gondola chair usually kept at a writing desk in the Veronese Room. She was light enough for several workmen or staff to carry, and so she traveled through her treasured spaces, this way and that, as if floating on the waters of the Grand Canal.

In 1923, Ida Agassiz Higginson sent a letter from Rome, reminding her lifelong friend of their long-ago Italian lessons and their conversation about the Poldi Pezzoli. Remember, Ida wrote, how the palazzo had inspired Isabella to have her own "house filled with beautiful pictures and objects of Art, for people to come and enjoy. And you have carried out the dream of your youth and given great happiness to hundreds of people."

The wide world came to her in letters. Berenson wrote frequently of his travels, from Venice and Rome to Cairo, where he wrote teasingly: "We think of you here—the real Cleopatra we have known!" His letters stirred memories of her own adventures: "I should love to go to Greece with you—what a difference that would make to me! What a joy to again take my coffee and see the sun come up on the top of the Acropolis as I used to do."

Matthew Stewart Prichard—freed from the German camp at the end of 1917 but never quite himself again—sent long missives from London about his life there, about his somewhat obscure notions on art and religion, about the political scene. In a response dated May 1922, she was full of encouragement for him, suspecting what her friend needed. Addressing him "Dearest Prichard," she exclaimed: "One of the most wonderful letters I ever read! I think you are the most forgiving and devoted of friends. If you could only be here to sit with me now in the spring blossoms that are bursting; and let me see you, even if nothing more ever came of it . . . How very interesting the description of the religious ceremonies at Lyons is. I had never heard of the two crosses or of the dalmatic being different. Many thanks to you, dear friend, for telling me these things."

Hans Coudenhove, whom Gardner had met decades before in Venice, fussed over her in his letters sent from a region in central Africa that is now Malawi, where he had lived since 1898 as farmer, explorer, and essayist. Whenever his letters arrived, she insisted on writing back immediately, knowing her replies might take months to reach him and wanting to keep the conversation going. Coudenhove, an Austrian count, had what Gardner greatly enjoyed—charm, erudition, a good story. He had grown up in the most formal, aristocratic part of Europe, in Bavaria, but his family's depleted finances prompted his move to equatorial Africa. He and Isabella had friends in common, including Frank Crawford, and he affectionately remembered in his letters his conversations with Henry James.

The two had an equal passion for gardens and animal life. He reported on the rumble of a lion's hunting voice, saying it was the "perfect expression, not of blood thirstiness, but of despair." In June 1922, he sent her two elephant figurines the size of dice, made of warthog ivory by a Chikala craftsman. She noted that their little legs didn't let them stand upright, to which he teased back that they had gotten seasick on their Atlantic crossing and they needed time to adjust. Maybe they reminded her of the two ivory elephant figures Jack had bought for her for Christmas almost forty years before, when they'd spent Christmas week in Singapore.

In a subsequent letter, Coudenhove asked if she still kept any horses. She replied that she didn't have "a horse or anything now" but, to allay his worry, said: "I am trying to keep up my courage. I'm quite an invalid, but cheerful to the last degree. I think my mind is all right and I live on it. I keep up a lot of thinking, and am really very much alive."

Isabella's joie de vivre and intelligence flare out from Sargent's 1922 portrait—a light undimmed by age or illness. Sargent had come to Fenway Court on a beautiful September morning to make one last portrait of his friend, which he finished before noon. The watercolor is small, just 17 by 12½ inches. She received it from him less than two weeks later and mounted it in a simple gold frame. Her chambermaid, Agnes, called it "a fleecy cloud from heaven," and she herself called it "just a sketch, and amusing." Her pleasure, though, is obvious in a letter she sent the next month to Berenson: "Did I tell you of Sargent's wonderful sketch in watercolour of me which keeps everyone's tongue busy wagging? Even I think it is exquisite." Pleased with the attention, she also speculated that its success

had something to do with how it had been "utterly unpremeditated" by both sitter and painter.

Isabella kept Sargent's late-life tribute where it had been painted—in the Macknight Room. She placed it on top of a large bookcase, so that it faces and is reflected in an enormous eighteenth-century Venetian mirror on the opposite wall. Paul Manship's *Diana* stands on a table under the mirror, with its waterlike surface. It is as if Isabella always wanted to be looking into the past—the Venetian past as well as her own.

When standing in front of the mirror, visitors see their own reflection and also Isabella's, discernible in the background like a ghostly presence.

Thirty-Three

SPRING

1923–24

A little-seen documentary from the 1970s about the Isabella Stewart Gardner Museum, funded by the National Endowment for the Arts, includes interviews with a few of her relatives, some of them quite elderly. The film documents a moving story from the last years of Isabella's life, which took place on a spring morning in 1923. Isabella, increasingly frail, insisted on taking a taxi to see the newest member of the Gardner family, a baby boy who had been born just hours before, at 2 A.M. on April 14, which happened to be Isabella's eighty-third birthday. George Peabody Gardner Jr., her great-nephew, and his wife, Rose, had previously stated that if the child was a boy, they would name him John Lowell Gardner. This, of course, was the name of Isabella's father-in-law; of Jack, her husband of thirty-eight years; and of little Jackie. Rose Gardner recalled that Great-Aunt Isabella had not favored the idea; she "looked rather unhappy about it and didn't say much."

But now the little boy had been born on her birthday, and she was determined to see him. When she arrived at Green Hill, she requested that the baby be brought down to the car. The nurse placed the newborn in her arms, and she cradled him for a long while. It must have seemed like a visitation from long ago. Something shifted, as if a circle had been closed, for

after this moment she was "simply delighted" with his name. Rose Gardner remembered this scene through tears.

―※―

NOT LONG AFTER, ISABELLA SENT WORD TO HER FRIENDS AT SOCIETY OF Saint John the Evangelist that she was failing and wanted communion immediately. The record does not mention who came, only that she was conscious but weak. Her niece Olga Monks rushed to her side. Then, miraculously it seemed, Isabella revived and regained her strength. Mary Berenson wrote from Athens in May to express great relief upon hearing that she was better, and by July, Isabella returned to what she loved to do in warm weather—travel by motorcar, to be out in the world. She did not mind the wind in her face.

Morris Carter prepared for the future. He described in his notes in September that he had read to Isabella from her 1913 document, "Suggestions for Running a Museum." He made some emendations to the plan, citing an agreement she had made at the start of 1922 that Fenway Court would be open from 10 A.M. to 1 P.M. on Mondays, Wednesdays, and Fridays, during a season that would last from October 1 to May 1.

Isabella's letters that spring were full of tenderness. She wanted to see people, wanted them to be close, as if reaching out her long hands to them. "A thousand, thousand thanks, dearest, for your enchanting note," she said in a note to Caroline Sinkler. "I wish I could have been with you there by the fire." She also asked Caroline to tell Piatt and Henry Sleeper to "try to see me" if they came to Boston—"I want very much to have a glimpse of each of them." And, as ever, she was attentive to the smallest beautiful detail: "It was a joy indeed to see you," she told Caroline, and to "remember your black, curly feather with pleasure."

Isabella was giving away some of her treasures. She sent a cherished watch to Helen Appleton and an outsize jade to Elsie de Wolfe, with whom she had traveled in Paris in 1906. Olga Gardner Monks wrote a letter of thanks after receiving a photograph of Jack Gardner, which Isabella had kept on display above her bed since early in her marriage. "Uncle Jack's picture is hung and it is lovely to have it in my room," Olga said. Olga also inherited the two diamonds, "The Light of India" and "The Rajah" that Isabella had purchased in 1886. She evenly split the longest rope of pearls, her signature

jewelry, to give to seven women, five of whom were in the Gardner family: Olga and her sister Ellen Gardner Loring; George Peabody Gardner's wife, Esther; and two of Julia Gardner Coolidge's daughters-in-law. Ralph Curtis's daughter, Sylvia, and Helen Appleton's daughter, also Sylvia, inherited the other two strings. Sylvia Curtis received one of her rubies.

At Christmastime, the children from Saint John's House, an orphanage in nearby Arlington affiliated with the Society of Saint John the Evangelist, came to Fenway Court and sang carols, as they had done for a number of years. Isabella was, according to the brothers, "bravely holding her own." When Father Spence Burton came to call in March, he found Isabella "feeble" though "as charming and attractive as ever." She seemed better that spring than she had in previous years, as if her spirit strengthened even "as her body grew more frail," as Olga observed. To Olga's surprise Isabella still had energy enough to visit the Museum of Fine Arts for ninety minutes, bringing her usual intense interest to everything she saw. She went out in a motorcar for her birthday and in June wrote to the Berensons: "My news is uninteresting, but very good. I am well and living the quiet summer life of Boston."

Then, on July 9, Isabella suffered a severe heart attack. Father Powell, her confessor, rushed to her side, as did Father Burton. Later, Olga sat with the two men on the roof of Fenway Court, reminiscing. The next day Father Burton found Isabella "very weak" but "courageous, merry, affectionate, and devout." What did the two talk about? Burton didn't say in his recollection, only that "there is no one quite like her." Two days later she slipped into unconsciousness. On July 14, she awoke once more, another phase in the cycle of decline and recovery, from light to dark and back again. Father Burton said it seemed as if "she cannot die." He and Father Powell continued to tend to her.

She still recognized people and was able to speak in her last hours, then fell into a peaceful sleep and died at 10:40 P.M. on July 17, the same day as her father, thirty-three years before. She was eighty-four years old. Olga had stayed by her side the whole time, something Isabella knew, so that "she was not alone."

A decade before, Isabella had written out very precise directions for what was to come next. In the morning, her body was transported from her boudoir on the fourth floor to the first floor of the museum, and her casket was placed alongside the small Spanish Chapel. The purple pall from Venice,

used twenty-six years before at Jack's funeral, now covered her. For three days, she was attended by sisters from the Society of Saint Margaret and the Order of Saint Anne; private services were performed. The outdoor garden, near the Chinese Loggia, was filled with pink petunias and birdsong. Lilies, larkspur, foxgloves, and hollyhocks lined the cloister near her coffin. The courtyard was a mass of intensely fragrant trumpet lilies in large vases, with palm trees reaching to the glass roof high above.

"Mrs. John L. Gardner Dies at Fenway Court Her Museum-Home" was the headline in the *Boston Evening Transcript,* the first of a series of articles the newspaper published in the coming days. One commented: "For many years she had occupied a position which was unique in Boston." The *Boston Globe* noted that she had a "rather fine contempt for what people might say about her."

On the morning of July 21, Fathers Powell and Burton performed the solemn Requiem Mass at Fenway Court, with family and a few friends in attendance. Then a large cross of white roses was placed on her coffin, which was carried out of Fenway Court on the shoulders of the men whom she had employed at the museum and her Brookline gardener. Bolgi, who had been

her majordomo since the building of the museum more than two decades before, stood at the door, dressed in his Italian gold-embroidered regalia, proudly holding his staff as her coffin passed. The funeral service at Church of the Advent was attended by hundreds. Olga Gardner Monks's son, Rev. Gardner Monks, was one of the celebrants. The choir of fifty men and boys sang the same hymns sung at Jack Gardner's funeral twenty-six years before: "Ten Times Ten Thousand" and the great Scottish Anglican hymn "Abide with Me," her favorite, with these opening lines: "Abide with me; fast falls the eventide / The darkness deepens; Lord with me abide." Soon after, she was buried in the Gardner family mausoleum at Mount Auburn Cemetery in Cambridge, surrounded by other prominent Boston families and ancient trees. A small plaque marks her resting place between her husband, Jack, and her son, Jackie.

Her will pronounced that Fenway Court was to be "for the education and enjoyment of the public forever." She left an endowment sufficient to ensure it would survive in perpetuity. After her death, Fenway Court was renamed the Isabella Stewart Gardner Museum, according to her wishes. Morris Carter noted that he had heard her say, in her later years, that she had resolved never to own anything she would mind losing. She made her point by quoting to him the last lines of "Aladdin" by James Russell Lowell: "Take, Fortune, whatever you choose, / You gave, and may snatch again—."

OLGA GARDNER MONKS WROTE TO BERNARD BERENSON SOON AFTER Isabella's death about how it seemed "strange to go to Fenway Court and lonely." She also told Berenson how Bolgi reported that he "often thought he heard her calling him."

On August 6, a book arrived at the museum. The volume, which memorialized the politician and diplomat Bellamy Storer, had been privately printed the year before by his wife, Maria Longworth Storer. Isabella had wanted a copy for her shelves. The inside frontispiece is a passage written by the bishop of Laval and based on Saint Augustine. It is not true, the writer urges, "to imagine that those whom death has taken leave us . . . Our dead are invisible to us, but they are not absent." This slim book was the last item to be added officially to the museum's collection.

The following April 14, sixteen members of the Society of Saint John the Evangelist, dressed in their brown robes, gathered early at the museum's third-floor chapel to celebrate the first memorial Mass, fulfilling a promise they had made to Isabella. Because it was Easter week that year, the service could not be a requiem but rather was a festal Mass, in which the celebrants said prayers for her soul and served communion. They sang unaccompanied, their voices rising and falling with the sound of the courtyard fountain below. The morning sunshine poured through the thirteenth-century French glass window at the front of the chapel, spilling color onto its stone floor. It was spring, her favorite time of year.

Epilogue

LACRIMAE RERUM, OR THE TEARS OF THINGS

A prosperous couple poses in a somewhat separated way in the large, square painting, their cheeks rosy, as if they have stepped in from the cold, their fashionable white collars aglow against their jet-black clothing. The man stands, the woman sits; the man looks directly at the viewer; the woman's gaze is directed elsewhere, but where is not entirely clear. Across from them, in the lower left-hand corner of the painting, is an empty chair, its legs a clear dark outline against the buff-colored floor. The ruby seat cushion is just barely visible in the dark interior. A critic describes the "oddly expectant and momentary air of the entire arrangement."

Rembrandt painted this double portrait, *A Lady and Gentleman in Black,* in 1633. Isabella purchased it through Berenson and Colnaghi in the fall of 1898, a few weeks before Jack Gardner died. She could not have known what the museum conservators discovered when they cleaned the painting in the 1970s: Rembrandt had painted out a small child, a boy, originally positioned between the man and woman. There

is no record as to why he did this. Perhaps the unnamed subjects of this double portrait changed their minds about having the child pictured with them. Perhaps the child had died. In any case, this unseen presence clarifies aspects of the painting, including the woman's distracted expression and the unusual arrangement between the figures. The extra empty space a velvety black, draws the viewer's eye and keeps it at bay at the same time.

The frame around the double portrait, with its gold finish, is now all that remains of the painting in the Dutch Room at the Isabella Stewart Gardner Museum. In the middle of the night on March 18, 1990, thieves stole thirteen pieces of art valued at over $500 million: masterpiece paintings by Vermeer, Rembrandt, and Manet; drawings by Degas and Rembrandt; a nineteenth-century bronze eagle finial; and an ancient Chinese Gu, or ceremonial vessel, that Isabella bought in 1922. The investigation is ongoing, with reports from time to time that the FBI is getting closer to solving the case; at the same time, those allegedly involved are aging, and

some have died. Theories abound as to what happened. There are several recent books about the theft, innumerable articles and essays, podcasts and documentaries.

Five empty frames now mark the spots where the missing paintings were, to remind us of what was there and what has been lost.

Isabella would have been devastated, and she would have been furious. But she would have persevered, as did the director of the museum then, Anne Hawley. The chair of the board at the time was John Lowell Gardner, known as Jack, the little boy Isabella had cradled in her arms on the morning of his birth in 1923. Jack Gardner, in his steady way, assured Hawley that she had the board's support, giving her and her staff courage to move forward, to keep to Isabella's vision, and eventually to expand the museum with the transformative addition by Renzo Piano in 2012,bringing Fenway Court into the twenty-first century, alive and vibrant, like the rising phoenix on the museum's seal.

Isabella Stewart Gardner had put herself on display in Fenway Court—her taste, her passions, her sorrows, her nerve, her capacious curiosity, her relationships. All of it. But she kept things hidden too. In later years, people often wondered why she did not put down in writing the reasons behind what she did in the museum—the sequence of rooms and the import of her installations. Maybe she did not put in writing what she wanted us to experience in the museum because to do so would lock down its meaning. We would have looked to her, and not to ourselves, as the authority. She wanted us to make meaning of what we see and hear and feel in the galleries' embrace, to chase beauty for ourselves. There is always more to find and more to say. Just as she wished.

ACKNOWLEDGMENTS

Acknowledgments are often the last pages written, though debts begin right from the start. Every book needs a hero, and this one has many. First among equals is Shana McKenna, the head archivist at the Isabella Stewart Gardner Museum, whose wisdom and unending generosity made so much possible. She can spot Gardner's handwriting from across the room, and early on she said something I put in my notes: "Gardner is never one thing. She is always this *and* that." It was also at the museum archives where I first met Alexandra Bush, who has since been my brilliant research assistant. She has read every page and saved me from mistakes. Lisa Feldmann, former archivist at the museum, cleared her calendar for multiple weeks to read drafts and then joined Alexandra to help me across the finish line with rigorous attention to details. I'm proud to call them friends.

I will never forget my first walk through the museum with Tess Fredette. Her knowledge about Gardner's use of textiles opened the galleries to my imagination. At a moment early on, Casey Riley leaned across our table during a lunch at Café G and said: "I hope you go for it." Mary Newell DePalma stood with me at the museum's courtyard and revealed insights, as did Pieranna Cavalchini. George Steel shared with me his understanding of Gardner's passion for music. Rina Sandler and Ann Walt Stallings answered my many questions, and Gianfranco Pocobene made it possible for me to see Titian's great painting up close in the conservation room, not minding when I burst into tears, overcome by its beauty.

Director Peggy Fogelman gave me her unwavering support in pursuing Gardner's biographical story, providing full access to the museum's extraordinary archival and collection materials, and for that open access I am truly thankful. I never once was denied seeing something at the museum that I

wanted to see. I'm grateful too for conversations with curator Diana Seave Greenwald, who reviewed several chapters for accuracy.

John Higgins and Nano Chatfield welcomed me for a week in Maine, where I was able to walk the beach named after Isabella and look through family papers. Rebecca Gardner Campbell reached out to see how I was doing, talking with me about her remarkable family and introducing me to her father. Anne Hawley graciously invited me for tea one summer afternoon, and her empathy for my task in trying to get Gardner's story right proved hugely encouraging.

I have benefited from the largesse of many at the Massachusetts Historical Society, including Catherine Allgor, Elaine Heavey, Peter Drummey, Anne Bentley, Kanisorn Wongsrichanalai, and the late Anna Clutterbuck-Cook. Brenda Lawson, archivist extraordinaire, met me for lunch just when I needed her friendship most. For several years, I have worked with two leading biographers, Megan Marshall and Julie Dobrow, to arrange programming for the New England Biography Series at the Society. I'm grateful for our camaraderie, and I'm glad for Megan's question over lunch that set me on this path: "Have you ever thought about writing on Gardner?"

The Boston Athenaeum shipped books to me during the worst of the pandemic, when everything was closed, as did Michelle Yost at Van Wylen Library at Hope College. She also found for me obscure references, while Todd Wiebe ordered for the library new titles he knew I needed to read.

Several institutions opened their archives, making this a better book. Elizabeth Peters of the Cotting School in Lexington, Massachusetts; Daphne Noyes at the Church of the Advent, Boston; Mary Chitty and Elizabeth Richardson at Emmanuel Church, Boston; Bonnie Recca and Harry Krauss at Grace Church in New York City; and Meg L. Winslow at Mount Auburn Cemetery. Mary A. Chatfield introduced me to the Society of the Saint John the Evangelist, where Brother James Koester generously shared records. Audrey Chapius and Abigail Altman welcomed me and my students at the American Library in Paris to do research in the city that so shaped Gardner's education. Claudine Sablier, archivist at Boucheron, shared purchase receipts and a wonderful line about pearls and what they represented for a woman in nineteenth-century Paris: "love and power." I am grateful to several repositories at Harvard University, especially the Schlesinger, Houghton, and Baker Libraries.

ACKNOWLEDGMENTS

I early on had grant support for this book, first with an inaugural Ina and Robert Caro Research/Travel Fellowship given by Biographers International Organization, followed by a 2018 Public Scholar Award from the National Endowment for the Humanities. I also received generous funding from Hope College, including leaves from teaching and research monies for students: Katrin Kelley, Melanie Burkhardt, Sarah Lundy, Hannah Jones, and Aine O'Connor. For twenty years, I was part of Hope's vibrant academic community. Of my many colleagues, I wish to thank especially James Boelkins, Peter Schakel, Stephen Hemenway, Kathleen Verduin, Christiana Salah, Janis Gibbs, Lauren Janes, Wayne Tan, Heidi Kraus, Daina Robins, Michelle Bombe, Julia Randel, Deborah Van Duinen, Kelly Jacobsma, and the late Ron Fleischmann, who helped me secure funding from the NEH. Jack and Julie Ridl convened conversations around their kitchen table about art and creativity, often joined by Elizabeth Trembley, who brought her paints. I talked with Marsely Kehoe many mornings about art and writing; and I had the great fortune of starting my career at Hope with Jeanne Petit, whose friendship never wavered. Conversations with Dana VanderLugt, former student now friend, give me what my mom most prized: roots and wings. I couldn't be more proud that our books will be published within months of each other.

My agent, Zoë Pagnamenta, took a chance on me and this book, and her confidence and truth-telling made it possible for me to finish. My editor, Deanne Urmy at Mariner Books, cared about Gardner and her story as much as I do. She entered into my manuscript and lived there for a time, ever an advocate for lines clearer and deeper. She sharpened every page with her wide knowledge and exacting standards. I'm grateful to the team at Mariner Books: Ivy Givens for her skill with production complexities; Mark Robinson for a beautiful cover; also Jessica Vestuto, Dale Rohrbaugh, Alison Bloomer, and Liz Psaltis; and Megan Wilson, whose emails bring cheer. Susanna Brougham's copy edits were precise and clarifying. Frederick Courtright helped me with illustrations and permissions, as did Maggie Goldstein at the museum.

Jeanne Curley walked with me through Beauport on Gloucester Harbor; R. Tripp Evans shared his original research on A. Piatt Andrew and the Dabsville group. Carlo Buonomo corrected my descriptions of Rome and Florence. Ronni Baer generously shared with me her wide knowledge of art, as did Wanda Corn and Sebastian Smee. Judith Fetterley never flagged in her

encouragement, nor did Barry Shank who read chapters and often gave me a red thread to make my way out of dark places. I'm thankful to Alice Wohl's sharp editing of several chapters and to Dave Haley, who scoured my pages for names and places, creating a chart for me to keep track of them. Thank you also to Sarah Holt, Sarah Chace, Kimberly Hamlin, Gabby Garschina, Maristela Nicolini, and Richard Boyajian for making my perfect writing desk. Pamela Toler practically crawled through a Zoom screen one day to encourage me, and we've been friends ever since. Marianne Brown and George Mutter rushed over to my house with a recent book on the photographer Thomas Marr at exactly the right moment. Laura Selene Rockefeller's graceful theatrical interpretation of Clover Adams, performed in New York and Boston, lifted my spirits during my last months of writing. I'm grateful also to all those at The Mount, Edith Wharton's home in the Berkshires, who have welcomed me, including Patricia Pin, Susan Wissler, and Nynke Dorhout.

Suzanne Koven reviewed my first book, after which we became friends and writing partners. I sent my chapters to her first, which she returned with lightning speed and brilliant humor, always giving me a path forward. Naomi Gordon many times saved the day with her candor and generosity. As I raced to meet deadlines, she opened her homes for me to stay and work, one not a thousand feet from Gardner's own Beacon Street address.

Several writers whom I greatly admire have become dear friends: Rachel Cohen, Deborah Lutz, and Janice Nimura. I feel fortunate to serve on the board of Biographers International Organization, and I'm indebted especially to Linda Leavell, Steve Paul, Sarah Kilborne, Heather Clark, and Michael Gately. I'm also glad for the chance to talk about the craft of biography every month with, among others, Anne Boyd Rioux, Paige Bowers, Heath Lee, Lynne Bermont, Daphne Geanacopoulos, Etta Madden, Patricia Loughlin, and Vanda Krefft.

I owe so much that is good in my life to my dear friends Paul Karsten and Julia de Jonge, first recipients of my prose all those years ago, often written in red ink. I'm deeply grateful for the friendships of Tim Gerhold and Annie Thompson; Wilson and Chris Lowry; Bob Perry and Geraldine Kish Perry; Jon Ames and Beth Rosen; and Charlie and Sally Wyman. The Boyer family in Paris showed us the city and beyond, making possible a glorious day at Giverny.

ACKNOWLEDGMENTS

When I was really stuck, three places helped most: Hancock Church in Lexington for embodying what matters most; the Waltham YMCA with community pools that gave renewal; and Cold Spring Park, where I met and trained with Matt Supple every Tuesday morning. He taught me about strength and gave a motto for life and writing: build one good day.

A special thank you to Mary A. Chatfield, and to Dick and Ruth Stravers—all exemplars of a well-lived life. My admiration abounds too for Mary A. Bundy, who last spring, at the age of ninety-eight, presented an exhibit of her many landscapes and portraits.

My siblings showed forbearance with my absences at family occasions, as did my husband's family. I'm grateful for the good humor of my brothers, Greg Dykstra and Stuart Dykstra; for my sister Ellen Stahl's long texts; and for assuring calls with my sisters-in-law, Sabina Dykstra and Ellen Dykstra, who also provided my author photograph. Sammy-cat kept me company though never learned to write endnotes. I feel fortunate to have so many nieces and nephews in my life. When Benjamin Dykstra and Juliana Culbert moved east, they also brought their cheer and delicious dinners; special thanks to Benjamin for taking care of my computers and for his photograph of the Grace Church window.

This book is dedicated to my husband, Mike Bundy, for his patience during some bleak moments, pandemic-related and otherwise, when it did not seem possible I would be able to tell Isabella's story. I got lost several times, but his quiet confidence and optimism lit the way. He has a genius for people and stories and putting hard things into words. This is for you, my sweet man, whom I've always known where to find at the end of the day.

A NOTE ON SOURCES

The Isabella Stewart Gardner papers are vast, dating from a 1492 signed letter by Ferdinand V, king of Spain, to 1924, the year of Gardner's death. The nearly two hundred boxes of materials in eight languages include dealer files for her art purchases, notebooks and diaries, financial records, rare manuscripts, signed letters of notables, memorabilia, and photograph albums documenting her gardens, houses, and the museum galleries. Gardner kept hundreds of newspaper clippings, even hiring a clipping service when she was often in the news. Her twenty-eight travel albums dating from 1867 and her fifteen guest books, full of signatures, witticisms, photographs, and sketches by family members and friends, compose a rich and varied record of a full life. I have kept the complete titles of the albums and guest books in my chapter endnotes so readers can easily find the digitized copies on the Isabella Stewart Gardner Museum website: gardnermuseum.org.

Gardner had a book collection of over three thousand volumes, with many rare titles and a wide selection of works by her contemporaries. She kept this collection in several locations. Her personal libraries at 152 Beacon Street and at Green Hill in Brookline were eventually moved to Fenway Court, with selected editions kept close at hand in her private fourth-floor apartment. Records of titles kept in her apartment are managed by the Registrar to the Collection. Other volumes were placed in the galleries, including the first-floor Macknight and Blue Rooms, where she kept works by contemporary authors; the Short Gallery on the second floor; and the Long Gallery, where one of several cases is the Dante Case, lined with priceless copies of the poet's works. Books were also kept in the first-floor Vatichino, a small room next to the Macknight Room, which Gardner used to store part of her personal archive. She also compiled two catalogs of her books—*A Choice of Books* in 1906 and *Manuscripts and Bindings*, a more scholarly

consideration, in 1922, both published by Merrymount Press. If I refer to a book in her personal library, I indicate as much in the endnote. All titles in the collection can be found on the museum's website.

Gardner's incoming correspondence is wide ranging, and much is transcribed and accessible via the museum archives and the Archives of American Art at the Smithsonian Institution. Gardner exhibited many letters in the museum's fifteen glass-topped cases, along with manuscripts, concert programs, photographs, and other items that she wanted to showcase in relation to the artwork on view. There is a large collection of Gardner family papers at the Massachusetts Historical Society and a smaller set managed by the family. For the sake of clarity when quoting Gardner's unpublished prose, I have infrequently and silently modified spellings and punctuation, especially dashes, of which she was fond. I have indicated any larger changes using ellipses or brackets in the text. I derived purchase prices from a range of sources—dealer records, receipts, and museum publications, and double-checking these prices with the museum's public-facing website that provides these details for each object in the collection.

The published sources are almost as voluminous as the primary sources. There are two collections of Gardner's correspondence, the first and largest the letters between her and Bernard Berenson, art connoisseur, dealer, and friend, from 1887 to the end of her life. Her side of the Berenson correspondence constitutes the largest known cache of letters written by her. A collection of letters to Gardner written by Henry James was published by Pushkin Press in 2009.

I frequently consulted *Fenway Court,* published by the museum since 1970 as a yearly journal focusing on aspects of the collection, Gardner's social circle, and debates within art history. After 1992, the journal became a vehicle to publish papers given at the museum's scholarly symposia; after 1998, the title *Fenway Court* was replaced by the individual symposia titles. Volumes 4 through 25 can be found at the museum's Virtual Reading Room: gardnermuseum.org/organization/virtual-reading-room.

Other museum publications were always within my reach: *The Eye of the Beholder: Masterpieces from the Isabella Stewart Gardner Museum,* edited by former curator Alan Chong; *Gondola Days: Isabella Stewart Gardner and the Palazzo Barbaro Circle,* an exhibition catalog published in 2004; and *Journeys East: Isabella Stewart Gardner and Asia,* an exhibition catalog from

2009. *Journeys East,* in addition to reprinting much of Gardner's two diaries and correspondence produced during her travels in 1883–84, includes several essays by scholars on whom I depended, especially Alan Chong, Christine M. E. Guth, Noriko Murai, and Greg M. Thomas.

In recent years, the museum has published a number of volumes in its Close-Up series, and I am indebted to several of these, including those covering Titian's *The Rape of the Europa,* Bourdichon's *Boston Hours,* Raphael's *Pope's Librarian,* Piermatteo D'Amelia's *Annunciation,* and *Sargent on Location,* about John Singer Sargent's artist in residency at Fenway Court after its opening in 1903.

Museum publications have shifted to a strong focus on its founder, notably with a remarkable set of titles starting with the 2017 *Isabella Stewart Gardner Museum: A Guide* edited by then curator Christina Nielsen. This was followed in 2022 by a companion volume, *Isabella Stewart Gardner: A Life,* by curators Nathaniel Silver and Diana Seave Greenwald, a compelling short-form telling of her life with new details about the sources of family wealth and an explication of Gardner's complicated will. Also in 2022, the museum reproduced many pages from Gardner's travel albums, accompanied by exploratory essays in the exhibition catalog *Fellow Wanderer: Isabella Stewart Gardner's Travel Albums.*

Morris Carter, her first biographer, was a man and writer of his era; his attitudes and use of language seem antiquated and are sometimes offensive today. That said, Carter's biography, published in 1925, was helpful to me because he knew Gardner in the years before she hired him to work at the museum full-time in 1919; he was every day at her side after her stroke that year. I consider Carter's biography as a secondary source where his editorializing is noticeable, but also as a primary one insofar as some passages capture the force of Gardner's own voice. We know he started making notes for his volume when he began working for her full-time. She liked to regale him with scenes, commentary about people, and quips, which he took down in his notes. He used some in his published biography, and the rest are saved in the Morris Carter Papers in the museum's archives.

In writing her 1965 biography, Louise Hall Tharp had the advantage of knowing personally many people who knew Gardner, and she packed every page with detail and incident. But she was also anxious about who Gardner was as a woman and often seemed to apologize to her readers for her subject.

She used—maybe overused—newspaper reports and gossip columns without placing them into full context.

Douglass Shand-Tucci's *The Art of Scandal: The Life and Times of Isabella Stewart Gardner* provided key evidence about Gardner's religious faith, evidence I was able to pursue further at the archives of the Society of Saint John the Evangelist in Cambridge, Massachusetts.

Several other books, and their writers, taught me through their work how to write this book, including Rachel Cohen's biography of Bernard Berenson—my copy is so battered, it has lost its original cover; Cynthia Saltzman's *Old Masters, New World: America's Raid on Europe's Great Pictures;* and Christopher Benfey's *The Great Wave: Gilded Age Misfits, Japanese Eccentrics, and the Opening of Old Japan.* Casey Riley's groundbreaking scholarship on Gardner's use of photography to realize and secure her vision for the museum has been influential. I am indebted to Colm Tóibín for his many insights about a wide range of things, but especially about Henry James and John Singer Sargent; also to Anne-Marie Eze's scholarship on Gardner's book collection as well as her astute essay on Anders Zorn; and to Erica E. Hirshler's wide-ranging scholarship on American art. Sukie Amory's deft interpretation of Gardner and horticulture in her two-part essay "Gardner in the Garden," published in *Hortus* in 2013, also guided my path.

LIST OF ILLUSTRATIONS

This list includes credit and identifying information for text images; credit information and captions for color illustrations are to be found in the insert. Unless otherwise specified, all illustrations are courtesy of the Isabella Stewart Gardner Museum, Boston. More information about each can be found at gardnermuseum.org.

Jacket *Isabella Stewart Gardner in Venice,* Anders Leonard Zorn, 1894, oil on canvas.

xii *Fenway Court, Album: Fenway Court,* 1902–22, Thomas E. Marr and Son, 1902, gelatin silver print on paper.

2 *Courtyard, Fenway Court, Album: 152 Beacon Street and Fenway Court,* 1900–1922, Thomas E. Marr and Son, 1903, gelatin silver print on paper.

13 *Isabella Tod Stewart,* Thomas Sully, 1837, oil on canvas.

14 (left) *David Stewart,* maker unknown, 1860–65, watercolor and graphite over photo mechanical reproduction on paper.

14 (right) *Adelia Smith Stewart,* maker unknown, 1855–60, hand-colored albumen print.

19 Grace Church Stewart Family window detail, Benjamin Dykstra (photograph), 2023, courtesy Grace Church in New York, New York.

23 *Helen Ruthven Waterston,* Alonzo Hartwell, 1856, crayon with white detail on paper, Collection of the Massachusetts Historical Society, Boston.

31 *Isabella Stewart Gardner,* maker unknown, about 1858, salted paper print with watercolor and crayon additions.

35 *Sketch of a Western Scene,* John Lowell Gardner Jr., about 1860, ink on paper.

36 *John Lowell Gardner Jr.,* John Adams Whipple, 1862, courtesy Mansion House Archives, Roque Island, Maine.

39 *Catharine Peabody Gardner and John Lowell Gardner Sr.,* Allen and Rowell, circa 1858 or 1859, courtesy Mansion House Archives, Roque Island, Maine.

LIST OF ILLUSTRATIONS

47 *John L. Gardner Jr., Isabella Stewart Gardner, and Benjamin W. Crowninshield,* maker unknown, 1861, albumen on paper.
51 *Isabella Stewart Gardner and John L. Gardner III,* John Adams Whipple, 1864, albumen on paper.

76 Hieroglyphics chart, *Travel Album: Egypt and Sudan,* 1874–75, Isabella Stewart Gardner, ink, paper.
79 Album page with painting of women praying, *Travel Album: Egypt and Sudan,* 1874–75, Isabella Stewart Gardner, ink, paper.
86 Tray containing ushabti, scarabs, amulets, and beads, makers unknown, nineteenth century, stone, ceramic, wood, string.

88 *William Amory Gardner, Joseph Peabody Gardner Jr. and Augustus Peabody Gardner,* Allen and Rowell, about 1876, albumen on paper.

97 *Front View of 152 Beacon Street, Album: 152 Beacon St. and Fenway Court,* 1900–1922, Thomas E. Marr and Son, 1900, gelatin silver print on paper.
98 *Entrance, 152 Beacon Street,* Thomas E. Marr and Son, 1900, gelatin silver print.
100 *Henry James,* Elliott and Fry, 1884, albumen print.
101 *F. Marion Crawford,* maker unknown, about 1882, albumen on card.
106 *Clasped Hands of F. Marion Crawford and Isabella Stewart Gardner,* A. B. Cross, about 1882, ink on albumen print.

115 Album page with sumo wrestlers and pressed leaves, Tokyo, *Travel Album: Japan, Volume I,* 1883, photographs, ink, paper, botanicals.

130 *Palazzo Barbaro, Grand Canal, Venice,* Paolo Salviati, late nineteenth century, albumen print.

139 *Isabella Stewart Gardner on the Lawn at Green Hill, Brookline, Massachusetts,* unknown maker, 1893, gelatin silver print.
142 *Olga Gardner Monks at 16 or 17,* Conly Portraits, about 1885 or 1886, Courtesy Mansion House Archives, Roque Island, Maine.
145 Album page with *Portrait of Eleanor of Toledo and Her Son, Giovanni de' Medici,* Bronzino, *Travel Album: Great Britain, France, Germany, Austria, and Italy, Volume I,* 1886, photographs, ink, paper.

LIST OF ILLUSTRATIONS

147 *Miniature Portraits of John "Jackie" Lowell Gardner III, Isabella Stewart Gardner, Joseph Peabody Gardner Jr., and John L. Gardner Jr.,* W. Caflin (miniature), about 1865; E. Tilton and Company (JLG and ISG tintypes), about 1860; unknown maker, about 1880–86, painted miniature, tintypes.

149 *John Singer Sargent in His Studio, with Portrait of Madame X,* Adolphe Giraudon, about 1885, Smithsonian Institution, Archives of American Art.

153 *Berenson Case,* Joseph B. Pratt, 1941, gelatin silver print.

159 *Isabella Stewart Gardner,* John Thompson, 1888, platinum print on paper with autograph in ink.

165 *Isabella Stewart Gardner, John Lowell Gardner Jr., and Others in Seville,* maker unknown, 1888, albumen print.

166 *The Virgin of Mercy,* workshop of Francisco de Zurbarán, about 1640, oil on canvas.

175 *Isabella Stewart Gardner and Friends in Costume,* Notman Photograph Company, about 1888–89, Collection of the Massachusetts Historical Society.

180 *Isabella Stewart Gardner,* Dennis Miller Bunker, 1889, oil on canvas.

181 *Isabella Stewart Gardner in Sitting Room at Beach Hill,* unknown maker, 1884, albumen print.

188 *Interior of Saint Augustine,* unknown maker, undated, photograph, courtesy of the Society of Saint John the Evangelist Archives, Cambridge, Massachusetts.

190 *Reception Before Myopia Hunt Club Ball, Boston,* James Notman, June 28, 1891, gelatin silver print.

191 *Titian Room, Twenty Photographs of the Second and Third Floor Galleries, Fenway Court, Boston,* 1903–26, Thomas E. Marr and Son, 1915, gelatin silver print.

194 *Ignacy Jan Paderewski,* London Stereoscopic Company, 1892, albumen print on card.

196 *Virgin and Child with a Swallow,* Francesco Pesellino, about 1453–57, tempera on panel, via Bridgeman Art Library.

197 *Hallway in the Palazzo Barbaro, Venice,* Isabella Stewart Gardner or John L. Gardner Jr., Travel Album: Europe and the United States, about 1897, gelatin silver print.

203 *Boudoir, 152 Beacon Street, Boston,* Thomas E. Marr and Son, 1900, gelatin silver print.

LIST OF ILLUSTRATIONS

208 *The Omnibus,* Anders Zorn, 1892, oil on canvas, via Bridgeman Art Library.

220 *Study for Isabella Gardner III,* Anders Zorn, 1894, pencil on paper.

221 *The Story of Lucretia,* Sandro Botticelli, 1499–1500, tempera and oil on panel, via Bridgeman Art Library.

225 *Horus Hawk, Fenway Court, Boston,* Thomas E. Marr and Son, 1915, gelatin silver print.

231 (top) *Garden with Colossal Statue, Green Hill, Brookline, Massachusetts,* Thomas E. Marr and Son, about 1900, gelatin silver prints.

231 (bottom) *Japanese Garden, Green Hill, Brookline, Massachusetts,* Thomas E. Marr and Son, about 1900, gelatin silver prints.

235 *Red Drawing Room with View of* Rape of Europa, *152 Beacon Street, Boston,* Thomas E. Marr and Son, 1900, gelatin silver print.

242 *List of Things for Museum: Pictures in Red Drawing Room,* 25, Isabella Stewart Gardner, March 25, 1897–December 26, 1898, handwritten ink and graphite on paper in a leather binding with gilded edges.

253 *John L. Gardner Jr. and Unidentified Man on the Steamship "Polly,"* unknown maker, August 27, 1898, gelatin silver print.

258 *Fenway Court During Construction: Isabella Stewart Gardner on Ladder,* maker unknown, 1900, gelatin silver print.

268 *West Side View of Courtyard Stairs and Columns, Album: 152 Beacon Street and Fenway Court,* 1900–22, Thomas E. Marr and Son, 1902, gelatin silver print.

271 *Fenway Court During Construction: Stylobate Lion,* Isabella Stewart Gardner, 1900, gelatin silver print.

276 *Courtyard, Fenway Court,* Thomas E. Marr and Son, *Album: Fenway Court,* 1902–22, gelatin silver print on paper.

278 *First Chinese Room, Fenway Court, Album: 152 Beacon Street and Fenway Court, 1900–1922,* Thomas E. Marr and Son, gelatin silver print on paper.

280 *Foot,* maker unknown, sixteenth century, marble.

281 *Raphael Room, Fenway Court,* Thomas E. Marr and Son, *Twenty Photographs of the Second and Third Floor Galleries, Fenway Court, Boston,* 1903–26, gelatin silver print.

LIST OF ILLUSTRATIONS

284 *Music Room, North Wall, Fenway Court,* Thomas E. Marr and Son, 1914, gelatin silver print.

292 *Gothic Room,* Thomas E. Marr and Son, 1926, glass plate negative.

294 *Portrait of Charles Martin Loeffler,* John Singer Sargent, April 10, 1903, oil on canvas, via Bridgeman Art Library.

295 *John Singer Sargent Painting Mrs. Fiske Warren (Gretchen Osgood) and Her Daughter Rachel in the Gothic Room [1],* John Templeman Coolidge, 1903, platinum print.

296 *Virgin and Child,* workshop of Lorenzo Ghiberti, about 1425–50, painted and gilded stucco.

298 *Bernard Berenson at Villa I Tatti,* maker unknown, 1903, gelatin silver print.

306 Guest book page with photographs of Okakura Kakuzo, *Guest Book: Volume V, July 19, 1907–May 5, 1909,* Isabella Stewart Gardner, 1905–7, commercially made guest book, ink, paper, photographs.

316 *J. B. Potter's Sketch,* John Briggs Potter, 1906, albumen print of original sketch.

322 *Chapel,* Thomas E. Marr and Son, *Twenty Photographs of the Second and Third Floor Galleries, Fenway Court, Boston,* 1903–26, gelatin silver prints.

323 *Isabella Stewart Gardner,* Baron Adolf de Meyer, 1906, platinum print.

325 *Construction of Carriage House, Three Photographs of Fenway Court from the Southwest,* unknown maker, 1907–8, gelatin silver print on board.

329 *Isabella Stewart Gardner with A. Piatt Andrew and Jack Mabbett at Red Roof, Gloucester, Massachusetts,* unknown maker, June 26, 1908, gelatin silver print.

340 *Teobaldo "Bolgi" Travi in the North Cloister, Fenway Court,* Thomas E. Marr, 1904, gelatin silver print.

342 *Isabella Stewart Gardner and George Gardner Monks at Green Hill,* Thomas E. Marr, May 1900, gelatin silver print.

345 (top) *Isabella Stewart Gardner, A. Piatt Andrew, Okakura Kakuzo, Caroline Sidney Sinkler, and Henry Davis Sleeper on the Terrace at Red Roof,* Thomas E. Marr and Son, October 6, 1910, collodion print.

345 (bottom) *Isabella Stewart Gardner and A. Piatt Andrew at Red Roof, Gloucester, Massachusetts,* Thomas E. Marr, October 6, 1910, gelatin silver print.

348 *Isabella Stewart Gardner in Pearls,* unknown maker, about 1915, *Boston Herald-Traveler,* Photo Morgue, Boston Public Library.

351 *Matthew Stewart Prichard,* unknown maker, about 1895, platinum print.

355 *Chinese Room, South Wall,* Isabella Stewart Gardner Museum, 1961, photographic print.

357 *Section Through Court and Tapestry Room Looking Towards Rear,* Willard Thomas Sears, about 1914, ink on linen.

359 *View of* El Jaleo, *Spanish Cloister, Fenway Court, Album: 152 Beacon Street and Fenway Court,* 1900–1922, Thomas E. Marr and Son, 1915, gelatin silver prints on paper.

360 *Votive Stele,* maker unknown, 543 CE, limestone.

362 *Little Salon, Twenty Photographs of the Second and Third Floor Galleries, Fenway Court, Boston,* Thomas E. Marr and Son, 1903–26, gelatin silver print.

366 *American Field Services Ambulance in France,* A. Piatt Andrew, 1916, gelatin silver print.

374 *John Singer Sargent and Isabella Stewart Gardner, from A. Piatt Andrew Photo Albums,* unknown maker, 1919, photograph, courtesy Historic New England Library and Archives.

380 *Diana,* Paul Manship, 1921, bronze.

386 *Isabella Stewart Gardner's Funeral,* Arthur E. Marr, July 21, 1924, gelatin silver print.

390 *A Lady and Gentleman in Black,* Rembrandt van Rijn, 1633, oil on canvas.

391 *Crest of the Isabella Stewart Gardner Museum: C'est Mon Plaisir,* Sarah Wyman Whitman, 1900, sandstone.

NOTES

LIST OF ABBREVIATIONS

The abbreviations below are used for frequently cited personal names, libraries, archives, manuscript collections, and published sources I used most frequently. I have listed other published sources in a select bibliography. A full citation for those titles and others are given in the endnotes on first use and subsequently cited with author's last name and an abbreviated title.

PERSONAL NAMES

APA: Abram Piatt Andrew
BB: Bernard Berenson
FMC: Francis Marion Crawford
GAG: George Augustus Gardner
GOW: Gretchen Osgood Warren
GPG: George Peabody Gardner
GTL: Gaillard Thomas Lapsley
HA: Henry Adams
HC: Hans Coudenhove
HJ: Henry James
HLH: Henry Lee Higginson
HRW: Helen Ruthven Waterston
HWS: Henry W. Swift
ISG: Isabella Stewart Gardner
JLG Jr.: John Lowell Gardner Jr.
JLG Sr.: John Lowell Gardner Sr.
JPG Jr.: Joseph Peabody Gardner Jr.
JSS: John Singer Sargent
MHA: Marian "Clover" Hooper Adams
MHE: Maud Howe Elliott
MSP: Matthew Stewart Prichard
RWH: Robert W. Hooper
WTS: Willard T. Sears

LIBRARIES, ARCHIVES, AND MUSEUMS
Houghton: Houghton Library, Harvard University
ISGM: Isabella Stewart Gardner Museum, Boston
Mansion: Mansion House Archives (private), Roque Island, Maine
MHS: Massachusetts Historical Society
SSJE: Society of Saint John the Evangelist Archives, Cambridge, Massachusetts

MANUSCRIPT COLLECTIONS
APA Diaries: Abram Piatt Andrew papers, Box 1, Folder 14, Hoover Institution Library & Archives
GFP: Gardner Family papers, Ms. N-1273, MHS
GTL Letters: Gaillard Lapsley Material, 1895–1939, Edith Wharton Collection, Yale Collection of American Literature, Beinecke Rare Book and Manuscript Library
HA Papers: Henry Adams papers, 1890–1938, Ms. N-1776 4th Gen., MHS
HRW Copybook: Helen Ruthven Waterston letters to Helen Thayer and other letters after 1858 copied in a 1859 notebook, Ms. N-60, MHS
HRW Diaries: Helen Ruthven Waterston diaries, 1823–59, Ms. N-60, MHS
HWS-P: Henry W. Swift papers, ISGM
ISG Papers, ISGM: Unpublished ISG correspondence, papers, and other materials, such as commonplace books and single albums. Out of respect to the museum, ISGM is added to the abbreviation. Travel albums and guest books are also part of this large collection. They are listed with identifying information for the volume only.
JLGJr-P: John Lowell Gardner Jr. papers, 1838–98, ISGM
MC Papers: Morris Carter papers, ISGM

PUBLISHED SOURCES
Benfey: Christopher Benfey, *The Great Wave: Gilded Age Misfits, Japanese Eccentrics, and the Opening of Old Japan* (New York: Random House, 2003).
Beholder: Alan Chong, Carl Zahn, and Richard Lingner, eds. *Eye of the Beholder: Masterpieces from the Isabella Stewart Gardner Museum* (Boston: Isabella Stewart Gardner Museum, in association with Beacon Press, 2003).
Carter: Morris Carter, *Isabella Stewart Gardner and Fenway Court* (Boston: Houghton Mifflin Company, 1925).
Cohen: Rachel Cohen, *Bernard Berenson: A Life in the Picture Trade* (New Haven, CT: Yale University Press, 2013).
Gondola: Elizabeth Anne McCauley, Alan Chong, Rosella Mamoli Zorzi, and Richard Lingner, eds. *Gondola Days: Isabella Stewart Gardner and the Barbaro Circle* (Boston: Isabella Stewart Gardner Museum, distributed by Antique Collectors' Club, 2004).
HA Letters: The Letters of Henry Adams, ed. J. C. Levenson et al. (Cambridge, MA: Belknap Press, 1982–88), 6 vols.
HJ Letters: The Letters of Henry James, ed. Leon Edel (Cambridge, MA: Belknap Press, 1975–83), 4 vols.
HJ/Zorzi: Henry James, *Letters to Isabella Stewart Gardner,* ed. Rosella Mamoli Zorzi (London: Pushkin Press, 2009).
Inventing: Alan Chong and Noriko Murai, *Inventing Asia: American Perspectives Around 1900* (Singapore: Asian Civilizations Museum, 2014).
ISGAL: Diana Seave Greenwald and Nathaniel Silver, *Isabella Stewart Gardner: A Life* (Princeton and Oxford: Princeton University Press, 2022).

ISG/BB Letters: The Letters of Bernard Berenson and Isabella Stewart Gardner, 1887–1924 (with correspondence by Mary Berenson), ed. Rollin Van N. Hadley (Boston: Isabella Stewart Gardner Museum, 1987).

ISGM Guide 2017: Christina Nielsen with Casey Riley and Nathaniel Silver, *Isabella Stewart Gardner: A Guide* (Boston: Isabella Stewart Gardner Museum; New Haven, CT: Yale University Press, 2017).

Journeys: Alan Chong, ed., *Journeys East: Isabella Stewart Gardner and Asia* (Boston: Isabella Stewart Gardner Museum, 2009).

Memorial: Frank A. Gardner, *Gardner Memorial: A Biographical and Genealogical Record of the Descendants of Thomas Gardner, Planter, Cape Ann, 1624, Salem (Naumkeag), 1626–74, through his son Lieut. George Gardner* (Salem, MA: Newcomb and Gauss Company, printers, 1933).

My Cousin: Maud Howe Elliott, *My Cousin F. Marion Crawford* (New York: The Macmillan Company, 1934).

Tharp: Louise Hall Tharp, *Mrs. Jack: A Biography of Isabella Stewart Gardner* (New York: Congdon and Weed, 1965).

LMHA: Letters of Mrs. Henry Adams, 1865–1885, ed. Ward Thoron (Boston: Little, Brown and Company, 1936).

WTS Diary: Luisia Lambri, Pieranna Cavalchini, and Amanda Esteves-Kraus, *Portrait* (Boston: Isabella Stewart Gardner Museum, 2012). This catalog, published in conjunction with Luisa Lambri's exhibition "Portrait," presented at the Isabella Stewart Gardner Museum, January 19–October 15, 2012, reprinted much of the diary of Willard T. Sears.

EPIGRAPH

vii *It was only a picture:* Virgil, *The Aeneid,* trans. W. F. Jackson Knight, rev. ed. (London: Penguin Books, 1958), 42.

PROLOGUE: NOTES ON A MUSEUM

3 *"an installation artist":* Anne Hawley, *New York Times,* April 23, 2000.

3 *to enter "Isabellaland":* Francine Prose, "Boston, Where Puritan Meets Sybarite," *New York Times,* September 12, 1993.

3 *"What manner of woman":* Anne O'Hagan, "The Treasures of Fenway Court," *Munsey's Magazine* 34, no. 6, March 1906, 674.

3 *"Years ago I decided":* ISG to Edmund Hill, June 21, 1917, ISG Papers, ISGM.

3 *she "filled the air":* MC Papers.

4 *was "like dynamite":* MC Papers.

4 *with a "gliding walk":* Margaret Chanler, *Autumn in the Valley* (Little, Brown, and Company, 1936), 35.

4 *she "annihilated the thought":* MC Papers.

4 *"I said I wished":* MC Papers.

4 *she "rarely expressed":* Lily Lawlor to Morris Carter, June 19, 1936, MC Papers.

4 *"When I knew her":* Morris Carter to Mary Garstang, December 26, 1963, MC Papers.

4 *"I am obliged":* ISG to Lester Leland, n.d., ISG Papers, ISGM.

5 *"you have her":* MC Papers.

5 *On September 14, 1922:* For citation information about John Singer Sargent as an artist-in-residence at Fenway Court and about this 1922 portrait, see Chapters 25 and 32.
6 *"both clarity and mystery":* Colm Tóibín, "Shadow and Substance," in *Henry James and American Painting,* ed. Colm Tóibín, Marc Simpson, and Declan Kiely (University Park: Pennsylvania State University Press, 2017), 38.
7 *"a wonderful sketch":* Margaret Chanler, *Autumn in the Valley,* 41.

ONE: A NEW YORK GIRL, 1840–55

11 *for her speed:* An early childhood anecdote notes her swiftness. When Belle was four or five years old, her grandmother Stewart brought her to see a traveling circus, and when Belle spied the big-top tent up ahead, she started running toward it pell-mell, wanting to see inside. A butler was sent after her, according to Morris Carter, "but she was an unusually good runner, always best runner in school, and was just crawling under the tent, when butler grabbed her by the leg and pulled her back. Most ignominious moment in her life ('ignominious,' her word)." MC Papers.
11 *10 University Place:* 1846 is the first year the family is listed in the New York directories at 10 University Place. *Doggetts New York City Directory for 1846 and 1847* (New York: John Doggett Jr., 1846), 373.
12 *a "constant river":* William Bobo, *Glimpses of New York City* (Charleston: J. J. McCarter, 1852), 11–13. Laura Cumming gives a vivid portrait of Broadway in the 1850s in her book *The Vanishing Velázquez: A 19th-Century Bookseller's Obsession with a Lost Masterpiece* (New York: Scribner, 2016), 178–82.
12 *"Beautiful candelabras":* Lydia Maria Child, *Letters from New York, Second Series* (New York: C. S. Francis, 1845), 96.
12 *"hackney cabs and coaches":* Charles Dickens, *American Notes for General Circulation,* ed. Patricia Ingham (New York: Penguin Classics, 2000), 91.
12 *"rested sociably against trees":* Henry James, *Henry James: Autobiographies,* ed. Philip Horne (New York: Library of America, 2016), 65.
12 *bequest of $75,000:* Carter, 8. Carter does not indicate where he got the figure of $75,000. He excludes the detail about Madame Stewart debating about what to do with the inheritance in his biography. The detail comes, instead, from his notes. MC Papers.
12 *She chose the latter:* John Tod, *The History of the Tod Family* (privately printed, 1917), 25.
13 *outlawed slavery in 1827:* For details on the Smith, Tod, and Stewart families and their connections to slavery, see *ISGAL,* 19–25, 142–43.
13 *Her essays published:* See *Queens County Agricultural Society,* vol. 2 (Albany: County Agricultural Societies, 1842).
13 *several of her dresses:* Much later Isabella wrote to Corinna Putnam Smith (she went by Corinna Lindon Smith), when she was giving away many of her things to younger women she cared about, "These . . . dresses are heirlooms—many were my grandmother's." ISG to Smith, n.d., Mc433 Corinna Putnam Smith Papers, Schlesinger Library, Harvard University.
13 *"Presented to Isabel Stewart":* *The New Testament of our Lord and Saviour Jesus Christ* (New York: American Bible Society, 1847). Isabella kept this slim volume with other memorabilia in a small archive room next to the Macknight Room, which she called the Vatichino, a made-up word meaning "diminutive Vatican."

14 *Irish and Scottish linen:* David Stewart's firm was located first on Pine Street, then on Fulton, Reade, and Duane Streets.

14 *at Saint John's Church:* Records of Saint John's Church in Brooklyn list the Stewart wedding on May 7, 1839.

14 *according to his passport:* David Stewart's US-issued passport in 1878 lists his height as 5 feet 11 ½ inches.

15 *comfortable financial standing:* Both portraits of David Stewart and Adelia Stewart hang in the Vatichino.

15 *her disapproving mother:* MC Papers. Tharp portrays Adelia as timid and "baffled" by her rambunctious daughter, unsure of how to manage her, but without providing evidence for these conclusions. Tharp, 7.

15 *"her arms wide open":* Julia Gardner to CPG, October 8, 1859, GFP.

15 *"photographs of royalties":* Adelia Stewart, Album: Photographs of Royalties, 1870, ISG Papers, ISGM.

15 *family genealogy chart":* Genealogy Chart, ISG Papers, ISGM.

15 *sold to pay them off: ISGAL,* 20.

16 *"one of 10 sons":* Genealogy Chart, ISG Papers, ISGM.

16 *one of Mary's dresses:* These were most likely gifts from Alfred John Rodwaye to Isabella as a relic of Mary, Queen of Scots, in 1897. See Gilbert Wendell Longstreet and Morris Carter, *General Catalogue* (Boston: 1935), 250. She displayed these items and several others with a connection to the queen in her Mary, Queen of Scots, Case, ISGM. See also *ISGAL,* 17.

16 *was "hereby certified":* Lifetime Membership Certificate for the Stewart Society, April 19, 1921, ISG Papers, ISGM.

16 *1839 as her birth year:* There is some question in the record as to whether Isabella was born in 1839, not 1840. Her parents were married on May 2, 1839. If she was born on April 14, 1839, did she move the date to 1840 to protect this information? Her marriage record in the Grace Church Registry points to the 1839 date, as does a 1924 letter from the Mount Auburn Cemetery superintendent to William C. Endicott, stating that the papers the cemetery received on her death listed her age as eighty-five years, three months, and three days. If correct, that would make the date of birth April 14, 1839. John F. Peterson to William C. Endicott, July 24, 1924, Mount Auburn Cemetery Files, copy of letter in Subject Files, ISGM. Other sources pointing to an 1839 date include *The Pickering Genealogy, Comprising the Descendants of John and Sarah Burrill Pickering of Salem* (privately printed, 1887); and Elizabeth Ward Perkins, "Mrs. Gardner and Her Masterpiece: The Gift of Fenway Court to the Public," *Scribner's Magazine* 77 (March 1925), 227–35. Morris Carter described to Endicott how he and Olga Gardner Monks, Isabella's niece, settled on the 1840 date: "I found a large genealogical chart on which her birth is given as 1840. We decided that that date was the best we could do," adding that it "hardly seemed as if Mrs. Gardner would have falsified a record so carefully made—but perhaps she did." MC to William C. Endicott, March 7, 1930, MC Papers. Her birth records have not been located in New York. The mausoleum plaque in the Gardner Family Tomb at Mount Auburn Cemetery reads "Born April 14, 1840."

16 *from their earliest books:* Copies can be found in ISG Personal Library, ISGM.

17 *"devote her time":* Ann Haddad, "Ladies of Refinement," Merchant House Museum blog, September 27, 2018.

17 *hanging above their heads:* Okill Academy records, ISG Papers, ISGM. The building at 8–10 Eighth Street still stands. Built in 1838, it was at one point the first home of the Whitney Museum of Art and is now a school for art. Okill, also spelled O'Kill, was the only daughter of Sir Peter Jay, niece of the Supreme Court justice John Jay. Her mother, Anne Erwin, was a very early feminist, influenced by Wollstonecraft. Anne Erwin refused to marry because she could not make herself say the "honor and obey" part of the vows. Mrs. Okill was divorced and sometimes went by Miss Okill. Whether the Stewart parents knew of the history is not known. For more on Okill and her Academy, see Ann Haddad, "Ladies of Refinement: The Women Who Educated the Tredwell Daughters," Merchant House Museum blog, September 27, 2018; *Memorial History of the City of New-York,* ed. James Grant Wilson (New York: New York History Company, 1892–93), vol. 3, 361.

17 *Her signature "I. Stewart":* Copies in ISG Personal Library, ISGM.

17 *"This is done very badly":* ISG Sketchbook, 1853–54, ISG Papers, ISGM. The inside tag indicates the sketchbook was produced in Paris.

17 *any angle in the city:* For an early history of Grace Church, see Rev. William R. Huntington, "The Staying Powers of a Downtown Church," sermon delivered on March 8, 1896.

18 *a yearly rent of $52:* List of Pew Purchases, Grace Church Archives, New York City.

18 *"keeping up with the Joneses":* Hermione Lee, *Edith Wharton* (New York: Vintage, 2008), 22. Edith Jones would marry Teddy Wharton at another New York church, but she later set the iconic wedding of May Welland and Newland Archer in *The Age of Innocence* at Grace Church, with its "flower-banked altar." Edith Wharton, *The Age of Innocence* (New York: Penguin Books, 2019; first published D. Appleton and Company, 1920), 154.

19 *lasted nineteen days:* James Stewart obituary, *New York Times,* April 17, 1881.

TWO: "A FAR-FAMED CITY," 1856-58

20 *"A place in thy memory":* Delafield is nowhere else mentioned in Isabella's papers. ISG, Autograph Album, 1856-1861, ISG Papers, ISGM.

21 *the "far-famed city":* HRW Diaries, November 23, 1856.

21 *"ripped open the belly":* Baron Haussmann, as quoted in Alistair Horne, *Seven Ages of Paris* (New York: Vintage Books, 2002), 234.

21 *"City of Light":* Philip Carr, "Haussmann's Paris Is Finished at Last," *New York Times,* January 23, 1927.

21 *"cultivated their genealogies":* Ernest Samuels, *Henry Adams: The Middle Years* (Cambridge, MA: Belknap Press, 1958), 7.

21 *an "almost irresistible power":* Rachel McCrindell, *The School-Girl in France, or the Snares of Popery: Warning to Protestants Against Education in Catholic Seminaries,* 4th ed. (New York: J. K. Wellman, 1846), 363. Mrs. Stewart's copy was published in Philadelphia in 1850.

22 *Stained-glass windows topped:* HRW to Helen Thayer, March 7, 1857, HRW Copybook.

22 *an emphasis on rote learning:* Christina de Bellaigue, *Educating Women: Schooling and Identity in England and France, 1800–1867* (Oxford: Oxford University Press, 2007), 234. De Bellaigue notes that the system of "education developed by the Jesuits in the early modern period had established the outline of a highly formalized and hierarchical institutional model of schooling."

22 *so "new that they rustled":* HRW Diaries, December 8, 1856.

22 *A first breakfast followed:* HRW to Helen Thayer, March 7, 1857, HRW Copybook.
22 *Her French composition book:* Composition Book: French Idioms with English Translations, 1856–57, ISG Papers, ISGM.
22 *"Why hast thou abandoned me?":* HRW Diaries, December 30, 1856.
22 *a "sincere lover":* Mary Elizabeth Fiske Sargent, ed., *Sketches and Reminiscences of the Radical Club of Chestnut Street, Boston* (Boston: James R. Osgood and Company, 1880), 130. Rev. Coquerel's son, also named Athanase Coquerel, gave a talk on the relation of art and Christianity to Boston's Radical Club shortly before his death in 1875. See also Athanase Coquerel, *Four Sermons in English* (London: Longmans, Green and Company, 1872); and Athanase Coquerel, *Protestantism in Paris : A Series of Discourses Translated from the French* (Boston: Crosby, Nichols and Company, 1854).
23 *"if it was against the rules":* Tharp, 10.
24 *"a New York girl":* HRW Diaries, December 8, 1856. Helen Ruthven Waterston's diaries and letters, not discovered before, are the main primary sources for Isabella's life and education in Paris, beyond her own friendship album and composition book. Waterston kept daily diaries from 1855 to 1858.
24 *as "bright, intelligent":* HRW Diaries, January 5, 1857.
24 *"jolly and splendid":* HRW Diaries, January 5, 1858.
24 *"as pleasing as ever":* HRW Diaries, November 29, 1856.
24 *"what should I do":* HRW Diaries, January 22, 1857.
24 *the 1856 London editions:* Isabella would keep her copies of Jane Austen novels from this time in the Vatichino.
24 *one another's albums:* Helen's and Julia's signatures appear twice in Isabella's papers—once in her autograph album and again in a document where the names are arranged in the shape of an open fan. ISG Papers, ISGM.
24 *all sorts of "absurd things":* HRW Diaries, January 21, 1857; other details gleaned from entries dated December 17 and 30, 1856.
24 *older brother, Jack Gardner:* HRW Diaries, December 25, 1856.
24 *its "generous hospitality":* Memorial, 129.
25 *"the most flourishing condition":* Rebecca Russell Lowell Gardner to Nina Lowell, February 22, 1852, GFP. Nina, Jack's first cousin, was two years older.
25 *list of friends and relatives:* This characteristic is seen in a long, rambling letter to his brother George Augustus Gardner from Italy: "If you meet any of my classmates, please remember me to them and say I have not forgotten the two pleasant years I spent at Cambridge and their kindness to me when I came away. Give my best love to Eliza [George's wife] and tell her that though I enjoy exceedingly her weekly letters to Father and Mother, I expect to derive even more pleasure from one addressed to myself, which from an insinuation she lately made, I presume now to be on its way. Also give my love to Joe if he has returned from his Western tour and a kiss for me to each of your children. I am your affectionate brother, John L. Gardner." JLG Jr. to GAG, May 2, 1858, Naples, GFP.
25 *Jack's father had requested:* Jack withdrew from Harvard in 1856, when war was looming. His father wrote to the president of Harvard College, requesting that his son be taken out of the sophomore class to go to Europe with the family. Jack was a member of the class of 1858. He was active in the college society called Institute of 1770. MC Papers.
25 *on Christmas Day:* HRW Diaries, December 25, 1856.
25 *"appeared very pleasing":* HRW Diaries, December 24, 1856.

25 *New Year festivities:* HRW Diaries, December 30, 1856.
26 *"swore by our brooches":* HRW Diaries, January 26, 1857.
26 *"We hear it's splendid":* HRW Diaries, March 5, 1857.
26 *"The Queen had suffered":* Alexandre Dumas, *La Comtesse de Charny*, vol. 4 (Boston: Little, Brown, and Company, 1890), 317.
26 *"As has been seen":* Dumas, *La Comtesse de Charny*, vol. 4, 425.
27 *while "in America":* The book scandal is relayed in HRW Diaries, March 12 and 14, 1857.
28 *after Helen and Julia:* HRW to Helen Thayer, June 28, 1857, HRW Copybook.
28 *"the name of Isabella Stewart":* HRW Diaries, June 4, 1857.
28 *Helen called "jollification":* HRW Diaries, January 26, 1857.
28 *"No friendship is so cordial":* ISG Commonplace book, 1868, ISG Papers, ISGM.
28 *the "statues and pictures":* HRW Diaries, December 2, 1857.
28 *"Isabella in Rome!!":* HRW Diaries, November 20, 1857.
29 *as "beautifully dressed":* Ellen Emerson to William Emerson, December 30, 1856, *The Letters of Ellen Tucker Emerson*, vol. 1, ed. Edith E. W. Gregg (Kent: Kent State University Press, 1982), 124.
29 *traveling everywhere together:* Tharp mistakenly writes that Ida's father and stepmother, Louis Agassiz and Elizabeth Cary Agassiz, were in Rome at this time and had organized the Italian lessons. This is not the case, according to Helen's diary. See Tharp, 15–16.
29 *"literally with open arms":* HRW Diaries, December 16, 1857.
29 *her "warm cordial manner":* HRW Diaries, December 19, 1857.
29 *"She has grown vey stout":* HRW Diaries, December 16, 1857.
29 *"sunny & beautiful":* HRW Diaries, December 16, 1857.
29 *"arrayed in white satin":* HRW Diaries, December 25, 1857.
30 *"Bella Stewart," Helen reported:* HRW Diaries, December 26, 1857.
30 *she had "greatly improved":* HRW Diaries, January 1, 1858.
30 *For Helen's birthday:* HRW Diaries, January 6, 1858.
30 *"Belle's mind was entirely engrossed":* HRW Diaries, December 28, 1857.
30 *the occasion in her diary:* HRW Diaries, January 11, 1858.
31 *on a more human scale:* See Orhan Pamuk, "Small Museums," *New York Times*, March 20, 2014. "Small museums can be like novels in their ability to make our hearts beat faster and with the emotional depth of a personal story."
31 *"If I ever have any money":* Quoted in Tharp, 16. The genealogy of this line is hard to trace because Tharp cites a 1923 letter by Ida Agassiz Higginson in her notes, but this sentence does not appear in that letter. If these are not Isabella's exact words, they capture the spirit of what Ida does write, a letter quoted more in full in Chapter 32.
32 *"Isabella Stewart from her father":* Henrietta Lee Palmer, *The Stratford Gallery; or The Shakespeare Sisterhood* (New York: D. Appleton and Company, 1859). First edition copy in ISG Personal Library, ISGM.

THREE: MR. AND MRS. JACK, 1859–61

33 *She first saw:* Julia Gardner to JLG Sr., October 1859, letter reprinted in Carter, 20. The original letters by Julia Gardner to her father have not been located. Tharp speculates in her notes that they were given to the Coolidges, Julia's husband's family.
33 *Often a single painting:* Laura Cumming compares Broadway and its numerous galleries in these years to London's Old Bond Street. *The Vanishing Velázquez*, 178–79.

33 *of "wayside flowers":* Mark Twain (Samuel Clemens) wrote his impressions of the painting to his brother; cited in Kevin J. Avery, *Church's Great Picture—The Heart of the Andes* (New York: The Metropolitan Museum of Art, 1993), 43.
33 *the "finest painting":* John K. Howat, foreword to Avery, *Church's Great Picture*, 5. Church would become a trustee of the New York Metropolitan Museum of Art, founded in 1870, as his reputation as a painter went into eclipse.
34 *"New Yorkers compare":* Belle copied out a series of quotes from Kemble's writing on an undated sheet of paper. ISG Papers, ISGM. *Extracts from Fanny Kemble's Journal* was originally published in 1863.
34 *the high, narrow brownstones:* Tharp gives a further description of the brownstone based on a photograph she saw at the New York Historical Society that I could not relocate. The house was "the width of only one room plus stair and hallway—with an iron balcony across the front parlor windows. Iron railings protected the areaway and kitchen windows were below the street level. Railings with brass ornaments flanked the high front steps. Within, Italian workmen, wearing little paper caps to keep the wet plaster out of their hair, molded the high ceilings at cornice and center with a riot of fruit and flowers." Tharp, 16.
34 *"I have been enjoying":* Julia Gardner to JLG Sr., February 14, 1859, reprinted in Carter, 16.
34 *"we jolly three":* HRW Diaries, January 22, 1857.
34 *undetected heart defect:* Helen died on July 25, 1858.
34 *a decade before:* Helen's mother, Anna Waterston, copied out a letter from Sophia Hawthorne, the novelist's wife, in a copybook, as if wanting to memorize its lessons. Hawthorne recalled their visit with the Waterstons in Rome the year before, remembering the crocus colors of Helen's white-and-purple dress the day they all went to the Galleria Borghese in Rome; HRW Copybook.
35 *the city's Athenaeum:* The Boston Athenaeum changed addresses several times from its founding in 1803 to 1849, when it moved to its current location at 10 1/2 Beacon St. There was a sculpture gallery on the first floor, a library on the second, and a painting gallery on the third.
35 *Jack gave her small sketches:* Jack sent Belle a series of sketches and short notes during this early period of their courtship. The sketches and notes are from the ISG Papers, ISGM.
36 *"Please accept, dear Belle":* JLG Jr. to ISG, February 22, 1859, ISG Papers, ISGM.
36 *"the most popular young American":* Letters and Journals of General Nicholas Longworth Anderson, 1854–1892, ed. Isabel Anderson (New York: Fleming H. Revell, 1942), 124.
36 *Jack was "handsome":* CPG to GAG, March 18, 1857, GFP.
37 *At five foot eight inches:* Jack's passport from 1883, when he was forty-five years old, lists this height; copy printed in *Journeys,* 100. Tharp is mistaken when she says he stood over six feet tall. Tharp, 18.
37 *several times in Helen's journals:* December 25, 1856; January 1 and February 22, 1857. HRW Diaries.
37 *the "usual sights":* JLG Jr. to GAG, May 2, 1858, GFP. For all the detail that Jack included in this letter, he made no specific mention of Belle.
37 *"If you want to ask":* Carter, 17. Carter goes on to note that Eliza Gardner "said afterward that she suspected [her brother's love for Belle] from a walk that Jack and Belle took out the new Beacon Street." Tharp elaborates on Eliza's intelligence of this

relationship, which enlivens her biographical storytelling, but she provides no further documentation beyond Carter's mention of Eliza. Tharp, 19–20.

38 *"To use your expression":* JLG Jr. to GAG, February 25, 1859, GFP.

38 *"happiest of human beings":* ISG to Julia Gardner, New York, February 28, 1859; letter reprinted in Carter, 17. The original of this letter has not been located.

38 *pepper from Sumatra: Memorial,* 143. Joseph Peabody's own son had been poised to take over the large family shipping empire, but he had died tragically young. See Walter Muir Whitehill, *Captain Joseph Peabody, East India Merchant of Salem (1757–1844): A Sketch of His Life* (Salem: Peabody Museum, 1962), 39–40; see also *ISGAL,* 27.

38 *to what she saw:* Catharine Peabody Gardner diaries, Gardner Papers, Mss 899, Baker Library, Harvard University.

38 *things for their houses: Memorial,* 151–54.

38 *her "vivifying influence":* ISG Autograph Album, 1856–61, ISG Papers, ISGM.

39 *"My dear Mr. Gardner":* ISG to JLG Sr., March 1, 1859, GFP.

39 *"to buy the best":* Maud Howe Elliott, *Three Generations* (Boston: Little, Brown, and Company, 1923), 379.

39 *a keen observer of people:* Alexander Agassiz to ISG, London, December 2, 1899, ISGM. Alexander was the brother of Ida Agassiz Higginson.

40 *woman's nude torso:* JLG Jr., sketch of nude woman tucked into the textbook *The Works of Horace;* copy in ISG Personal Library, ISGM.

40 *being "dignified, affable":* Brookline Chronicle obituary of John L. Gardner Sr., July 26, 1884, quoted in *Memorial,* 154.

40 *a "tower of strength":* Charles Perkins to ISG, December 16, 1898, ISG Papers, ISGM.

40 *Julia reported to her father:* Julia Gardner sent her mother and father three letters about this visit dated October 8 to October 17, 1859, reprinted in Carter, 18–21.

40 *through Green-Wood Cemetery:* The Stewart family mausoleum is in Green-Wood Cemetery, where Belle's parents and three siblings are buried.

41 *"In this city": New York Times,* April 12, 1860.

41 *"a very blushing bride":* MC Papers.

41 *a wedding gift: Memorial,* 202.

41 *Peabody grandfather's trade:* There is no evidence that the Gardners ever owned or traded in enslaved people, though of course importing sugar and molasses from the Caribbean involved trading with businesses that did. See *ISGAL* 27–28. For more on Gardner business and real estate, see also *Memorial,* 148–54.

42 *On September 10:* Records show the following: "Still born son, Sept. 10, 1860, exactly five months after her wedding to Jack earlier that April (10th)." The unnamed boy was reburied with little Jackie when the Gardner crypt was erected in 1859. The location of the first burial is unknown. I am indebted to curator Meg L. Winslow for sharing her research on the Gardner family history; Mount Auburn Cemetery Historical Collections & Archives, Cambridge, Massachusetts.

42 *"Her ways were different":* Carter, 23.

42 *the many sewing circles:* Tharp, 29; see also Jean Strouse, *Alice James: A Biography* (New York: New York Review of Books, 2011; first published in 1980), 133–35.

42 *murmur of negative gossip:* Jack's youngest sister, Eliza Gardner, and ISG were not close, as per a conversation with descendants, perhaps because Eliza felt competitive in some way with her sister-in-law.

43 *wealth and privilege:* According to John Jay Chapman, himself a New Yorker and later friend of Isabella's, upper-crust Boston had always been a kind of "aristocracy. Its

chief rulers were parsons in the eighteenth-century and business men in the nineteenth." Chapman, *Memories and Milestones* (New York: Moffat, Yard and Company, 1915), 244.
43 *"What do you know":* John Gardner Coolidge, undated comment, Subject Files, ISGM.
44 *"everything is respectable":* HA to Charles Milnes Gaskell, June 14, 1876, *HA Letters*, vol. 2, 275.
44 *would she ever admit it?:* Tharp quotes Isabella (without documentation) later remarking: "If I am not happy, do you think I would tell you!" Tharp, 26.
44 *found Boston impossibly dull:* Morris Carter made this note about Isabella and Boston: "Found Boston dull and made frequent long visits to N.Y. and stayed with parents." MC Papers.
44 *stay with Belle's family:* David Stewart gave his son-in-law a gracefully bound republication of *The Book of Common Prayer,* simply inscribed: "D Stewart, Decr. 25th 1861." Jack added his own signature and the date. ISG Personal Library, ISGM.
44 *Goupil and Company:* Goupil, along with Samuel Avery, Michael Knoedler, and George A. Lucas, were the principal New York art dealers of the time. See "Creating Cultural and Commercial Value in Late Nineteenth-Century New York Art Catalogues," in *Art Crossing Borders: The Internationalisation of the Art Market in the Age of Nation States, 1750–1914,* eds. Jan Dirk Baetens and Dries Lyna (Leiden: Brill, 2019).
44 *He carefully listed:* JLG Jr., Purchase lists, Dealer Files, ISGM.
45 *Jack's gift to Belle:* These Antoinette prints were not included in the museum collection and were likely later owned by descendants. While there are Goupil receipts for the two prints described in the chapter, there is no description of the first one. Both Jack and an inventory for Isabella's fourth-floor apartment at Fenway Court list a print of *Gluck A' Trianon.* There may have been three Antoinette images. There is a photocopy of a third print in the archives subject files, which shows Antoinette sitting on a bench in front of her chateau on the grounds of Versailles, holding a sleeping child on her lap. The rotund king, at last a father, stands behind his consort, observing the domestic scene with a bemused expression, as if to say "All will be well."
45 *"a devoted husband":* JLG Sr. to GAG, January 24, 1871, GFP.

FOUR: "REMAINING DEAR ONES," 1862–65

46 *evade the authorities:* Carol Bundy, *The Nature of Sacrifice: The Biography of Charles Russell Lowell Jr., 1835–1864* (New York: Farrar, Straus, and Giroux, 2005), 67–68, 85–86. See also Thomas H. O'Connor, *Civil War Boston: Home Front and Battlefield* (Boston: Northeastern University Press, 1997).
48 *"I was too young":* Carter, 16.
48 *woke very early:* ISG to Lilian Aldrich, February 6, n.d., Thomas Bailey Aldrich Papers (MS Am 1429), Houghton.
48 *filled a small notebook:* JLG Jr., 1860/1861 Notebook, JLGJr-P.
48 *"A woman's environment":* As quoted in Hermione Lee, *Edith Wharton* (New York: Vintage Books, 2008), 135.
48 *her pursuit of music:* For a comprehensive assessment of ISG and music, see Ralph P. Locke's two essays, "Living with Music: Isabella Stewart Gardner" and "Playing for Mrs. Gardner Alone: The Violinist Harrison Keller Reminisces," in *Cultivating Music in America: Women Patrons and Activists since 1860,* ed. Ralph P. Locke and Cyrilla Barr (Berkeley: University of California Press, 1997), 90–123.
49 *The Episcopal congregation:* For an overview of Emmanuel Church as well as a listing of pew owners, see Mary Chitty, "Emmanuel Church Boston Parishioners and

Pew Deeds," unpublished resource, Parish Archives, Emmanuel Church in the city of Boston. For more on Frederic Dan Huntington, see Douglas C. Stange, "The Conversion of Frederic Dan Huntington (1859): A Failure of Liberalism?" *Historical Magazine of the Protestant Episcopal Church* 37, no. 3 (1968): 287–98.

49 *antislavery stance:* Susan Swan, *Emmanuel News* 5, no. 6, February 1999; for the congregation's connection with the Stowe family, see also Joan D. Hedrick, *Harriet Beecher Stowe: A Life* (New York: Oxford University Press, 1994), 302–3.

49 *Everyone called him Jackie:* John Lowell Gardner II was George Augustus Gardner's son Johnny, who was born after Jackie, in 1867. The family must have agreed that Johnny take the II designation after Jackie's death in 1865. Jack was known as John Lowell Gardner Jr. See *Memorial,* 198 and 211; also, *Lowell Genealogy* lists Jackie as JLG, 3rd, 86.

50 *the shape of a ship's keel:* Gerald W. R. Ward, *Cabinetmaker and the Carver* (Boston: Massachusetts Historical Society, 2013), 38.

50 *"in such a kind":* JLG Jr. to GAG, November 14, 1865, GFP.

50 *To consecrate her sense:* Carter, 25; Belle is listed in the Emmanuel Church Register, Emmanuel Church, Boston, Archives.

51 *"siege with the baby":* JSG to CPG, November 4, 1864, as reprinted in Carter, 27.

51 *"Aunty Belle is very well":* JLG Jr. to George Peabody Gardner, Boston, December 6, 1864, GFP.

52 *began with pouring rain:* Elizabeth Cabot Putnam Lowell to Augustus Lowell (son), March 12, 1865. "Our two weeks rain has cleared off with a cold bitter wind with a bright sun." Lowell Family Papers, MS Am3166, Houghton.

52 *fever, then pneumonia:* Jackie's death certificate lists lung fever and pleurisy, but family memories mention pneumonia, a more likely cause. ISG Papers, ISGM.

52 *"The time for a change":* CPG to GAG, March 5, 1865, GFP.

52 *"Half cloudy":* Anna Cabot Lowell diaries, 1818–94, Ms. N-1512, MHS.

52 *She insisted on washing:* Tharp, 36.

52 *"Gardner—In Boston":* Obituary for John Lowell Gardner III, *New York Times,* March 19, 1865.

52 *"I felt very sorry":* Lucia Gray Swett Alexander to CPG, Villa Brichieri Bello Sguardo, Florence, received in Paris on April 25, 1865, ISG Papers, ISGM.

53 *to be near his wife:* JPG Sr. to GAG, November 21, 1865, GFP. "As Belle is not very well he has not returned to the office. Poor girl! She is having her ups and downs just now, and so is Harriet. I wrote you some lines since that we had been blessed with another boy. Harriet's convalescence made [such?] progress, but on Sunday she was seized with an acute attack of disease . . . and she is now suffering. The boy is a fine child."

53 *"the three C's":* CPG to GAG, December 23, 1863, GFP.

53 *"your terrible bereavement":* JLG Jr. to GAG and Eliza Gardner, November 10, 1865, GFP.

54 *"Words cannot convey":* JPG to GAG and Eliza Gardner, November 10, 1865, GFP.

54 *"I write in the first moments":* JLG Sr. to GAG, November 10, 1865, GFP.

54 *A generation before: Memorial,* 155.

54 *"Belle and I can understand":* JLG Jr. to GAG, November 15, 1865, GFP. George wrote from Switzerland five days later to his cousin, Augustus Lowell, of the burial arrangements for Caty and Sammy: They had made "several excursions to Lausanne in order to arrange about the fence, etc., for our lot in the cemetery. The cemetery is beautifully situated at the top of a high hill, and commands a view of the lake and all the neighboring mountains. We could not have chosen a lovelier spot in which to leave our

darlings." GAG to Augustus Lowell, November 20, 1865, Lowell Family Papers, MS Am 3166, Houghton.

55 *"Belle did everything":* Elizabeth Cabot Putnam Lowell to Augustus Lowell, December 10, 1865, typescript. Lowell Family Papers, MS Am 3166, Houghton. This letter is worth quoting at length. From this source we know that Belle was pregnant again after Jackie's death. It also gives powerful details for how she related with the Gardner family.

> I am always an anxious person, and cholera has been so fatal to poor Eliza Gardner [GAG's wife] that I fully sympathized with her mother [Mrs. Peabody] in her solicitude for her children and remaining grandchildre.... When ... I returned from our visit to Mrs. Peabody, the first thing we heard was the death of Harriet Gardner [Jack's older brother Joe's wife, at thirty years]. Mrs. Gardner [Belle's mother-in-law] tells me that her sons are entirely submissive (Joe, George A., and Jack), that they show a truly Christian obedience to the will of their heavenly Father, and remember in their great affliction their long and happy life, overflowing as they say they have been with every blessing. Mrs. Gardner's anxiety has not ceased until within three days, for Belle, Jack's wife. She had been very delicate since the death of her child [Jackie, in March 1865] and was to be confined again some 4 or 5 months hence. But when Harriet Gardner so suddenly passed away, the servants sent to Jack Gardner, and being near, they were there before Joseph, and Belle did everything for Harriet that she had insisted upon doing for her own child. She [Belle] was constantly with Joe, the excitement and shock kept her up until after the funeral, when she was taken ill and remained so for four days before she got through—causing great anxiety—Joseph seemed to forget himself in his solicitude and watched with John [Jack], who never left his wife. Now she is getting on though weak.

55 *"extravagantly fond":* Tharp, 37. This second letter, presumably also by Elizabeth Cabot Putnam Lowell to her son, Augustus Lowell, has not been located at Houghton Library or in any other archive.

55 *no more children:* It is wrong to imagine that because deaths of babies and toddlers numbered a quarter of all deaths in the nineteenth century, parents were less attached to their children. Pat Jalland challenges this notion, expressed by Lawrence Stone: "parents in earlier centuries limited their emotional investment in young children because of high infant mortality." Jalland, citing Linda Pollock, argues that "relations between parents and children have changed remarkably little through the centuries." She goes on to argue that "parents did not feel that several remaining children would compensate for the loss of any one, however alarming the child mortality statistics." "Like us," she writes, "most Victorians believed that the death of a child was the most distressing and incapacitating of all. What consolation could any parent find on the death of a beloved child—then or now?" Consolation literature, according to Jalland, "offered a further rationalization to bereaved parents with the argument that a benevolent God had removed their children from an unhappy world of pain, sin, temptation, and doubt." The child in death was finally safe from the sorrow of this world. This was the view the Gardner family members expressed in a number of ways in their 1865 consolation letters. Pat Jalland, *Death in the Victorian Family* (London: Oxford University Press, 1996), 119, 121–23.

55 *the display cases:* Isabella included in Fenway Court's galleries large display cases, eventually fifteen in all, most in the Blue and Yellow Rooms and in the Long Gallery on the third floor. In each, she arranged correspondence, photographs, sketches, manuscripts,

and other memorabilia to convey the fullness and complexity of her social world. She was her own archivist, but these cases had glass tops—she wanted visitors to see these materials and their close relation to the artwork in the galleries. As Casey Riley points out, "assemblages within the cases furnish evidence of Gardner's soaring ambitions for her public memory." Casey Riley, "To Make a Case: Isabella Stewart Gardner's Archival Installations at Fenway Court," in *Boston's Apollo: Thomas McKeller and John Singer Sargent*, ed. Nathaniel Silver (Boston: ISGM; distributed by Yale University Press, 2020), 157.

56 *Mrs. Putnam had buried":* For more on Mary Lowell Putnam, see Bundy, *The Nature of Sacrifice*, 196–97.

56 *"I must write to you":* Mary Lowell Putnam to ISG, Thursday morning, undated, ISG Papers, ISGM. Though the letter is undated, it seems clear it was written close to the time of Jackie's death. Putnam's reference to not knowing of Belle's grief also hints that she may be referring to the miscarriage reported by Elizabeth Cabot Putnam Lowell to her son, Augustus, in the December 10 letter cited above. Elizabeth Cabot Putnam Lowell was a close cousin of Mary Lowell Putnam, so they would have had occasion to talk.

56 *"ruin of private happiness":* Virginia Woolf, *Roger Fry* (London: Vintage, 2003; originally published in 1940), 104.

FIVE: A RETURN, 1866–67

59 *Jackie's goose-necked cradle:* Ward, *Cabinetmaker and the Carver*, 38.

59 *as "keeping house":* U.S. Census Bureau, Boston, 1870.

59 *"an incubator":* Erica E. Hirshler, introduction to *At Home on Beacon Hill: Rose Standish and Her Family,* by B. June Hutchinson (Boston: Board of Governors, Nichols House Museum, 2011), xv.

60 *a commonplace book:* ISG, 1866 Commonplace Book, ISG Papers, ISGM.

60 *"sympathies were freely given":* 1866 Commonplace Book, ISG Papers, ISGM.

60 *"sofa invalids":* MC Papers.

60 *getting horribly seasick:* Carter, 49–50. The way Carter describes this, in his notes for his biography, is a little different: "Mrs. Gardner, poor traveler, would shut herself up all alone in compartment with blinds all drawn, and neither see nor speak to anyone. Could not endure dirt or noise or light of travel. Mr. Johns and Mr. Gardner would sit in next compartment and smoke. Crossing the ocean, she immediately went to her cabin, took down her hair, braided it in one small pig-tail, twisted it up on her head, got into her berth and stayed there, and lived on champagne all the way over." MC Papers.

61 *fifty-four pages:* Travel Album: Germany, Denmark, Norway, Sweden, Russia, Poland, the Western United States, Florida, Mexico, and Cuba, 1867–86. Hereafter, Travel Album, 1867–86. Isabella used the first thirteen pages of this album for travel to Europe and Russia in 1867. She repurposed this volume twice more: in 1881 for travel to the western United States and a brief trip to Cuba in 1886.

61 *of masterpiece paintings:* For a discussion of these albums as "self-assembled archives" and their key role, see Casey Riley's definitive "Self-Assembled: Isabella Stewart Gardner's Photographic Albums and the Development of Her Museum, 1902–1924," in *Photographs, Museum, Collections: Between Art and Information*, ed. Elizabeth Edwards and Christopher Morton (London: Bloomsbury Academic, 2015), 47–63. Christine M. E. Guth notes that "the creative practices Gardner employed at Fenway Court were prefigured in small scale in the albums that she assembled as souvenirs of her travels . . . All involved the construction of imaginative narratives using metaphors

of movement and place as well as juxtapositions and layering of contrasting forms, patterns, and textures." Guth, "Asia by Design: Women & the Collecting & Display of Oriental Art," in *Journeys*, 60. See also Diana Seave Greenwald and Casey Riley, eds., *Fellow Wanderer: Isabella Stewart Gardner's Travel Albums* (Princeton, NJ: Princeton University Press, 2022), esp. 19–33.

61 *"We saw a swan":* Travel Album, 1867–86.
61 *"all is barrenness":* Robert Bowden, ed. and rev., *Black's Guide to Norway* (Edinburgh: Adam and Charles Black, 1867). Jack had also purchased a copy of John Murray's *The Knapsack Guide to Norway,* ISG Personal Library, ISGM.
61 *reins of the white horse:* It is not clear from documentation whether the servant was the one they hired or was connected with the horse and carriage. JLG Jr. and ISG in Norway, June 1867, albumen print, ISGM.
62 *Nizhniy Novgorod:* Belle spelled the name of the city, later known as Gorky, after the Russian writer who born there in 1868, "Nijni Novgorod."
62 *If he'd been stoic:* Something of his stoic posture can be found in a later letter written to his brother George on the occasion of the death of William Endicott, George and Eliza's two-year-old son, who died in 1870: "It has pleased God to take him away and you must submit." JLG Jr. to GAG, Beverly, June 29, 1870, GFP.
62 *Jack's brother Joe: Memorial,* 188.
63 *"homelier than ever":* Nicholas Longworth Anderson, July 14, 1868, in *The Letters and Journals of General Nicholas Longworth Anderson: Harvard, Civil War, Washington, 1854–1892,* ed. Isabel Anderson (New York: F. H. Revell, 1942), 195.

SIX: "MRS. GARDNER'S ALBUM," 1868–73

64 *These included:* Carter, 52. JLG Jr., Purchase lists, Dealer Files, ISGM.
64 *making a profit: Memorial,* 148–57; see also *ISGAL,* 27–28.
65 *"If you had started":* MC Papers.
65 *unearned luck:* MC Papers.
65 *"a hard worker":* JLG Sr. to GAG, January 24, 1871, GFP.
65 *The "whole weight":* JLG Sr. to GAG, June 13, 1871, GFP.
65 *Jack traveled outside:* JLG Jr., List of Trips 1851–83, JLGJr-P.
65 *disagreements between members:* Jack was a member of the following clubs: "Somerset, Algonquin, Tavern, Boston Art Club, the (Brookline) Country Club, and the Boston Athletic Association." *Memorial,* 201; see also Tharp, 18.
65 *"John is busy":* CPG to GAG, March 14, 1870; and JLG Sr. to GAG, December 6, 1870, GFP.
65 *"is very pleasant":* JLG Sr. to GAG, December 6, 1870, Boston, GFP.
65 *did crochet work:* One of Belle's efforts is in the museum's third-floor chapel: a linen table covering with a crocheted edge that spells out her first name.
66 *She spent time:* Unfortunately, no letters she wrote and very few she received were preserved from this time period.
66 *played her piano:* Belle had piano lessons in Italy as a teenager. Jack listed a piano in his notebook on the furnishings at 152 Beacon Street. It seems reasonable to assume she played the piano from time to time. JLG Jr., "Notebook on Furnishing 152 Beacon Street," JLGJr-P.
66 *Belle had kept:* The music historian Ralph P. Locke identified some of these untitled scores as typical for eighteenth-century music for domestic performances, noting that the copyist left off the composers and the song titles. Email with author, December 2, 2020.

66 *play backgammon:* Carter, 24.
66 *boulevard in Paris:* For descriptions of the city during this time, see Jane Holtz Kay, *Lost Boston* (Amherst: University of Masschusetts Press, 2006), 179.
66 *"enjoy the great beauty":* CPG to GAG, June 14, 1872, GFP.
66 *Newport, one summer:* CPG to GAG, July 2, 1872, GFP.
66 *Belle wrote satiric:* Emily Thornwell, *Lady's Guide to Perfect Gentility* (New York: Derby and Jackson, 1856). Copy in ISG Personal Library, ISGM.
67 *"no invitation to enter":* Gladys Brooks, *Boston and Return* (New York: Atheneum, 1962), 140.
67 *were fancy balls:* For more on the popularity of these balls, see Kate Strasdin, *The Dress Diary: Secrets from a Victorian Woman's Wardrobe* (New York and London: Pegasus Books, 2023), 207–13.
67 *also called assemblies:* Cleveland Amory, *The Proper Bostonians* (New York: E. P. Dutton and Company, 1947), 262–68.
67 *buildings in Paris:* "Horticultural Hall, Boston," *Harper's Weekly* 40, no. 537 (April 13, 1867): 225–26.
67 *the current fashions:* Carter noted that at assemblies, Belle "regularly danced cotillion with Richard Fay, Theodore Chase, or Hollis Hunnewell. Society was small then and parties were great fun." MC Papers.
68 *When she met:* Carter, 30.
68 *"very fine" pearls:* Purchase receipt, Dealer Files, ISGM.
68 *Women pictured:* Adelia Stewart, Album: Photographs of Royalties, 1870, ISGM. Susan Hiner, citing Charles Baudelaire and Walter Benjamin, argues for the "dialectical nature of fashion both to convey a fixed social meaning and to change and reinvent itself to survive: it is the agent of both hierarchy and subversion." Hiner, *Accessories to Modernity: Fashion and the Feminine in Nineteenth-Century France* (Philadelphia: University of Pennsylvania Press, 2010), 16.
69 *"young men watched":* Carter, 30.
69 *"Accept my respectful":* Unnamed source quoted in Carter, 30.
69 *was "most favored":* Maud Howe Elliott, *Three Generations* (Boston: Little, Brown, and Company, 1923), 378.
69 *"who undressed you?":* Tharp, 43.
69 *"No wonder so many":* Carter, 30. Dr. Bigelow was the father of William Sturgis Bigelow.
69 *reported in her diary:* Anne Bentley alerted me to this online source. Scott C. Steward, "Pomps and Vanities," *Vita Brevis* (https://vitabrevis.americanancestors.org/2015/02/pomps-and-vanities/) February 18, 2015.
69 *"Belle goes to New York":* CPG to GAG, March 14, 1870, GFP.
69 *like Boston's, "hieroglyphic":* Edith Wharton, *The Age of Innocence*, ed. Laura Dluzynski Quinn (New York: Penguin Group, 1996; originally published 1920), 36.
69 *the "sifted few":* Oliver Wendell Holmes, "A Rhymed Lesson," in *The Poetical Works of Oliver Wendell Holmes*, vol. 1 (Boston: Houghton, Mifflin, 1891), 125.
70 *more "in grooves":* Edward L. Pierce, *Memoir and Letters of Charles Sumner*, vol. 3 (London: Low, Marston and Company, 1893), 5.
70 *"fossilized conventions":* Unnamed newspaper, quoted in Carter, 90.
70 *"virtues and vices":* Paul Goodman, "Ethics and Enterprise: The Values of the Boston Elite, 1800–1860," *American Quarterly* 18 (1961): 441.
70 *"slight mental cramp":* John Jay Chapman, *Memories and Milestones,* 240. Clara K. Rogers, a musician several years younger than Belle but acquainted with Beacon Hill's

intolerance for stepping outside its social norms, drolly noted "Boston's shy appreciation of genius." *Memories of a Musical Career* (Boston: privately printed, 1932), 416.

70 *"don't get intimate"*: ISG to MHE, October 19, 1883, ISG Papers, ISGM. The museum holds these letters as typed transcriptions by Morris Carter, 1924; the location of the originals is unknown.

70 *the commonplace book:* The quotations that follow are the commonplace book's early pages, except for the quote by Ruskin. Belle seems to have kept this book at hand for years; friends she would not meet until the 1880s appear in its later pages. ISG, 1868 Commonplace Book, ISGM. I am grateful to Lisa Feldmann for pointing me to this key source for Belle's early life.

71 *"in the way of gaiety"*: CPG to GAG, January 2 and February 19, 1871, GFP.

71 *"Bombardment of Paris"*: *New York Times,* January 8, 17, and 19, 1871.

71 *educated in France:* For this connection between Boston and Paris, see especially David McCullough, *A Greater Journey: Americans in Paris* (New York: Simon & Schuster, 2011), 107–36.

71 *"May our nation"*: William Lloyd Garrison, "Aid for the Suffering of France," *Boston Advertiser,* January 20, 1871. Newspaper clippings about the charity efforts and the fair in particular were collected by the fair's secretary, Frederic H. Viaux. Viaux Family Papers, 1870–1958, Ms. N-1704, Box 1, MHS. Jack and Belle donated $100, while George gave $300 and their father another $2,500.

72 *In the months leading:* Viaux kept meticulous notes. The executive committee held its first meeting on December 5, 1870, at the French consulate and met weekly through the holiday season. Committee members included Martin Brimmer, Thomas Cushing, Leverett Saltonstall, T. Jefferson Coolidge, John Amory Lowell, George A. Gardner, John L. Gardner Jr., Joseph P. Gardner, and Horatio G. Curtis. Committee members for the art gallery were Mrs. Charles C. Perkins, William H. Hunt, Edward Perkins, Henry Sayles, William Whitmore, and Henry P. Kidder. The Ladies Committee, headed by Abby S. May, was formed on January 2. Belle does not appear on any of these lists but, as with many such charitable activities, men outnumber women as committee members while their unlisted wives did much of the work. That most likely was the case here. Viaux Family Papers, 1870–1958, Ms. N-1704, Box 1, MHS.

72 *an exhibition gallery: Exhibition of Paintings for the Benefit of the French.* Boston: printed by Rand, Avery, and Frye, 1871. Box L 1871, MHS.

73 *bound as a keepsake:* ISG Papers, ISGM.

73 *"help the sufferers"*: Louis Agassiz, "What Is the Object of Our Fair?" *Balloon Post* (Boston), April 11, 1871.

73 *"Mrs. Gardner's Album"*: Susan Hale, *Balloon Post* (Boston), April 15, 1871.

73 *include at Fenway Court:* JLG Jr., Purchase lists, Dealer Files, ISGM.

SEVEN: "ZODIACAL LIGHT," 1874–75

74 *"a faithful friend"*: David Stewart Jr. graduated from Columbia College (now part of Columbia University) with a degree in the arts; he was a member of the Peithologian Society, a debate and literary club. *Catalogue of Officers and Graduates of Columbia University,* 15th ed. (New York: printed for the University, 1912), 134. An obituary in an unidentified newspaper reprints a special resolution by his Columbia class, which reads in full: "Whereas, our beloved classmate, David Stewart, Jr., has been relieved by death from the sufferings of a painful illness, which he bore with Christian fortitude. Resolved, that we deplore the departure of a faithful friend, a finished gentleman and

Christian man, and that we sympathize deeply with his family for the loss of one whose character and disposition have ever endeared him to all who knew him." Clipping in Subject Files, ISGM.

74 *James as "half-witted":* Harold Jefferson Coolidge to MC, December 20, 1923. Coolidge references a line in one of his mother's letters, which says: "Mrs. Gardner's brother, who was half-witted." He asks: "Why not leave out the last three words, which are rather painful, and don't add anything to the story." MC Papers.

74 *an old bearded man:* ISG, Autograph Album, 1856–61, ISG Papers, ISGM.

75 *She also kept: The Poetical Works of John Keats,* ed. William Michael Rossetti (London: E. Moxon, Son, and Company, n.d.). The book is inscribed: "Belle with a 'Happy New Year' from David Jany 1st 1873." ISG Personal Library, ISGM.

75 *"Many people [came]":* November 7, 1874, JLG Jr., Travel Diary, 1874, JLGJr-P.

75 *boat trip on the Nile:* For a vivid overview of travel on the Nile, see Toby Wilkinson, *The Nile: A Journey Downriver Through Egypt's Past and Present* (New York: Alfred A. Knopf, 2014), esp. 3–25; 234–61.

75 *"When I went on deck":* December 10, 1874, as cited in *Inventing,* 66.

76 *and paraffin candles:* Murray's *Handbook for Travellers in Egypt,* 4th ed. (London: John Murray, 1873), xix–xx.

76 *bought recently translated: The Iliad of Homer,* translated by Theodore Alois Buckley (London: Bell and Daldy, 1873); and *The Odyssey of Homer,* translated by Theodore Alois Buckley (London: Bell and Daldy, 1872). Belle inscribed each volume of Homer's epics with "I. S. Gardner, The Nile/75," and kept both in her personal library.

76 *She took along:* Belle mentioned that she read Buckle's monumental history "one winter on the Nile" to Edmund Hill in November 29, 1915. ISG Papers, ISGM.

77 *"With a few touches":* December 18, 1874, as quoted in *Inventing,* 69.

77 *she found the scene:* December 10, 1874, as quoted in *Inventing,* 66. Belle kept two diaries on this trip and also a travel album with one large photograph per page, all of which I use to tell the story. *Inventing Asia: American Perspectives Around 1900* reprints passages from these diaries. Otherwise, all other quotations by Belle are taken from the following primary sources: Travel Diary: Egypt, vol. 1, 1874–75 (abbreviated as Diary 1); Travel Diary: Egypt, the Holy Land, and Europe, vol. 2, 1875 (abbreviated as Diary 2); Travel Album: Egypt, the Holy Land, Greece, and Turkey, 1874–75.

77 *travelers on the Nile:* Lawrence M. Berman, "Aboard the *Ibis:* The Gardners' Nile Voyage, 1874–1875," in *Inventing,* 67.

77 *"The harvest scenes":* ISG, March 16–19, 1875, Diary 1.

77 *teenager Teddy Roosevelt:* Edmund Morris, *The Rise of Teddy Roosevelt* (New York: Coward, McCann, and Geoghegan, 1979), 36–37.

77 *That same year:* Robert D. Richardson, *Emerson: The Mind on Fire* (Berkeley: University of California Press, 1995), 569.

78 *"great blow little go":* ISG, March 28, 1875, Diary 1.

78 *"its hostility to locusts":* Thomas Gold Appleton, *A Nile Journal* (Boston: Roberts Brothers, 1876), 33. Another published account from that same season became the definitive book on the journey: *A Thousand Miles up the Nile,* by the British traveler and Egyptologist Amelia Edwards.

78 *folded her wings:* ISG, December 24, 1874, Diary 1.

78 *Jack tried to learn:* Belle put one of his photos in the back pages of her Egypt diary; it may be a photo of their boat *Ibis.*

78 *"No wind, we went":* ISG, December 22, 1874, Diary 1.

- 78 *"As I lay upon":* ISG, December 24, 1874, Diary 1.
- 78 *a purchased photograph:* See Douglas R. Nickel, *Francis Frith in Egypt and Palestine: A Victorian Photographer Abroad* (Princeton, NJ: Princeton University Press, 2004); see also discussion of Isabella's albums "as travel documentaries" in Greenwald and Riley, *Fellow Wanderer,* 23.
- 78 *"The temple now consists":* ISG, January 20 and 21, 1875, Diary 1.
- 79 *"when I got away":* ISG, December 16, 1874, Diary 1. They later lunched "with 40 centuries looking down upon us," Belle wrote, quoting what Napoleon had said about the Sphinx.
- 80 *women "rarely handsome":* ISG, December 16, 1874, Diary 1.
- 80 *she'd "never seen":* ISG, December 18, 1874, Diary 1.
- 80 *watching "graceful women":* ISG, December 21, 1874, Diary 1.
- 80 *they were "so vain":* ISG, December 27, 1874, Diary 1.
- 80 *crewmen "trotted by":* ISG, December 28, 1874, Diary 1.
- 81 *"I have never had":* ISG, January 16, 1875, Diary 1.
- 81 *"It was a most exciting":* ISG, February 11, 1875, Diary 1.
- 81 *"It was really sad":* ISG, February 22, 1875, Diary 1.
- 82 *"there was nobody":* ISG, February 23, 1875, Diary 1.
- 82 *to say "goodbye":* February 25, 1875, Diary 1.
- 82 *to "glorious Karnak":* ISG, March 15, 1875, Diary 1.
- 82 *"looming" in the distance:* As quoted in *Inventing,* 82.
- 83 *"a tremendously energetic":* GAG to GPG, July 8, 1886, GFP.
- 83 *"struck with the difference":* ISG, April 10, 1875, Diary 2.
- 83 *"Impossible to describe":* ISG, May 2, 1875, Diary 2.
- 83 *"The most delicious bath":* ISG, May 9, 1875, Diary 2.
- 84 *"not feeling very well":* ISG, June 6, 1875, Diary 2.
- 84 *"Glorious to be there":* ISG, June 24, 1875, Diary 2
- 84 *"Wretchedly—so to bed":* ISG, July 9 and 10, 1875, Diary 2.
- 84 *"two terrible telegrams":* ISG, July 16, 1875, Diary 2.
- 85 *Joe had sat down:* HA to Sir Robert Cunliffe, August 31, 1875, *HA Letters,* vol. 2, 233; see also note 9, 236.
- 85 *an "accidental shooting":* Parish Register, Emmanuel Church, Boston. Thanks to Mary Richardson for making this resource available.
- 85 *the first objects:* Carter, 46–47.
- 85 *Years later, Belle placed:* She kept her desk, with its drawer of objects, in the first-floor Macknight Room, which also functioned as her office. This is where she kept the two bottles of Egyptian sand.
- 86 *always, always remember:* It may be that Morris Carter added the sand to these bottles.

EIGHT: "MILLIONAIRE BOHÉMIENNE," 1876–80

- 87 *"tow-haired gentlemen":* Howe, *Three Generations,* 378.
- 88 *eventual inheritance:* John Lowell Gardner Sr. did not own land on the North Shore. The purchasing of property there started with Joseph Gardner.
- 88 *low sonorous voice:* There is conflicting testimony about the sound of her voice, whether low or high, but all agree that it captivated listeners and was one of her more notable and attractive attributes. Tharp, in her endnotes, tells a story of a visitor who, upon hearing Belle speak in the next room, expected to meet a young girl, because of the high pitch of her voice. Tharp, 332.

88 *were "so enthusiastic":* Amory Gardner to MC, October 7, 1925, MC Papers.
89 *"devotion and rigor":* John Jay Chapman, quoted in Tharp, 59.
89 *"symptoms of scare":* Amory Gardner to MC, October 7, 1925, MC Papers.
89 *"Act to the best":* JLG Jr. to GPG, September 27, 1886, Venice, GFP.
89 *traditional Catholic practices:* For a history of the congregation, see *The Parish of the Advent in the City of Boston: A History of One Hundred Years* (Boston: Parish of the Advent, 1944).
89 *meals and religious instruction:* Eldridge Pendleton, *Press On, The Kingdom: The Life of Charles Chapman Grafton* (Cambridge, MA: Society of Saint John the Evangelist, 2014), 41–42.
89 *"was never intended":* As quoted in Pendleton, *Press On,* 41; see also letter from George Shattuck to Richard Benson, April 14, 1881, SSJE.
89 *near Oxford, England:* Grafton's family was from Salem, Massachusetts, and had ties via the sea trade and marriage with the Gardner family since the seventeenth century. Jack's sister-in-law, Harriet Amory Gardner, was a cousin of Grafton. Pendleton, *Press On,* 42. See also, Douglass Shand-Tucci, *The Art of Scandal: The Life and Times of Isabella Stewart Gardner* (New York: Harper Perennial, 1998), 31–32. For tensions within American Anglo-Catholicism, see Jackson Lears, *No Place of Grace: Antimodernism and the Transformation of American Culture, 1880–1920* (New York: Pantheon Books, 1981), 198–200.
90 *"teaching her to pray":* Pendleton, *Press On,* 43. See also Richard Lingner, "Isabella Stewart Gardner's Spiritual Life," in *The Art of the Cross: Medieval and Renaissance Piety in the Isabella Stewart Gardner Museum,* edited by Alan Chong and Giovanni De Appolonia (Boston: ISGM, 2001), 29–39.
90 *"Our faith might cause":* ISG, undated note, ISG Papers, ISGM.
90 *"Mrs. Jack Gardner":* The clipping was cut out of a newspaper that remains unidentified; it was not the *Boston Globe* or the *New York Times.* She saved the clipping, and all that were to follow. These eventually migrated into Morris Carter's papers, which he kept in preparation for his biography. Newspaper Clipping File, ISGM.
90 *With little fanfare:* Belle paid $100 at Doll and Richards for the Whitman pastel and $505 for the La Farge at an auction at nearby Leonard and Company. JLG Jr., Purchase lists, Dealer Files, ISGM.
91 *"tastes of the day":* The city's collectors, as represented at the 1871 Paris Fair, for instance, had bought from the Barbizon School. See also Erica E. Hirshler, *Impressionism Abroad: Boston and French Painting* (London: Royal Academy of Arts, 2005).
91 *Doll and Richards:* Doll and Richards had started out by selling art supplies, looking glasses, and picture frames. By 1867, the establishment had changed its emphasis to the sale of oil paintings. In 1871, it moved to 145 Tremont, and its name became Doll and Richards. By 1878, the establishment had taken over the Warren Building at 2 Park Street, around the corner from the Athenaeum. See Beth A. Treadway, "The Doll & Richards Gallery," *Archives of American Art Journal* 15, no. 1 (1975): 12–14.
91 *only the Boston Athenaeum:* Megan Marshall describes the art scene in antebellum Boston in *The Peabody Sisters: Three Sisters Who Ignited American Romanticism* (Boston: Houghton Mifflin, 2005), 203–5.
91 *the nation's centennial:* Neil Harris, "The Gilded Age Revisited: Boston and the Museum Movement," *American Quarterly* 14, no. 4 (Winter 1962), 545–66; Julia de Wolfe Addison, *The Boston Museum of Fine Arts* (Boston: L. C. Page and Company, 1910).

NOTES

92 *"epoch of American collecting":* Van Wyck Brooks, *The Dream of Arcadia* (New York: E. P. Dutton, 1958), 237–40.

92 *Women such as:* Dianne Sachko Macleod argues that for these women and others, including the creator of Fenway Court, "collecting had a liberating effect." See her *Enchanted Lives, Enchanted Objects: American Women Collectors and the Making of Culture, 1800–1940* (Berkeley: University of California Press, 2008), 1. See also Erica E. Hirshler, "Mrs. Gardner's Rival: Susan Cornelia Warren and Her Art Collection," *Fenway Court,* 1988, 46–55; Wanda Corn, "Art Matronage in Post-Victorian America," *Cultural Leadership in America: Art Matronage and Patronage* (ISGM, Fenway Court) vol. 27, 9–24.

92 *"a slight hostility":* Chapman, *Memories and Milestones,* 133.

92 *the "discouraging task":* Carter, 93.

92 *"not only what":* Chapman, *Memories and Milestones,* 139–40.

93 *"a matter of craft":* Rachel Cohen, *Bernard Berenson: A Life in the Picture Trade* (New Haven, CT: Yale University Press, 2013), 45.

93 *In Norton's class notes:* Charles Eliot Norton Misc. Papers, MS Am 1088.5, Box 3, Houghton.

93 *their taste and character:* Charles Eliot Norton Papers, MS Am 1088, Houghton.

93 *she "loved Norton":* ISG to John Jay Chapman, June 2, 1915, John Jay Chapman Papers, 1841–1940, MS Am 1854, Houghton. Belle admired Chapman's recently published *Memories and Milestones,* which has a long chapter on Norton. She wrote that she had never before "read anything about him that I liked."

94 *"We have been":* JLG Jr. to GAG, June 12, 1879, London, GFP.

94 *utterly "fascinating":* MHA to RWH, July 13, 1879, *LMHA,* 155.

94 *"even more mad":* MHA to RWH, July 27, 1879, *LMHA,* 159.

94 *the "awful gowns":* MHA to RWH, July 21, 1879, *LMHA,* 159.

95 *"many interesting things":* JLG Jr. to JLG Sr., August 17, 1879, GFP.

95 *"as absurd and vulgar":* MHA to RWH, September 21, 1879, *LMHA,* 180.

95 *the "great Mr. Worth":* MHA to RWH, September 21, 1879, *LMHA,* 179–80.

NINE: THE COSMOPOLITAN, 1880–83

96 *"'being remembered'":* HJ to ISG, January 29, 1880, *HJ Letters,* vol. 2, 265.

96 *"ladies were charming":* HJ to ISG, December 7, 1881, in *HJ Letters,* vol. 2, 364.

97 *knew of her acumen:* HLH to ISG, October 18, 1881: "The concerts begin at 8 o'clock—and the rehearsals at 2 ½ o'clock—on Fridays . . . I sincerely trust that neither you nor any other music-lover will hesitate to express openly disapproval of bad work. The orchestra and the good cause need it." ISG Papers, ISGM.

98 *bought a graphic flag:* There is a debate about whether this flag was an original one commissioned between 1812 and 1815 or a precise commemoration flag made somewhat later. See Adolph S. Cavallo, *Textiles: Isabella Stewart Gardner Museum* (Boston: ISGM, 1986), 160–61.

98 *Her drawing room:* Carter, 52.

98 *pleased her eye:* Alan Chong gives a full overview of Belle as decorator and furniture collector in *Furnishing a Museum: Isabella Stewart Gardner's Collection of Italian Furniture* (Boston: ISGM, 2011), 16–31.

99 *"San Antonio Justice":* Travel Album, 1867–86. For a thoughtful discussion of these western images, in particular the problematic nature of the outlaw photograph, see Greenwald and Riley, *Fellow Wanderer,* 193–205.

- 99 *"his mind was full"*: L. O. Howard, "Biographical Memoir of Edward Sylvester Morse, 1898–1925," *National Academy of Sciences* 17, no. 1, 14.
- 99 *"simplicity and taste"*: Benfey, 66.
- 100 *to "see you one"*: HJ to ISG, February 13, 1882, *HJ/Zorzi*, 82.
- 100 *a "hesitating manner"*: Edith Wharton, "Henry James in His Letters," *Quarterly Review*, vol. 234 (July 1920), 185–202. See also Marie P. Harris, "Henry James, Lecturer," *American Literature* 23, no. 3 (1951): 302–14. Virginia Woolf would describe Henry James as a "cosmopolitanized American" and also said he remained all his life "inscrutable, silent, and assured." Woolf, *Genius and Ink* (London: TLS Books, 2019), 66, 72.
- 100 *novella*, Daisy Miller: Leon Edel, *Henry James: The Middle Years, 1882–1895* (New York: Avon Books, 1962), 41. Henry James would send Belle a copy of *Parisian Life Under Louis XVI* sometime in 1882. Perhaps it came in his September 3 letter from London, when he gave an update on his play: "Poor Daisy Miller, in her comic form, has been blighted by cold theatrical breath, and will probably never be acted. She will in that case only be published. But she had two evenings' success, and that simply satisfies your very faithful friend." *HJ Letters*, vol. 2, 384.
- 100 *smelled of a forest*: The *Boston Journal* reported on the "absence of either furnace or steam heat" at 152 Beacon Street. Instead, Belle relied on "open fires. These huge fires are kept going all the time. She has cones and all sorts of fragrant and pretty burning weeds to throw on them, and a delicious odor of the forest pervades the house." *Boston Journal*, April 14, 1893.
- 100 *the "sound of your"*: HJ to ISG, November 12, 1882, *HJ/Zorzi*, 104.
- 102 *His extensive travel*: *My Cousin*, 94.
- 102 *"one of the handsomest"*: *My Cousin*, 42.
- 102 *"My splendid boy"*: *My Cousin*, 138.
- 102 *"With me, things"*: FMC to Louise Crawford Terry, January 3, 1882, as quoted in John Pilkington Jr., *Francis Marion Crawford* (New York: Twayne Publishers, 1964), 46.
- 102 *"shuffle the cards"*: Sam Ward to Louisa Crawford Terry, September 18, 1881, quoted in *My Cousin*, 97.
- 103 *"might join forces"*: *My Cousin*, 122.
- 103 *"A married lady"*: Quoted in Pilkington, *Francis Marion Crawford*, 47. Pilkington goes on to explain: "Mrs. Gardner was going to New York to examine the widely discussed art collection of William Henry Hurlbert, and Crawford of course was making the trip in search of additional opportunities to write articles."
- 103 *"To My True Love"*: FMC manuscript poems, ISG Papers, ISGM.
- 103 *"Beacon-streeters"*: MHA to RWH, March 5 and 12, 1882, *LMHA*, 359 and 364. See also Natalie Dykstra, *Clover Adams: A Gilded and Heartbreaking Life* (Boston: Houghton Mifflin Harcourt, 2012), 99–102.
- 103 *"If you hear rumors"*: FMC to Louisa Terry, March 26, 1882, as quoted in Pilkington, *Francis Marion Crawford*, 47.
- 104 *"My lady late"*: FMC manuscript poems, ISG Papers, ISGM.
- 104 *at Prides Crossing*: It may be she stayed at Alhambra; the record is unclear. This was a small white cottage that Jack's brother Joseph Gardner lived in until he died. It was used later by William Amory Gardner as his summer home and is now a dorm at Endicott College.
- 104 *there with unusual force*: Lucy Larcom, *A New England Girlhood* (Boston: Houghton, Mifflin and Company, 1889), 108.
- 104 *visible from the road*: *Boston Journal*, April 14, 1893.

104 *"The life here":* Pilkington explains: "Early in August, he accepted the Gardners' invitation to spend three weeks with them in their home at 'Beverly Farms' a few miles north of Boston. His letters to Sam Ward show how thoroughly he enjoyed the work, and relaxation on the Gardner estate." *Francis Marion Crawford,* 53–54.

105 a *"criminal conversation":* Debby Applegate, *The Most Famous Man in America: The Biography of Henry Ward Beecher* (New York: Doubleday Press, 2006), 142.

105 *"holding her affection":* MC Papers.

105 *them in her letters:* William A. Coles, "Isabella Stewart Gardner and the Brownings," *Fenway Court,* vol. 21 (1987), 25–29.

106 *from Dante's* Paradiso: A. B. Cross, "Hands of Francis Marion Crawford and Isabella Stewart Gardner," albumen print, Crawford/Chapman Case, Blue Room, ISGM.

106 *"the latter cannot endure":* MHA to RWH, December 11, 1881, *LMHA,* 307. There are a series of letters from Mrs. Bell to Isabella, starting in 1911, which suggest a friendlier relationship. See ISG Papers, ISGM.

106 *a leading member:* This club was started in the 1840s as a place to meet for lectures, activism, and self-improvement. Maud Howe and her mother, Julia, were members, as was Ida Agassiz Higginson, Belle's childhood friend. Isabella is listed as a member in the club's records, though the organization hardly appears in her papers, making it hard to determine her level of involvement. There is one undated letter to the club sent by Isabella in the early twentieth century. See ISG Papers, ISGM; also the Records of the New England Women's Club, 1843–1970, MC 178; M-145, Folio box 2, Schlesinger Library, Radcliffe Institute.

107 *for the "desolation":* HJ to William Dean Howells, March 20, 1883, reproduced in Michael Anesko, ed., *Letters, Fictions, Lives: Henry James and William Dean Howells* (London: Oxford University Press, 1997), 239. Henry James wrote to Belle, commenting on the weather: "You have had a hot summer but I pray you have had a merry one. My sister writes me you kindly came to see her and were all freshness and grace. Your journey to Japan and India is a coup de génie: won't you take me with you as your special correspondent—and companion? (I mean special—companion.)" HJ to ISG, September 3, 1882, *HJ Letters,* vol. 2, 384.

107 *mother's home in Rome:* Frank had been encouraged to return on the advice of his sister and aunt too, because he was finishing a writing project.

107 *"You are not, darling":* Tharp, 82.

107 *"I will ask you not":* Tharp, 82.

107 *almost from the start:* Frank married Bessie Berdan; Maud Howe Elliott describes her and the wedding in *My Cousin,* 190.

108 *weeks after his departure:* Margaret Chanler, *Roman Spring* (Boston: Little, Brown, and Company, 1934), 119.

108 *color to Jackie's:* It is also interesting to note that there is no lock of Jackie's hair in the museum. She named the display case in the Blue Room after her friendship with Crawford.

108 *$40,000 line of credit:* Tharp, 84.

TEN: THE WAY OF THE TRAVELER, 1883–84

111 *in Japan "bewitching":* ISG to MHE, June 30, 1883, *Journeys,* 123. The citations for this chapter come principally from two published sources: Morris Carter's biography, which reprints long passages from Isabella's travel diaries; and *Journeys East,* the comprehensive exhibition catalog edited by curator Alan Chong and published in 2009. Here

NOTES

Chong and a range of scholars discuss Isabella's relationship to Asia and reprint many selections from the Gardner correspondence, diaries, and travel albums. A key correspondent during this period of travel is Maud Howe Elliott. Early on, Carter used these letters in his biography, but the originals have been lost. The museum has transcribed copies. For the Howe letters in this chapter, I have included the date of a letter when possible and indicated if it is reprinted in *Journeys*. Otherwise, I have drawn from the Howe transcribed copies. For Belle's diaries, I use entries reprinted in Carter, 59–88, where possible. Letters between Jack and his family are from the Gardner Family Papers at the Massachusetts Historical Society, though several of these are also reprinted in *Journeys*.

111 *"I was wretched"*: ISG to Anna "Nina" Lyman Mason Gray, July 5, 1883, John Chipman Gray Correspondence, 1800–1932, MS Am 2152, Houghton.
111 *"The papers say"*: ISG to MHE, July 30, 1883, ISG Papers, ISGM.
112 *"awash with a perfect"*: JLG Jr. to GAG, June 17, 1883, *Journeys*, 103.
112 *"so much more Japanese"*: ISG to MHE, June 30, 1883, *Journeys*, 123. See also Isabella Bird's description of fashion in *Unbeaten Tracks in Japan*, vol. 1 (London: John Murray, 1880), 38.
112 *there'd been "no end"*: JLG Jr., to GPG, July 5, 1883, GFP.
112 *"It is a much more"*: ISG to Anna "Nina" Lyman Mason Gray, July 5, 1883, Houghton.
112 *expect from Morse's lectures:* Edward Sylvester Morse, *Japan Day by Day, 1877, 1878–79, 1882–83*, vol. 1 (Boston: Houghton Mifflin, 1917), x.
113 *closed to foreigners, a* sakoku: There had been trade via Nagasaki with the Dutch and Chinese before Perry. See Benfey, xiv–xvi, 31–33.
113 *in her travel album:* JLG Jr. Diary, June 20, 1883, *Journeys*, 108; Travel Album: China and Japan, vol. 2. For a description of the Gardners' arrival in Japan and their preparations for travel, see *Journeys*, 104. For an interpretation of this image, see David Odo, "Deceptive Intimacy," *Fellow Wanderer*, 176–77.
113 *"very respectable in appearance"*: JLG Jr. to GPG, July 5, 1883, GFP.
113 *was a little boy:* Dykstra, *Clover Adams*, 18–19.
113 *"not happy himself"*: Margaret Chanler, *Autumn in the Valley* (Boston: Little, Brown, and Company, 1936), 25.
113 *depression and suicide:* Roger Warner, "Seeing Hokusai in Boston? Thank This Eccentric Brahmin," in *Boston Globe*, March 29, 2015.
114 *"tokens of an alternative life"*: Benfey, 73.
114 *"every conceivable place"*: ISG to MHE, June 30, 1883, *Journeys*, 123.
114 *"fresh, enthusiastic greeting"*: ISG to MHE, July 30, 1883, ISG Papers, ISGM.
114 *"man had done his best"*: ISG to MHE, July 23, 1883, *Journeys*, 144.
114 *"A shirt or waistcoat"*: JLG Jr. to GPG, August 24, 1883, *Journeys*, 166.
115 *"I was immensely amused"*: ISG to MHE, August 24, 1883, *Journeys*, 155.
116 *"It straggles over"*: ISG to MHE, August 24, 1883, *Journeys*, 166. The August 24 text comes from one letter, which *Journeys* splits on two separate pages.
116 *"I've not had time"*: ISG to MHE, August 24, 1883, ISG Papers, ISGM.
116 inro *medicine boxes:* For a listing of all the objects in the museum from Japan, including those purchased on this 1883 trip, see *Journeys*, 410–21.
117 *for her albums: Journeys*, 170–71.
117 *"How beautiful are"*: ISG to MHE, August 24, 1883, *Journeys*, 155.
117 *the "horrid women"*: ISG to MHE, October 19, 1883, ISG Papers, ISGM.

117 *"gentle obedience, chastity"*: As quoted in Amy Stanley, *Stranger in a Shogun's City: A Japanese Woman and Her World* (New York: Scribner, 2020), 13.
118 *"tear himself away"*: ISG to MHE, June 30, 1883, *Journeys*, 123. For more on Belle's largely personal response to Japan and Asia more broadly, see especially Alan Chong and Noriko Murai's introduction to *Inventing*, 9–15.
118 *and entertaining letters:* John Gardner Sr. called Belle's letters "graphic" in a letter to Jack, July 23, 1883, JLGJr-P.
118 *the "best letter writer"*: TJC to ISG, April 26, 1884, ISG Papers, ISGM.
118 *his prodigious reading:* JLG Sr. to JLG Jr., September 1, 1883, JLGJr-P. I found no record of John Gardner Sr. traveling to Asia himself.
118 *"dirty, small, crowded"*: ISG to MHE, September 15, 1883, *Journeys*, 187.
118 *fired her imagination:* Greg M. Thomas vividly explains this dynamic, this "flow of contrasts," in "Dust and Filth and Every Kind of Picturesque and Interesting Thing," in *Journeys*, 428.
119 *Peking "bewitched" Belle:* ISG to MHE, October 19, 1883, *Journeys*, 211.
119 *"in very low voices"*: ISG Diary, September 24, 1883, *Journeys*, 193.
119 *"I am & have been"*: JLG Sr. to JLG Jr., October 29, 1883, JLGJr-P.
119 *"neck out of the mule litter"*: ISG to MHE, October 19, 1883, *Journeys*, 211.
120 *"closely bound up"*: *Journeys*, 424.
120 *"peace, contemplation"*: Carter, 89. He goes on: "As she grew older, she regretted the gradual Europeanizing of Asia, the destruction of variety, the increase of uniformity and monotony, the passing of those things which were the outgrowth and the expression of natural environment and national character." A recent account of Belle's travels, in *Fellow Wanderers,* points out the "imperial underpinnings of her project," explaining that current analyses within art history and within museums now seek "a decolonized perspective on institutions . . . in the twenty-first century." See especially 30–33.
120 *the "marble terrace"*: ISG Diary, October 5, 1883, *Journeys*, 206.
120 *of Eastern aesthetics:* Greg M. Thomas explains how Belle's album keeping functioned as a kind of dialogue, with "the traveler exploring a foreign society while the foreign experience helps shape the traveler's personal identity." See *Journeys*, 429–30.
120 *"with its feet"*: ISG Diary, October 27, 1883, *Journeys*, 219.
121 *"this alone paid"*: ISG to MHE, October 28, 1883, ISG Papers, ISGM.
121 *"beautiful, beautiful, beautiful"*: ISG Diary, October 28, 1883, *Journeys*, 219.
121 *"A most wonderful city"*: ISG Diary, October 31, 1883, *Journeys*, 224.
121 *carts and elephants:* ISG to MHE, November 12, 1883, ISG Papers, ISGM.
121 *"A wonderful ride"*: ISG Diary, November 18, 1883, Carter, 71.
121 *her colorful memories:* Carter, 75.
122 *"very dirty [and] old"*: ISG Diary, November 21 and 22, 1883, Carter, 72–74.
122 *"We passed through"*: ISG to MHE, December 23, 1883, ISG Papers, ISGM.
122 *hawks and owls:* H. N. Ridley, "Birds in the Botanic Gardens, Singapore," *Journal of the Straits Branch of the Royal Asiatic Society,* no. 31 (1898): 73–89.
122 *"it is good"*: ISG to MHE, late December, ISG Papers, ISGM.
123 *"The way of the traveler"*: ISG to Kate Foote, March 3, 1884, Autograph File A–G, Houghton. Kate Foote was the wife of the composer and organist Arthur Foote.
123 *"an uncanny sort of place"*: ISG to MHE, January 7, 1884, Carter, 80.
123 *"even a sensation"*: ISG to MHE, January 18, 1884, Carter, 81.

123 *"As this is our very last":* ISG to GAG, April 17, 1884, GFP.
124 *"There we mean":* ISG to MHE, March 5, 1884, ISG Papers, ISGM.

ELEVEN: "A WHIRLWIND OF SUGGESTION," 1884

125 *"Strange morning":* ISG Diary, May 14, 1884, ISG Papers, ISGM.
126 *"It feels cold to us":* JLG Jr. to GAG, May 23, 1884, GFP.
126 *she made records:* ISG, "Notes on Art History," 1883, ISG Papers, ISGM.
127 *"funny" in her diary:* ISG Diary, May 23, 1884, ISG Papers, ISGM. It is not entirely clear which paintings these might have been at Sant'Alvise.
127 *The purpose of her album:* Travel Album: Italy, 1884.
127 *"The youth of America":* Oscar Wilde, *A Woman of No Importance,* in *The Complete Works of Oscar Wilde,* 5th ed. (New York: HarperCollins, 2003), 470.
128 *the "aesthetic presence":* HJ to William James, September 25, 1869, reprinted in *Letters from the Palazzo Barbaro,* ed. Rosella Mamoli Zorzi (London: Pushkin Press, 1998), 68.
128 *"art and life seem":* Henry James, *Italian Hours* (New York: Penguin Books, 1995; first published in 1909), 21.
128 *not entirely clear:* The Gardners were not close to Jack's youngest sister, Eliza Gardner Skinner, for unknown reasons, though a descendant remembered that Eliza and her family somehow stood apart from the rest of the Gardners. They did not stay at Roque Island, for example.
129 *"Titles two to a penny":* For details on Mrs. Bronson's Venice salon, see Rosella Mamoli Zorzi's "'Figures Reflected in the Clear Lagoon': Henry James, Daniel and Ariana Curtis, and Isabella Stewart Gardner," in *Gondola Days,* especially 134–40.
129 *her palace each autumn:* Mrs. Bronson would later say about Browning that "surely no woman ever had so pure and holy a love given to her." Tharp, 145.
129 *school for poor children:* See also Robert G. Collmer, "Three Women of Asolo: Caterina Cornaro, Katharine de Kay Bronson, and Eleonora Duse," *Mediterranean Studies* 12 (2003), 160.
129 *"If you are happy":* As quoted in Leon Edel, *Henry James: The Conquest of London, 1870–1881* (New York: Avon Books, 1978; first published in 1962), 442.
129 *"absurdly easy to know":* HJ to ISG, May 2, 1884. He wrote to Mrs. Bronson the same day. *The Complete Letters of Henry James, 1883–1884: Volume 2* (Lincoln: University of Nebraska Press, 2019), 102–4.
129 *Belle's "octagon character":* Bronson to ISG, January 4 (possibly 1892), ISG Papers, ISGM.
129 *"You love all things":* Bronson to ISG, January 4 (possibly 1892), ISG Papers, ISGM.
130 *an obscure scuffle:* MC Papers. Carter's notes read: "Sept. 7, 1923, Mr. Henry Swift told me that Daniel Curtis had a row with Judge Churchill over a seat in a railroad train, and pulled the Judge's nose. The judge had Curtis arrested and he was tried. He was defended by Louis [Lewis] Stackpole, who was inclined to treat the matter lightly, but he lost his case, and Curtis was sent to jail. This so infuriated him that after his release he left the country and never returned. He settled in Venice, bought the Palazzo Barbaro, and made it a treasure house of beauty."
130 *a large wellhead:* For a beautiful description of the Barbaro, see Anne Hawley, *Gondola Days,* vii.
131 *how "old ghosts seemed":* Henry James, *Italian Hours,* 39.
131 *"leaving one's gondola:* Laura Ragg, "Venice When the Century Began," *Cornhill Magazine* 153 (1936), 3. Ragg also writes: "The patriarchal existence of large patrician families (the Venetians were always prolific) living in great palazzi called by names

illustrious in the history of the Republic, coloured their social fabric and lent a peculiar cachet to their hospitality. It clothed their formal receptions with a curious, but pleasing, atmosphere of unreality."

131 *"a whirlwind of suggestion":* Henry James, *The Wings of the Dove* (New York: Penguin Classics, 2008; originally published 1902), 367.
131 *"O Venezia benedetta":* Travel Album: Italy, 1884.
132 *elevate a woman:* According to Aileen Ribeiro, Worth felt his skills were equal to those of a great artist." His taste during this period was understated, with plain fabrics, sashes, ribbons, and bows. Ribeiro, *Clothing Art: The Visual Culture of Fashion, 1600–1914* (New Haven, CT: Yale University Press, 2017), 333–34.
132 *James had died in 1881:* "The Light of India" and "The Rajah" (one 25 ½ carats; one 12 3/8); the first cost $35,000 and the other $11,700. These could be worn as a necklace or hairpin. Subject Files, ISGM.
132 *a token of love:* For the powerful symbolism of pearls, see Molly Warsh, *American Baroque: Pearls and the Nature of Empire, 1492–1700* (Chapel Hill: University of North Carolina Press, 2018), esp. 7–8, 13–19.
132 *"Monsieur John L. Gardner":* Boucheron Sales Book, accessed in person, May 2018, at Boucheron, 26, place Vendôme, 75001 Paris, France. I wish to thank Claudine Sablier, Boucheron archivist, for showing me these documents and also for the title of this chapter, a phrase she used in explaining the meaning of pearls for nineteenth-century Paris fashion.
133 *Belle felt "in despair":* HJ to Grace Norton, August 2, 1884, *The Complete Letters of Henry James, vol. I,* edited by Michael Anesko et al. (Lincoln: University of Nebraska Press, 2018), 190–91. James did take note of Belle's friendship with two other Americans then staying in London, Alice Mason and Ellen Fearing Strong, both women separated from their husbands. The former, the widow of Clover Adams's cousin William Sturgis Hooper, had married Charles Sumner in 1866, a notoriously unhappy union, rumored to be unconsummated, which ended in a long separation and then a contentious divorce. She took her maiden name, Mason, after the Sumner debacle. Mrs. Charles Strong had been stained by the scandal of a much-talked-about affair based in Newport, though a gossipy murk has obscured which party had been betrayed. James found the three women as a group a single "representative American woman." Fusing them together in this way, forging a fictional character he could deploy later, he presumed that the Gardner marriage too was unhappy.
133 *"Some of the cleverest":* Carter, 90. Carter added another interesting detail by way of explanation: her remarkable promptness. She liked to be first—to celebrations, to the theater, to Boston Symphony Orchestra performances. But this quickness extended somewhat anxiously to her communication with others, as if speed might blunt social criticism: "Every letter, every invitation was answered as soon as read, and every gift acknowledged so speedily that it often seemed as if the note of thanks were delivered before the gift could have been received." Carter, 93.
133 *"Not a charitable eye":* MC Papers.

TWELVE: "THE FIDDLING PLACE," 1884–87

134 *"dignified, affable":* Brookline Chronicle, July 26, 1884, as quoted in Tharp, 105.
134 *"in us and our doings":* Joseph Peabody to GAG, August 11, 1884, GFP.
134 *"there is consolation":* JLG Sr. to ISG, July 10, 1883, Mansion House Archives.
135 *On their arrival:* JLG Jr. Diary, August 4, 1884, JLGJr-P

135 *over his jacket sleeve:* For descriptions of nineteenth-century mourning codes, see especially Karen Halttunen, *Confidence Men and Painted Women: A Study of Middle-Class Culture in America, 1830–1870* (New Haven, CT: Yale University Press, 1982), 124–52; see also Sarah Nehama, *In Death Lamented: The Tradition of Anglo-American Mourning Jewelry* (Boston: Massachusetts Historical Society, 2013).

135 *for several days:* When Jack relayed these details, he said: "There is no news to report." JLG Jr. to GAG, September 4, 1884, GFP.

135 *Once, she advised:* Morris Carter put it this way in his notes: "Advice to young hostesses that guests don't mind poor dinners but are pleased to reflect how much better their own dinners are." MC Papers.

136 *"Mrs. Gardner invited me":* Clayton Johns, *Reminiscences of a Musician* (Cambridge: Washburn and Thomas, 1929), 44; see also Carter, 91.

136 *"O, dear no":* Locke and Barr, *Cultivating Music in America,* 123.

136 *"The key to your heart":* Anders Zorn to ISG, April 26, 1894, ISG Papers, ISGM.

136 *The young women attending:* Barbara Miller Solomon writes that "established eastern elites—Boston Brahmins, Philadelphia Main Liners, and Hudson Valley New Yorkers—preferred to educate daughters privately at home, in boarding school, and through travel abroad." Families "prepared daughters for a life of leisure, not work." Solomon, *In the Company of Educated Women* (New Haven, CT: Yale University Press, 1985), 64.

136 *Norton had long held:* For a summary of Norton's career-long engagement with Dante, his founding of the Dante Society, and his aims for it, see Kathleen Verduin, "Bread of Angels: Dante Studies and the Moral Vision of Charles Eliot Norton," *Dante Studies, with the Annual Report of the Dante Society* 129 (2011), 63–97.

136 *one of seven women:* Two of the other women were the reformer Caroline Healey Dall and Anne Eliot Ticknor, daughter of the scholar of Spanish literature George Ticknor.

137 *"part of the soul's":* Lowell, as quoted in Linda Docherty, "Translating Dante: Isabella Stewart Gardner's Museum as *Paradiso*," *Religion and the Arts* 22 (2018), 196. After Longfellow's death in 1882, Lowell took over as the society's president, followed by Norton.

137 *She anonymously paid:* Maureen Cunningham, "The Dante Quest," *Fenway Court* (1972): 21.

137 *a check for $400:* Belle replied so quickly to Norton's request that he had to momentarily return her check because he was not at all sure he could get the project off the ground. The school in Athens would prove to be a large success. Carter, 98.

137 *a warm Southern spring:* Clover told her father the city looked like a "gigantic tulip bed." MHA to RWH, March 5, 1885, Adams Family Papers, 1639–1889, Ms. N-1776, MHS.

137 *Clover took photographic:* There is no record as to whether Belle received these two photographs before or after Clover's death in 1885; they are now in the Okakura Case in the Blue Room on the first floor.

137 *"would take people's":* Tharp, 128.

137 *"Mrs. Jack Gardner":* HA to John Hay, February 22, 1885, *HA Letters*, vol. 2, 575.

138 *lush, green fields:* Nina Fletcher Little, *Some Old Brookline Houses* (Brookline: Brookline Historical Society, 1949), 87–92.

138 *threat of disease: Memorial,* 153.

138 *his beloved place:* Sukie Amory, "Gardner in the Garden, Part One: À Bas les Arts! Let's Dig in the Garden," *Hortus: A Gardening Journal* 107, vol. 27, no. 3 (Autumn 2013),

63. Amory credits JoAnne Robinson, former landscape researcher at the ISGM, for the insight that Belle and her father-in-law also "bonded over horticulture."

138 *across two walls:* "Even by today's standards the rooms would not be considered uncomfortably large . . . The dining room has a wooden floor painted black and white check. In the parlor, there is antique Chinese wallpaper." Karen Curran, "Green Hill, Brookline," *Boston Globe,* August 11, 1996.

138 *won many prizes:* Amory, "Gardner in the Garden, Part One," 64–65.

139 *of "rainbow mist":* Hildegarde Hawthorne, "A Garden of the Imagination: Mrs. John L. Gardner's at 'Green Hill,' Near Boston," *Century Magazine,* July 1910, 448.

139 *how "each mood":* Benjamin Brooks, "A New England Garden Home," *Country Life in America,* March 1902, 152.

139 *the "superb show":* Sullivan, July 1, 1890, *Journal,* 18. I am indebted to Shana McKenna's vivid description of the Green Hill gardens in her "Green Hill and its Gardens," ISGM blog, July 28, 2020.

139 *Hiroshige's woodblock prints:* Amory, "Gardner in the Garden, Part One," 68. The iris bed was an unlikely success; no one thought they would grow at Green Hill because of the climate. See Carter, 96.

140 *stay for several weeks:* The first time Belle signed the family guestbook was on May 10, 1883, when she and Jack stayed on Roque Island before departing for Japan. Mansion House Archives.

140 *Irises, wild roses:* Flowers that grew on Roque Island are listed in notes in Belle's hand, ISG Papers, ISGM.

140 *the "luxurious appointments":* CPG to JLG Jr., July 16, 1883, GFP. I am indebted to John Higgins for these details and his vivid description of the Old Farmhouse.

140 *"Faerie Realm of Pine":* John L. Gardner II (son of GAG) Guestbook, Mansion House Archives.

140 *the craggy coastline:* For more about Roque Island, see Eugene C. Donworth, *Washington County Railroad Monthly,* May 1900; see also Roque history, www.roquehistory.com. For the dates, some in Belle's hand, of when she and Jack stayed at Roque, see ISG Papers, ISGM. A decade later, she told Bernard Berenson that she enjoyed canoeing out to see the seal colonies. ISG to BB, August 14, 1896, *ISB/BB Letters,* 62.

140 *"those unforgettable moments":* ISG to Loeffler, February 22, 1909, ISG Papers, ISGM. ISG wrote: "One has to suffer oneself to know what such a blow is to another—my mother died like that, when I was away, and suddenly . . ."

141 *"a great lover":* Charles Eliot Norton to ISG, July 23, 1886, as quoted in Carter, 97–98.

141 *"Books, I fear":* ISG to Charles Eliot Norton, July 12, 1886, Charles Eliot Norton Papers, MS 1088, Houghton. For more on Belle and collecting rare books, see Carter, 97–100; *Beholder,* 71–72; and Cunningham, "The Dante Quest," *Fenway Court* (1972) 21–24. For a full discussion of her rare book and manuscript collection, see Anne-Marie Eze, ed., "Isabella Stewart Gardner Museum: Italian Renaissance Books," in the exhibition catalog *Beyond Words: Illuminated Manuscripts in Boston Collections* (McMullin Museum of Art, Boston College; distributed by the University of Chicago, 2016), 233–361. For the Dante Case in the Long Gallery, see *ISGM Guide* 17, 171. For more on the Botticelli drawings of Dante's *Divine Comedy,* see Joseph Luzzi, *Botticelli's Secret: The Lost Drawings and the Rediscovery of the Renaissance* (New York: W.W. Norton and Company, 2022).

141 *"Your Aunt is better":* JLG Jr. to GPG, September 27, 1886, GFP.

142 *"the fiddling place":* JLG Jr. to GPG, July 8, 1886, GFP.

143 *the German soul:* This elevation of Germanic character took on a sinister aspect when Wagner's music became, in the words of Alex Ross, the soundtrack to the rise of Nazism. For more discussion of this complex phenomenon, see Ross's *Wagnerism: Art and Politics in the Shadow of Music* (New York: Farrar, Straus, Giroux, 2020).
143 *had "nearly enough":* JLG Jr. to GPG, August 2, 1886, GFP.
143 *At the gravesite:* Carter, 101.
143 *into her travel album:* Travel Album: Great Britain, France, Germany, Austria, and Italy, Volume I, 1886.
143 *declared his wife "happy":* JLG Jr. to GPG, August 2, 1886, GFP.
144 *thought Vienna "delightful":* JLG Jr. to GPG, September 4, 1886, GFP.
144 *become "much depressed":* JLG Jr. to GPG, September 16, 1886, GFP.
144 *with a young man:* This was supposedly Logan Pearsall Smith, according to Douglass Shand-Tucci in his book *The Art of Scandal*, 83–84, 91. Smith was the brother of Bernard Berenson's wife, Mary.
144 *"would also give you":* JLG Jr. to GPG, September 27, 1886, GFP.
146 *an occasional quotation:* Travel Album: Great Britain, France, Germany, Austria, and Italy, Volume I, 1886; and Travel Album: Italy, France, and Great Britain, Volume II, 1886.
146 *There was more to do:* JLG Jr. to GPG, October 3, 1886, GFP.
146 *Lee "most astounding":* As quoted in Leon Edel, *Henry James: The Middle Years, 1882–1895* (New York: Avon Books, 1978; first published in 1962), 115.
146 *a letter to Belle:* JLG Jr. mentions Belle and Vernon Lee in his diary, October 8, 1886, JLGJr-P; the scene is more fully described in *Gondola*, 13.
146 *"He was a dear":* JLG Jr. to GPG, October 18, 1886, GFP.
147 *"particularly charmed":* Ralph Curtis to ISG, October/November 1886, ISG Papers, ISGM.
147 *the "wittiest man":* John Jay Chapman, as quoted in Tharp, 120.
147 *curate and furnish:* See *ISGM Guide 17*, 114.

THIRTEEN: LOVE AND POWER, 1886–88

148 *his Paris studio:* John Singer Sargent's studio had been at 41, boulevard Berthier.
148 *concealed private lives:* What is hard to capture now, in the twenty-first century, is the danger of homosexual desire, which, if found out, was often ruinous, unacceptable in polite society. I am indebted to Colm Tóibín for his many insights about Henry James and John Singer Sargent. Tóibín observes that Henry James likely "used the shadowy shape of his own uneasy and ambiguous homosexuality to nourish his work." "Henry James: Shadow and Substance," in *Henry James and American Painting* (New York: The Morgan Library and Museum, published by Pennsylvania State University Press, 2017), 36–40. The same may be said of Sargent, as Tóibín argues in "Secrets and Sensuality: The Private Lives of John Singer Sargent and Henry James," in *Boston's Apollo: Thomas McKeller and John Singer Sargent* (Boston: ISGM; distributed by Yale University Press, 2020), 117–31. See also Trevor Fairbrother, *John Singer Sargent: The Sensualist* (New Haven, CT: Yale University Press, 2000).
148 *"civilized to his fingertips":* HJ to Grace Norton, February 23, 1884, *HJ Letters*, vol. 3, 32.
149 *"It is difficult":* The 1887 *Harper's* profile was subsequently republished in *Picture and Text* in 1893, and that amended version is collected by John L. Sweeney in Henry James, *The Painter's Eye: Notes and Essays on the Pictorial Arts*, first published in 1956 (republished by Madison: Wisconsin University Press, 1989), 217.
149 *that "Ralph Curtis":* JSS to ISG, October 1886, ISG Papers, ISGM.

150 *the "radical strangeness"*: Susan Sidlauskas, "Painting Skin: John Singer Sargent's 'Madame X,'" *American Art* 15, no. 3 (2001): 10. See also Trevor J. Fairbrother, "The Shock of John Singer Sargent's 'Madame Gautreau,'" *Arts Magazine* 55 (January 1981): 93.

150 *the hostile reviews:* Jean Strouse, "Sargent & His People," *New York Review of Books*, October 8, 2015. Sargent made occasional trips to the United States until his death in 1925.

150 *he "only half liked":* HJ to Elizabeth Boott, June 4, 1884, as quoted by Fairbrother, "The Shock," 94.

150 *leaving painting altogether:* Tóibín, "Secrets," 117–18.

150 *"I am rejoiced":* GAG to JLG Jr., December 20, 1886, GFP.

150 *niece by marriage:* Selah Strong Smith and Ann Carpenter had nine children, including Adelia Smith Stewart (Belle's mother) and Mary Ann Smith (Hicks), who married John Mott Hicks, the parents of Mary Smith Hicks Peck. New York Genealogical and Biographical Society Research Report Case: C20190206A (Dykstra), May 2019. This second Stewart marriage is characterized in *ISGAL* as an "uncomfortable overlap," linking it to the absence of David Stewart in the museum collection. See *ISGAL*, 26–27.

150 *conveyed the title:* Financial Records, ISG Papers, ISGM.

151 *Venice and Florence:* Jack listed all purchases in the last pages of his travel diaries, noting the place, date, and price of each item. JLG Jr. 1886 Diary, JLGJr-P.

151 *Paris and London:* Both Carter and Tharp claim it was on this 1886 trip that Whistler gave Belle his sketches for his famed 1877 Peacock Room (later reinstalled at the Freer Gallery of Art), so-called because of the artist's use of the peacock as both a figure in various scenes throughout the room and as a design motif. This was not the case. Whistler gave them to the American painter Harper Pennington in roughly 1885; Pennington then gave them to Belle in 1904. She would include them in the Sargent/Whistler Case in the Long Gallery. Belle had a particular fondness for peacocks and would acquire more representations of the flamboyant bird. For more about the drawings, see Rollin van N. Hadley, ed., *Drawings: Isabella Stewart Gardner Museum* (Boston, 1968), 37–41.

151 *a "whirl of hurry":* Whistler to ISG (likely October 1886), ISG Papers, ISGM.

151 *"a more brilliant proof":* Whistler to ISG (likely later October 1886), ISG Papers, ISGM.

151 *spilling over its rim:* Belle bought a third Whistler pastel, *Lapis Lazuli*, executed the same year as the first two, in 1895 from the artist. It pictured a nude woman lounging on a blue couch, her robe open, with an outstretched hand holding an open fan. She put all three pastels, together with the small oil, lined up in a vertical row in the Veronese Room of Fenway Court. See *ISGM Guide 17*, 147.

152 *"looked very handsome":* JLG Jr. to GPG, February 8, 1887, GFP.

152 *found Belle "not easy":* As quoted in Nancy Whipple Grinnell, *Carrying the Torch: Maud Howe Elliott and the American Renaissance* (Hanover, NH: University Press of New England, 2014), 60–61. Grinnell later mentions the rift between the friends but does not speculate as to the reasons. *Carrying*, 111–12.

152 *Belle inscribed the inside:* Annie Fields, *A Week Away from Time* (Boston: Roberts Brothers, 1887). A copy can be found in ISG Personal Library, ISGM.

152 *She had met:* This meeting can be dated from several sources, including a letter from Berenson to Belle from Munich, dated July 28, 1897, in which he writes: "It fully confirmed my first impression of you, eleven years ago, and since then I have lived and seen much." *ISG/BB Letters*, 91–92.

153 *"Berenson has more":* Cohen, 46.

153 *thoroughgoing anti-Semitism:* Cohen traces this prejudice at Harvard and within the field of art history. She also notes that Berenson converted to Christianity at Trinity Church, inspired by the preaching of its rector, Phillips Brooks, but also his desire to escape his origins. Cohen, 46–49.

154 *on the lower left:* For a close reading of this display case, see Riley, "To Make a Case," 166–68.

154 *his attentions on canvas:* See especially Richard Ormond's introductory essay, "Sargent and the Arts," in *Sargent: Portraits of Artists and Friends* (London: National Portrait Gallery, 2015), 9–21; Ruth Bernard Yeazell, "Sargent's Other Portraits," *Raritan* 36, no. 1 (2016): 114–37.

154 *course of his commission:* Tharp, 131. The chronology in Sargent's catalogue raisonné does not say Sargent stayed with the Gardners, only that he took a studio on nearby Exeter Street and that he began her portrait at the end of December 1887. Richard Ormond and Elaine Kilmurry, *John Singer Sargent: The Early Portraits, Complete Paintings, vol. 1* (New Haven, CT: Yale University Press, 1998), xvi. See also Erica E. Hirshler, "Sargent in Boston and New York, 1888–1912: Venn Diagrams," in Ormond, *Sargent: Portraits,* 173–77; and Hirshler, *Sargent's Daughters: The Biography of a Painting* (Boston: MFA Publications, 2009), 132.

154 *"the gymnasium door":* Ellery Sedgwick, *The Happy Profession* (Boston: Little, Brown and Company, 1946), 60–61.

155 *in this heated scene:* Sargent's sexual life was kept hidden, out of preference or necessity, most probably both. For a full and nuanced discussion, see Paul Fisher, *A Grand Affair: John Singer Sargent in His World* (New York: Farrar, Straus, and Giroux, 2022).

155 *Ned Boit didn't make:* Boit Papers, Diaries for 1887–88, Archives of American Art, roll 83, as cited in Subject Files, ISGM.

155 *in the painting itself:* For how the portrait shows influences from Asia, see Kathleen Weil-Garris Brandt, "Mrs. Gardner's Renaissance," *Fenway Court: Imaging the Self in Renaissance Italy* (Boston: ISGM, 1990–91), 21.

156 *an emotional remove:* Colm Tóibín notices how Sargent "developed a way of making his subjects seem both close and distant. His way of painting a face appeared to capture a vivid sense of life while also managing to depict a fine detachment." *Henry James and American Painting,* 38.

156 *as "translucent alabaster":* Gertrude Fay to Rollin Van N. Hadley, October 14, 1976, Rollin Hadley Papers, ISGM.

156 *"a lemon with a slit":* Lucia Fairchild recorded Sargent's comment about Isabella in her diaries, which are in part reprinted in Lucia Miller, "John Singer Sargent in Diaries of Lucia Fairchild 1890 and 1891," *Archives of American Art Journal* 26, no. 4 (1986): 6.

157 *"had been done":* Carter, 104–5.

157 Woman, An Enigma: For an extended discussion of the portrait and its title, see Weil-Garris Brandt, "Mrs. Gardner's Renaissance," 15–18. See also "Art in Boston: The Sargent Portrait Exhibition at St. Botolph Club," *Art Amateur* (April 1888): 110; "Exhibition of Mr. Sargent's Paintings at the St. Botolph Club," *Boston Evening Transcript,* January 30, 1888. The Table Gossip section of the *Boston Daily Globe* reported that over "5000 people, by actual count, visited the Botolph Club while the Sargent portraits were on exhibition." February 19, 1888

157 *"slightly 'uncanny' spectacle":* Henry James, *The Painter's Eye: Notes and Essays on the Pictorial Arts,* ed. John L. Sweeney (Madison: University of Wisconsin Press, 1989), 218.

157 *"You must let me":* Frances Lang to ISG, January 30, 1889, ISG Papers, ISGM. The transcription of this letter surmises that the date was 1889.
157 *was "cut very low": Town Topics,* n.d., likely February 1888.
157 *required "more dignity":* "Art in Boston," 110.
158 *in Boston: "The newspapers":* JSS to ISG (possibly 1888), ISG Papers, ISGM.
158 *time to "gain pause":* Susan Hale, *Boston Sunday Globe,* February 19, 1888.
158 *"It looks like hell":* JLG Jr. to ISG in an undated letter, copied by Morris Carter, MC Papers; on October 10, 1894, Jack sent a cablegram from Venice, declining a request by an unnamed correspondent to exhibit Sargent's portrait of Isabella. JLG Jr., 1894 Travel Diary, JLGJr-P.

FOURTEEN: SEEING WONDER, 1888–89

160 *"What a wonderful":* HJ to ISG, March 18, 1888, ISG Papers, ISGM.
161 *traveled before to Spain:* Richard L. Kagan reviews the literature written about Spain by a range of English-speaking writers, including Irving, in *The Spanish Craze: America's Fascination with the Hispanic World, 1779–1939* (Lincoln: University of Nebraska Press, 2019), 133–48.
161 *the "rugged mountains":* Washington Irving, *The Alhambra: A Series of Tales and Sketches of the Moors and Spaniards* (New York: G. P. Putnam, 1861; originally published in 1849), 14.
161 *published in 1845:* Richard Ford, *A Handbook for Travellers in Spain,* 6th ed., vols. 1 and 2 (London: John Murray, 1882). Jack signed his name in the first volume; copy in ISG Personal Library, ISGM. Isabella purchased copies of the original 1845 edition in London in 1888.
161 *She pasted photographs:* Travel Albums: Volume I, Spain, 1888, and Volume II, Spain and Portugal, 1888.
162 *"the greatest painter":* Ford, *Handbook,* 47.
162 *realism and humanity:* Richard Ormand, "Sargent's *El Jaleo,*" *Fenway Court* (1970), 4. Peter Schjeldahl poses a question: "Why is Velázquez almost certainly the greatest of painters? . . . No other artist has taken both the representational and the decorative functions of painting to such dizzying heights. Velázquez's fusion of truth and beauty can be felt up close, in art's most caressing and efficient brushstroke. And it registers with equal force from a certain distance—the viewpoint at which the strokes snap into a stunning likeness of the subject, and innumerable colors (most of them blacks and grays) clear their throats and sing. A Velázquez says, 'This is so.' And we know it's true." "The Spanish Lesson," *The New Yorker,* November 10, 2002.
162 *"Velázquez, Velázquez":* Carolus-Duran, as quoted in H. Barbara Weinberg, "American Artists' Taste for Spanish Painting," *Manet/Velázquez: The French Taste for Spanish Painting* (New Haven, CT: Yale University Press for the Metropolitan Museum of Art, 2003), 295.
162 *unhurried brushstrokes:* Jonathan Brown and Carmen Garrido, *Velázquez: The Technique of Genius* (New Haven, CT: Yale University Press, 1998), 174–80.
163 *a person alive:* About Velázquez Peter Schjeldahl says simply: "He conquered time . . . Work by work, Velázquez perpetuates a present tense of reality into a future that is imminent, always." "The Reign in Spain," *The New Yorker,* January 2, 2012.
163 *"Her quick eyesight":* MC Papers.
163 *lower right corner:* The Neapolitan baroque painter Luca Giordano called Velázquez's supreme masterpiece, "Las Meninas" (1656), which depicts Philip's daughter the Infanta

Margarita and her attendants, "the theology of painting." As quoted in *The New Yorker*, January 2, 2012.

163 *"this painting accepts"*: Laura Cumming, *The Vanishing Velázquez*, 5–6. For a summary of the many ways this painting has been interpreted, see also Brown, *Velázquez: Technique*, 181–94.

163 *the "strong tincture"*: William Howe Downes, as quoted in Hirshler, *Sargent's Daughters*, 203.

163 *"one of his most"*: Ford, *HandBook*, 58.

164 *"I write to you from Seville"*: Ralph Curtis to ISG, February 9, 1888, ISG Papers, ISGM.

164 *"One who has not seen "*: Travel Album: Spain and Portugal, Volume II, 1888.

164 *"enough of bullfights"*: JLG Jr. to GPG, April 29, 1888, GFP.

165 *spectacle was "tremendous"*: JLG Jr. to GPG, May 29, 1888, GFP. See also Carter, 106–7. The Gardners were strong supporters of several anti-cruelty organizations in Boston, including the Massachusetts Society for the Prevention of Cruelty to Animals.

166 *old master painting*: Inscribed below the Virgin's foot was a shortened version, in Latin lettering, of Genesis 2:10: "And a river went out of Eden to water the garden . . ." This was discovered in 1940, when considerable overpainting and varnish were removed from the canvas. In Isabella's time, this part of the painting was filled with puffy clouds. Philip Hendy, *European and American Paintings in the Isabella Stewart Gardner Museum* (Boston: Trustees of the ISGM, 1974), 300.

166 *"Your Aunt bought"*: JLG Jr. to GPG, May 24, 1888, GFP. Jack gives further details about the painting: it "was shipped on a sailing vessel for New York . . . I also enclose the receipts of the seller of the picture in which he states the period at which it was painted. This may be necessary to enable you to get it through without duty as an old painting. When it arrives, please send it to my house." See also Carter, 107; Tharp, 138.

167 *"What is most"*: Travel Album: Spain and Portugal, Volume II, 1888; Ford, *Handbook*, 377. For an in-depth discussion of the Spain albums, see Madeleine Haddon, "Isabella Stewart Gardner's Travel Albums from Spain," *Fellow Wanderer*, 55–69.

167 *"The severe, simple"*: Ford, *Handbook*, 372.

167 *"And there is no conqueror"*: Ford, *Handbook*, 374. See also Irving, *Alhambra*, 70.

168 *"Your energetic Aunt"*: JLG Jr. to GPG, April 29, 1888, GFP.

168 *"travelling and sightseeing"*: JLG Jr. to GPG, May 24, 1888, GFP.

168 *"At last we have"*: JLG Jr. to GAG, June 13, 1888, GFP.

168 *writers, and hangers-on*: Daniel Curtis recorded the guest list for a typical soiree in his diary: "JL Gardners, Idita de Hurtado and her husband, Marchese Bentivoglio d'Aragona, Princess da Montenegro, Mrs. Paffius, Mocenigo, the S. Howes, Dr. Clotaldo Pincco, R. Browning, Wm Rh Coolidge, &c, &c." Daniel Curtis Diary, no. 449, July 17, 1888, Biblioteca Nazionale Marciana, Venice, Italy.

168 *the "season is over"*: JLG Jr. to GPG, July 3, 1888, GFP.

168 *"trust your eye"*: Carter, 110.

169 *"with motion and light"*: She installed the fireplace in the music room at Green Hill, where it was often lit for musical performances, and later in the Raphael Room on the second floor of Fenway Court. See Gilbert Wendell Longstreet and Morris Carter, *General Catalogue* (Boston, Printed for the Trustees, 1935), 118.

FIFTEEN: "DAZZLING," 1889

173 *"Tonight is the night"*: Ellen Coolidge to Frances Curtis, April 26, 1889, Curtis Family Papers, 1766-2000, Schlesinger Library, Radcliffe Institute, Harvard University.

173 The *"social atmosphere": Saturday Evening Gazette*, April 1889.
173 *"La Primavera by Botticelli":* Ellen Coolidge to Frances Curtis, April 26, 1889, Curtis Family Papers, Schlesinger.
174 *"fine, old tapestries":* "Boston's Fancy Ball," *New York Times*, April 26, 1889.
174 *Boston's high society: Boston Daily Globe* listed all the women on the dais: "Mrs. Martin Brimmer, Mrs. W. F. Apthorp, Mrs. Edward Codman, Mrs. Samuel Eliot, Mrs. J. L. Gardner, Mrs. William W. Greenough, Mrs. R. P. Hallowell, Mrs. B. J. Lang, Mrs. C. G. Loring, Mrs. A. L. Mason, Mrs. Edward Robinson, Mrs. F. P. Vinton and Mrs. Henry Whitman." *Boston Daily Globe*, April 27, 1889.
174 *with his Merry Men:* Isabella collected photographs of the evening, which included two of Johns and Bunker; Dennis Miller Bunker as a Troubadour at the Boston Art Students' Association Ball, 1889; and Clayton Johns in Costume, 19th century, ISG Photographs, ISGM.
174 *review titled "Fairyland": Boston Daily Globe*, April 27, 1889.
175 *helped supply costumes:* Ruth Cabot recounted to Frances Curtis that Isabella had suggested a Cabot relative go to the ball as Primavera by Botticelli. March 30, 1889, Curtis Family Papers, Schlesinger.
175 *There'd been gossip:* Isabella Curtis to Frances Curtis, April 15, 1889, Curtis Family Papers, Schlesinger.
176 *most "successful beauty":* HA to Elizabeth Cameron, May 2, 1889, *HA Letters*, vol. 3, 173.
176 *feature of student albums:* See Anthony Calnek, *The Hasty Pudding Theatre: A History of Harvard's Hairy-Chested Heroines* (Cambridge: The Hasty Pudding Club, 1986); see also Anna Clutterbuck-Cook, "Miss Nathan Appleton Takes the Stage," Object of the Month blog, MHS, June 2019.
176 *"our historical other selves":* "The Artists Festival," *Saturday Evening Gazette*, 1889.
176 *Vienna Opera in 1884:* John N. Burk, "Wilhelm Gericke: A Centennial Retrospect," *Musical Quarterly* 31, no. 2 (April 1945), 16–87.
177 *Now the program:* Carter, 114–15.
177 *In February 1889:* Carter, 113.
177 *court-concerts in March:* Carter, 115.
177 *"high life" might be:* Envelope, to ISG, date indecipherable, ISG Papers, ISGM.
177 *"Heretofore," the paper noted:* "Mrs. Jack's Latest Lions," n.p., December 30, 1896.
177 *"Mrs. Jack's Latest Lion":* "Mrs. Jack's Latest Lion," *Boston Sunday Post*, January 31, 1897. See also *ISGAL*, 12–15.
178 *"cozily tucked up beside":* As quoted in Tharp, 155.
178 *"there are all sorts":* ISG to Mrs. Aldrich, October 8, 1888, ISG Papers, ISGM.
178 *to make a redingote:* Charles Frederick Worth for the House of Worth, fancy dress, late 1880s, early 1890s. Silk velvet with embroidery and beading, Peabody Essex Museum, gift of Isabella Stewart Gardner, 1923 (116746).
179 *what they might miss:* Carter, 115.
179 *"She's a will o' wisp":* Carter, 34.
179 *brother, John Jr.:* The best overview of Bunker and his work is by Erica E. Hirshler in *Dennis Miller Bunker: American Impressionist* (Boston: Museum of Fine Arts, 1994), 18–89.
179 *down to the chair:* I thank Shana McKenna for pointing out this similarity. Isabella would own her own Moroni when she bought his *Portrait of a Bearded Man in Black* (1576) in 1895. *La Dama in Rosso* (1556–60) was purchased by the National Gallery in London in 1876.

SIXTEEN: IN THE MIDDLE OF THINGS, 1890–91

182 *"Travelling must be":* BB to ISG, September 12, 1888, *ISG/BB Letters,* 26.

183 *"You must see":* JSS to ISG, March 1890, as quoted in Carter, 117.

183 *"On stage, the torsal":* Town Topics, April 3, 1890, a gossip newspaper published in New York, as quoted in "Notes on John Singer Sargent in New York, 1888–1890," *Archives of American Art Journal* 22, no. 4, 1982, 31.

183 *"paint a portrait or two":* JSS to ISG, February 28, 1890, ISG Papers, ISGM. See also Carter, 117–18.

184 *sort of "rude gesture":* Corinna Lindon Smith, *Interesting People: Eighty Years with the Great and the Near-Great* (Norman: University of Oklahoma Press, 1962), 118.

184 *"world-renowned* pas-seul": As quoted in Tharp, 145.

185 *"Whoever heard":* As quoted in Carter, 118.

185 *"New England conscience":* ISG to BB, August 18, 1896, *ISG/BB Letters,* 63.

185 *"intensely respectable":* HJ to ISG, June 24, 1890, *HJ/Zorzi,* 154.

185 *"most important churches":* Carter, 120.

185 *London: "Aunty Belle":* GAG to GPG, undated, GFP.

185 *relief: "Installed at":* JLG Jr. 1890 Diary, JLGJr-P.

186 *rooms were "delightful":* JLG Jr. to GPG, August 5, 1890, GFP.

186 *"an enchanting dream":* JLG Jr. to GPG, August 30, 1890, GFP.

186 *"my books don't sell":* HJ to Robert Louis Stevenson, January 12, 1891, *HJ Letters,* vol. 3, 326.

186 *"snatch of Venice":* HJ to ISG, June 24, 1890, *HJ Letters,* vol. 3, 294.

187 *"building hospitals":* Clayton Johns, *Reminiscences of a Musician* (Cambridge: Washburn and Thomas, 1929), 65.

187 *"4 gilt wood things":* JLG Jr. 1890 Diary, JLGJr-P.

187 *a lacy, ethereal effect:* Betty Hughes Morris, *A History of the Church of the Advent* (Boston: Church of the Advent, 1995), 156–57. See also *Memorial,* 204.

188 *"easier even to worship":* John Winthrop to ISG, March 29, 1891, ISG Papers, ISGM.

188 *Saint Augustine started:* For a history of Saint Augustine Church, which joined with Saint Martin Mission to become the Church of Saint Augustine and Saint Martin in 1908, see undated essay by Eldridge Pendleton, SSJE, Archives of the Church of the Advent, Cambridge, Massachusetts. See also *The Record: Mission Church of Saint John the Evangelist, Boston,* vol. 2, no. 4 (September 1891): 3-7, and saintaugustinesaintmartin.org.

188 *of about $12,000: The Record,* 1891, 7.

189 *The simple Italianate:* Sister Catherine Louise, SSM, *The House of My Pilgrimage: A History of the American House of the Society of St. Margaret, 1873–1973* (Glenside, PA: Little Page Press, 1973), 59–70.

189 *According to a story:* This scene of Isabella at the Boston Lying-In Hospital has long been part of the oral history of the Society of Saint John the Evangelist. See Brother James Koester, SSJE, sermon preached at the ISGM, April 14, 2018, SSJE Archives.

189 *ball in downtown Boston:* Documentation of the ball's location in 1891 was not found; the same ball in 1903 was held at the Somerset Hotel.

189 *photographer, James Notman:* James Notman, photographs of Myopia Hunt Club Party, June 28, 1891, ISGM.

192 *"sadly at the window":* A. J. Jephson to ISG, February 8, 1901, ISG Papers, ISGM. Jephson reminded her of their time on Roque Island in the summer of 1891; details of her time there are taken from Jephson's recollections.

192 *She canceled all:* "Personal and Social Gossip," *Sunday Herald,* July 26, 1891, 23: "Owing to the death of the father of Mrs. John L. Gardner, she was not one of the party on the coach Independence Friday last, as was expected."

SEVENTEEN: THE CONCERT, 1892

193 *"a musical meteor":* Johns, *Reminiscences of a Musician,* 53.
194 *"out of the kindness":* Johns, *Reminiscences of a Musician,* 54. This scene is described in Carter, 122–23. Johns remembered he was the only other person at the private concert, a memory contradicted somewhat by later accounts. Tharp cites a woman who claims she too was present for the evening performance and dinner, but Tharp doesn't specify more than the name and "museum archives" on how she knows this. She also gives a slightly different account of what happened than Carter. Tharp, 158–59.
194 *her "charming idea":* HLH to ISG, February 27, 1892, ISG Papers, ISGM.
195 *The Gardners lodged:* All these details come from JLG Jr. 1892 Diary, JLGJr-P.
195 *together that spring:* During a four-week span, the Gardners and Whistlers dined together five times, sometimes as a foursome and sometimes as part of a larger group. JLG Jr. 1892 Diary, JLGJr-P.
195 *an impromptu lunch:* For an account of this luncheon, see Nancy Whipple Grinnell, *Carrying the Torch: Maud Howe Elliott and the American Renaissance* (Hanover: UP of New England, 2014), 52–53.
195 *the "apostle of the":* Boston Globe, January 25, 1882.
195 *called him "fatuous":* HJ to ISG, January 23, 1882, *HJ/Zorzi,* 77. For Wilde's 1882 American tour and the intersection of aestheticism and Gilded Age culture, see Mary Warner Blanchard, *Oscar Wilde's America: Counterculture in the Gilded Age* (New Haven, CT: Yale University Press, 1998).
197 *It was discovered:* Carter, 126. Christie, Manson & Woods, *Catalogue of the Very Valuable Collection of Ancient and Modern Pictures of Frederick Richards Leyland, Esq.* (London, May 28, 1892), lot 60, 14.
198 *"fierce familiarity" with:* Henry James, *Italian Hours* (New York: Penguin Books, 1995; first published in 1909), 208.
198 *Jack's word—"enchanting":* JLG Jr. to GPG, August 13, 1892, GFP.
198 *a music aficionado:* Fanny Peabody Mason was the only daughter of William Powell Mason and Fanny Peabody Mason, sister of George Augustus Gardner's wife, Eliza Peabody Gardner.
198 *he'd "growled about":* JLG Jr. to Theodore Dwight, July 5, 1892, ISG Papers, ISGM.
198 *the "ancient world":* HJ to ISG, April 15, 1892, *HJ/Zorzi,* 173.
198 *"charming open door":* HJ to ISG, April 19, 1892, *HJ/Zorzi,* 176. Henry James had spent time in these Barbaro rooms before, during an extended stay in 1886, but never at the same time as the Gardners.
198 *and "gazed upward":* HJ to Ariana Curtis, July 10, 1892, *Letters from the Palazzo Barbaro,* ed. Rosella Mamoli Zorzi (London: Pushkin Press, 1998), 121.
199 *hair "not quite 'up'":* HJ to ISG, September 3, 1892, *HJ/Zorzi,* 190.
199 *"the little lady":* HJ to Ariana Curtis, July 10, 1892, *Letters from the Palazzo Barbaro,* 121. Jack's 1892 diary is littered with the names of friends, many from Boston, whom they walk with, dine with, or ride with in gondolas or the faster vaporetto boats that he favored. They include Mr. and Mrs. George Howe, Theodore Dwight, Fanny Mason, and the young artist who would become a close friend—Joseph Lindon Smith.

199 *the Gardners' itinerary:* The majority of the furniture Isabella placed in Fenway Court was purchased in Venice. Jack had a stronger interest in furniture than in paintings. For related details, see Fausto Calderai and Alan Chong, *Furnishing a Museum: Isabella Stewart Gardner's Collection of Italian Furniture* (Boston: ISGM, 2011).
199 *"I want to know":* HJ to ISG, July 29, 1892, *HJ/Zorzi,* 186.
200 *the fiery disaster:* For the siege of Paris and its aftermath, see Colin Jones, *Paris: The Biography of a City* (New York: Penguin Books, 2004), 323–28; see also Alistair Horne, *Seven Ages of Paris* (New York: Vintage Books, 2002), 279–83, 296–300.
200 *another staggering sum:* Telling the story of the purchase of this ruby, Carter claims that it became "her favorite jewel." Carter, 126–28. Boucheron Sales Book.
200 *"sullied and defaced":* *New York Times,* December 24, 1876.
200 *Belle had bought:* JLG Jr., Purchase lists, Dealer Files, ISGM.
201 *Isabella arranged with:* Carter, 134–35; see also Francis Suzman Jowell, "Thoré-Bürger's Art Collection: 'A Rather Unusual Gallery of Bric-à-Brac,'" *Simiolus* 30, no. 1/2 (2003): 54–119.
202 *raise a glass:* JLG Jr. Diary 1892, JLGJr-P.
202 *"Lunched today with":* Thomas Russell Sullivan, *Passages from the Journal of Thomas Russell Sullivan, 1891–1903* (Boston: Houghton Mifflin Company, 1917), 5.
202 *the second to America:* See Cynthia Saltzman, *Old Masters, New World: America's Raid on Europe's Great Pictures* (New York: Penguin Books, 2009), 46.
202 *"a perfectly clear":* Carter, 125.
203 *"busy all day packing":* JLG Jr. Diary 1892, JLGJr-P.
203 *got back to Boston:* JLG Jr. Diary 1892, JLGJr-P.

EIGHTEEN: TO REMAKE THE WORLD, 1893

205 *was only half-built:* Many of the details on the exposition come from Erik Larson, *The Devil in the White City: Murder, Magic, and Madness at the Fair That Changed America* (New York: Vintage Books, 2003). See also *World's Columbian Exposition* (Chicago: W. B. Conkey, 1893).
205 *"out-Eiffel Eiffel":* Quoted in Larson, *The Devil in the White City,* 15.
205 *"I figure you somehow":* HJ to ISG, May 1, 1893, *HJ/Zorzi,* 197. James added a memory of his recent stay at the Barbaro: "I wish I could have a little marble hall at the top of it, with thirteen screens and a pink mosquito-netting."
205 *the sculptor Rodin:* For a complete list of these items, see *World's Columbian Exposition, 1893,* 60–64.
206 *appeals to Congress:* Anna R. Paddon and Sally Turner, "African Americans and the World's Columbian Exposition," *Illinois Historical Journal* 88, no. 1 (1995): 19–36.
206 *a single word: "Slavery":* Ida B. Wells, *The Reason Why the Colored American Is Not in the World's Columbian Exposition,* with contributions by Frederick Douglass, Irvine Garland Penn, and Ferdinand Lee Barnett (Chicago: privately printed, Miss Ida B. Wells, 1893). See David W. Blight, *Frederick Douglass: Prophet of Freedom* (New York: Simon & Schuster, 2018), 726–30, and Gail Bederman, *Manliness and Civilization: A Cultural History of Gender and Race in the United States, 1880–1917* (Chicago: University of Chicago Press, 1995), 1–44.
206 *"Your enthusiasm knows":* Ralph Curtis to ISG, November 26, 1893, ISG Papers, ISGM.
207 *"Never had there been":* John J. Flinn, *Official Guide to the World's Columbian Exposition* (Chicago: The Columbian Guide Company, 1893), 62. There were countless publications related to the exposition, but this was the official guide.

208 *end of their conversation:* Carter, 137.
208 *His work would move:* See Anne-Marie Eze's comprehensive "Zorn in Boston: Isabella Stewart Gardner's 'Faithful Painter,'" in *Anders Zorn: A European Artist Seduces America* (Boston: ISGM; London: Paul Holberton Publishing, 2013), 55–65.
209 *found "Boston standing":* HA to John Hay, August 12, 1893, *HA Letters*, vol. 4, 119.
209 *own "hopeless confusion":* Sullivan, May 21, 1893, *Journal.*
210 *"a complete success":* Sullivan, July 1, 1893, *Journal.*
210 *"I don't know":* ISG to Lilian Aldrich, November 17, 1893, ISG Papers, ISGM.
210 *Boston had "definitely":* Carter, 142. Carter makes this comment in reference to the women of Boston, but it is applicable to both women and men. She had expanded her social circle through a mix of sponsoring young artists, hosting soirees, and becoming someone to know.
210 *The pages of these:* ISG Guest Book Vol. 1, 1893–1894.
210 *"helpless and hot":* HJ to ISG, August 5, 1893, *HJ/Zorzi*, 205.
211 *The Bourgets arrived:* Carter, 139.
211 *a "terrible sport":* Paul Bourget, *Outre-mer: Impressions of America* (New York: C. Scribner's Sons, 1895), 331.
211 *"delicate and invincible":* Bourget, *Outre-mer,* 108.
212 *Land's End, in Newport:* Edith Wharton wrote about her friendship with the Bourgets in "Memories of Bourget from Across the Sea," translated from Wharton's French by Adeline Tinter, *Edith Wharton Review* 8, no. 1 (Spring 1991), 23–31. See also Hermione Lee, *Edith Wharton* (New York: Vintage, 2007), 96–97, 404.
212 *pounded the piano:* Carter, 141.
212 *his "grateful feelings":* Anders Zorn to ISG, 1893, ISG Papers, ISGM
212 *"compliments of the author":* The authorship of Berenson's first book is complicated. Mary Costelloe, with whom he was living and whom he would marry in 1900, had written the first draft of the book as an essay in the fall of 1891. By the time of its publication, under Berenson's name, it was "hard to distinguish Costelloe's contributions from Berenson's . . . The book did, though, have many of Berenson's characteristic turns of thought and phrase." Cohen, 93.
212 *his "morning coffee":* BB to ISG, April 28, 1889, *ISG/BB Letters,* 31.
212 *had "put a stop":* BB to ISG, March 11, 1894, *ISG/BB Letters,* 38.
212 *"I have heard nothing":* ISG to BB, March 15, 1894, *ISG/BB Letters,* 38.
213 *"want a Botticelli?":* BB to ISG, August 1, 1894, *ISG/BB Letters,* 39.

NINETEEN: "THE AGE OF MRS. JACK," 1894–95

214 *said "keenly alive":* BB to ISG, December 4, 1898, *ISG/BB Letters,* 162.
214 *"teaches us not only":* Bernard Berenson, *The Central Italian Painters of the Renaissance* (New York: G. P. Putnam's Sons, 1900), 67. Cohen gives a full description of Berenson's maturation as an art connoisseur. For Berenson's Paterism, see especially 39–41, 48; 124–25.
215 *"I greatly value":* Walter Pater to ISG, October 1, 1886, ISG Papers, ISGM.
215 *She would list: A Choice of Books from the Library of Isabella Stewart Gardner, Fenway Court* was first printed by Merrymount Books in 1906. Walter Pater, *Imaginary Portraits* (London: Macmillan and Company, 1887); Pater, *The Renaissance: Studies in Art and Poetry* (London: Macmillan and Company, 1888). She signed the opening page of both books: "I. S. Gardner London August 1888." Copies in ISG Personal Library, ISGM.
215 *"What is important":* Pater, *Renaissance,* 2.

215 *"To burn always"*: Pater, *Renaissance*, 154.
215 *"Berenson is here"*: ISG to Gaillard Lapsley, September 25 or 26, 1897, GTL Letters.
215 *"lightening photographer"*: This and all subsequent quotations in paragraph are from "Mrs. John L. Gardner," *Boston Sunday Globe*, April 1, 1894.
216 *"A leader of society!"*: This and all subsequent quotations in next two paragraphs are from "Mrs. John L. Gardner—The Home Life and Treasures of Boston's Famous Social Leader," *Boston Journal*, April 14, 1893.
217 *"As Mrs. Gardner"*: Carter, 144.
217 *"neuralgia and rheumatism"*: Theodore Dwight to ISG, August 27, 1894, ISG Papers, ISGM.
217 *"I am distressed"*: FMC to ISG, July 28, 1894, ISG Papers, ISGM.
217 *By June 30:* All the details of this trip come from JLG Jr. 1894 Diary, JLGJr-P.
217 *"never came off"*: JSS to ISG, August 27, 1894, ISG Papers, ISGM. Isabella would later place the carpet at the center of the Titian Room in Fenway Court.
218 *Paderewski had recommended:* Tharp, 159.
218 *"having tea together"*: Carter, 146.
218 *"most imbecile life"*: Minnie Bourget to ISG, May 30, 1894, ISG Papers, ISGM.
218 *"the deluge of people"*: *The Complete Notebooks of Henry James*, ed. Leon Edel and Lyall H. Powers (New York: Oxford University Press, 1987), 126. See also Leon Edel, *Henry James: The Treacherous Years, 1895–1901* (New York: Avon Books, 1969), 139–40.
218 *noise and commerce:* Some of James's venom may be attributed to his woeful state of mind in the months after his close friend Constance Fenimore Woolson died by suicide in Venice at the start of 1894. See Anne Boyd Rioux, *Constance Fenimore Woolson: Portrait of a Lady Novelist* (New York: W. W. Norton, 2016), 309–17.
219 *"the age of Mrs. Jack"*: *The Complete Notebooks of Henry James*, 126.
219 *social and cultural gravity:* I am indebted to Alexandra Bush for this insight.
219 *to the Palazzo Barbaro:* JLG Jr. 1894 Diary, JLGJr-P. For the fascination with gondoliers, see *Gondola*, 109–16.
219 *"Mrs. G. held"*: Thomas Jefferson Coolidge, *The Autobiography of Thomas Jefferson Coolidge, 1831–1920* (Boston: Massachusetts Historical Society, 1923; first printed by Merrymount Press, 1903), 182.
219 *"ten days of healing"*: ISG Guest Book, vol. 1, 1893–94.
219 *"by far the most"*: Francis Hopkinson Smith, *Gondola Days* (Boston: Houghton Mifflin, 1897), 157.
219 *He conveyed her hauteur:* For more on this etching, see Alan Chong, "Artistic Life in Venice," *Gondola*, 104.
220 *guests to "come out"*: Tharp, 181.
220 *"stay just as you are!"*: Carter, 147.
220 *he had "finished"*: JLG Jr., October 22, 1894, Diary, JLGJr-P.
221 *an "airy diaphanous"*: *Sunday Boston Herald*, July 9, 1893.
221 *likeness was "excellent"*: *New York Times*, February 10, 1894.
221 *"The other is a portrait"*: ISG to Joseph Lindon Smith, November 4, 1894, as quoted in *Gondola*, 105.
221 *as "grandly majestic"*: As quoted in Anne-Marie Eze in "Zorn in Boston," 60. Eze correctly points out that Zorn's *Isabella Stewart Gardner in Venice* would become the "iconic, official" portrait of Gardner in part because Sargent's painting had been banished from public view. Eze, 61.
221 *"How much do you"*: BB to ISG, August 1, 1894, *ISG/BB Letters*, 39.

222 *support and "kindness":* BB to ISG, August 1, 1894, *ISG/BB Letters*, 39. Patricia Lee Rubin documents the complicated purchasing process for this painting in "'Pictures with a Past': Botticelli in Boston," in *Botticelli: Heroines and Heroes*, ed. Nathaniel Silver (Boston: ISGM; London: Paul Holberton Publishing, 2019), 21–23.
222 *"Italian pictures were":* Cohen, 119.
222 *"the living and breathing":* Cohen, 120. See also Scott Nethersole, "Botticelli, Lucretia, and the Visualization of Violence," in *Botticelli: Heroines and Heroes*, 57–77.
222 *"It has been a weary":* Bigelow to ISG, March 12, 1895, ISG Papers, ISGM.
223 *cold and snowy:* Minnie Bourget to ISG, January 15, 1895, ISG Papers, ISGM.
223 *a generation before:* William Whetmore Story's children, Julian, Waldo, and Edith, had all established themselves in Rome.
223 *the following Sunday:* Isabella recounted the scene to Thomas Russell Sullivan, which he detailed in his journal: "She has the power of presenting such scenes very vividly." Sullivan, July 8, 1895, *Journal*. A slightly different version of this meeting can be found in Carter, 149–50.
224 *truly "a lady":* Carter, 150.
224 *the "most quintessential":* ISG Guest Book, vol. 2, 1894–96.
224 *Battersea Reach:* Beholder, 200.
224 *"a pane of glass":* Quoted in Patricia de Montefort, *Whistler and Nature* (London: Paul Holberton Publishing, 2018), 58.
224 *felt much improved:* This information comes from a copy of a letter from Jack to Waldo Story, July 25, 1895. The original letter cannot be located.
224 *She placed Zorn's:* Eze, "Zorn in Boston," 60–61.
224 *In Rome, a day before:* Belle purchased the statue from Galleria Sangiorgi in Rome on April 13, 1895. For more about the figure of Horus, see Judith E. Hanhisalo, "Horus: The Divine Falcon," *Fenway Court*, 1971, 22.
225 *a kind of talisman:* Shana McKenna, "Visiting Fenway Court in the Days of Isabella," Inside the Collection blog, ISGM, February 8, 2022.
225 *her "museum idea":* ISG to BB, April 27, 1900, *ISG/BB Letters*, 214.

TWENTY: A POEM, 1896
226 *the sky "like smoke":* ISG to BB, December 2, 1895, *ISG/BB Letters*, 43.
226 *"Dear Mr. Berenson":* ISG to BB, December 2, 1895, *ISG/BB Letters*, 43.
227 *"are so desirable":* BB to ISG, November 17, 1895, *ISG/BB Letters*, 42.
227 *"forgery, misattribution":* Cohen, 115.
227 *"I have had very bad luck":* ISG to BB, December 2, 1895, ISG/BB Letters, 43.
227 *"It may be only":* ISG to BB, December 2, 1895, *ISG/BB Letters*, 43.
227 *"Mr. Gardner thinks it":* ISG to BB, December 3, 1895, *ISG/BB Letters*, 43.
228 *"possess a collection":* BB to ISG, December 18, 1895, *ISG/BB Letters*, 45.
228 *"the golden charm":* Francis Brinley Wharton to ISG, April 8, 1913, ISG Papers, ISGM.
228 *"bitten by the Rembrandt":* Isabella bought the Rembrandt portrait via the art dealers Colnaghi and Company in London on February 16, 1896, with arrangements made by Berenson. See *Beholder*, 142–43; also Saltzman, *Old Masters, New World*, 72.
228 *"I shall sell my clothes":* ISG to BB February 2, 1896, Box 55, 1894–1908, Bernard and Mary Berenson Papers, Biblioteca Berenson, I Tatti, Harvard University Center for Italian Renaissance Studies, Florence, Italy. I saw a manuscript copy of this letter in person at I Tatti, thanks to the archivist Ilaria Della Monica.
229 *Mrs. G's "newest treasure":* Thomas Russell Sullivan, March 10, 1896, *Journal*,

229 *By late April:* Isabella bought this painting in April 1896 from Colnaghi and Company for £600 via Bernard Berenson. She would look for other Isabellas for her collection.
229 *"a potent attraction":* BB to ISG, March 25, 1896, *ISG/BB Letters,* 51.
229 *"Isabella d'Este is here":* ISG to BB, April 25, 1896, *ISG/BB Letters,* 52.
229 *"a tête-à-tête":* The full quotation reads: "Happiness of the collector, happiness of the solitary: a tête-à-tête with things." Walter Benjamin, *The Arcades Project,* translated by Howard Eiland and Kevin McLaughlin, prepared on the basis of the German volume edited by Rolf Tiedmann (Cambridge, MA: Belknap Press, 1999), 866.
229 *"They and music":* BB to ISG, April 25, 1896, *ISG/BB Letters,* 52.
229 *"tightly swathed round":* MC Papers.
229 *Green Hill Stable:* Tharp, 187. Isabella directed a yearly donation of seventy-five dollars to the Massachusetts Society for the Prevention of Cruelty to Animals in memory of her three favorite horses, Dolly, Pluto, and Lady Betty. See Diana Seave Greenwald, "ISG and Her Horses," Inside the Collection blog, ISGM, April 26, 2022.
230 *"with the birds":* BB to ISG, April 25, 1896, *ISG/BB Letters,* 52.
230 *made "a past for":* GTL to ISG, July 28, 1896, ISG Papers, ISGM.
230 *"a great outdoor":* Benjamin Brooks, "A New England Garden Home: The Summer Seat of Mrs. Gardner, A Piece of Individualism in Landscape-Gardening," *Country Life in America,* March 1902, 150.
230 *the "subtle harmony":* Hildegarde Hawthorne, "A Garden of the Imagination: Mrs. Gardner's at 'Green Hills,' Near Boston," *Century Magazine,* vol. 80, 447.
230 *"grubbing in the earth":* As quoted in Amory, "Gardner in the Garden, Part One," 68. I am indebted to Sukie Amory's graceful two-part article on Gardner and her gardens for these details. See esp. 64–68.
232 *"Busy Ella" was:* Smith, *Interesting People,* 154.
232 *"One of the few greatest":* BB to ISG, May 10, 1896, *ISG/BB Letters,* 55.
233 *observed, "there's nothing":* BB to ISG, June 22, 1896, *ISG/BB Letters,* 58.
233 *hitches and wrangling:* For the longer story of this purchase, see Nathanial Silver, *Titian's Rape of Europa* (Boston: ISGM, 2021), 20–25; see also Saltzman, *Old Masters, New World,* 72–81. Charles FitzRoy describes in detail how Berenson played his cards in his May 10 letter, accusing him of "skullduggery," in *The Rape of Europa: The Intriguing History of Titian's Masterpiece* (London: Bloomsbury, 2015), 170–74.
233 *"When comes Europa?":* ISG to BB, 19, 1896, *ISG/BB Letters,* 59.
233 *"I hope you have ":* ISG to BB, August 2, 1896, *ISG/BB Letters,* 61.
233 *But* Europa *was one:* See Matthias Wivel et. al., *Titian: Love, Desire, Death* (London: National Gallery Company, distributed by Yale University Press, 2020), esp. Nathaniel Silver on *Europa,* 167–72; also Charles FitzRoy, *The Rape of Europa: The Intriguing History of Titian's Masterpiece* (London: Bloomsbury, 2015).
234 *"There is the whole"* ISG to BB, August 2, 1896, *ISG/BB Letters,* 61.
234 *"She has come!":* ISG to BB, August 25, 1896, *ISG/BB Letters,* 64.
234 *"I am having":* ISG to BB, September 11, 1896, *ISG/BB Letters,* 65.
234 *"I am breathless":* ISG to BB, September 19, 1896, *ISG/BB Letters,* 66. All quotations to the end of the paragraph are from this letter.
234 *tears "all of joy!":* ISG to BB, September 19, 1896, *ISG/BB Letters,* 66.
234 *"Dear Mrs. Gardner, TITIAN":* ISG to BB, September 19, 1896, Mary and Bernard Berenson Papers, Biblioteca Berenson, I Tatti, Harvard University.
234 *"Boston was changed":* Charles Eliot Norton to ISG, January 9, 1902, ISG Papers, ISGM.

235 *"The very thought of it":* ISG to BB, September 19, 1896, *ISG/BB Letters,* 66.
236 *"He says it's disgraceful":* ISG to BB, August 18, 1896, *ISG/BB Letters,* 63.

TWENTY-ONE: "LIST OF THINGS FOR THE MUSEUM," 1897

237 *the* Boston Chronicle: "Disastrous Fire, Prof. Sargent's 'Holm Lea' Badly Damaged on Monday Night Last," *Boston Chronicle,* December 19, 1896.
238 *"While all the members":* William Phillips to Mr. Metcalf, April 10, 1942, MS Am 1178, Houghton. William Phillips was also the great-nephew of Wendell Phillips and later ambassador to Canada.
238 *were chatty letters:* There are four letters from Charles Sargent to Isabella in the ISGM, all of them friendly, one signing off "horticulturally yours" and complimenting her on one of her hats.
238 *"His Majesty is here!":* ISG to BB, February 8, 1897, *ISG/BB Letters,* 75.
238 *manner as the Titian:* ISG to BB, January 1, 1897, *ISG/BB Letters,* 72.
238 *"When do you think":* ISG to BB, January 1, 1897, *ISG/BB Letters,* 72.
239 *"I have been unpacking":* ISG to BB, February 8, 1897, *ISG/BB Letters,* 75.
239 *"Few characters in history":* Walter Armstrong, *Velázquez: A Study of His Life and Art* (London: Seeley and Company, Limited, 1897), 26.
239 *"He is glorious":* ISG to BB, February 8, 1897, *ISG/BB Letters,* 75.
239 *go back and forth:* For a concise account of this exchange, see Ernest Samuels, *Bernard Berenson: The Making of a Connoisseur* (Cambridge, MA: Belknap Press, 1979), 248–50.
239 *March 1897, she purchased:* Carter, 162; Dealer Files, ISGM. See also Kathleen Weil-Garris Brandt, "Mrs. Gardner's Renaissance," 10–30.
240 *"the light of his soul":* Carter noted this detail in his handwritten notes for his biography of Isabella but excluded it from the published text. MC Papers. See also Travel Album: Spain, vol. 1.
240 *"frank but slight":* Richard Norton to ISG, December 5, 1897, ISG Papers, ISGM. For more about this extraordinary purchase, see Christina Nielsen, ed., *Life, Death, and Revelry* (Boston: ISGM; London: Paul Holberton Publishing, 2018), esp. 12–29.
241 *the notebook's title:* ISG, "List of Things for Museum," March 25, 1897–December 26, 1898, ISG Papers, ISGM.
241 *draw up preliminary plans:* WTS Diary, September 1, 1896. These plans are, unfortunately, no longer extant.
241 *Maybe they could buy:* Carter, 162; see also Tharp, 203.
241 *A friend remembered:* Corinna Lindon Smith recounts a dinner when Jack and Isabella discussed the advantages and disadvantages of various plans; see her *Interesting People,* 154.
241 *the Emerald Necklace:* For a vivid description of Olmsted's Emerald Necklace, see Hugh Howard, *Architects of an American Landscape: Henry Hobson Richardson, Frederick Law Olmsted, and the Reimagining of America's Public and Private Spaces* (New York: Atlantic Monthly Press, 2022).
242 *a "homemade universe":* Susan Stewart, *On Longing: Narratives of the Miniature, the Gigantic, the Souvenir, and the Collection* (Durham, NC: Duke University Press, 1993), 162.
242 *"Things to be taken":* "List of Things for Museum," ISG Papers, ISGM.
243 *"Here I am again":* ISG to BB, May 3, 1897, *ISG/BB Letters,* 83.
243 *She enjoyed his wit:* Lee, *Edith Wharton,* 248.
244 *"She is the one":* BB to Mary Costelloe, as quoted in Samuels, *Berenson,* 286.

244 *or building facades:* For a detailed accounting of these purchases, see Giovanna De Appolonia, "A Venetian Courtyard in Boston," *Gondola,* 177–200.
244 *"The Sicilian dream":* ISG to GTL, October 22, 1897, GTL Letters.
244 *child-size marble sarcophagus:* Jack bought this sarcophagus, along with six other ancient sculptures, for 5,000 francs via the art dealer Saturnino Innocenti. See also Dealer Files, ISGM.
244 *the head of Medusa:* Henry Louis Gates Jr. is eloquent about the floor: "Medusa, depicted in the mosaic, was one of the three Gorgons whom Herodotus places in a region he calls Libya, adjoining the land of darkness. Alone of her sisters, Medusa was mortal and, initially, a beautiful maiden, until Athena turned her hair into serpents, because she had slept with Poseidon. And where I come from, in my culture, that hair would be known as bad or kinky hair. So, at the heart of this museum, staring us in our faces as we gaze upon Mrs. Gardner's garden, our primal Egyptian god stands guard over a first-century Roman mosaic pavement, at the center of which is a dreadlocked head of a woman from North Africa. I think of this garden as the sunken garden of Western civilizations. And I think of it as a metaphor for the construction of our idea of Western culture itself, as well of the place of the African presence in it." Henry Louis Gates Jr., "Mrs. Gardner's Sunken Garden," *Beholder,* 2. See also Anne Hawley, *Beholder,* 2.
244 *had seen this mosaic:* Jack wrote in his diary on March 12, 1895: "Went at 11am with Prof. Lanciani and a party to visit the Colonna gardens, then w/went to see the mosaic pavements found at Villa Livia. One about 5 metres square abt 26 small pieces, say 5 pces wide and 5 or 6 long. Middle piece abt one metre square. Design—Gorgon's head in the middle, arabesques, and a few birds in outer pieces . . . Asking price . . . 30,000 lire." JLGJr-P, ISGM.
245 *"I cry for Italy":* ISG to GTL, November 6, 1897, GTL Letters.
245 *"What fun you must":* BB to ISG, November 17, 1897, *ISG/BB Letters,* 100.
245 *"one seething storm":* ISG to GTL, December 25, 1897, GTL Letters.
245 *"No sleep and no food":* ISG to BB, December 25, 1897, *ISG/BB Letters,* 113.

TWENTY-TWO: "I ALWAYS KNEW WHERE TO FIND HIM," 1898

246 *"Everywhere bits of Italy":* ISG to BB, January 20, 1898, *ISG/BB Letters,* 120.
247 *Visitors tired her out:* Isabella described details of her fall and her response to Gaillard Lapsley, February 12, 1898, GTL Letters.
247 *"French grande dame!":* Sullivan, February 8, 1898, *Journal,* 233.
247 *"lamentable little accident":* HJ to ISG, April 3, 1898, *HJ/Zorzi,* 255.
247 *"She will be lifted":* "Boston's Society Leader Laid Up in Bed with a Broken Leg," *New York Times,* February 14, 1898.
247 *Wagner's* Lohengrin: Carter, 171.
247 *"Mrs. Jack Gardner is":* As quoted in Tharp, 205.
247 *"pièce de résistance":* Unnamed newspaper, May 22, 1898, clip kept in Archives Subject Files, ISGM.
247 *patronesses of art:* Weil-Garris Brandt, "Mrs. Gardner's Renaissance," 12.
248 *"chose what they want":* ISG to BB, May 16, 1898, *ISG/BB Letters,* 137.
248 *"They paint, they paint":* ISG to GTL, May 16, 1898, GTL Letters.
248 *"The air from the sea":* ISG to BB, July 18, 1898, *ISG/BB Letters,* 145.
248 *"raking in 1st prizes":* ISG to BB, July 18, 1898, *ISG/BB Letters,* 145.
248 *"Such festivities, such smart":* ISG to BB, September 9, 1898, *ISG/BB Letters,* 151.
248 *"here it is wild":* ISG to GTL, August 6, 1896, GTL Letters.

NOTES

248 *"a little too much"*: ISG to BB, September 9, 1898, *ISG/BB Letters*, 151.
249 *"Let us aim awfully high"*: ISG to BB, September 19, 1896, *ISG/BB Letters*, 66.
249 *almost "semi-sacred"*: As quoted in *ISGM Guide 17*, 96.
249 *scribe and librarian:* For a detailed discussion of questions about the attribution for Isabella's Raphael and a comparison to a portrait of the same figure, a painting now in Florence, see Nathaniel Silver, *Close-Up: Raphael and the Pope's Librarian* (Boston: ISGM; London: Paul Holberton Publishing, 2019), 7–9.
249 *"one of Raphael's"*: BB to ISG, January 16, 1898, *ISG/BB Letters*, 119.
249 *far greater fortunes:* The bibliography of art collecting is long. Jean Strouse gives a summary of the American art market in 1890s, and its turn to old masters, in *Morgan: American Financier* (New York: Random House, 1999), 375–76; see also Cynthia Saltzman, *Old Masters, New World: America's Raid on Europe's Great Pictures* (New York: Penguin Books, 2008), esp. 2–7. Richard L. Kagan explains how wealthy Americans "looked abroad to create the artistic and cultural patrimony their nation supposedly lacked." Art collecting, especially art from Europe, was construed as both a "civic or patriotic activity" and an assertion of wealth via "conspicuous consumption" in Thorstein Veblen's 1899 formulation. Old masters, according to Kagan, became the "real markers of status." Kagan, *The Spanish Craze: America's Fascination with the Hispanic World, 1779–1939* (Lincoln: University of Nebraska Press, 2019), 234–35.
249 *immense financial resources:* See William L. Vance, "Berenson and Mrs. Gardner: 'A Rivalry of Aspirations," *New England Quarterly* 61, No. 4 (December 1988), 576.
249 *who "seemed to want":* Strouse, *Morgan*, 485. For more on Morgan's voraciousness in buying, see Cohen, 168; Saltzman, *Old Masters*, 93–96.
250 *1897: over $250,000:* Carter Inventory, 1923, ISGM. For a list of art expenditures year by year, along with sum totals in today's dollars, see *ISGAL*, 155.
250 *"thinks every bad"*: ISG to BB, January 12, 1898, *ISG/BB Letters*, 116.
250 *confused "too easily"*: ISG to BB, February 18, 1898, *ISG/BB Letters*, 124.
250 *purchase "quite impossible"*: ISG to BB, February 23, 1898, *ISG/BB Letters*, 125.
250 *who "hates it"*: ISG to BB, March 3, 1898, *ISG/BB Letters*, 128.
250 *"affair seems a mystery"*: ISG to BB, March 7, 1898, *ISG/BB Letters*, 128.
250 *"Mr. G. says find out"*: ISG to BB, March 7, 1898, *ISG/BB Letters*, 128.
250 *"Inghirami is yours"*: BB to ISG, March 13, 1898, *ISG/BB Letters*, 128.
251 *letting Isabella know:* This is a complicated issue sorted out in somewhat varying ways. See Cohen, 125–28; Samuels, *Berenson*, vol. 1, 298–302; Vance, ""Rivalry," 588.
251 *Berenson worried endlessly:* Mary Berenson wrote in her diary for June 23, 1898: "Our last week in Venice was one of great anxiety—business complications with Mrs. Gardner—Bernhard was awfully worried and felt at times almost suicidal." *Mary Berenson: A Self-Portrait from Her Letters and Diaries*, ed. Barbara Strachey and Jayne Samuels (New York: W.W. Norton, 1983), 76.
251 *that "cheating Gardner"*: Cohen, 127.
251 *"As there are at least"*: BB to ISG, July 31, 1898, *ISG/BB Letters*, 147.
251 *"I have just got"*: ISG to BB, August 30, 1898, *ISG/BB Letters*, 150.
251 *"My dear friend"*: ISG to BB, September 25, 1898, *ISG/BB Letters*, 154.
252 *"how are you?"*: ISG to BB, October 10, 1898, *ISG/BB Letters*, 155.
252 *"Please, dear friend"*: BB to ISG, October 18, 1898, *ISG/BB Letters*, 155–56; two fragments are dated in Isabella's hand.
252 *"And do you understand"*: ISG to BB, November 7, 1898, *ISG/BB Letters*, 158.
252 *"The November gray"*: ISG to BB, December 3, 1898, *ISG/BB Letters*, 161.

NOTES

253 *"We have had such storms":* ISG to BB, December 3, 1898, *ISG/BB Letters,* 161.
254 *Jack Gardner died:* Carter, 173; Tharp, 209–11.
254 *make Green Hill flourish:* John Gardner Sr. gave Green Hill to Jack, who then bequeathed it to Isabella.
254 *"one of the best-known":* Boston Evening Transcript, December 12, 1898.
255 *"running rough shod":* MC Papers.
255 *come to him always:* Carter, 52.
255 *"uproariously" at a dinner:* MC Papers.
255 *"perverseness in her":* MC Papers.
255 *given her "his heart":* MC Papers.
255 *"My Mopsa is little":* JLGJr-P.
255 *"It has been interesting":* Frances Rollins Morse to William James, December 28, 1900, in *The Correspondence of William James,* vol. 9, July 1899–1901, ed. Ignas K. Skrupskelis and Elizabeth M. Berkeley (Charlottesville: University Press of Virginia, 2001), 400.
256 *gardens at Green Hill:* MC Papers.
256 *"You may well suppose":* James Whistler to ISG, undated letter, ISG Papers, ISGM.
256 *"I can't tell you":* HJ to ISG, February 2, 1899, *HJ/Zorzi,* 233–34.
256 *"My dear Mrs. Gardner":* Henry Higginson to ISG, December 12, 1898, ISG Papers, ISGM.
257 *print of Marie Antoinette:* Olga Gardner Monks to ISG, March 1923, 1923, ISG Papers, ISGM. Monks's letter reads in part: "Uncle Jack's picture is hung and it is lovely to have it in my room. It will always mean a great deal to me. The other picture I am going to hang in the library and I shall always think of them as over your bed."
257 *most likely from this time:* Mary S. Munro (wife of Dr. John C. Munro), October 21, 1934, MC Papers.

TWENTY-THREE: FENWAY COURT, 1899–1901

261 *"Z—was very dear":* ISG to GTL, January 30, 1899, GTL Letters.
261 *"in touch with the world":* ISG to GTL, January 30, 1899, GTL Letters.
262 *Charles Gounod's Faust:* Display Ad 17—no title, *New York Times,* January 10, 1899, 14.
262 *Her nephew Amory Gardner:* ISG to GTL, January 30, 1899, GTL Letters.
262 *reading detective fiction:* Carter, 247.
262 *When he arrived:* WTS Diary, December 29, 1898, 7.
262 *"Called on Mrs. J. L.":* WTS Diary, December 30, 1898, 7.
262 *the purchase deed:* Property Deed and Plan to Augustus Peabody Loring, Henry M. White, January 14, 1899, ISG Papers, ISGM.
263 *The bequest was split:* Tharp, 216.
263 *the trust "to pay over":* This is the language in the will: "I may have any power of testamentary appointment, except the property mentioned in the preceding article, to my said cousin John Chipman Gray and my said nephews George Peabody Gardner and Augustus Peabody Gardner, and their heirs, as joint tenants, but in trust nevertheless: 1st To pay the net income to my wife during her life; 2nd To pay over, transfer and convey to my wife or her appointee, the whole, or from time to time, any portion of the trust fund or property then existing in their hands, as she may in writing appoint free and discharged from all trusts, but this is not to affect the power of the trustees to changes investments in the trust fun as is hereafter provided." Will of JLG Jr., June 6, 1896, JLGJr-P.
263 *"she had a level head":* MC Papers.
263 *"too much of mental":* ISG to BB, January 22, 1899, *ISG/BB Letters,* 167.
264 *she felt "torn in a":* ISG TO BB, May 17, 1899, *ISG/BB Letters,* 174.

264 *being "on the hunt"*: ISG to BB, May 23, 1899, *ISG/BB Letters*, 176.
264 *"Tell me exactly what"*: ISG to BB, May 31, 1899, *ISG/BB Letters*, 177.
264 *"almost as jewel-like"*: BB to ISG, January 22, 1899, *ISG/BB Letters*, 166.
264 *was "something wrong"*: ISG to BB, May 31, 1899, *ISG/BB Letters*, 177.
265 *Sears reported in his diary*: WTS Diary, 9.
265 *the glittering prize inside*: "Mrs. Jack Gardner's Palace Mystifies Back-Bay Bostonians," *Philadelphia Press*, March 17, 1901; "Weird Wall Shuts Mrs. 'Jack' Gardner's Palace in from the World . . ." *Boston Herald*, June 19, 1901. An early reviewer wrote of the "grace and glory" of the interior. Anne O'Hagan, "The Treasures of Fenway Court," 663.
266 *settled part of the city*: Hugh Howard, *Architects of an American Landscape: Henry Hobson Richardson, Frederick Law Olmsted, and the Reimagining of America's Public and Private Spaces* (New York: Atlantic Monthly Press, 2022), 191.
266 *from Italian workrooms*: James J. Rorimer, curator of medieval art at the Metropolitan Museum in New York, told Morris Carter that as far as he knew, "Mrs. Gardner was the first person in America to acquire architectural details." Rorimer to MC, January 14, 1939, MC Papers.
266 *She met Berenson for dinner*: Samuels, *Berenson*, 306–7.
266 *he told her about*: For the story of this purchase, see Silver, *Europa*, 26–28.
266 *thought about her* Europa: ISG to BB, August 16, 1899, *ISG/BB Letters*, 187.
266 *the price was "insanity"*: ISG to BB, August, 11, 1899, *ISG/BB Letters*, 186.
267 *"cagey prince, rival dealers"*: Patricia Lee Rubin, "'Pictures with a Past': Botticelli in Boston," in *Botticelli: Heroines and Heroes*, ed. Nathaniel Silver (Boston: ISGM; London: Paul Holberton Publishing, 2019), 23–26. Samuels expertly untangles this purchase in *Berenson*, 303–6. See also *Beholder*, 58.
267 *"a grand old* temporale": ISG to BB, August 16, 1899, *ISG/BB Letters*, 187.
267 *"au niveau de la mer"*: ISG to BB, August 25, 1899, *ISG/BB Letters*, 188.
267 *She asked him when Boston*: ISG to Sears, August 16, 1899, as quoted in Carter, 178.
267 *"It is most interesting"*: ISG to WTS, August 16, 1899, ISG Papers, ISGM.
267 *The receipt from the dealer*: Francesco Dorigo, Dealer Files, ISGM.
268 *"how I hate Genoa"*: ISG to BB, October 18, 1899, *ISG/BB Letters*, 191.
268 *"all the gems she could"*: HA to Lady Curzon, November 28, 1899: "She and I are agreed that, short of an income of five million a year, nothing worth doing can be done." *HA Letters*, vol. 5, 63.
268 *"to see all her Van Eycks"*: HJ to Charles Eliot Norton, November 28, 1899, *HJ Letters*, vol. 4, 124.
268 *full of "valuable things"*: Henry James, *The Spoils of Poynton* (New York: Penguin Books, 1987; first published in 1897), 49.
269 *Isabella hated being there*: ISG to BB, December 6, 1899, *ISG/BB Letters*, 197.
269 *to dine "in peace"*: ISG to BB, December 26, 1899, *ISG/BB Letters*, 198.
269 *"Keep well," she wrote*: ISG to BB, January 19 1900, *ISG/BB Letters*, 201.
269 *found "very slow work"*: ISG to BB, February 11, 1900, *ISG/BB Letters*, 205.
269 *had bought through him*: ISG to BB, December 26, 1899, *ISG/BB Letters*, 199.
269 *"Don't let all this"*: ISG to BB, February 4, 1900, *ISG/BB Letters*, 203. Casey Riley's interpretation of this catalog is especially insightful as to how Isabella used photography to document and secure her collection. Riley, "Self-Assembled: Isabella Stewart Gardner's Photographic Albums and the Development of Her Museum," ed. Elizabeth Edwards and Christopher Morton, in *Photographs, Museums, Collections: Between Art and Information* (London: Bloomsbury Academic, 2015), 47–63.

269 *called it a "jolly idea":* BB to ISG, Easter Sunday, 1900, ISG/BB Letters, 213.
270 *ended up raising $1,500: Annual Report 1900,* Donations to the Land and Building Fund, Cotting School, Lexington, MA. I am grateful to Elizabeth Peters at the Cotting School for her help in reconstructing this part of Isabella's story.
270 *"Mecca of fashionable Boston": Boston Daily Globe,* March 30, 1900. Francis "Fanny" Rollins Morse, who later helped found the School of Social Work at Simmons College, agreed with the newspaper's assessment of the occasion in a letter to William James on March 21, 1900. *William James Correspondence* (Charlottesville: University Press of Virginia, 1992–2004, vol. 9), 592.
270 *project on the Fenway:* In addition to Carter, Tharp, the *Gardner Memorial,* and ISGM guides to the museum, I drew from several other sources, including Linda J. Docherty, "Collection as Creation: Isabella Stewart Gardner's Fenway Court," in *Memory and Oblivion,* (Dordrecht: Springer Netherlands), 217–21; Anne Higonnet, *A Museum of One's Own: Private Collecting, Public Gift* (New York: Periscope Publishing, 2009), esp. 157–67; "Mrs. Gardner's Museum of Myth," *RES: Anthropology and Aesthetics,* no. 52 (Autumn 2007), 212–20; Elizabeth Ward Perkins, "Mrs. Gardner and Her Masterpiece," *Scribner's* 76, no. 3 (March 1925): 227–35. See also *ISGAL,* 90–97.
270 *"my man of business":* Tharp, 127. Tharp describes George Peabody Gardner's frustration that his Aunty Belle absorbed too much of his time, though she does not provide direct documentation.
270 *this sort of foundation:* Carter, 183–84.
271 *column or capital:* Melba, *Melodies and Memories* (New York: George H. Doran Company, 1926),145.
271 *"would not be bothered":* John Evans, August 10, 1900, WTS Diary, 18.
272 *"I am fighting":* ISG to BB, March 19, 1900, *ISG/BB Letters,* 210.
272 *"I am well aware":* Carter, 184–85.
272 *to "get on a piece":* ISG to BB, March 4, 1900, *ISG/BB Letters,* 207.
273 *"get me a piece":* ISG to BB, October 1, 1900, *ISG/BB Letters,* 229.
273 *"one toot for mason":* Carter, 186.
274 *"This ungrateful America":* ISG to BB, April 27, 1900, *ISG/BB Letters,* 213.
274 *"It is always the same":* ISG to HWS, September 8, no year, HWS-P.
274 *was set at $50,000:* Incorporation Records, ISGM.
274 *but not much more:* Linda Docherty rightly notes that bringing European Old Masters of this caliber to Boston gave Gardner unrivalled social standing, observing that "Gardner reveled in the power and pleasure of possession." Docherty, "Translating Dante: Isabella Stewart Gardner's Museum as *Paradiso,*" *Religion and the Arts* 22 (2018), 203.
275 *familiar spiritual comfort:* "Services in Mrs. Gardner's Palace Chapel," unnamed paper, December 25, 1901. Isabella by this point had started using a newspaper service, which clipped any report that mentioned her. This clipping is stamped with the service's date stamp. Newspaper Clipping File, ISG Papers, ISGM.
275 *a way, started it all:* Isabella moved the Zurbarán from the chapel to Spanish Chapel on the first floor in 1915.
275 *"I think I shall call":* ISG to BB, September 19, 1896, *ISG/BB Letters,* 66.
275 *"I send a dear little":* ISG to BB, December 23, 1901, *ISG/BB Letters,* 280.
275 *"command of lighting":* Riley, "Self-Assembled: Isabella Stewart Gardner's Photographic Albums and the Development of Her Museum," 52. For more on Marr and his son Arthur Marr, see Ron Polito, *T. E. Marr (& Son): Isabella Stewart Gardner's Photographers*

and More, *Their Lives, Their Work, Their Photographic Techniques* (Waltham, MA: The Photographic Historical Society of New England, 2021).
275 *"your letters make me"*: Anders Zorn to ISG, May 23, 1894, ISG Papers, ISGM.

TWENTY-FOUR: GOD IS IN THE DETAILS, 1902–3

278 *easy or obvious meanings*: My understanding of Fenway Court has been greatly influenced by Alan Chong's scholarship, as when he asks: "Was her museum intended to provide the raw materials, narrative suggestions, and interconnections between media for viewers to fashion their own appreciation of culture, even if unhistorical?" See Chong, "Mrs. Gardner's Museum of Myth," *Res* 52, 213.
278 *"woven into the shape"*: As quoted in Chong, "Mrs. Gardner's Museum as Myth," *Res* 52, 220.
279 *wasn't really Chinese*: *Journeys*, 30. Alan Chong speculates that Isabella called it a Chinese room to avoid the growing fad in America for so-called Japanese rooms.
279 *There were pieces*: Chong, "Introduction," *Journeys*, 28. She paid $25,000 in 1902 for six sculptures that included these Buddhas as well as a twenty-four-handed statue of Guanyin.
279 *and "random Orientalism"*: *Beholder*, 174.
280 *It is a masterpiece*: For Isabella's purchase of this painting, its provenance, and later identification as by D'Amelia, see especially Nathaniel Silver, *Close-Up: Piermatteo D'Amelia* (Boston: ISGM, 2016).
281 *"foot in the mouth"*: Sebastian Smee, "A Foot, Poetic in Its Singularity," *Boston Globe*, March 10, 2015.
281 *of the maternal bond*: *ISGM Guide 17*, 105.
282 *symbols of the Virgin Mary*: I am indebted to the expertise of Tess Fredette, the senior textile conservator at the museum for two decades. Her explanations of her work in conserving the Yellow Room, Raphael Room, and Titian Room were particularly central to my understanding of how Isabella used textiles of all kinds to support and amplify her vision. See also interview with Fredette in the *Boston Globe,* October 15, 2021; and Tess Fredette, "Silk Walls: Bold, Colorful, and Meaningful," Inside the Collection blog, ISGM, July 13, 2021.
282 *all the other galleries*: A. W. McClure Jr. wrote to Isabella, "I am told the Rafael is your favorite room." The letter has no date. ISG Papers, ISGM.
283 *her "house is only"*: ISG to BB, January 17, 1902, *ISG/BB Letters,* 282.
283 *"There is but one thing"*: Lucy Allen Paton, *Elizabeth Cary Agassiz: A Biography (*Boston: Houghton Mifflin Company, 1919), 377.
283 *"Build as thou will"*: Poem by Thomas Bailey Aldrich, ISG Papers, ISGM.
283 *"What an Easter"*: ISG to BB, April 1, 1902, *ISG/BB Letters,* 285.
283 *"This place this morning"*: ISG to BB, May 23, 1902, *ISG/BB Letters,* 288.
284 *"half of me seems gone"*: ISG to BB, July 29, 1902, *ISG/BB Letters,* 295.
284 *"I still go daily"*: ISG to Mary Berenson, November 22, 1902, *ISG/BB Letters,* 308.
284 *"note of triumph"*: Melba, *Melodies and Memories,* 145.
284 *"Finished," she wryly noted*: ISG to Mary Berenson, November 22, 1902, *ISG/BB Letters,* 308.
285 *her "long flowing black"*: Anne Hawley and Alexander Wood give a vivid account of the occasion in "A Sketch of a Life: Isabella Stewart Gardner," *Isabella Stewart Gardner Museum: Daring by Design* (Boston: ISGM, 2014), 7–9. I have drawn details from

a range of sources, including notes written by the former museum archivist Susan Sinclair, which she based on various newspaper reports, some with bibliographic information and some without: also Carter, 199–201; Tharp, 3–4, 242–45.

285 *smell of burning coal:* Tharp, 243.
286 *"a freeze of Best Boston":* MC Papers.
286 *restaurant in provincial France:* Tharp, 245. R. W. B. Lewis explains that Isabella and Edith Wharton were "unable to warm up to one another. Their comparable energies clashed; the assertiveness of each grated on the other; their assurance in matters of art and travel was in conflict. Edith, in addition, was never at ease with breezy and coquettish women—partly because, as she sometimes wistfully confessed, she would have liked herself to have more of those qualities." *Edith Wharton: A Biography* (New York: Harper and Row, 1977), 115.
286 *without any echo:* As quoted in Tharp, 244.
287 *"will long be memorable":* Boston Post, January 2, 1903.
287 *"your house beautiful":* Julia Ward Howe to ISG, n.d., ISG Papers, ISGM.
287 *her "poetic conception":* Charles Eliot Norton to ISG, January 2, 1902 (possibly 1903), ISG Papers, ISGM.
287 *"wonderpalace" or adequately:* Gericke to ISG, January 4, 1903, ISG Papers, ISGM.
287 *"perfection of all things":* William James to ISG, January 3, 1903, ISG Papers, ISGM.
287 *"turned by your praise":* ISG to Charles Eliot Norton, January 3, 1903, as quoted in Tharp, 245.
287 *work of scholarship:* Cohen, 133.
287 *"All went well":* ISG to BB, January 17, 1903, *ISG/BB Letters,* 313.
287 *"Mrs. Gardner's Art Museum":* Boston Daily Globe, February 24, 1903.
288 *"Our life in America":* Fanny B. Ames to ISG, April 20, 1903, ISG Papers, ISGM.

TWENTY-FIVE: UNFATHOMABLE HEART, 1903–4

289 *"No more self-contained":* "Mrs. Jack's Palace," *New York Sun,* February 22, 1903.
290 *"You are a creator":* HA to ISG, February 9, 1906, *HA Letters,* vol. 6, 5.
290 *"I fancy no one":* ISG to BB, January 19, 1904, *ISG/BB Letters,* 327.
290 *"You ask if I am happy?":* ISG to BB, August 2, 1904, *ISB/BB Letters,* 342.
290 *and cultural authority:* Anne Higonnet argues that Isabella made herself a cultural leader by exercising the "authority of a museum," which "far exceeded her role as a collector . . . Gardner's genius lay in her understanding that she could be the individual who controlled and designed that authority. In order to do so, she had to understand how to exert authority in specifically visual forms that went beyond the art objects that she acquired." Higonnet, "Private Museums, Public Leadership: Isabella Stewart Gardner and Art of Cultural Authority," in *Cultural Leadership in America: Art Matronage and Patronage* (Boston: ISGM, *Fenway Court* vol. 27), 79. According Wanda Corn, Fenway Court made "visible the line that was crossed by a few wealthy women in the late nineteenth century from being angels of culture within a domestic setting to being queens of culture in public." Corn, "Art Matronage in Post-Victorian America," in *Cultural Leadership in America,* 23. See also Anne Higonnet, *A Museum of One's Own* (New York: Periscope Publishing, 2009), 157–67.
290 *Early on, a woman:* Tharp, 262.
291 *"so little information":* "Mrs. Gardner's Art Museum Opened to Inspection," *Boston Globe,* February 24, 1903.
291 *"a bundle of nerves":* Smith, *Interesting People,* 166.

291 *"past weeks have taught"*: ISG to HWS, March 16, possibly 1903, HWS-P. There is some debate in the papers about whether this letter was written in 1903 or 1908. For more details on what it was like to visit Fenway Court in the early years, see Shana McKenna, "Visiting Fenway Court in the Days of Isabella," Inside the Collection blog, ISGM, February 8, 2022.
292 *"every day it gets more"*: JSS to ISG, Tuesday, no day or month, 1903, ISG Papers, ISGM.
292 *"a rabbit in the presence"*: As quoted in Charles Merrill Mount, *John Singer Sargent* (New York: W.W. Norton, 3rd ed., 1969), 206.
292 *"trains of baggage"*: JSS to ISG (possibly 1903), ISG Papers, ISGM.
293 *not bow and scrape:* Tharp, 115. Tharp notes that Isabella favored Loeffler above all others whom she supported but does not provide direct documentation.
293 *to float on air:* Ralph P. Locke, "Charles Martin Loeffler: Composer at Court," *Fenway Court*, vol. 8 (1974), 30–37; see also Ellen E. Knight, *Charles Martin Loeffler: A Life Apart in American Music* (Champaign: University of Illinois Press, 2010).
294 *friendship with both artists:* I drew details of Sargent's residency at Fenway Court from the excellent account by Casey Riley in "An Artist-in-Residence: John Singer Sargent at Fenway Court," in *Sargent on Location: Gardner's First Artist-in-Residence* (Boston: ISGM, 2018), esp.15–25.
294 *economics at Harvard:* For an account of this first meeting of Isabella and A. Piatt Andrew, see also Tharp, 276–77.
295 *"went over to Fenway Court"*: APA Diary, April 15, 1903.
296 *Gretchen Warren worried:* See Riley, "An Artist-in-Residence," 28–33.
297 *"At the risk of boring"*: JSS to ISG, no day or month, 1903, ISG Papers, ISGM.
297 *"into curl papers"*: ISG to BB, May 6, 1906, *ISG/BB Letters,* 376.
297 *"we talk and eat horse"*: ISG to BB, June 17, 1903, *ISG/BB Letters,* 317.
297 *"owning 150,000 acres"*: ISG to BB, May 19, 1903, *ISG/BB Letters,* 315.
297 *a "figure of consequence"*: Cohen, 83.
297 *"Hip, hip, hurrah"*: ISG to BB, October 6, 1903, *ISG/BB Letters,* 322.
298 *"What a government!"*: ISG to HWS, October 12, 1903, HWS-P.
298 *"it is astonishing"*: JSS to ISG, December 16, 1903, ISGP.
299 *in a "state of vigil"*: ISG to BB, October 10, 1903, *ISG/BB Letters,* 324.
299 *"she refuses to show"*: Barbara Strachey and Jayne Samuels, eds., *Mary Berenson: A Self-Portrait from Her Letters and Diaries* (New York: W.W. Norton, 1983), 111.
299 *the "whole thing is"*: *Mary Berenson,* 112.
299 *for roughly $40,000:* Richard Norton to ISG, May 7, 1900, ISG Papers, ISGM. For Berenson's reaction on seeing the tondo, see *Mary Berenson,* 112–13, and Cohen, 155.
299 *his competitor and nemesis:* For the tondo attribution, see Patricia Lee Rubin, "'Pictures with a Past,'" 27–29.
299 *the city seemed "very quiet"*: ISG to BB, January 13, 1904, *ISG/BB Letters,* 326.
299 *that "you had for me"*: ISG to BB, January 19, 1904, *ISG/BB Letters,* 327.
300 *"All the papers are full"*: ISG to BB, January 19, 1904, *ISG/BB Letters,* 327. See Tharp, 266–67; *ISGAL,* 111.
300 *"I am really very poor"*: ISG to BB, July 30 and August 5, 1903, *ISG/BB Letters,* 320–21.
300 *"It is just as much"*: ISG to Paul Sachs, September 22, 1922, Paul J. Sachs Papers, HC 3, Harvard Art Museum Archives, Harvard University. By 1922, Sachs was Harvard professor of art; he had left his family's investment firm.
300 *throughout Fenway Court:* Chong, "Gardner Style," *Furnishing a Museum,* 20.

300 *152 Beacon Street:* Tharp, 260.
301 *young fashionable ladies:* ISG to BB, January 29, 1904, *ISG/BB Letters,* 330.
301 *Saint John the Evangelist:* Mary P. Chatfield, "Cowley Fathers and Mrs. Jack," unpublished essay, 2012. I am indebted Mary for her essay, for her deep interest and insight into Isabella's life of faith, and for her expertise in classics. She pointed me in many good directions and introduced me to Brother James Koester and the archives of SSJE.
301 *"I don't like the curiosity":* ISG to APA, December 21, 1916, APA Papers.
301 *her nephew Amory Gardner:* William Amory Gardner was called Billy as a boy, Amory as he got older, and sometimes "Wag."
301 *audience as Groton students:* "Father and Not the President," *Boston Daily Globe,* May 25, 1904.
302 *"is happy to leave her":* ISG to BB, March 31, 1904, *ISG/BB Letters,* 331.
302 *that her "beautiful Degas":* BB to ISG, April 18, 1904, *ISG/BB Letters,* 332.
302 *made "miserably conscious":* HJ to ISG, July 23, 1904, *HJ Letters to ISG,* 252.
303 *and "unfathomable heart":* Henry James, *The Golden Bowl* (New York: Penguin Books, 1987; first published in 1904), 536.
303 *"extraordinary little woman":* HJ to Jessie Allen, October 22, 1904, *HJ Letters,* 329.
303 *"things" were "the sum":* Henry James, *The Spoils of Poynton* (New York: Penguin Books, 1987; first published in 1897), 49.
303 *"her palace of art":* HJ to Jessie Allen, October 22, 1924, *HJ Letters,* vol. 4, 329.
303 *as "wonderfully-gathered":* Henry James, *The American Scene,* ed. Leon Edel (Bloomington: University of Illinois Press, 1968; first published 1906), 254–55.
304 *his "great learning":* As quoted in Carter, 223.
304 *"I had put magnificent":* ISG to BB, December 24, 1904, *ISG/BB Letters,* 355.

TWENTY-SIX: "LONESOME CLOUD," 1904–5

305 *famed* Tale of Genji: See *Journeys,* 419–21. It may be that Gardner purchased this screen some time later. See *ISGAL,* 54–55.
305 *Soon after their meeting:* Carter, 223.
305 *"so interesting, so deep":* ISG to BB, October 24, 1904, *ISG/BB Letters,* 351.
306 *of Buddhism and Shinto:* Most Japanese practiced a combination of imported Buddhism of various sects and indigenous, animist Shinto. I am indebted to Christopher Benfey for many of the details of Okakura's life story, his time in Boston, and his worldview, brilliantly conveyed in *The Great Wave: Gilded Age Misfits, Japanese Eccentrics, and the Opening of Old Japan* (New York: Random House, 2003), 75–108; see also Benfey's introduction to Kakuzo Okakura, *The Book of Tea* (New York: Penguin Books, 2010; first published in 1906), vii–xix. Numerous ISGM publications detail and explore Okakura, his friendship with Isabella, and his wide influence in Boston. I was guided especially by the first three essays by Alan Chong, Christine M.E. Guth, and Noriko Murai in *Journeys,* 14–94; see also *East Meets West: Isabella Stewart Gardner and Okakura Kakuzo,* ed. Victoria Weston (Boston: ISGM, 1992); and Nagahiro Kinoshita, "Okakura Kakuzo," in *Inventing Asia: American Perspectives Around 1900* (Boston: ISGM, *Fenway Court,* no. 33, 2014), 39–48.
307 *"you were Japan to me":* As quoted in Benfey, "Tea with Okakura," *New York Review of Books,* May 25, 2000.
307 *more lasting:* For Okakura's relationships with women, see Benfey, 87–89.
307 *to Western observers:* Benfey, 93.

307 *but as an equal one:* Benfey, 91–92; see also *Journeys,* 80–81; and Kinoshita, "Okakura Kakuzo," 40–41.
308 *a "vivid cultural rhyme":* Benfey, 104.
308 *"busy at the Museum":* ISG to BB, May 12, 1904, *ISG/BB Letters,* 335.
308 *path to her Japanese garden: Journeys,* 23–26.
308 *"scribbles (as he calls it)":* ISG to Mary Berenson, September 28, 1904, *ISG/BB Letters,* 349.
309 *"plus his two friends:* ISG to BB, August 2, 1904, *ISG/BB Letters,* 342. For a description of this summer, see also Sukie Amory, "Gardner in the Garden, Part Two: A Shadow Glides on the Stairway of Jade," *Hortus: A Gardening Journal* 108, vol. 27, no. 4, Winter 2013, 52–53.
310 *"Do love it":* ISG to Mary Berenson, September 28, 1904, *ISG/BB Letters,* 349. Isabella included Okakura's poem with this letter, which is reprinted in *Journeys.*
310 *Essentially, the argument:* Bigelow was furious with Isabella about this dispute, for meddling in the affairs of the MFA, and there seems to have been a falling out; they would eventually reconcile for reasons also never exactly explained. This dispute is recounted in Carter, *Reminiscences,* 17–23.
310 *"People do seem":* ISG to BB, January 25, 1906, *ISG/BB Letters,* 374.
310 *"this Lady of the Fens":* BB to ISG, February 7, 1906, *ISG/BB Letters,* 375.
310 *"Will you pour tea":* Okakura to ISG, November 7, 1904, ISG Papers, ISGM.
310 *"we will be very honored":* Okakura to ISG, November 11, 1904, ISG Papers, ISGM.
311 *"I am still full":* ISG to BB, January 22, 1905, *ISG/BB Letters,* 360.
311 *an American context: Journeys,* 31.
311 *a feather brush:* Okakura sent these tea service items to Isabella in a square wooden box, which she kept. Its surface is stamped with postage and dates, looking almost like colophons on a Chinese scroll painting. See *Journeys,* 385.
311 *"the jiujutsu men":* ISG to BB, May 3, 1905, *ISG/BB Letters,* 364.
311 *"founded on the adoration":* Okakura, as quoted in *Journeys,* 390.
311 *stages of tuberculosis: Boston Daily Globe,* May 2, 1905.
311 *The next month:* ISG to Lilian Aldrich, June 3, 1905, Thomas Bailey Aldrich Papers (MS Am 1429), Houghton.
312 *Again, he elevated her:* I am grateful to the insight and rigorous scholarship of Alan Chong in his introduction to *Journeys,* 14–51. I have adopted his perspective—that Okakura understood Isabella's aloneness in a way that her other friends did not. As Chong writes, Okakura's poems "dwell on loneliness, both his and hers." *Journeys,* 35.
312 *a "word-painting":* As quoted in *Journeys,* 81–82; Noriko Murai examines the poem in further depth in *Journeys,* 81–83.
312 *Inevitably, rumors swirled:* Benfey, 96.
313 *She would be the focus:* "Mrs. Jack Reported Engaged," *Boston Post,* February 19, 1906. The paper reported that Isabella wore "blue brocade trimmed with costly lace."
313 *"over some hairs":* Okakura to ISG, November 22, 1910, ISG Papers, ISGM.
313 *"fusion of past":* As quoted in Benfey, 85.
313 *"I seem to go back":* Okakura to ISG, March 18, 1906, ISG Papers, ISGM.

TWENTY-SEVEN: "THE WHOLE INTERESTING WORLD OF PARIS," 1906

314 *"I have never imagined":* ISG to HWS, July 29, 1906, HWS-P .
314 *"Three weeks out of nine":* As quoted in David Brown, *The Last American Aristocrat: The Brilliant and Improbable Education of Henry Adams* (New York: Scribner's, 2020), 386.

315 *That was exactly what:* "I saw Henry Adams yesterday," Isabella wrote to Swift in mid-July "and was with him in his auto all the afternoon, seeing old Cathedral glass." Again, she marveled at the speed: "these motor cars do cover the ground." ISG to HWS, July 17, 1906, HWS-P.

315 *"I envy you everywhere":* ISG to BB, September 29, 1905, *ISG/BB Letters,* 367.

315 *"very—very bald":* As quoted in Dykstra, *Clover Adams,* 50.

315 *a "surviving capacity":* As quoted in Brown, *Aristocrat,* 387.

316 *"You have given me:"* HA to ISG, February 9, 1906, *HA Letters,* vol. 6, 5.

316 *"The delight of its":* Henry Adams, *Mont Saint Michel and Chartres* (New York: Penguin Books, 1986; privately printed 1904; first published by Houghton Mifflin, 1913), 359.

317 *"your wonderful book":* ISG to HA, May 14, 1906, HA Papers.

317 *"I feel as though":* HA to ISG, February 9, 1906, *HA Letters,* vol. 6, 5.

317 *"Dear Mr. Adams":* ISG to HA, February 10, 1906, HA Papers.

317 *"For personal reasons:* ISG to HA, June 29, 1906, HA Papers.

317 *"to see the Prado again!":* ISG to Sarah Orne Jewett, June 30, 1906, Sarah Orne Jewett Compositions and Other Papers (MS Am 1743), Houghton.

317 *It has "such wonders":* ISG to BB, July 9, 1906, *ISG/BB Letters,* 380.

317 *"I feel about [the Louvre]":* As quoted in Carter, 216.

318 *She dressed "incognita":* ISG to HA, June 26, 1906, HA Papers.

318 *the end of the year:* The Louvre bought the other portion of the window that same year. See also Madeline H. Caviness et. al, "The Gothic Window from Soissons: A Reconsideration," *Fenway Court* (1983), 6–25.

318 *"Fancy!" she exclaimed:* ISG to HA, July 30, 1906, HA Papers.

318 *bring a "power binocle":* HA to ISG, June 27, 1906, HA Papers.

319 *a "great hymn interrupted":* Edith Wharton, *A Motor-Flight Through France* (DeKalb: Northern Illinois University Press, 1991), 17.

319 *together once before:* HA to Lady Curzon, November 28, 1899, *HA Letters,* vol. 5, 62–63.

319 *its astounding "appetite":* Adams, *Mont Saint Michel and Chartres,* 134.

319 *"intelligence" about museums:* HA to Elizabeth Cameron, August 22, 1906, *HA Letters,* vol. 6, 26.

319 *"has no reason":* HA to Elizabeth Cameron, August 25, 1906, *HA Letters,* vol. 6, 26. John Briggs Potter and Matthew Stewart Prichard accompanied Isabella and Adams to Chartres.

319 *the "history of our roves":* This whole letter is reprinted in Carter, 218–19.

320 *"My dear Lilla":* This letter by Isabella is quoted in private memoirs by Perry's niece, an account cited in Meredith Martindale and Nancy Mowell Mathews, *Lilla Cabot Perry, an American Impressionist* (Washington, D.C.: National Museum of Women in the Arts, 1990), 119.

320 *calling it "a famous old":* JSS to ISG, unknown date, ISG Papers, ISGM. Sargent explained: "I know you are glad to hear of chances of getting good pictures, and there will be a capital one soon in Paris, the sale of Theodore Duret's things, 13th of March, Galerie Georges Petit."

321 *"nos beaux yeux":* John T. Morse, *Thomas Sergeant Perry: A Memoir* (Boston: Houghton Mifflin, 1929), 68.

321 *had been "very uncertain":* For this detail about Monet destroying his own work and for the meeting between Isabella and Monet, see Martindale, *Lilla Cabot Perry,* 119. Theodore Robinson wrote admiringly of Monet, saying, "To my mind no one has yet

painted out-of-doors quite so truly." Robinson, "Claude Monet," *Century* 44 (September 1892): 698.
321 *"perfect in every way"*: ISG to MHE, November 11, 1906, ISG Papers, ISGM.
321 *"I love the things"*: ISG to BB, July 9, 1906, *ISG/BB Letters,* 380.
321 *"things and people are"*: ISG to BB, December 25, 1906, *ISG/BB Letters,* 391.
322 *"I had pleasant days"*: ISG to HA, October 21, 1906, HA Papers. See Ernst Scheyer, "Henry Adams as a Collector of Art," *Art Quarterly* 25, no. 3 (Autumn 1952): 221–33.
323 *"old Italian stone chimney"*: ISG to HA, June 20, 1908, HA Papers.
323 *was "meant as experiment"*: HA to ISG, July 30, 1908, ISG Papers, ISGM.

TWENTY-EIGHT: "UNDYING BEAUTY AND LIGHT," 1907–9
324 *"All is still confusion"*: ISG to BB, January 5, 1907, *ISG/BB Letters,* 392.
324 *"January has gone galloping"*: ISG to BB, January 14, 1907, *ISG/BB Letters,* 393. The newspaper reported an unusual number of cases of grippe and "severe cases of coughs and colds" in the city because of the mild weather. *Boston Daily Globe,* January 9, 1907, 3.
324 *be finished soon after:* See Sebastian Smee about the controversial decision to tear down the carriage house in 2009 to make room for the Renzo Piano addition. For more about this structure, the meaning of its name Altamara, and how it connected to Isabella's vision for Fenway Court, see Robert Colby, "Palaces Eternal and Serene: The Vision of Altamura and Isabella Stewart Gardner's Fenway Court," in *Bernard Berenson: Formation and Heritage,* ed. Joseph Connors and Louis A. Waldman (Florence: Villa I Tatti, The Harvard Center for Italian Renaissance Studies, 2014), 69–99.
325 *"very hard work and secrecy"*: ISG to BB, March 16, 1907, *ISG/BB Letters,* 396.
325 *"tramped" through the galleries:* ISG to BB, February 17, 1905, *ISG/BB Letters,* 362.
325 *in her word "wearisome"*: ISG to BB, November 26, 1907, *ISG/BB Letters,* 414.
325 *"really truly" a Velázquez:* ISG to BB, October 18, 1906, *ISG/BB Letters,* 385.
326 *"Of course I may conclude"*: BB to ISG, October 25, 1906, *ISG/BB Letters,* 386.
326 *"what a whacker that"*: BB to ISG, October ?, 1906, *ISG/BB Letters,* 386.
326 *high stakes of collecting:* For a vivid description of the art market at the turn of the century, see Cynthia Saltzman, *Old Masters, New World: America's Raid on Europe's Great Pictures* (New York: Penguin Books, 2008), 213–19.
326 *the "figures now asked"*: BB to ISG, August 14, 1907, *ISG/BB Letters,* 403.
326 *"he's snugly tucked away"*: ISG to BB, November 27, 1906, *ISG/BB Letters,* 388.
326 *"MUM is the word"*: ISG to BB, March 16, 1907, *ISG/BB Letters,* 396.
326 *Apsley House in London:* See Eric Young. "Notes on Spanish Paintings in the Isabella Stewart Gardner Museum," *Fenway Court* (1979), 24–35; Carter, 218.
326 *"longing so to see"*: Anders Zorn to ISG, late March, 1907, ISG Papers, ISGM.
326 *to be court portraitist:* Fredrick R. Martin had discovered and acquired *A Seated Scribe* in Istanbul in 1905. Isabella paid over $7,000 for it in 1907. See Eze, "Faithful Painter," 61–62.
326 *an "adorable and exquisite"*: ISG to BB, October 3, 1907, *ISG/BB Letters,* 409.
327 *"farming, gardening, etc."*: ISG to BB, July 9, 1907, *ISG/BB Letters,* 380.
327 *been grown from seed:* Carter, 208–9. The newspapers reported that Isabella had taken on a "novel role." *Boston Globe,* August 21, 1905.
327 *gardens were blooming:* ISG to HWS, August 23, 1907, HWS-P. See also Dakota Jackson, "Urban Gardening and Isabella's Flower Day Prizes," Inside the Collection blog, July 6, 2021.

327 *"all dressed to an inch":* HDS to APA, September 1, 1908, *Beauport Chronicle: The Letters of Henry Davis Sleeper to Abram Piatt Andrew Jr., 1906–1915,* ed. E. Parker Hayden Jr. and Andrew L. Gray (Boston: Historic New England, 2005), 39.
327 *"I am in America":* FMC to ISG, May 6, 1907, ISG Papers, ISGM. See Tharp, 286–89.
327 *with a precious gift:* Crawford liked to recall their time together in affectionate letters— "eleven years ago this day Mr. Isaacs was published. Do you remember?" FMC to ISG, December 5, 1893, ISG Papers, ISGM. For a photograph and description of the Tiffany binding, see *ISGAL,* 53. See also Pilkington, *Francis Marion Crawford,* 105–6.
328 *"Palazzo Isabella" was both:* FMC to ISG, undated letter (possibly 1907), ISG Papers, ISGM. It would be their last meeting. Crawford died two years later.
328 *"Don't get lonely":* BB to ISG, August 1, 1906, *ISG/BB Letters,* 381.
328 *"I was indigo blue":* ISG to BB, July 9, 1907, *ISG/BB Letters,* 400.
328 *"Yes, Ross is delightful":* ISG to BB, July 9, 1907, *ISG/BB Letters,* 400.
328 *She replied, "Woe is me!":* ISG to BB, August 26, 1907, *ISG/BB Letters,* 405.
330 *The close circle:* Andrew Gray, "A New England Bloomsbury," *Fenway Court* (1974), 1–4.
330 *but not the desire:* What is also clear, according to Evans, is "a sense of individuals forming romantic same sex relationships." R. Tripp Evans, "The Smart Set at Red Roof" (online lecture, The History Project, Historic New England, February 11, 2021). I am grateful to Evans for bringing Dabsville to life in his talk and for generously sharing with me his original research.
330 *to use on the bed:* MC Papers.
330 *often accompanied her:* Carter, *Reminiscences,* 29.
331 *two words: "Music, tears":* APA Diary, December 20, 1907.
331 *"Let me say just this":* APA to ISG, December 21, 1907, ISG Papers, ISGM.
331 *"Your village is Fogland":* ISG to APA, September 12, 1907, *From Y to A, Letters from ISG to APA,* privately printed.
331 *She was again in trouble:* For more detail about this fiasco, see Tharp, 280–82. The custom house records were destroyed, but Tharp was able to base her account on records held by her publisher, Little, Brown and Company. See her endnote 4, 343. See also "The Gardner-Chadbourne Case," *New York Times,* December 7, 1908.
332 *large, unforgettable fresco: Beholder,* 53.
332 *"What a masterpiece":* JLS to ISG, June 11 and August 4, 1903, ISG Papers, ISGM.
332 *"Dear Sir," she began:* ISG to J. P. Morgan, December 5 (probably 1908), Morgan Library, New York. The letter is marked in pencil in another hand: "To Father [Morgan] from 'Mrs. Jack' Gardner."
333 *the "misguided person": Boston Globe,* August 24, 1908.
333 *"A lady in a Philadelphia":* Ralph Curtis to ISG, October 3, 1911, ISG Papers, ISGM.
333 *"People talked about":* Nellie Melba, *Melodies and Memories,* 142–43.
333 *"I am tired and weary":* ISG to BB, September 4, 1908, *ISG/BB Letters,* 425.
333 *"Every day people are":* HWS to ISG, October 22, 1908, HWS-P.
334 *"My position now is":* HSG to HWS, October 23, 1908, HWS-P.
334 *museum six years before:* At about this time, and perhaps as a thank-you for offering the Gothic Room as the portrait's setting, Warren and the women members of her family—her mother, Margaret Osgood; her sister Molly; and daughters Rachel and little Marjorie—created a letter case made from an elaborate robe from Qing dynasty China. "You cannot imagine how much loving thought has gone into it, for months we have spoken of 'Mrs. Gardner's portfolio,'" she wrote in the note that accompanied

- the gift. She marked where the toddler Marjorie had made two stitches with a small hair ribbon on the case's left edge, adding: "You know you are just in the midst of us all, where we keep you warm and safe." GOW to ISG (probably 1903), ISG Papers, ISGM.
- 334 *"a little easy happiness"*: GOW to ISG, n.d., reprinted in *Sargent on Location*, 46.
- 334 *"daily I miss him"*: HLH to ISG, December 5, 1908, ISG Papers, ISGM.
- 334 *"We the signors"*: "Tribute Book of Autographs," 1909, Tapestry Room, ISGM.
- 335 *"is full of loving gratitude"*: GOW to ISG, April 14, 1909, reprinted in *Sargent on Location*, 48.
- 335 *"That I am writing"*: ISG to GOW, April 15, 1909, 48.
- 336 *"everybody has heard of"*: ISG to BB, January 19, 1907, *ISG/BB Letters*, 393.
- 336 *"Many a woman who"*: Carter, 222. Carter also writes in the same passage that the "great pleasure of her later life was the steadily increasing and deepening affection of old friends and the ardent devotion of new friends. She loved love, and every token of affection she cherished; the little gifts of children, made perhaps in their kindergarten classes, she not only preserved, but kept about where she could see them."

TWENTY-NINE: SEEING AND HEARING MODERNISM, 1910-13
- 339 *"I have been away"*: ISG to BB, February 5, 1910, *ISG/BB Letters*, 465.
- 339 *the end of 1909:* For a review of the art tariff debate, see Kimberly Orcutt, "Buy American? The Debate over the Art Tariff," *American Art* 16, no. 3 (2002): 82–91; see also Robert E. May, "Culture Wars: The U.S. Art Lobby and Congressional Tariff Legislation During the Gilded Age and Progressive Era," *Journal of the Gilded Age and Progressive Era* 9, no. 1 (2010): 37–91; and Strouse, *Morgan*, 609.
- 340 *"peridots with emeralds"*: ISG to BB, July 4, 1917, *ISG/BB Letters*, 603.
- 340 *She had a telephone:* MC Interview, MC Papers.
- 340 *continued on as housemaid:* For Isabella's enduring loyalty to Margaret Lamar, see *ISGAL*, 101.
- 340 *her "life is save daily"*: ISG to BB, July 4, 1917, *ISG/BB Letters*, 603.
- 341 *considered very daring:* MC Interview, MC Papers.
- 341 *Ruth St. Denis: Program for Entertainment in Aid of the Holy Ghost Hospital for Incurables at Fenway Court, Boston, Featuring Ruth St. Denis,* May 2, 1906, Music Case, Yellow Room, ISGM. Isabella's interest in African American music, especially the production of *The Red Moon*, is described in *ISGAL*, 118–19.
- 341 *"poetry in motion"*: *Boston Evening Transcript*, May 3, 1906.
- 341 *at the Majestic Theater:* A. Piatt Andrew attended the performance with Isabella. APA Diary, January 2, 1909.
- 341 *had "fallen in love"*: ISG to BB, January 9, 1908, *ISG/BB Letters*, 417.
- 341 *would "give me much"*: ISG to Sarah Orne Jewett, early January 1909, Sarah Orne Jewett Compositions and Other Papers, MS Am 1743.2–1743.27, Houghton.
- 342 *performed two short plays:* APA Diary, January 8, 1908.
- 342 *invited Lady Gregory:* "Lady Gregory at Fenway Court," *Boston Daily Globe*, March 1, 1912.
- 342 *"you are a darling"*: Colm Tóibín, *Lady Gregory's Toothbrush* (Dublin: Lilliput Press, 2002), 78.
- 343 *"I am so busy"*: ISG to BB, May 25, 1910, *ISG/BB Letters*, 471.
- 343 *For his hockey games:* Tharp, 290.

343 *"Oh, you Red Sox":* ISG Guest Book, vol. 12, 1912.
343 *"almost causing a panic":* Town Topics, vol. 68, July–December, 1912, 6.
343 *"with the use of her":* Smith, *Interesting People,* 185–87.
344 *his word, a "nonentity":* Carter, *Reminiscences,* 8.
344 *"sincere and thorough":* Tharp, 307.
344 *made brief mentions:* Carter, July 5 and 6, ISG Guest Book vol. 10, 1909-10.
344 *on his "little house":* Carter, *Reminiscences,* 43.
344 *a pair of images:* It is not known if Thomas Marr or his son Arthur Marr used photographic assistants in the field or in the studio. See Ron Politio, *T. E. Marr (&) Son, Isabella Stewart Gardner's Photographers—and More: Their Lives, Their Work, Their Photographic Techniques* (Waltham, MA: Photographic Historical Society of New England, 2020), 49.
344 *"It is so pleasant":* Mary Berenson to ISG, January 16, 1914, *ISG/BB Letters,* 505.
344 *"she had risen at six":* Ellery Sedgwick, *The Happy Profession* (Boston: Little, Brown and Company, 1946), 171.
344 *"Of all our set":* HA to Elizabeth Cameron, October 7, 1912, *HA Letters,* vol. 6, 563.
345 *"I am not over well":* ISG to BB, July 30, 1910, *ISG/BB Letters,* 476.
345 *"it is the first time":* BB to ISG, August 12, 1910, *ISG/BB Letters,* 476.
345 *"mum's the word":* ISG to BB, August 22, 1910, *ISG/BB Letters,* 477.
346 *"seized me and made":* ISG to BB, April 10, 1911, *ISG/BB Letters,* 486.
346 *she was "critically ill":* New York Times, May 21, 1911.
346 *"digitalis and lie still":* ISG to BB, May 8, 1911, *ISG/BB Letters,* 487.
346 *"I am obeying all":* ISG to BB, [May/June] 1911, *ISG/BB Letters,* 488.
346 *Monks for safekeeping:* ISG to Olga Monks, August 1, 1912, ISG Papers, ISGM. For a transcription of this letter, see *ISGAL,* 134.
346 *"That it should be opened":* "Suggestions for Running Museum, I. S. Gardner in the Fenway," ISG Papers, ISGM.
347 *tensions in his life: Henry James,* by Cecilia Beaux, is now at the National Portrait Gallery, Smithsonian Institution, Washington, D.C. Beaux had found him an almost impossible subject. For more, see Sarah Burns, "Under the Skin: Reconsidering Cecilia Beaux and John Singer Sargent," *Pennsylvania Magazine of History and Biography* 124, no. 3 (2000): 317–47.
347 *"a reprieve from death":* HJ to ISG, October 24, 1911, *HJ/Zorzi,* 303.
347 *"your faithfullest, and from":* HJ to ISG, April 20, 1914, *HJ/Zorzi,* 308–9.
347 *"Okakura goes to Japan":* ISG to BB, August 5, 1911, *ISG/BB Letters,* 491.
347 *his poetry: "One Pathway":* Okakura, Guest Book vol. 11, October 1910, opening page.
347 *"When you left I have":* Okakura to *Kowun* [Lonesome Cloud], October 4, 1911, reprinted in Carter, 235–36.
348 *"she chattered away":* HA to Elizabeth Cameron, January 11, 1912, *HA Letters,* vol. 6, 493.
348 *"I have finished":* ISG to HA, June 10, 1909, HA Papers, MHS.
348 *"in movement and energy":* HA to Elizabeth Cameron, October 6, 1912, *HA Letters,* vol. 6, 563.
349 *between Quinn and Isabella:* Tóibín, *Lady Gregory's Toothbrush,* 76.
349 *New York collector:* John Quinn to ISG, January 14, 1913, ISG Papers, ISGM.
349 *in "the art way":* The Davies speech was printed in the Amory Show catalog for its New York opening.
349 *"I received your letter":* ISG to John Quinn, January 16, 1913, Archives of American Art, Walter Kuhn Collection.

NOTES

349 *focus of the show:* Hugh Eakins, *Picasso's War: How Modern Art Came to America* (New York: Crown, 2022), 44. See also "The Armory Show at 100: Primary Documents," *Archives of American Art Journal* 51, 3–4.

350 *a "total degeneracy":* "Cubists Depart; Students Joyful," *Chicago Daily Tribune*, April 17, 1913, as quoted by Anjulie Rao in "SAIC and the Armory Show," School of the Art Institute of Chicago, SIAC.com.

350 *interest in modern art:* Louis Menand, "Modern Art and the Esteem Machine," *The New Yorker*, July 4, 2022.

350 *"surprised New York":* As quoted in Eakins, *Picasso's War*, 53.

350 *the "international cubist":* APA, March 12, 1913, APA Diary.

350 *the "sorriest spectacle":* Boston Herald, April 28, 1913, front page.

351 *"It is very agreeable":* Amy Lowell to ISG, June 19, 1916, ISG Papers, ISGM.

351 *A young T. S. Eliot:* There are three letters from Eliot to ISG dated 1915 to 1918, ISG Papers, ISGM.

351 *"The formula is":* MSP to ISG, November 26, 1909, ISG Papers, ISGM.

351 *Matisse "brought down":* MSP to ISG, November 22, 1910, ISG Papers, ISGM.

351 *"goes from strength":* MSP to ISG, June 5, 1912, ISG Papers, ISGM.

351 *instinct and intuition:* For the relation between Bergson's philosophy, Matisse's art practice, and Matthew Stewart Prichard, see Philip Hook, *Modern: Genius, Madness, and One Tumultuous Decade That Changed Art Forever* (New York: The Experiment, 2021), 209–10.

352 *learning from Bergson:* Isabella owned a copy of Bergson's seminal 1913 book, *The Philosophy of Change*.

352 *"you have the feeling":* MSP to ISG, December 18, 1910, ISG Papers, ISGM.

352 *"every picture contains":* MSP to ISG (possibly in 1909), ISG Papers, ISGM.

352 *the first Matisse painting:* Karen Haas, "Henri Matisse: A Magnificent Draughtsman," *Fenway Court* (1985), 37. The collector Sarah Choate Sears also gave Isabella a Matisse drawing sometime in 1910. The Annual Exhibition of the Watercolor Club in Boston held a show of Matisse's work in early 1911, and Isabella clipped a newspaper report of the show. For more on the complicated backstory of her collection of works by Matisse, see Anne McCauley's entry on Matisse in *Beholder*, 218–21.

353 *"his heartfelt gratitude":* As quoted in Benfey, 281.

353 *"Through Godly deeds":* "Verses Read at the Memorial Service for Okakura Kakuzo at Fenway Court," compiled by ISG and Benjamin Ives Gilman, typescript copy, ISG Papers, ISGM.

353 *Okakura's "great spirit":* Caroline Sinkler to ISG, October 13, 1913, ISG Papers, ISGM.

353 *Even so, people noticed:* Chong, "Introduction," *Journeys*, 35.

353 *"He knew of your loneliness":* MSP to ISG, September 18, 1913, ISG Papers, ISGM.

354 *"was the first person":* Mary Berenson to her family, January 10, 1914, Strachey, *Mary Berenson*, 111. For more on Mary Berenson, see Cohen, esp. 71–83.

354 *"I really do feel":* Letter reprinted in Carter, *Reminiscences*, 45–46.

354 *"The trouble always is":* ISG to Thomas Bailey Aldrich, Christmas Eve (no year), ISG Papers, ISGM.

354 *cure for grief was work:* Carter, 240.

354 *"Work is the best thing":* ISG to HWS, June 8, 1906, HWS-P.

354 *commission for his work:* HWS to Willard T. Sears, December 23, 1913, ISG Papers, ISGM. Swift wrote: "You are to take charge of the destruction of the music room at Fenway court and the building in its place of the extension of FC according to the plans already made by you of which the blueprints are in Mrs. G's possession."

355 *"long dialogue with Asia"*: Chong, "Introduction," *Journeys*, 38. The submerged Chinese Room no longer exists; the museum converted the space for other purposes in 1970. For this complicated story, see Chong, "Introduction," 46.

355 *bamboo scoop, and bowl*: Louise Allison Cort, "Mrs. Gardner's 'Set of Tea-Things,'" *Journeys*, 385–98.

THIRTY: THE DANCER, 1914

356 *the "music of stormy"*: Carter, 211; *Boston Daily Globe*, January 30, 1914.

356 *the "unearthly beauty"*: Philip Hale, 1914, untitled newspaper clipping, Subject Files, ISGM.

356 *"last time that anyone"*: Carter, 240

356 *would "be no more"*: MB to ISG, August 11, 1914, *BB/ISG Letters*, 527.

356 *"Oh, so busy!"*: ISG to BB, February 13, 1914, *ISG/BB Letters*, 513.

357 *"I am writing in"*: ISG to BB, July 15, 1914, *ISG/BB Letters*, 525.

357 *the design herself*: Corinna Lindon Smith describes this scene in her *Interesting People*, 168.

357 *"the best picture"*: As quoted in Volk, *El Jaleo*, 21.

358 *throw them in the fire*: Thomas Jefferson Coolidge to ISG, April 26, 1884, ISG Papers, ISGM. In the same letter, he wrote that her letters "ought to be collated with all the others and published."

358 *The museum staff may*: John Singer Sargent's El Jaleo (Washington, D.C.: National Gallery of Art, 1992), 72–73. This deficit would soon change, and the MFA now holds the most complete collection of Sargent's work of any museum.

358 *by a delivery receipt*: Records show that Frank Bayley moved *El Jaleo* to Fenway Court in December 1914. Dealer receipt DF26, Dealer Files, ISGM.

358 *"wills can be changed"*: Carter, *Reminiscences*, 53.

358 *Whether Coolidge gave*: This story is sorted out from earlier sources by Mary Crawford Volk in *John Singer Sargent's* El Jaleo (Washington, D.C.: National Gallery of Art, 1992), 73–81.

359 *out into the space*: See Alan Chong, "Mrs. Gardner's Museum of Myth," *Res* 52 (Autumn 2007), 218.

359 *to "sit and watch"*: Melba, *Melodies and Memories*, 144.

360 *promise of salvation*: For this insight about the Spanish Cloister, I am indebted to George Steel, music curator at the ISGM, who said at a museum online presentation that the Spanish Cloister represented the "twin poles of life—celebration of life, then a loss of life. It's personal."

360 *called them "darlings"*: ISG to BB, March 27, 1914, *ISG/BB Letters*, 516.

361 *"tide of my interests"*: As quoted by Cohen, 178.

361 *the "finest thing"*: BB to ISG, *ISG/BB Letters*, 520.

361 *her appetite for more*: See *Beholder*, 180–82; see also Nancy Berliner, "Listening, Learning, Meditating: Isabella's Journey with Chinese Art," ISGM blog post, December 7, 2020.

361 *"I only wish I had"*: ISG to BB, July 27, 1914, *ISG/BB Letters*, 525.

361 *"Now promise to save"*: ISG to BB, May 7, 1914, *ISG/BB Letters*, 521.

361 *"From the Raphael Room"*: *Catalog for Fenway Court Edited Draft by Isabella Stewart Gardner*, 1914–15, ISG Papers, ISGM.

362 *the rest of her life*: *ISGM Guide 17*, 113–14.

363 *"The time is near":* ISG to Lillie Lawlor, December 29, 1914, Miscellaneous manuscripts collection, 1600–1993 (Ms.N-2195), MHS.
363 *"Mrs. Gardner's Fenway Palace":* "Mrs. Gardner's Fenway Palace, Just Remodeled, Artistic Triumph," *Boston Sunday Post,* March 28, 1915.
363 *"New Steps Towards":* "New Steps Towards Perfection in Mrs. Gardner's Venetian Palace," *Boston Evening Transcript,* April 1916.
363 *"better than ever before":* Henry Sleeper to APA, April 8, 1915, *Beauport Chronicle,* 85.
363 *"these new rooms":* Maud Howe Elliott, *Three Generations,* 377.

THIRTY-ONE: BLOOD AND THUNDER, 1915–18

364 *"never really believed":* Gertrude Stein, *The Autobiography of Alice B. Toklas* (New York: Penguin Press, 2020 reprint), 175.
364 *had been "stranded in":* Ralph Curtis to ISG, October 24, 1914, ISG Papers, ISGM.
364 *home in gold bullion:* Tharp, 300.
364 *"The War has cast":* MB to ISG, August 11, 1914, *ISG/BB Letters,* 525.
364 *"terrified of the Zeppelin":* Thomas Whittemore to ISG, October 15, 1914, ISG Papers, ISGM.
365 *"Our old world is dead":* HA to Charles Gaskell, July 10, 1916, *HA Letters,* vol. 6, 734.
365 *"heating my big steamer":* ISG to BB, October 7, 1916, *ISG/BB Letters,* 589.
365 *"Last night I motored":* *Letters Written Home from France in the First Half of 1915* (privately printed, 1916), 3.
365 *caused some consternation:* Grey, "A New England Bloomsbury," 4.
365 *the "way of the armies":* Grey, "A New England Bloomsbury," 1.
365 *"most interesting job":* APA, as quoted in Arlen J. Hansen, *Gentleman Volunteers: The Story of the American Ambulance Drivers in the First World War* (New York: Arcade Publishing, 1996; reprinted 2011), 43.
366 *two thousand volunteers:* A. Piatt Andrew, "For the Love of France," *Outlook* 114 (December 27, 1916): 923–31.
366 *"Your car, dear Y":* APA to ISG, December 19, 1915, ISG Papers, ISGM.
366 *when he was captured:* Thomas Whittemore to ISG, October 21, 1914, ISG Papers, ISGM.
367 *"perhaps a year ago":* ISG to Elisina Tyler, June 24, 1915, ISG Papers, ISGM.
367 *the "poor weary bones":* ISG to Elisina Tyler, October 2, 1915, ISG Papers, ISGM.
367 *the rally grounds:* "Common First Fells War Invasion: Army Tents and Persuasive Recruiting," *Boston Daily Globe,* May 27, 1917.
368 *the embassy in Paris:* John Gardner Coolidge, *War Diary in Paris, 1914–1917* (Cambridge, MA: Riverside Press, 1931), 15.
368 *"These are sad times":* Lillie Lawlor was a New York art dealer. Lawlor later described the look of a letter she had received from Isabella: "This was a lovely linen paper and folded so— with a Seal, not an envelope. Like a lovely Italian Renaissance letter. She was so dear to me." Lillie Lawlor to Morris Carter, June 9, 1917, MC Papers.
368 *"I am pro only":* ISG to BB, September 25, 1916, *ISG/BB Letters,* 588.
368 *see the courtyard:* ISG to BB, May 18, 1917, *ISG/BB Letters,* 602.
368 *"I am not pitying":* ISG to BB, July 4, 1917, *ISG/BB Letters,* 603.
369 *previously been conductor:* Details on Karl Muck and this controversy have been drawn from Neil Swidey's excellent article "Sex, Spies, and Classical Music: The BSO Scandal You've Never Heard Of," November 5, 2017. See also Tharp, 301–6.

369 *"You live so near him":* MC Papers.
370 *"You can never know":* Karl Muck to ISG, August 9, 1919, ISG Papers, ISGM.
370 *"You and I are very good":* ISG to Henry Sleeper, n.d., MC Papers.
370 *twentieth-century architecture:* Ralph Adams Cram, "Reims Cathedral, *Yale Review* 7 (1919): 34–53.
371 *Reims cathedral became:* Elizabeth Emery, "The Martyred Cathedral: American Attitudes Toward Notre-Dame de Reims During the First World War," in *Medieval Art and Architecture After the Middle Ages,* ed. Janet T. Marquardt and Alyce A. Jordan (Newcastle upon Tyne: Cambridge Scholars Publishing, 2009).
371 *the American Field Service:* See James William Davenport Seymour, ed., *History of the American Field Service in France, "Friends of France," 1914–1917* (Boston: Houghton Mifflin, 1920).
371 *"A mere patch of color":* Shirin Fozi, "'A Mere Patch of Color': Isabella Stewart Gardner and the Shattered Glass of Reims Cathedral," in *Memory and Commemoration in Medieval Culture* (Farnham, UK: Ashgate Publishing, 2013), 321–44.

THIRTY-TWO: "VERY MUCH ALIVE," 1919–22

374 *work, "night and day":* JSS to ISG, (possibly 1918), ISG Papers, ISGM.
374 *which Sargent "devoured":* JSS to ISG, June 1916, ISG Papers, ISGM.
374 *"unless it is Loeffler's":* JSS to ISG, (possibly 1918), ISG Papers, ISGM.
374 *"Where and when do we":* JSS to ISG, March 26, 1918, ISG Papers, ISGM.
375 *Caroline Sinkler confided:* Caroline Sinkler to ISG, February 8 (possibly 1917 or 1918), ISG Papers, ISGM.
375 *"more magnificent than":* Henry Adams reports on Isabella's D.C. visit in a letter to Elizabeth Cameron, February 1, 1918, *HA Letters,* vol. 6, 782.
375 *had been "overwhelming":* ISG to Edmund C. Hill, September 24, 1918, ISG Papers, ISGM.
375 *"It is not as easy":* As quoted in Amory, "Gardner in the Garden, Part One," 68.
375 *"Rose and I love":* GPG to ISG, March 13, 1920, ISG Papers, ISGM.
375 *had been "a hard year":* ISG to Joseph Lindon Smith, 1919, ISG Papers, ISGM.
375 *Saint Francis House:* I drew the gift amounts from undated essay by Br. Eldridge Pendleton, SSJE, "The Relationship of Isabella Stewart Gardner and SSJE," Church of the Advent Archives.
376 *". . . in the Chapel":* ISG signed note, 1919, SSJE.
376 *had been as generous:* Fr. Spence Burton wrote several letters to Isabella in April, 1919, in one calling her "the foundress" of the monastery; April 10, 1919, ISG Papers, ISGM. On her birthday, Burton wrote again, saying that every room held "some memorial of your kindness and generosity to us." Burton to ISG, April 14, 1919, ISG Papers, ISGM.
376 *"intelligence, good judgement":* Ross to MC, February 14, 1919, letter quoted in MC, *Reminiscences: Did You Know Mrs. Gardner?; Morris Carter's Answer* (Boston: privately printed at the Industrial School for Crippled Children [Cotting School]), 56.
376 *"came into the room":* MC Oral Interview, MC Papers.
377 *McKeller as his model:* See Nathaniel Silver and Paul Fisher in *Boston's Apollo,* 11–61.
377 *"awfully hard for her":* MC to Mary Garstang, December 26, 1963, MC Papers.
378 *Helen Mixter Appleton:* MC Oral Interview, ISGM.
378 *Caroline as "Dearest deare":* ISG to Caroline Sinkler, early 192?, Beauport Manuscript Collection, (MS036), Historic New England. Isabella's letters to Sinkler were more

NOTES

affectionate than most in her correspondence, but few other details are known about their friendship.

378 *by him until the end:* Carter, 247. For more about Isabella's love of dogs and the four she named in her will—fox terriers Kitty Wink and Patty Boy; collies Foxey and Roly (also spelled Rowley), see Diana Seave Greenwald, *Isabella Stewart Gardner: Dog Lover* (Boston: ISGM, 2020).

378 *had been "all perfect":* As quoted in Carter, 250.

378 *"on the couch sumptuously":* Margaret Chanler, *Autumn in the Valley,* 41.

379 *a "tall brass urn":* Edward Weeks, *My Green Age* (Boston: Little, Brown, and Company, 1973), 107.

379 *One attendee remembered:* Walter Muir Whitehall, "A Fable for Historical Editors," *New England Quarterly* 39, no. 4, December 1966, 3.

379 *She paid $50,000:* ISG/BB Letters, 626–28, 633–37.

379 *in a gondola chair:* Isabella referred to this chair as a gondola chair, but it was more likely a seat from a gig, a two-wheeled carriage made for one person. Chong, *Furnishing a Museum,* 99.

379 *her own "house filled":* Ida Agassiz Higginson to ISG, March 8, 1923, ISG Papers, ISGM.

380 *"We think of you here":* ISG to BB, November 21, 1921, *ISG/BB Letters,* 640.

380 *"I should love to go":* ISG to BB, November 2, 1922, *ISG/BB Letters,* 652.

380 *"One of the most":* ISG to MSP, May 11, 1922, ISG Papers, ISGM.

381 *the "perfect expression":* HC to ISG, February 4, 1922, ISG Papers, ISGM.

381 *two elephant figurines:* HC to ISG, January 22, 1922, ISG Papers, ISGM. This first elephant sent by Coudenhove arrived with only a leg remaining, so he sent two more, as he told her in a letter dated later that spring, May 6, 1922.

381 *She noted that their:* HC to ISG, August 30, 1922, ISGM. Morris Carter reported that the two figurines arrived at the museum on June 14, 1922. MC Tagebuch, ISGM.

381 *Maybe they reminded:* ISG 1883/1884 Diary, December 25, 1883, ISG Papers, ISGM.

381 *"a horse or anything":* ISG to HC, November 15, 1922, ISG Papers, ISGM.

381 *"a fleecy cloud from heaven":* ISG to Charles M. Loeffler, September 15, 1922, ISG Papers, ISGM.

381 *"Did I tell you":* ISG to BB, October 24, 1922, *ISG/BB Letters,* 652.

382 *its waterlike surface:* Jack bought the mirror for 800 lire in July 1892 from the dealer Consiglio Ricchetti while he and Isabella were staying in Venice. Dealer Files, ISGM.

THIRTY-THREE: SPRING, 1923–24

383 *"looked rather unhappy":* Richard Leacock, director, *Isabella Stewart Gardner/Boston,* (1977), National Endowment for the Arts, 30 minutes.

384 *she was "simply delighted":* Leacock, 1978.

384 *described in his notes:* MC Papers.

384 *"A thousand, thousand":* ISG to Caroline Sinker, May 31, 1923, Beauport Manuscript Collection (MSO36) Historic New England, Boston.

384 *"Uncle Jack's picture":* Olga Monks to ISG, undated letter, ISG Papers, ISGM. She added that "it will always mean a great deal to me. The other picture I am going to hang in the library and I shall always think of them as over your bed."

384 *She evenly split:* MC Papers; Subject Files, ISGM.

385 *"bravely holding her own":* Mission House Diary, SSJE.

385 *found Isabella "feeble":* Mission House Diary, SSJE.

385 *"as her body grew":* Olga Monks to BB, September 14, 1924, letter printed in *ISG/BB Letters,* 667.
385 *"My news is uninteresting":* ISG to BB, June 11, 1924, *ISG/BB Letters,* 667.
385 *"she was not alone":* Olga Monks to BB, September 14, 1924, letter printed in *ISG/BB Letters,* 667.
386 *"For many years":* Boston Evening Transcript, July 18, 1924.
386 *"rather fine contempt":* Boston Globe, July 18, 1924.
387 *The choir of fifty men:* MC to Innes Young, December 2, 1952, MC Papers.
387 *"for the education":* As quoted in *ISGAL,* 141.
387 *"Take, Fortune, whatever":* MC Papers.
387 *seemed "strange to go":* Olga Monks to BB, September 14, 1924, letter printed in *ISG/BB Letters,* 667.
387 *"To imagine that those":* Maria Longworth Storer, *In Memoriam Bellamy Storer: With Personal Remembrances of President McKinley, President Roosevelt, and John Ireland, Archbishop of St. Paul* (Boston: The Merrymount Press, 1923).
387 *This slim book was:* August 6, 1924 entry, MC *Tagebuch* (daybook), MC Papers.
388 *The following April 14:* Mission House Diary, SSJE.

EPILOGUE: *LACRIMAE RERUM,* OR THE TEARS OF THINGS

389 *the "oddly expectant":* John Walsh Jr., "Child's Play in Rembrandt's *A Lady and Gentleman in Black,*" *Fenway Court* (1976), 1. Walsh writes that the "picture is somewhat formulaic—wealthy couple, man and wife, but Rembrandt invests it with complexities." See also Hendy, *European and American Paintings in the Isabella Stewart Gardner Museum,* 200.
389 *the museum conservators:* Walsh, "Child's Play," 1–7. The painting had been changed in other ways—the canvas was originally larger on the left side. It was trimmed after its paint layer had hardened. The chair was likely added later by another hand "to balance the composition." See Josua Bruyn et al., *A Corpus of Rembrandt Paintings,* vol. 2, 1631–34 (Dordrecht: Springer Netherlands, 1986), no. C67.

SELECTED BIBLIOGRAPHY

Adler, Kathleen, Erica E. Hirshler, and H. Barbara Weinberg. *Americans in Paris, 1860–1900*. London: National Gallery, 2006.

Amory, Suki. "Gardner in the Garden," 2 parts. *Hortus*, no. 107 (Autumn 2013): 51–72, and no. 108 (Winter 2013), 47–66.

Baer, Ronni. *The Poetry of Everyday Life: Dutch Painting in Boston*. Boston: MFA Publications, 2002.

Baxter, Sylvester. "An American Palace of Art: Fenway Court, the Isabella Stewart Gardner Museum in the Fenway." *Century* LXVII, vol. 3 (January 1904): 362–82.

Benfey, Christopher. *Degas in New Orleans: Encounters in the Creole World of Kate Chopin and George Washington Cable*. Berkeley: University of California Press, 1999.

Berenson, Bernard. *Aesthetics and History*. Garden City, New York: Doubleday, 1954.

———. *The Central Italian Painters of the Renaissance*. New York: G. P. Putnam, 1897.

Blight, David W. *Frederick Douglass: Prophet of Freedom*. New York: Simon & Schuster, 2018.

Breslow, Rebecca. "Humanity in a Tea-cup: Isabella Stewart Gardner and Okakura Kakuzo," *Chanoyu Quarterly*, no. 85 (1996): 47–48.

Brooks, Benjamin. "A New England Garden Home," *Country Life in America*, no. 1 (1902).

Brooks, Gladys. *Boston & Return*. New York: Athenaeum, 1962.

Brown, Jonathan, and Carmen Garrido. *Velázquez: The Technique of Genius*. New Haven, CT: Yale University Press, 1998.

Burns, Sarah. *Inventing the Modern Artist: Art and Culture in Gilded Age America*. New Haven, CT: Yale University Press, 1996.

Calderai, Fausto, and Alan Chong. *Furnishing a Museum: Isabella Stewart Gardner's Collection of Italian Furniture*. Boston: Isabella Stewart Gardner Museum, 2011.

Chanler, Margaret. *Autumn in the Valley*. Boston: Little, Brown, and Company, 1936.

Chong, Alan, and Giovanna De Appolonia. *The Art of the Cross: Medieval and Renaissance Piety in the Isabella Stewart Gardner Museum*. Boston: Isabella Stewart Gardner Museum, 2001.

Chong, Alan, and Noriko Murai. *Inventing Asia: American Perspectives Around 1900*. Singapore: Asian Civilizations Museum, 2014.

Cohn, Marjorie B. "Turner, Ruskin, Norton, Winthrop," *Harvard University Art Museums Bulletin 2*, no. 1 (1993): 1–77.

Colby, Robert. "Palaces Eternal and Serene: The Vision of Altamura and Isabella Stewart Gardner's Fenway Court." In *Bernard Berenson: Formation and Heritage*, ed. Joseph Connors and Louis A. Waldman. Villa I Tatti: The Harvard Center for Italian Renaissance Studies, 2014, 69–99.

Collmer, Robert G. "Three Women of Asolo: Caterina Cornaro, Katharine de Kay Bronson, and Eleonora Duse," *Mediterranean Studies,* no. 12 (2003): 155–67.

Cumming, Laura. *The Vanishing Velázquez: A 19th Century Bookseller's Obsession with a Lost Masterpiece.* New York: Scribner, 2016.

Cunningham, Maureen. "The Dante Quest," *Fenway Court* (1972): 18–25.

De Waal, Edmund. *The Hare with Amber Eyes: A Family's Century of Art and Loss.* New York: Farrar, Straus and Giroux, 2010.

Docherty, Linda J. "Collection as Creation: Isabella Stewart Gardner's Fenway Court." In *Memory and Oblivion: Proceedings of the XXIXth International Congress of the History of Art,* ed. Wessel Reinink and Jeroen Stumpel. Dordrecht: Kluwer Academic Publishers, 1999, 217–21.

———. "Translating Dante: Isabella Stewart Gardner's Museum as *Paradiso,*" *Religion and the Arts,* vol. 22 (2018): 194–217.

Dowling, Linda. *Charles Eliot Norton: The Art of Reform in Nineteenth-Century America.* Hanover, NH: University of New England Press, 2007.

Dupont, Christian Y. "Reading and Collecting Dante in America: Harvard College Library and the Dante Society." *Harvard Library Bulletin 22,* no. 1 (Spring 2011), 1–57.

Edel, Leon. *Henry James: The Conquest of London.* Philadelphia: J. B. Lippincott & Co., 1962.

———. *Henry James: The Middle Years.* Philadelphia: J. B. Lippincott & Co., 1962.

Elliott, Maud Howe. *Three Generations.* Boston: Little, Brown, and Company, 1923.

Emery, Elizabeth. "From the Living Room to the Museum and Back Again: The Collection and Display of Medieval Art in the Fin De Siecle." *Journal of the History of Collections 16,* no. 2 (2004): 285–309.

Eze, Anne-Marie. "Isabella Stewart Gardner Museum: Italian Renaissance Books." In *Beyond Word: Illuminated Manuscripts in Boston Collections,* ed. Jeffrey F. Hamburger, et. al., exh. cat. Boston: McMullen Museum of Art, 2016.

Fairbrother, Trevor J. *John Singer Sargent: The Sensualist.* New Haven, CT: Yale University Press, 2000.

———. "Notes on John Singer Sargent in New York, 1888-1890." *Archives of American Art Journal 22,* no. 4 (1982): 27–32.

———. "The Shock of John Singer Sargent's 'Madame Gautreau,'" *Arts Magazine,* vol. 55 (January 1981): 90–97.

Fergusson, Maggie. *Treasure Palaces: Great Writers Visit Great Museums.* London: The Economist by Profile Books Ltd, 2016.

Fields, Annie. *A Week Away from Time.* Boston: Roberts Brothers, 1887.

Fisher, Paul. *The Grand Affair: John Singer Sargent in His World.* New York: Farrar, Straus and Giroux, 2022.

Gayford, Martin, and Philippe de Montebello. *Rendez-vous with Art.* London: Thames & Hudson, 2014.

Goldfarb, Hilliard T. *The Isabella Stewart Gardner Museum.* New Haven, CT: Yale University Press, 1995.

Greenwald, Diana Seave, and Casey Riley, eds. *Fellow Wanderer: Isabella Stewart Gardner's Travel Albums.* Princeton, NJ: Princeton University Press, 2022.

Grinnell, Nancy Whipple. *Carrying the Torch: Maud Howe Elliott and the American Renaissance.* Hanover and London: University Press of New England, 2014.

Hadley, Rollin Van N., *Drawings: Isabella Stewart Gardner Museum.* Boston: Published by the Trustees, 1968.

Halttunen, Karen. *Confidence Men and Painted Women: A Study of Middle-Class Culture in America, 1830–1870.* New Haven, CT: Yale University Press, 1982.

Harris, Neil. "The Gilded Age Revisited: Boston and the Museum Movement." *American Quarterly 14*, no. 4 (1962): 545–66.

Hawley, Anne. "Isabella Stewart Gardner: An Eye for Collecting." In *Before Peggy Guggenheim: American Women Art Collectors,* ed. Rosella Mamoli Zorzi, (Venice: Marsilio, 2001), 59–64.

Hedrick, Joan D. *Harriet Beecher Stowe: A Life.* New York and Oxford: Oxford University Press, 1994.

Hendy, Philip. *European and American Paintings in the Isabella Stewart Gardner Museum.* Boston: Isabella Stewart Gardner Museum, 1974.

Higonnet, Anne. *A Museum of One's Own.* New York: Periscope Publishing, 2009.

———. "Museum Sight." In *Art and Its Publics: Museum Studies at the Millennium,* ed. Andrew McClellan. Malden, MA: Blackwell Press, 2003.

———. "Private Museums, Public Leadership: Isabella Stewart Gardner and Art of Cultural Authority." In *Cultural Leadership in America: Art Matronage and Patronage,* ed. Wanda Corn. Boston: Trustees of the Isabella Stewart Gardner Museum, 1997.

———. "Where There's a Will . . . ," *Art in America 77,* no. 5 (May 1989), 65–75.

Higginson, Henry Lee. *Life and Letters of Henry Lee Higginson,* ed. Bliss Perry. Boston: The Atlantic Monthly Press, 1921.

Hirshler, Erica E. *Dennis Miller Bunker: American Impressionist.* Boston: Museum of Fine Arts, 1994.

———. "Sargent in Boston and New York, 1888–1912: Venn Diagrams." In *Sargent: Portraits of Artists and Friends.* London: National Portrait Gallery (2015): 173–177.

———. *Sargent's Daughters: The Biography of a Painting.* Boston: MFA Publications, 2009.

Howard, Leland Ossian. "Biographical Memoir of Edward Sylvester Morse, 1898–1925," *National Academy of Sciences 17,* no. 1, 14.

Howe, M. A. DeWolfe, ed. *John Jay Chapman and His Letters.* 1st ed. Boston: Houghton Mifflin Company, 1937.

James, Henry. *Collected Travel Writings: Great Britain and America* and *Collected Travel Writings: The Continent.* New York: The Library of America, 1993.

———. *The Complete Letters of Henry James, 1883–1884: Volume 2.* Lincoln: University of Nebraska Press, 2019.

———. *Italian Hours.* With an introduction by John Auchard. Reprint. New York: Penguin Books, 1995.

———. *The Wings of the Dove.* New York: Charles Scribner's Sons, 1902.

Johns, Clayton. *Reminiscences of a Musician.* Cambridge: Washburn & Thomas, 1929.

Kagan, Richard L. *The Spanish Craze: America's Fascination with the Hispanic World, 1779–1939.* Lincoln: University of Nebraska Press, 2019.

Kennedy, Kate, and Hermione Lee, eds. *Lives of Houses.* Princeton, NJ: Princeton University Press, 2020.

Kilmurry, Elaine. *John Singer Sargent: The Early Portraits, Complete Paintings, Volume I.* New Haven, CT: Yale University Press, 1998.

Larson, Erik. *The Devil in the White City: Murder, Magic, and Madness at the Fair That Changed America.* New York: Vintage Books, 2003.

Lears, Jackson. *No Place of Grace: Antimodernism and the Transformation of American Culture, 1880–1920.* New York: Pantheon Books, 1981.

Lee, Hermione. "The Art of Biography No. 4": Interview with Louisa Thomas. *Paris Review*, vol. 205 (Summer 2013), 135–65.

———. *Edith Wharton*. New York: Vintage Books, 2008.

Locke, Ralph P., and Cyrilla Barr, eds. *Cultivating Music in America: Women Patrons and Activists Since 1860*. Berkeley: University of California Press, 1997.

Longstreet, Gilbert Wendel, and Morris Carter. *General Catalogue*. Boston: Isabella Stewart Gardner Museum, 1935.

Macleod, Dianne Sachko. *Enchanted Lives, Enchanted Objects: American Women Collectors and the Making of Culture, 1800–1940*. Berkeley: University of California Press, 2008.

Manley, Deborah, ed. *Women Travelers in Egypt: From the Eighteenth to the Twenty-First Century*. Cairo: University of Cairo Press, 2012.

Matar, Hisham. *A Month in Sienna*. New York: Random House, 2019.

Matthews, Rosemary. "Collectors and Why They Collect: Isabella Stewart Gardner and Her Museum of Art," *Journal of the History Collections* 21 (2009).

McCarthy, Kathleen D. *Women's Culture: American Philanthropy and Art, 1830–1930*. Chicago: University of Chicago Press, 1991.

McCarthy, Mary. *The Stones of Florence*. New York, London: A Harvest/HBJ Book, Harcourt Brace Jovanovich, Publishers, 1959.

Miller, Lucia. "John Singer Sargent in Diaries of Lucia Fairchild 1890 and 1891," *Archives of American Art Journal 26* no. 4 (1986): 2–16.

Morse, Edward Sylvester. *Japan Day By Day, 1877, 1878–79, 1882–83, Volume 1*. Boston: Houghton Mifflin, 1917.

Nehama, Sarah. *In Death Lamented: The Tradition of Anglo-American Mourning Jewelry*. Boston: Massachusetts Historical Society, 2013.

Nickel, Douglas R., *Francis Frith in Egypt and Palestine: A Victorian Photographer Abroad*. Princeton, NJ: Princeton University Press, 2004.

Norwich, John Julius. *Paradise of Cities: Venice in the 19th Century*. New York: Vintage Books, 2004.

O'Connor, Thomas H. *Civil War Boston: Home Front and Battlefield*. Boston: Northeastern University Press, 1997.

Ormond, Richard. "Sargent and the Arts." In *Sargent: Portraits of Artists and Friends*. London: National Portrait Gallery, 2015, 9–21.

Pamuk, Orhan. *The Innocence of Objects: The Museum of Innocence*, translated by Ekin Oklap. New York: Abrams, 2012.

Puleo, Stephen. *A City So Grand: The Rise of an American Metropolis, Boston 1850–1900*. Boston: Beacon Press, 2010.

Ragg, Laura. "Venice When the Century Began." *Cornhill Magazine 153* (1936): 2–16.

Ribeiro, Aileen. *Clothing Art: The Visual Culture of Fashion, 1600–1914*. New Haven, CT: Yale University Press, 2017.

Riley, Casey. "Self-Assembled: Isabella Stewart Gardner's Photographic Albums and the Development of Her Museum," ed. Elizabeth Edwards and Christopher Morton. In *Photographs, Museums, Collections: Between Art and Information* (London: Bloomsbury Academic, 2015), 47–63.

———. "To Make a Case: Isabella Stewart Gardner's Archival Installations at Fenway Court." In *Boston's Apollo: Thomas McKeller and John Singer Sargent*, ed. Nathaniel Silver. Boston: Isabella Stewart Gardner Museum; distributed by Yale University Press, 2020, 155–73.

Rioux, Anne Boyd. *Constance Fenimore Woolson: Portrait of a Lady Novelist*. New York: W. W. Norton, 2016.

Ross, Alex. *Wagnerism: Art and Politics in the Shadow of Music.* New York: Farrar, Straus, Giroux, 2020.

Rubin, Patricia. "Portrait of a Lady: Isabella Stewart Gardner, Bernard Berenson, and the Market for Renaissance Art in America." *Apollo 150* (September 2000), 207–22.

Saarinen, Aline. *Proud Possessors.* New York: Random House, 1958.

Saltzman, Cynthia. *Old Masters, New World: America's Raid on Europe's Great Pictures.* New York: Penguin Books, 2009.

Santayana, George. *Person and Places,* 2 vols. London: Constable, 1944–53.

Schjeldahl, Peter. "The Reign in Spain: Velázquez and the King," *The New Yorker,* January 2, 2012.

———. "The Spanish Lesson: Manet's gift from Velázquez," *The New Yorker,* November 18, 2002.

Sedgwick, Ellery. *The Happy Profession.* Boston: Little, Brown and Company, 1946.

Shand-Tucci, Douglass. *The Art of Scandal: The Life and Times of Isabella Stewart Gardner.* New York: HarperCollins, 1997.

Shaw, Prue. *Reading Dante: From Here to Eternity.* New York: Liveright, 2014.

Silver, Nathaniel. *Botticelli: Heroines and Heros.* Boston: Isabella Stewart Gardner Museum; London: Paul Holberton Publishing, 2019.

———. *Close-up: Raphael and the Pope's Librarian.* Boston: Isabella Stewart Gardner Museum; London: Paul Holberton Publishing, 2019.

Smith, Corinna Lindon. *Interesting People: Eighty Years with the Great and the Near-Great.* Norman: University of Oklahoma Press, 1962.

Smith, Logan Pearsall. *Unforgotten Years.* Boston: Little, Brown, 1939.

Smith, Jane S. *Elsie de Wolfe: A Life in the High Style.* New York: Atheneum, 1982.

Stanley, Amy. *Stranger in a Shogun's City: A Japanese Woman and Her World.* New York: Scribner, 2020.

Stansell, Christine. "Women Artists and the Problems of Metropolitan Culture: New York and Chicago, 1890–1910." In *Cultural Leadership in America: Art Matronage and Patronage,* ed. Wanda Corn. Boston: Trustees of the Isabella Stewart Gardner Museum, 1997.

Stebbins, Theodore E. *The Lure of Italy: American Artists and the Italian Experience, 1760–1914.* Boston: Museum of Fine Arts, 1992.

Stewart, Susan. *On Longing: Narratives of the Miniature, the Gigantic, the Souvenir, the Collection.* Durham and London: Duke University Press, 1993.

Strouse, Jean. *Alice James: A Biography.* New York: New York Review of Books, 2011; originally published in 1980.

———. *Morgan: American Financier.* New York: Random House, 1999.

———. "Sargent & His People," *New York Review of Books,* October 8, 2015.

Sullivan, T. R. *Passages from the Journal of Thomas Russell Sullivan, 1891–1903.* Boston: Houghton Mifflin Company, 1917.

Sweeney, John L., ed. *Henry James: The Painter's Eye, Notes and Essays on the Pictorial Arts.* Madison: University of Wisconsin Press, 1989.

Tóibín, Colm. "Henry James: Shadow and Substance." In *Henry James and American Painting,* ed. Colm Tóibín, Marc Simpson, and Declan Kiely. New York: Morgan Library and Penn State University Press, 2017, 36–40.

———. "Secrets and Sensuality: The Private Lives of John Singer Sargent and Henry James." In *Boston's Apollo: Thomas McKeller and John Singer Sargent,* ed. Nathaniel Silver. Boston: Isabella Stewart Gardner Museum; distributed by Yale University Press, 2020, 117–31.

Tostmann, Oliver, ed. *Anders Zorn: A European Artist Seduces America.* Boston: Isabella Stewart Gardner Museum; London: Paul Holberton Publishing, 2013.

Vance, William L. "Berenson and Mrs. Gardner: A Rivalry of Aspirations." *The New England Quarterly 61,* no. 4 (1988): 575–95.

Verduin, Kathleen. "Bread of Angels: Dante Studies and the Moral Vision of Charles Eliot Norton," *Dante Studies, with the Annual Report of the Dante Society,* no. 129 (2011): 63–97.

Voorsangers, Catherine Hoover, and John K. Howatt, eds. *Art and the Empire City: New York, 1825–1861,* exh. cat. New York: The Metropolitan Museum of Art; New Haven, CT: Yale University Press, 2000.

Warsh, Molly. *American Baroque: Pearls and the Nature of Empire, 1492–1700.* Chapel Hill: University of North Carolina Press, 2018.

Weber, Caroline. *The Queen of Fashion: What Marie Antoinette Wore to the Revolution.* New York: Picador, 2006.

Weinberg, H. Barbara. "American Artists' Taste for Spanish Painting." In *Manet/Velázquez: The French Taste for Spanish Painting.* New Haven, CT: Yale University Press for The Metropolitan Museum of Art, 2003.

Wilkinson, Toby. *The Nile: A Journey Downriver Through Egypt's Past and Present.* New York: Knopf Doubleday Publishing Group, 2014.

Young, Eric. "Notes on Spanish Paintings in the Isabella Stewart Gardner Museum." *Fenway Court* no. 17 (1979): 24–35.

INDEX

NOTE: *Italic page numbers* indicate photographs.

Abbott, Henry, 12
abolitionism, 43, 46–47, 49, 92
Abu Simbel, 82, 86
Adams, Abigail, 59
Adams, Charles, 344
Adams, Clover, 44, 94–95, 103, 105, 106, 113, 137, 234, 268, 307
Adams, Henry, 176, 214, 314–19, *316*, 322–23, 344
 on Boston society, 21, 43–44
 The Education of Henry Adams, 109, 315, 323, 348
 at Fenway Court, 289–90, 315–17, 334
 in Japan, 307
 Joe Gardner's suicide, 85
 in London, 94–95
 Mont Saint Michel and Chartres, 316–17
 in Paris, 245, 268, 314–15, 317, 318–19
 in Washington, D.C., 103, 137–38, 315, 348, 375
 during World War I, 365
Adams, John, 59
Aeschylus, 39
Agassiz, Alexander, 65, 211
Agassiz, Elizabeth, 28–29, 283
Agassiz, Ida. *See* Higginson, Ida Agassiz
Agassiz, Louis, 28–29, 72, 73
Age of Innocence (Wharton), 69–70
Agostini, Domenico, 186
Agostini, Gigi, 219
Agricultural Society of New York, 13
Aidé, Charles Hamilton, 195
Alcott, Louisa May, 59
Aldrich, Lillian, 211
Aldrich, Thomas Bailey, 211, 283, 354
Alexander, Lucia Gray, 52
Alexandria, Egypt, 75–76
Alhambra, the, 167–68
Allston, Washington, 72, 91
Altamura, 324–25
American Association of Painters and Sculptors, 348–49
American Field Service, 365–66
American Indians, 99
American Jockey Club, 230
American Revolution, 43
American Scene, The (James), 303
American School of Classical Studies, 240
Ames, Fanny Baker, 288
Andersen, Andreas, 248
Andersen, Hans Christian, 61
Anderson, Anna, 189
Anderson, Nicholas Longworth, 62–63
Andrew, Abram Piatt, 216, 301, 328–31, 350, 379, 384
 Dabsville colony, 328–31, *329*, 344, *345*, 373–74, 378
 at Fenway Court, 294–95, 363, 365
 Okakura's memorial, 353
 during World War I, 365–67
Andrew, John, 46
Andromeda's Reef, 83
Angkor Wat, 121–22
Annunciation, An (Piermatteo), 280, 281
anti-Semitism, 153
Apollo Club, 174
Appleton, Helen Mixter, 189, 378, 384, 385

Appleton, Randolph, 190
Appleton, Thomas Gold, 43, 69, 77, 78
Apthorp, Octavie, 174
Apthorp, William Foster, 174, 186, 286
Arabia, 41, 321
Aristophanes, 39
Armory Show (1913), 349–50, 351
Arnold Arboretum, 237
"art for art's sake," 94, 214
Arthur, Prince, 81
Art Institute of Chicago, 274, 349–50
Asakusa Shrine, 114
Ascot Races, 94
Atkinson, Charles Montague, 138, 230, 341
Atlantic Monthly, 136, 152, 211, 283, 354, 378–79
Austen, Jane, 24

Back Bay, 66, 91, 94, 138, 241
Bagni di Lucca, 101
Bakst, Léon, 350
Ballet Russes, 350
Balloon Post, 72
Barbizon School, 91
Bardini, Stefano, 272–73, 275
Barnum, P. T., 12
Barrett, Elizabeth, 105
Basilica of Saint Francis of Assisi, 197–98
Basilica San Vitale, 197
Battista, Giovanni, 126
Battle of Ball's Bluff, 56
Bayreuth, 142–43, 177, 243
Beach Hill, 88, 104, 152, 211, 224, 249
Beacon Street, 35, 37, 38
 no. 145, 59
 no. 150, *97,* 97–98, *98*
 no. 152, 41, 48, 50, 59, 66, 85, 135–36, 155, 209, 270, 300
 no. 241, 101
Beard, George, 60
Beato, Antonio, 78
Beauvais, 318–19
Beaux, Cecilia, 294, 311, 330, 347
Beecher, Catharine, 49
Beecher, Henry Ward, 104–5
Beethoven, Ludwig van, 66, 136, 144, 177, 193, 304

Bell, Helen Choate, 106–7
Belle, 85
belle époque, 200
Bellini, Gentile, 326–27
Bellini, Giovanni, 126, 127, 239, 280, 282, 326, 379
Bellows, George, 349
Benfey, Christopher, 114, 308
Ben Hur (Sedgwick), 154
Berenson, Bernhard, 152–53, 212–13, 240, 243–44, 297–99, *298,* 353–54, 364, 376
 background of, 152–53
 letters, 153–54, 182, 212, 214, 215, 217, 226–29, 232–34, 235, 236, 239, 245, 246, 248, 263–65, 268, 269–70, 272, 274, 283–84, 290, 308, 315, 321, 324, 328, 339, 340, 345–46, 347, 356–57, 360, 368, 380, 384, 387
 paintings and acquisitions of Isabella, 213, 221–22, 226–29, 232–36, 238–39, 249, 250–53, 263–65, 266–67, 325–26, 328, 361, 379
Berenson, Mary, 257, 284, 297, 299, 300, 308, 309–10, 344, 353–54, 356, 360, 364, 384
Bergson, Henri, 351–52
Berlioz, Hector, 177
Besarel, Valentino, 199
Bierstadt, Albert, 194–95
Bierstadt, Mary Hicks Peck Stewart, 150–51, 184, 194–95
Bigelow, Henry Jacob, 49, 60, 69
Bigelow, Susan Sturgis, 113
Bigelow, William Sturgis, 113–14, 117–18, 222–23, 234, 279, 307, 310, 311, 353, 360–61
Biltmore, 297
birth of Isabella, 11, 16
Black's Guide to Norway, 61
Black Ship, 307
Blake, William, 70
Blue Boy, The (Gainsborough), 232–33
Blue Room, 108, 283
Bode, Wilhelm von, 328
Bois de Boulogne, 37, 95
Boit, Edward Darley "Ned," 66, 155, 157, 163

INDEX 481

Bonnici, Giovanni Maria, 76, 82, 83
Book of Tea, The (Okakura), 308, 311, 353, 374
Borghese Palace, 199, 240, 266
Borgo Allegro, 235, 275
Borgo Sansepolcro, 332
Boston Advertiser, 71
Boston Art Club, 65
Boston Artists' Festival, 173–76, *175*, 177, 229
Boston Athenaeum, 35, 43, 72, 91
Boston Brahmins, 6, 43–44, 46–47, 67, 69–70
Boston Chronicle, 237
Boston Common, 35, 41, 91, 113, 265, 367
Boston Evening Transcript, 254, 286, 341, 363, 386
Boston Globe, 99, 158, 174, 195, 215–17, 270, 287, 291, 333, 356, 367, 386
Boston Great Fire of 1872, 64, 241
Boston Herald, 220–21, 350
Boston Journal, 216
Boston Lying-In Hospital, 189, 263
Boston Museum of Fine Arts, 91–92, 114, 209, 212, 254, 263, 266, 304, 310, 344
 Artists' Festival, 173–76, *175*
Boston Opera House, 341
Boston Post, 286–87, 363
Boston Public Library, 43
Boston Red Sox, 343
Boston Symphony Orchestra, 43, 66, 97, 102, 143, 174, 176, 218, 229, 285, 293, 307, 334, 369–70
Boston University, 153
Botticelli, Sandro, 5, 141, 145, 221–23, 266–67
Botticini, Francesco, 280
Boucher, François, 64
Boucheron, Frédéric, 68, 132, 146, 176, 184–85, 200
Bourget, Minnie, 210, 212, 218–19
Bourget, Paul, 210–12, 303
Bowditch, Charles Pickering, 286
Bowditch, Cornelia, 286
Brady, Mathew, 12
Brahms, Johannes, 66, 136, 174, 177, 218

Brimmer, Marianna, 174, *175*, 175–76, 204, 219
Brimmer, Martin, 174, 204
Bronson, Katherine de Kay, 128–29, 186
Bronzino, 145, 156
Brook at Medfield, The (Bunker), 191–92
Brookline Public Library, 263
Brooks, Van Wyck, 92
Browning, Robert, 105, 129
Brown-Séquard, Charles-Édouard, 72
Buckle, Henry Thomas, 76
Buddhism, 90, 103, 114, 117, 306
Bullard, Ellen, 189
Bulwer-Lytton, Edward, 40
Bunker, Dennis, 174, 179–80, *180*, 191–92, 247, 363
Bunker, John Jr., 179
Burckhardt, Charlotte Louise, 157
Burma (Myanmar), 123
Burton, Spence, 375–76, 385, 386–87
Busoni, Ferruccio, 212
Butts, Margaret, 264
Butts, William, 264
Byron, George Gordon, Lord, 164, 202

Café de Paris, 200
Café Florian, 125–26
Cairo, Egypt, 76, 77, 78, 80, 81–82, 83, 124
California, 98–99
calling cards, 36, 44, 67
Calvinism, 49
Cambodia, 122, 132
Camera Work, 323, 350
Cameron, Don, 315
Cameron, Elizabeth, 315, 319
Camp Wheeler, 375
Carney Hospital, 247
Carpaccio, Vittore, 126–27
Carrer, Antonio, 168–69, 199
Carter, Morris, 74, 336, 343–44, 354
 background of, 343–44
 Fenway Court and, 277, 288, 344, 358, 376, 377–78, 384, 387
 on Isabella and Boston society, 42, 133, 210
 Isabella and Civil War, 48
 on Isabella and viewing paintings, 163

Carter, Morris (cont.)
 on Isabella's appearance, 69
 Isabella's birth date, 16
 Isabella's childhood, 15
 on Isabella's collecting, 202, 263
 on Isabella's courtship and relationship with Jack, 105, 255
 on Isabella's personality, 4–5, 120, 179, 336
 on Isabella's travels, 217
 on Norton, 92
Casa Alvisi, 128–29
Castagno, Andrea del, 328
Centennial Exposition (1876), 95, 112
Cepero, Jacopo Lopez, 166
Cervantes, Miguel, 161
Chadbourne, Emily, 331–33
Champollion, Jean-François, 77
Chanler, Margaret, 7, 108, 378
Chapman, John Jay, 70, 88–89, 93, 375
Chartres Cathedral, 268, 319, 370–71
Chase, William Merritt, 184, 193–94
Cheney, Edward, 141
Chicago, 204–7, 299–300
Chicago, Burlington, and Quincy Railroad, 254
Child, Lydia Maria, 12
Childers, Erskine, 334–35
Childers, Mary "Molly" Alden, 335
childhood of Isabella, 13–19
China, 102–3, 117–23
Chinese Loggia, 361, 370
Chinese Room, 279, 283, 354–55, *355*, 361
Choice of Books, A (Gardner), 215, 317, 327
Chong, Alan, 278, 279, 354–55
Christ Carrying the Cross (Bellini), 239
Christie, Manson and Woods, 196–97
Church, Frederick Edwin, 33–34, 184
Church of England, 89
Church of Saint Augustine, *188,* 188–89
Church of the Advent, 89–90, 187–89, 217, 256–57, 275, 301, 379, 387
Cimabue, 126, 145
Cima da Conegliano, 280, 281
City Beautiful, 327

City of Rome, 135, 183
City of Tokio, 111
Civil War, 46–48, 49–50, 52, 56, 62, 99, 161
Clemens, Samuel, 33
Clerle, A., 199
Cleveland, Grover, 137
Cochran, W. Bourke, 313
Cohen, Rachel, 222, 227, 251–52
Collège de Paris, 351–52
Collins, Alfred Quinton, 198
Collins, Mary, 198
Colnaghi and Company, 222, 250–53, 264–65, 267, 389
Columbia College, 44, 74
Comte, Auguste, 337
Concert, The (Vermeer), 1, 201–2, 203, 213, 234
Concord School of Philosophy, 137
Conscience Whigs, 47
Coolidge, Archibald Cary "Archy," 59, 226
Coolidge, Ellen, 128, 173
Coolidge, Harold Jefferson, 74, 226, 274
Coolidge, J. R., Jr., 370
Coolidge, John, 50, 135, 368
Coolidge, John Templeman, 296
Coolidge, Joseph Randolph, 50, 59, 261
Coolidge, Julia Gardner, 15, 23–30, 34–35, 38, 40, 50, 157, 173, 176, 243, 385
Coolidge, Thomas Jefferson, 118, 157, 176, 219, 357–58
Cooper, James Fenimore, 12
Copenhagen, 61
Copley, John Singleton, 72
Copley Society, 173, 350
Coquerel, Athanase, Jr., 22, 73
Corazza Café, 195
Coronation of Napoleon (David), 33
Corot, Jean-Baptiste-Camille, 90–91, 97, 205, 242
Corpus Domini Day, 128
Costelloe, Mary, 244
Cotting School, 247, 270, 301
Cotton Whigs, 47
Coudenhove, Hans, 381

INDEX

Crawford, F. Marion "Frank," 100–108, *101, 106,* 132, 217, 223, 374, 381
 background of, 101–2
 Fenway Court visit, 327–28
 relationship with Isabella, 101–8, 111, 122, 133, 158, 255, 313
Crawford, Louisa Ward, 101, 102
Crawford, Thomas, 101, 223
Crawford's Notch, 158
Crivelli, Carlo, 250–51, 253, 264, 279
Cross, A. B., 105–6
Crowninshield, Benjamin, 47, *47*
Cuba, 89, 141
Cuba (ship), 53
Cumming, Laura, 163
Curtis, Ariana, 130–31, 144, 198–99, *199*
Curtis, Daniel, 130–31, 144, 147, 275
Curtis, Lisa de Wolfe Colt, 318, 334
Curtis, Mary F., 72
Curtis, Ralph, 130, 144, 146–47, 149, 164, 165, 185, 199, 200, 206–7, 217, 240, 318, 326, 333, 334, 364, 377
Curtis, Sylvia, 385
Cushing, Howard, 247

Dabsville, 330–31, 335, 344, 366, 373, 375, 378
Daguerreian Miniature Gallery, 12
dahabiyya, 76–77
Daisy Miller (James), 95, 100
Dalla Torre, Moise, 199
Damascus, 84
Damrell, John, 272
Damrosch, Walter, 247
Dante Alighieri, 102, 104, 106, 126, 136–37, 141, 144–45, 196, 212, 327, 367
Dante Case, 141, 327
Dante Society, 136–37
Daughters of Edward Darley Boit, The (Sargent), 66, 155, 157, 163
Daughters of the American Revolution, 16
David, Jacques-Louis, 33
Davidge, Joanna, 330
Davies, Arthur B., 349
da Vinci, Leonardo, 126, 145
Dead Sea, 83, 84

death of Isabella, *386,* 386–87
Degas, Edgar, 302, 350, 379
Delafield, Sue, 20
della Robbia, Giovanni, 5
del Sarto, Andrea, 145
de Meyer, Adolf, 323, *323,* 348
de Wolfe, Elsie, 48, 384
Dexter, Josephine "Josie," 218, 219
Dexter, Katherine, 218, 219
Diana (Manship), 379, 380, *380, 382*
Dibblee, Benjamin, 252
Dickens, Charles, 12, 88, 124, 262
Dickinson, Emily, 5
Dingley Act, 249
Divine Comedy, The (Dante), 137, 141, 196, 327
Dr. Claudius (Crawford), 104
Dr. Jekyll and Mr. Hyde (Stevenson), 209
Doll and Richards, 73, 91, 97
Don Quixote (Cervantes), 161
Dorigo, Francesco, 244, 267
Dormition and Assumption of the Virgin (Fra Angelico), 361
Douglass, Frederick, 206
Draper, Eben, 300
Drawings of the Florentine Painters (Berenson), 243–44, 287
Dred, 25
Drinker, Henry, 294
Dryden, John, 132
Dumas, Alexandre, 26–27, 43
Düsseldorf Gallery, 12
Dutch Room, 283, 286, 304, 342, 344, 361, 376, 390
Duveneck, Frank, 128–29
Dwight, Theodore, 217
Dyer, Louis, 168
Dysart, William Tollemach, Earl of, 195

Ed Dayr Colossus, 80
Edgeworth, Maria, 60
Education of Henry Adams, The, 109, 315, 323, 348
education of Isabella, 16–17, 20–27
Effendi, Ali Muraad, 82
église de la Madeleine (Paris), 24, 25, 37
église Saint-Roch (Paris), 25

Egypt, 75–82, 85–86, 117
Eliot, George, 70
Eliot, T. S., 349, 351, 367
El Jaleo (Sargent), 6, 157, 184, 357–60, 377
Elliott, John, 152
Elliott, Maud Howe, 42, 216, 363
 on Frank Crawford, 101, 102, 107, 108, 111, 122
 on Isabella and her nephews, 87–88
 Isabella's Asia tour, 114, 115, 116, 117, 119
 letters, 111, 114, 115, 116, 117, 119, 122–23, 124, 319, 322
 in Newport, 135
 in Rome, 223, 319
 wedding of, 152
Emerald Necklace, 1, 241, 265–66
Emerson, Ellen, 29, 77
Emerson, Ralph Waldo, 29, 72, 77, 93, 306
Emmanuel Church, 48–49, 50, 52, 89
Endicott, William C., 137, 254
Erie Canal, 11
Eugenia, Isabella Clara, 239–40
Evans, John, 271
Evans, R. Tripp, 330
Exposition Universelle (1889), 208

Fable of Arachne (Velázquez), 163–64, 233
Fabritius, Carel, 201, 202
Fair for the Relief of Suffering in France, 71–72
Faure, Jean-Baptiste, 350
Fay, E. A., 137
Fenollosa, Ernest, 114, 117, 211, 306–7, 308
Fenollosa, Lizzie Millett, 114, 211
Fenway Court
 collection and layout, 277–84
 construction of, *258*, 265–66, 270–74, *271, 325*
 design of, 265–66, 267
 endowment, 298, 346, 387
 incorporation and board of directors, 274
 Isabella's initial idea for, 241–42
 Isabella's move to, 274–75
 land purchase for, 262–63
 opening night of, 284–87
 opening of, 1–3, *2*, 5, 287–88
Ffoulke, Charles and Sarah, 315
Field, Charles, 188–89
Field Museum of Natural History, 207
Fields, Annie, 152, 211, 341
Fields, James T., 152
Fiesole, 146
Fitzgerald, John F. "Honey Fitz," 341, 368
Florence, 28, 144–46, 197, 364
Florio, 107
Foote, Arthur, 177
Forbes, Margaret, 34
Forbes, Robert Bennet, 34
Ford, Richard, 161, 163–64
Fra Angelico, 1, 28, 145–46, 174, 361
Francia, Francesco, 280
Franck, César, 136
Franco-Prussian War, 71–72, 73, 200
Freedom (Crawford), 101
French Enlightenment, 22
French Revolution, 25, 72, 195
Frick, Henry Clay, 249–50
Fry, Roger, 325
Fugitive Slave Act, 46
Fuller, Margaret, 43, 59
funeral of Isabella, *386*, 386–87

Gainsborough, Thomas, 232–33
Galerie de Valois, 132
Galleria Pitti, 145
Gallerie dell'Accademia, 130
Gardner, Augustus Peabody "Gussie," 53, 85, *88*, 135, 189–90, *190*, 226, 367–68
 death of, 375
 death of brother Joe, 146
 European tour, 94–95
 guardianship of Isabella and Jack, 87–89, 94–95
 Massachusetts congressman, 365, 368
 as trustee of Jack's estate, 263
 during World War I, 367–68, 375
Gardner, Catharine Elizabeth Peabody, 23–24, 25, 27, 28, 36, 38, 41, 42, 52, 65–66, 71, 119
Gardner, Catherine, 50, 53–54, 328
Gardner, Elizabeth Pickering, 41–42

INDEX 485

Gardner, Eliza Endicott, 38, 50, 53–54, 55, 142
Gardner, George Augustus "Gag," 36–38, 41, 49, 50, 53–54, 126, 138, 141–42, 150, 168, 185
Gardner, George Peabody, Jr., 343, 368, 375, 383
Gardner, George Peabody "Georgy," 50, 51, 261, 270, 328
 letters, 51, 89, 113, 143, 144, 146, 152, 166, 168, 185
 at Paris *pension,* 51, 53
 as trustee of Jack's estate, 254, 263, 266
Gardner, Harriet Sears Amory, 50, 53, 55, 85, 87
Gardner, John "Jack" Lowell, Jr., 3, *36,* 253
 appearance of, 37, 65, 132–33
 at Artists' Festival, *175,* 176
 Asia tour, 111–23
 business interests of, 41–42, 48, 64–65, 246
 children and family life, 50–55, 87, 89
 during the Civil War, 47, *47,* 49–50
 death and estate of, 253–55, 263
 Egypt tour, 75–82, 83, 85–86
 engagement to Isabella, 37–40
 European tours, 60–62, 141–42, 161, 164–66, 167–68, 184–85, 195–203, 217–18, 223–24, 245
 Fenway Court and, 5, 241
 first meetings with Isabella, 35–36
 funeral service of, 256–57
 in Paris, 24–25, 36, 37
 personality of, 36–37, 39–40
 in Venice, 124, 125–31, 185–87, 198–99, 219–20, 224, 243–44
 wedding to Isabella, 40–41
Gardner, John Lowell, 34, 38–39, 40, 118, 230, 254, 383
 business interests of, 41–42, 64, 65–66
 death of, 134–35
 European tour, 23, 25, 28
Gardner, John Lowell, III "Jackie," 49, 50–53, *51,* 54–55, 75, 383, 391
Gardner, Joseph, 38–39, 40, 49, 50, 53, 54, 55, 62, 88, 140, 144, 226
 suicide of, 84–85, 87

Gardner, Joseph, Jr., 50, 85, 87, *88,* 135, 144
 European tours, 94–95, 141
 guardianship of Isabella and Jack, 87–89, 94–95, 141, 144
 suicide of, 146–47, 148, 150
Gardner, Rebecca Russell Lowell, 24–25
Gardner, Rose Grosvenor, 375, 383
Gardner, Samuel, 50, 54
Gardner, William Amory, 50, 85, *88,* 135, 262, 301
 death of brother Joe, 146
 European tour, 94, 142–43
 Fenway Court and, 274
 at Groton School, 154, 226, 301–2
 guardianship of Isabella and Jack, 87–89, 94–95, 144
Garrison, William Lloyd, 43, 46, 71
Gassed (Sargent), 373–74
Gaujelin, Madame, 302
Genoa, 268
Gericke, Wilhelm, 176–77, 218, 285, 287
Gilchrist, Connie, 94
Gilded Age, 127
Giorgione, 239
Giottino, 227
Giotto, 126, 145, 197–98
Giusti Garden, 185
Giverny, 320–21, 350
Glaenzer, Eugene, 302
Gluck, Christoph Willibald, 44–45
Godwin, Beatrix, 195
Golden Bowl, The (James), 303
Goldfinch, The (Fabritius), 201, 202
Gothic Room, 6, 158, 272, 292–93
Gould, Jay, 205
Gounod, Charles, 261–62
Goupil and Company, 44–45
Grace Church (Jamaica), 13, 17
Grace Church (New York City), 17–19, *19,* 40–41, 74, 75
Grafton, Charles Chapman, 89–90
Granada, 167–68
Gray, Amy Heard, *175,* 175–76
Gray, Anna Lyman, 112
Gray, Hedwiga Regina, 69
Gray, John Chipman, 263, 274
Great Pyramids of Giza, 79, 82

Great Wall of China, 119
Greece, 82–83, 84–85
Greene Street, 11, 14
Green Hill, 41–42, 65, 66, 134, 138–39, 142–43, 152, 187, 209–10, 226, *230,* 231, 234, 243, 248, 269, 297, 327, 342–43, 368, 375, 383
 the gardens, 138–39, *139,* 187, 209, 230, *231,* 232, 237, 243, 248, 264, 301, 327, 342–43
 sale to great nephew, 375
Green Hill Stable, 229–30
Green-Wood Cemetery, 18, 40, 140, 192
Gregory, Augusta, 342, 349
Grimes, Leonard, 43
Grosvenor Gallery, 94, 149
Groton School, 154, 226, 248, 301–2, 344
Guardi, Francesco, 224, 227–28
Guérin, Eugénie de, 70
Guggenheim, Moses Michelangelo, 199
Gutekunst, Otto, 222, 251–52

Hakodatè, Isatsu, 113
Hale, Nathan, 72
Hale, Philip, 356
Hale, Sarah Preston Everett, 72
Hale, Susan, 72–73, 158
Hall, Arthur, 89–90
Hallowell, Sara T., 205
Halton (horse), 230
Hamburg, 60, 61
Ham House, 195
Hamman, Édouard, 44–45
Handel and Hayden Society, 43
Harding, Chester, 91
Harmony in Yellow and Gold (Whistler), 94–95
Harper's Weekly, 67–68, 148–48
Harte, Bret, 72
Harvard College, 23, 25, 36, 43, 49, 87, 94, 153, 176, 211, 254, 256, 294, 329–30, 344
Harvard Music Association, 66, 87–88
Hassam, Childe, 248
Hasty Pudding Club, 176
Haussmann, Baron, 21
Havemeyer, Henry O., 205

Havemeyer, Louisine, 92, 349
Hawley, Anne, 3, 391
Hawthorne, Hildegarde, 230, 375
Hawthorne, Nathaniel, 96, 105, 223, 230
Hay, John, 137–38
Heart of the Andes, The (Church), 33–34, 184
Hecla Mines, 234
Hegel, Georg Wilhelm Friedrich, 306
Helleu, Paul César, 205–6
Henri, Robert, 349
Henschel, Georg, 102
Hicks, Mary Ann Smith, 150
Higginson, Henry Lee, 47, 48, 97, 143, 194, 256, 259, 260, 293, 334–35, 355, 369
Higginson, Ida Agassiz, 28–29, 31, 65, 143, 283, 334–35, 379
Holbein, Hans, 144, 264, 266, 293
Holiday, Henry, 18–19
Holmes, Oliver Wendell, 211
Holmes, Oliver Wendell, Sr., 43, 211
Holy Ghost Hospital, 341
Homer, 76, 78
Homer, Winslow, 91
Hong Kong, 118, 120–21
Hooper, Edward, 234
Hooper, Robert, 94
Hopkinson's Preparatory School, 87
Horus, 224–25, *225*
Hosmer, Harriet, 105–6
Hotel Boylston, 41
Hotel Britannia, 144
Hotel de l'Europe, 125–26, 144, 168
Hôtel Drouot, 200–202
Hôtel du Rhine, 146
Hotel Westminster, 184–85, 199, 200, 217
House in Good Taste, The (Wolfe), 48
Howe, Julia Ward, 42, 56, 59, 72, 101, 107, 137, 152, 178, 195, 212, 285, 287
Howe, Maud. *See* Elliott, Maud Howe
Howell, Chester A., 371
Howells, William Dean, 107
Hudson, Adelia Hicks, 40–41
Hugo, Victor, 21
Hungerford, Margaret Wolfe, 122–23

Hunt, William Morris, 72, 91, 97
Huntington, Archer M., 349
Huntington, Frederic Dan, 49
Hurlbert, William Henry, 103
Hydaspes, 75

Ibis, 77–82
Ibsen, Henrik, 195
India, 112, 118, 122–23
Indian Herald, 101–2
Industrial School for Crippled Children, 247, 270
Ingersoll, Nathaniel, 138
Innocenti, Saturnino, 244
inro, 112, 116, 305
Interior of the Abbey Church of Saint Denis, The (Helleu), 205–6
Irving, Washington, 161

Jacque, Charles-Émile, 73, 90
James, Alice, 100, 198, 211, 269
James, Henry, 72, 95, *100*, 198, 214, 218–19, 249, 302–3, 315, 317, 346–47
 childhood of, 12, 91
 Daisy Miller, 95, 100
 death of, 374
 Fenway Court and, 303, 334
 The Golden Bowl, 303
 letters, 96, 107, 128, 132, 133, 160–61, 185, 186, 205, 210, 247, 256, 302–3, 346–47
 in London, 96, 132, 142, 146, 148–49, 162, 195, 217
 in Paris, 95, 205, 268
 The Portrait of a Lady, 99–100
 return to America, 346–47
 Sargent and, 6, 148–49, 157
 The Spoils of Poynton, 268, 303
 in Venice, 128, 129, 131, 198–99
 The Wings of the Dove, 131, 303
 during World War I, 365
James, Robertson, 346
James, William, 91, 128, 211, 255, 285, 287, 329, 346
Japan, 102–3, 107, 111–18, 306–8
Japanese Art Institute, 307
Japanese Festival, 311

Java, 112, 122
Jay, James, 16
Jay, John, 16
Jefferson, Thomas, 50
Jephson, Arthur, 191
Jerusalem, 83
Jeune, Mathieu Befort, 64
jewelry, 68, 132–33, 200. *See also* pearls
Jewett, Sarah Orne, 211, 317, 341
Johns, Clayton, 135–36, 174, 177, 186–87, 193, 194, 210, 219, 243, 364
Jones, Edith Newbold, 18
Jones, George Frederic, 18
Jones, Lucretia Rhinelander, 18
Jordan, 83
Joyce, James, 349

Kansas-Nebraska Act, 46
Karnak, Egypt, 57, 81, 82, 83, 86
Keats, John, 75
Kellar, Harry, 247
Kellogg, Clara Louisa, 307
Kemble, Fanny, 34
Kendell, H. R., 42
Kennedy, John F., 368
Kent, Elijah, 15–16
Kent, Rachel, 15–16
Khmer Empire, 121
Kneisel Quartet, 342
Knox, Thomas, 113
Kreisler, Fritz, 374
Kuki, Hatsu, 307
Kyoto, 115, 116–17, 118, 120, 305

La Bruyère, Jean de, 70
La Danse (Matisse), 352
Lady and Gentleman in Black, A (Rembrandt), 389–90, *390*
Lady with a Rose, A (van Dyck), 239
Lady with the Rose (Sargent), 157
La Farge, John, 91, 242, 278, 304, 307, 318, 374
Laird, Alexander, 16
Laird, Allan Stewart, 16
Lamar, Margaret, 340
Lamb House, 256
Lamentation over the Dead Christ (della Robbia), 5

Lamentation over the Dead Christ (Raphael), 279
Landino Dante, 141
Landor, Walter Savage, 70
Landscape Dawn Newport (Whitman), 91
Lane, Hugh, 349
Lang, B. J., 157, 174
Lang, Francis, 157–58, 174
Langen Schwalbach, 217–18
La Peña, Narcisse Virgile Diaz de, 90
Lapsley, Gaillard Thomas, 230, 243, 244, 245, 248, 261–62
Las Meninas (Velázquez), 163
Lavin, Ella, 266, 319, 330, 340, 375
Lawlor, Lillie, 362–63, 368
Lawrence, Amos, 46
Layard, Henry, 128–29
Lebanon, 84
Leo XIII, Pope, 223
Lepanto, 41
Leschetizky, Theodor, 193
Les Dindons Blanc (Monet), 240, 320
Les Trente Millions de Gladiator, 95
Leyland, Frederick, 196–97
Liberator, 46, 71
Lincoln, Abraham, 52, 53
Lippi, Filippino, 227
Lippi, Fra Filippo, 197
Liszt, Franz, 143
Little, Lena, 304
Little Note in Yellow and Gold, A (Whistler), 151
Little Salon, 362, *362*
Loder, George, 18
Lodge, Henry Cabot, 103
Loeffler, Charles M., 136, 210, 212, 243, 247, 293–94, *294*, 312, 316, 350, 353, 374
London, 94, 95, 141–42, 148–49, 176, 185, 195–97, 243, 268–69
London Academy of Art, 149
Longfellow, Gilbert, 140
Longfellow, Henry Wadsworth, 136
Long Gallery, 5, 141, 155, 196, 292, 299, 327
Longworth, Alice Roosevelt, 313
Loring, Augustus Peabody, 262–63

Loring, Ellen Gardner, 50, 53, 385
Loring, Katharine, 128
Loring, Louisa, 128
Louvre Museum, 22, 31, 131–32, 168, 203, 222, 317
Love's Greeting, The (Rossetti), 196–97
Lowell, Abbott, 53
Lowell, Amy, 350–51
Lowell, Anna Cabot, 52
Lowell, Augustus, 53
Lowell, Francis C., 41–42
Lowell, James Russell, 55, 136–37
Lowell, Katharine Bigelow, 53
Lowell, Nina, 128
Lowell, Percival, 53, 113
Loÿs, Lord Berresford (Hungerford), 122–23

Mabbett, Jack, *329*, 329–30, 331
Macknight, Dodge, 347, 357, 363
Macknight Room, 6, 85, 283, 292, 363, 368, 378, 382
MacVeagh, Wayne, 224
Madame X (Sargent), *149*, 149–50, 151, 152, 154, 158
Madonna of the Goldfinch (Raphael), 28
Madrid, 161–64, 168, 317
Malacca, 123
Mancini, Antonio, 224
Manet, Édouard, 350, 390
Manship, Paul, 379, 380, *380, 382*
Manuscript Club, 177
Marble Faun, The (Hawthorne), 105
Marguerite (Story), 30
Mariana de Austria (Velázquez), 162
Marie Antoinette, 24, 26–27, 44–45, 174–75, 178, 179, 257, 362
Marius the Epicurean (Pater), 214–15
Marr, Arthur, 3, 344
Marr, Thomas, 3, 275, 344
Martini, Simone, 293
Mary, Queen of Scots, 16
Mary Baker Eddy, 90
Mason, Fanny Peabody, 198
Massachusetts Bay Colony, 43
Massachusetts General Hospital, 43, 71, 263

INDEX

Massachusetts Historical Society, 43
Massachusetts Horticultural Society, 139, 230, 249
Massachusetts Institute of Technology, 43
Materna, Amalie, 143, 177
Matisse, Henri, 351–52
Matsuki, Bunkio, 279
Mazzantini, Luis, 164–65
McCall, D. S., 349
McClellan, George B., 77, 81, 82
McKeller, Thomas, 377
Meiji, Emperor of Japan, 112, 116–17
Melba, Nellie, 261–62, 284, 333, 335–36, 359
Mellon, Andrew, 249
Mendelssohn, Felix, 364
Metropolitan Museum of Art, 33, 250, 325
Metropolitan Opera, 261–62
Milan, 31, 146, 319
Mill, John Stuart, 93
Millais, John Everett, 94
Millet, Jean-François, 90–91
Mills, Abraham, 17
Milton Hill, 34
Mitchell, August, 17
Mitchell, Weir, 195
Monet, Claude, 227, 240, 320–21, 349, 350
Monks, Gardner, 387
Monks, George, 243
Monks, Olga Gardner, 141–42, *142*, 179, 226, 243, 346, 377–78, 384–85, 387
Monte Cassino, 319
Mont Saint Michel and Chartres (Adams), 316–17
Moreno, Carmen Dauset, 183–84
Morgan, J. P., 132, 192, 249, 328, 332, 349, 360
Morgan, M. J., 132
Moroni, Giovanni Battista, 179, 224, 227
Morse, Edward Sylvester, 99, 102–3, 112–13, 114
Moscow, 62
Moszkowski, Moritz, 174
Mouhot, Henri, 121
Mount Auburn Cemetery, 16, 42
Mount Carmel Convent, 84

Mount Krakatoa eruption of 1883, 122
Mount Vesuvius, 37
Mozart, Wolfgang Amadeus, 66, 136, 177, 285, 366
Mr. Isaacs (Crawford), 102, 104
Mrs. Gardner in White (Sargent), 6–7
Muck, Karl, 369–70
Muir, John, 99
Munich, 143–44
Murillo, Bartolomé, 91, 161
Murray, John, 76
Museum of Fine Arts. *See* Boston Museum of Fine Arts
Music Hall, 66, 87–88, 194
Music Room, at Fenway Court, 311, 341, 342, 353, 354, 356
Myopia Hunt Club, 189

Nabob, 41
Naples, 31, 34, 37
Napoleon Bonaparte, 77, 98, 126
Napoleon III, 21, 60, 64
National Gallery (London), 94, 162, 202, 203, 228, 328
neurasthenia, 60
New England Women's Club, 106
Newport, 66, 91, 135, 211, 248
New York Herald, 210–11
New York Stock Exchange, 365
New York Sun, 289
New York Times, 41, 52, 71, 174, 221, 246–47, 346
New York World, 103
Nichols, Edward, 273
Nichols, Grace, 377
Nicolai, Otto, 174
Nielsen, Alice, 356
Nielsen, Christina, 281
Night and Morning (Bulwer-Lytton), 40
Night-thought, A (Okakura), 309–10, 312
"Night Thoughts" (Okakura), 312
Night Watch (Rembrandt), 174
Nikko, 114, 167
Nile River, 76–82, 84, 85–86
Nippon Exhibition, 310–11
Nocturne: Blue and Silver (Whistler), 224
Noonday (Hunt), 97

North American Review, 320
Norton, Charles Eliot, 114, 133, 203, 214, 223, 240, 268, 306
　background of, 92–93
　Berenson and, 152, 153
　Dante and, 136, 137, 141, 152
　Fenway Court and, 285, 287
　Harvard lectures, 92–93, 102, 136, 152
　Titian's *Europa,* 234
Norton, Grace, 133
Norton, Richard, 240, 266–67, 299
Norton, Sara, 285
Norton, Susan Sedgwick, 93
Norway, 61, 64
Notman, James, 189–90
Notre-Dame de Reims, 370–72, 377
Novelli, Ermete, 341–42
Nuremberg, 85

Oberammergau Passion Play, 185
O'Brien, Hugh, 187
O'Callaghan, Mary, 112, 119
Oddie, Lily, 40–41
Okabe, Kakuya, 308–9
Okakura Kakuzō, 114, 305–13, *306*
　background of, 306–7
　The Book of Tea, 308, 311, 353, 374
　at Dabsville, 344, *345*
　death of, 352–54, 355
　at Fenway Court, 304, 305, 308–9, 311, 363
　relationship with Isabella, 114, 304, 305–13, 328, 344, 347, 360
Okakura Shuzo, 307
Okill, Mary, 16–17, 20
Okill Academy, 16–17, 20
Old Barn Under Snow, Newport, The (La Farge), 91
Olga of Montenegro, 129
Olmsted, Frederick Law, 205, 237, 241, 265
Omnibus, The (Zorn), 208, *208*
"On Beauty" (Emerson), 93
On the Terrace (La Peña), 90
Oratoire du Louvre (Paris), 22, 199
Osaka, 115
Osgood, Hamilton, 295–96
Oslo, 61

Our Lady of Good Voyage, 378
Outre-Mer: Impressions of America (Bourget), 210–12
Owl, The, 140
Oxford movement, 89

Paderewski, Ignacy Jan, 193–94, *194*, 217, 218
Pagan Poem, A (Loeffler), 294
Paget, Violet, 146
Palazzo Avogadro, 199
Palazzo Barbaro, 124, *130*, 130–31, 144, 168, 185–87, 198–99, 219–20, 224, 243–44, 261, 266, 267–68
Palazzo Rusticucci, 223
Palmer, Henrietta Lee, 32
Palmer, Potter, 204, 205, 206, 274, 290, 325
Panic of 1857, 28
Panic of 1890, 187
Panic of 1893, 209
Panic of 1907, 328, 329, 331
Papanti, Louis, 68
Papanti Dance School, 67–68
Paris, 20–28, 37, 61, 64, 71–72, 73, 75, 95, 131–33, 146, 148, 184–85, 195, 199–203, *203*, 217, 245, 314–15, 317, 318–19, 320, 375
Paris Commune, 72, 73
Paris Fair (1871), 91–92
Parker House Hotel, 62
Parsifal (Wagner), 143, 183
Parthenay, 359, 360
Passion-flowers (Howe), 56
Pasteur, Louis, 295
Pater, Walter, 146, 214–15
Paton, Thomas, 14
Payne-Aldrich Tariff Act, 339
Peabody, Elizabeth, 59
Peabody, Frank, 189
Peabody Academy of Science, 99
pearls, 68, 132–33, 146, 156, 176, 223, 384–85
Peking, 118–19, 120
Perkins, Alice, 189
Perkins, Mary, 102
Perry, Commodore, 113, 307
Perry, Lilla Cabot, 320–21

Perry, Thomas Sergeant, 320
Pesellino, Francesco, 197, 280
Peto, Harold, 187, 217
Pezzoli, Gian Giacomo Poldi, 31
Philip IV in Brown and Silver (Velázquez), 162, 238–39, 242
Phillips, Wendell, 43
Phillips, William, 238
Piano, Renzo, 391
Piazza San Marco, 125–26
Pickert, A., 85
Picture of Dorian Gray (Wilde), 195
Piermatteo D'Amelia, 280, 281
Piero della Francesca, 332
Pierson, Charles L., 274
Pisani, Evelina van Millingen, Countess, 129, 186
Pissarro, Camille, 205
Plato, 93
Poldi Pezzoli, 31, 241, 278, 379
Pollaiuolo, Piero del, 328
Pope, Louise, 349
Portrait of a Bearded Man in Black (Moroni), 224, 227
Portrait of a Lady (James), 99–100
Portrait of a Lady (Moroni), 179
Portrait of a Lady in a Turban (Torbido), 229
Portrait of Innocent X (Velázquez), 325–26, 361
Post, Emily Price, 67
Potter, John Briggs, 247, 304, *316,* 328, 335, 363
Pourbus, Frans, 239–40
Powell, Frederick, 353, 385, 386–88
Prado Museum, 161–64, 203, 233, 240, 317, 322, 325
Prendergast, Maurice, 349
Prichard, Matthew Stewart, 283, 292, 304, 310, 328, 331, 344, *351,* 351–52, 353, 363, 366–67, 380
Prides Crossing, 62–63, 88, 104, 178, 343
Proctor, George, 218, 219, 243, 247, 291, 299, 304, 356, 363
Prose, Francine, 3
Prospect Cemetery, 18
Proust, Antonin, 350
Putman, William Lowell, 56
Putnam, Mary Lowell, 55–56

Quincy, Josiah, 23
Quinn, John, 348–49

Ragg, Laura, 131
Rape of Europa, The (Titian), 164, 190, 233–36, *235,* 242, 246, 266, 282, 286
Raphael, 28, 126, 145, 201, 202, 249, 279, 280
Raphael Gallery, 328
Raphael Room, 282–83, 361
Ravenna, 197
Red Cross, 377
redingote, 178, 179
Redon, Odilon, 349
Red Roof, 329, 330, 344, 373–74
Red Studio, The (Matisse), 351
Reims Cathedral, 370–72, 377
Rembrandt van Rijn, 174, 196, 201, 246, 251, 286, 304, 342
 A Lady and Gentleman in Black, 389–90, *390*
 Self-Portrait, 228–29, 234, 242
Reminiscences (Carter), 358
Renaissance, The (Pater), 214, 215
Renwick, James, 17
Republican Party, 47
Ribera, Jusepe de, 161
Richardson, H. H., 315
Riley, Casey, 275
Risorgimento Italy, 129, 249
Robert, Fernand, 201–2, 318
Rockefeller, John D., 249
Rodin, Auguste, 205, 349
Rogers, Clara Kathleen, 177
Rokkaku, Shisui, 308–9
Rome, 28–30, 37, 101, 223–24, 224–25, 244, 268
Roosevelt, Kermit, 301–2
Roosevelt, Theodore, 291–92, 301–2
Roosevelt, Theodore, Jr., 301–2
Roque Island, 139–40, 152, 191, 232
Ross, Denman, 328, 335, 353, 376
Rossetti, Dante Gabriel, 94, 196–97
Roux, Alexander, 48
Rubens, Peter Paul, 1, 144, 161, 286
Rubin, Patricia Lee, 267
Ruffin, George Lewis, 43

Ruhleben, 366–67
Ruskin, John, 70–71, 93, 126, 127, 151, 214
Russell and Company, 14
Russia, 61–62
Russo-Japanese War, 308
Rye School, 268

Sacred and Profane Love (Titian), 266
Sadajirō, Yamanaka, 279
Sagamore Farm, 144
Saint Augustine, Florida, 141
St. Botolph Club, 157, 160, 184, 358
St. Denis, Ruth, 341
Saint Francis House, 375–76
Saint-Gaudens, Augustus, 192, 315
Saint George Slaying the Dragon (Crivelli), 250–51, 253, 264, 279
Saint John's Church (Brooklyn), 14
Saint John's House, 385
Saint Patrick's Cathedral, 17
Saint Peter's Basilica, 29–30
Saint Petersburg, 61–62
Saint-Saëns, Camille, 202
Sand, George, 60, 70
San Miguel Chapel, 98
Santa Fe Railway, 176
Santa Maria della Salute, 125, 128, 131
Sargent, Charles Sprague, 237–38, 256
Sargent, John Singer, 148–50, *149*, 160, 195, 203, 205, 298, 353, 373–75, *374*, 376–77, 379
 artist-in-residence at Fenway Court, 289, 291–97, *294, 295*, 328–29
 Carmencita performance, 183–84
 The Daughters of Edward Darley Boit, 66, 155, 157, 163
 El Jaleo, 6, 157, 184, 357–60, 377
 Fenway Court visit of 1922, 5–7
 Gassed (Sargent), 373–74
 Madame X, 149, 149–50, 151, 152, 154, 158
 Persian carpet purchase, 217, 240
 portrait of Isabella of 1888, 154–58, 215–16
 portrait of Isabella of 1903, 289
 portrait of Isabella of 1922, 6–7, 381–82

 urges purchase of Monet, 240, 320
 during World War I, 364, 373, 375
Sargent, Minnie, 238
Satow, Ernest, 113
Saturday Evening Gazette, 173, 176
Savoy Hotel, 195, 266
Schoenberg, Arnold, 356
School-girl in France, or the Snares of Popery, The (McCrindell), 21–22
Schubert, Franz, 144, 177, 193, 304
Schuyler, Harriet, 195
Schuyler, Philip, 195
Scuola di San Giorgio degli Schiavoni, 126–27
Seabury, Frank, 189
Sears, Mary Crease, 334
Sears, Willard T., 232, 241, 262, 265, 267, 270–74, 283, 354
Sedgwick, Ellery, 154–55, 344
Seville, 164–65
Shakespeare, William, 20, 32, 173, 176, 192, 304
Shanghai, 117–18, 120
Shaw, Quincy Adams, 234–35
Sheep in the Shelter of the Oaks (Jacque), 73
Sicily, 244
Siege of Paris, 71–72, 73, 200
Simmons College, 288
Singapore, 112, 122–23
Sinkler, Caroline, 42, 216, 330, 344, *345,* 353, 374–75, 378, 384
Skinner, Eliza Gardner, 25, 37, 128, 135, 138
Skinner, Francis, 128
Skinner, Frank, 135
slavery, 13, 46–47
Sleeper, Henry Davis, 330–31, 344, *345,* 363, 370, 371, 376–77, 379, 384
Smith, Anna Carpenter, 15
Smith, Corinna, 184, 291, 343
Smith, Francis Hopkinson, 219
Smith, Joseph Lindon, 184, 219, 221, 240, 243, 247, 281, 291, 326, 332, 340, 343, 376
Smith, Selah, 15
Society for the Prevention of Cruelty to Children, 301

INDEX

Society of Saint John the Evangelist, 89–90, 188, 207, 301, 353, 375–76, 384, 385, 388
Socrates, 60
Soiree Musicale, 72
Somerset Club, 104, 252
"Song of Joys, A" (Whitman), 191
Spain, 160–68
Spanish Chapel, 167, 275, 354, 359, 385–86
Spanish Cloister, 6, 354, *357,* 357–60
Spinners, The (Velázquez), 163–64, 233
Spoils of Poynton, The (James), 268, 303
Stanton, Elizabeth Cady, 178
Steichen, Edward, 350
Stein, Gertrude, 364
Stevenson, Robert Louis, 209
Stewart, Adelia, 11, 18–19, 75, 140
Stewart, Adelia Smith, *14,* 14–15, 34, 135
 children and family life, 11, 18–19, 34, 74
 death of, 140–41
 Europe tour, 20–21, 26, 27, 28–30
 Isabella's engagement, 37–38
Stewart, Charles, 12
Stewart, David, *14,* 14–15, 32, 48, 135
 business interests of, 14–15, 34, 65, 85
 children and family life, 11, 18–19, 32, 34, 74
 death of, 191–92
 death of Adelia, 140–41
 Europe tour, 20–21, 28–30
 family background of, 12
 Isabella's engagement, 37–38
 marriage to Mary Hicks Peck, 150–51, 184
Stewart, David Jr., 11, 19, 20–21, 30, 44, 74–75, 140
Stewart, Isabella Tod, 12
Stewart, James Arrott, 11, 12, 16, 19, 34, 44, 74, 140
Stewart and Paton, 14
Stieglitz, Alfred, 323, 350
Stone, Lucy, 43, 178
Stones of Venice, The (Ruskin), 126, 127
Storer, Bellamy, 387

Storer, Maria Longworth, 387
Storm on the Sea of Galilee, The (Rembrandt), 251
Story, William Wetmore, 30, 223
Story of Lucretia, The (Botticelli), 221–23, 234, 242, 279–80, 282
Stowe, Harriet Beecher, 25, 49
Strong, Agnes, 377
Strong, Richard, 377
Strouse, Jean, 250
Stuart, Gilbert, 72, 91
Study in Orange and Blue, The (Whistler), 151
sugoroku, 310
Sullivan, Thomas Russell, 202, 209, 229, 243, 247
Sully, Thomas, 12–13, *13*
Sumner, Charles, 43
sumo wrestling, 115–16
Sunday, Billy, 301
Sweden, 61–62, 208
Swift, Henry, 270, 274, 291, 298, 314, 317, 333, 377
Syria, 82–84

Taft, William Howard, 329
Tagore, Rabindranath, 353
Taj Mahal, 123
Tale of Genji, 138, 305, 355
Tales of the Alhambra (Irving), 161
Tapestry Room, 322, 361, 362
Tarbell, Edmund C., 247
taxes and tariffs, 249, 274, 297–99, 300, 326, 331–34, 339
Taylor and Company, 16
Technische Hochschule, 101
Tell el-Amarna, 80
Temple Koorneh, 80
Temple of Esnah, 78–79
Temple of Luxor, 80–81
Ten American Painters, 248
Tenth Street Studio Building, 33, 184, 193
ter Borch, Gerard, 251
Terrace, The, Saint Tropez (Matisse), 352
Thatcher, William, 341
Théâtre des Variétés, 195

Theatre François Company, 94
Thompson, John, 158–59, *159*
Thoré-Bürger, Théophile, 200–201
Thorndike, Paul, 254
Thornwell, Emily, 66–67
Thorvaldsen, Bertel, 60, 61
Tianjin, 118
Ticknor and Fields, 152
Tiffany, 48, 132, 327
tiffin, 114
Tilton, Elizabeth, 104–5
Tintoretto, 127, 161, 196, 227, 228
Tirindelli, Pier Adolfo, 219
Titian, 1, 33, 126, 145, 161, 164, 190, 266
 The Rape of Europa, 164, 190, 233–36, *235,* 242, 246, 266, 282, 286
Titian Room, 5, 283
Tocqueville, Alexis de, 70
Tóibín, Colm, 6
Tokyo, 112, 113, 114, 116, 304
Tokyo Art Institute, 307
Tokyo Imperial University, 114, 306–7
Tommaso Inghirami (Raphael), 249, 250, 279
Torbido, Francesco, 229
Torre, Moisè Dalla, 199
Town Topics, 154, 178, 183, 184, 247
Travi, Teobaldo "Bolgi," 273, 340–41, 386, 387
Trinity College, 101
Tristan and Isolde (Wagner), 142–43
Tuckernuck Island, 113–14
Turner, J. M. W., 149, 227
Twachtman, John Henry, 248
Twain, Mark, 211
Tyler, Elisina, 367
Tyler, Royall, 367

Uffizi Gallery, 28, 145, 233
Umberto I of Italy, 223–24
Uncle Tom's Cabin (Stowe), 25
Unitarianism, 49, 90, 92
University of Freiburg, 366
University of Heidelberg, 101
University Place, no. 10, 11

van Dyck, Anthony, 161, 239, 286
Vanity Fair, 350

Velázquez, Diego, 160, 162–64, 227, 233, 238–39, 242, 317, 325–26
Venetian Painters of the Renaissance (Berenson), 212–13
Venice, 124, 125–31, 133, 142, 144–45, 168–69, 185–87, 198–99, 219–20, 224, 243–44, 267–68, 283–84
Venus (Titian), 33
Venus de' Medici, 28
Vermeer, Johannes, 1, 200–203, 213, 234, 390
Verona, 185
Veronese, Paolo, 161, 174
Veronese Room, 151, 283, 379
Victoria, Queen, 81, 143
Vienna, 61, 62, 85, 144
Vienna Opera, 176
View of the Riva Degli Schiavoni and the Piazzetta (Guardi), 227–28
Vigilance Committee, 46
Villa Livia mosaic, 244–45, 274–75
Vincent Club, 301
Virgin and Child (Conegliano), 281
Virgin and Child (Ghiberti), 296, *296*
Virgin and Child in the Clouds, The, 280–81
Virgin and Child over Saints (Martini), 293
Virgin and Child with a Swallow (Pesellino), 197
Virgin and the Child with an Angel (Botticelli), 266–67, 299
Virginian, The (Wister), 177
Virgin of Mercy (Zurbarán), *166,* 166–67, 359
Vladimir, 83
Volpi, Elia, 332
von Arnim, Bettina, 70

Wadi Halfa, Egypt, 81–82
Wagner, Richard, 142–43, 176–77, 183, 243, 247
Wagner Society, 195
Ward, Sam, 102, 103, 104, 107
Warren, Fiske, 295–96
Warren, Gretchen Osgood, 42, 216, *295,* 295–96, 334–35
Warren, Ned, 296

Warren, Samuel, 233, 296
Warren, Susan, 92, 233, 274
Washington, D.C., 41, 89, 103–4, 137–38, 297, 339, 340, 348, 375
Washington Monument, 137
Waterston, Anna Cabot Lowell Quincy, 23, 25, 27
Waterston, Helen, 9, 23–30, 34–35, 37, 41
Waterston, Robert Cassie, 23
Watkins, Carleton, 99
Webster, Daniel, 43
Week Away from Time, A (Fields), 152
Weeks, Edward, 378–79
Wells, Ida B., 206
Wharton, Edith, 69–70, 100, 211–12, 243, 285, 286, 319, 335, 361
Whig Party, 47
Whistler, James Abbott McNeill, 2, 94–95, 128, 149, 151–52, 176, 195, 196, 203, 214, 224, 256, 268, 350, 374
White, Henry M., 262–63
White, Stanford, 192
White Fox, The (Okakura), 353
White Mountains, 89
Whitman, Sarah Wyman, 56, 91, 174, 211
Whitman, Walt, 191
Whittemore, Thomas, 352, 353, 364
Widor, Charles-Marie, 318
Wilde, Oscar, 127, 195, 214, 215

Wilkinson, J. G., 76
Wilson, Woodrow, 367
Wings of the Dove, The (James), 131, 303
Wister, Owen, 177
Woman, An Enigma (Sargent), 157–58
Woman of No Importance, A (Wilde), 127
Woolf, Virginia, 214
World's Columbian Exposition (1893), 204–7, 211, 213, 274, 290
World War I, 364–72, 375
Worth, Charles Frederick, 68, 69, 95, 131–32, 135, 176, 178, 184, 190, 223, 245, 286
Wunderkammer, 5, 290

Yeats, W. B., 342
Yellow Room, 143, 218, 224, 283, 294, 352
Yellowstone National Park, 99
Yokohama, 112–13
Yosemite, 98, 99
Yu-Hai, 119–20

Zorn, Anders, 136, 207–9, *208,* 212, 219–21, *220,* 223, 261, 275, 326–27, 350
Zorn, Emma, 208, 212, 219
Zurbarán, Francisco de, 161, 166, 275, 359

ABOUT
MARINER BOOKS

MARINER BOOKS traces its beginnings to 1832, when William Ticknor cofounded the Old Corner Bookstore in Boston, from which he would run the legendary firm Ticknor and Fields, publisher of Ralph Waldo Emerson, Harriet Beecher Stowe, Nathaniel Hawthorne, and Henry David Thoreau. Following Ticknor's death, Henry Oscar Houghton acquired Ticknor and Fields and, in 1880, formed Houghton Mifflin, which later merged with venerable Harcourt Publishing to form Houghton Mifflin Harcourt. HarperCollins purchased HMH's trade publishing business in 2021 and reestablished their storied lists and editorial team under the name Mariner Books.

Uniting the legacies of Houghton Mifflin, Harcourt Brace, and Ticknor and Fields, Mariner Books continues one of the great traditions in American bookselling. Our imprints have introduced an incomparable roster of enduring classics, including Hawthorne's *The Scarlet Letter*, Thoreau's *Walden*, Willa Cather's *O Pioneers!*, Virginia Woolf's *To the Lighthouse*, W.E.B. Du Bois's *Black Reconstruction*, J.R.R. Tolkien's *The Lord of the Rings*, Carson McCullers's *The Heart Is a Lonely Hunter*, Ann Petry's *The Narrows*, George Orwell's *Animal Farm* and *Nineteen Eighty-Four*, Rachel Carson's *Silent Spring*, Margaret Walker's *Jubilee*, Italo Calvino's *Invisible Cities*, Alice Walker's *The Color Purple*, Margaret Atwood's *The Handmaid's Tale*, Tim O'Brien's *The Things They Carried*, Philip Roth's *The Plot Against America*, Jhumpa Lahiri's *Interpreter of Maladies*, and many others. Today Mariner Books remains proudly committed to the craft of fine publishing established nearly two centuries ago at the Old Corner Bookstore.